TUTTLE

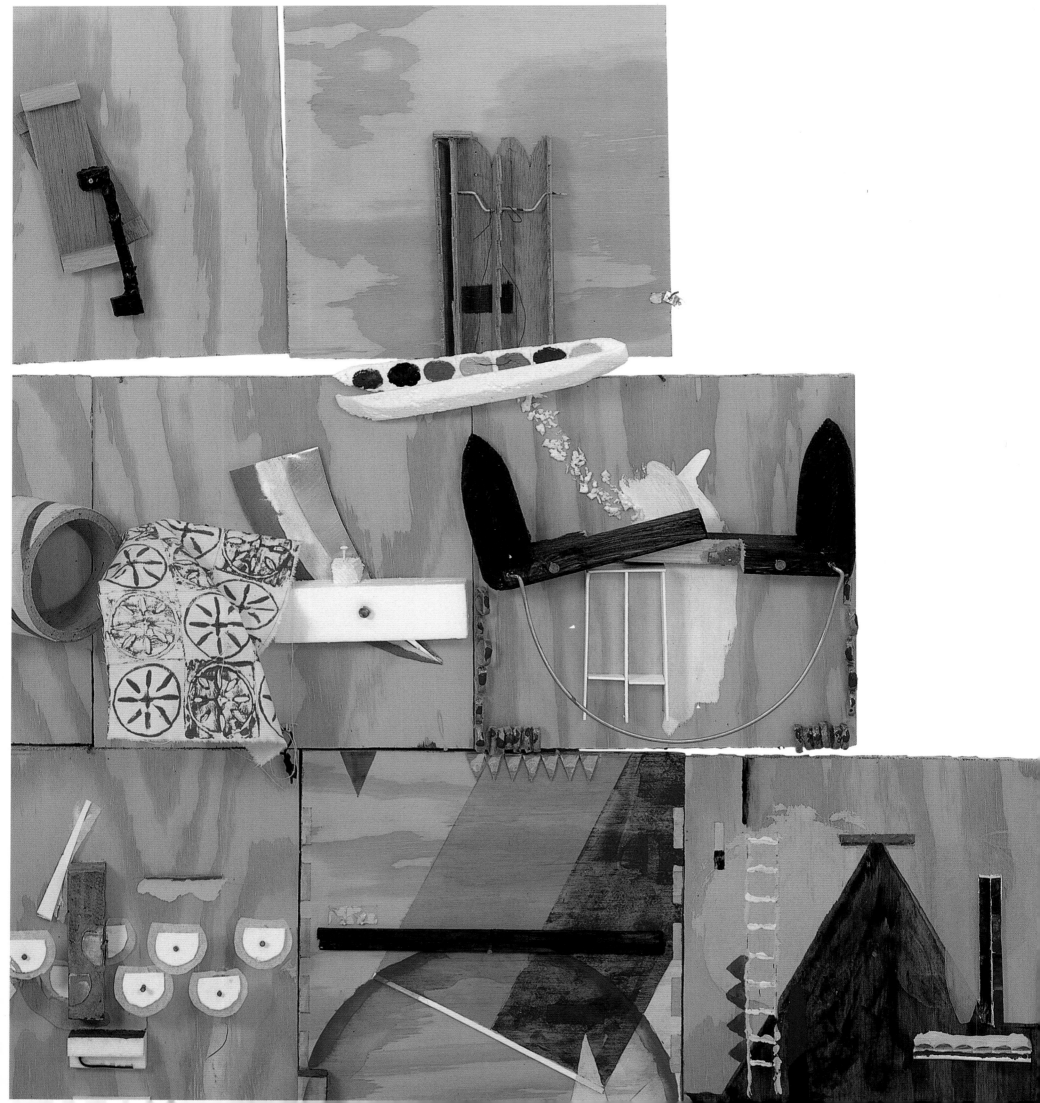

THE ART OF
RICHARD TUTTLE

edited by Madeleine Grynsztejn

with essays by Cornelia H. Butler Richard Shiff Katy Siegel Robert Storr

SAN FRANCISCO MUSEUM OF MODERN ART
in association with D.A.P. / DISTRIBUTED ART PUBLISHERS, INC., NEW YORK

CONTENTS

1960 1970 1980

1990

2000

Plates throughout in loosely chronological order

LENDERS TO THE EXHIBITION

Brooke Alexander, New York

The Art Supporting Foundation to the
San Francisco Museum of Modern Art

Angelo Baldassarre, Bari, Italy

John Berggruen Gallery, San Francisco

Rosalind and Walter Bernheimer, Waban,
Massachusetts

Marilena and Lorenzo Bonomo, Bari, Italy

The Edward R. Broida Collection

Donald L. Bryant, Jr., Saint Louis

Centre Pompidou, Musée national
d'art moderne—Centre de création
industrielle, Paris

Francesco Clemente, New York

Penny Cooper and Rena Rosenwasser,
Berkeley

Douglas S. Cramer

Crown Point Press, San Francisco

Elisabeth Cunnick and Peter Freeman,
New York

Des Moines Art Center

Ziba and Pierre de Weck, London

Frances Dittmer, Aspen, Colorado

Dr. J. Drolshammer, Zurich

Anne and Joel Ehrenkranz, New York

Mimi Floback, Tavernier, Florida

Fogg Art Museum, Harvard University
Art Museums

Fondation Cartier pour l'art
contemporain, Paris

FRAC Auvergne, Clermont Ferrand,
France

Peter Freeman, Inc., New York

Laura D. and Marshall B. Front, Chicago

Gilles Fuchs, Paris

Anthony Grant, Inc., New York

Didier Grumbach, Paris

Alvin Hall, New York

Susan Harris and Glenn Gissler, New York

Heinz Herrmann, Baden, Switzerland

Marguerite and Robert Hoffman, Dallas

Emanuel Hoffmann Foundation

Sammlung Hoffmann, Berlin

Hort Family Collection

Elsa and Theo Hotz, Zurich

Indianapolis Museum of Art

The Israel Museum, Jerusalem

IVAM, Instituto Valenciano de Arte
Moderno, Generalitat Valenciana,
Valencia, Spain

Kaiser Wilhelm Museum, Krefeld,
Germany

Kohlberg Kravis Roberts & Company

Kolumba, Cologne, Germany

Kunsthaus Zug, Switzerland

Kunstmuseum Winterthur, Switzerland

Collection Lambert en Avignon, France

Yvon Lambert, Paris

The LeWitt Collection, Chester,
Connecticut

Helen Marden, New York

Henry S. McNeil, Philadelphia

Greta Meert, Brussels

Byron R. Meyer, San Francisco

Modern Art Museum of Fort Worth

Moderna Museet, Stockholm

Museum of Contemporary Art, Chicago

The Museum of Contemporary Art,
Los Angeles

Museum of Contemporary Art, North
Miami, Florida

The Museum of Modern Art, New York

National Gallery of Art, Washington,
D.C., the Dorothy and Herbert Vogel
Collection

Brooke and Daniel Neidich, New York

Judith Neisser, Chicago

Norton Museum of Art, West Palm Beach,
Florida

Onnasch Collection, Berlin

Rainer and Susanna Peikert, Zug,
Switzerland

Heidi Pfanzelt, Germany

Private collections

Private collection, Cologne

Private collection, courtesy Fondation
H. Looser, Zurich

Private collection, courtesy Greenberg
Van Doren Gallery, Saint Louis

Private collection, Houston

Private collection, Mülheim/Ruhr,
Germany

Private collections, New York

Private collection, Switzerland

Christiane and Lothar Pues, Essen,
Germany

The Rachofsky Collection, Dallas

Craig Robins, Miami, Florida

Mary and David Robinson, Sausalito,
California

San Francisco Museum of Modern Art

San Francisco Museum of Modern
Art Research Library

Ulrike and Franziska Schmela, Düsseldorf

Spencer Collection, the New York
Public Library

Sperone Westwater, New York

Sprengel Museum Hannover, Germany

Stedelijk Museum Amsterdam

Stenn Family Collection, Chicago

Donna and Howard Stone, Chicago

Marion Boulton Stroud, Philadelphia

Shirley Ross Sullivan, San Francisco

Heinz Teichmann, Germany

Connie and Jack Tilton, New York

Richard Tuttle

Annemarie and Gianfranco Verna, Zurich

Joel Wachs

Walker Art Center, Minneapolis

Angela Westwater and David Meitus,
New York

Whitney Museum of American Art,
New York

The Ginny Williams Family Foundation,
the Collection of Ginny Williams

Mary and Harold Zlot, San Francisco

DIRECTOR'S FOREWORD

At a 1972 exhibition of Richard Tuttle's *Wire Pieces,* a visitor to Betty Parsons Gallery in New York approached the venerable dealer and asked whether the artist's work could be described as minimalist. Parsons curtly replied, "To hell with *isms,* Richard Tuttle is a great artist. He's in love with the new." This is a fitting summation of a career in which Richard has consistently bucked the dominant movements of his time to produce an enormously inventive, utterly unique body of work—one that sets into motion a series of questions that go to the very heart of what it is to make art. At times he has traversed the outer limits of impermanence and transience, seeking to create objects that are barely there yet reshape our perception of reality in fundamental ways, while at other moments he has undertaken large-scale, site-specific installations that are truly breathtaking in their formal sophistication and orchestration of multiple elements. As a by-product of these practices, the artist has also spurred an intensive rethinking of the long-standing, if not always perfectly aligned, partnership between artists and museums, pushing for a richer, more multifaceted form of collaboration. It is for these reasons that SFMOMA is particularly proud to be staging *The Art of Richard Tuttle,* the artist's first American retrospective since his 1975 exhibition at the Whitney Museum of American Art, New York. We have long been looking forward to the opportunity to present his striking work, and we hope that our audiences will take the same pleasure in encountering its distinctive beauty firsthand and considering its many implications.

Given the delicate nature of the artist's pieces and the complexities of installing them, we must begin by offering our heartfelt thanks to the lenders to the exhibition (listed opposite), who have graciously entrusted us with their works during the exhibition's national tour. We would like to think that their willingness to make such a profound commitment is due in no small part to the professionalism of the SFMOMA staff, which has demonstrated exceptional creativity and dedication in bringing this exhibition and catalogue to fruition. We also salute the Museum's board of trustees for their courage and foresight in supporting the project from its inception.

These same exemplary qualities have been demonstrated by our institutional partners in presenting *The Art of Richard Tuttle,* and we would like to express our gratitude to the individual directors and curators who have worked so closely with us in this venture, namely Adam D. Weinberg and David Kiehl at the Whitney Museum of American Art; Jeff Fleming at the Des Moines Art Center, along with Susan Lubowsky Talbott; John R. Lane and Charles Wylie at the Dallas Museum of Art; Robert Fitzpatrick and Elizabeth A. T. Smith at the Museum of Contemporary Art, Chicago; and Jeremy Strick and Cornelia H. Butler at the Museum of Contemporary Art, Los Angeles.

Of course, a project of this complexity and ambition cannot be realized without significant financial assistance from enlightened benefactors, which *The Art of Richard Tuttle* has had in abundance. The exhibition is generously underwritten by The Henry Luce Foundation, Mimi and Peter Haas, the Edward E. Hills Fund, Helen and Charles Schwab, and Agnes Gund and Daniel Shapiro. Additional support has been provided by the Andy Warhol Foundation for the Visual Arts, the National Endowment for the Arts, Shirley Ross Sullivan and Charles Sullivan, the Irving Stenn Family, the Kadima Foundation, the Frances R. Dittmer Family Foundation, Jeanne and Michael Klein, Tim Nye and the MAT Charitable Foundation, Craig Robins, Louisa Stude Sarofim, Sperone Westwater, Joseph Holtzman, and Emily Rauh Pulitzer. Finally, Anthony and Celeste Meier, the Neisser Family Fund, and Marion Boulton Stroud have supported the catalogue, while Carolyn and Preston Butcher provided accommodations in San Francisco for the artist.

I would like to conclude by commenting on the remarkable collaboration of Richard Tuttle and Madeleine Grynsztejn, SFMOMA's Elise S. Haas Senior Curator of Painting and Sculpture, who have worked together closely and creatively to realize this rewarding exhibition. Madeleine has proven herself to be an exceptionally sensitive observer of, and tireless advocate for, the artist's work, and we owe her boundless thanks for her unparalleled efforts. In turn, Richard has been exceedingly generous in offering his time, energy, and attention to all facets of the project. For this we are eternally grateful, but even more so for his creating art that continually surprises and provokes, and in so doing enables us to see the world with fresh eyes. NEAL BENEZRA

ACKNOWLEDGMENTS

Mounting an exhibition of Richard Tuttle's work requires a level of international collegiality and generosity that is everywhere evident in this project. I join Neal Benezra in thanking the lenders to the exhibition, both public and private, who have parted with cherished and fragile artworks for the sake of this undertaking. Many colleagues played a role in ensuring access to collections and facilitating loans. For their hospitality and guidance I am happily indebted to Elke Ahrens, Marja Bloem, Tiffany Chestler, Angela Choon, Dietmar Elger, Beate Ermacora, Matthias Haldemann, James Kelly, Ingrid Kolb, Yvonne Kopp, Kevin Lay, Matthew Marks, Franz Meyer, Tobias Meyer, Éric Mézil, Linda Norden, Laura Paulson, Evelyne Pomey, Grazia Quaroni, Robert Rainwater, Jonas Storsve, Poul Erik Tøjner, Jane Tschang, and Ulrich Wilmes. The holdings of the National Gallery of Art and Kolumba were crucial to the realization of our vision for the exhibition; I particularly thank Judith Brodie, Molly Donovan, Carlotta Owens, Hugh Phibbs, Andrew Robison, Alicia Thomas, and Barbara Wood in Washington, D.C., and Bernhard Mattäi, Joachim Plotzek, Katharina Winnekes, and Dagmar Wolff in Cologne. Others, including Lynn Corbett, Anita Duquette, Miguel Fernández-Cid, Adrienne Fish, Dwight Hackett, Cathy Leff, Joshua Mack, Magnus Malmros, Jeannie Greenberg Rohatyn, Ingrid Schaffner, Michael and Christine Tacke, and Lilian Tone, offered invaluable assistance with matters of archival and photographic research.

During the course of this undertaking, I have incurred many debts to gallery representatives, curators, scholars, critics, collectors, artists, and friends whom I value greatly and whose contributions were extremely helpful. Special acknowledgment goes to that distinctive group of people who have demonstrated a long-standing devotion to the artist and his work; they have made an immeasurable difference in my thinking and greatly increased the pleasure of my research. I extend warmest thanks to Kathan Brown, Jennifer Gross, Joseph Holtzman, Brenda Richardson, Jock Truman, and Marcia Tucker. I would also like to recognize Susan Harris, who generously volunteered astute observations and important archival materials, and Peter Freeman, whose keen intelligence and munificence have been tremendously supportive. Mel Bochner, Arne Glimcher, Klaus Kertess, Brice Marden, Robert Pincus-Witten, and Kiki Smith shared vivid recollections during interviews and casual conversations. Christine Jenny has been a valuable friend and resource throughout the preparation of the exhibition, providing intelligent insights based on her doctoral work on Tuttle as well as assistance in gathering archival materials, viewing collections, and securing loans. I have also been sustained by the following individuals, all of whom lent an ear, shared ideas, or gave suggestions and encouragement along the way: Richard Armstrong, Michael Auping, David Frankel, Ann Goldstein, Dieter Schwarz, Ann Temkin, and

Sylvia Wolf. Finally, no Tuttle exhibition would be possible without the participation of Herbert and Dorothy Vogel, who have given graciously of their time, thoughts, and access to their wonderful apartment. Making their acquaintance has been one of this project's greatest rewards.

To gather together a comprehensive presentation of more than forty years of Tuttle's work, I have turned for assistance to the artist's gallery representatives, past and present, each of whom has been unfailingly helpful in providing information and documentation. Angela Westwater and her staff at Sperone Westwater have been a constant source of support and insight; she, David Lieber, and Karen Polack deserve particular gratitude for their unparalleled assistance in locating important artworks, facilitating arrangements, and providing materials. Annemarie and Gianfranco Verna of Annemarie Verna Galerie have my utmost thanks for their extraordinary generosity and expert advice throughout the project; they are also major lenders to the exhibition. Ulrike Schmela of Galerie Schmela has been an invaluable ally in securing important loans and has also shared key works from her own collection. Marilena and Lorenzo Bonomo, with Vittoria Fanelli, gracefully welcomed us to their gallery in Bari, Italy, and have also lent significantly to the show. Jack Tilton and his staff—Dana Gramp, Michelle Hailey, and Nicole Russo—have been staunch supporters of this project, and the exhibition has benefited immeasurably as a result. Other gallery representatives who have presented Tuttle's work over the years paid gracious and diligent attention to our inquiries and provided much-needed support and materials. We are particularly indebted to Brooke Alexander, with Owen Houhoulis; Irving Blum; Mary Boone, with Ron Warren; Elisabeth Cunnick; Ugo Ferranti; Joseph Helman; Rhona Hoffman; Fredericka Hunter; Erhard Klein; Michael Kohn; Tomio Koyama; Yvon Lambert, with Nicolas Nahab; Lawrence Markey; Greta Meert; Anthony Meier; Victoria Miro; Valerie Wade; and Daniel Weinberg.

My superb colleagues at SFMOMA claim a significant share in realizing this intricate and complicated project, and I am grateful to them for their goodwill and enthusiastic support. Essential to an ambitious undertaking of this kind are the encouragement and sage counsel of director Neal Benezra, to whom I owe a special debt for allowing the project to develop to its fullest potential. The seeds of the show were sown in 2000 under the tenure of former director David A. Ross. Thanks to the wise oversight of Ruth Berson and Marcelene Trujillo, with Emily Lewis and Jillian Slane in attendance, the exhibition and tour have remained on excellent organizational footing throughout. Heather Sears has done a splendid job with registrarial responsibilities, demonstrating patience in coordinating the transport of artworks and ingenuity in working through the difficult logistics of touring the show. Under Jill Sterrett's gifted direction and foresight, conservators Michelle Barger, Gwynne Barney, and Amanda Hunter Johnson presided over works of unorthodox material and construction with exceptional care, judiciousness, and creativity. Also working tirelessly on behalf of the project have been Barbara Rominski and the staff of the SFMOMA Library. Susan Backman and Don Ross provided crucial imaging assistance during the planning phases of this exhibition. The exemplary installation was overseen by Kent Roberts and John Holland, who, aided by a hard-working team of installers and by preparator Greg Wilson, brought to the task their superb organizational abilities and professional dedication. James Williams and Jennifer Sonderby deserve thanks for their conception of the graphics and printed materials for the exhibition's presentation in San Francisco. Julie Charles, Tana Johnson, Peter

Samis, and Gregory Sandoval created a rich and innovative schedule of educational programming to accompany the retrospective. J Mullineaux and his staff—Elizabeth Epley, Jonathan Lehman, Andrea Morgan, Lynda Sanjurjo-Rutter, and Misty Youmans—have risen wonderfully to the challenge of funding the exhibition. I also thank Nancy Price, Libby Garrison, and Robyn Wise for bringing this presentation to the attention of the public through their media relations and marketing efforts.

In the Department of Painting and Sculpture, curatorial associate Tara McDowell has my deep respect and heartfelt thanks for her extraordinary contributions. Her coordination of every aspect of the presentation and the creative thinking and writing she brought to the catalogue have played an inestimable role in the development of the exhibition. I salute her professionalism, talent, tenacity, and humor. I am also indebted to Hae-Jin Kim for her graceful, steady, and calming influence as she provided excellent research and administrative assistance under tremendous pressure. The other members of the department—Janet Bishop, Jill Dawsey, and Joshua Shirkey—have lent support in countless ways, offering advice and encouragement and relieving me of myriad tasks by taking on additional burdens themselves. I also thank Suzanne Feld for her participation during the early stages of the project.

I owe profound thanks to those in SFMOMA's Publications Department who took on the extremely demanding task of producing this catalogue, particularly Chad Coerver, who was remarkably patient, generous, insightful, and funny throughout the process. I owe many thanks to Karen Levine for adding sharpness and clarity throughout the design and editing process with her voluminous fact-finding efforts. I am also greatly indebted to Lindsey Westbrook for her tireless determination and detailed commitment to the project. With her keen eye and skillful oversight of the volume's production, Nicole DuCharme has contributed immeasurably to our efforts. Without the care and intelligence of these individuals, this book would not exist. The Publications team joins me in thanking Joseph N. Newland for his astute and thoughtful editing; Lori Cavagnaro for assembling the most comprehensive Tuttle exhibition history to date; and Elaine Luthy for constructing a useful and refined index under truly challenging time constraints. We also thank Megan Carey and Olga K. Owens for their invaluable assistance in compiling footnotes and performing bibliographic research. If the catalogue does visual justice to Tuttle's art, it is thanks to the elegant design work of Lorraine Wild, Robert Ruehlman, and their associates at Green Dragon Office. Cornelia H. Butler, Richard Shiff, Katy Siegel, Elizabeth A. T. Smith, Robert Storr, Adam D. Weinberg, and Charles Wylie deserve our gratitude for their scholarly and original contributions to the publication. We are pleased to have D.A.P. as our partner in publishing this catalogue, and we salute Sharon Gallagher, Donna Wingate, Elisa Leshowitz, and their colleagues for their passionate support of the project.

A corps of interns and volunteers provided able and enthusiastic assistance with research and administration. We owe particular thanks to Phillip Bloom, Felicia Palmer, Emily Scheinberg, and Anuradha Vikram as well as to Carina Cha, Adrianne Hamilton, Lauren Jacks, Lise Jeantet, Jeanne Nidorf, Tiffany Pek, and Georgina Perrins. Denise Cassuto, Eveline L. Kanes, Miriam Paeslack, Cornelia Sterl, and Suzanne Stolzenberg provided much-appreciated translations of important German and Italian texts.

There is no way for me to give adequate thanks to Tom Shapiro, whose perceptive comments and unfailing and vital encouragement, patience, and support have helped me in every way. I also wish to thank Mei-mei Berssenbrugge for her valuable contributions to this project. She and Martha Tuttle deserve much gratitude for welcoming me into their home and for their generous cooperation, understanding, and forbearance throughout the organization of this exhibition.

My greatest gratitude is extended to Richard Tuttle, whose art and ideas inspired this project in the first place. Richard has until now controlled much of the treatment of his own work in exhibition, which is why I thank him for his generosity in agreeing to a "traditional" retrospective format, and I am all the more grateful for his entrusting me as a partner in this venture. He has contributed to the exhibition through the creation of artworks, endured countless conversations and interviews, given unstintingly and graciously of his time, and assisted in innumerable other ways. For his extraordinary efforts, and for the opportunity to be enriched by his friendship and his rigorous and deeply felt art, I am profoundly grateful. MADELEINE GRYNSZTEJN

1–10 **Untitled** 1964 each 3 x 3 x 3 in.

by Madeleine Grynsztejn

A UNIVERSE OF SMALL TRUTHS

Not Ideas about the Thing but the Thing Itself. WALLACE STEVENS, 1954[1]

To make something which looks like itself is, therefore, the problem, the solution.
RICHARD TUTTLE, 1972[2]

It seems almost unfair to attempt to characterize a body of work that has so assiduously evaded categorization for more than forty years. The relentless diversity of Richard Tuttle's art—its prolific invention and its cross-fertilization of painting, sculpture, drawing, installation, print-making, bookmaking, and design—speaks to an unwillingness to be limited to a particular description or class that goes to the very heart of his enterprise. *Independence*—from any aesthetic or cultural stricture such as traditional media categories, conventional artistic materials, or the separation of pictorial reality from the real world—is precisely the point of Tuttle's artistic endeavor. Independence is what drives the radically ambiguous nature of his work, which is neither sculpture nor painting nor drawing, neither two- nor three-dimensional, but a vivid and always-changing combination of all of the above.

Since 1964 Tuttle has finessed an impure, indeterminate art that hovers between all manner of seeming opposites: the pictorial and the literal, matter and atmosphere, fine art and the trash heap, the blunt material fact of reality and the metaphorical phantasm of representation, the order of an integral form and the chaos of its utter dissolution, the mystical and the earthbound. Tuttle's refusal to touch down on one side or another of these dichotomies is not a matter of ambivalence or indecision—it is a matter of blithely yet willfully sustaining in his work a sense of autonomy and vitality, conditions that arise precisely from this state of being "in between." The more a work of art purposefully oscillates between taxonomic and conceptual categories, the better its chances of escaping classification altogether and thus remaining a free agent whose deepest meaning is freedom itself. In order for work such as this to be successful, however, there falls on it the burden or pressure, perhaps greater than on other works of art, to resolve its ambiguities, if not in favor of known categories, then as a self-defined, emphatic visual entity. This is what Tuttle has undertaken his entire artistic career: the invention of a particular thing or concept or "new Visual Category"[3] whose specific yet enigmatic character marks it as a unique gestalt and impresses us with its being *real*.

Look across the entire spectrum of Tuttle's work and you see a lexicon of singular invented forms that stand only for themselves, without explicit reference to a recognizable image or universal. With every work he makes, he strives to create forms that exist on a par with other unique things in the world—as definitive and self-evident as a leaf or a shadow yet not of nature.[4] These objects vaunt an inherent force and reason whose "content" derives from their own compelling features—line, shape, volume, color, and texture—and they enter the world as fully formed entities in tune with the real physical parameters of the space in which they are located. They are *characters,* in every sense of the word: works of uncanny individuality, with eccentric, self-congruent

traits, specific features, "personhoods," even, showing qualities of fortitude and sincerity that pertain not just to them as individuals but to Tuttle's work as a whole and to his artistic practice. I also use the word character to point to the work's declarative and emblematic qualities, the fact that it looks and acts much like a word or a visual sign within an alternative visual language.[5] Ideogrammatic in nature, Tuttle's work prompts an urge to recognition—which, however, is always and deliberately forestalled. An eloquent expanding field deliberately resistant to conventional transcription, this unclassifiable, ineffable art lies outside words. If Tuttle's works approach anything already known, it is a particular *feeling* or spirit—the animating principles of ebullience, alertness, vivacity, tenderness, and poignancy, here made concretely manifest.

What I am describing, of course, is abstract art at its best and most profound. Yet surprisingly, even though abstraction is very much a part of our daily lives, both as a long-standing art-historical practice and as a pervasive visual language in the world, it continues to pose a challenge to public reception. Generally speaking, many viewers remain distrustful of autonomous forms bearing their own commentary and proffering meaning of a different sort from that provided by mimetic representation, with its more traditional associative readings. And yet, as emphatically anti-illusionist as Tuttle's art is, does it not reveal itself completely, and with a kind of pictorial honesty and generosity that invites rather than rebuffs the viewer? To a piece, his works are effortlessly knowable in constitution—they are structurally transparent, willfully legible, and also fortified by the stuff of our own world, the distinctive and tactile properties of recognizable material, weight, and texture. These objects present themselves to us fully, and the result, if anything, is a higher rather than lesser coefficient of reality—a far cry from the elitist opacity of which abstraction is sometimes accused. Yes, the work lacks recognizable representational imagery, but in eliminating such traditional references it also and at the same time opens up an alternate mode of understanding, one less dependent on received wisdom and outside analysis and more defined by a fresh, immediate, and primary practice of observation, sensation, and symbolization—a root act of experience, if you will.

Richard Tuttle was born in 1941 and grew up in Roselle, New Jersey, the second of four children in an educated family that was comfortably well-off. Tuttle's mother came from Bethlehem, Pennsylvania, a center for Moravian mysticism that produced many poets, including the imagist writer H.D. (Hilda Doolittle). Poetry was ever-present in Tuttle's early life; he recalls his maternal grandmother keeping newspaper clippings of poems in her pockets. His paternal grandfather, too, loved poetry, and he gave drawing lessons to Tuttle's elder brother. In fact, he was the first person that the artist saw drawing, when Tuttle accompanied his brother to these lessons. To a boy of four or so, the wonder of a line emanating from the hand to form a recognizable image made a deep and indelible impression: "I was so struck with what was in front of my eyes...it gave me the idea that

there's an intelligence in the hand."[6] Tuttle's father, an engineer by profession, and his mother, a homemaker, were both children of the Great Depression, and also religious. The family can trace its paternal lineage back to an early-seventeenth-century British arrival in Massachusetts, its maternal lineage to Germany in the early eighteenth century.

Lutheran, Congregationalist, and Presbyterian faiths ran thick through the family, and these Protestant roots are not to be lightly dismissed as a backdrop for Tuttle's development. Calvinist doctrine, encompassing notions of labor, salvation as a personal responsibility, and in particular an emphasis on individual experience without the intercession of dogma or ceremony, fed Tuttle's thinking and, eventually, his artistic strategies.[7] Take his approach to material: a democratic aesthete, Tuttle sees poetic and imagistic value in all manner of things, but specifically in the kind of stuff one would normally discard: the litterings of the workspace, the remainders from studio activity, outright trash—materials that would otherwise be lost were it not for the artist salvaging them. This activity of redeeming "without the rhetoric of redemption,"[8] a central, constant aspect of Tuttle's methodology, invests worthless elements with an unexpected significance that informs the work's content. His production's prolificness—which he considers necessary for participation in a democratic society—may also recall the Protestant work ethic that posits industry as one of the foremost vehicles for salvation.

Tuttle had to look no farther than his family tree for an artistic equivalent to the idea of religion as a matter of the individual standing directly in front of God without mediation: he counts

plate 11

the luminist painter John Frederick Kensett among his paternal ancestors. Luminism, an indigenous and distinctly American art movement of the 1850s and 1860s, was tied to American transcendentalist philosophy and its abolition of the ego for the sake of a reconciliation with the Divine.[9] This spiritual quest had an empirical basis in the intense contemplation of "spirit in the fact,"[10] that is, in the observation of nature, particularly its lambent light (hence the palpable light that seems to emanate from these landscape canvases). Certain aspects of the luminist ethos have endured in American art, and Tuttle seems to share its impetus to achieve an unmediated, noninstitutionalized access to the manifest world. For the Luminists

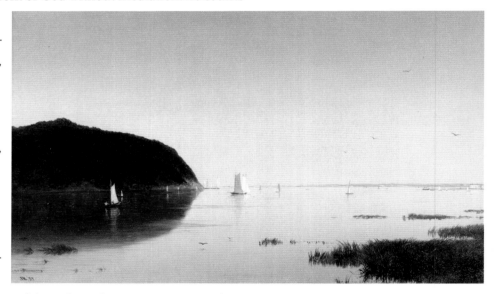

(conditioned as they were by the representational strategies of their day), this aspiration is evident in the quality of anonymity inherent in an "egoless" brushstroke that excises the hand of the artist. Tuttle's method is also self-effacing: no "signature style" interferes with his attempts, in making his work and in shaping the viewer's experience of it, to achieve an *a priori* free experience that permits an absolute being-there. Tuttle has made it his stated wish to get out of the way of his work,

11 John Frederick Kensett **Shrewsbury River, New Jersey** 1859
Oil on canvas, 18 1/2 x 30 1/2 in.
Collection of the New-York Historical Society, on permanent loan from the New York Public Library

to "brush aside the utilitarian symbols, the conventional and socially accepted generalities, in short, everything that veils reality from us, in order to bring us face to face with reality itself."[11]

All this puts Tuttle in the tradition of American Transcendentalism, which combines equal doses of metaphysics and pragmatism in its attempt to give specific form to the immaterial. It also makes him something of a mystic. To understand Tuttle's work, one must take it whole, including the artist's attachment to the mystical in a time when there is a general shyness among the avant-garde about art that claims a spiritual role. Tuttle himself is unapologetic: "The job of the artist," he claims, "is to come up with ideas of how the mystic can be accommodated." "The main *subject* of my work," he has also said, "is this kind of perfection, it's an experience I've had, it's a kind of metaphysical, or maybe someone else could say a 'mystical' experience that's happened, say, three times or four times in my life and I would like it to happen every day and I would like to be able to make a picture or a sculpture where other people can have that experience because when you have that it also clears the mind."[12] Tuttle's work, as if to sustain in suspension the answer to the question of spirituality in a secular age, hovers between the unsentimentally material or roughly secular and the headily exalted or transcendental—precisely the location that might be described by the Hindu phrase *neti neti* ("not this, not that"), where Brahman, or the Emersonian Oversoul, or the Divine, may be located.

Tuttle's first serious face-to-face introduction to contemporary art took place in 1958; while considering colleges as a teenager he traveled to Pittsburgh and visited the Carnegie Institute of Technology and the 1958 Pittsburgh International (known today as the Carnegie International), which that year was organized by Gordon B. Washburn, one of the preeminent curatorial talents

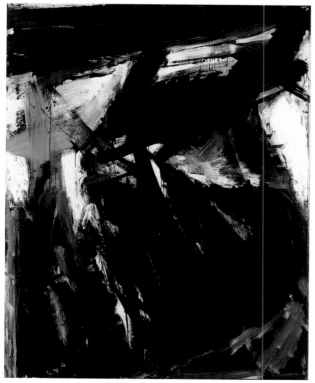

of the 1950s and 1960s. Tuttle recalls being particularly impressed with the work of Franz Kline, a key protagonist in the movement of Abstract Expressionism. The young Tuttle responded to Kline's forceful calligraphic line, even in out-scale painted form. Tuttle would have also undoubtedly noticed the scarred, sand-covered canvases of Antoni Tàpies, winner of the First Prize in Painting in 1958, thus setting into motion an early awareness of the canvas as raw material and not simply as ground for illusionistic effects.

In the end Tuttle chose to attend Trinity College, in Hartford, Connecticut, from 1959 to 1963. While the college's curriculum was conservative and offered him little of interest, he benefited from extracurricular artistic activities, designing and painting sets for theater productions and serving as editor and art editor for two editions of the college yearbook. The 1963 *Trinity Ivy*, designed by Tuttle, combined

plate 12

12 Franz Kline **Siegfried** 1958
Oil on canvas, 103 x 81 1/8 in.
Carnegie Museum of Art, Pittsburgh,
gift of Friends of the Museum

plate 13 his own landscape-inspired <u>woodcut illustrations</u> with a poem by a fellow student, marking an early interaction of his own work with poetry and giving him his first opportunity to test the limits of book design and production.

Of critical importance to Tuttle's intellectual and artistic growth were his frequent visits to the Wadsworth Atheneum in Hartford, which had not long before hired Samuel J. Wagstaff Jr. as curator of paintings. Wagstaff and Tuttle met in Tuttle's junior year at Trinity, when the two men participated in a radio roundtable discussion on the topic of contemporary art. (Tuttle was the student representative on the panel.) Thus began a close friendship and a critical art education for Tuttle: "Weekends were spent in New York witnessing the birth of Pop and the classic period for 'Happenings' and meeting the artists of that time."[13]

Wagstaff soon introduced Tuttle to an artistic community that was quite small by today's standards but extraordinarily heterogeneous and lively. Vivid and dizzyingly contradictory directions in the arts existed simultaneously, from the newly celebrated Pop movement (which made its debut in the winter of 1962) to nascent strains of Minimalism, all of which Tuttle experienced just a few years before these impulses settled into competing dogmas and rigid polemics. This highly diversified and energetic proliferation of new forms of expression reacted against mid-century modernism's aesthetic of self-referentiality, autonomy, and subjectivity predicated on an authorial self. It pointed, by contrast, to the advent of a "youth generation" whose questioning of authority and institutional hierarchy would come to full bloom in the counterculture of the mid-1960s. In this climate of open possibilities arose "a desire for a kind of *tabula rasa* that would allow not just a new art style or movement, but new ways of conceiving of, experiencing, and distributing art."[14] Central to these new efforts, and what the many-faceted artistic experiments of the late 1950s to early 1960s held fundamentally in common (from Jasper Johns, Robert Rauschenberg, and Allan Kaprow to Frank Stella and the Minimalists) was a strategy of literalness that abjured metaphor and allusion in favor of an insistent materiality and formal transparency. The emerging avant-garde asserted the actual, the immediate, and the firsthand as extensions of the desire for a concrete and irreducible experience freed from history, through which one could access a bedrock of identity and certainty.[15] Reality, in its material-physiological facticity rather than its interior interpretative sense, became the touchstone for a generation of artists and intellectuals. The overturning of the preconceived and the illusionistic in favor of an oppositional emphasis on the artwork's exterior capacities became a hallmark of the most advanced art forms of the early to mid-1960s, and would stay with Tuttle throughout his life.

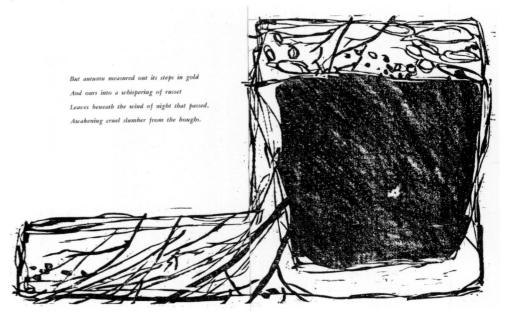

But autumn measured out its steps in gold
And ours into a whispering of russet
Leaves beneath the wind of night that passed,
Awakening cruel slumber from the boughs.

Tuttle also witnessed new and varied examples of artworks that deliberately sought to blur the traditional boundaries separating painting and sculpture, the second and third dimensions, and—by extension—illusion and reality. The groundbreaking nature of the project is evident in efforts to find a new nomenclature to describe its cutting-edge aesthetic—not sculpture or painting but "specific objects" (Donald Judd), "proposals" (Dan Flavin), or "structures" (Sol LeWitt).[16] These investigations into a novel pictorial-sculptural realm were being given their most serious consideration by artists of the soon-to-be-baptized movement of Minimalism, a trend to which Tuttle would have been particularly attuned given that his friend and mentor Sam Wagstaff would shortly curate what has come to be acknowledged as the first exhibition to examine the minimalist aesthetic, *Black, White, and Gray*.[17] In fact, across Tuttle's diverse and disparate oeuvre, one fundamental constant is the merging of the pictorial and the sculptural in the form of the low relief. This physical structure is visible from the start of Tuttle's artistic trajectory in the slightly raised "constructed paintings" in his first solo show of 1965. It continues on through the delicately volumetric wire works of the early 1970s and collage pieces of the late 1970s, the wall- and floor-bound assemblages of the 1980s, and in particular the shallow, layered wood constructions of the 1990s to the present.

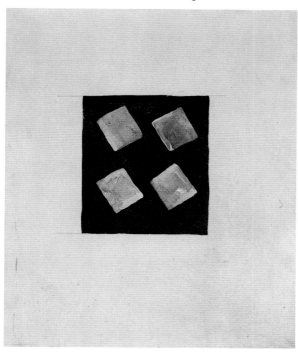

After graduating from Trinity in the spring of 1963, Tuttle moved into a tiny studio in New York City, on East Seventh Street between First and Second avenues, and enrolled at the tuition-free Cooper Union. In the realm of young work but nevertheless instructive are early paintings such as *Four Squares* of 1964, which bears the orthogonal shapes that were the order of the day in avant-garde circles but sets them on the bias, so that they form diamond-shaped elements floating on a black ground against a white canvas. It was around this time that the twenty-two-year-old artist produced the work that marks the start of his mature artistic career, his untitled paper cubes of 1964. Tuttle created this group of palm-size cubes by variously cutting and folding sheets of cardstock in an intensive investigation of the orthogonal. Depending on the degree of perforation, the compositions run from fairly compact to very open—a strategy of variation within a repetitive modular system that would place Tuttle close enough to the minimalist camp for the paper cubes to be reproduced in Barbara Rose's 1965 article "ABC Art" in *Art in America,* one of the definitive statements codifying and consolidating the movement.[18] The delicacy of the cubes and their handmade quality distinguishes them somewhat from Minimalism as it is generally understood, and may entail a sense of expressive content; but the fact that they are hollow is squarely in keeping with minimalist tenets, and literally

plate 14

plates 1–10, 39

plate 15

and metaphorically excludes any notions of "interiority" that would align them with the by-then outmoded psychological model of the unified, humanist self, a concept at the center of Abstract Expressionism. Whatever interiority is made visible here is absolutely literal, not conveyed through heavily brushed metaphors for subjectivity.

Tuttle's paper cubes were precocious in evincing several characteristics that have consistently informed his work since then. There is, first of all, a delicate yet striking balance between volume and void, negative and positive space: in puncturing the cube structure to reveal its interior without disassembling any one of its planes, Tuttle created a three-dimensional work that looks as if it is made as much out of air as out of mass. This effect has become an integral element of Tuttle's repertoire, as have a disarmingly exposed structure that actively resists illusion, a daring embrace of modest size, and the use of paper (commonly a surface for drawing) as a sculptural material (as opposed to a tougher and more traditional wood or metal medium). Significantly, too, the paper cubes were meant to be held, making for an aesthetic experience that is literally firsthand, as free as possible from preconceptions or intermediaries, whether artistic, historical, or immediately physical.[19] In exploring ways of giving immediate experience a primary place in aesthetics, Tuttle, like other artists of his generation, landed on the strategy of sensory engagement, making works that privilege touch over the traditionally sovereign sense of sight and engage raw sensation ahead of detached intellect. While the paper cubes actually exercise touch, Tuttle's work would henceforth also actively recall touch—primarily by employing tactically familiar materials drawn from everyday life. This is the prime motivating factor driving his use of fabric and textiles, not only as the standard cloth support for painting but as an active compositional surface element carrying an inherently tactile coefficient that speaks directly to our bodies, allowing us to grasp the work in terms of touch as well as sight.[20]

It was at this time that Tuttle conceived the idea of becoming a pilot, an enthusiasm that led him to enlist in the United States Air Force. Immediately upon exiting the Whitehall Street Induction Center in Lower Manhattan, Tuttle—an otherwise shy young man—reached for a public phone, called the artist Agnes Martin, introduced himself, and asked if he might visit her in her studio on nearby South Street. Tuttle was in his twenties, Martin in her fifties. The younger artist respected Martin's artistic individualism: "She basically stood alone. That was a quality I admired."[21] Martin's allover gridded paintings had come into their own only a year before, in 1963. For Tuttle, what set them apart from their various affiliations—ranging from the hard-edge geometric abstractions of former Coenties Slip studio-mates Ellsworth Kelly and Jack Youngerman to works by younger Minimalists with whom she shared exhibitions—was their infusion of what Tuttle calls "a spirituality of the mind" into reductive compositions and Martin's attempt to break down visual form to its utter basics.[22]

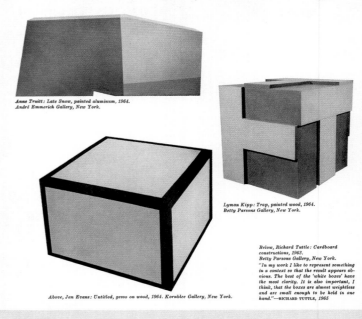

Anne Truitt: Late Snow, painted aluminum, 1964.
André Emmerich Gallery, New York.

Lyman Kipp: Trap, painted wood, 1964.
Betty Parsons Gallery, New York.

Above, Jan Evans: Untitled, gesso on wood, 1964. Kornblee Gallery, New York.

Below, Richard Tuttle: Cardboard constructions, 1963.
Betty Parsons Gallery, New York.
"In my work I like to represent something in a context so that the result appears obvious. The best of the 'white boxes' have the most clarity. It is also important, I think, that the boxes are almost weightless and are small enough to be held in one hand."—RICHARD TUTTLE, 1965

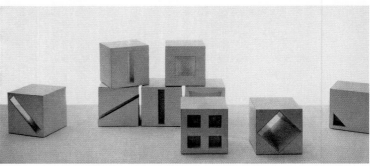

Her geometric vocabulary was rooted in her desire to give form to the immaterial, and to this end she made use of elements that had no correlates in the physical world—the point and the straight line.[23] Such metaphysical aims aligned Martin with her abstract expressionist peers, even as she dispensed with their stress on heroic subjectivity, opting instead for the quieter, detached ideals of Buddhism, Taoism, and Zen, interests she shared with her gallery-mate Ad Reinhardt.

Tuttle's own personal and artistic temper disposed him toward Martin's program. During their first encounter, he bought a small drawing of hers called *Grass* (1963), a nine-by-nine-inch work on paper comprising multiple vertical and horizontal lines. "I just sensed there

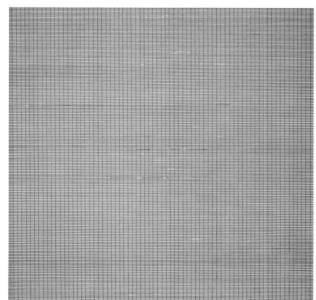

was something to be learned from it," the artist has said, and in fact Martin's line was of crucial interest for him. "Agnes made us able to see line for itself," he says. "She made line apparent."[24] Like Martin, Tuttle gives primacy to line as an organizing element. He sees himself as having "completed" her line through his own, the basis for his work in Postminimalism. Tuttle shares much else with this kindred spirit a generation older than he: writing on Martin in words equally appropriate to himself, he discerns an impulse to give full rein to "the nonobjective as [much] as the objective world.... What do we see then? An emotion—for example, the truth of happiness."[25] Martin's description of working "by inspiration" as opposed to "by intellect—by comparisons, calculations, schemes, concepts, ideas" could in turn apply equally well to Tuttle.[26] Both artists create images that are utterly concrete yet evocative of the most subtle abstract states. Sensing the increasingly crushing stance of a rationalist Minimalism, Tuttle found an oppositional model in the work of this aesthetic fellow traveler, and their mutually nourishing friendship continued until her death in 2004.

Martin contributed to the development of Tuttle's artistic career in another crucial way when she introduced the young artist to Jock Truman, then director of Betty Parsons Gallery in New York. Tuttle began working for Parsons as a gallery assistant in the fall of 1964, following a twelve-week tour of duty with the U.S. Air Force that resulted in his honorable discharge. His experiences at the gallery would be fundamental and formative to his artistic evolution. Founded by Parsons in the fall of 1946, by the mid-1950s the gallery had become the leading showcase for the work of the Abstract Expressionists, whose exhibitions there changed the course of modern art.[27] When Tuttle began working at the gallery, a number of Abstract Expressionists were still frequenting it—especially Barnett Newman, a regular visitor and advisor even after he stopped exhibiting there in 1951. In a 1946 essay Newman wrote for Parsons's inaugural show, which he also curated, on Native American art of the Northwest Coast, Newman described how in such work "a shape was a living thing, a vehicle for an abstract thought-complex."[28] This comment speaks to the philosophical underpinnings of the gallery with which Tuttle would exhibit from 1965 until Parsons's death in 1982. Here art was seen as part of a fundamental, universal, and ancient human drive toward the

plate 16

15 Page from the article "ABC Art" by Barbara Rose, **Art in America** magazine, October–November 1965, showing (at bottom) Richard Tuttle's **Untitled** (1964) among works by Anne Truitt, Lyman Kipp, and Jan Evans

16 Agnes Martin **Grass** 1963
Ink on paper, 9 x 9 in.
Collection of Richard Tuttle

independent object carrying symbolic value. "These paintings," Newman explained of his own works, "are not 'abstractions,' nor do they depict some 'pure' idea. They are specific and separate embodiments of feeling, to be experienced, each picture for itself. They contain no depictive allusions."[29] Likewise, Tuttle eschewed representation and associations in an effort to make a specific object that would prompt the experience of absolute presentness, overlaid with a metaphysical experience of being in the here and now.

Betty Parsons Gallery became a source of artistic encouragement and inspiration, "a harbor," Tuttle has said. The gallery's commitment to the intangible and intuitive aspects of art emboldened the young artist in the same direction, even as his own generation's revolt against the legacy of Abstract Expressionism was already well under way. At the time of Tuttle's contact with Newman, the older artist enjoyed high standing among a younger generation that credited him with having set the stage for Minimalism; what they ignored, however, and what Tuttle on the other hand found compelling, was the emotional content that drove the reductive material facts of Newman's pictures. To fully comprehend Tuttle's work, one must take into account his self-appointed role as something of the preserver, the last of the Betty Parsons "school" and its humanist program. He stands out among his peers for the way he consciously kept his feet in both worlds, staying close to the Parsons circle while remaining true to his own time and nature—for while his admiration for the New York School was unshakable, he could not be disposed to its generational bravura and moral absolutism.

In the manner of old-fashioned galleries, Parsons's artists socialized with one another, and as such the gallery became a social bedrock for Tuttle. There was Parsons herself, with her talent to detect "with seismographic delicacy...this quality—which for want of a better word we must call 'poetic,'"[30] to whom Tuttle turned for the wisdom that her decades-long involvement in the art world could provide. There was also Ruth Vollmer, an artist who showed with Parsons and who held a European-style salon in her Central Park West apartment, where she gathered artists, scientists, and musicians. Here Tuttle would come to know the young artists who would become his peers in Postminimalism: Mel Bochner, Eva Hesse, and Robert Smithson. Interestingly, however, Tuttle was not part of any studio community—still in learning mode, he sought out not like-minded artists but "eyes": "The most important is to find someone who has good eyes. Someone who can see."[31] His circle of mentors past and present includes not only Wagstaff, Martin, and Parsons, but also the decorative-arts dealer John Gordon, whose gallery was located across from Parsons's and who imbued in Tuttle the belief that an object anchors the ineffable values of a larger culture; Washburn, who as director of Asia House Gallery hired Tuttle as an exhibition installer, thus facilitating the artist's first direct contact with exceptional examples of Asian art and initiating his lifelong engagement with Eastern aesthetics and metaphysics; and, particularly since 1970, collector Herbert Vogel, whom Tuttle regards as his most important extra set of "eyes that can see."

On his return to New York from his military tour of duty, Tuttle had found a new place to work on Eighth Avenue between Twenty-first and Twenty-second streets. It was in this studio that he began to make his constructed paintings.[32] Initially these consisted of canvas sewn

plates 40–54, 292

over shaped, dimensional wood constructions that merged painting and sculpture, in terms of both their material fabrication and their siting—hung on the wall as often as laid on the floor. Tuttle soon dispensed with the canvas overlay in a series of wall reliefs and floor sculptures made from wood and painted in off-key, uniform matte monochromes. To produce these works—some of which required nearly twenty coats to achieve the right color—he used a rough-bristle brush and a dry, unostentatious paint application that he shared not only with Parsons artists Reinhardt and Newman, but also with such generational cohorts as Stella, LeWitt, and Judd. The bare-bones, workmanlike quality of the painted surface had the effect of displacing attention away from the piece's pictorial qualities and toward its rimmed sculptural form. Significantly, the genesis of the constructed paintings lies in drawing: each shape was first rendered on paper and adjusted several times over until the desired image was reached; it was then transferred to a doubled paper template from which two identical shapes were cut out of thin sheets of wood using a fretsaw. These shapes were joined by a strip of wood, from one to three inches thick, that accurately followed the contour of the edges, giving the work a literal if shallow material presence that physically projected into space once installed. The hollow form of each piece was hammered together using countless nails in a time-consuming process that placed deliberate emphasis on the constructed nature of the works. The term *constructed paintings* calls attention to the fact that these breakthrough pieces are handmade and emphatically material. Inherent in the fact of their having been built is the message that each is a truly invented form—"above all *that shape.*"[33]

I quote Judd here because it is worth exploring how Tuttle's work at this time both overlapped with and diverged from minimalist tenets. Tuttle's constructed paintings, in their actual thickness and their uniquely articulated profiles, work like minimalist objects to create convincing unitary forms, or gestalts.[34] Even when, as in *Chelsea*, the floor-based *Fountain*, or *Drift III* (all plate 41 / plate 50 / plate 53 1965), the works are made up of multiple components, they are nevertheless conjoined in such a way as to convey a convincing "wholeness" that "occurs all at once" (to use key Judd terminology).[35] Judd's seminal text "Specific Objects" was published in the same year that Tuttle's constructed paintings were first exhibited. Passages from this essay strike one as tight descriptions of Tuttle's own "new three-dimensional work":

> *The best new work in the last few years has been neither painting nor sculpture. Usually it has been related, closely or distantly, to one or the other…. Much of the motivation in the new work is to get clear of these forms…. The new work obviously resembles sculpture more than it does painting, but it is nearer to painting…. In the new work the shape, image, colour and surface are single and not partial or scattered.*[36]

Hence Tuttle's *Abstract* (1964), like Judd's first horizontal progression made in the same year, is a plate 45 / plate 17 painted surface/shape/object that conflates the sculptural and the pictorial to create a highly specific, self-evident form: a real object occupying real space and possessing actual (versus illusionistic) volume.[37] Yet here, as in other constructed paintings, Tuttle breaks with Minimalism's primary insistence on the work's physical presence by inviting illusion and allusion through ideogrammatic forms and evocative titles, such as *House* (1965). His works have a pronounced identity almost too plate 43

distinct for Minimalism's signature anonymity: *Abstract* hangs vertically like bones on a spine (its semicircular shapes will be a recurrent form in Tuttle's visual vocabulary). Even when

plate 47

he does evoke the modular, geometric compositions of Minimalism, as in *Equals* (1965) or *Chelsea*, their wobbly contours and installation on the bias depart too greatly from Minimalism's stern

plate 40

symmetry and resolutely abstract composition.[38] Other works, such as *Drift III* or *Sum Confluence* (1964), carry titles with poetic reverberations that make their unusual shapes all the more inscrutable. Such works align Tuttle with the more personal geometries favored by Parsons's circle, especially Kelly and Martin, both of whom engaged a more organic vocabulary than the Minimalists. Critic and curator Lawrence Alloway, for one, positioned Tuttle's work as "a continuation of the Hard Edge phase of the [Parsons] gallery...part of the current of post-expressionist, systemic art."[39]

 At the start of the summer of 1965, Tuttle asked Parsons to show his work. She agreed,

plate 63

and so, in the following season, Tuttle had his first one-person exhibition, becoming the youngest artist in Parsons's venerable stable. His artistic debut was positively received by the press (including the critic Lucy Lippard, who within a year would organize *Eccentric Abstraction,* the exhibition that announced the new direction of Postminimalism), and their response positioned the artist as the newest member within the ranks of "painter-sculptors." By 1965 it was no longer unusual for a painting to be eccentrically shaped or carry a shallow thickness, nor was it uncommon for a freestanding sculpture to be polychromatic. Yet what utterly differentiated Tuttle's work from other artists mining this vein was the particular quality of his line as manifested in his work's literal

plate 44

edge, best seen in pieces such as *Silver Picture* (1964), a pure line-into-object.[40] Derived at their root from the drawn line, Tuttle's constructed paintings retain the originary vibrancy and tremor of the hand at work. It is in these pieces that we first see Tuttle's inimitable quavering limning, with its capacity to infuse his pieces with the animated energy and distinction of a living organism. "It is by their contours that he is most eloquent," wrote Gordon Washburn in the brochure accompanying Tuttle's first solo show, "the subtlety of their modulations giving them the air of faintly breathing...like tender living things."[41]

 These works are the earliest manifestations of a drawing-centered aesthetic strategy that Tuttle would pursue throughout his career: he transposes the methods, materials, and liminality of drawing onto painting, sculpture, even architecture, and in so doing he exceeds and overturns the traditional bounds of each. At the same time, he also maximally teases out each individual medium's formal capacity. Drawing, for example, may resolve itself in a profusion of ways: as the physical contour or cut edge of a painting, the double-hemmed seam of an unstretched canvas, the creases across a dyed cloth surface, the vector of a wire as it moves through space, the ready-made strand of a cotton rope, the incised skeins of a scored wooden surface, or the dried glue filaments crisscrossing an

17 Donald Judd **Untitled** 1964
Lacquer on wood, 5 x 25 1/2 x 8 1/2 in.
Collection of Aaron I. Fleischman

assemblage—not to mention the pencil line drawn on a flat sheet of paper. The essential properties of painting are likewise atomized throughout Tuttle's work; colored strokes, materials such as stretcher bars and canvas supports, and the means of hanging and framing are each treated as separate and independent values, taken apart and then eccentrically reconstituted. Even the traditionally resistant properties by which sculpture has long been defined—weight, mass, closed volume, and stasis—are simultaneously negated and restaged. In Tuttle's work, a sculpture is placed on the wall and made to behave like a picture; volumes contract to lines and planes that are then radically opened back up again, their insides and outsides made equivalent so that the work is almost undone as a closed, solid shape. Thus he both expands and explodes the definitions of sculpture, painting, and drawing by doing two things at once: he merges art forms to create composite works, and in that same process he separates out and redeploys the elements that constitute the determining factors of each individual medium. The challenge of this two-pronged approach comes in holding these disparate and now radically opened art forms together at the very edge of chaos—the most vivid examples of which would appear in the 1980s with Tuttle's wall and floor assemblages, wherein each medium's multiple material determinations are tested to their internal limits as well as against one another.

In the late fall of 1965, following his successful solo show at Parsons, Tuttle moved to Paris to become the first resident American artist at the Cité Internationale des Arts, on a C. Douglas Dillon Foundation grant that provided him a studio and a stipend. There he constructed several freestanding works from cut and assembled blocks of wood that deliberately explored elemental and rudimentary shapes. This group would lead to the polychromed *Wheel* (1966), which was among the first works the artist exhibited in Europe at Alfred Schmela's gallery in Düsseldorf in 1968. The timing for a stay in Europe was poor, however, as it abruptly extricated Tuttle from the positive reception of his work in New York; he quickly became artistically paralyzed in Paris and returned home after only six months. Upon arriving in New York City he moved into a new studio in a storefront near the Hudson River, on Eleventh Avenue between Fifty-first and Fifty-second streets. At the same time he rented a small apartment upstairs from the studio, where he would remain until 1996. Shortly thereafter he produced his "tin pieces," forms made in much the same way as the constructed paintings, from a double template transferred onto a thin sheet of silvery galvanized iron from which the pieces were cut and fitted together with a thin soldered band to create narrow, boxlike forms with welded seams. Tuttle produced two bodies of such work, the second of which was made in three versions, each consisting of twenty-six pieces corresponding to the number of letters in the English alphabet. It was the second such version that constituted his second show at Betty Parsons Gallery in 1967.[42]

plate 55

plate 57

plate 18

plate 56

When Tuttle initially exhibited *Letters (The Twenty-Six Series)* (1966), he arranged the pieces on a tablelike platform and, as in the case of his earlier paper cubes, invited the visitor to hold the works in his or her hand. When the work was shown again in 1975 as part of Tuttle's first survey at the Whitney Museum of American Art, New York, it was initially installed constellation-like across a wall, then later laid out on the floor. These divergent presentations fulfilled the artist's instructions that the work be exhibited in any way the installer wished, thus welcoming a continuous visual evolution of the work through installation. A contemporaneous review of the Parsons show commented on this "do-it-yourself aspect" of the work, noting that it was "indicative of a strong trend towards audience participation characteristic of several types of recent sculpture."[43] It is worth dwelling on this direct address of the work to the spectator, for Tuttle made *Letters* dependent on the physical engagement of the viewer in a manner far more radical than the phenomenological turn that artists such as Robert Morris were just then introducing into the minimalist dialogue. Whereas Morris's large plywood sculptures at the time intruded into the viewer's space but resisted touch, the physically modest *Letters* invited the viewer to interact with the artwork on a much more tangible and immediate level, suggesting that the work must be completed in experience.

Such moves beyond a purely visual and toward a phenomenological experience of art typically go hand in hand with an eschewal of the allusory. Yet Tuttle's *Letters,* despite their concrete

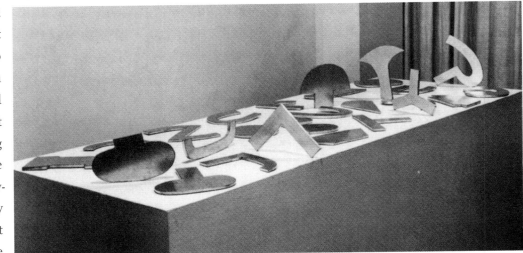

structure, allude to the Roman alphabet through their letterlike forms and the number of constituent objects. Each individual emblem in *Letters* calls to mind a primal integer in a given semiotic system and as such sets off a chain of near-associations and descriptions: each calligram *signifies,* although what it signifies is purposefully not made clear. Meaning accrues, without resolution. *Letters* is striking for the way in which it connotes language without embodying it. At the same time, the forms assume a highly specific presence at the level of matter, as abstract sculpture. The power of the work derives from the overlapping of two distinct systems at the threshold of comprehension: the sculptural is inflected with the linguistic, and, conversely, the marks used to represent the spoken word take on an obdurate glyphlike physicality. In the end, they articulate themselves as presences rather than representations, "the letter using itself, not depicting."[44]

In creating work that is calligraphic while effectively forestalling specific discourse—in alluding to and then deferring a logic of language—Tuttle consciously refrains from conveying meaning along normative channels in order to advocate a language outside of standard conventions.

18 Installation view of **Letters (The Twenty-Six Series)** (1966) at the 1967 exhibition **Richard Tuttle,** Betty Parsons Gallery, New York

Of his 1989 suite of drawings *40 Days*, he has written: "I would prefer to think that language plates 249–51
and image are two worlds constantly seeking stability, the best possible relationship the two can
have, that is neither language, *nor* image, and *that* is what the drawings are about."[45] The cre-
ation of a fruitful, unstable field between known systems of representation—between the verbal
and the visual here, among painting, drawing, and sculpture elsewhere—is, as we have seen, a
fundamental principle of Tuttle's enterprise. He "un-writes" calligraphy and its cousin, draw-
ing; "de-skills" painting and sculpture; and deliberately cultivates a denotative incoherence in
order to achieve a fundamental independence from assumed or received systems and to create an
altogether new space for communication—to invent, according to Tony Smith (for whom Tuttle
was working as an assistant at just this time), "patterns, forms, rhythms, orders by which we
might live more intelligibly."[46] It should come as no surprise that the twenty-five-year-old Tuttle
should attempt to escape from "cultural confinement"[47]; every bit a part of his place and time, he
was in sync with an era of broad dissent against all forms of tradition and authority—linguistic,
aesthetic, not to mention governmental—living as he was in a period that saw the rise of an anti-
establishment culture actively agitating against an escalating war in Vietnam as well as racial and
sexual inequities at home.

 Diction, syntax, and the structure of the alphabet have remained compositional tropes
for the artist as he maintains his aspiration to achieve cognition without denotation. Probably the
clearest indicator of Tuttle's involvement with lexicon systems is his frequent use of the alphabet
to structure and title his work in series. Examples include *A 1* through *Y 1*, a 1981 series of twenty- plates 33, 195–98
five assemblages; the sculptural components, each named after a letter of the alphabet, in *Inside* plate 310
the Still Pure Form (1990); and, more recently, the series *Type* and *Blue/Red Alphabet* (both 2001).
Meanwhile, the shapes of letters and type inform the artist's most "Tuttle-ish" leitmotif shapes,
such as the commalike *Dish* and the asterisk form of *Fountain* (both 1965), the *U*-shaped cloth plate 46 / plate 50
piece *Untitled* (1967), and *P*-shaped elements in *Memento, Five, Grey and Yellow* (2002). Finally, plate 74 / plate 354
Tuttle's works often recall narrative sentence structures in their sequential installation, as in the
left-to-right phrasing across the gallery wall of *Beethoven Stop on the Way to Egypt* (1986) or *Forms* plate 206 / plate 248
in Classicism (1989), whose components seem as if connected by an *and, or,* or *is.*

 It is informative that Tuttle's *Letters* were exhibited in the same year as the publication
of Sol LeWitt's 1967 essay "Paragraphs on Conceptual Art,"[48] which baptized a then-burgeoning
artistic direction that brought the aesthetic primacy of visuality to a crisis (a process already set in
motion by the perceptually reductive work of Minimalism). Conceptual artists such as LeWitt and
Lawrence Weiner privileged the ideational content of art and asserted that the visual form was no
longer considered art's necessary condition.[49] This position prompted two broad currents. One fo-
cused on numerical and linguistic systems, making them the basis for the production of artworks
that themselves critiqued visual perception (exemplified in works by Bochner and Joseph Kosuth).
The other, related current led to works that, in their renunciation of the physical object and the
process of perception, went so far as to "dematerialize" the object of display altogether (as in the

case of Robert Barry's *Inert Gas* series and Michael Asher's curtain of blown air). Clearly, language as a mode of inquiry and as a medium took on enormous importance in advanced art circles at this time, encouraged by the emergence of structuralist thought in the United States and the newly translated and influential writings of philosophers and intellectuals such as Ludwig Wittgenstein and Maurice Merleau-Ponty. It is interesting to note, then, how Tuttle, in typically contrarian fashion, set himself to creating works that were adamantly *in*articulate. While artists like Bochner (and Johns before him) opened up the space between referent and sign, text and visual form, in order to question their certitude and exaggerate the discrepancies between such systems of knowledge, Tuttle used the incommensurability between such systems to create a new, alternative order of glyph-matter that is both unillusionistic and symbolic. While Conceptual art was healthily skeptical of language's once-assumed certitude, Tuttle was skeptical of analytical logic itself. Perhaps

plate 19

his work in this arena comes closest to the drawings and writings of Robert Smithson, a friend of the artist. The following passage in particular puts one in mind of Tuttle's artistic efforts: "Language operates between literal and metaphorical signification. The power of a word lies in the very inadequacy of the context it is placed, in the unresolved or partially resolved tension of disparates.... Here language is built, not written. Yet, discursive literalness is apt to be a container for a radical metaphor."[50]

Tuttle has spoken often to his antianalytical stance: "When I surrender my intellect, when I give up its special child, then I proceed to step into a kind of unknown situation which I find is creative, as opposed to the intellectual in this case."[51] Tuttle diverges from Conceptualism's rationalistic strain in his devotion less to philosophical, mathematical, or linguistic tracts than to the lyrical—specifically poetry, a medium that, like Tuttle's own work, mines a more affective language. Compare LeWitt's instructions for wall drawings to Tuttle's sentence "This is an attempt at a black and white center with the black form acting like a shadow and trying to be like white, which it is" for an example of Tuttle's more wistful wordage. Mention has been made of his youth among poetry lovers; he is well versed in the historical developments of modern poetry, and particularly in a tradition of innovative experimentation that emphasizes the material, typographical dimensions of words and acknowledges the silent empty spaces around them as much as the text itself—from Stéphane Mallarmé's late-nineteenth-century Symbolism through Italian Futurism, Dada, and post–World War II concrete poetry up to Carl Andre's typescript poems. Since 1977 Tuttle has collaborated regularly with poets in the production of books—most importantly with Mei-mei Berssenbrugge, whom he married after their collaboration on *Hiddenness* (1987)—always with a view to making an object in which the poem and the picture relate, not as text to illustration, but as complementary parts of a single uncommon discourse.[52]

19 Robert Smithson **A Heap of Language** 1966
Pencil on paper, 6 1/2 x 22 in.
Museum Overholland, Amsterdam

Tuttle is smitten with the book form in addition to poetry; indeed, his book work is of such importance and so highly regarded as to enjoy a focused study elsewhere in this publication.[53] For the purposes of this essay, suffice it to say that Tuttle's attraction to the book medium extends his deep-seated interest in a sustained and intimate dialogue between the object and its reader/viewer via the experiences of sight, touch, and sound. In keeping with his methodology, he has continually trafficked between the production of books and objects, using each medium as a conceptual stepping stone to accelerate developments in the other, as in the case of the book *Story with Seven Characters* (1965), whose floating glyphs anticipate the constellation-like wall installation of *Letters (The Twenty-Six Series)*. The book *Interlude: Kinesthetic Drawings* (1974) allowed the artist to catapult himself from the production of wire works to the *Wood Slats. Two Books* (1969), which includes one thick and one slender volume, galvanized Tuttle in the direction of progressively thinning down his artwork's dimensionality, aligning him with the strain of Conceptual art that sought the dematerialization of the art object.

plate 366

plates 356–57

plates 126–28

"Words and walls were the basic building blocks"[54] of avant-garde practice in the mid-1960s, which saw artists like Tuttle, as well as LeWitt and Weiner, bridge the intimate plane of the page and the public space of the wall. Where Tuttle's work comes closest to the conceptual camp—in particular its aforementioned immaterial strain—is in the *Paper Octagonals*, first exhibited in 1970.[55] These appeared toward the end of a five-year period during which Tuttle's work underwent a successive reduction in its object quality, most clearly demonstrated by his work with the octagonal shape, made first in cloth, then in paper, and finally in wire. Tuttle made a total of twelve *Paper Octagonals,* their shapes based on a square set on its side and cut off at its corners: while the first examples have a pronounced symmetry, the later ones are more eccentric (with the last "octagonal" being nine-sided). In a conceptual vein, the works derive from templates in much the same way that LeWitt's wall drawings are rooted in written instructions, with both methods raising provocative questions regarding originality, authorship, and circulation. For example, Tuttle's *11th Paper Octagonal* exists as an unlimited edition (it was initially distributed inside an exhibition catalogue); its composition, like the others, is left open to chance as the owner may attach the work to the wall on either side and in any direction he or she wishes. This incorporation of flux and change—the defining characteristic of living things—is a critical ingredient in Tuttle's overall oeuvre and finds ultimate expression in the refusal of any singular compositional resolution or final state. Each *Paper Octagonal*'s composition is further opened to contingencies when pasted directly to the wall, where it achieves a distinctive surface as the wall's texture shows through the thin paper and becomes very nearly inseparable from it. Underlying texture augments these qualities of transparency. Thus the work treads a fine line at the edge of complete dematerialization, but, significantly, it never completely renounces its (discrete) objecthood. Tuttle's art is contingent and tenuous, yes—but also and always tangibly material. Finally, the sheer beauty of these works lies in their gossamer buoyancy once installed, and particularly in their almost magical capacity to catch and hold ambient light, as if internally illuminated.

plates 23, 85–94

plate 21 / plate 20

plate 22

plate 23

plate 85

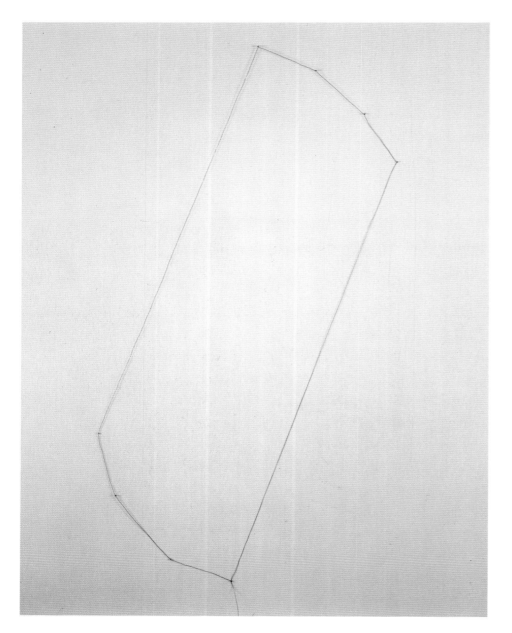

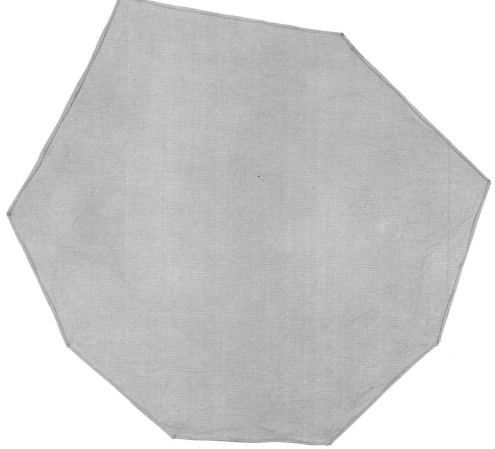

20 Richard Tuttle **Wire
 Octagonal (#7)** 1971
 Wire and nails, 49 x 17 in.
 Private collection, Dallas

21 Richard Tuttle **Purple Octagonal** 1967
 Dyed canvas and thread, 54 7/8 x 55 1/2 in.,
 orientation variable
 Museum of Contemporary Art,
 Chicago, gift of William J. Hokin

22 Diagram of the making of **11th Paper
 Octagonal,** from the catalogue of the exhibition
 **Richard Tuttle: Das 11. Papierachteck und
 Wandmalereien / Richard Tuttle: The 11th Paper
 Octagonal and Paintings for the Wall** at Kunstraum
 München, Munich, 1973

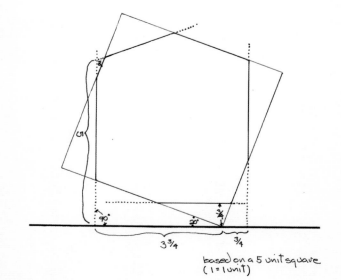

based on a 5 unit square
(1 = 1 unit)

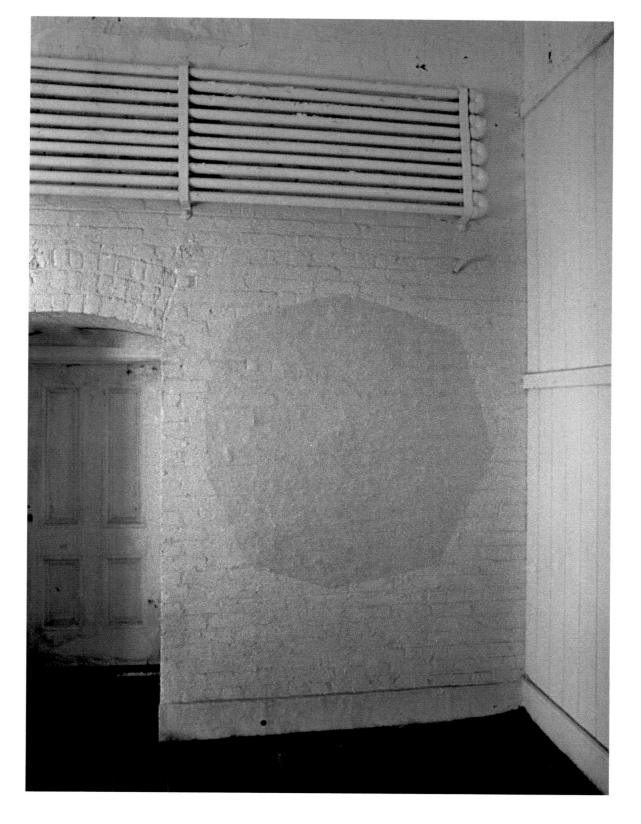

23 Installation view of the 1973 exhibition
Richard Tuttle at the Clocktower
Gallery, Institute for Art and Urban
Resources, New York, showing
12th Paper Octagonal (1970)

plates 21, 72–84

Immediately after making *Letters (The Twenty-Six Series)*, Tuttle made a group of dyed <u>cloth pieces</u> that, when exhibited at Betty Parsons Gallery in 1968, placed him squarely at the center of the postminimalist vanguard. Tuttle went about making these works by washing sixty-inch-square sections of canvas and then hand-cutting them into the shapes of paper templates he had worked up in <u>watercolor studies</u>. (It was the way in which these watercolors saturated and also physically pulled at their newsprint surfaces, causing a surface rippling and slight relief, that led Tuttle to the decision to dye rather than paint his cloth pieces). The dimensions of these cut shapes suggest the circumference of the artist's arm span. Once cut, the canvas was roughly sewn with a double-sided hem and, lastly, balled up and submerged in a tub filled with Tintex, a common liquid household dye that soaked directly into the canvas weave so that surface and color became absolutely integrated. The canvas was subsequently hung up with clothespins to dry, and the wrinkles and uneven coloring inherent to the dyeing process were allowed to remain, giving each work a unique if recessive surface inflection and slight modulations in color. Once dry, the same work could be hung loosely on the wall, with as few nails as possible and free of any stretcher armature, or laid seemingly casually on the floor. It was also assigned no specific orientation, not even a front or back. The radical nature of this position is echoed in Scott Burton's essay for the 1969 exhibition *When Attitudes Become Form: Works—Concepts—Processes—Situations—Information* at the Kunsthalle Bern, Switzerland, one of the shows that consolidated the postminimalist sensibility:

plates 58–61

plate 24

> *The humbleness of Richard Tuttle's wrinkled, dyed, nailed-up pieces of cloth is rivaled only by their grandiosity of conception—they have no back, no front, no up or down, they may be attached to the wall or spread out on the floor. Imagine making an object which will maintain its integrity in all circumstances yet which exerts absolutely no demands on its situation.*[56]

Initially these cloth pieces, some with cut-out centers, were eccentric in shape and obliquely referential, as in *Untitled* (1967), which may be read as the flattened outline of an arch and its shadow, or perhaps an infinity sign.[57] Elsewhere, contours derive from a three-dimensional, square-cornered *U* shape seen in perspective, but whose interior angles have been excluded (as in two <u>untitled works</u> of 1967)—hence Tuttle's term for these works as "drawings of three-dimensional structures in space."[58] Tuttle himself described *Canvas Dark Blue* (1967) as "the outline of a square with three diagonals coexistingly crossing out and supporting the square."[59] As he progressed, the cloth pieces became less complex in source and silhouette, finally taking on an eight-sided configuration: the first to do so, *First Green Octagonal* (1967), derived its shape from the asymmetrical superimposition of two

plate 79

plates 74, 81

plate 80

plate 82

volumetric rectangles. There followed a suite of classic octagonally shaped cloth pieces, each evoking various takes on the overlapping of two flat squares. It was as if the minimalist cube, in its exhaustion, had collapsed into flat cloth, passing from sculpture into painting.

Indeed, Tuttle's cloth pieces can be considered emblematic of the challenge posed to Minimalism by its emerging counterpart, Postminimalism, which arose even as Minimalism was reaching its public heights in 1966. As Robert Pincus-Witten has written, "The complexity of the Post-Minimalist situation is exemplified by the fact that the exhibition called *Ten,* one of the important exposures of Minimalist sensibility then at its apogee, opened on the same day in September 1966, and in the same building as *Eccentric Abstraction,* which was one of the first surveys of counter-Minimalist sensibility."[60] Postminimalism was also often identified as "Process art" for its emphasis on and revelation of the means by which a piece is executed (such means becoming so primary as to be inseparable from the very meaning of the work) and "Anti-Form"[61] for its exploration of the inherent properties of unorthodox and often malleable materials. The eventual preferred nomenclature, Postminimalism, would shortly develop a vigorous international profile in the United States and Europe, particularly in the form of Arte Povera in Italy (where it was concentrated in Turin and Milan) and in the work of Joseph Beuys in Düsseldorf. The trend encompassed a heterogeneous and ever-changing constituency of artists, most around thirty years old, who created highly diverse and divergent work in a tremendous range of materials and styles that were nevertheless conceptually and methodologically congruent. Their activities were supported by and consolidated in various exhibitions on both sides of the Atlantic, the most important of which included Tuttle's work at their nucleus: among them, *When Attitudes Become Form,* curated by Harald Szeemann in 1969; *Anti-Illusion: Procedures/Materials,* organized by two young curators, James Monte and Marcia Tucker, for the Whitney Museum of American Art in 1969; *Documenta 5* in Kassel, Germany, in 1972; and *Arte come arte,* organized by Germano Celant in Milan in 1973. Tuttle was celebrated in the press as part of a coterie of "with-it" Young Turks: he was profiled in a 1968 issue of *Time* along with "process artists" Robert Morris, Bruce Nauman, Robert Ryman, and Keith Sonnier.[62] In the art press, one of Tuttle's untitled 1967 works appeared on the cover of *Artforum* in February 1970 as part of the first in-depth assessment of his work up to that point, while *36th Wire Piece* (1972) was reproduced on the cover of *Arts Magazine* in November 1972. There is no question that in the early 1970s Tuttle's work, always considered "way out on the outer edge,"[63] fell in line with a larger artistic zeitgeist.

plate 25

plate 391

plate 392

And yet, even within this extraordinarily diverse and idiosyncratic arena, Tuttle's art stood out as something of an anomaly. The challenge that his "very controversial works"[64] posed to viewers at the time resulted from their location at the utter extreme of both painting and sculpture. Tuttle's cloth pieces constituted a frontal assault on what seemed to be every essential attribute of painting. He dismantled its elemental properties, dispensing not only with the traditional rectangle,

24 Installation view of the 1969 exhibition
 **When Attitudes Become Form: Works—
 Concepts—Processes—Situations—
 Information** at Kunsthalle Bern, Switzerland,
 showing Richard Tuttle's **Bow-Shaped Light
 Blue Canvas** (1967)

stretcher support, and frame, but also with paint itself: "Even the least stringent definition would indicate that to qualify as a painting, a surface must at the very least be *painted*. Tuttle's *Octagons* are dyed."[65] At the same time, the cloth pieces were recognized for their pronounced physicality and shaped construction as well as the three-dimensional volume apparent through surface incident— seams, wrinkles, slightly undulating surface—that, no matter how discreet, lent the works their objecthood. As such, they also joined a generational attack on sculpture's traditional properties by "pictorializing" it: Hesse, Alan Saret, Richard Serra, and Sonnier were among those artists who, like Tuttle, brought painterly qualities of color and gesture to three-dimensional work.[66] In sum, the cloth pieces made Tuttle the most pictorial of the postminimalist sculptors, and the most sculptural of the postminimalist painters.[67] Contemporary commentators honed in on the radically ambiguous status of the works: "It is not possible to say whether a Tuttle is a painting or a sculpture; it uses properties of both and is probably neither."[68] "They are flatter than the flattest 'pure' painting and yet curiously their non-dimensionality gives them a strong sculpturelike presence."[69]

25 Photograph published in the article "The Avant-Garde: Subtle, Cerebral, Elusive," **Time** magazine, November 22, 1968, showing (from left to right) artists Keith Sonnier, Bruce Nauman, Robert Ryman, Bill Bollinger, Robert Morris, Richard Tuttle, and David Lee

26 Installation view of the 1964 exhibition **Frank Stella** at Leo Castelli Gallery, New York, showing (from left to right) **Henry Garden, Ileana Sonnabend,** and **Charlotte Tokayer** (all 1963)

Where Tuttle's cloth pieces do find a certain kinship is with the work of painters such as Robert Mangold, Brice Marden, and Ryman, who were then affiliated with Klaus Kertess's Bykert Gallery, which opened in the fall of 1966 and quickly became an outpost for painterly Post-minimalism. Tuttle had exhibited his _Yellow Triangle with Three Thicknesses_ (1967) there in 1968 as part of a group show that included Marden's painting, and Tuttle's work was also tied to Ryman's in contemporary art reviews.[70] Linking all of these artists was a highly conscious scrutiny of the concrete properties of painting. Both Tuttle and Mangold, for example, focused on shaped forms that attempted to marry painting to sculptural objecthood. Tuttle's pieces shared with Marden's paintings a restrained yet perceptually rich palette of muted, offbeat, monochromatic hues—gray green, oyster pink, mottled tan—carried on skinlike surfaces. Ryman's practice provides a particularly lively comparison—not only early on, when he and Tuttle used unstretched canvas installed directly on the wall and a process-oriented paint application that emphasized the behavioral properties of the medium as it performed on a given support, but again in the mid-1970s, when both would give prominent visibility to a piece's mode of attachment to the wall, highlighting the symbiosis between work and supporting surface. Finally, all of their output reveals the precedent of Stella, whose contemporary shaped paintings Tuttle was undoubtedly aware of: there is a correspondence between his cloth pieces and Stella's 1960–61 _Copper_ series paintings in right-angled configurations of an _L, T,_ or _U,_ as well as the 1963 polygon-shaped canvases with open centers in purple metallic paint. When Tuttle first entered the art world, Stella was bringing painting to the edge of a sculptural terrain, primarily by eliminating the frame and thickening his stretcher bars so that the painting projected, objectlike, from the wall. Poised at the very edge of three dimensions, his work opened up the possibility for a group of younger painters and sculptors, including Tuttle, to question its premise and take things even further.

plate 78

plate 26

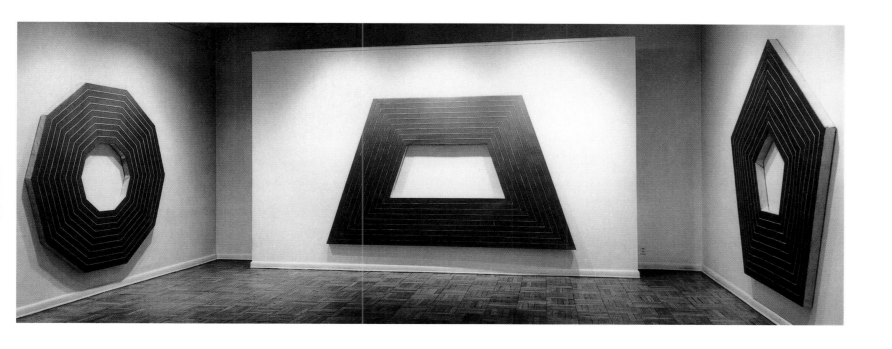

The filament was a signature element of Postminimalism, encompassing Serra's ribbons of torn lead, Barry's nylon threads, Hesse's skeins of latex-dipped rope, Sonnier's lacy electrical cords, Nauman's cursive loops of neon tubing, Gordon Matta-Clark's architectural cuts, and Smithson's *Spiral Jetty* earth inscription. Tuttle's commitment to line as a primary form of visual expression, evident from the inception of his career, coincided at this time with the output of a group of peers who extended line into real space—hung from the ceiling, leaned against the wall, scattered across the gallery floor. At the forefront of the most radical experiments in drawing undertaken by his generation, Tuttle's liminal work of the 1970s—his wire works, *Rope Pieces,* and collage pieces—physically embodied and complicated line, never more so than in his audacious yet humble wire works of 1971 to 1974.[71] These developed out of the cloth octagonals, which, as part of Tuttle's penchant for visual reduction at this time, he eventually constructed in wire, allowing their silhouettes to take on ever more unorthodox dimensions—including an "octagonal" square (1971). Eventually the geometry of the octagonal broke up and took wing in works that interlace pencil line, wire, and shadow, fusing volume, surface, light, and space into breathtakingly original entities.

plate 108

To watch Tuttle make one of the *Wire Pieces* of 1972 is to recognize the degree to which it results from a full-on physical engagement. The artist begins by standing in front of a wall at a short distance, shoeless and with pencil in hand as he relaxes his body and gathers his mind into a concentrated, meditative state. What he is doing is remembering—less at a visual than at a neuro-muscular level—the pencil line he is about to make, recapturing the specific original movements, the private choreography that enacts the line: hence the reason Tuttle calls making these works "an activity." This is the same method that he uses to execute *Ten Kinds of Memory and Memory Itself,* first installed at Daniel Weinberg Gallery in San Francisco in 1973, in which the pencil line comes off the wall to become three-dimensional lengths of string on the ground.[72] Because Tuttle dispensed with the template stage in the making of these works, they can never be duplicated but must be re-executed by the artist, and they are necessarily unique each time.

plates 110–17

plate 121

Once the kinetic root for the *Wire Piece* is tapped, Tuttle moves only his head and his right arm—the work thereby assuming human proportions—and with deliberate and serene attention, slowly draws a light pencil line in one go without lifting the pencil from its surface. The passage of the pencil across the wall produces random concentrations of miniscule deposits of graphite as it registers every bump, and also evinces varying thicknesses that correspond to the artist's mental and physical state at that moment—the degree of his steadiness, even his pulse. Once the pencil line is drawn, Tuttle begins to unspool a long filament of floral wire. He nails one end of the wire to the point of origin of the pencil line, and then painstakingly and methodically guides the wire to conform to the pencil line's trajectory. (In the first ten *Wire Pieces,* the wire followed the pencil line in its every irregularity; as Tuttle continued to make the works, the pencil and the wire were composed more contrapuntally and, finally, in *48th Wire Piece,* independently of each

plate 119

27 Installation view of the 1992 exhibition
The Poetry of Form: Richard Tuttle, Drawings from the Vogel Collection at the Instituto Valenciano de Arte Moderno, Valencia, Spain, showing work by Tuttle and Julio González

other.) The free end of the wire may then be secured with a nail to the end of the pencil line or be left untethered, causing the wire to spring out from the wall. The wire curves, loops, and swirls in response to the stored "memory" of its previously coiled state, to its manipulation at the hands of the artist, and to the force of gravity, and all of these interactions are unique in each installation. The wire also casts a shadow, the third critical linear element in this visual continuum, its density modulated by the wire's proximity to the wall and by the angle and level of lighting. The shadow conforms neither to pencil nor wire, and in its independence leaves the artist behind altogether, allowing the work to, in a sense, complete itself.[73]

The provocative and complex implications of these highly original works may best be described along a series of paradoxes. A *Wire Piece* is simultaneously completely self-evident in its structure yet illusionistically intricate; it carries no mysteries yet is full of surprises. Its contents ricochet among different levels of illusion and reality, yet it remains a unified whole. It is absolutely embedded in the world, indeed dependent on light and walls for its very existence, yet it has the insubstantiality of an inspired idea. There is so little material, so little topical surface to speak of with a *Wire Piece*, yet there is a palpable occupation of space—particularly when the work is seen at an angle, as is the artist's preference, when its sculptural qualities come to the fore. Its overlapping lines of pencil, wire, and shadow create spatial crosscurrents that unquestionably materialize space (as sculpture does), yet it dispenses with actual volume, mass, and weight. In this way Tuttle joins drawing to sculpture and also to painting (via the work's attachment to the planar wall that is the zone of painting). One is reminded of the work of Julio González, whose ambition as a sculptor was to "draw in space,"[74] and of Lucio Fontana, whose slashed and punctured canvases access tangible dimensions beyond the painting's flat surface. Not surprisingly, Tuttle admires both of these artists for their courageous efforts to incorporate real space as well as mass into their work. His deep respect and knowledge of their oeuvres is evidenced in his writing on Fontana and his 1992 installation involving sculptures by González.[75]

plate 71

plate 27

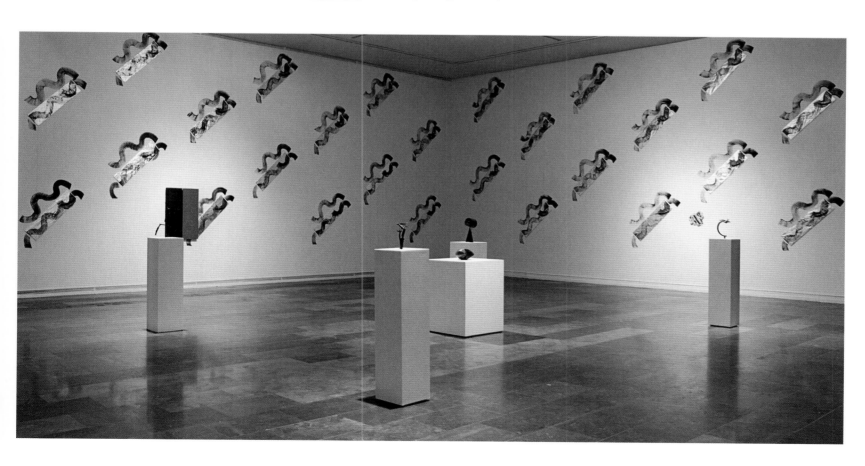

These works come very close to being truly alive, and an important aspect of what makes them feel so vital is, paradoxically, their utter impermanence. Like Tuttle's *Paper Octagonals*, each *Wire Piece*'s installation also presumes its eventual destruction. Beyond the work's physical insubstantiality, we are touched by the knowledge of its short life span, no matter how magical, how salient. In fact, the *Wire Pieces* suffer the very real risk of extinction, in that their production is entirely dependent on the living artist (hence his joking reference to them as "life insurance").

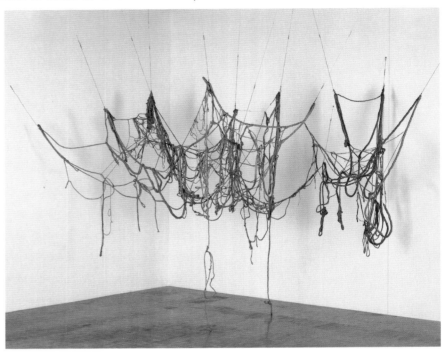

Rarely do artworks point so candidly to issues of mortality, especially the artist's own. Yet Tuttle's oeuvre in general evinces a disdain for permanence in its embrace of mutable displays and perishable materials, its often vulnerable scale, and its phantasmagoric quality. A knowing fragility is a central attribute of his work, as intrinsic to its power and meaning as the sense of emotional dignity and physical integrity that it conveys in the face of such transience. In this way Tuttle's art approaches that of his colleague Hesse, who of all the Postminimalists comes closest to Tuttle's merging of painting, sculpture, and drawing in works such as *Right After* (1969) and *Untitled* (1970).[76] It is known that Hesse struggled with the fact that she was using fatally unstable materials, yet she was attracted to them for their ability to achieve "a moment in time, not meant to last."[77] Likewise, Tuttle has stated, "people like something that lasts; I like something that vanishes."[78] In embracing ephemerality and refusing timelessness, Tuttle, like Hesse, opted for a freedom from history and a focus on the immediate present that is precisely what gives his work its signal animus.

plate 28

plates 133–39

With his collage pieces of 1978, Tuttle furthered his investigation into "a nervous space"[79] merging pictorial and sculptural qualities. The works, as before, are constructed in stages. First Tuttle "draw[s] with scissors"[80] to cut heavy, textured watercolor paper into abstract shapes, which behave more like objects than drawings thanks to their palpable if discreet corporeality. Within this series of eighty works, the paper constructs rarely exceed nine inches in length and often take a sectioned curve or ovoid form. Frequently there is a folding action that allows both the front and back of a single sheet of paper (normally mutually exclusive planes) to play visual roles. This paper element is brushed with a wash of watercolor thin enough to allow the texture of the paper to show through; it is then glued directly to the wall. Lifting away from itself on the hinge-fold, the element casts a subtle shadow and creates real volume and depth—not their pictorial inference—so that the work approaches the condition of a low relief sculpture. Each collage piece is completed when Tuttle extends its form beyond the paper border onto the wall itself, here

in pencil, there with a translucent wash of matching color. Image and surface, figure and ground, artwork and the world inextricably join forces in these color-shape installations.

In their reinstallation these works also fuse past and present, as the paper elements are redeployed and the drawn and painted extensions on the wall are made anew in situ. Such a strategy locates the works in a unique temporal dimension that bucks chronological time in favor of an "interchronic"[81] temporality. The collapsing of different modes of duration is clearly of great interest to Tuttle, for he has pursued this practice in subsequent works, including the series _Line_ _Pieces_ (1990) and _"I See"_ (1993). As with the collage pieces, these more recent works require that the preexisting object be accompanied by pencil lines rendered on the wall by the artist. Catching and holding the spontaneity of the moment in this way is of prime importance to Tuttle; it is one way in which he can better ensure the preservation of his work's moment of inception and, by extension, its success as "something which flickers between a relationship with the alive, and with itself."[82]

plates 317–18

plate 242

The collage pieces also point to a prime characteristic of all of Tuttle's work: its singular correspondence with its environment. Like other members of his generation, Tuttle jettisoned the pedestal and the frame, barrier conventions that had isolated the zone of "high" art from the everyday arena of its viewer, in the process causing the role of the "ground" to shift to the literal space of the floor or the wall to which the work was now attached. Ever since then, the setting has played a critical role in the overall impact of Tuttle's production, furnishing the final pictorial ingredient, on a par with the work itself. The architectural container and its properties—wall, light, surface incident, architectonic idiosyncracies (window, door, radiator grille)—provide a "frame" and pivotal counterpoint to the works themselves. It is in its interaction with the environment that Tuttle's art comes to full fruition, not only formally but also in terms of "content"—in the tension and energy that the works release in installation. It is because _Drift III_ is placed at a deliberate slight angle from the rectilinear coordinates of the gallery that it seems unmoored from its setting, tilting upward and away in the direction of the work's gently curving right side. Because _3rd Rope_ _Piece_ (1974) is installed thigh-high and isolated on a large expanse of wall, an even stronger sense of vulnerability—already present in the work's fragility and small size—comes into play. Then there are those works, like the _Paper Octagonals_, that literally cannot be experienced apart from the space that houses them. Conversely, other works draw the surface area of the room into their visual fabric, as in the space of wall that is held between and vivified by the two elements constituting _Equals_. It should be said, however, that Tuttle's work is not site-specific so much as unconditionally site-responsive. It is crucial to the artwork that it be put in "a situation"[83] under specific lighting conditions, at a precise height, and occupying the requisite amount of space needed to complete the piece. But it is the object only and not the site that demands these definitive circumstances in order to achieve that sense of "rightness" Tuttle always seeks, which makes the piece come alive. Hence the artist always takes care to be involved in the installation of his work, sensitive as he is to its final and crucial activation in space.

plate 53

plate 125

plate 47

plate 128

Tuttle's precise attention to the height of his objects from the floor was first prompted by the suite of eight *Wood Slats,* produced in 1974, which in their pronounced verticality marked a strong departure from the postminimalist emphasis on the horizontal axis. These thin plywood trapezoidal quadrilaterals are made to stand on their short, narrow sides and are nailed through their surfaces to the wall; the tallest and most slender, the *8th Wood Slat,* registers an upward velocity that helped Tuttle to zero in on a preferred point-height. From then until the late 1980s, Tuttle assigned a specific height to his works, including his drawings, a number of whose titles—such as *60" Center Point Works (8)* (1975)—double as height instructions. Tuttle has chosen a height of fifty-four inches off the ground, just below the average eye level, as central to his work. Hence the typical spectator looks slightly over the top edge of each work, the effect of which is that the object seems to reveal itself more readily and fully to the viewer, who in turn becomes that much more dynamically engaged by a wholly available piece.[84] Arrived at intuitively, this location is for Tuttle the place "where knowingness happen[s],"[85] both for the object in its fully manifested form and for the viewer with whom this relatively low height stimulates a direct physical interaction.

A visual coefficient of height and a distinguishing, even infamous, feature of Tuttle's work is its frequently small size and paradoxical command of large space. Even in the 1970s, when artists from Christo to Joel Shapiro demonstrated a heightened interest in extreme scale, Tuttle's small sculptures "shocked" viewers with their barely there yet insistent presence.[86] Take, for example, *3rd Rope Piece,* first exhibited in his ten-year survey exhibition at the Whitney Museum of American Art in 1975. It is quite simply a three-inch-long, three-eighths-inch-diameter piece of plain bleached cotton rope (such as might still be used for clotheslines), whose frayed edges the artist ruffles up before nailing the piece through its center and two ends to the wall, as if it were a naturalist's specimen. Hardly there, it is nevertheless, as the Whitney exhibition's curator, Marcia Tucker, wrote, "startling because, seen from a distance, [it is] powerfully present in the room despite [its] very small size.... What happens in viewing [it] is that the rope loses its substance and the shadow just underneath it becomes a stronger visual presence than the piece itself. The rope isolates the wall rather than vice versa, playing a peculiar trick of figure-ground reversal with its environment as well as with itself."[87]

plates 130–32, 291, 293 / plates 300–301

In other words, the visual incident engendered by this work takes place not so much in it as around it, as its effects extend to environmental proportions.[88] Here Tuttle's *3rd Rope Piece* fulfills Carl Andre's definition of sculpture as "place." An important precedent for Tuttle, Andre describes place as "an area within an environment, which has been altered in such a way as to make the general environment more conspicuous."[89] Indeed, as Tuttle's small sculptures from this period oblige us to scrutinize them more closely, so too do they insist on an intensified apprehension of their, and our, surroundings, without in any way "filling up" much actual space. This is not easily accomplished, and in fact it relies on an impeccable sense of measure and proportion that strikes just the right triangulated balance of the object in relation to one's body and to the room's volume. Using an intuitive approach, Tuttle, as no other artist, has tested the limits of a

29 Photograph published in the article "Phoenix in Venice," **Time** magazine, July 26, 1976, showing Venice Biennale visitors viewing Richard Tuttle's **Portrait of Marcia Tucker; at Venice** (1976)

work's material reduction and located his pieces at the living edge beyond which they would fail or even disappear as artworks. The works, then, though physically slight, are far from conceptually modest, and their radicality is reflected in their contemporaneous reception. Critics and curators recognized that Tuttle "dared to test by what few constituent features"[90] art could be made, thus effectively "pushing the question of what art is more than anyone else."[91] It was due precisely to the iconoclastic extreme to which Tuttle took this investigation that his first retrospective in 1975 was pummeled so mercilessly by the press, to whom the work appeared as simply too much of a renunciation. The response to this survey show has become the stuff of legend and is the focus of a separate text in this volume.[92] Yet, as devastating as the reception was for the artist, it did not dissuade him from pursuing the ground zero of inverse scale-to-space relations, nor the related paradoxical link between scant materiality and significant impact. To wit, as one of the American representatives to the 1976 Venice Biennale, Tuttle exhibited a small sculpture made of wood, "no larger than two joints of a finger, stuck on the wall and identified by a label that occupies more space than the object itself."[93] Meanwhile, a 1979 survey of his diminutive collage pieces at the Stedelijk Museum Amsterdam met a welcome at times as hostile as that accorded the Whitney show.

plate 29

 Still, Tuttle persisted. In a private mode, he explored small-size sculptures throughout the 1970s. What is interesting about these works is how successfully they resist the latent pejorative notions that often pertain to small-size art. Small scale may connote preciousness, insignificance, timidity; the reason Tuttle's works stubbornly resist such characterizations is that they are not, in fact, miniature at all, but of the size and scale necessary to convey specific content and affect. In each of his works, whatever its size, Tuttle finds an internal measure, a physical proportion that is "just right" insofar as it correlates precisely to the work's intentions. Tuttle's uncanny, instinctive sense of aesthetic rightness and the discretion of his discrimination make for his rare knack of never producing a sculpture that is bigger—or smaller—than it ought to be.

Even as Tuttle in the 1970s stretched the parameters of what might materially constitute a work of art, he embarked on a prolific period of making drawings using the most basic and traditional form of inscription: the graphic mark on a page. Drawing became a daily, solitary occupation for the artist, who often worked in spiral-bound sketchbooks. In these <u>drawings from the 1970s</u>, one sees a consistent approach to the page. Having chosen a piece of paper, Tuttle would seldom crop it; as with his use of the wall, the whole sheet—complete with any perforated edges—was employed as a kind of readymade connection to the world outside. The drawings'

plates 147–94

objecthood was also emphasized by the fact that many of them were originally exhibited directly on the wall and without frames, in an unmediated relationship with the physical space. Tuttle has a feeling for the paper as much as for the form that he creates. Media are applied lightly so that the paper's texture becomes an integral part of the work's physicality, and the "void" of the paper field is made to register as much as the "weight" of the image.

The forms rendered in the drawings are often unitary, isolated figures centered on the page, not linked to any place on the surface and thus made to seem adrift and vulnerable, all the more so given their frequently small scale relative to the paper's overall surface. Occasionally the drawings reveal repetitive motifs, which register as equally weightless and unmoored. Tuttle draws luminous, clear, and airy shapes that are physically slight yet far from sensually meager. There is no trace of the work of drawing—no *pentimenti* that speak to any struggle—suggesting a spontaneous, at-one-go production. For the most part Tuttle is attracted to innocent, nonstatic images—not squares but diamonds, diagonals, circles, and especially spirals, forms that appear over and over throughout

plate 30

his work in all media (most spectacularly in a <u>1996 installation</u> of a massive canvas wending its way, nautilus-like, through the galleries and stairwell of the Kunsthaus Zug, Switzerland).

It is in these works on paper that one can most clearly consider the quality of line that is the elementary particle out of which Tuttle's many-sided explorations evolve. What impresses most is the searching and ruminative nature of his line: how it conveys not thinking so much as a prediscursive state of mind, a preliminary probing that announces an emerging but still unknown thought and direction. This is a line perennially in the process of evolving rather than already attained and executed on the page—a fully formed *formative* line, an actual physical "becoming" that is fully expressive in its own right.

30 Richard Tuttle **Replace the Abstract Picture Plane I** 1996
Cotton twill, grommets, wood, acrylic, string, and monofilament, dimensions variable
Kunsthaus Zug, Switzerland

If drawing has traditionally been regarded as cognition made visually manifest—if it comes closer than any other medium to the visible transmission from conception to execution—Tuttle's mark is exceptional in the maximum degree to which it locates itself at this very threshold. Hence its tremulous responsiveness, its full and sensitive attachment to the hand and the body, its extreme sensitivity "to the actual event of making the line."[94] This "event" issues from a questioning mind, which inflects a physical impulse, which generates a gesture, which results in images that are saturated with rumination. Tuttle's drawing is a felt approximation of thinking itself; as he has said, "the actual physical making of a drawing is very similar to comprehension."[95] Comprehension, not illustration: Tuttle frees line from its traditional role as describing or outlining "reality." His is "a line that doesn't represent anything beyond itself. In other words, the means to represent does not represent anything."[96] It is its own realization, separate and discrete, an autonomous and active player in the pictorial field.

That Tuttle refers to his artistic end product, whatever its medium, as "drawing" points to the central importance of this continual coming-into-coherence that his line so beautifully embodies. In a 1986 letter to a friend about a painting he was working on at the time, Tuttle writes, "This morning as I was painting it a second time I knew as I applied the paint that this was drawing or could be drawing—that the particular surface I was looking for was 'drawn,' not painted. I guess from the beginning I was attracted to this surface, its ultimate advantages, that drawing is the door to something real—in the sense we want to see something art *creates*, not art, itself."[97] That is to say that in all of his work, Tuttle desires for us to see—and for his work to remain in—the space where experience is generated, not depicted: the here and now of invention.

As invention has its roots in the conjectural, so too is Tuttle's enterprise at its base fundamentally speculative. "Some of my best work begins with a question and I try to answer that question. The question with [the *Wire Pieces*] was 'what would black and white look like simultaneously?'"[98] The question that led to *Rest* (1970s), to cite another example, was "Is there a way to see 'touching'...?"[99] Questions necessarily exclude certainty and preconception, open up to an unbounded space of possibilities, and privilege the experimental. "Where is what is hidden?" "What is the space in between?" "What is the opposite of a point?" Tuttle's answers take the form of "visual *satori,* the sudden wordless comprehension of a Zen parable,"[100] and are of such delicate contingency—literally held together by so much ephemeral connective tissue—that they seem to suggest that we are best served by conditional responses rather than definitive answers. Tuttle's speculative approach extends to his working method, which he has described as "a phase of search and research."[101] In response to an initial feeling or mental image,[102] a hypothesis is tested out, step by unpremeditated step—thus the artist intuits his way through to the creation of an object that is not known in advance and that may very well surprise him in the end, as the final work may not in any way resemble the initial impetus. This kind of modus operandi infuses each of Tuttle's works with a spirit of inquiry, improvisation, and discovery.

plate 293

Tuttle's artistic evolution in the 1980s echoed a general reaction in the art world to the reductive formalism and reserve that had come to dominate artistic discourse in the preceding decade. By the late 1970s and early 1980s, an eclectic range of artistic activities—heralded as pluralism—had broadened expression considerably. "Art in the last few years has generally emerged from personal experiences rather than ideologies,"[103] pronounced the curators of the 1977 Whitney Biennial, to which Tuttle contributed. A year later, the same museum's exhibition *New Image Painting* announced the resurgence of recognizable imagery (if abbreviated), narrative association (if furtive), and expressiveness (if halting) after a decadelong period of abstract art's dominance. Within two years a promiscuous art industry exuding material extravagance at every level was launched. Pattern and Decoration painters and their East Village affiliates joined American Neo-Expressionists and their European counterparts in a pigment-loaded revival of painting of great plastic, optical force and subjectivity; meanwhile, in an oppositional camp, a theory-conscious appropriation art harshly examined consumer society and the conventions of representation by dismantling and redeploying mass-media imagery and questioning individual agency by presenting the self as a social and cultural construction. Finally, commodity and neo-geo art made irony and reflexivity the predominant sensibility among a generation of artists who placed everything in "visual quotation marks."[104] By 1984 the art market was booming with unprecedented numbers of new collectors, dealers, critics, and curators, not to mention artists armed with graduate degrees and commercial savvy, all spurred on by hyperactive media attention fueled by avid public interest. Tuttle's work, while staying its own course, nonetheless shared in the heightened theatricality and maximum materiality of the period as well as in its taste for imaginative association and individual expressiveness.

While in the 1970s Tuttle explored a reduction in both materials and visibility, the 1980s saw his work become extravagantly robust and heterogeneous, in terms of both materials and volumetric scale. There was a palpable sense of expansion from the perimeter in all directions, an impetus that generally manifested itself in a move from wall-dependent assemblage-constructions in low relief to high relief and on to fully in-the-round constructions. Tuttle's dimensional expansions began with the so-called framed drawings, a term given to numerous series of drawings for which the artist constructed frames that are integral to the overall work. While the first of these series appeared as early as 1974 (*Paris Arles*), they did not become a focal point for the artist until 1980, commencing with *India Work*, a suite begun during a six-week trip to India; the artist made drawings in Jaipur on local notebook paper—one of many

plate 207

plates 208–10

31 Richard Tuttle **Portland Works:
Group I (detail) 1976
Watercolor on airmail paper in handmade
wood frame, 12 1/8 x 9 x 1 1/8 in.
Collection of Rosalind and Walter
Bernheimer, Waban, Massachusetts

instances of Tuttle's preference for materials drawn from the immediate environment—and later encased them in nearly identical, beautifully contrived pine frames. This series was shortly followed by *Hong Kong Set* (1980) and *Brown Bar* (1981). Numerous bodies of framed drawings ensued, including several, such as *Portland Works*, in which the artist circled back to an earlier set of drawings (these were made in 1976 on airmail paper that had previously been glued directly to the wall) and framed them in highly specific fashion, essentially creating a new work of art in the process. Over the next two decades, Tuttle's frames would mingle with as often as encircle the elements contained within—cutting across the internal composition (see the horizontal magnet bands in *Icelandic* [1994]), riding inside rather than outside the drawing (as in *Verbal Windows* [1993]), or, in the case of *System of Color* (1989) and *When We Were at Home* (2002), taking over entirely as a primary compositional ingredient.

plates 211–20 / plates 221–22

plate 31

plate 235 / plates 232–34

plate 231 / plate 32

The use of the frame marked a dramatic change of direction for Tuttle, who with his peers had banished the frame and pedestal from the gallery in the 1960s. So it is safe to assume that his "rediscovery" of the frame and its preponderance in his work of this period point to a central aspect of his practice. With the framed drawings he overtly attended to, indeed insisted upon, the meeting point between the artwork and its supporting surface. Though utilitarian, the connection of the artwork to the wall is an important ideational zone for Tuttle: it is the threshold where illusion and reality, art and the world, literally meet. In extending his art to encompass the frame—traditionally a functional boundary cordoning off the picture from the outside world—he wished to conjoin and confound the illusory and the real, the work and the space.[105] One sees this intent manifested from very early on—in the paper cubes of 1964, for example, which are equal parts mass and space. In 1979 Tuttle wrote of his 1970s collage pieces, "The signs partly belong to the paper partly belong to the wall…. What matters is the fact that the object is partly the wall partly emerges from the wall without being able to get separate from the wall."[106] The 1974 *Wood Slats* constitute another attempt to create works that are perceptually unified with their surrounds, for they are painted on their thin sides to match exactly the color of the wall against which they are hammered absolutely flush, in a further effort to slim down an already-fine interstice between wall

plates 126–28

and piece. The mixed-media *System of Color* incorporates the backs of wide wooden framelike sections whose open arrangements visually integrate the wall into the pictorial space, generating a compositional interdependence between frame and field. Tuttle's will to make an artwork that is inseparable from real space also accounts for his ventures into wall drawing, which began in 1970 and include, among the most ambitious examples, *Blocks* (1988) and *Inside the Still Pure Form* (1990).

plate 310

32 Richard Tuttle **When We Were at Home #19** 2002
Acrylic and wood on plywood, 16 x 17 1/2 in.
Galerie Ulrike Schmela, Düsseldorf

Tuttle has asserted on numerous occasions that his oeuvre resides "between calligraphy and architecture," referring to the zone where what is made by the hand touches matter and space. Since this is the arena he wishes to volatize, he is deeply attentive to the real points of contact between his pieces and their environmental ground, the locations where the distance between work and architecture collapses. This is why he gives prime symbolic and visual status to the ancillary hardware of picture-making—nails, framing strips, picture wire. This hardware is plainly visible throughout his work: the *Rope Pieces,* the *Wood Slats,* and more recent series such as *New Mexico, New York* (1998) and *Ten* (2000) are but a few examples where the affixing elements—here, nails—are driven through the very surface of each object, playing a visual as well as functional role.

plates 37, 326–31 / plates 347–48

I*ndia Work, Hong Kong Set, Finland Group*—titles like these attest to the nomadism of Tuttle's lifestyle during most of the 1980s. He has always enjoyed traveling and draws creative sustenance from the activity, making art along the way, at all hours and anywhere.[107] (This partly accounts for his art's often-transportable size.) Seen in this light, pieces such as the *Indonesian Works* (1983–84), *Egyptian Works* (1986), and *La Terre de Grenade* (1985) take up the mantle of the hallowed "travel sketch," a repository for images and thoughts garnered on an artist's formative "grand tour." *40 Days* (1989) is perhaps the most impressive of these works—a stunningly beautiful, wordless account of a voyage taken by Tuttle and Berssenbrugge (who was pregnant at the time) from Hawaii to Japan to China to Thailand to Switzerland to Austria and additional points between. The first drawing, made on January 5, 1989, was inspired by the sight of a bank of clouds hovering over the Pacific Ocean from an airplane window. This horizonless bird's-eye view is maintained as a device throughout the sequence until the last image, which was made in Vienna at the close of the trip while overlooking a garden in springtime. Each image is a record of internal as well as external events, a map covering an emotional as much as a geographical terrain. Uppermost in the artist's mind while making this ensemble was the concept of generation, biological as well as artistic. Fecundity is everywhere evident: in the large number of drawings that constitute this suite, in the rich overlay of line and color, and in the multiple orientations taken by the drawings in their final installation.

plates 229–30 / plates 227–28

plates 249–51

Tuttle's restlessness in the early to mid-1980s was stimulated by the increasing interest in his work expressed by galleries and museums abroad. Europe proved particularly receptive: there were exhibitions in Brussels, Cologne, Geneva, Helsinki, London, and Rome; gallery representation in France, Germany, Italy, and Switzerland; and works entering important European collections. In the spirit of the founding "post-studio" generation to which he belongs, Tuttle responds avidly to working in varied circumstances, for he feels that installing his work in multiple contexts advances his aesthetic thinking: he has written that "making an exhibition is a unique

33 Richard Tuttle **K 1** 1981
Acrylic, plywood, sawdust,
and nails, 7 7/8 x 5 1/4 x 1 3/8 in.
Stedelijk Museum Amsterdam

opportunity to see something," to "produce new knowledge."[108] His extensive exhibition history may be explained by the fact that he makes crucial creative headway through exhibitions—even *after* exhibitions. As a result, when a visitor to the opening of a Tuttle show returns for a second look, it is not unusual to find that subtle yet essential adjustments have been made to the pieces on view—surfaces repainted, nails removed. This retooling and refining of the work in the public sphere is integral to Tuttle's working method.

Special mention should be made of Tuttle's highly regarded notebook drawings, the most extensive of the framed drawing series. The notebook drawings encompass eight discretely titled and visually consistent suites of works. One of these was exhibited at *Documenta 7* in 1982; another won Tuttle the Biennial Prize at the seventy-fourth annual *American Painting and Sculpture* exhibition at the Art Institute of Chicago that same year. The works in *Old Men and Their Garden* (1982), the last of these groups, have crudely made double frames—inner frames painted white and surrounded by strips of raw fir—that produce the effect of telescoping in on the image. Inside each frame is a sheet of blue-lined, red-margined notebook paper, a plane made specifically for writing but here turned on its side into a patterned ground for imagery. Floating on these ready-made vertical bands are translucent puffs of gouache so evanescent as to have the air of something fleeting and only momentarily captured, like a breath. Capitalizing on the inherent properties of his materials, Tuttle has expertly allowed the thin pools of wash to soak and buckle the paper surface, introducing a subtle dimensionality that radiates out from the central form, which itself resonates with references—a dragonfly, grasses, a ghostly angel shape. (This last is a reminder that this particular suite was made as an elegy for Parsons, who died in 1982.) Fittingly, the final piece in the group is executed in black ink and exhibits the graphic fluency of Asian brush drawing, in which the speed and certainty of the gesture communicate strong feelings.

plates 223–25, 244

The framed drawings paved the way for the wall-bound assemblage-constructions, which Tuttle began building out of leftover material from *India Work*. The first series of assemblages, initially shown at Galerie Yvon Lambert, Paris, in 1981, marked a turn toward overt dimensionality not seen in Tuttle's work since the 1960s. Wall-dependent assemblage would continue to occupy Tuttle through numerous bodies of work until 1986, coinciding with his showing at the high-profile Blum Helman Gallery, a prime contributor to the heady atmosphere infusing New York's 1980s art scene. *B 1* and *K 1* (both 1981) demonstrate his initial tendency to stay within a limited range of materials (predominantly raw, painted, and scored wood) and to adopt a dense construction that allows for only a shallow spatial register.[109] With each subsequent body of assemblages, the compressed quality and limited material range progressively opened up to become highly volumetric configurations made from a plethora of disparate and

plate 195 / plate 33

inventive media, shapes, textures, and colors. As always, the sense of improvisation and informality characteristic of these pieces was arrived at by way of the most agile methodology, evincing equal measures of control of and surrender to material—a practice arising from a mind at once offhand and precise, and possessing the rare skill of seeing potential in the most unlikely things and conjunctions.

A number of Tuttle's favored materials derive from the margins of artistic practice, such as the packing trade (cardboard, bubble wrap, Styrofoam). Sometimes the artist will accidentally come across something where he is working that will prompt the creation of a piece: a single nail, for example, left by a previous artist-resident on the floor of a Vienna studio became the material locus that led to *Beethoven Stop on the Way to Egypt* (1986). Materials are not restricted to the workspace, however: Tuttle is a connoisseur of street junk, as evidenced by the bits of broken colored glass and Pepsi can that form part of *Two or More XII* (1984) or by the blue-painted twig that graces *Monkey's Recovery for a Darkened Room, 6* (1983). The coarse and banal quality of these found objects keeps Tuttle's visual refinement and tasteful flourishes well in check.

Tuttle is particularly drawn to surfaces that have the capacity to reflect, play with, and incorporate ambient light—hence his deployment of cellophane wrap, glass fragments, plastic grocery-store bags, and aluminum. Materials like these inform the series *Two or More* (1984), particularly *Two or More III,* whose common superstructure is an airy layering of alternately opaque and transparent substances that promote a play of light and shadow. Along with light, color also assumed a central importance for Tuttle during this period, with his formerly subtle palette giving way to brilliant unmixed hues. Rather than simply tinting the surface, color assumes material substance, as in the carved Styrofoam blocks at the heart of *Monkey's Recovery I, #3* (1983), the double-mound form in *Two or More XII,* or the extra-thick deposits of white paint that enliven *Two or More IX.* Finally, what ties nearly all of Tuttle's materials together is their synthetic nature, which bespeaks a contemporary quality. Even when working with messy castoffs, he takes care that they not be decayed or antique looking, so as not to inadvertently generate feelings of nostalgia or melancholy for things or times past.[110] In its palpable factuality, its dependence on the viewer's immediate sensory response, and its embedded and exuberant here-and-now state, Tuttle's work is in every way present-minded.

Tuttle clearly chooses his materials more for their formal attributes than for associative meanings deriving from an original function or past use. There are actually very few instances in which a found object is left untouched and its denotative sense preserved (the Pepsi can in *Two or More XII* is probably the most obvious example). More often than not, he transforms and redeploys objects drawn from

plate 206

plate 203

plate 200

plate 202

plate 201

plate 205

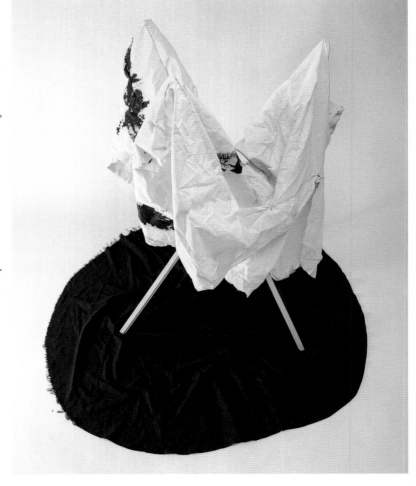

the everyday so that their extra-artistic inferences are mitigated or lost inside the new compound-object. And yet, while the object's initial meaning is never privileged, it can't help but maintain a vestigial recollection (even the part-object is not immune from reference), and in fact this serves a critical purpose, for it fortifies the assemblage's reality quotient by getting the world into the picture.[111]

At the same time, Tuttle's own artistic vocabulary, previously restrained in its approach to illusion and allusion, loosens to a degree not previously seen in his work: materials take on such recognizable shapes as a horseshoe, a boat, a leaf, even the female figure. Together these developments put into play a new dialectic between abstract form and recognizable subject. A loose symbiosis is established between abstraction and figuration, matter and meaning, in which, significantly, one term is not favored over the other. These polarities are evoked but not merged, so that each in effect functions independently. Tuttle's work is what sculpture looks like when it oscillates perceptually and conceptually between form and content, raw matter and pictorial representation, with both idioms cohabiting in novel physical rhythms and arrangements that forge a larger if enigmatic meaning.

The deliberately loose syntax between form and content also extends to the physical construction of these works. Tuttle's procedures for making the wall assemblages involve a wide array of tenuous connective techniques (gluing, tying, propping, stitching) and materials (hot-glue filament, paper tabs, Scotch tape). What holds the work together is emphasized rather than hidden—to the point where *Monkey's Recovery for a Darkened Room, 6,* Tuttle's masterpiece of the period, is a sculpture of pure connectives shunning a material core. Paradoxically, rather than synthesize, these widespread systems of affixing, in their explicit precariousness, visibly *undermine* any sense of stability—and that is precisely the point. The apparently makeshift technique is part of a deeply considered strategy of exemplifying and giving form to flux rather than representing it illusionistically. The traditional concepts of finish, architectonic stasis, and formal resolution all founder on the very real capacity of the wall assemblages to fall apart—and, in any case, such criteria are anathema to works that are dedicated to objectifying the transient. It is just this unstable axis that readies the ground for "emblems of immanence."[112]

In the floor drawings, the most visually robust and rambunctious works of the 1980s, Tuttle demonstrates his mastery of forms that are as close to collapsing into their individual parts as they are to cohering into sculptural wholes.[113] Executed intermittently between 1987 and 1989, this group of twenty pieces marked the assemblage's migration from the vertical plane of the wall to the horizontal surface of the floor, where it took on three dimensions and a large (by Tuttle standards) if indeterminate scale: "not-quite-object, not-quite-monument, not-quite-creature, not-quite-dwelling."[114] Nonchalantly placed in the middle of the room, the works ask to be approached and apprehended from all angles. In this passage around the work, the viewer experiences not

plates 34, 252–63, 265

34 Richard Tuttle **Five** 1987
Wood, canvas, fabric, acrylic, and
linen thread, 41 x 59 x 61 3/4 in.
Collection of the artist

only an unfolding sequence of visual surprises, but also an utter dissipation of fixed coordinates and an even greater sense of physical dispersal brought to bear on an already open and elastic form. Transparent and spare in construction, the floor drawings teeter on the threshold between form and its undoing, armature and affect—and animate and inanimate. Perhaps because, like us, these works are freestanding and share the same space of lived experience as our own bodies, they seem singularly animated—playful, a bit sloppy, something "between creature and toy."[115] A great part of their appeal lies in the fact that, as tenuously constructed as they are, they are nevertheless tenacious—and like anything fragile that holds together, they earn our respect and affection while stirring our own sense of vulnerability.

plate 262

plate 265

plate 247

The main materials in the floor drawings are lengths of wood arranged into skeletal structures and hooded or draped with cloth (this gesture recalls Tuttle's early practice of placing his cloth pieces on the floor).[116] The structure often takes the form of an undulating arabesque (*There's No Reason a Good Man Is Hard to Find I* [1988]) or the fabric is made to curve into a serpentine swag (*Turquoise I* [1988]). These forms call to mind the spiraling bodies and billowing garments of the Baroque, a period of long-standing and deep interest to Tuttle—never more so than during the mid-1980s, when he spent regular intervals in Vienna and exhibited work in the gilded and mirrored halls of a late-Baroque palace.[117] It makes sense that he would be attracted to the ideas and visual vocabulary of that era, with its easy interplay between two and three dimensions inside a shallow space, its polychromatic interlocking of architecture with painting and sculpture. The knowing fusion of the exalted and the humble (the supernatural and the human) exemplified by the Baroque is likewise taken up in his so-called lightbulb pieces (such as *Done by Women Not by Men* [1989]),

plate 303

each of which incorporates light—a preeminent symbol of spiritual and religious energy—here literally brought down to earth in the form of common fluorescent lamps and colored bulbs. Another defining feature of the Baroque, the fold, is a favored construct of Tuttle's as well. Since at

plate 129

least 1974, with *4th Summer Wood Piece*, which precedes the oft-folded collage pieces, Tuttle has used the action of folding in a quintessential manner—to swell next-to-no-volume into mass and thereby articulate space. Further to his own interests, the fold "insists on surface and materiality, a materialism that promotes a realistic visual rhetoric in its wake."[118] In other words, the fold helps us to see material as material, keeping the work in a fundamentally physical sphere as opposed to a symbolic one, as if Tuttle were insisting that the metaphysical be solely contained within and achieved through physicality.

plate 307

The floor drawings span a period of great change in the artist's life: his marriage in 1987; a removal from New York in 1988 to Galisteo, New Mexico; and the birth of a daughter, Martha, in 1989. The group of floor drawings titled *Sentences* chronicles Tuttle's impressions of his child's birth: *Sentences II* (1989) is decorated with ovoid forms inspired by the contours of a baby's head (and clearly referencing Constantin Brancusi's 1915 sculpture *Newborn*). These happy events were shadowed by illness and death among Tuttle's close family, and he began in this period to show his work against toned walls, which not only provided a "frame"—an optical backdrop and unifying factor—but also chromatically conveyed what he felt was a turbulent period in his life. That sense would remain with him until 1996, when the toned walls left his repertoire.

With the turn of the decade from the 1980s to the 1990s, Tuttle's position in the art world shifted in ways that reflected, on the one hand, a codification of the now-historical Post-minimalist movement and, on the other, a positing of his work as prescient of and influential for an emerging generation of artists. Enough time having passed to allow the artistic period of the mid-1960s to mid-1970s to be synopsized, it became clear what Tuttle's role was among his post-minimalist peers. The 1990 exhibition *The New Sculpture 1965–75: Between Geometry and Gesture* plate 387
at the Whitney Museum of American Art was one of the first and most important shows to con-secrate the movement, and it displayed Tuttle's works in the first gallery alongside those of Hesse and Nauman. Concurrently, the art of the 1960s took on new importance for work of the 1990s by artists such as Tom Friedman, Felix Gonzalez-Torres, Jim Hodges, Gabriel Orozco, and Kiki Smith, among others. The resonances between these young artists' methodologies and Tuttle's ap-proach manifested in a subjective if subdued content infusing minimalist structures; a direct and unpretentious use of materials within loosened formal parameters embracing the artist's "touch"; and a quality of temporality, in the form of a deceptively casual execution, transient substances, and precarious presences. These developments occurred in a climate that generated no overriding cohesive movement or "superstars." The upshot of working in a productively unfocused, heroless moment was that the ensuing art scene perforce supported the exercise of individual vision, past and present. In this context Tuttle began to be represented to the public eye as something of a hip "old master" whose maverick example exerted a "burgeoning influence on a younger generation of artists." "Tuttle is in the air again," offered *The New Yorker* in 1992.[119] Later in the decade the *New York Times* concurred: "Much of the work you see in galleries now—installations of humble materials, low-key abstractions, spare Zenlike interventions of one sort or another—owes a debt to him."[120] And the more specialized New York art press shared the consensus: "Out of step with the excessive '80s, Tuttle's frail constructed pieces now look perfectly au courant. In fact, Tuttle seems to be the godfather to a slew of younger funky formalists."[121]

Despite (or perhaps because of) this critical acclaim and artistic influence, Tuttle has always seen himself as operating at the culture's fringes, for such is the inevitable location of indi-vidual consciousness, admired or not. This self-perception has its counterpart in his love of mar-ginal spaces: he has regularly endowed margin zones—the edge of a frame, the gutter of a book, the periphery of a room—with aesthetic import. This predilection was vividly brought to a head in a 1992 exhibition at Mary Boone Gallery, New York.[122] Into this central bastion of the 1980s art plate 316
boom Tuttle inserted a group of twenty-four near-invisible assemblages, averaging no more than a few inches tall or wide, placed at the bottom of the gallery walls. A pencil line ascended from each of these tiny works, beginning one-quarter of an inch off the floor and reaching the ceiling, where it continued at a right angle away from the wall for another eighteen inches, arcing slightly over the viewer. The assemblages obliged the viewer to squat down for a closer look, while the pencil lines guided his or her gaze upward. As subtly present as they were, the floor-bound sculptures and tall bands of parallel pencil lines utterly commanded the gallery, snapping the careful architecture of this highly successful commercial space into sharp focus while at the same time quietly subverting it by insinuating into it a market-defiant work.

Tuttle's move to New Mexico, his primary residence for ten years beginning in 1988, had an immediate and ongoing impact on his work. Having initially installed himself in Galisteo, Tuttle eventually purchased property in Abiquiu atop a mesa affording a spectacular 360-degree view of virtually unspoiled desert landscape. The tranquil expansiveness, starkly radiant light, gentle palette, and natural geometries of his New Mexico surroundings clearly inform *Inside the Still Pure Form*, a richly complex installation involving wall painting, low-relief sculptures, and drawings that occupied two floors of New York's Blum Helman Gallery in 1990. For this work, Tuttle encircled the walls of both gallery spaces with five continuous bands of color—each composed of a thin pencil line on top of which lay a tinted wash—that were arranged in such a way as to suggest an abstracted landscape: two bands of different-colored blue (manganese and cobalt) installed skyward, two kinds of yellow (a yellow ocher and an Indian yellow) located at the level of an imaginary horizon line, and a viridian green placed close to the floor. The bands were absolutely congruent with their architectural support and remained continuous as the wall surface rounded corners and accommodated a reception desk, windows, and doors. Riding on top of this environmental wall work were fifty-four low-relief sculptures and framed drawings installed above, below, and directly on the painted bars, looking much "like musical notes on the stave."[123] The assemblages were made from wood scrap found in New Mexico and spray-painted white, the drawings (entitled *You and Me* and *The Table and a Chair*) from toned pastel notebooks whose pages ranged in color from light to very dark, and whose surfaces Tuttle covered with energetic vectors of vividly colored brushstrokes.

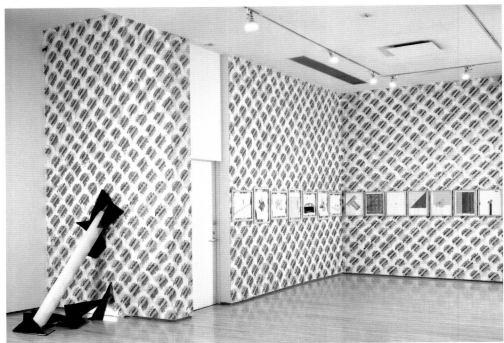

In its specific relationship to the site, its physical encompassing of the viewer, and its urging of a temporal passage across the space of two separate locations, *Inside the Still Pure Form* exhibits the classic characteristics of installation art, at precisely the moment when the medium reached full maturity.[124] Within Tuttle's own artistic trajectory, this development is a natural outgrowth of a constant and astute factoring of the artwork with its environment. Recent years have seen him take this skill and attention to the gallery milieu to new heights, creating some of the most personal and visually enthralling exhibitions of his career: displaying work in sky-high vertical swaths, spiral formations, or concurrently in two separate locales (as in a two-part exhibition located in Porto, Portugal, and nearby Santiago de Compostela, Spain, in 2002).[125] Tuttle is never one simply to hang new work; his shows consist of calculated arrangements that intentionally blur the line between artwork and exhibition design. (For a 1987 exhibition in Zurich, he circumscribed Annemarie Verna Galerie with a painted black

plate 310

plates 354–55

plate 378

35 Installation view of the 2004 exhibition **Richard Tuttle: It's a Room for 3 People** at the Drawing Center, New York, showing **Village V** (2004)

36 Pages from **Artforum** magazine, February 2002, showing "Cosmic Relief," a sequence curated by Richard Tuttle featuring an essay by Robert Storr and artworks by Jean Fautrier, Agnes Martin, Constantin Brancusi, Carlo Crivelli, John Constable, and Peter Halley

"horizon line" above which he hung his work. His 2004 show at the Drawing Center in New York plate 35
included a patterned mural backdrop for some suites of new work.) Tuttle was indoctrinated early
on in the importance of controlling the exhibition space as well as "the hang"; Betty Parsons Gallery,
after all, had been designed by Tony Smith, and its shows were sometimes curated by Newman.
For his first show there, Tuttle had painted a wall gray to carry *Chelsea*; and his 1975 Whitney sur-
vey was rearranged twice after the exhibition opened to highlight the impact of different viewing
conditions on individual artworks. In 1995, for the *North/South Axis* exhibition at the Museum of
Fine Arts in Santa Fe, Tuttle changed the installation continually in response to organized weekly
audience discussions.

This last-mentioned show enacted the reciprocal relationship that Tuttle feels his work
has with its audience. The exhibition space is of course central to him, but so is the human inter-
action that takes place within it. The importance Tuttle gives to the work's public dimension may
be traced to his generational roots: artists who came into their own in the 1960s argued "against
the location of meaning inside the work of art, where one presumes to find the personality of the
artist."[126] Instead, meaning was located "outside the art object, in its physical setting or in viewers'
responses, rather than 'inside' it, in the literary or psychological import of an image."[127] For Tuttle
and his phenomenologically oriented peers, the work can only be known and completed—and
continually renewed—in social experience, in the meaning brought to bear by the collective: "art,
artist, collector, viewer, curator, collection, exhibition, and institution."[128]

In recent years Tuttle has returned with renewed concentration to the subject of the low relief or
bas-relief—a structure much in the air at the time of his artistic education, and one that initially
launched his career in the form of the constructed paintings. The bas-relief remains a special artis-
tic and intellectual preoccupation for the artist, as is made evident by his choice of it as the focus of
the pages he curated in the journal *Artforum* in February 2002.[129] This circular interest in the wall plate 36
relief is Tuttle's privilege after a decades-long refinement of a distinctive visual language. Rather
than following a linear trajectory over time, his work reveals an achronological complexity that

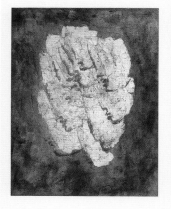

Cosmic Relief
Richard Tuttle

points to a strikingly early maturation of vision and program and a corresponding indifference to chronological "progress." He prefers instead to delve deep into chosen dominant strains in different periods, a method that has enriched rather than diminished his output.

Tuttle's long-standing and keen sensitivity to relief in all its subtle and precisely tuned permutations testifies to a desire to make "the realest of real things."[130] The relief form, whether it be a single, slightly raised surface or a thin overlapping of layers, occupies actual space and throws real shadows—aspects that underscore any pitch for true-to-life objecthood. The shaped relief lends an obdurate corporeality to the *Waferboards* (1996), which constituted Tuttle's first show at Sperone Westwater, New York, and were the last works to be exhibited against toned walls. These golden forms are made from a composite product of pressed aspenwood scraps, its vividly flecked surface enlivening avian shapes recalling feathers, wings, or warbling chests. Held by nails at their edges and cantilevered this way and that on the wall, the works seem to hover nervously between touching down and flying away, evoking the fanciful grace and lightness of birds and engendering a sense of animated disequilibrium that is wholly intrinsic to their content.

Tuttle shortly followed these works with the overlapping plywood surfaces of *New Mexico, New York* (1998), a title that refers to the beginning of his dual-state residency.[131] The envelope-like shapes of these works invoke the idea of circulation from one place to another. Each is constructed from two layers of quarter-inch plywood, the top "flap" always smaller and made to run flush along one side of the larger substrate. The wood grain shows like moiré patterns through diluted acrylic paint, and the surfaces also reveal pencil outlines and painted shapes suggestive of rivers and paths—motifs, again, of passage and movement—riding independently

<div style="margin-left:2em">

plates 322–25

plates 37, 326–31

</div>

37 Richard Tuttle **New Mexico, New York, E, #4** 1998
Acrylic on plywood, 20 x 24 1/4 x 1/2 in.
Collection of Mimi and Peter Haas

of the relief structure. Tuttle took up the same conjunction of layered shallow relief and evocative visual patterning with *"20 Pearls"* (2003), in which two pieces of foam board are superimposed but reversed: as in the *Waferboards*, shaped outer contours readily engage the surrounding space and lend the works vitality and verve. Tuttle's palette has never been more sensual than it is here, as shapes by now familiar to his repertoire—leaf and square forms—receive candy-colored surfaces that make an unapologetic and immediate appeal to the senses in advance of any intellectual analysis. Aesthetic pleasure itself is the subject of these pieces, and it is distilled in their very realization.

plates 146, 349–53

In many of his recent works, Tuttle takes as his primary format a plywood panel ten or eleven inches square and a quarter-inch deep. He arrived at these preferred dimensions while producing the eight prints of *Any Two Points* (1999): floating inside each of these square sheets of paper are embossed blocks of pure color that bring Tuttle's investigation of the low relief to its subtlest and most refined state.[132] These rectangular or square colored shapes and their dynamic geometric distribution across the surface of the paper led Tuttle to the compositional arrangements in *"Two with Any To"* (1999), where the embossed block is transformed into a painted piece of lumber, its location on the surface of the square wood panel varying from piece to piece. Completing the composition are painted shapes, raw wood-grain patterning, and the carefully choreographed shadows cast by the wood block, which interact with the other components: for example, in the way the shadow's outer edges may coincide (depending on the infinitely varied possibilities of the light source) with the outermost green points of the painted star in *"Two with Any To, #1."* Such material protrusions and their shadow plays reach ornate heights in *Ten, A* (2000), one of four works made from ten individual wood panels installed in pyramidal fashion low on the wall.

plate 38

plates 341–46

plate 341

plate 347

With *Replace the Abstract Picture Plane IV* (1999), Tuttle assigned to the wood-relief structure a weighty ideological role.[133] Each of forty square fir panels is bisected vertically by a drawn pencil line, on either side of which a different color appears; the one on the right consistently has a greater optical weight, generating a kind of visual staccato when the works are installed as a group. The pieces are made to float slightly out in front of their white boxed frames, which in turn protrude from the supporting wall surface on quarter-inch plinths. The resultant impression is of a physical and optical advance and recession that refuses to settle on a single continuous plane. This jostling is a deliberate strategy to disable the perception of the work as an uninterrupted continuum, like a screen or a picture plane; instead, what one actually "sees," what Tuttle seeks to instantiate, is the disruption of the traditionally dominant position of the illusionistic picture plane in the task of interpreting the world. As Tuttle would have us be aware, the classic picture plane is an invention of Renaissance easel painting. So successful was this vehicle as a form of making the world understandable—both physically and ontologically—that Western culture has adapted the flat and unified

plates 339–40

38 Richard Tuttle **Any Two Points, #6** 1999
Color aquatint with woodcut and
drypoint, ed. of 25, 11 1/8 x 11 1/8 in.
Published by Crown Point Press

picture plane as the visual tool for all manner of visual and intellectual cognition, from the view out a car window, to the cinema screen, to the way we structure inner consciousness. We "see" things as if they existed as a unified, flat field. It is Tuttle's contention that this way of perceiving and processing the world is outmoded and limits our capacity to fully understand ourselves and the world around us,[134] and it is therefore his ambition to create works that confound and disrupt inherited ideas about what constitutes a picture plane or image, and to undermine their primacy. Tuttle's project, beyond this particular work, is to undo, so as to rethink, the visual tools we have invented and indoctrinated ourselves to comprehend by. This is the meaning of the title *Replace the Abstract Picture Plane,* in which the verb should be taken in the imperative—an exhortation to each of us to upend our received pictorial habits and allow for a more visceral and individual engagement of the senses "to bring about an awareness of consciousness,"[135] which in turn would place us squarely in the here and now.

Tuttle has stated, "I am placing in a world that is mostly concerned with recognition a thing whose primary involvement is perception."[136] His works are arguments in favor of a precognitive mode of perception that would allow one to see the world without the constraint of perceptual and intellectual habits. The artist—and the viewer in turn—engages in an ever-present and direct facing of experience, one that takes place prior to those operations of mind that would define our observations and perforce also standardize and even dictate our perceptions and responses. This activity reawakens us to a fresh experience of the palpable present: the sympathetic observer of Tuttle's art is invited to share in an attitude of enhanced attention that is subsequently available for transposition, from the art object to the world at large, every day. Tuttle's work proposes and fosters acts of the imagination that return to the viewer the ability to associate creatively with the world, to undertake the movement toward meaning that is at the core of art and human experience.

The idea of an art providing a direct experience of reality, as opposed to a secondary, representational one, is one of modernism's most powerful and enduring aspirations. Postmodern criticality has held this old-fashioned and indeed impossible ideal under suspicion, particularly since the 1970s and 1980s. What gives Tuttle's efforts in this arena their sense of legitimacy is the fact that his approach keeps well in check the regressive bluster and forceful assertions of absolute certainties that have traditionally accompanied such undertakings. In his quest to figure out "how to maintain the achievements of modernism, particularly in a world dead to them,"[137] Tuttle recovers modernism's best qualities in a subversive, deliberately nongeneral, and imperfect sublime. Not for Tuttle the creation of a single, unadulterated, and absolute "truth"; instead, each piece constitutes a palpable, believable, seemingly inevitable "little truth," a graceful and fearless aesthetic presence in front of which one encounters not a depicted image but the thing itself. The artist is "after essences," certainly; "not streamlined Platonic ones," however, "but informal, folded, asymmetrical, lumpy, hairy little entelechies."[138] This universe of small truths addresses the viewer on the spot in a continually constructed present that helps us to feel what it is to *be.*

NOTES

Warm thanks are extended to Richard Tuttle for undergoing numerous conversations and interviews with unstinting thoughtfulness and grace; to Tom Shapiro for his unflagging and essential support; and to Chad Coerver, Karen Levine, Joseph N. Newland, and Peter Samis for their sage and elegant intellectual contributions. To my expert and generous readers, David Frankel and Sylvia Wolf, I am profoundly grateful.

1 "Not Ideas about the Thing but the Thing Itself," *The Collected Poems of Wallace Stevens* (New York: Alfred A. Knopf, 1993), 534.

2 Richard Tuttle, quoted in "Work Is Justification for the Excuse," in *Documenta 5* (Kassel, Germany: Museum Fridericianum, 1972), section 17, page 77.

3 Richard Tuttle, quoted in Dierk Stemmler, "Ten Designs for a Poster, 1985," in *Richard Tuttle* (Mönchengladbach, Germany: Städtisches Museum Abteiberg, 1985), 82.

4 A passage Tuttle once selected from the writings of René Descartes speaks eloquently to the artist's own work: "What is most to be noticed in all this is the generation of the animal spirits, which are like a very subtle wind, or rather like a very pure and lively flame." Quoted in *Plastic History* (Munich: Wassermann Galerie, 1992), unpaginated.

5 Here I am also deliberately invoking Tuttle's first book, *Story with Seven Characters* (1965; pl. 366). The glyphs or "characters" Tuttle creates and deploys across the pages of this book embody the various definitions of the word *character*: they act like personalities in a story, and they are "eccentric" as well as ideogrammatic in form.

6 Richard Tuttle, unpublished interview by Mei-mei Berssenbrugge, 25–26 October and 12 November 1990, courtesy Richard Tuttle and Mei-mei Berssenbrugge. My thanks to Susan Harris for generously sharing this transcript with me.

7 Tuttle touched on the topic of Calvinist doctrine in a lecture titled "The Defense of Puritanism," given at Naropa University, Boulder, Colorado, in June 2003.

8 Briony Fer uses this term to describe the work of Eva Hesse. See her essay "The Work of Salvage: Eva Hesse's Latex Works," in *Eva Hesse*, ed. Elisabeth Sussman (San Francisco: San Francisco Museum of Modern Art; New Haven, CT: Yale University Press, 2002), 94. The redeployment of detritus was also practiced by several other artists of Tuttle's generation, including Barry Le Va and Robert Morris.

9 See Barbara Novak, *American Painting of the Nineteenth Century: Realism, Idealism, and the American Experience*, 2nd ed. (New York: Harper & Row, Icon Editions, 1979), and my master's thesis, "The Basis for a Relationship between Eastern Philosophy and Luminist Works" (Columbia University, 1985).

10 Ralph Waldo Emerson, "The Transcendentalist," in *The Portable Emerson*, ed. Carol Bode, in collaboration with Malcolm Cowley, rev. ed. (Harmondsworth, UK: Penguin Books, 1981), 93.

11 Passage selected by Richard Tuttle from the work of Henri Bergson, in *Richard Tuttle. △s: Works 1964–1985 / Two Pinwheels: Works 1964–1985* (London: Coracle Press / Institute of Contemporary Arts; Edinburgh: Fruitmarket Gallery, 1985), readings 3.

12 Richard Tuttle, transcript of lecture, Skowhegan School of Painting and Sculpture, 4 August 1995; Richard Tuttle, "I Do Believe That Chaos and Form Are…It's the Same," in *Richard Tuttle: Chaos, die/the Form*, ed. Jochen Poetter (Baden, Germany: Staatliche Kunsthalle Baden-Baden, 1993), 173.

13 Richard Tuttle, in *Richard Tuttle: North/ South Axis and the Poetry of Form*, exhibition brochure (Santa Fe: Museum of Fine Arts, Santa Fe, 1995), unpaginated.

14 Lucy R. Lippard, "Intersections," in *Flyktpunkter / Vanishing Points* (Stockholm: Moderna Museet, 1984), 11.

15 This general condition was best summarized by Susan Sontag in her 1966 book *Against Interpretation, and Other Essays*, rev. ed. (repr., New York: Farrar, Straus & Giroux, 1986).

16 David Batchelor, *Minimalism* (Cambridge, UK: Cambridge University Press, 1997), 66. Minimalism's productively indeterminate ontology would stand as an important precedent and model for Tuttle, who as a fledgling artist would have recognized the pitch for freedom and independence in the slightly older artists' resistance to traditional categories and efforts toward self-definition.

17 *Black, White, and Gray* was on view January 9 through February 9, 1964, at the Wadsworth Atheneum, Hartford. See James Meyer, "Introduction to the 'minimal' 1: 'Black, White, and Gray,'" in *Minimalism: Art and Polemics in the Sixties* (New Haven, CT: Yale University Press, 2001), 77–81.

18 Barbara Rose, "ABC Art," *Art in America* 53 (October–November 1965): 57–69. At the same time, Tuttle's paper cubes announced the disassembling of the cube that would become a characteristic of Postminimalism, additional examples of which would encompass Richard Serra's *One Ton Prop (House of Cards)* (1969) and Hesse's *Metronomic Irregularity* (1966), among others.
 It should be noted that Rose dates the paper cubes to 1963, a year earlier than indicated in my essay. Tuttle does seem to have begun work on other paper cubes in late 1963, but the particular set exhibited here is ascribed to 1964.

19 My observations on the aesthetic strategy of touch as a way to achieve a primary experience in art owe a great debt to the writings of Richard Shiff. See in particular his "Constructing Physicality," *Art Journal* 50 (Spring 1991), 42–47; and "Autonomy, Anatomy, Actuality," in *Robert Mangold* (London: Phaidon, 2000), 7–56. See also "Donald Judd: Fast Thinking," in *Donald Judd: Late Work* (New York: PaceWildenstein, 2000), 4–23; and "Bridget Riley: The Edge of Animation," in *Bridget Riley*, ed. Paul Moorhouse (London: Tate Publishing, 2003), 81–91.

20 This also explains Tuttle's forays into designing clothing-sculptures, such as his *Pants* of 1979 (pl. 311), which engage the wearer's whole body at a visceral level.

21 Quoted in Michael Auping, "On Relationships," in *Agnes Martin / Richard Tuttle* (Fort Worth: Modern Art Museum of Fort Worth, 1998), 81.

22 Richard Tuttle, conversation with the author, 12 March 2005.

23 See Barbara Haskell, *Agnes Martin* (New York: Whitney Museum of American Art / Harry N. Abrams, 1992), 104.

24 Quoted in Auping, "On Relationships," 81; conversation with the author, 12 March 2005.

25 Richard Tuttle, "What Does One Look at in an Agnes Martin Painting? Nine Musings on the Occasion of Her Ninetieth Birthday," *American Art* 16 (Fall 2002): 92.

26 Agnes Martin, quoted in Haskell, *Agnes Martin*, 135.

27 See Lee Hall, *Betty Parsons: Artist, Dealer, Collector* (New York: Harry N. Abrams, 1991). The Parsons stable included, among others, Mark Rothko, Robert Motherwell, Willem de Kooning, Ad Reinhardt, Barnett Newman, Clyfford Still, Hans Hoffmann, and Jackson Pollock. Pollock's three landmark shows of 1947–50 were all held there.

28 Ann Temkin, "Barnett Newman on Exhibition," in *Barnett Newman*, ed. Ann Temkin (Philadelphia: Philadelphia Museum of Art; New Haven, CT: Yale University Press, 2002), 30.

29 Ibid., 37.

30 Thomas B. Hess, quoted in Calvin Tomkins, "Profiles: A Keeper of the Treasure," *The New Yorker*, 9 June 1975, 60.

31 Tuttle, lecture, Skowhegan.

32 Tuttle originally made approximately one hundred and fifty constructed paintings but subsequently destroyed around half of these, and there are about sixty known works at the present time.

33 Donald Judd, quoted in Bruce Glaser, "Questions to Stella and Judd," in *Minimal Art: A Critical Anthology*, ed. Gregory Battcock (New York: E. P. Dutton, 1968), 155.

34 *Gestalt* is a term used in psychology to denote a whole, fully graspable thing; even when seen from a provisional and partial point of view, we infer its wholeness because its form is so basic. The experience is that "one sees and immediately 'believes' that the pattern of one's mind corresponds to the existential fact of the object" (Robert Morris, "Notes on Sculpture, Part 1," in *Continuous Project Altered Daily: The Writings of Robert Morris* [Cambridge, MA: MIT Press, 1993], 6). See also Kenneth Baker, *Minimalism: Art of Circumstance* (New York: Abbeville Press, 1988), 71.

35 Quoted in Shiff, "Donald Judd: Fast Thinking," 5.

36 Donald Judd, "Specific Objects" (1965), in *Minimalism*, ed. James Meyer (New York: Phaidon, 2000), 207–10.

37 It is interesting to point out that while both works are modular compositions in the minimalist vein, Tuttle's piece is assembled from separate physical units, one year before the appearance of Judd's trademark vertical stacks composed of unlinked, identical relief elements.

38 I say this even as I wish to qualify my point on Minimalism's reductivist tendencies in light of recent studies by David Batchelor, Hal Foster, and Alex Potts, among others, all of whom have highlighted Minimalism's embrace of sensual optical effects that approach illusionism.

39 Lawrence Alloway, *Pattern Art: 20th Anniversary 1946–1966*, exhibition brochure (New York: Betty Parsons Gallery, 1966), unpaginated; an exhibition commemorating the anniversary of Betty Parsons Gallery. One should especially acknowledge Kelly's shaped, hybrid painting-sculptures of the 1950s as precedents for Tuttle's own explorations, though Tuttle did not respond to the roots of Kelly's reductivist abstractions in a close observation of the real world.

40 According to the artist, while making works such as *Silver Picture*, he "was thinking about giving line dimensionality, and wondering if a painting could act like a line instead of being the ground for a line" (quoted in Auping, "On Relationships," 82). This ambition carried over to later works such as *Memento, Five, Grey and Yellow* (2002; pl. 354), which Tuttle describes as "a line and a form." Tuttle credits the invention of the concrete line as a real material condition of a work to Carl Andre, as well as to Andre's linear sculptures made of abutting bricks and the way the elements connect in his carpetlike floor sculptures made from metal squares. These find correspondences in Tuttle pieces such as *Chelsea* (pl. 41), in which individual panels painted mauve, pale green, and salmon are yoked together to generate a single object.

41 Gordon B. Washburn, *Richard Tuttle: Constructed Paintings*, exhibition brochure (New York: Betty Parsons Gallery, 1965), unpaginated.

42 The first body of "tin pieces" numbered around forty, the next three were identical in number (twenty-six) and in configuration but not in depth, with the last suite being the thinnest. This final group, the only one to remain intact after its showing at Galerie Schmela in 1968, is the one included in this exhibition (see pls. 56–57).

43 James R. Mellow, review, *Art International* 11 (20 April 1967): 61.

44 Richard Tuttle, artist's statement, in *Overview* [Crown Point Press newsletter], June 2004, 1–2. It should be said that there is a long history of radical artistic experimentation with forms of language (with which Tuttle is well versed), particularly in the first decades of twentieth century avant-garde practice, which saw such artist-ideographers as Jean Arp, Paul Klee, Joan Miró, Pablo Picasso, and Kurt Schwitters stretch the possibilities of art through calligraphic abstraction. Interesting in connection to Tuttle is that the exhibition Barnett Newman organized for Betty Parsons Gallery's inaugural show in 1947 was titled *The Ideographic Picture*; in the accompanying text Newman advocated for the meaningful nonverbal character of a visual symbol (see Temkin, *Barnett Newman*, 30). More recently, Cy Twombly and Brice Marden have explored this territory (see *Abstraction, Gesture, Ecriture: Paintings from the Daros Collection* [Zurich: Scalo, 1999]).

45 Richard Tuttle, *40 Tage: Mit Einem Text des Kunstlers / Zeichnungen* (Bonn: Galerie Erhard Klein; Vienna: Galerie Hubert Winter, 1989), 42.

46 Smith, archives, "The Pattern of Organic Life in America," ca. 1943, quoted in Doris von Drathen, "Away from Categories: An Alternative View of Tony Smith and Carl Andre," *Art Press* 224 (May 1997): 44.

47 Robert Smithson, quoted in Lucy R. Lippard, ed., *Six Years: The Dematerialization of the Art Object from 1966 to 1972* (Berkeley and Los Angeles: University of California Press, 1973), vii.

48 Sol LeWitt, "Paragraphs on Conceptual Art," *Artforum* 5 (June 1967): 79–83.

49 LeWitt's "Ideas alone can be works of art.... All ideas need not be made physical" was seconded by Lawrence Weiner, who in 1968 pronounced that his works "need not be built," since the work already permanently existed as language.

50 Robert Smithson, "Language to Be Looked at and/or Things to Be Read" (1967), in *Robert Smithson: The Collected Writings*, ed. Jack Flam (Berkeley and Los Angeles: University of California Press, 1996), 61.

51 Quoted in Christine Jenny Egan, "Drift—Transformationen im Werk Richard Tuttles, 1965/1975" (Ph.D. diss., Kunsthistorisches Seminar, Basel, 2001).

52 Tuttle's joint endeavors with contemporary poets include projects with Simon Cutts, Larry Fagin, Barbara Guest, Charles Bernstein, Ilma Rakusa, and Anne Waldman.

53 See Katy Siegel's "As Far as Language Goes" in this volume.

54 Lippard, "Intersections," 24.

55 Tuttle's *Paper Octagonals* were included in an important early exhibition called *Using Walls (Indoors)*, at the Jewish Museum in New York in 1970, devoted to wall works that could be executed on the spot. (The exhibition was shut down after the opening by a majority vote of the participating artists in protest of the Vietnam War.) It is worth mentioning that the *Paper Octagonals* were first shown as a complete group at Clocktower Gallery in 1973, its first year of programming, and that Tuttle participated in P.S. 1's inaugural exhibition in 1976. Both organizations announced a new kind of exhibition situation for the 1970s that originated in Europe and made available unusual and highly inflected environments that further galvanized artists to be situational in their art-making. The 1970s gave birth to a whole movement—"site-specific art"—that was characterized by an immediate reference to, if not a merging with, its physical location. The central impact of the gallery space on the artwork, and the recognition of it as a nonneutral container to be engaged directly, was pervasive and has been well summarized in Brian O'Doherty's important book *Inside the White Cube: The Ideology of the Gallery Space* (San Francisco: Lapis Press, 1986).

56 Scott Burton, "Notes on the New," in *Live in Your Head: When Attitudes Become Form: Works—Concepts—Processes—Situations—Information*, by Harald Szeemann (Bern, Switzerland: Kunsthalle Bern, 1969). European critics were equally impressed by Tuttle's groundbreaking work: Germano Celant saw the cloth pieces as part of a strain of "American 'Cool' Painting," and gave the work a special mention for "break[ing] the rule of the rigidity of the placement of all of the art that has been seen up till now in favor of a principle of multidirectionality and ubiquity" (Celant, "La 'pittura fredda' americana / American 'Cool' Painting," *Domus* 523 (June 1973): 49.

57 See Angelica Zander Rudenstine, *Modern Painting, Drawing, & Sculpture: Collected by Emily and Joseph Pulitzer, Jr.*, vol. 4 (Cambridge, MA: Harvard University Art Museums, 1988), 902.

58 Robert M. Murdock, *Richard Tuttle* (Dallas: Dallas Museum of Fine Arts, 1971), unpaginated. More recently, Tuttle has said of such work, "It was drawn as a three-dimensional figure in space, which was two-dimensionalized to its outline, so that the wrinkles accounted, I suspect, for its loss of three-dimensionality. I was interested in how it completes itself visually after such a loss" (*Richard Tuttle: Community* [Chicago: Arts Club of Chicago, 1999], 8). I would like to thank Peter Freeman for his helpful observations on this topic.

59 Richard Tuttle to Dr. Jost Herbig, letter, 13 February 1973, in *Bilder Objekte Filme Konzepte* (Munich: Stadtische Galerie im Lenbachhaus, 1973), 160.

60 Robert Pincus-Witten, *Postminimalism* (New York: Out of London Press, 1977), 106. Pincus-Witten is credited with coining the term *Postminimalism*, which, as with any greatly useful rubric, is also limiting in that it places perhaps too much emphasis on the works' relationship to and reaction against Minimalism. Pincus-Witten's *Postminimalism* remains among the most important summations of artistic practices from 1966 to 1976. Also indispensable to any study of Postminimalism is *The New Sculpture 1965–75: Between Geometry and Gesture*, ed. Richard Armstrong and Richard Marshall (New York: Whitney Museum of American Art, 1990); and, more recently, Cornelia H. Butler's *Afterimage: Drawing through Process* (Los Angeles: Museum of Contemporary Art; Cambridge, MA: MIT Press, 1999), both of which give Tuttle central focus. See also Carter Ratcliff, *Out of the Box: The Reinvention of Art 1965–1975* (New York: Allworth Press / School of Visual Arts, 2000).

61 This term comes from the title of Robert Morris's celebrated essay, published in *Artforum* in 1968, where he wrote that "Recently, materials other than rigid industrial ones have begun to show up.... A direct investigation of the properties of these materials is in progress" (reprinted in Morris, *Continuous Project Altered Daily*, 46).

62 "The Avant-Garde: Subtle, Cerebral, Elusive," *Time*, 22 November 1968, 70–77.

63 John Perreault, "A Healthy Pluralism," *Village Voice*, 17 February 1972, 22.

64 "Tuttle has managed to carve out a style and a form that is all his own and I have a feeling that these new and very controversial works will establish him as a young artist to be reckoned with. They are very far out. They are simple but not simple-minded. They are not beautiful. But they are in some sense outrageously 'poetic'" (John Perreault, "Simple, Not Simple-Minded," *Village Voice*, 18 January 1968, 16–17).

65 Marcia Tucker and James Monte, *Anti-Illusion: Procedures/Materials* (New York: Whitney Museum of American Art, 1969), 28. In this way Tuttle also took up and simultaneously subverted the explorations in Color Field or "stain" painting—thin pigment poured onto unprimed canvas to merge paint and support—being undertaken by Helen Frankenthaler, Morris Louis, Kenneth Noland, and Jules Olitski.

66 Robert Pincus-Witten, "The Disintegration of Minimalism: Five Pictorial Sculptors," in *Eye to Eye* (Ann Arbor, MI: UMI Research Press, 1984), 119–22. See also Richard Armstrong, "Between Geometry and Gesture," in *The New Sculpture*, 14.

67 Proof of this midpoint stance lies in Tuttle's exhibition record: a *Wire Piece* was included in *Arte come arte* (in Milan, Italy, in 1973), predominantly a painting show, while a cloth piece appeared in the tellingly titled *Door beeldouwers gemaakt / Made by Sculptors* in Amsterdam in 1978. The former exhibition aligned Tuttle with painters Jo Baer, Kelly, Robert Mangold, Marden, Martin, Newman, Ad Reinhardt, Robert Ryman, and Frank Stella; the latter primarily with Andre, Joel Shapiro, and Serra. See *Arte come arte* (Milan: Centro Comunitario di Brera, 1973); and *Door beeldouwers gemaakt / Made by Sculptors* (Amsterdam: Stedelijk Museum Amsterdam, 1978).

68 Burton, "Notes on the New," unpaginated.

69 Perreault, "Simple," 16–17.

70 See, for example, Carter Ratcliff's "New York Letter," in *Art International* 14 (20 May 1976): "Ryman engages the complexities of perception and matter which condition scale, light, and depth, and this links him to Tuttle and Marden" (p. 76). Interestingly, Hesse coupled Ryman and Tuttle in her journal: "Painting can be extended to Ryman, Tuttle. If Art seemingly had rules they're all temporary and there to be broken" (quoted in Lucy R. Lippard, *Eva Hesse* [New York: New York University Press, 1976], 85).

71 Of profound influence to this generation of artists was Jackson Pollock's scaling up and freeing up of drawing as he transformed line into painted skeins on mural-size grounds. In his wake, Tuttle and others were given license to transfer drawing's parameters and methods to other media. My use of "audacious yet humble" paraphrases Scott Burton's comment in "Time on Their Hands," *ARTnews* 68 (Summer 1969): 43.

72 It should be noted that these works appeared at a time of enormous interest in the body as a medium in advanced art practices, including Body and Performance art as well as experimental dance (see Cornelia H. Butler's essay in this catalogue). Marcia Tucker has described the *Wire Pieces* as "a way of drawing with the body" (Tucker, interview by the author, 7 January 2002).

73 "The Wire Pieces are an experiment to surrender authorship, how to make something and to be as little involved" (Tuttle, "I Do Believe That Chaos and Form Are," 172).

74 Julio González wrote "to draw in space" in 1932. See Josephine Withers, *Julio González: Sculpture in Iron* (New York: New York University Press, 1978), 134.

75 Richard Tuttle, "A Love Letter to Lucio Fontana," in *Lucio Fontana* (Amsterdam: Stedelijk Museum Amsterdam; London: Whitechapel Gallery, 1988), 60–65. Tuttle created a room for González sculptures within an exhibition of his own work in 1992 at the Instituto Valenciano de Arte Moderno, Valencia, Spain.

76 Tuttle and Hesse were working at the outer perimeters of a generational concern with creating emphatically provisional work: "The ancient notion that life is short and art long has been challenged by artists as diverse as Richard Serra, Bill Bollinger, Richard Tuttle, Bruce Nauman and Robert Barry, all of whom create in some way 'short art'" (Burton, "Time on Their Hands," 40).

77 Bill Barette, *Eva Hesse Sculpture* (New York: Timken Publishers, 1989), 212. Although Hesse knew that the materials she was working with would deteriorate, it is unclear whether she would have accepted the degree to which her pieces have actually degenerated. See Ann Temkin (introduction) and Chad Coerver (ed.), "Uncertain Mandate: A Roundtable Discussion on Conservation Issues," in *Eva Hesse* (San Francisco: San Francisco Museum of Modern Art; New Haven, CT: Yale University Press, 2002).

78 *Richard Tuttle: Portland Works 1976* (Cologne: Galerie Karsten Greve; Boston: Thomas Segal Gallery, 1988), 9.

79 Richard Tuttle, conversation with the author, 21 November 2003.

80 Collage was famously described by Henri Matisse as "drawing with scissors" (Bernice Rose, *Drawing Now* [New York: Museum of Modern Art, 1976], 11).

81 Pamela M. Lee, "Some Kinds of Duration: The Temporality of Drawing as Process Art," in Butler, *Afterimage*, 37. In describing a print that includes a drawn pencil line, Tuttle has said, "I liked how it was expressing something like past time pressing against present time" (quoted in Ronny H. Cohen, "Minimal Prints," *Print Collector's Newsletter* 21 [May–June 1990]: 46). The incorporation of real time and duration into the artwork was of course of central interest to artists who matured in the 1960s; see Briony Fer, "Some Translucent Substance, or the Trouble with Time," in *Time and the Image*, by Carolyn Bailey Gill (Manchester, UK: Manchester University Press, 2000).

82 Richard Tuttle, in *Richard Tuttle* (Amsterdam: Stedelijk Museum Amsterdam, 1979), unpaginated.

83 "A situation" is Ryman's term for the ingredients of lighting conditions and wall textures necessary to bring a work to final fruition. See Yve-Alain Bois, "Ryman's Lab," in *Abstraction, Gesture, Ecriture*, 108.

84 See also Shiff, "Donald Judd: Fast Thinking," 11.

85 Quoted in Susan Harris, "Finding a Way to Go On: Tuttle in the Dorothy and Herbert Vogel Collection," in *The Poetry of Form: Richard Tuttle, Drawings from the Vogel Collection* (Amsterdam: Institute of Contemporary Art; Valencia, Spain: Instituto Valenciano de Arte Moderno, 1992), 49.

86 Christo's *Running Fence* was installed in 1976, Shapiro's first exhibition of small geometric configurations evocative of houses, chairs, boats, and coffins in 1973. Two 1976 articles in *Artforum* were devoted to the topic of small-size sculpture: "Notes on Small Sculpture" by Carter Ratcliff in April, and "The Size of Non-Size" by Douglas Davis in December; both pointed to "a flood" of small sculptures saturating the art market then. According to another writer of the time, "Tuttle has been at the forefront of the movement towards smaller sculptures" (Ann-Sargent Wooster, review, *ARTnews* 77 [April 1978]: 156).

87 Marcia Tucker, *Richard Tuttle* (New York: Whitney Museum of American Art, 1975), 7. Tucker's essay remains among the very best writings on Tuttle's work.

88 "Small work is generally not thought of as environmental, but Tuttle's 'objects' are a means of focusing us to see the space they are represented in. It is impossible not to confront the bare cube of the room; the gallery floor and radiator grill in the process of looking for/at these small works" (Wooster, review, *ARTnews*, 156).

89 David Bourdon, "A Redefinition of Sculpture," in *Carl Andre: Sculpture, 1959–1977* (New York: Jaap Rietman, 1978), 28.

90 Robert Pincus-Witten, interview by the author, 9 January 2002.

91 Marcia Tucker, interview by the author, 7 January 2002.

92 See Adam D. Weinberg's case study and Robert Storr's essay, both in this volume.

93 Hilton Kramer, "Our Venice Offering—More a Syllabus than a Show," *New York Times*, 2 May 1976.

94 Richard Tuttle, "Tuttle on Martin," in *Agnes Martin / Richard Tuttle*, 10.

95 Jurgen Glaesemer, "Appendix III: A Talk with Richard Tuttle," in *List of Drawing Material of Richard Tuttle & Appendices*, by Gianfranco Verna (Zurich: Annemarie Verna Galerie, 1979), 352.

96 Richard Tuttle, quoted in Auping, "On Relationships," 83.

97 Published in "Kabinet Overholland," *Bulletin Stedelijk Museum* (June 2001): unpaginated (emphasis added).

98 Richard Tuttle, quoted in Guy Cross, "Interview with Richard Tuttle," *The Magazine* (Santa Fe), 3 April 1995, 12.

99 *Richard Tuttle: Small Sculptures of the 70s* (Zurich: Annemarie Verna Galerie, 1998), 24.

100 Peter Frank, review, *ARTnews* 75 (January 1976): 126.

101 Quoted in Paul Gardner, "Taking the Plunge," *ARTnews* 97 (February 1998): 112.

102 "I would first want to say that a mental image comes from behind a surface...before it *appears* in our minds.... [W]hat is its outside representation?" (Richard Tuttle, "Notes for Sleep Time," in *Richard Tuttle: Sprengel Museum Hannover* [Hannover, Germany: Sprengel Museum Hannover, 1990], unpaginated). "I normally will have an idea that comes to mind and that would be in terms of colors, a passage, or rhythms of force, and then my problem is to go and try to make that in the real world" (transcription of filmed interview with Richard Tuttle, Indianapolis Museum of Art, summer 1993).

103 Barbara Haskell, Marcia Tucker, and Patterson Sims, introduction to *1977 Biennial Exhibition: Contemporary American Art* (New York: Whitney Museum of American Art, 1977), 6.

104 Pepe Karmel, "Oedipus Wrecks: New York in the 1980s," in *Jasper Johns to Jeff Koons: Four Decades of Art from the Broad Collections*, by Stephanie Barron and Lynn Zelevansky et al. (Los Angeles: Los Angeles County Museum of Art; New York: Harry N. Abrams, 2001), 114.

105 Tuttle is well familiar with the historical tradition of artist's frames, the intention of which has been to blur the boundary between artwork and architectural container—Seurat's painted frames being prime examples.

106 Quoted in "Richard Tuttle: Tre Mostre a Roma alla Galleria Ugo Ferranti, 1975, 1977, 1978," *Domus* 591 (February 1979): 47.

107 Tuttle's artistic sojourns began in 1968 with a six-month visit to Japan. A 1969 trip to Turkey with Parsons and Washburn resulted in his first "travel sketches," which led to such works as *Drawing Developed from Travel-Sketches Made in Turkey* (pl. 154). To this day, Tuttle relishes making drawings in hotel rooms, resulting in works such as *Sustained Color* (pls. 266–86).

108 For the source of the first quote see note 13; the second quote is from a conversation between Tuttle and the author, 20 March 2005.

109 Such materials and organizing principles are reminiscent of the roots of the assemblage tradition initiated by the cubist collage—specifically, by Pablo Picasso's *Still Life with Chair Caning* of 1912, which launched the incorporation of materials drawn from the real world into the plane of pictorial illusion, a strategy taken to experimental heights by the Russian constructivist reliefs to which Tuttle's work bears formal resemblances.

110 As such, his assemblages refused the patina of a historicist strain that was in evidence during this period (one thinks of the paintings of Ross Bleckner or the photography of Mike and Doug Starn).

111 See Briony Fer, *On Abstract Art* (New Haven, CT: Yale University Press, 1997), 19, and the chapter "Imagining a Point of Origin: Malevich and Suprematism."

112 Robert Storr, *Philip Guston* (New York: Abbeville Press, 1986), 38. Tuttle's pieces are also undoubtedly informed by the concept of *wabi sabi*, which describes a traditional Japanese aesthetic sensibility based on an appreciation of the transient beauty of the physical world, rooted in the ancient Buddhist valuing of ephemerality. (Though characteristically, by his own admission, he would value the opposite as well.)

113 "Floor drawings" is the name Tuttle gave to four groups and two single works, comprising a total of twenty sculptures, that were first brought together for a 1991 exhibition in Amsterdam. The first group of six sculptures, titled by number (as in *Six*), was initially shown in 1987 at Blum Helman Gallery in Los Angeles; a second group of five sculptures, *There's No Reason a Good Man Is Hard to Find*, was shown at Blum Helman Warehouse in New York in 1988; *Turquoise*, consisting of three sculptures, premiered at Galerie Meert Rihoux in Brussels in 1988; and *Sentences* comprises four sculptures first exhibited in a 1989 group show at Sperone Westwater in New York. An additional sculpture, *Sand-Tree 7*, was initially exhibited at Galerie Schmela in Düsseldorf in 1988, while the artist recalls that *There's No Reason a Good Man Is Hard to Find VI* debuted at Michael Klein Gallery in New York the same year. For more on Tuttle's floor drawings, see Susan Harris's superb essay "Twenty Floor Drawings," in *Richard Tuttle* (Amsterdam: Institute of Contemporary Art; The Hague: Sdu, 1991).

114 This is to paraphrase Tony Smith, whose large-scale sculpture Tuttle helped build and still admires. See Michael Brenson, "Remarks on *Moondog*," in *Tony Smith: Moondog* (New York: Paula Cooper Gallery, 1997), unpaginated.

115 Donald Kuspit, review, *Artforum* 27 (February 1989): 127.

116 These are the same materials that Tuttle has turned to for his largest sculptures to date, *Replace the Abstract Picture Plane I* (1996; pl. 30) and *Memento, Five, Grey and Yellow* (2002; pl. 354).

117 Tuttle was not alone in his interests: the mid-1980s saw a number of cultural practitioners—artists, philosophers, art historians—propose a correspondence between the postmodern period and the Baroque. The philosophy of the Baroque era resurfaced as a focus of semantics and literary theory thanks to the work of Dutch scholar Mieke Bal (see, for example, her *Quoting Caravaggio: Contemporary Art, Preposterous History* [Chicago: University of Chicago Press, 1999]) and French philosopher Gilles Deleuze (especially his 1986 *The Fold: Leibniz and the Baroque* [repr., Minneapolis: University of Minnesota Press, 1993]). Artists like Belgian sculptor Lili Dujourie and American painter David Reed examined the Baroque's visual tropes in their own work, as did Frank Stella, whose 1986 book *Working Space* (Cambridge, MA: Harvard University Press) focused on Caravaggio's treatment of pictorial space, and whose large-scale metal-relief paintings of the mid-1980s bear a superficial resemblance to Tuttle's assemblages in their treatment of interleaving forms that half-depict, half-objectify space.

118 Bal, *Quoting Caravaggio*, 30.

119 Preceding two quotations from "Goings On about Town: Art," *The New Yorker*, 27 January 1992, 10.

120 Michael Kimmelman, "At the Met with Richard Tuttle: Influence Cast in Stone," *New York Times*, 14 May 1999.

121 Michael Duncan, review, *Art in America* 83 (September 1995): 106. European reports concurred: "[Tuttle] is certainly in vogue with young artists and students at present" (Deborah Parsons, "Material Metaphysics," *London Student*, 3 December 1996, 16).

122 The group of works shown at Mary Boone Gallery, entitled *Fiction Fish*, is one of three bodies of line pieces Tuttle produced. The second group of line pieces was exhibited at Laura Carpenter Fine Art in Santa Fe in 1992, the third and last at the Staatliche Kunsthalle Baden-Baden in Germany in 1993.

123 Ingrid Schaffner, review, *Artscribe* 87 (Summer 1991): 68.

124 Installation art first began to gather momentum in the mid-1970s. By 1990 it was established as a genre and became the focus of the 1991–92 exhibition *Dislocations* at the Museum of Modern Art, New York, and of the 1991 Carnegie International in Pittsburgh.

125 In relation to Tuttle's exhibition practices, one should mention as well his artist-curated shows of collections, a popular museological practice beginning in the mid-1980s. Tuttle's ventures in this area began with a 1988 exhibition at New York's P.S. 1, in which he combined his artwork with his own collection of nineteenth-century glass. Tuttle was subsequently invited to exhibit his work within the permanent-collection galleries of the Sprengel Museum Hannover, Germany, home to Kurt Schwitters's *Merzbau* environment, an obvious and important precedent for Tuttle's work (Tuttle was asked to hang his *System of Color* alongside Schwitters's collages [pl. 231]). In 1992 Tuttle and the curator Alma Ruempol organized *Oxyderood / Red Oxide* at the Museum Boymans-van Beuningen in Rotterdam: using the color of red oxide as the unifying feature, Tuttle chose fifty objects from his private collection of ceramics, textiles, and glass and combined these with fifty objects from the museum's archeological holdings and fifty of his own artworks. In 2004 Tuttle curated a show of vintage and contemporary Indonesian textiles in Santa Fe (pl. 383) and an exhibition in Miami, *Beauty-in-Advertising*, that incorporated selections from the permanent collection of the Wolfsonian—Florida International University (pl. 384).

126 James Cuno, *Minimalism and Post-Minimalism: Drawing Distinctions* (Hanover, NH: Hood Art Museum, Dartmouth College, 1990), 10.

127 Baker, *Minimalism*, 21.

128 Jennifer Gross, in *Richard Tuttle: Community*, 24.

129 Richard Tuttle, "Artists Curate: Cosmic Relief," *Artforum* 40 (February 2002): 116–21. This article highlighted Tuttle's eclectic pantheon of masters of the "almost low-relief form," including Constantin Brancusi, John Constable, Carlo Crivelli, Jean Fautrier, Arshile Gorky, Peter Halley, and Augustus Saint-Gaudens.

130 Ibid., 117.

131 Tuttle later subtitled this body of work *Conjunction of Color*, to place emphasis on the meeting of colors that takes place on these surfaces ("Richard Tuttle, 19 February 1998," in *Inside the Studio: Two Decades of Talks with Artists in New York*, ed. Judith Olch Richards [New York: Independent Curators International, 2004], 190–93).

132 It is unfortunately beyond the scope of either this essay or its exhibition to examine the significant work Tuttle has undertaken in the area of printmaking, beginning in 1973 with his first print, *In Praise of Economic Determinism*, published by Brooke Alexander. As with Tuttle's books, the prints are important as artworks unto themselves and as aesthetic stepping stones in the development of work in other media. Just as essential to Tuttle's work as an artist is the collaborative nature of the printmaking process, as opposed to the solitary practice of the studio. On this account, Kathan Brown of Crown Point Press in San Francisco has proven a particularly vital colleague for Tuttle, as have Alexander, Greg Burnet, Bill Goldston, and the staff of printers at ULAE in Bay Shore, New York.

133 This work is one of four separate pieces, each titled *Replace the Abstract Picture Plane* and distinguished by a roman numeral, that were made over the course of a three-year project of multiple exhibitions at the Kunsthaus Zug in Switzerland beginning in 1996.

134 "The picture plane needs replacing like everything else does. Like replacing the car battery when it goes weak." Richard Tuttle, quoted in Kathan Brown, "Richard Tuttle: Any Two Points," *Overview* [Crown Point Press newsletter], May 2000.

135 Richard Tuttle, conversation with the author, 15 December 2003.

136 Quoted in Richard Whelan, review, *ARTnews* 78 (Summer 1979): 186.

137 Richard Tuttle, "The Good and the Colors," in *Richard Tuttle, le bonheur et la couleur* (Bordeaux, France: CAPC Musée d'art contemporain de Bordeaux, 1986), 35.

138 Thomas B. Hess, "Private Art Where the Public Works," *New York*, 13 October 1975, 84. The title of my essay is taken from a comment Richard Tuttle made to the author on 30 October 2002, when he described his oeuvre as "an infinity of small truths."

39 **Untitled** 1964 each 3 x 3 x 3 in.

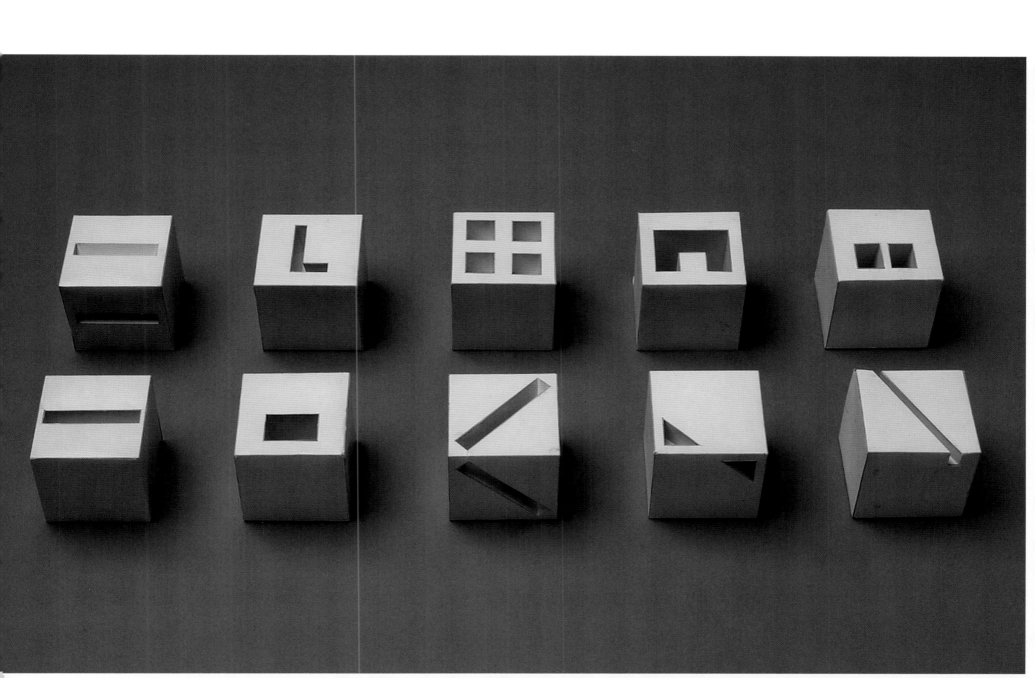

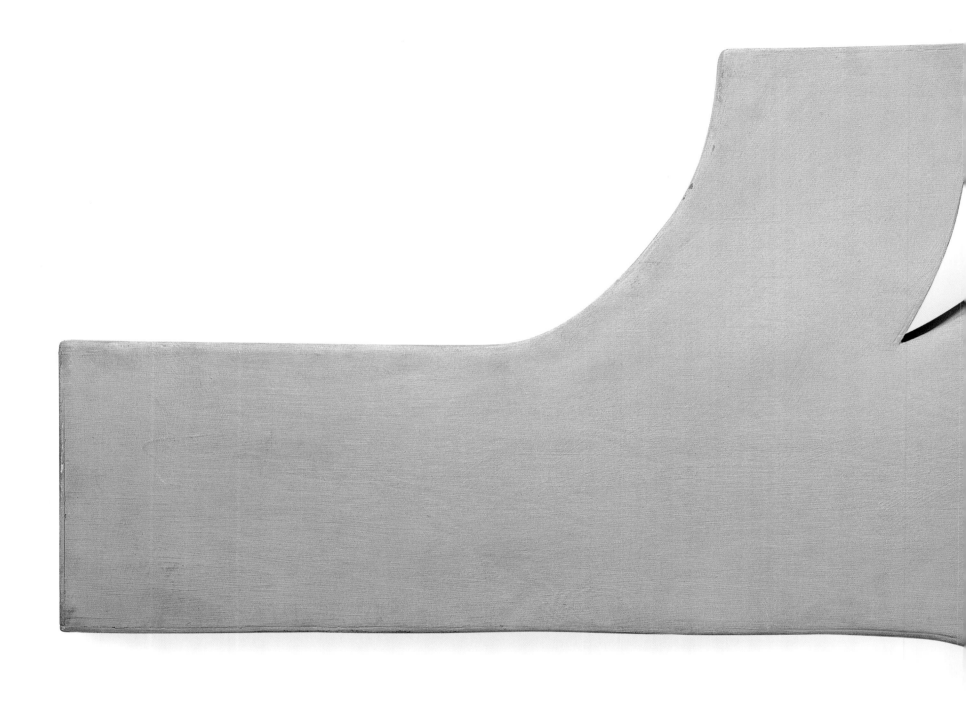

40 **Sum Confluence** 1964 20 5/8 x 36 1/2 x 3 in.

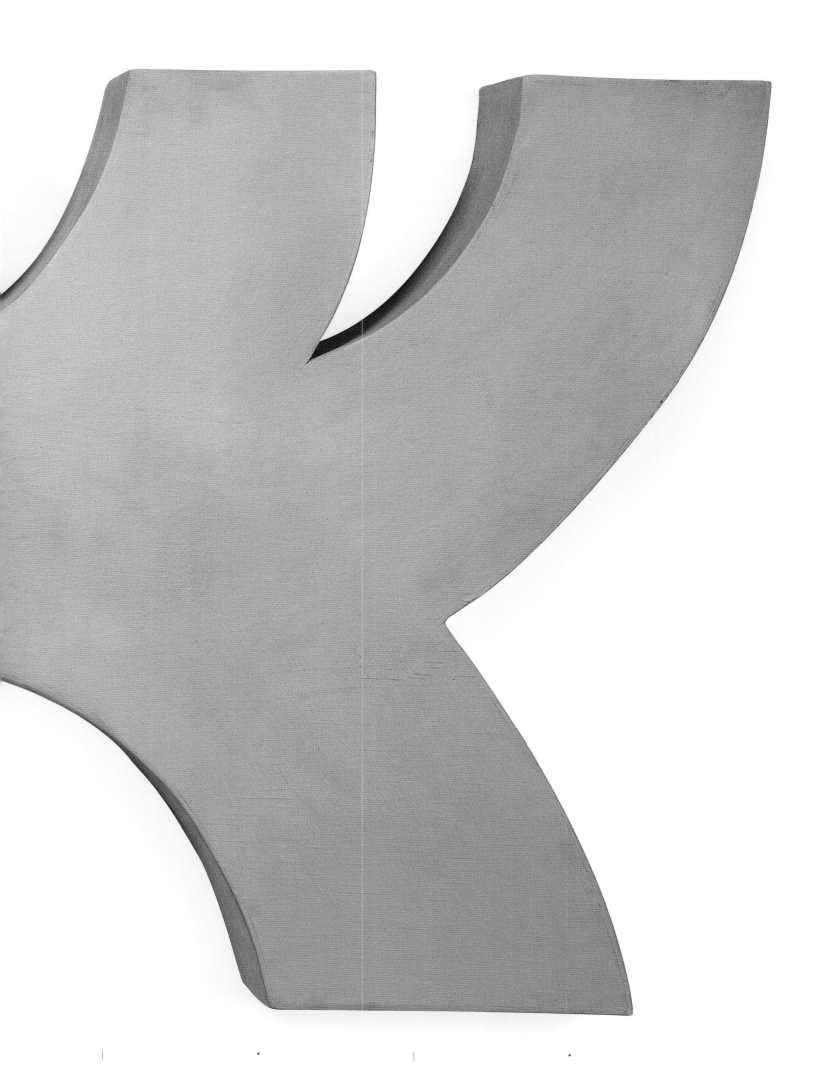

42

41

41 **Chelsea** 1965 37 3/8 x 37 3/8 x 3/4 in.

42 **Yellow Dancer** 1965 43 x 29 x 1 3/8 in.

43 **House** (detail) 1965 26 3/4 x 33 1/4 x 1 3/8 in.

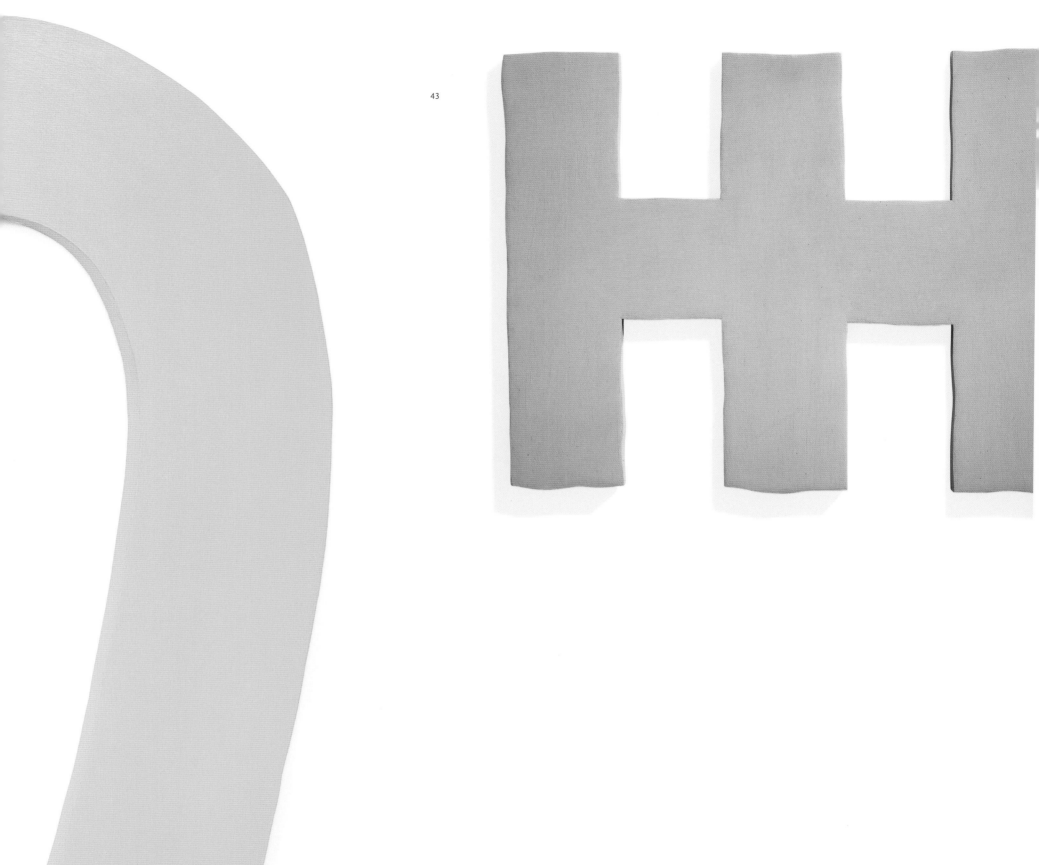

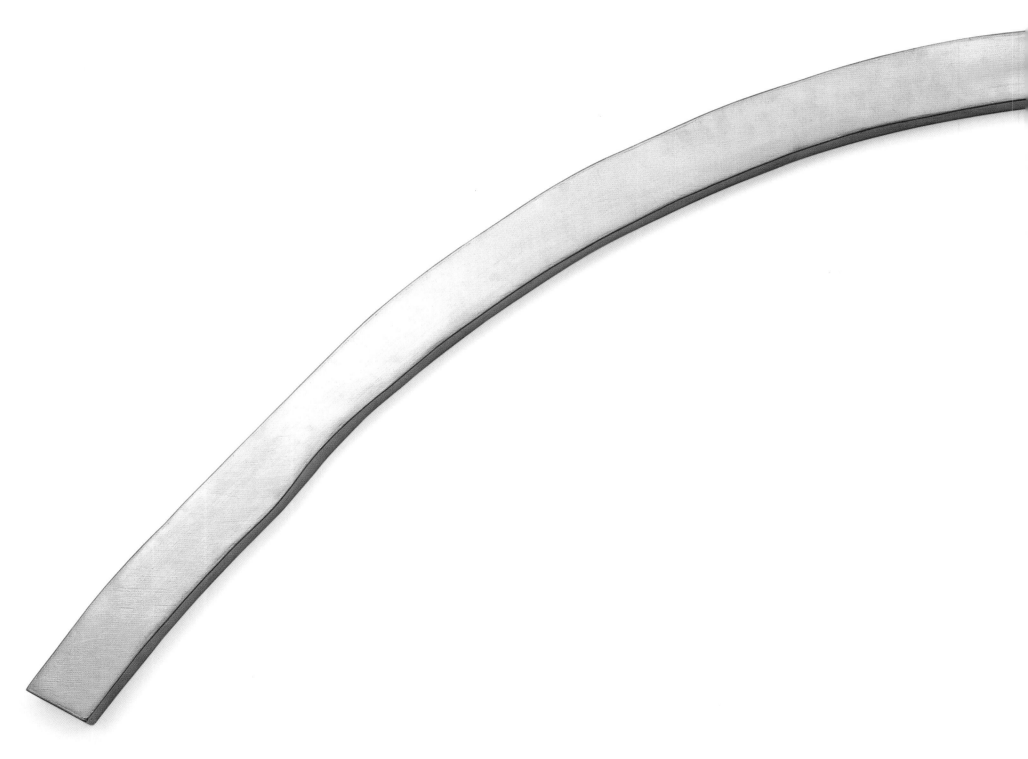

44 **Silver Picture** 1964 28 x 87 x 2 in.

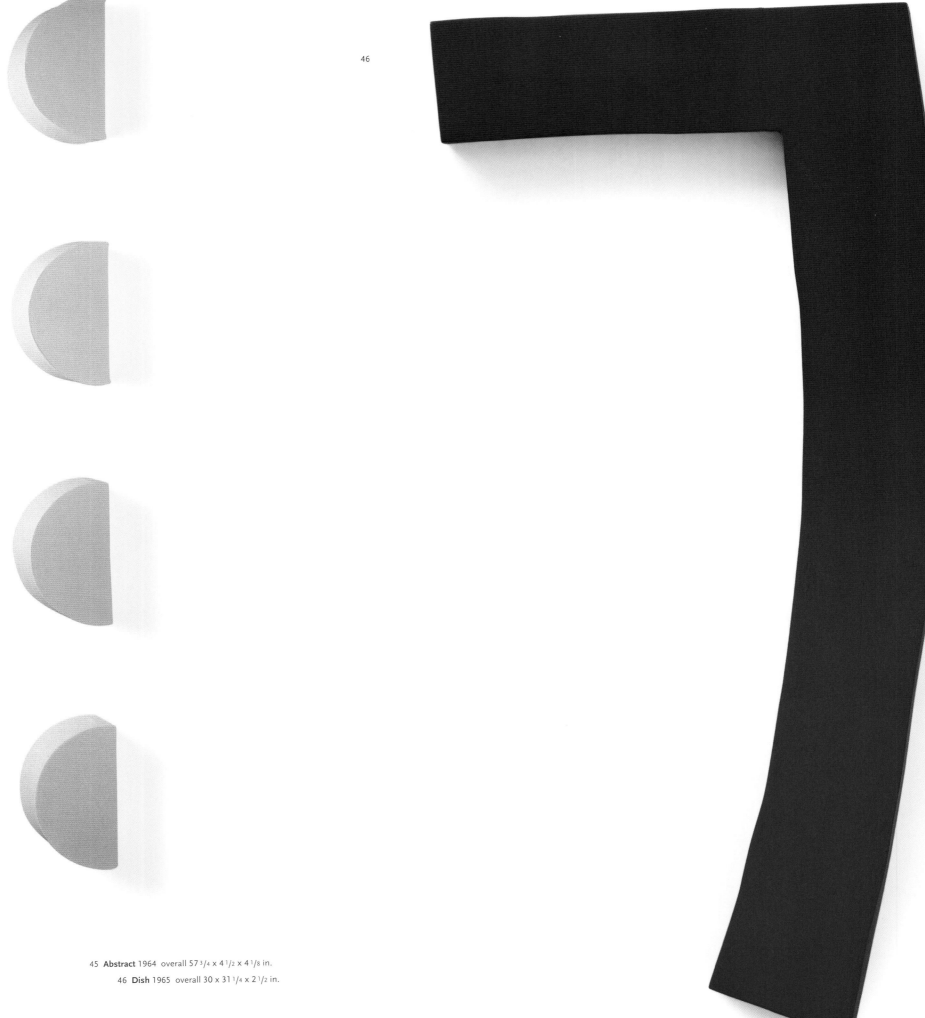

45 **Abstract** 1964 overall 57 3/4 x 4 1/2 x 4 1/8 in.

46 **Dish** 1965 overall 30 x 31 1/4 x 2 1/2 in.

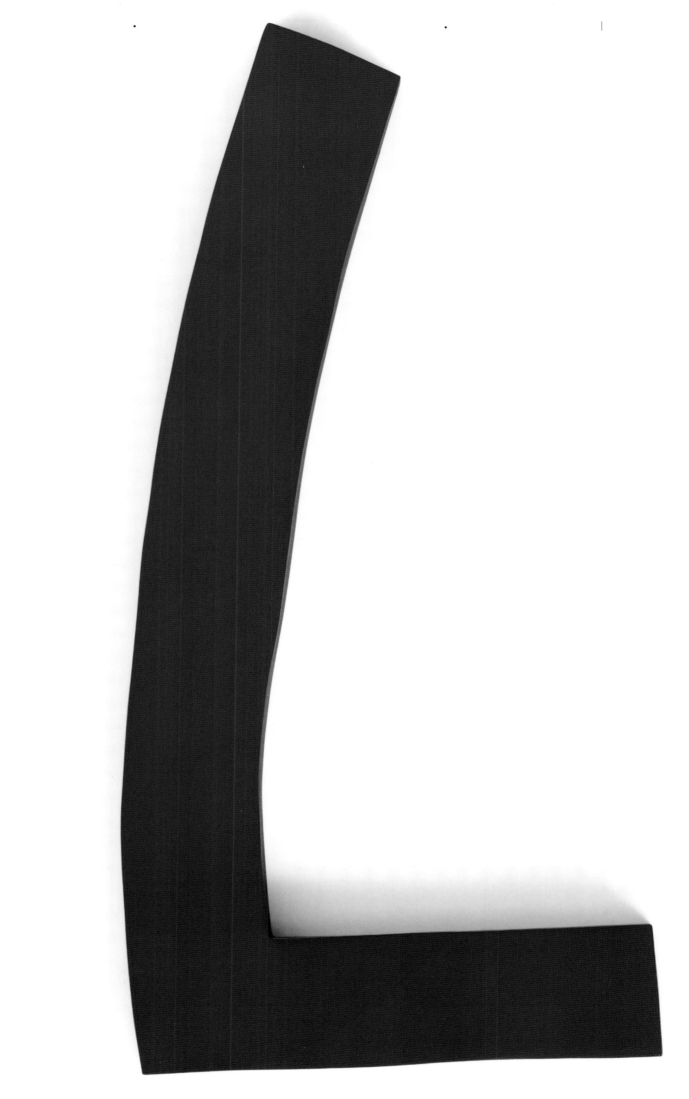

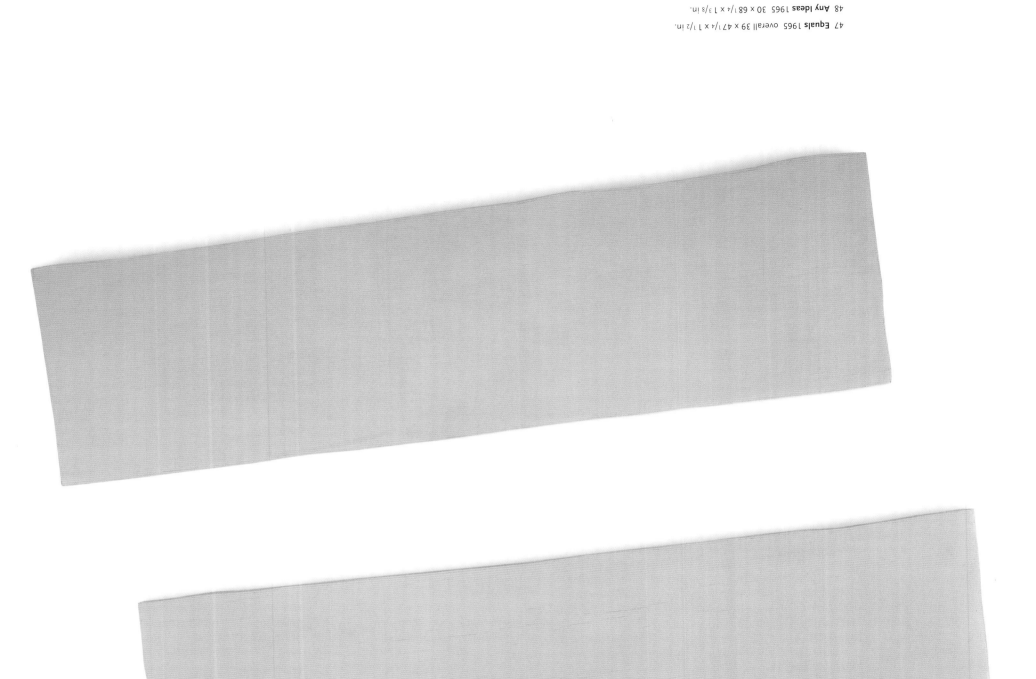

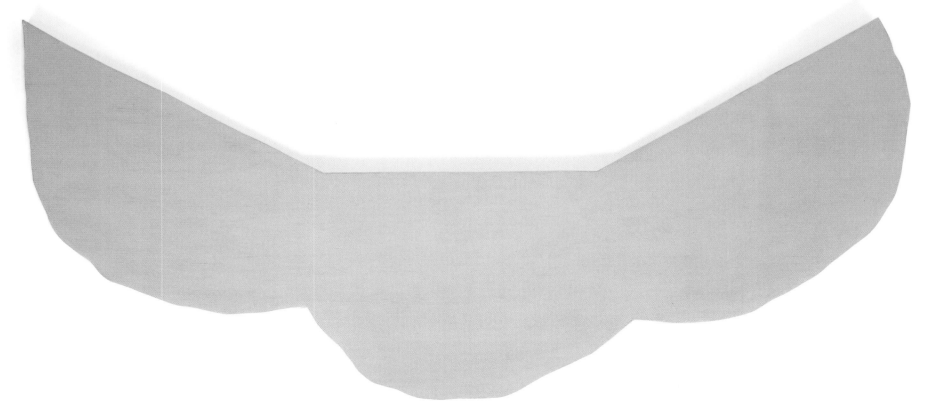

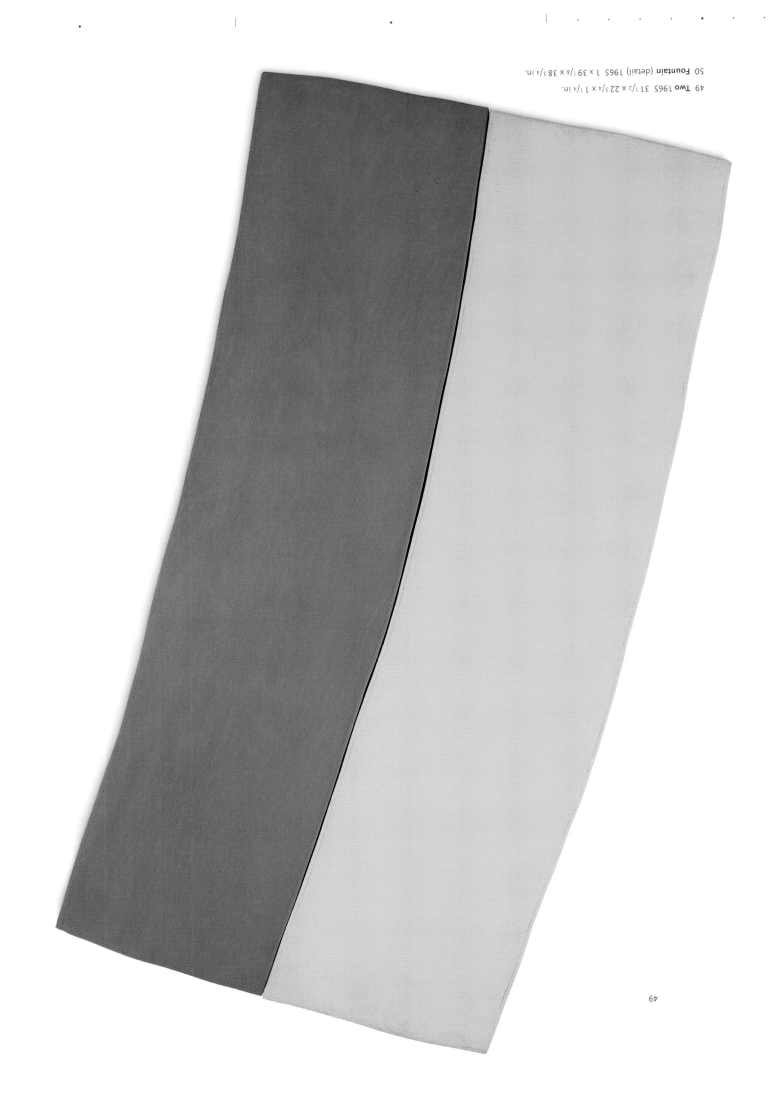

49 **Two** 1965 31 1/2 x 22 3/4 x 1 1/4 in.
50 **Fountain** (detail) 1965 1 x 39 1/8 x 38 3/4 in.

50

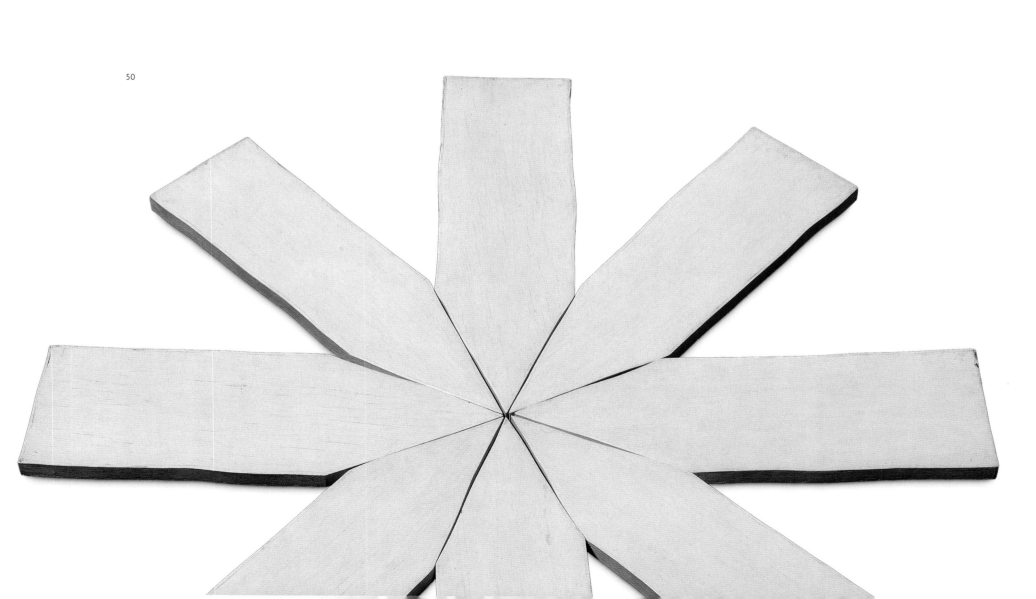

51

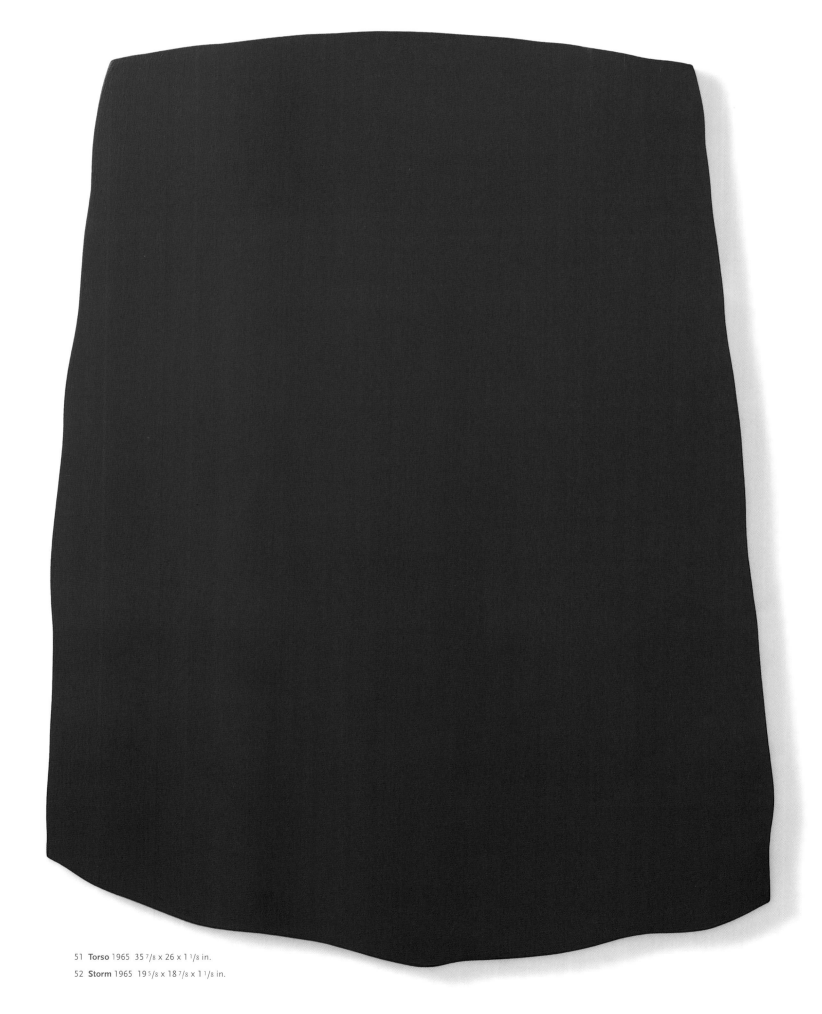

51 **Torso** 1965 35 7/8 x 26 x 1 1/8 in.

52 **Storm** 1965 19 5/8 x 18 7/8 x 1 1/8 in.

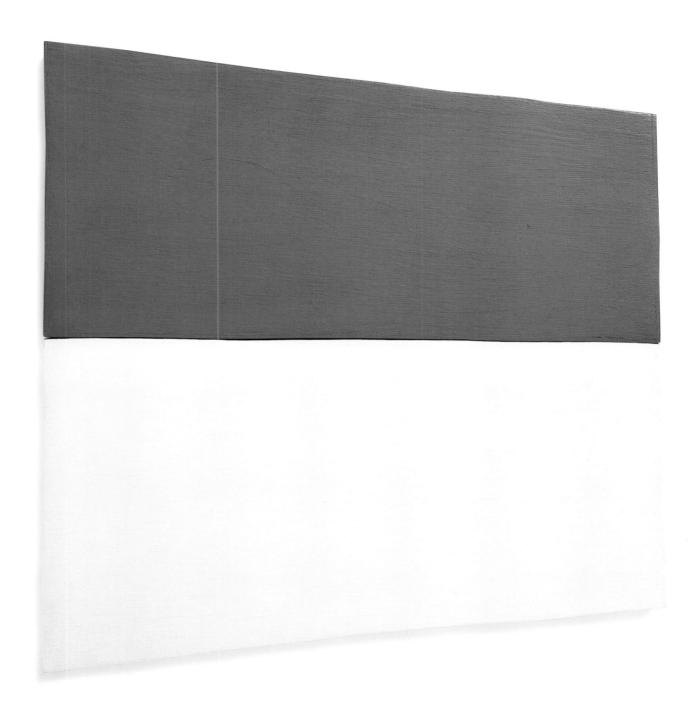

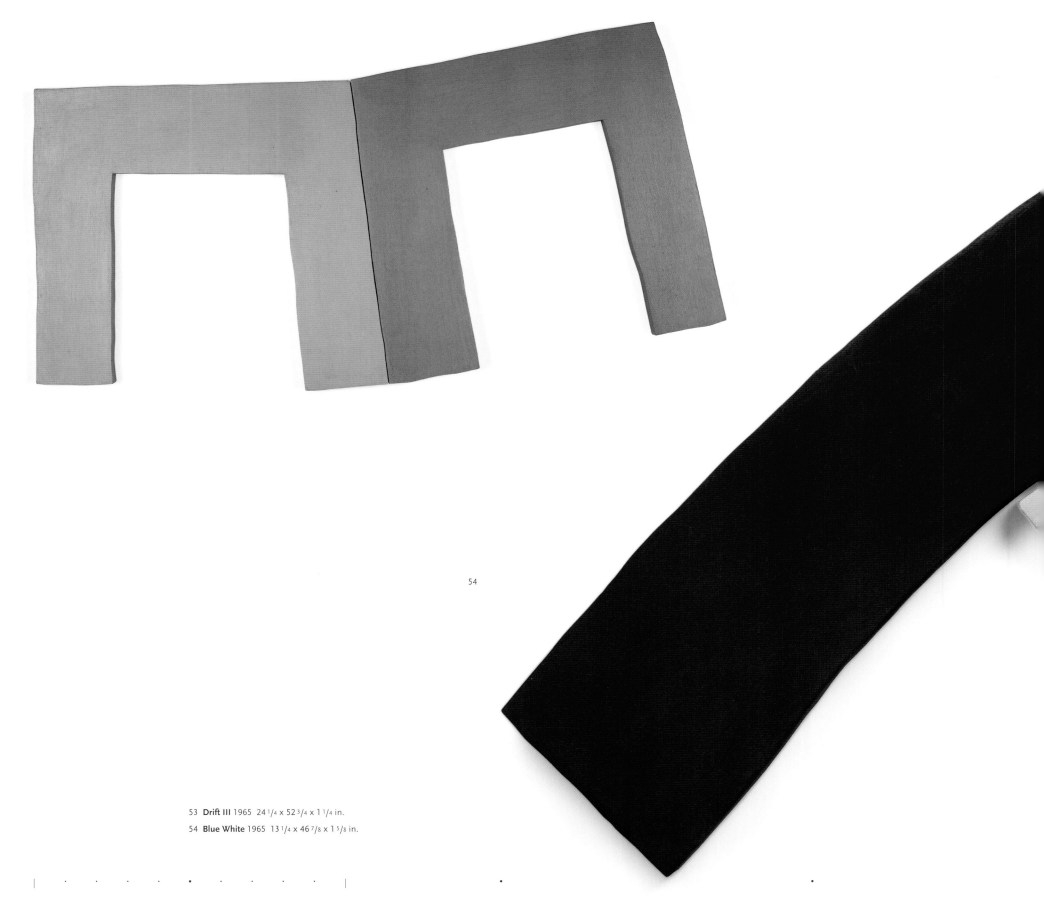

53

54

53 **Drift III** 1965 24 1/4 x 52 3/4 x 1 1/4 in.
54 **Blue White** 1965 13 1/4 x 46 7/8 x 1 5/8 in.

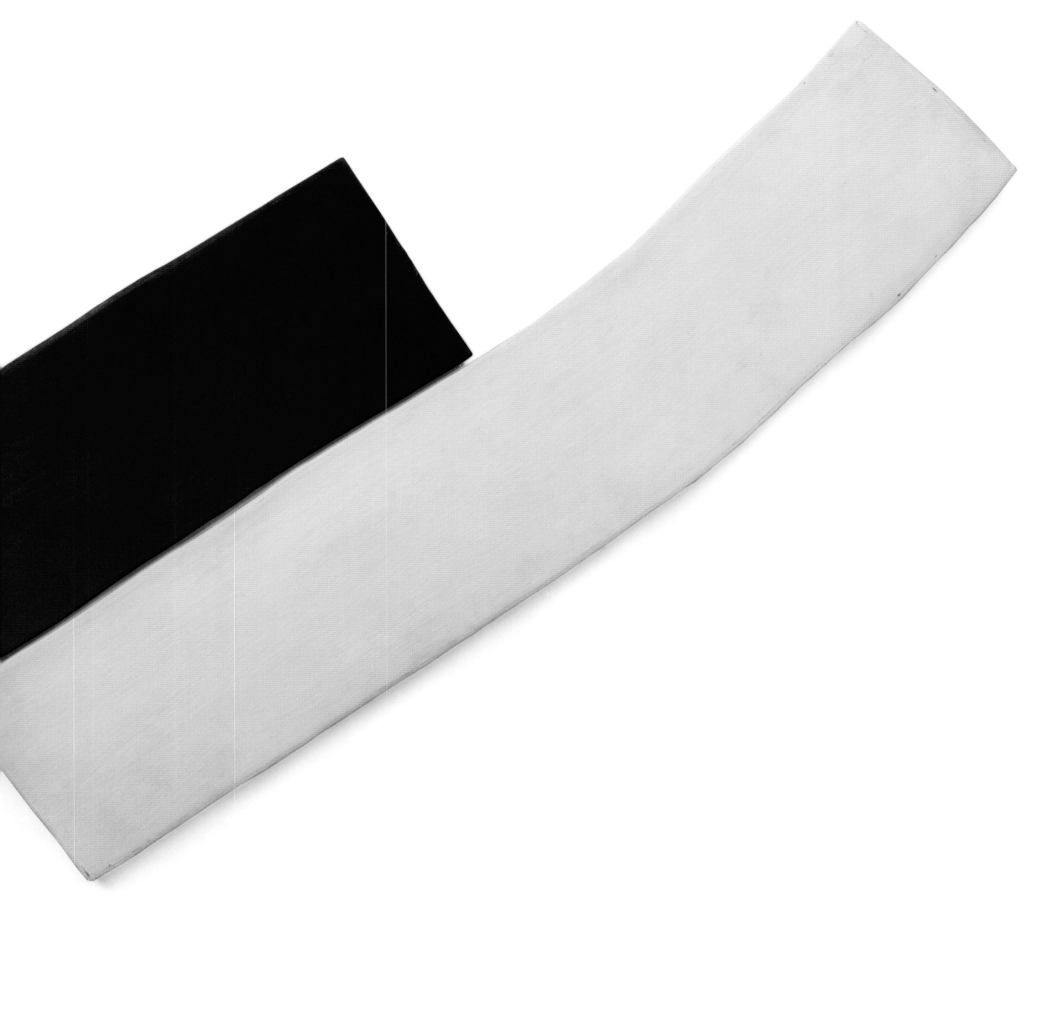

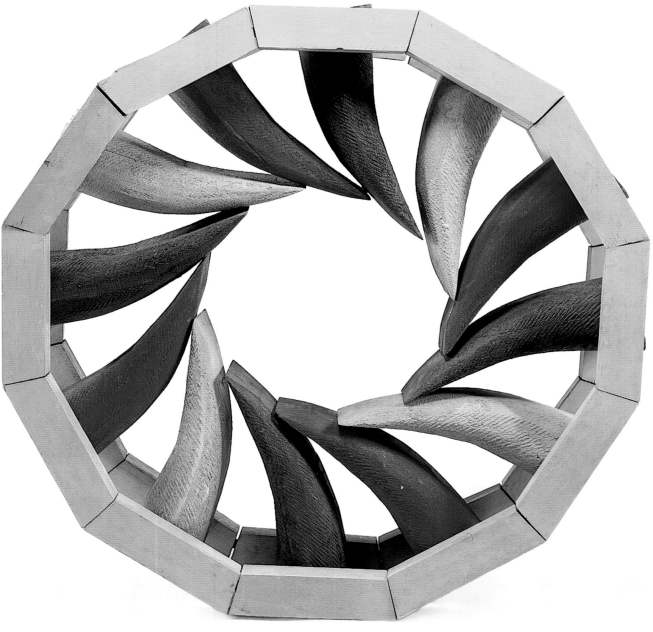

55 **Wheel** 1966 31 1/2 x 31 1/2 x 8 1/4 in.

56 Installation view of the 1975 exhibition **Richard Tuttle**
at the Whitney Museum of American Art, New York,
showing **10th Cloth Octagonal** (1968) at left
and **Letters (The Twenty-Six Series)** (1966) at right

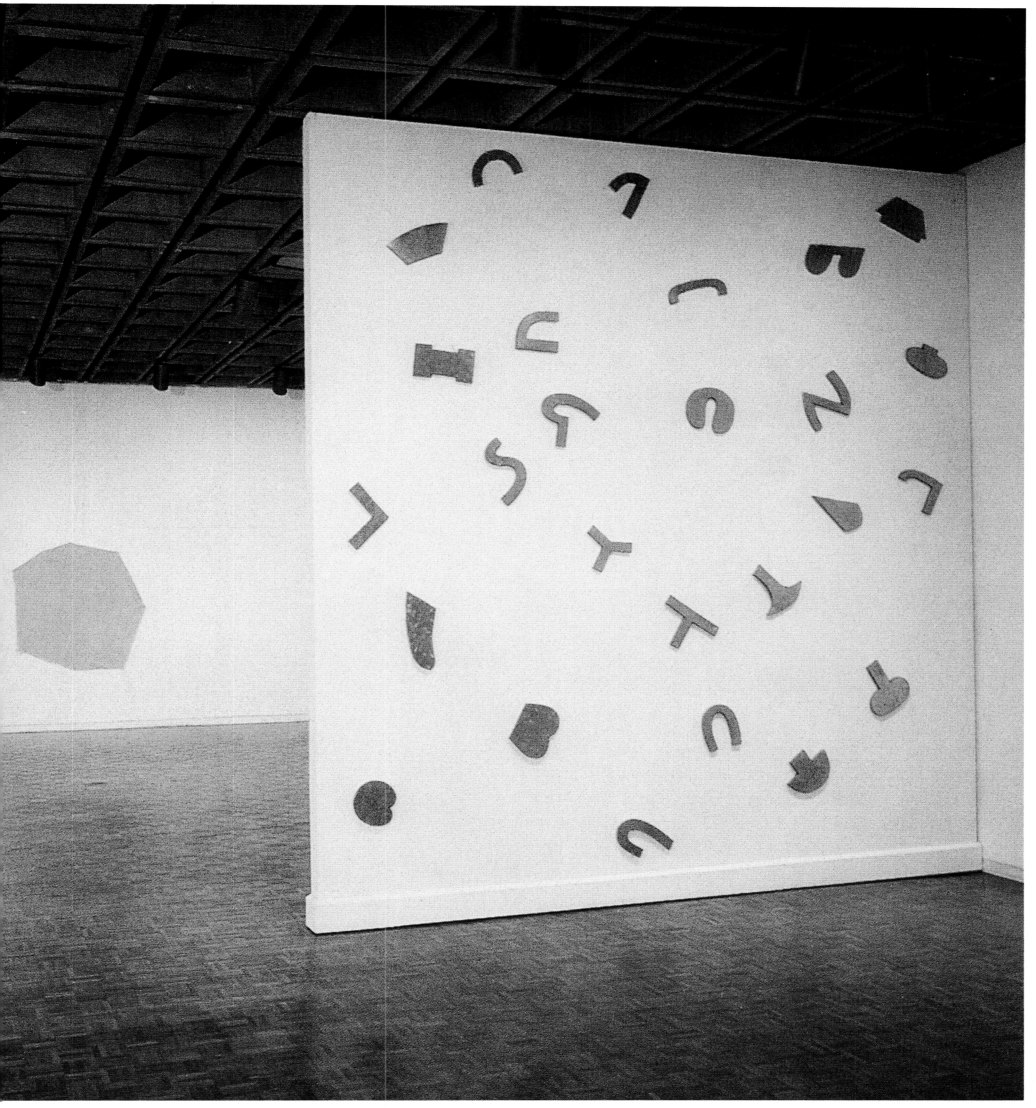

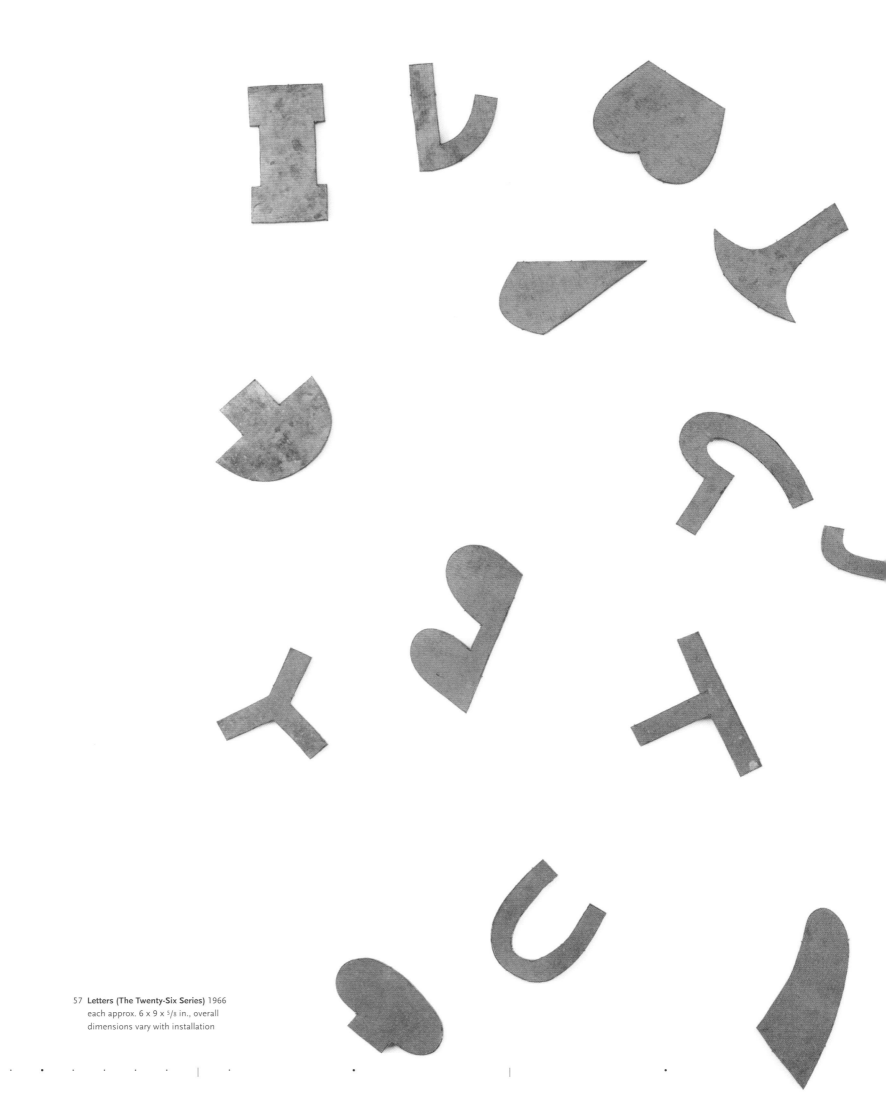

57 **Letters (The Twenty-Six Series)** 1966
each approx. 6 x 9 x 5/8 in., overall
dimensions vary with installation

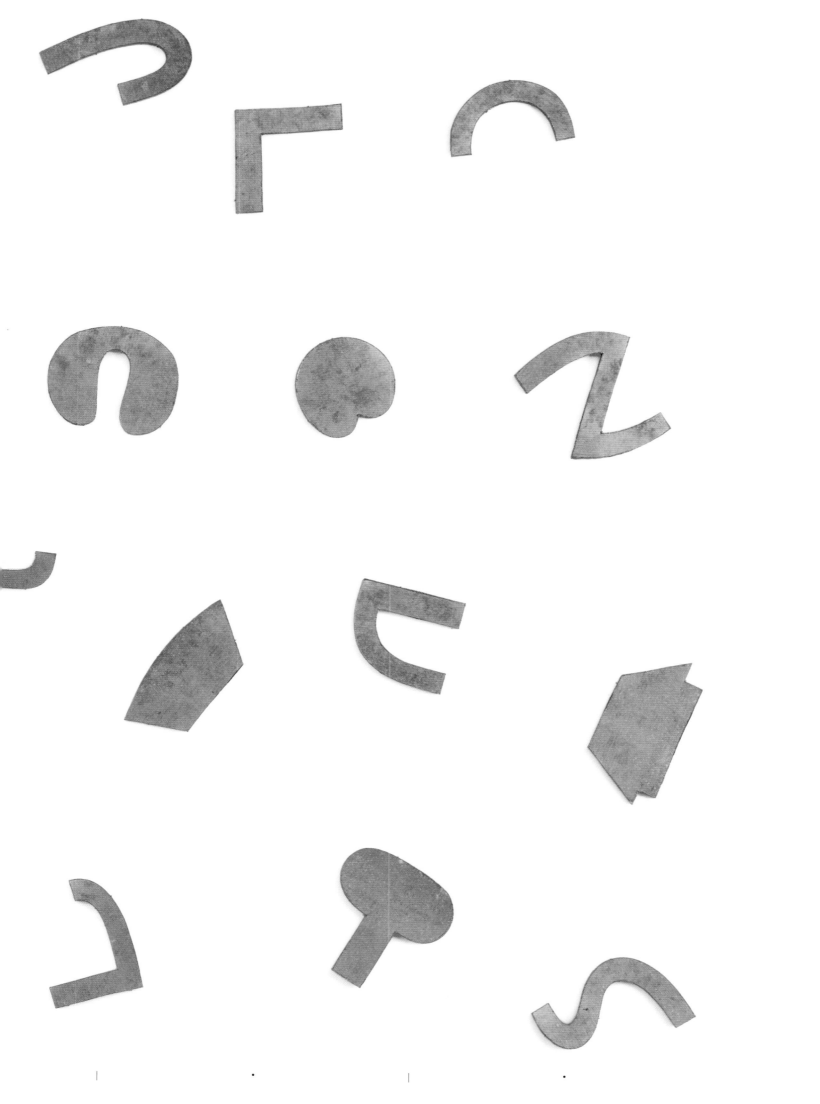

58–61 **Untitled** 1967 each 13 3/4 x 10 3/4 in.

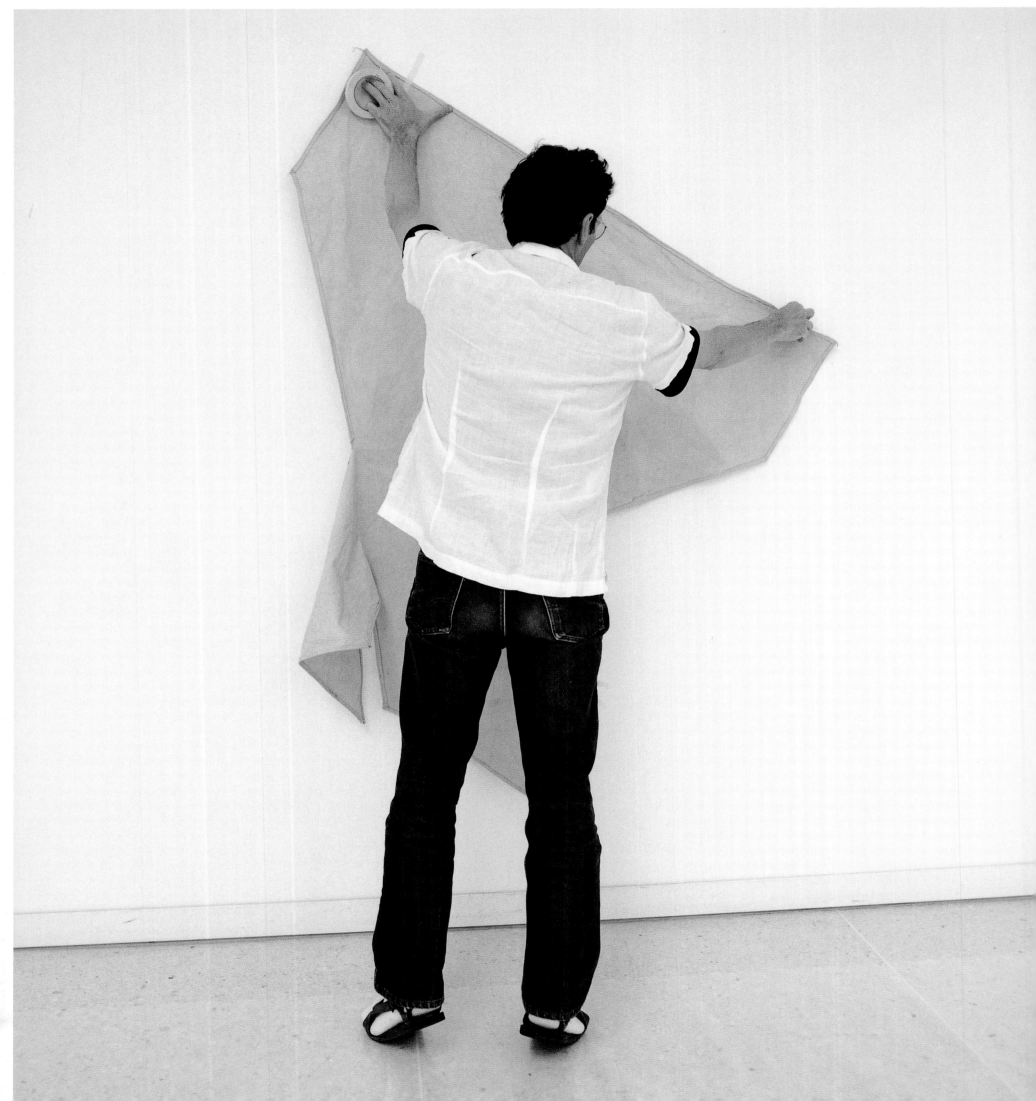

by Robert Storr

TOUCHING DOWN LIGHTLY

62 Richard Tuttle installing **Bow-Shaped Light
Blue Canvas** (1967) for the 1997 exhibition
**Projekt Sammlung: Richard Tuttle, Replace
the Abstract Picture Plane, Works 1964–1996**
at Kunsthaus Zug, Switzerland

Exquisiteness does not fare well in America. Neither do whimsy, dalliance, or humor. The virtues we celebrate publicly are those of ruggedness, purposefulness, and practicality, which, combined with impatience, make for a society that lurches fitfully from "can do" to "been there, done that." Refinement is also suspect. What we claim to value—though we have long since accustomed ourselves to gaudy products manufactured in bulk and on the cheap—are sturdy, well-made things with no frills. We like our art that way too or, according to some unwritten code of taste, are supposed to. The opposite qualities are thought of as alien to our culture, if they are not actually associated with other specifically foreign cultures.

Harking back to Harold Rosenberg's deliriously chauvinistic metaphor for the difference between "our" art and "theirs"—that is, American art and European art—is the difference between "coonskins" and "redcoats."[1] The coonskin-clad snipers of 1776 were shrewd, revolutionary, and above all authentic; the redcoats who wore stylish uniforms and marched in straight lines that made them easy targets were foppish, conservative, and absurd, not to mention doomed. They were the emissaries of the old aristocracy, whose decadence precipitated rebellion among the straightforward common folk of the United States. In Rosenberg's construct, the rebels of Tenth Street circa 1950 decolonized art in much the same way, thereby emancipating painting and sculpture from the overly rarefied tastes of an exhausted civilization. Following this scenario, Jackson Pollock wasn't just a cowboy who could draw, he was a latter-day hero of our independence movement.

With tongue firmly in cheek, Rosenberg was shamelessly appealing to the popular imagination, and, sly old ad man that he was, he knew exactly which buttons to push. Clement Greenberg skipped the historical analogies, but he too was quick to mark the difference between the undomesticated but vigorous talents of Pollock and the more cultivated though ostensibly raw sensibility of his French counterparts. Thus he would write in 1947, "Dubuffet's sophistication enables him to 'package' his canvases more skillfully and pleasingly and achieve greater instantaneous unity, but Pollock, I feel, has more to say in the end…. He is American and rougher and more brutal, but he is also completer."[2]

To be sure, there is another American tradition, in fact several, which eschew glorifications of roughness and brutality while adjusting practical reason to suit metaphysical or transcendentalist goals. But these tendencies also favor the plain over the fancy, the useful over the useless, and the durable over the ephemeral, allowing, of course, for emphasis on the fact that all life is fleeting compared to eternal salvation. They are the source of our great puritan art forms—the material culture of the Shakers, the poetry of Emily Dickinson, and the prose of Henry David Thoreau. Their modern equivalents range from Mark Tobey and Morris Graves to the third member of this Northwest Coast contingent, John Cage, and, by affiliation, to the legion of artists Cage influenced, many of whom, incidentally, thrived from the 1950s onward alongside "tough guys" such as David Smith and Jackson Pollock at the galleries of Betty Parsons and Marian Willard.

For much of the twentieth century, then, being an American artist meant actively avoiding anything that might be deemed slight, unserious, or, worse, precious.

That last word deserves a brief historical aside. The transformation of an adjective meaning something scarce, something of value, into one of belittling disparagement first occurred when it was applied to the nobles of seventeenth-century France—the so-called *précieuses ridicules*—whose elegant dress and speech were judged to be overly affected and effete by more robust courtiers. It has since come down to us with varying inflections from mild disdain to hearty contempt, and it now rates among the worst charges that can be leveled against a work by professors and students in an art school or by a critic addressing the general public presumed to have no truck with trifling aestheticism.

There is an obvious sexual politics to this, as well. Preciosity originated with the rise of eighteenth-century salons and the corresponding coming into social and cultural power of the women who set their style and intellectual agendas. The backlash against these urban hotbeds of art and ideas bore the stamp of an old landed gentry desperately trying to retrench itself against the onslaught of the Enlightenment. And what better way to dismiss cosmopolitanism and complexity than to associate them with a lack of virility. To be precious, therefore, was to be overly subtle, effeminate, and, by extension, inconsequential. Present-day echoes of such sentiments now issue from the mouths of bombastic politicians desperate to prove that they, unlike their opponents, are not "girlie men."

Which brings us in a roundabout way to Richard Tuttle, and, briefly, to his most vociferous detractor, Hilton Kramer. Kramer's 1975 attack on the artist's exhibition at the Whitney Museum of American Art in the *New York Times* is one of the benchmarks of the period, and, like the critic's out-of-hand dismissal of the new work of the veteran abstract expressionist painter Philip Guston five years earlier, it stands as a reminder of how narrow were the channels through which "mainstream" art was thought to flow by conservatives of this period. Guston's browbeating from Kramer came at the beginning of the final phase of a fifty-year career when Guston switched from gestural abstraction to a broad figurative style that combined dense allegory and the comics. What Kramer pounced on in a 1970 hatchet job titled "A Mandarin Pretending to Be a Stumblebum" was Guston's ostensible betrayal of high modernist art even as Kramer sarcastically noted that prior to this apostasy Guston's admirers saw him, in contrast to "Jackson Pollock, the cowboy of the New York School, all muscle and violence," as Abstract Expressionism's "poet, all sensibility and shimmering delicacy."[3]

Tuttle's humiliation at the hands of the *Times*'s tastemaker was predicated on a different set of values. But insofar as Kramer habitually railed against art that lacked pure aesthetic pleasure—in his eyes the pollutants usually being popular culture and politics—his complete insensitivity to the unencumbered poetics of Tuttle's work is striking. Pushing off from Mies van der Rohe's famous dictum that "less is more," Kramer romps maliciously through permutations of this phrase, implicitly directing them against minimalist work generally, and winds up by saying: "One is tempted to say that, so far as art is concerned, less has never been as less as this."[4] He then proceeds to toy with the notion that in and of itself work so spare as this could hardly be called "major," concluding that in the aggregate neither could it possibly meet the demands of occupying the spaces

of a major museum. With other variations, Kramer's assault returns again and again to the idea of smallness, refinement, or delicacy as a sign of inherent aesthetic weakness.

In the *Village Voice,* David Bourdon—a writer close to Andy Warhol who was usually open to the new, and far less prone to reflex hostility toward art that eschewed the muscularity of so much postwar American painting and sculpture—nevertheless described Tuttle's art as "gentle though fey," and found fault with it for being a "perverse type of interior decoration" and "niggardly, if not always precious."[5] Like Kramer, Bourdon also went after the show's curator, Marcia Tucker, for daring to mount such an exhibition in the first place, and then for failing to produce a catalogue at the opening, although her stated reason for this was to accommodate documentation of all cycles of the changing installation. Even though Tucker had the satisfaction of publishing these reviews when the book finally did appear (making it a unique and invaluable prototype of what a catalogue for a show based on contingency can be), the bad press eventually cost her her job. In recent decades, we have unfortunately become accustomed to American museums bumping members of their staffs for giving prominence to socially or culturally controversial works, but it is hard to think of another instance in which a respected and accomplished professional at a leading institution devoted to modern and contemporary art was banished because she showed art that was too refined for an informed audience.

It is remarkable, and very much to his credit, that Thomas B. Hess not only saw the merit in Tuttle's work but also took it upon himself to debunk Kramer's absurd vituperations. Remarkable because, as editor of *ARTnews* during Abstract Expressionism's heyday, he was a dedicated advocate of the heroic style represented by Pollock, Guston, Willem de Kooning, Barnett Newman, and all the other artists whose antithesis Tuttle was presumed to be by modernist hardliners. But then Hess had not forgotten that, if Kramer now and again sang the praises of these painters so as to strategically align himself with the public's growing enthusiasm, the better to mock more recent avant-gardes, Kramer nevertheless had dipped into the same bag of rhetorical tricks to write off these same painters in years past. Speaking of the invective Kramer showered on Tuttle, Hess wrote, "When you read such words as 'remorselessly and irredeemably...egregiously...pathetic...a bore and a waste...arid...debacle...farce,' from a critic who once called Jackson Pollock 'second rate' and Willem de Kooning a 'pompier,' then it's probable that something importantly different has come to notice."[6] Indeed, considering his diatribes against Pollock, de Kooning, and Guston on down through Johns, Nauman, and Tuttle, and so on into the present, Kramer has proven himself to be an unrivaled reverse indicator of talent. As such he has done an invaluable service to contemporary art despite his intention to do as much harm as he could. So far as Hess is concerned, his ability to see beyond the heights of his own generation's accomplishments and recognize those of younger artists is exemplary, particularly given that he traveled in circles that so often closed ranks when the "new" they had championed was eclipsed by the newer "new" of the 1960s and after. The writing he did in the 1970s at *New York* magazine after leaving *ARTnews* and his all-too-brief tenure as curator of modern and contemporary art at the Metropolitan Museum of Art are evidence of the

exceptional capacity for growth demonstrated by an editor, author, and acutely focused "eye" whose largely overlooked achievements parallel those of Clement Greenberg and Harold Rosenberg.

In the upper reaches of the institutional art world in the United States, Hess's enthusiasm remained an exception. Nor did Tuttle's ties to one of the pioneering galleries of the postwar era and the affinities between his work and that of other artists in its stable secure him a position within high modernism, American style. The gallery was Betty Parsons's, and the artists with whose work his sympathetically resonated included not only Pollock and Newman, but also Tony Smith, for whom Tuttle worked as an assistant in the construction of a number of sculptures; Ellsworth Kelly, whose radical formal and chromatic simplification and crisp facture Tuttle has matched in miniature; Agnes Martin, with whom he carried on a dialogue in words and images for many years; and the sculptor and draftswoman Ruth Vollmer, a less-well-known but also remarkable member of Parsons's enclave and host of her own salon, where older artists met younger ones such as Eva Hesse, Mel Bochner, and Thomas Nozkowski. Tuttle's hypernuanced art harmonized with specific qualities found in that of the others in the select company of people who—each in their own distinctive way—gave substance to Parsons's aesthetically rarefied and quasimystical concept of the modern.

It was at her gallery that Tuttle had his first one-man show in 1965, ten years before the furor over the Whitney exhibition. And it was this intimate environment as much or more than the wide-open art scene of the 1960s and early 1970s that had nurtured Tuttle, though Kramer seems to have been unaware of it when he wrote, "Mr. Tuttle...has for some years enjoyed an underground reputation as a minimal artist. On the basis of this exhibition, I think it would have been wiser to leave that reputation underground."[7] Kramer's hostility, nonetheless, sums up the bruising climate in which Tuttle emerged on the national stage. If it has taken him more than thirty years from the date of that "return-to-sender" review to reclaim his position by the same alternately austere and hedonistic, diffident and self-assertive means, then it says something not only about changes in American taste but also about the slowness with which those changes have come about, even as Americans have enjoyed the apogee of their cultural power internationally, and so, one would have assumed, a comparable confidence in supporting their best artists regardless of media, style, or generation.

plate 63

Against this background, further questions arise. Abroad and at home, the United States is often criticized for having aggressively promoted its own for reasons of patriotic pride and foreign policy. There is truth to this, though depending on the manner in which it was done, and barring crude boosterism or covert ideological motives, there is no cause for shame in a country celebrating its cultural achievements.[8] But it is also demonstrably true that the list of those who

63 Installation view of the 1965 exhibition **Richard Tuttle: Constructed Paintings** at Betty Parsons Gallery, New York, showing works from 1964–65

have received such institutional, critical, and economic backing as representatives of "The American Century" has been heavily abbreviated in practice when checked against an art-historically fair reckoning of those who have actually altered the way we think about art. This is especially so when it comes to artists whose work came to light in the 1970s, after a combination of forces had established key artists of the 1960s alongside the Abstract Expressionists as paradigmatically American figures. The signal event in this process was Robert Rauschenberg winning the grand prize for painting at the Venice Biennale of 1964, and not the least of the factors influencing the heavy international focus on American pop and minimalist artists was the crucial role played by Leo Castelli Gallery in New York and, for an important period, Sonnabend Gallery, its European collaborator in Paris run by Castelli's former wife, Ileana Sonnabend. Together they did much to raise Rauschenberg, Jasper Johns, Warhol, and others to worldwide prominence.

In this context, one of the methods of determining who is missing from the official rosters is to ascertain which American artists have been welcomed elsewhere at a time when America and American culture in general have been in disfavor there. Setting aside expatriates—for example, Joan Mitchell, who lived in France by choice from the late 1950s until her death in 1992, and Mark di Suvero, who left the United States in protest during the Vietnam War—the number is still large, but some patterns form. Among them is a prevalence of artists who figure prominently in Minimalism, Postminimalism, and Conceptualism, movements that, by virtue of the difficult intellectual, physical, and experiential demands they placed on the public generally, and on collectors and museums in particular, received far less attention and backing in the United States than they did in Europe, where populist impulses played a lesser role in the construction of the contemporary canon. There, curators, gallerists, and the critical community focused intently on artists representing these movements from the late 1960s through the 1980s, with the result that the most comprehensive groups of their works are—or

were—to be found in private hands or in institutions in Belgium, England, Germany, Italy, the Netherlands, and Switzerland. For instance, it has only been by means of the recent sales of parts of the Panza di Biumo and Jost Herbig collections that major works of this type have been repatriated to America and belatedly acquired by our leading museums, which, fixated on the hypothetical "mainstream," had passed them by when they were first made and readily available. The Guggenheim Museum thus owes its in-depth holdings of Carl Andre, Donald Judd, Robert Ryman, and other Minimalists to the prescience of Panza di Biumo. Such is also the case for the Museum of Modern Art, New York, which, as of 2002, could boast a glyphic wall sculpture in galvanized iron titled _Letters (The Twenty-Six Series)_ (1966), which featured prominently in Tuttle's 1975 Whitney exhibition and was even then owned by Herbig.

plates 56–57

To one degree or another, many names fall into this basket description, and most were associated in one way or another with a handful of galleries that included those of Alfred

64 Robert Ryman **Untitled** 1957
Casein, graphite, canvas, board, paper,
glass, and plywood, 9 5/8 x 8 1/2 in.
Collection of the artist

Schmela, Konrad Fischer, Heiner Friedrich, Yvon Lambert, Annemarie Verna, Rudolf Zwirner, and
Nigel Greenwood, all of which, with the exception of Fischer's, hosted Tuttle exhibitions. From a
chronological point of view, two artists stand out alongside Tuttle: Ryman and Nauman. Both had plate 64 / plate 65
survey exhibitions in New York early in the 1970s, less than a decade after their work first emerged.
Ryman's, in 1972, was at the Guggenheim Museum, which within a few years also showed Robert
Mangold and Brice Marden. Nauman's, in 1973, was at the Whitney Museum, and was organized
in collaboration with Jane Livingston of the Los Angeles County Museum of Art by none other than
Marcia Tucker. Relatively speaking, the survey of Ryman's paintings was treated with respect, but full
recognition of the artist's achievement in his own country has, until recently, lagged conspicuously
behind that which it has been given in Europe, especially when you consider, for comparison, the
attention devoted to Johns, a fellow Southerner and artistic autodidact the same age as Ryman with
whom Ryman's concern for surface, systemic marking, monochromy, and text-as-image overlaps
in thought-provoking ways. Nauman's exhibition was sharply criticized in the general press—once
more Kramer takes a dubious bow—and, as was the case for Ryman, his most fervent advocates
for the next ten years were for the most part in Europe.[9] In this connection one must not forget the
loyalty shown Nauman by Leo Castelli, with whom he continued to show in New York, but it does
suggest an aesthetic cutting-off point that experimental art reached in America in this period, one
that even Castelli's powers of persuasion could not overcome.[10]

Tuttle's circumstances were similar. Altogether Parsons gave Tuttle seven one-person
exhibitions between 1965 and 1975, and in addition to her efforts the dealers Joseph Helman, Daniel

Weinberg, and Nicolas Wilder picked up his cause, as did curators at the
Albright-Knox Art Gallery in Buffalo, the Dallas Museum of Fine Arts,
the Wadsworth Atheneum in Hartford, and the Museum of Modern Art
and Clocktower Gallery in New York City. But besides Parsons his most
consistent base of support was on the Continent, where the legendary
dealer Schmela first presented him at his Düsseldorf gallery in 1968.
Others soon followed suit, such that just prior to the Whitney exhibition,
Tuttle had had almost as many shows abroad as in the United States, a
very unusual statistic for a rising American talent at that time. Thereafter
the ratio shifted, and for almost three decades Tuttle was more visible in
Europe than in America, sometimes by an annual factor of as much as
two to one.

The story such details tell is a more interesting one than they
might superficially suggest. Certainly it is not one of romantic neglect;
Tuttle has always had his fans on both sides of the Atlantic, and the total
number of his exhibitions is impressive by any standard. In part their
sheer quantity is a consequence of his way of going about his work, which
in the main involves some measure of site-specificity. Although he is a

65 Bruce Nauman **Neon Templates
of the Left Half of My Body Taken
at Ten-Inch Intervals** 1966
Glass tubing, neon, and electrical
wires, 70 x 9 x 6 in.
Collection of Philip Johnson

maker of discrete objects, the framework in which they will be placed is of paramount importance. This is so whether that context means—as it did in the early days when, like many of his process-oriented contemporaries, he shunned traditional frames as such—the shape of a room and the proportions and material characteristics of its walls, or—as is frequently a concern nowadays—the structure of the work, its support, and its presentational devices up to and including traditional though idiosyncratic frames. Tuttle's ability to "make something out of nothing" and at the same time meticulously tailor that "something" to a given location has recommended him as an ideal collaborator for gallerists and curators disinclined to mount conventional displays of studio production. With Tuttle there is always an element of responsiveness to the space, novelty of means, and unpredictability, not to mention a penchant for connecting his gesture or intervention to the prevailing formal conditions or poetic mystique of the place to which he has been invited. Thus Paul Klee, Lucio Fontana, and a quite astonishing variety of modern masters have become his mentors or muses in the conception of the ensemble pieces in which he specializes.

plate 66

It is worth mentioning at this point that, in addition to Tuttle's declared interest in such historical figures, his work and working methods suggest intriguing parallels with those of a number of his European contemporaries as well. In particular, there is the late Blinky Palermo. In Palermo's many watercolors—it was one of his primary media—an apparently insouciant but in practice finely calibrated touch quickens images that otherwise belong to the established repertoire of mid-century geometric abstraction, a little as if one were watching an almost too-familiar thing being awkwardly and poignantly reborn. Although it is otherwise rarely the case in the generation of these artists, watercolor plays the same role for Tuttle, and his amorphous contours, often pallid hues, patched-together supports, and loosely brushed shapes, combined with his liberal use of "emptiness" and dispersal, are at times very similar to Palermo's deployment of these gestural, chromatic, and compositional elements. Furthermore, like Tuttle, Palermo was much concerned with the placement of forms—often eccentric ones—in real space: on walls high and low; above doors; propped on the floor; in relation to other, more symmetric, forms; and in the given shapes of architecture, which he highlighted by painting the walls as well as distributing things across them. Palermo's use of dyed fabric in place of painted surfaces, of soft materials in contrast to hard ones, and of openness and subtle irregularity in gentle tension with contained, iconic symmetries are hallmarks of his approach that also correspond with crucial aspects of Tuttle's practice. To speak of them in this connection is not to insist on the actual influence of one upon the other, though it is hard to imagine that Tuttle has been unaware of or indifferent to Palermo, but rather to stress the prior existence in Europe of a type of sensibility that Tuttle also possesses, and of the respect shown it there.

66 Blinky Palermo **Kissen mit Schwartzer Form**
(Cushion with Black Form) 1967
Oil on foam rubber, 20 1/2 x 16 1/2 x 3 7/8 in.
Bayerische Staatsgemäldesammlungen,
Sammlung Moderne Kunst in der
Pinakothek der Moderne, Munich

67 Installation view of the 1972 exhibition **Meisterwerke
des 20. Jahrhunderts** (Masterpieces of the Twentieth
Century) at Galerie Schmela, Düsseldorf, Germany,
showing gallery owner Alfred Schmela with
(above, from left to right) works by Kenneth Noland,
Morris Louis, Arman, and Gotthard Grauber
and (below) Richard Tuttle's **Chelsea** (1965)

My emphasis on Tuttle's exhibition history—not normally the subject of catalogue essays—is intended neither as special pleading nor as accreditation. Rather the aim is to look to the curiously imbalanced reception of his work in different cultural milieus so as to better understand what the work is and does, as well as to inquire into the causes and consequences of this disequilibrium. Against that backdrop, the themes evinced by Tuttle's European critics are revealing. Given the large number of individual items in his bibliography, the literature is surprisingly slim in substance—consisting for the most part of short reviews—and many repeat the same basic facts about Tuttle's New Jersey origins, his quiet emergence in the 1960s, and the debacle of his Whitney show. Some make a point of his "discovery" in 1968 by Schmela (who was prompted by Parsons and accompanied on his first studio visit by the German artist Erwin Heerich) and his participation a year later in Harald Szeemann's paradigmatic 1969 exhibition *When Attitudes Become Form: Works—Concepts—Processes—Situations—Information* in Bern, Switzerland. There, for the first time in a major venue he was directly associated with Nauman and Ryman, with the name of the latter figuring more frequently in these articles owing to the radical simplicity toward which both artists tended in that period. Indeed the generally brief, descriptive writing about Tuttle frequently

plate 67

resembles that devoted to Ryman. In both cases, this seems a reflection of the work having been so stripped down that commentators have been obliged to fall back on providing information about things whose perceptual subtlety and elusive conceptual basis deflect most art rhetoric. Certainly this is true of Ryman, whose own way of articulating his ideas tends to be matter-of-fact.

 Tuttle's is less so, though he often speaks in great detail about the formal issues governing the creation and installation of specific bodies of work. However, unlike the consistently plainspoken Ryman's habit of discouraging grand philosophical speculation or poetic flights of fancy, Tuttle's sometimes sibylline declarations open a door leading to the types of hermetic thought and language that enveloped European artists and movements of the same period. One is reminded, for example, of the critical discussion of Arte Povera, which, in connection with that tendency's recourse to and transformation of unconventional materials, frequently made allusion to medieval magic. Indeed, in his initial 1969 definition of Italy's then-new, nature-oriented aesthetic, Germano Celant employed the hyphenated term "artist-alchemist" to describe its exponents in contrast to what he viewed as the American artist's fixation on industrial and media technologies and on the modern social sciences, from academic linguistics, which according to Celant stifle the vitality of

language, to behavioral psychology, which subordinates being to cultural norms.[11] Likewise, Joseph Beuys's involvement with the spiritualist doctrines of Rudolf Steiner inflects his monologues with an often confounding oracular quality, which bears a resemblance to Tuttle's own rhetoric of free association. Unlike Beuys, though, Tuttle is not a systems builder or proselytizer. Still, he has in some quarters been subject to the same reticence that has greeted Beuys and Arte Povera's spokesmen and practitioners. After all, these are the very types of subjective or transcendentalist discourses that positivistic American formalism and its structuralist and poststructuralist offshoots turn a deaf ear to when they do not actually deride them. The meandering quality and obscure correlations typical of Tuttle's ruminations are part and parcel of his insistence on the essential ineffability of art. This too makes his work hard for rigorously "objective" analysts to swallow, not to mention his preoccupation with beauty, which avowedly antiaesthetic postmodernists scorn—though in retrospect this should have, but so far has not, fully established him as a central figure in the "beauty debates" of the last ten years. But while these dimensions of his approach grate gently but unrelentingly on the nerves of hard-boiled compatriots, Tuttle has found an eager audience among Europeans still disposed to metaphysics and loveliness.

 Such fellow feeling is reciprocated by Tuttle's broad interest in European culture, but that interest must be gauged against the rejection of traditional European art by Donald Judd, Frank Stella, and others during the 1960s—Tuttle's formative years. Most forcefully stated in a conversation

68 Frank Stella **Shoubeegi** 1978
Enamel and glitter on metal,
95 3/4 x 130 x 32 3/8 in.
San Francisco Museum of Modern Art,
gift of Harry W. and Mary Margaret
Anderson and Museum purchase

between Judd, Stella, and critic Bruce Glaser that was published in *ARTnews* in 1966, this rejection, which Stella partially recanted in his 1983–84 Norton Lectures at Harvard but which in the meantime held great sway in vanguard circles, not only stigmatized "composition" as being the equivalent of compromise or accommodation in the handling of form—as opposed to allowing for form's holistic self-assertion—but also implicitly viewed it as the vitiating subordination of painting and sculpture to imagery or architecture.[12]

Tuttle's early paper, cloth, wood, and wire pieces of the 1960s and 1970s lend themselves to unified or gestalt apprehension in much the way Judd's boxes and Stella's shaped canvases of the same period do, but they were arrived at without making a straw man out of European part-to-part-to-whole abstraction. Moreover, when Tuttle began in the 1980s to experiment with complex amalgamations of materials, exuberant color combinations, and irregular graphic gestures—in short, composition—they did not constitute a "maximalist" inversion of "minimalist" principles to the same extent that the related transformation in Stella's work did, nor did they prompt a revisionist, much less a historicist, reinterpretation of the old masters as justification. Rather, they grew organically out of previously restrained impulses. Stella's infatuation with and mimicry of the Baroque in the 1980s was presented simultaneously as a radical break with the modernist past and the enervating reductionism to which modernist abstraction had supposedly succumbed—hence a rupture worthy of vanguard practice—and a somersault backward into tradition that was meant to look like a leapfrog forward toward renewal. Bypassing Stella's logical gymnastics, Tuttle proceeded without laboriously argued theoretical alibis to explore elements of his sensibility that, however subdued, had always been manifest—his delicacy of touch, his penchant for ornamental reiteration and rephrasing, and his gift for improvisation and complication through bricolage.

plate 68

This recurrent term in Tuttle criticism deserves qualification, and doing so only emphasizes the correlation between his work and Stella's, and the differences between them. Stella's methodology is to posit a basic format and work around in variations until he has fully colonized the basic concept. Tuttle's approach is much the same insofar as he too picks a shape, or material, or position on the wall, and rings changes on it. However, the element of bricolage enters in with the apparent casualness with which he pursues his task, and the unprepossessing nature of most of the variables he selects. Thus a slender metal filament, a grade of thin plywood, a flimsy type of paper, and an assortment of simple cuts, contours, edgings, or marks become the genetic code of a series of unique pieces that, rather than nailing down the proof of a logically derived hypothesis or aggressively staking out territory in art history, vindicate a hunch while quietly infiltrating our common space. The makeshift component of Tuttle's practice is the disguise of a pacifist guerilla with expansive ambitions but free of the will to dominate.

69 Ivan Puni **Suprematist Relief-Sculpture**
1920s reconstruction of 1915 original
Wood, metal, paint, and cardboard on wood panel,
20 x 15 1/2 x 3 in.
The Museum of Modern Art, New York,
the Riklis Collection of McCrory Corporation

To the extent that Tuttle's exploitation of such postminimalist options took diminu-tive shape, his works may have struck some viewers as more rococo than baroque, but in the final analysis their lightness of construction and affect enlivens them and integrates them into their environment in ways Stella's ponderous demonstrations seldom achieve. In short, aesthetic inge-nuity and freshness are not functions of the largeness or obvious boldness of an artistic gesture.
plate 69 Ivan Puni, the Russian Constructivist whose polychromed wood, cardboard, and metal reliefs are an important precedent for both Tuttle and Stella, is proof of that. But in a country accustomed to the grand scale that Clement Greenberg attributed to "American-type painting," bigness fre-quently overshadows smallness.

Thus, having reversed course and become a high-level academic "composer," Stella found favor with American institutions and was showcased in their big halls. Tuttle, a chamber musician at least as inventive and far more nimble, "played" smaller rooms and spent much of his creative life "on tour" around the world.

Meanwhile, Europeans have more readily recognized, and have as a rule been more tol-erant of, Tuttle's attraction to Eastern philosophical sources than their American counterparts. Here strict Postmodernists have tended to lop off or ignore inconvenient references to philosophies and religions that steer art toward avenues leading away from concrete artistic facts or social and polit-ical contexts, such that the theosophical Piet Mondrian, the atavistically mystical Barnett Newman, and the Catholic Tony Smith have effectively been bowdlerized—that is to say secularized—for a generally skeptical contemporary art public. So too has the *I Ching*–throwing Zen devotee Cage. Postwar Europeans have on the whole been less squeamish, though sometimes too quick to suspend critical judgment, when it comes to such associations. In any event they have for the most part been prepared to consider seriously the artistic consequences of specific doctrines rather than dwell on their more questionable premises. Indeed, Europe has reserved honored places in its museums and art histories for artists like Cage's Baha'i friend Tobey—generally just an art-historical footnote to Abstract Expressionism in the United States—with whom one leading writer in Germany, Barbara Catoir, directly connects Tuttle. In almost the same breath, she also compares his work to haiku, while numerous others make equally direct reference to Tuttle's stated preoc-cupation with Buddhist ideas of "creation from the void" and "the search for beauty which excludes the ego."[13]

However, if Zenlike plainness represents one pole of Tuttle's art, whimsy and a tendency toward discursive elaboration and embellishment constitute the other. The scope of Tuttle's own making reflects his pluralistic taste as a connoisseur and collector. Given his unapologetic status as an avid and eclectic art lover—and in this he diverges markedly from many of his iconoclastic if not stridently antiaesthetic contemporaries—Tuttle's more arcane pronouncements provide occasions for crit-

70 Paul Klee **Geheime Schriftzeichen**
(Secret Lettering) 1937
Charcoal and gesso on newsprint,
19 1/8 x 13 in.
Private collection, Switzerland

ics to expatiate on ideas suggested by artists with whom he has acknowledged an affinity. Having previously mentioned the formally ingenious Klee, whose pictorial wit has been a touchstone for Tuttle, and the formally promiscuous Fontana, on whose work Tuttle wrote a lengthy statement that sheds useful light on his transition from the reductionism of his early works to the frankly, if not defiantly, decorative work of the 1980s onward, correlations have also been developed by European observers with major figures as remote from one another as Titian, Egon Schiele, and Yves Klein, as well as with minor ones such as the dour and today little-known Austrian modeler and carver Fritz Wotruba, whose sculptures Tuttle saw in New York while he was still a young artist, most likely in the Museum of Modern Art's much-maligned 1959 rejoinder to New York School abstraction, *New Images of Man*.[14]

plate 70

plate 71

The striking thing here is not just Tuttle's particular interests, but their range and apparent disparity. Where theory and canon construction have been the prevailing concern in so many American museums, universities, and art schools since the United States announced its art-world hegemony in the postwar era, Tuttle's multiple identities and equally numerous interests are at best an engaging distraction, and at worst an indication that the rationalized, teleological development of modernism may be losing its grip not because antimodernists have mounted a successful counterattack but because stylists are toying with the hard-won modernist certainties. In places where such empire-building is still the primary goal, the reticence regarding Tuttle carries a double message; he is too problematic to speak up for but has, over the long haul, proven himself to be too good—that is, formally innovative—to criticize openly.

For European observers reluctant to grant monolithic versions of American-style modernism unqualified benefit of the doubt—after all, it is precisely artists such as Fontana and Klein who were until very recently brushed aside or consigned to the third or fourth ranks in most American accounts of "mainstream" art—Tuttle's agile dance around the heavily fortified positions of competing modernist academies is exceptional and exemplary. Implicitly or explicitly, European critics weary both of the failed utopian promises of continental Constructivism and of what some see as the impersonal, machine-made rigidities of Minimalism—qualities occasionally interpreted as emblematic of utilitarian American might—have held Tuttle's work up as a counter term in contrast to those two intersecting tendencies. At times Ryman has served the same purpose— therein lies the reason these otherwise quite dissimilar artists have so often been linked—namely to stand for a kind of radical abstraction that abjures absolutist claims, and finds its fulfillment not through systematic paring down to preconceived essences, but instead through an intuitively arrived at sufficiency achieved by straightforward means. Or, as one critic writing of Tuttle in another context put it, "a modest American version of beauty."[15] From this angle Tuttle has come to personify

71 Lucio Fontana **Concetto spaziale**
 (Spatial Concept) 1952
 Oil and mixed media on canvas,
 19 5/8 x 15 3/8 in.
 Private collection

"the American *Homo ludens*," and is often regarded as the salutary cosmopolitan antithesis to the domineering tendencies otherwise expected from a country that has tended to see itself as the center of the world and its culture as the defining model for the second half of the twentieth century.[16]

After various synonyms for self-effacing, elusive, charming, playful, mystical, and given to magic—each one of which defines him in terms that underscore a kind of spiritual volatility, as distinct from the imposing presence typical of the modern "artist-as-hero"—the most common word in the writing on Tuttle produced in Europe is *nomad*. Thus, in a 1994 catalogue essay for an exhibition of American drawings in the collection of the Kunsthaus Zürich, Gerhard Mack notes in speaking of Tuttle's "independence from institutions" that "the nomad only needs space for a writing pad and a few pencils to be able to ever redefine his place in ever unknown locations."[17] It is a theme Mack also enunciated in a 1994 article on the artist in which he wrote, "Tuttle is the artist-as-nomad, one who travels light. He has even broken Diogenes' barrel. Every form of relation has been cut. 'Now man walks alone,' he quotes Beuys as saying in his portfolio *Plastic History*. Modernity's mobility simultaneously stands for uprooting as well as liberation.... Theodor Adorno states in his *Aesthetic Theory* that 'if art absorbed its own transitoriness out of sympathy with the ephemeral nature of life, it would be according to a truth that becomes aware of its own time core.' Richard Tuttle shifts this 'time core' to the center of his way of addressing modernism."[18] These are themes presaged by the writing of Peter Winter in 1990 and reiterated in various forms by numerous critics, for example Johanna Hofleitner, who, mindful of his interest in art of the past as well as of other cultures, aligns Tuttle's peripatetic career to temporal as well as spatial nomadism, calling him "an art-historical border-crosser of the late twentieth century."[19]

Cumulatively these references to transiency start, in Tuttle's case, by conjuring up visions of the artist as gypsy or troubadour and gradually shift attention, as the Adorno citation indicates, to an awareness of the actual precariousness of all that seems permanent in a modern world of fixed names and frozen ideologies in contrast with stateless populations, metamorphic identities, and contested frontiers. In an extended reflection on these and related ideas, Edith Krebs invokes not only Adorno and his fellow Frankfurt School collaborator Max Horkheimer but also Walter Benjamin, Marcel Proust, G. W. F. Hegel, and Vilém Flusser, the last of whom wrote in an essay titled "Nomads" that "we are indeed beginning to go about our lives homeless, shelterless, undefined and undefinable.... Settled peoples have split the world and themselves into portions, into 'nomai,' into idioms, and that is what they are sitting on, trying to own more and more of these portions. And nomads experience the connected, concrete reality, they travel within it and ride fields of options." "I have no doubt about one thing, however," Flusser concludes. "If we do not travel toward each other, we will eradicate each other. This is what we have to learn from the recent stone age, namely from Auschwitz."[20]

This is a heavy load to place upon Tuttle's fragile constructions. Only a German commentator might think to draw a connection between the Holocaust and colored bits of wood, paper, or cloth pinned to the wall or glued to each other or to chunks of foam board. Certainly, Tuttle makes no such leap himself. Even in his most sweeping philosophical statements about human consciousness the artist shies away from the human disasters of the twentieth century. Nor would he ever arrogate to himself the role of existential spokesman in quite the way Krebs's argument might suggest. To the contrary, it may be the relief—quite literally—that his work offers us from considering the worst we know about our situation that makes it not just appealing in the sense of being an escapist pleasure but necessary for maintaining some feel for what the unbounded, unencumbered imagination can do for itself and, given the opportunity, can show others. Like Klee, who is so often mentioned in relation to Tuttle and who in perilous times persisted in making delicate, witty, and in all other respects exquisite things, Tuttle is the creator of perishable delights in a period given to appalling destructiveness. Rather than critiquing power's excesses with totalizing alternatives, he does so by changing the subject to the poetics—that is the making—of being in the world. Rather than erect unyielding monuments to world-historical ideas, he leaves frail traces of specific intuitions. Along with Klee, Arp, and others with whom he has been compared, he belongs to that tribe of modernists who have found ways to loosen the constraints imposed on art by rigid doctrines of form or function. From his nearly immaterial wire works and *Paper Octagonals* to his emphatically material floor sculptures and recent paintings, Tuttle has consistently expanded the perimeter of his activity and loosened the aesthetic constraints that so many of his contemporaries have insisted on tightening. His improvisatory techniques are of a piece with his underlying conviction that, contra Yeats's apocalyptic vision of the Second Coming, the center will hold no matter how dispersed the elements that point toward or are visually tethered to it, so long as the hand that makes and scatters them acts freely and grants the same freedom to those elements and to the viewer who enters into the sphere that they reframe, reconfigure, and fill. From the microcosm of dangling paper silhouettes, pencil tracery, or pale watercolor wash to the macrocosm of rooms checkered with badges of color and jigsawed escutcheons, Tuttle's methods and motives are unchanging even as the specific images and objects he fashions undergo ceaseless mutation. The aim is to give the eye something to see while removing the blinders of intellectual habit and worldly preoccupation. Thus he liberates the eye and mind to roam in tandem from sensation to disinterested, even disembodied, thought and back again to sensation. Utilitarian societies resist such license, and condemn or condescend to those who take it upon themselves. But insofar as such societies are increasingly locked down by their incapacity to "think outside the box," artists who think expansively inside boxes paradoxically become useful to the very people least disposed to take them seriously. We have reached that point again in this country, and while Tuttle may once more suffer from being underestimated by hard-headed types of every stripe, more than ever his art could do us good.

plates 108–19 / plates 85–94

NOTES

1 Harold Rosenberg, "Parable of American Painting," *The Tradition of the New* (New York: Horizon Press, 1959), 13–22.

2 Clement Greenberg, "Review of Exhibitions of Jean Dubuffet and Jackson Pollock," *Arrogant Purpose: Clement Greenberg, The Collected Essays and Criticism, Volume 2*, ed. John O'Brian (Chicago: University of Chicago Press, 1986), 125.

3 Hilton Kramer, "A Mandarin Pretending to Be a Stumblebum," *New York Times*, 25 October 1970.

4 Hilton Kramer, "Tuttle's Art on Display at Whitney," *New York Times*, 12 September 1975.

5 David Bourdon, "Playing Hide and Seek in the Whitney," *Village Voice*, 29 September 1975, 97.

6 Thomas B. Hess, "Private Art Where the Public Works," *New York*, 13 October 1975, 83.

7 Kramer, "Tuttle's Art."

8 Recent debates among art historians have focused on the "export" of American art by public and private entities during the Cold War, and, in particular, on the programs of various United States government agencies and that of the International Council of the Museum of Modern Art, which in 1949 circulated the landmark exhibition *New American Painting*, which introduced much of Europe to Abstract Expressionism. Contributing to MoMA's engagement in this area were the obstacles met by the cultural arm of the State Department after its earlier promotion abroad of an exhibition of modern art that was subsequently attacked in Congress by conservatives for being un-American and subversive. As a result, the case for progressive art had to be made by private rather than public institutions. During the same time, the British Arts Council was formed and became active in sponsoring exhibitions of British art, and of course the Soviet Bloc countries also pursued an active campaign in the arts that among other things sent the famously sedentary Picasso to England as a delegate to the Sheffield Peace Conference. In sum, the lines separating the promotion of new art and artists, cultural diplomacy of a broader kind, and sheer propaganda are often hard to keep straight. This is especially true when the funding of cultural programs was covertly tied to governments or their secret services, as was notoriously the case with the Congress for Cultural Freedom in the 1950s and 1960s. Still, not all the exhibitions that were then or have since been supported abroad as a part of national cultural policies are to be judged by the standards of acute Cold War subterfuge. Without such combinations of public and private patronage the movement of art would be solely in the hands of interested commercial parties, and would most certainly be diminished in the aggregate.

9 On the occasion of Nauman's 1973 retrospective, Hilton Kramer followed the same strategy of denigration later used on Tuttle, and as was later the case he implicitly went after the curator, Marcia Tucker. In that condescending mode he wrote: "Mr. Nauman's exhibition is no easier to describe than it is to experience, for there is pathetically little here that meets the eye—a few sculptures of no sculptural interest, a few photographs of no photographic interest, a few video screens offering images that somehow manage to be both boring and repugnant.... [The] priority given to 'ideas' over the art object—the basic tenet of conceptual art—reduces aesthetic experience to a miniscule margin of ratiocination.... As a chapter of cultural history, [the exhibition] has a certain fascination. But as an aesthetic enterprise, Mr. Nauman's work bears the same relation to visual art as crossword puzzles do to literature. It keeps the mind busily engaged in problems that are without significance" (Hilton Kramer, "In Footsteps of Duchamp," *New York Times*, 30 March 1973). Thus, as John Canaday had done in the 1950s during the heyday of Abstract Expressionism, Kramer positioned the *New York Times* firmly on the conservative side of art history.

10 Oddly enough, the breakthrough in Nauman's reception in the United States came in the early 1980s, in response to a body of large, semi-abstract sculptures that were quite unlike the prevailing Neo-Expressionist and appropriationist work then in vogue. Peter Schjeldahl signaled this change of heart, and in many ways stimulated it, in his review of Nauman's 1982 exhibition at Leo Castelli's 142 Greene Street annex; see Schjeldahl, "Only Connect," *Village Voice*, 20–26 January 1982.

11 See Germano Celant, "Introduction to Arte Povera" (1969), in *Theories and Documents of Contemporary Art: A Sourcebook of Artists' Writings*, ed. Kristine Stiles and Peter Selz (Berkeley and Los Angeles: University of California Press, 1996), 662–66.

12 See Bruce Glaser, "Questions to Stella and Judd," in *Minimal Art: A Critical Anthology*, ed. Gregory Battcock (New York: E. P. Dutton, 1968), 148–64; and Frank Stella, *Working Space*, Charles Eliot Norton Lectures 1983–84 (Cambridge, MA: Harvard University Press, 1986).

13 Barbara Catoir, "Richard Tuttle, eine Austellung in Mönchengladbach: Raumen, Zeiche, Materialien," *Frankfurter Allgemeine Zeitung*, 15 November 1985; Angelika Affentranger-Kirchrath, "Punktierte Räume: Richard Tuttle bei Annemarie Verna," *Neue Zürcher Zeitung*, 15 August 1998; and Helga Meister, review, *Kunstforum International* 160 (June–July 2002): 381–82.

14 See Tuttle on Klee in Barbara Catoir, "Richard Tuttle im Munster," *Frankfurter Allgemeine Zeitung*, 16 March 2001; on Fontana in "A Love Letter to Fontana," in *Lucio Fontana* (Amsterdam: Stedelijk Museum Amsterdam; London: Whitechapel Art Gallery, 1988), 60–65. The occasion for Tuttle's reencounter with Fritz Wotruba was his reinstallation of the Kamm Collection at the Kunsthaus Zug, Switzerland, into which he incorporated a number of his own works. Reviewing that exhibition, a reporter wrote, "Tuttle says he has always been interested in the Viennese modern era. 'This combination of lust and suffering which are for example expressed in Egon Schiele's work, this polarity fascinates me,' the man from Santa Fe explains" (Mark Livingston, "Mit den Augen des Künstlers sehen," *Zuger Presse*, 20 November 1998).

15 Meister, review, 382.

16 Romeo Giger, "Homo ludens americanus: Richard Tuttle im Kunstmuseum Winterthur," *Neue Zürcher Zeitung*, 9 April 1992.

17 Gerhard Mack, "Richard Tuttle," *Amerikanische Zeichnungen und Graphik von Sol LeWitt bis Bruce Nauman, aus den Beständen der Graphischen Sammlung der Kunsthauses Zürich*, ed. Ursula Perucchi-Petri (Zurich: Kunsthaus Zurich; Ostfildern, Germany: Cantz, 1994), 141.

18 Gerhard Mack, "Richard Tuttle," *Künstler: Kritisches Lexikon der Gegenwartskunst*, vol. 26 (Munich: Weltkunst und Bruckmann, 1994).

19 Peter Winter, "Pappteller und Poesie: Richard Tuttle in einer Düsseldorfer Galerieausstellung," *Frankfurter Allgemeine Zeitung*, 6 February 1990; and Johanna Hofleitner, "Die Grenzen Erforschen: Neuigkeiten von Richard Tuttle in der Bawag Foundation," *Parnass* (Vienna) 3 (September–October 2000): 128.

20 Quoted in Edith Krebs, "There Is No Reason... Zu den Floor Drawings von Richard Tuttle," *Artis* 44 (March 1992): 48.

72 **Bow-Shaped Light Blue Canvas** 1967
52 3/8 x 51 3/4 in., orientation variable

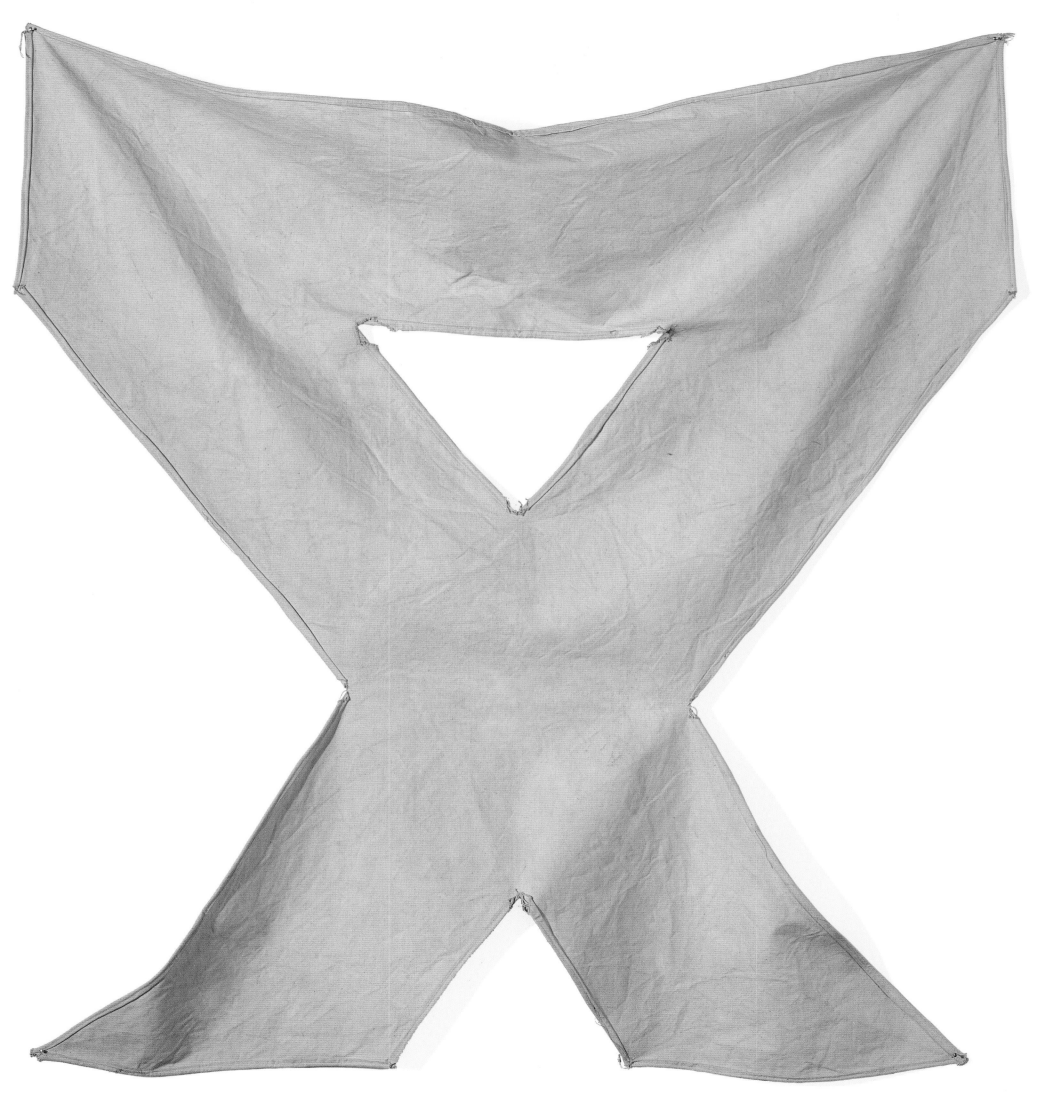

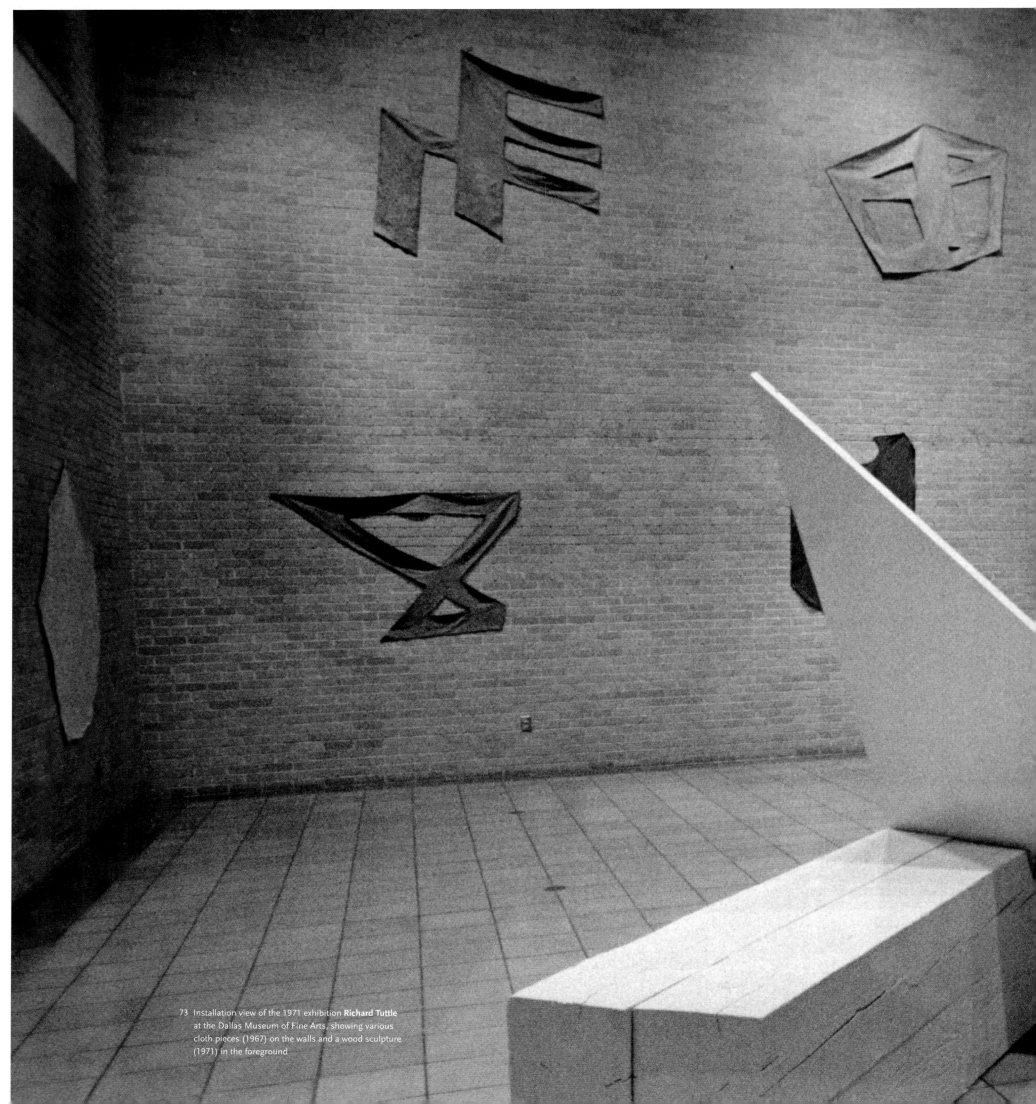

73 Installation view of the 1971 exhibition **Richard Tuttle**
at the Dallas Museum of Fine Arts, showing various
cloth pieces (1967) on the walls and a wood sculpture
(1971) in the foreground

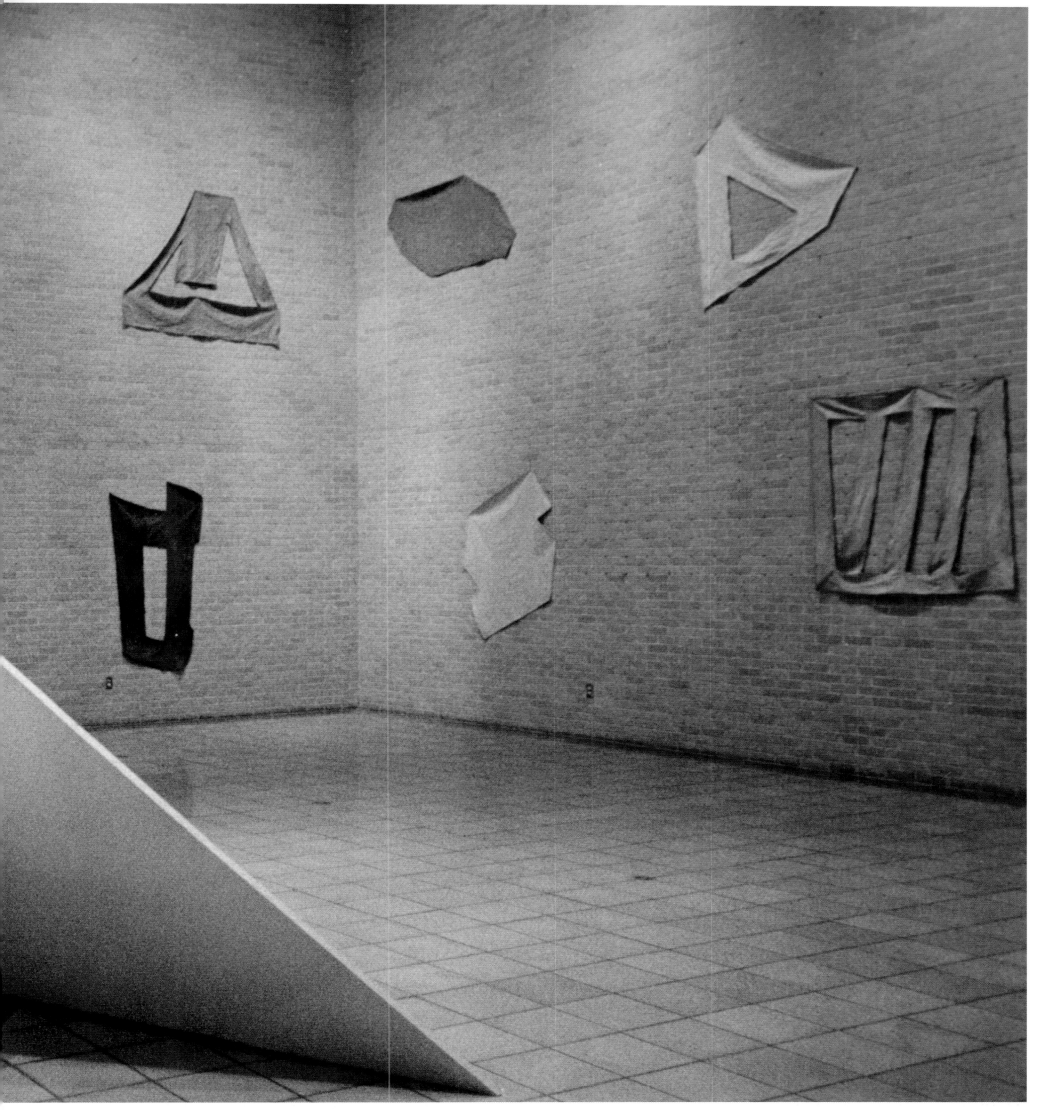

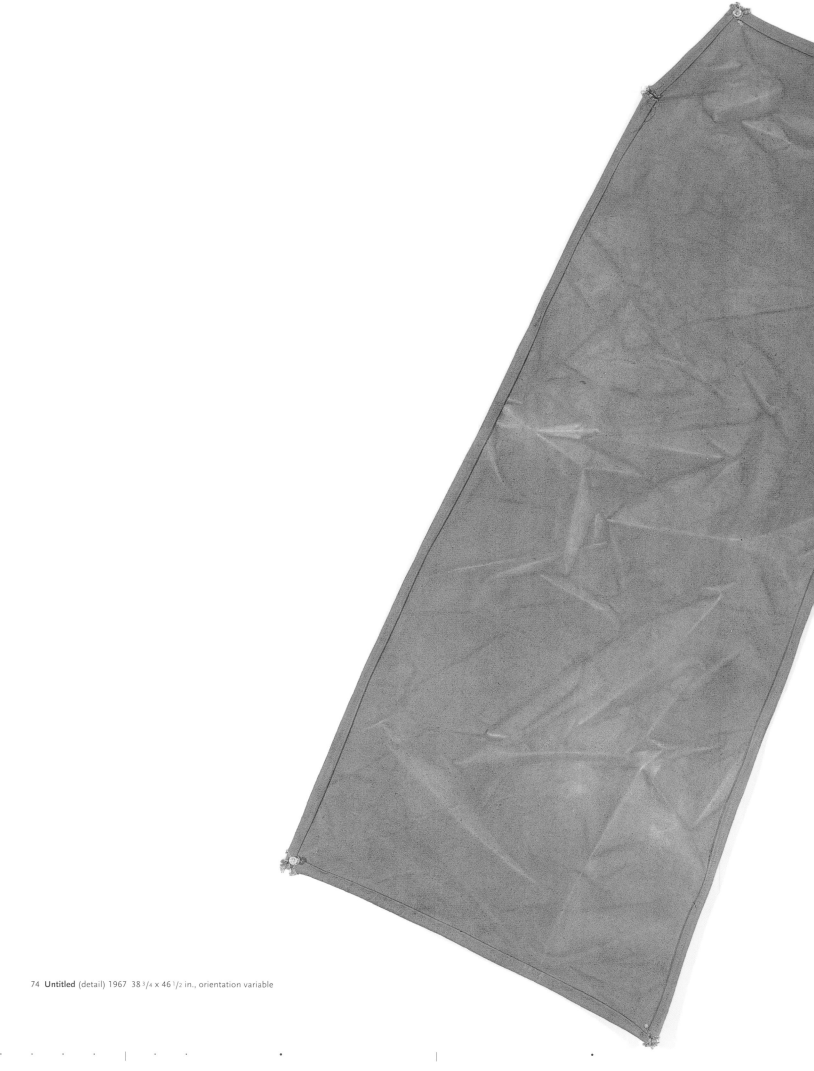

74 **Untitled** (detail) 1967 38 3/4 x 46 1/2 in., orientation variable

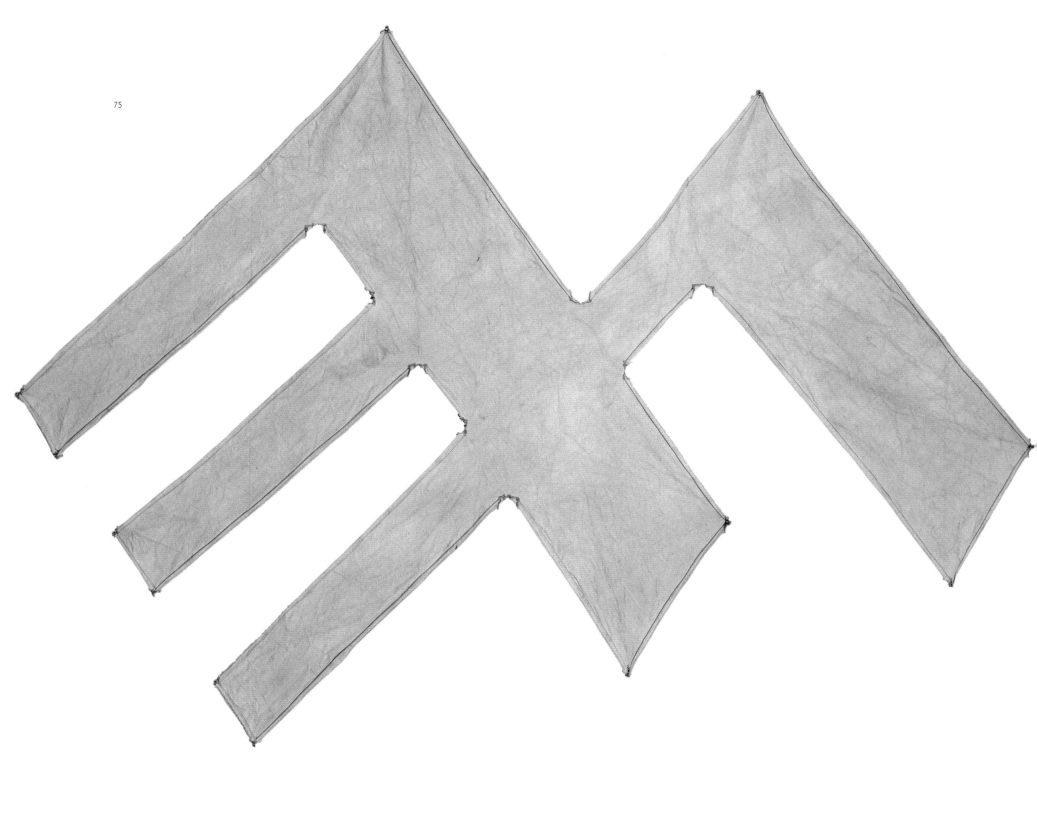

75

75 **Pale Blue Canvas** 1967 64 1/8 x 70 7/8 in., orientation variable

76 **W-Shaped Yellow Canvas** (detail) 1967 53 1/4 x 60 5/8 in., orientation variable

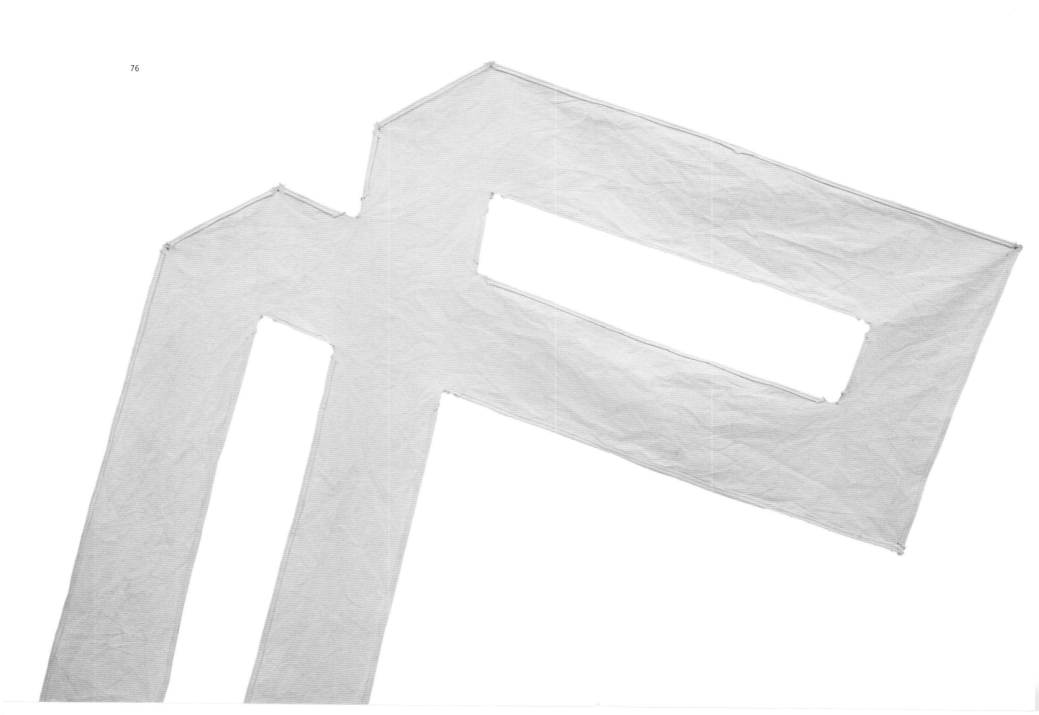

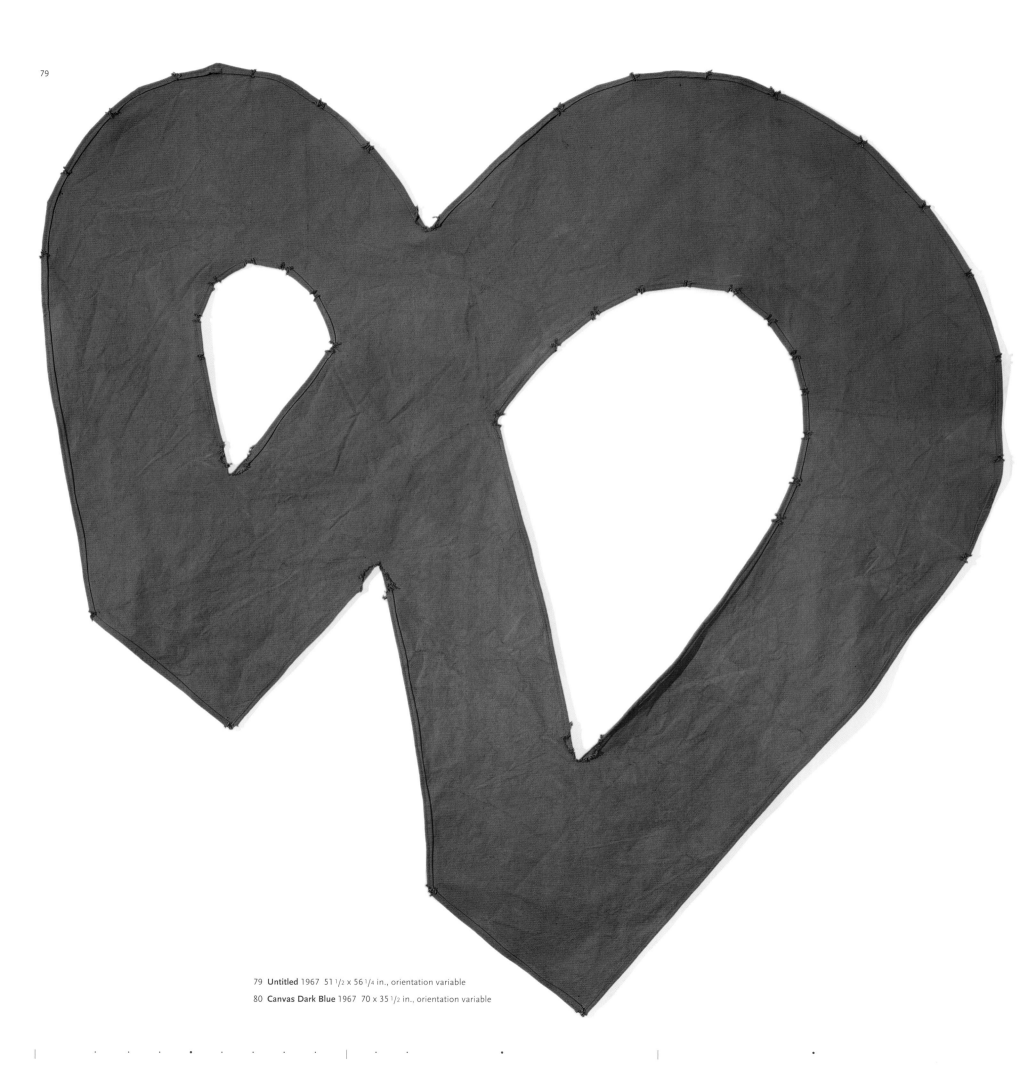

79 **Untitled** 1967 51 1/2 x 56 1/4 in., orientation variable
80 **Canvas Dark Blue** 1967 70 x 35 1/2 in., orientation variable

80

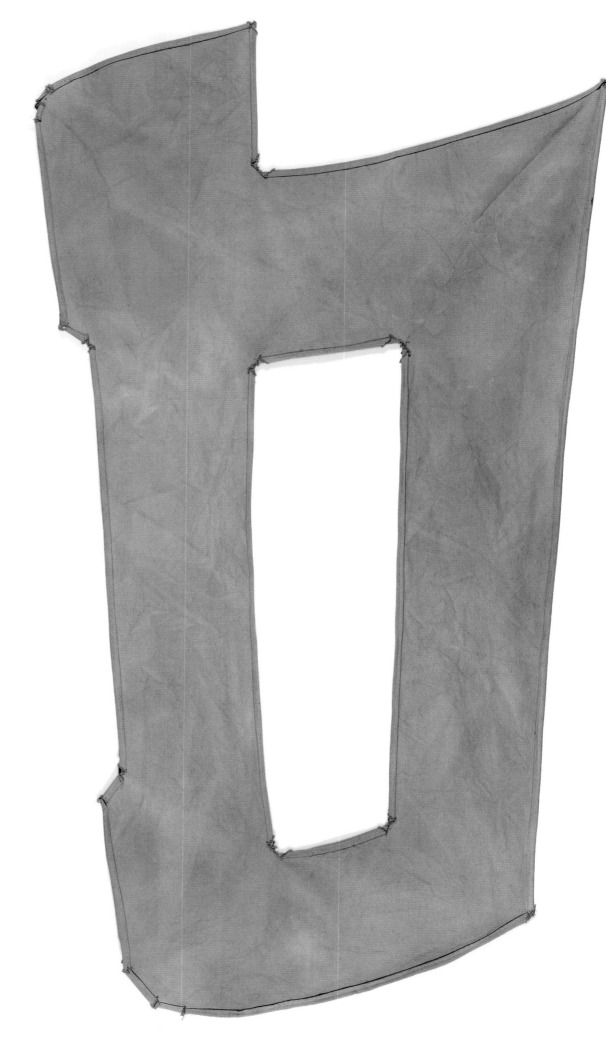

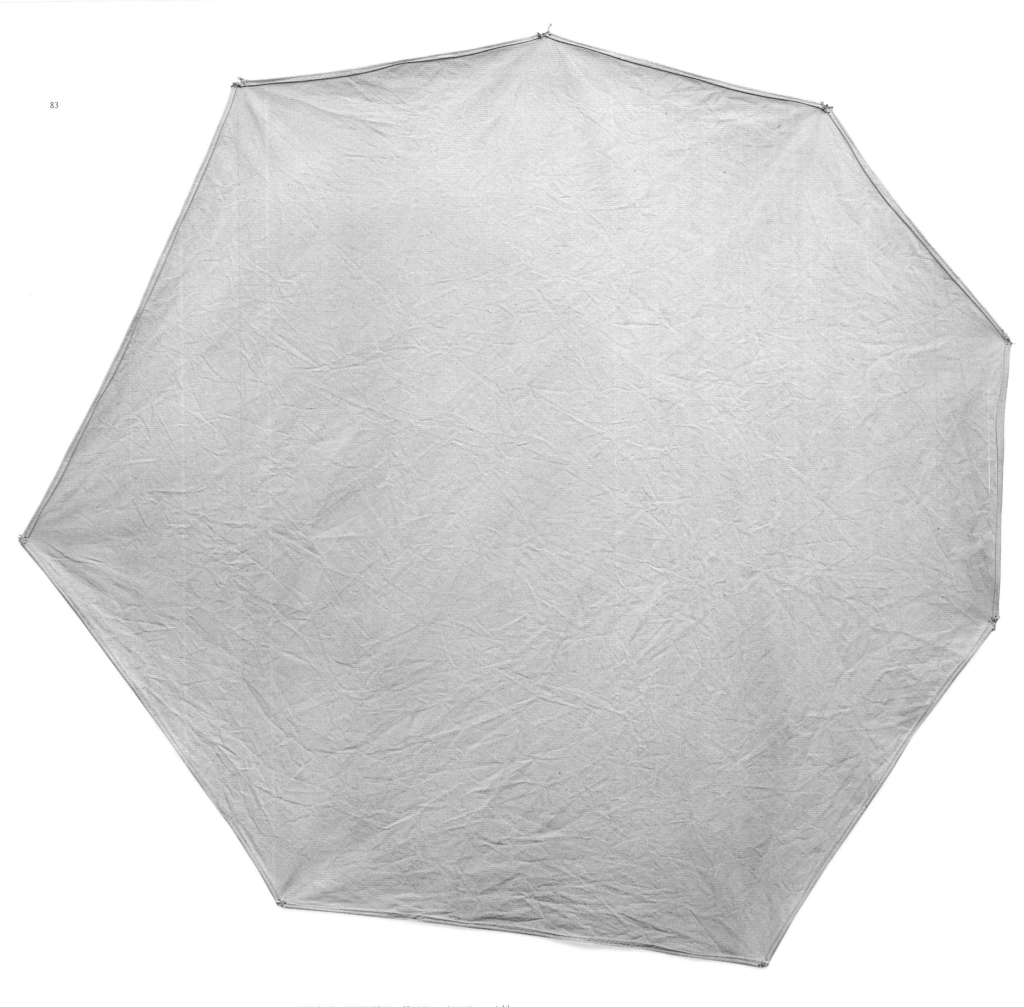

83 **Octagonal Cloth Piece** 1967 58 1/4 x 61 3/8 in., orientation variable
84 Richard Tuttle in his studio with cloth octagonals, ca. 1967

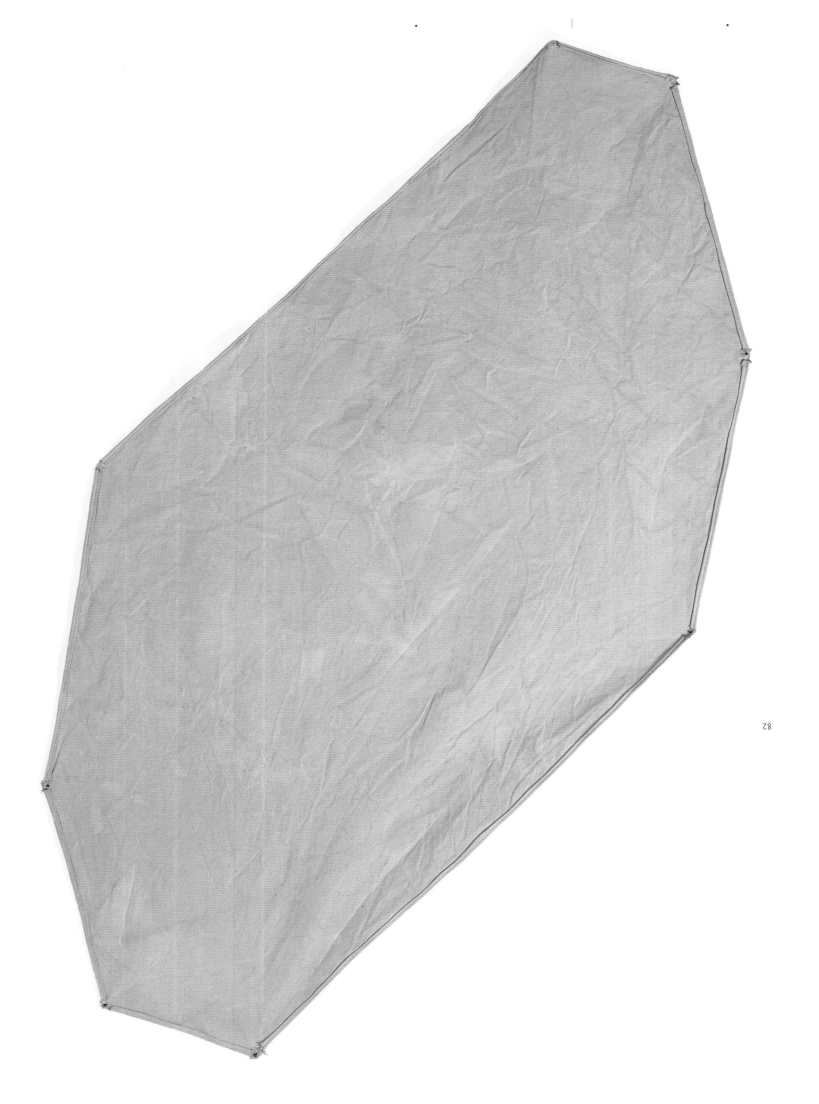

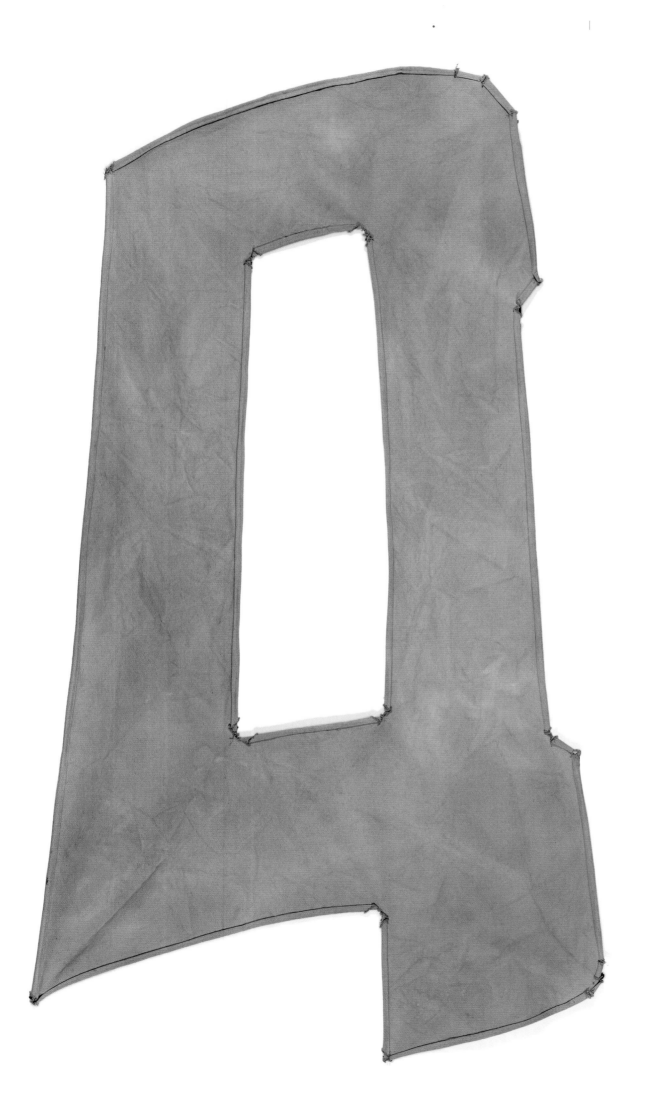

08

85 **11th Paper Octagonal** (detail) 1970 dimensions variable, orientation variable

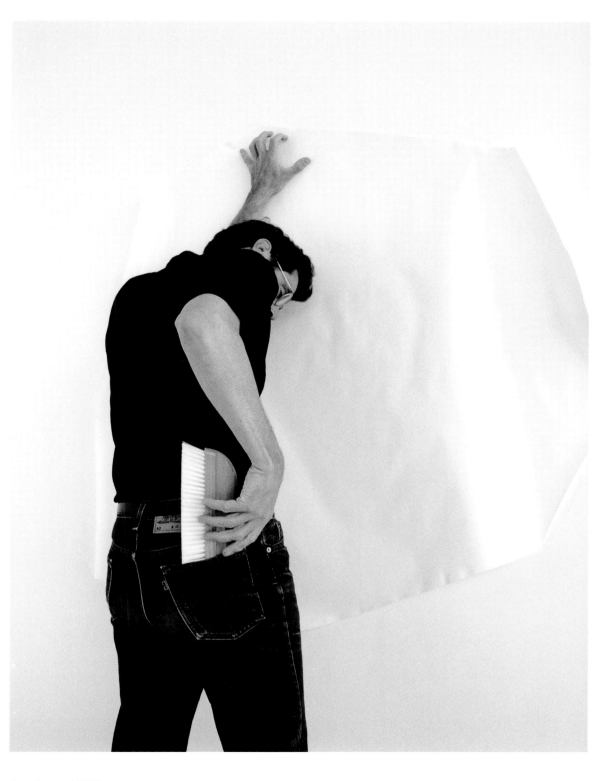

86–89 Richard Tuttle installing a **Paper Octagonal** (1970)
for the 1997 exhibition **Projekt Sammlung: Richard Tuttle,
Replace the Abstract Picture Plane, Works 1964–1996**
at Kunsthaus Zug, Switzerland

90 **1st Paper Octagonal** (detail) 1970 approx. 54 in. diameter, orientation variable

91 **8th Paper Octagonal** (detail) 1970 approx. 54 in. diameter, orientation variable

92 **5th Paper Octagonal** (detail) 1970 approx. 54 in. diameter, orientation variable

93 94

93 Installation view of the 2002 exhibition
 Richard Tuttle: Memento at the Museu
 Serralves de Arte Contemporânea,
 Porto, Portugal, showing a **Paper Octagonal**
 (1970) on the stairway wall

94 Installation view of **7th Paper Octagonal**
 (1970) with Steven Robinson at the home
 of his parents, Mary and David Robinson,
 in Sausalito, California, ca. 1977

95–105 **Untitled** 1971 each 13 3/4 x 10 3/4 in.

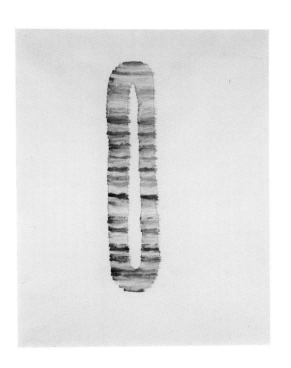

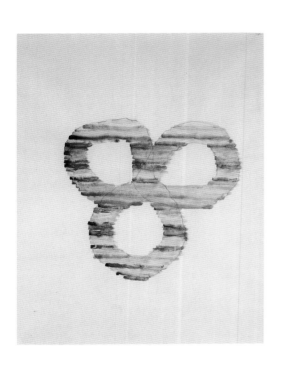

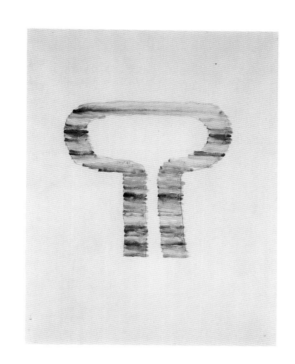

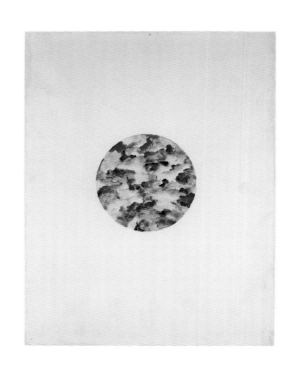

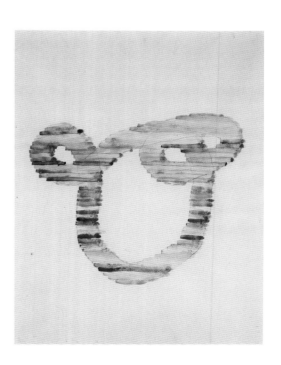

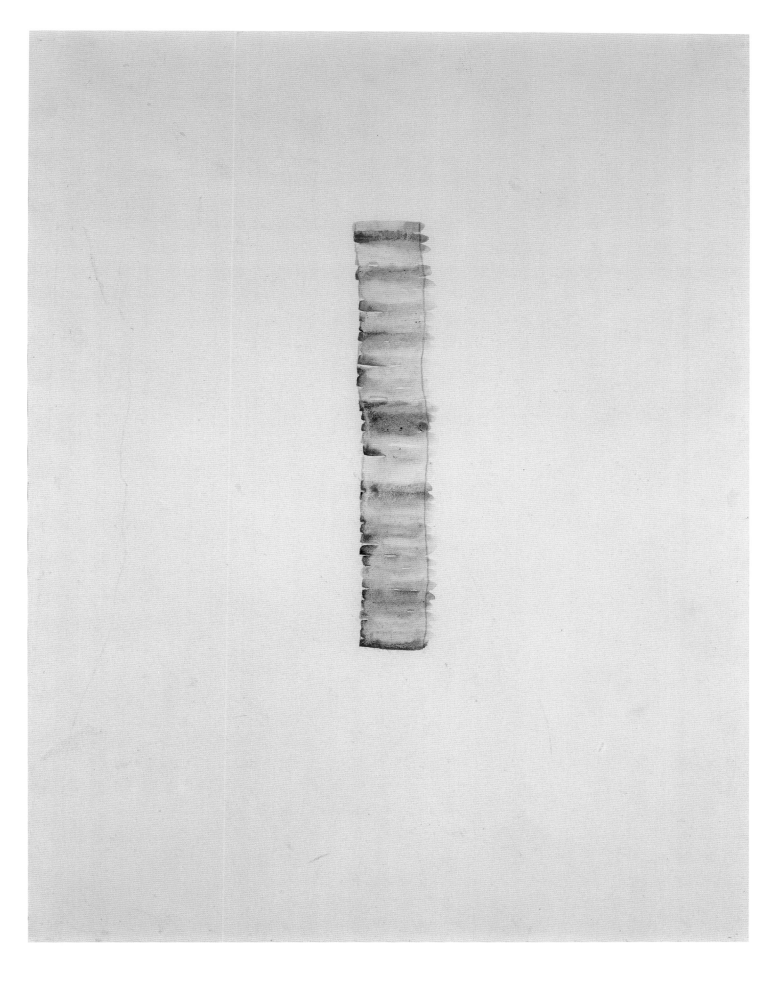

On view from February 10 to March 28, 1971, *Richard Tuttle* at the Dallas Museum of Fine Arts (now the Dallas Museum of Art) represents a milestone in the artist's career. His most comprehensive installation up to that point, the exhibition offered Tuttle a chance not only to review what he had been doing since the mid-1960s but to make new work within a laboratory-like atmosphere of creative risk. Curated by Robert M. Murdock, the DMFA's first curator of contemporary art (and, significantly, the first curator given any specialized title and area in the museum's history), the exhibition marked Murdock's debut in Dallas as well (he had started at the DMFA in the fall of 1970).

Installed at the museum's former Fair Park building, the exhibition comprised fifteen cloth pieces, seven framed drawings on paper, three wood reliefs, six *Paper Octagonals,* five freestanding sculptures, and an unspecified number of drawings that Tuttle drew directly on the walls of the gallery (see pls. 73, 106–7).[1] Tuttle made many works in Dallas specifically for the show—the wall drawings and the large-scale sculptures, or "constructions,"[2] as well as the 1970 *Paper Octagonals* that have to be re-created every time they are shown—and used the museum, as both place and idea, to do so (he was in residence in January and February 1971).

The artist described the process as such: "I think Bob Murdock would accept the idea we had then that the museum could act in an active and progressive way, not just as a storehouse for masterpieces." Clearly there were ideas—creative, associative, and thematic—that went beyond what Tuttle had attempted before. Central to the exhibition, Tuttle continued, was "an exploration of the tenets behind the *Paper Octagonals,* which to me took part in what was the basis of postwar American art, the idea of the ambiguity of near and far grounds. I came up in the Betty Parsons school, and she specialized in the kind of art that built on that ambiguity." The drawings that Tuttle made directly on the wall can be seen as extending this ambiguity even further than his white octagonal paper pieces placed onto a white wall. Tuttle's wall drawings were an ultimate fusion of near and far grounds as far as mark and surface are concerned. These wall drawings were at the time an integral yet ephemeral part of the exhibition: their forms were part of the exhibition's very being, but these forms disappeared after the show itself ended. Betty Parsons, when questioned at the press preview about Tuttle's privileging this kind of impermanence and invisibility—in short, the very issues for which her gallery had in the artist's view become the center—replied, according to Tuttle, "What's more permanent than the invisible?" This neatly encapsulates one of the many paradoxical qualities for which Tuttle's art has become known.

Tuttle agrees that Dallas was the most important, challenging, and certainly the most extensive presentation of his work to that date, and it was only the second time he had shown on his own in a museum. When planning the Dallas exhibition, Tuttle stated in a letter to Murdock: "I am particularly happy about the open-ended nature of the exhibition and the improvisational right-angle 'drawings' will give me the challenge and subsequent energy to deal with many problems that would otherwise bore me."[3] (Here Tuttle is speaking of wall drawings he would make in Dallas, studies of which are extant in the DMA archives.)

Murdock and Tuttle had known each other as undergraduate students at Trinity College in Hartford, Connecticut. Tuttle believes their association, while not particularly close in college, was key to making the Dallas show work, as it paved the way for each to understand the other's aims in bringing the exhibition to fruition. In August 2004 Tuttle recalled: "It was very, very exciting because the Dallas show was an artwork in itself. Bob was terrific because he allowed it to happen, he allowed my exhibition to become an artwork in itself. The catalogue still pleases me, and the die-cut cover form made of crack-and-peel paper was really a first. Those white forms were hand-placed on the white covers, and each one is different—so the catalogue was also transformed into an artwork."

Anne Bromberg, a museum lecturer at the time and now the museum's curator of ancient and South Asian art, characterized the exhibition in one word: "Witty." Carol Robbins, curatorial assistant for the exhibition, now the curator of the arts of the Americas and the Pacific, points out that the exhibition was important in demonstrating the DMFA's dedication to contemporary art, not only by presenting the exhibition but in the fact that a new curatorial post had been created to foster such projects in the city.

In conversation with this writer in the late 1990s, Tuttle described one way to look at the history of art as the tale of all sorts of objects, materials, and ideas trying to fight their way into the realm of the museum. In Dallas in 1971 the doors were thrown wide open. Looking back to that year's DMFA exhibition at Fair Park, and forward thirty-five years to 2006, when his retrospective will be at the DMA's downtown building (which opened in 1984), Tuttle remarked that the retrospective will provide an opportunity to assess just what it was he was attempting to do and what he may have achieved in his first Dallas project. He concedes that it is a crucial but not easy task: "The good stuff takes a long time to digest."

CHARLES WYLIE

106 Installation view of the 1971 exhibition **Richard Tuttle** at the Dallas Museum of Fine Arts, showing (left to right) the sculptures **Slope, Double Direction,** and **The Rise** (all 1971) and several wall drawings (1971) behind

This text is based primarily on a conversation between Richard Tuttle and the author on 13 August 2004, as well as previous conversations. Robert Murdock also contributed to the essay through conversations in August 2004. The author wishes to thank the artist, Madeleine Grynsztejn, Anne Bromberg, Carol Robbins, and Jacqueline Allen, the Mildred R. and Frederick M. Mayer Director of Libraries and Imaging Services, Dallas Museum of Art.

1 The Dallas exhibition included work that recently had been on view at the Albright-Knox and in previous venues, and presented works lent by the New York collectors Ted Carey, Charles Cowles, Mr. and Mrs. Peter J. Hoppner, and Jock Truman; from Betty Parsons and Betty Parsons Gallery, Tuttle's New York dealer; from Germany, Jost Herbig and Dr. Ruprecht Zwirner (the brother of Tuttle's German dealer, Rudolf Zwirner); and from Samuel J. Wagstaff Jr., curator of contemporary art at the Detroit Institute of Arts. (While significant in its own right, the Albright-Knox presentation was in an adjunct space of the Members Gallery, and the work had been shown before.)

2 The sculptures are no longer extant and, according to Madeleine Grynsztejn, the artist would not again create work on this oversize scale until 1996, with his *Replace the Abstract Picture Plane* installation at the Kunsthaus Zug, Switzerland, and then again in 2002, with his *Memento* series. The Dallas exhibition marked the first time the artist had created wall drawings in this manner.

3 Richard Tuttle to Robert Murdock, 10 November 1979, DMA archives.

107

107 Installation view of the 1971 exhibition **Richard Tuttle** at the Dallas Museum of Fine Arts, showing **Cube** (1971) in the foreground and two **Paper Octagonals** (1970) on the back wall

108 **1st Wire Bridge** 1971 37 1/2 x 38 1/2 x 1/2 in.

109 **10th Wire Piece** 1972 dimensions vary with installation

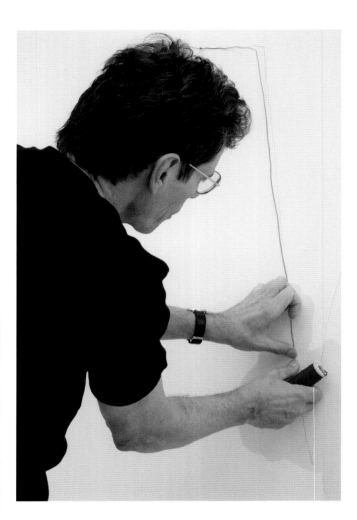

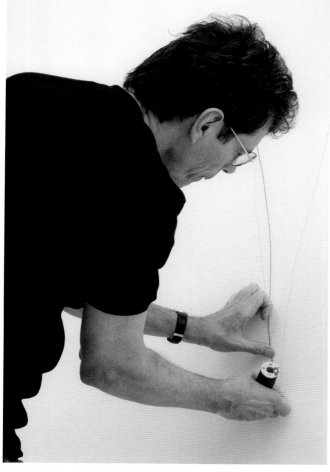
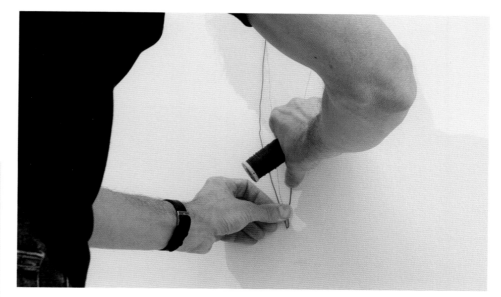
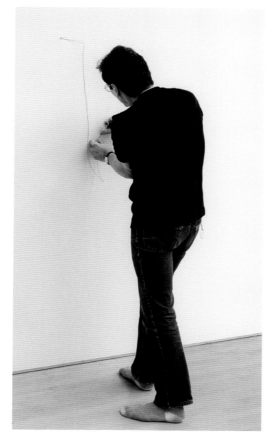

110–17 Richard Tuttle demonstrating the installation
of **10th Wire Piece** (1972) at the San Francisco Museum
of Modern Art in preparation for the 2005 exhibition
The Art of Richard Tuttle

118 **21st Wire Piece** (detail) 1972 dimensions vary with installation
119 **21st Wire Piece** (left) and **48th Wire Piece** (right) 1972 dimensions vary with installation

In her catalogue essay for Richard Tuttle's 1975 exhibition at the Whitney Museum of American Art, curator Marcia Tucker refers to the importance of memory in the artist's work. This is discussed at some length, particularly in regard to one of Tuttle's key early works, *Ten Kinds of Memory and Memory Itself* (1973; pl. 121). As Tucker describes it, in "a group of eleven string pieces or 'drawings' on the floor, Tuttle has choreographed each piece so that the work can be recreated by repeating the movement patterns which dictate how the string is to be placed on the floor." She continues, "The simplest, rounded semicircle (the 'memory itself' of the work's title) was, according to Tuttle, taken from the memory of a dimension (the distance between two parts) of an earlier wire sculpture. This kind of summarized recall, recreating a partial aspect of another work, is different from the literal recall called into use in making the other ten parts."[1] *Ten Kinds of Memory* is about different kinds of remembering using the eye, the mind, the body. It reflects the individuality of Tuttle's memory. Recollection, the process of reminding oneself of something temporarily forgotten, is the accretion of many factors, including associations, rumors, legends, discussion, and consideration of critical responses, as well as written and photographic documentation. How, then, is Tuttle's 1975 show remembered? What was its effect at the time, and what is its significance now?

Among recent responses to the show, one art editor recalled that "the Tuttle show almost got Marcia Tucker fired." A seasoned curator, who had not seen the exhibition, vaguely recalled hearing that the show was reported to have been "a phenomenal and unforgettable installation." Another said Tuttle's "radical statement galvanized and motivated the art world." When asked about his knowledge of the exhibition, an artist of a younger generation—who also had not seen the show—was very precise about its importance and said that it represented "a tremendous act of courage on the part of the artist and was an extraordinary example of a collaboration between an artist and a curator. Its accomplishment liberated me so that I can do other things in my work." Closer to the source, one painter who had an indelible memory of the exhibition found it to be "heartbreaking." She said it was the first time she saw a show where "I couldn't imagine taking those chances." Another painter who commented that it was the most beautiful exhibition he had ever seen distinctly remembered the frustration of outraged visitors who couldn't find the art. As Tuttle himself observed to me, there seems to be "a threshold beyond which a self-respecting viewer won't look."[2] Flora Miller Biddle, the Whitney's honorary chair at the time of the exhibition, wrote, "Marcia was the first to tell me, and Richard the first to convince me, that the viewer must contribute to the work [by] providing half the experience. The bit of rope Richard nailed on a wall changes, then changes again: at first, the tiny ragged

threads are *me*, lost in the vast smooth, impenetrable world of the wall...." She further recollects trying "to calm down a fractious reporter who was scorching mad, saying he was being fooled by a charlatan, and by a museum that didn't deserve the name. 'The emperor's new clothes,' he seethed." She also recalls that Tuttle "described going to visit his mother in wintertime on the train, during the exhibition at the Whitney, and how he stood freezing between the cars because he'd been so horrified by the critical attacks of strangers. He couldn't bear to be with people he didn't know."[3]

These comments suggest a range of present knowledge—indirect and direct—about the exhibition, its reputation, the controversy it engendered, and its effect on visitors and on those directly involved. But before considering the responses further, one must first review the facts of the exhibition itself.

Richard Tuttle opened at the Whitney Museum on September 12, 1975. The exhibition considered a decade of the artist's work and was founded on an unconventional conception by Tucker and Tuttle; it comprised three different installations (pls. 122–24). And, as Tucker wrote, "We did not attempt to be comprehensive but rather chose pieces according to the dictates of the space, each work's relationship to other pieces in the exhibition, and our own preferences."[4] Each installation, accomplished jointly by artist and curator, was presented on the second floor, the museum's smallest, and averaged twenty-five works, some comprising numerous elements, plus a room of drawings. The works were not shown chronologically, and objects from different series were intermingled to reveal continuity of certain imagery and ideas. Works were borrowed from private collectors, dealers, and the artist himself, accompanied by two pieces from the Whitney Museum. The two installation changes occurred in twenty-four-hour periods, on October 7 and November 4, and approximately 66 percent of the works appeared in only one installation: 12 percent of the works were included in two rotations and 20 percent were included in all three. Tuttle would have liked to have changed more of the works in each installation, but it was felt by the museum at the time that works borrowed from individual lenders had to be included in all three.[5] The objects themselves were from a number of different series, notably the three-inch paper cubes (1964), cloth pieces (1967–68), *Paper Octagonals* (1970), *Paintings for the Wall* (1970), *Rope Pieces* (1973–74), wire works (1971–74), and *Wood Slats* (1974). As can be garnered from these titles, the objects were made from a variety of ephemeral materials, and many of the works themselves tended to be small, if not minute. One, *8th Houston Work* (1975), measures a mere one-quarter by three-eighths of an inch. The greatest dimension of any given element is typically less than six feet, while *Letters (The Twenty-Six Series)* (1966; pl. 56) is an installation of variable dimensions made up of twenty-six soldered metal elements arranged on the wall or spread over the floor. For

each of the three installations Tucker selected a room of drawings "to illuminate the range of Tuttle's inventiveness and perception, as well as to clarify some of the issues contained in his other work."[6]

The catalogue was to be written by Tucker and produced after the exhibition so as to be able to respond to specific pieces and the multiple installations. During the show she made available a short mimeographed statement, and, in order not to have wall labels interfering with the spareness and intimacy of the installation, Tuttle prepared handwritten floor plans with all the relevant data on the pieces.

Given the small scale and unheroic materials of his art—which must have seemed insignificant in comparison to the grand gestures of pop and minimalist art of the time—it is not surprising that the work raised the ire of public and critics alike. No doubt the unpretentious, ephemeral, entropic, and what many thought arbitrary character of the exhibition, not to mention what some called "childlike" and even "feminine" characteristics, added fuel to the fire. In an article in the *Soho Weekly News,* Gregory Battcock offered a sampling of public voices, some pro and many con. "There is a healthy dependence on a museum context," one viewer begins on a positive note, and then says, "Without the museum the art world would sink." Another visitor quipped, "The show is actually a comment on the custodians of this building... they're terrified of rejecting anything so they accept this, which is nothing."[7] This point was vehemently stated in Hilton Kramer's *New York Times* review: "For in Mr. Tuttle's work, less is unmistakably less. It is, indeed, remorselessly and irredeemably less." He goes on to revile it as "a pathetic attempt to master [the galleries'] vast empty spaces" and a "bore and a waste."[8] In the *Village Voice* David Bourdon wrote that the exhibition "is so modest in ambition and unassuming in appearance that it almost asks to be damned with faint praise."

121 Installation view of **Ten Kinds of Memory and Memory Itself** (1973) at the 1974 exhibition **Richard Tuttle**, Galerie Yvon Lambert, Paris; the artwork was also shown in the first installation of the 1975 exhibition **Richard Tuttle** at the Whitney Museum of American Art, New York

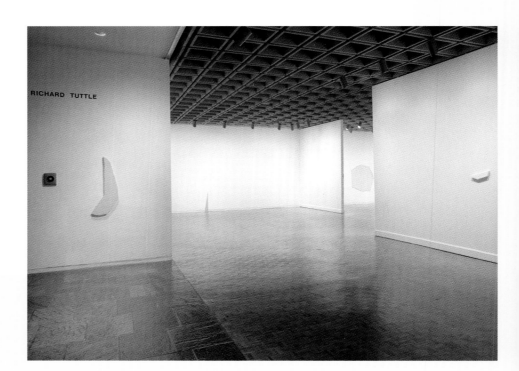

122 View of the first installation of the 1975 exhibition **Richard Tuttle** at the Whitney Museum of American Art, New York, showing (from left to right) **Shadow** (1965), **3rd Wood Slat** (1974), **9th Painting for the Wall** (1970), **10th Cloth Octagonal** (1968), and **8th Cincinnati Piece** (1975)

He viewed it as "a perverse type of interior decoration...it appears niggardly if not always precious."[9]

One would be mistaken to assume that the critical response was overwhelmingly negative. There was equal praise for the show by prominent critics. Thomas B. Hess in *New York* magazine responded to Kramer, writing that "Such heavy breathing, especially when couched in century-old forms of righteous bombast, often indicates that a strong presence has been encountered." He proclaimed that "Tuttle tries to switch on all the lamps, open the blinds and doors, and let the light flood in to show us—with the fine magician's panache of a natural artist—that the room itself has vanished."[10] And John Perreault announced, "An earmark of genius is that often the results of the genius look unbelievably simple."[11]

While reaction to the exhibition was divided, the most caustic critique was reserved for Tucker herself, the way she organized the exhibition and published the catalogue. Bourdon wrote, "The real scandal of the Whitney exhibition is not Tuttle's at all but the pretentious, unprofessional behavior of Marcia Tucker."[12] While Lawrence Alloway in *The Nation* revealed respect for Tuttle, he pronounced the exhibition unsuccessful and intoned, "To withhold the catalogue from the exhibition's visitors is an abrogation of the museum's educational responsibilities."[13]

Critiques of advanced contemporary art are perennial. What differentiated this debate was alarm regarding a shift in role of the curator, her seeming lack of critical distance and historical objectivity. Three decades ago it was commonly held that the artist produces the work and the museum/curator presents it—especially in the case of assessing the oeuvre of a single artist. Having the artist participate so actively in a museum exhibition was a violation of the then-tacit acceptance of two separate domains. Tucker's unabashedly collaborationist approach involved Tuttle in the conception and installation process, and openly acknowledged that the role of the museum had changed in response to current artistic practice. Moreover, the "three-page duplicated handout" was disparaged as not providing a historical framework thought necessary to view and understand the exhibition. In fact, Alloway assumed that the catalogue being published after the fact offered "a possible tactical advantage...enabl[ing] a curator to answer criticism."[14] Tucker herself posited that the exhibition approach "allowed an understanding of the physical nature of his work" and gave "insights into aspects of Tuttle's thought, attitudes, and method."[15]

What the 1975 exhibition acknowledged was what artist-critic Scott Burton has referred to as the notion of the "post-studio artist," for whom a significant part of the creative act takes place in the museum itself, in response to a particular set of gallery conditions.[16] Furthermore, the show considered critical reception of the art as a fundamental aspect of the landscape of artistic production. Tucker realistically accepted that the artist works in a physical, social, and critical arena larger than that of the museum context, and she realized that this does not in any way diminish the original contribution of the individual artist but rather adds to an appreciation of its richness. Recently, when asked about the legacy of the Whitney show, Tuttle reflected that it was one of a series of linked experiences: "I believe in the possibility of a total living art. That show supported this notion. Half was to create the solution, the other half was to create the problem."[17] Tuttle's comment suggests that collective memory of the exhibition might not be far from accurate. The exhibition indeed opened radical and controversial ways of making and presenting art. It also raised questions regarding the relationship of the artist to the museum that remain unanswered today.

ADAM D. WEINBERG

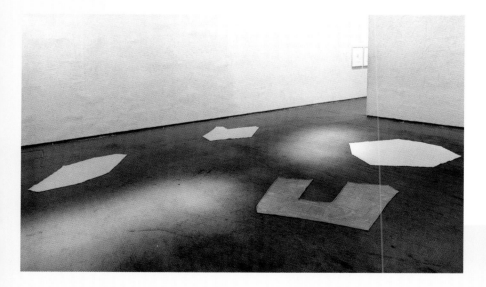

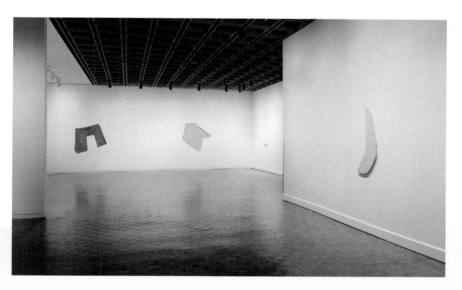

123 View of the second installation of the 1975 exhibition **Richard Tuttle** at the Whitney Museum of American Art, New York, showing (clockwise from left) **First Green Octagonal** (1967), **Grey Extended Seven** (1967), **10th Cloth Octagonal** (1968), and **Untitled** (1967)

124 View of the third installation of the 1975 exhibition **Richard Tuttle** at the Whitney Museum of American Art, New York, showing (from left to right) **Untitled** (1967), **Grey Extended Seven** (1967), **9th Plack** (1973), and **Shadow** (1965)

NOTES

1 Marcia Tucker, *Richard Tuttle* (New York: Whitney Museum of American Art, 1975), 12, 14.

2 Conversation with the author, 29 September 2004.

3 Flora Miller Biddle, *The Whitney Women* (New York: Arcade, 1999), 160–61.

4 Tucker, *Richard Tuttle*, 3.

5 Conversation with the author, 29 September 2004.

6 Tucker, *Richard Tuttle*, 21.

7 Gregory Battcock, "More or Less? The People Speak," *Soho Weekly News*, 23 October 1975, 23.

8 Hilton Kramer, "Tuttle's Art on Display at Whitney," *New York Times*, 12 September 1975.

9 David Bourdon, "Playing Hide and Seek in the Whitney," *Village Voice*, 29 September 1975, 97.

10 Thomas B. Hess, "Private Art Where the Public Works," *New York*, 13 October 1975, 83.

11 John Perreault, "Tuttle's Subtle Output," *Soho Weekly News*, 18 September 1975, 22.

12 Bourdon, "Playing."

13 Lawrence Alloway, "Art," *The Nation*, 11 October 1975.

14 Ibid. In fact, when the catalogue was published, not only did it respond to criticism of the work and Tucker's approach, it reprinted most of the aforementioned articles.

15 Tucker, *Richard Tuttle*, 83.

16 See Martha Buskirk, *The Contingent Object of Contemporary Art* (Cambridge, MA: MIT Press, 2003), 133.

17 Conversation with the author, 29 September 2004.

125 **3rd Rope Piece** 1974 $^1/_2$ x 3 x $^3/_8$ in.

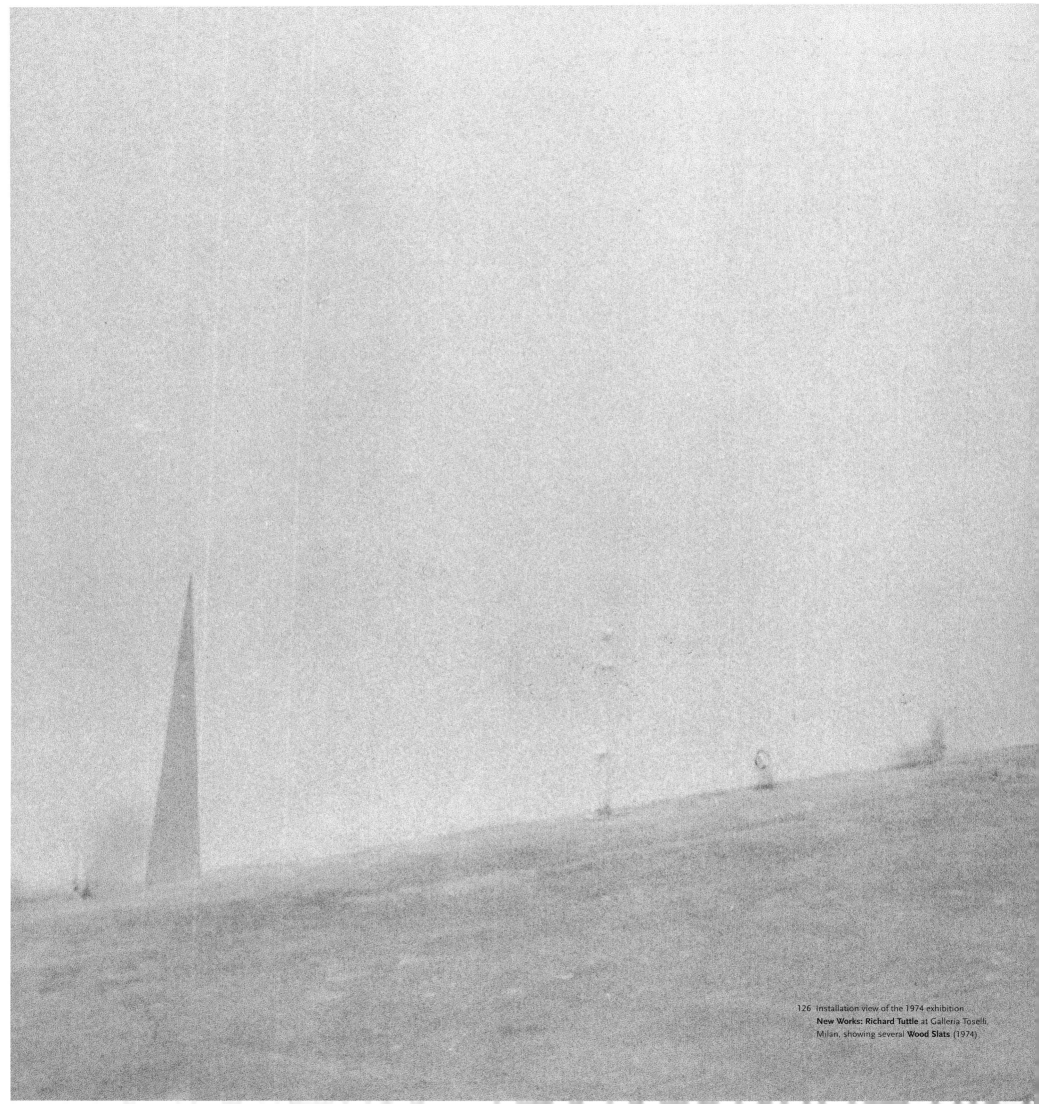

126 Installation view of the 1974 exhibition
New Works: Richard Tuttle at Galleria Toselli,
Milan, showing several **Wood Slats** (1974)

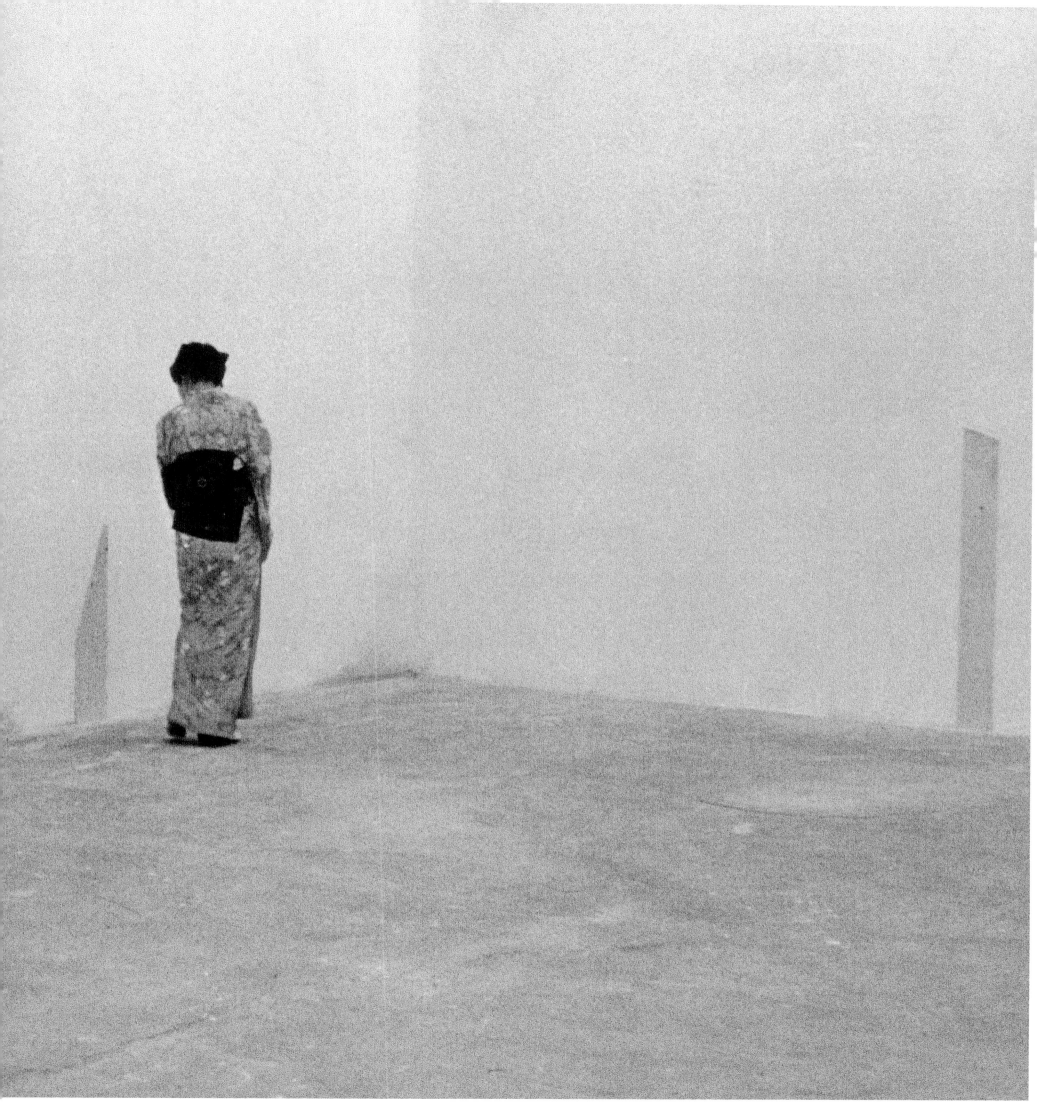

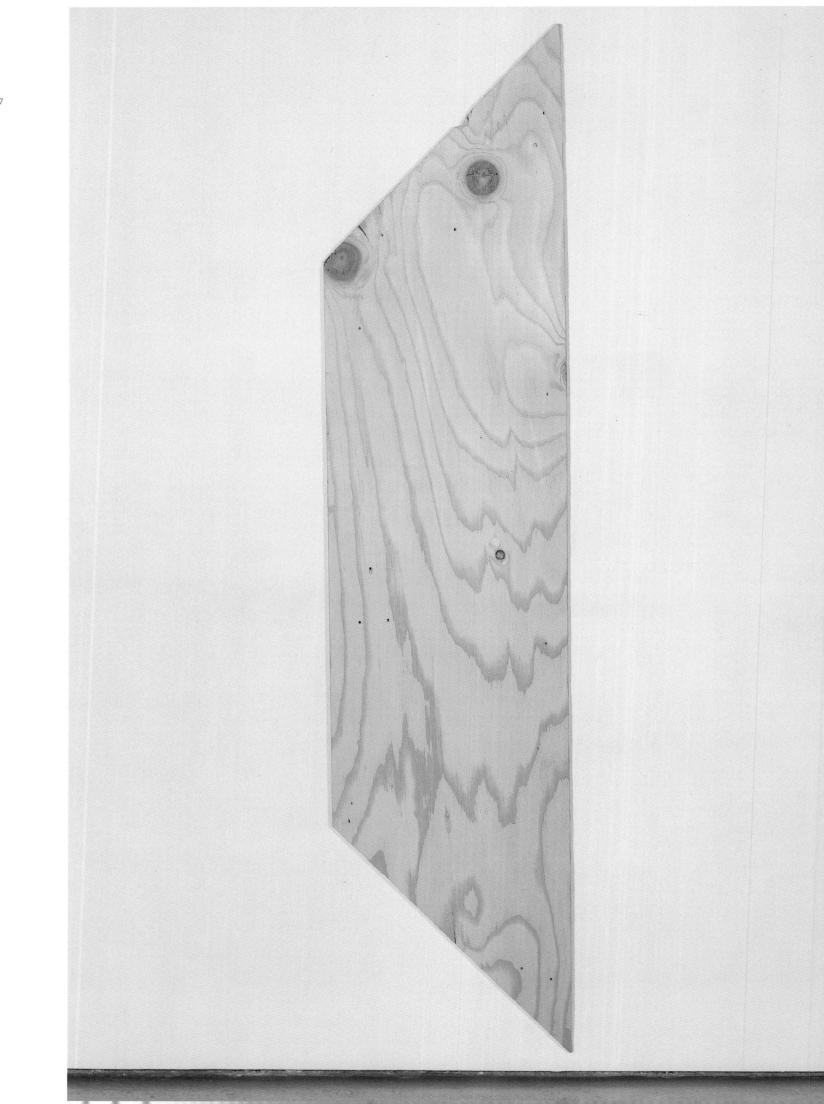

127 **7th Wood Slat** 1974 36 x 8 x 1/4 in.

128 **8th Wood Slat** 1974 36 x 3 x 1/4 in.

129 **4th Summer Wood Piece** 1974 30 x 20 x 1 in.

130

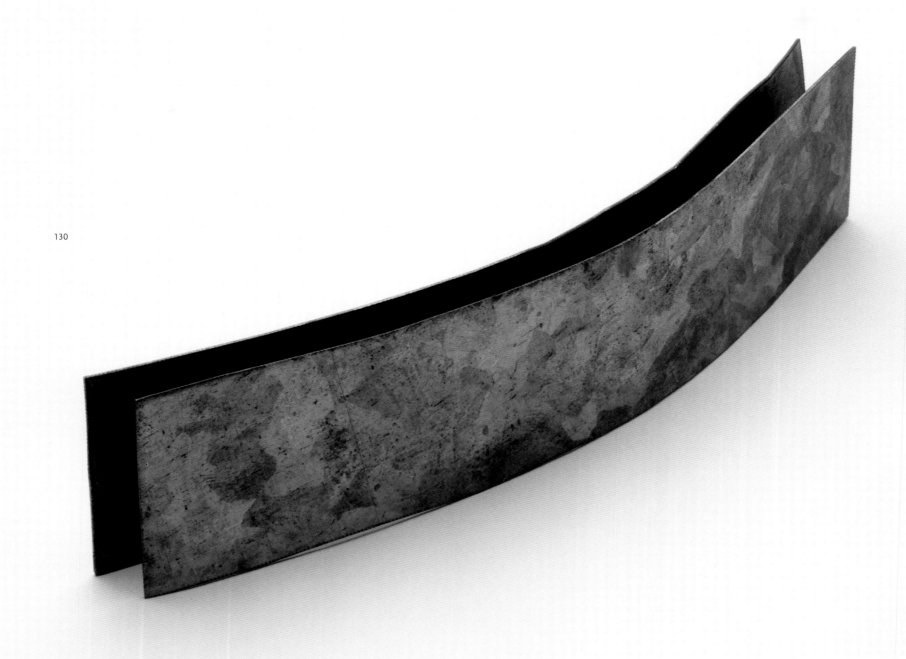

130 **Lines** 1970s overall 1 x 4⁷/₈ x 1¹/₈ in.

131 **White Rocker** 1970s 3 x 5 x 1 in.

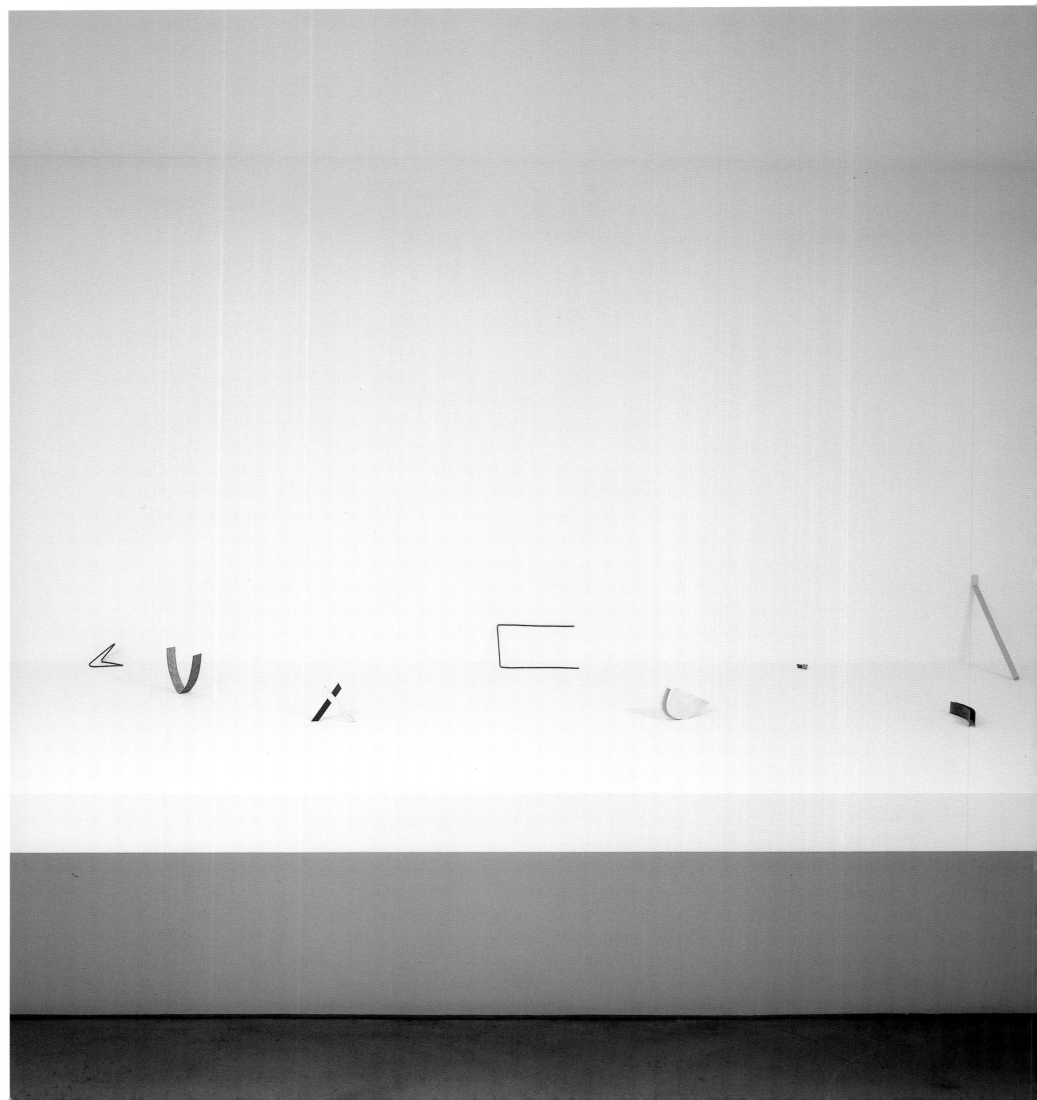

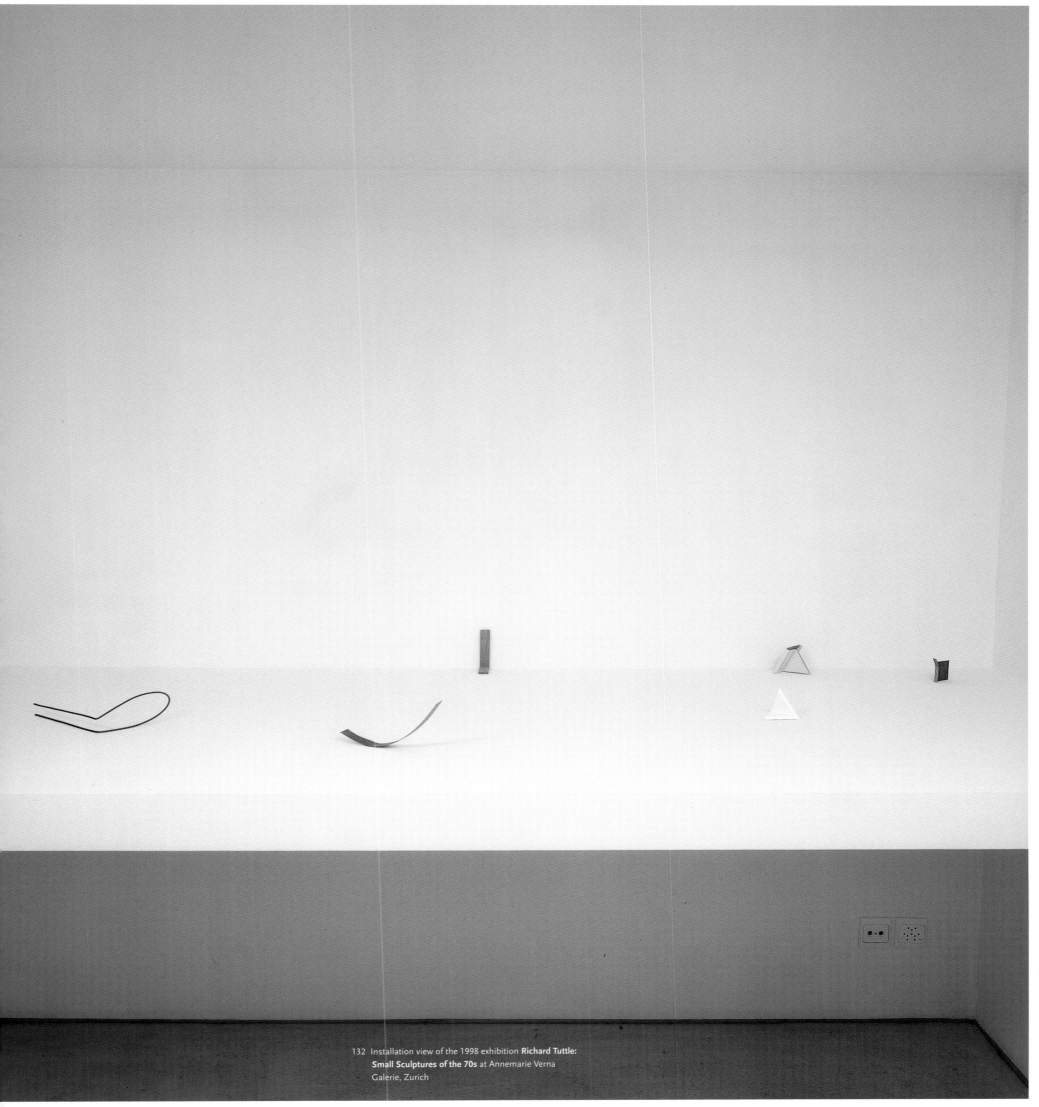

132 Installation view of the 1998 exhibition **Richard Tuttle:
Small Sculptures of the 70s** at Annemarie Verna
Galerie, Zurich

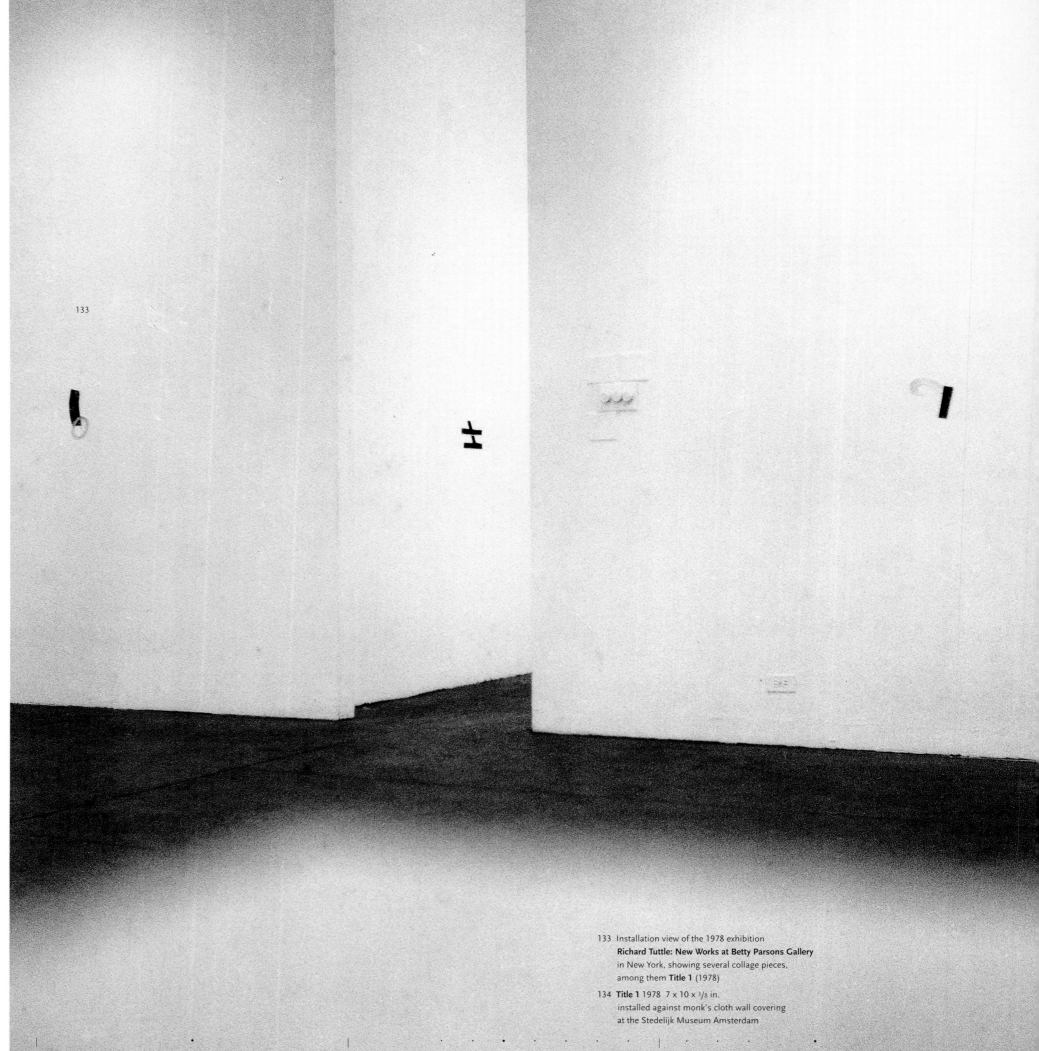

133

133 Installation view of the 1978 exhibition
Richard Tuttle: New Works at Betty Parsons Gallery
in New York, showing several collage pieces,
among them **Title 1** (1978)

134 **Title 1** 1978 7 x 10 x ³/₈ in.
installed against monk's cloth wall covering
at the Stedelijk Museum Amsterdam

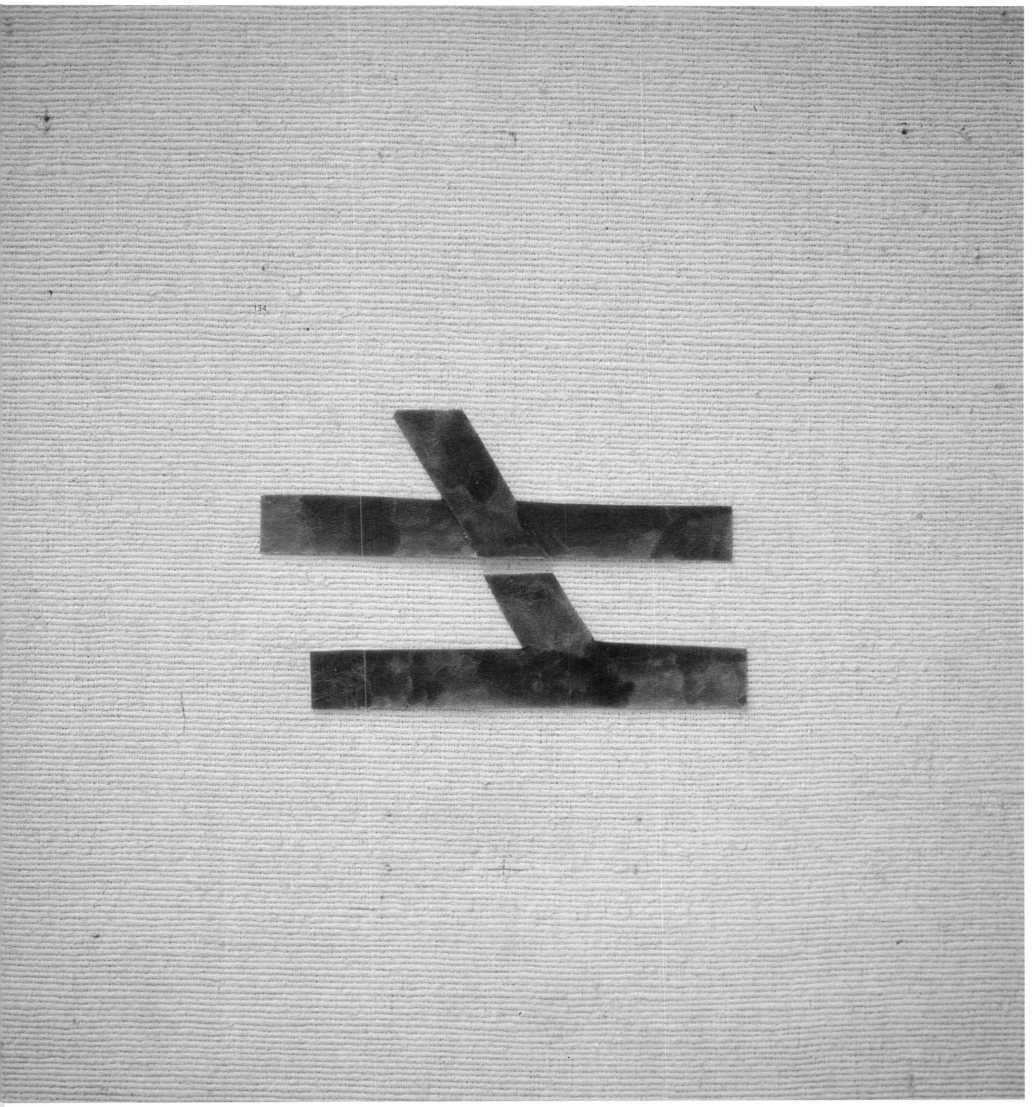

135

135 **Titre 2** 1978 7 1/2 x 9 5/8 x 3/8 in.
136 **Titolo 4** 1978 10 3/4 x 11 3/4 x 3/8 in.

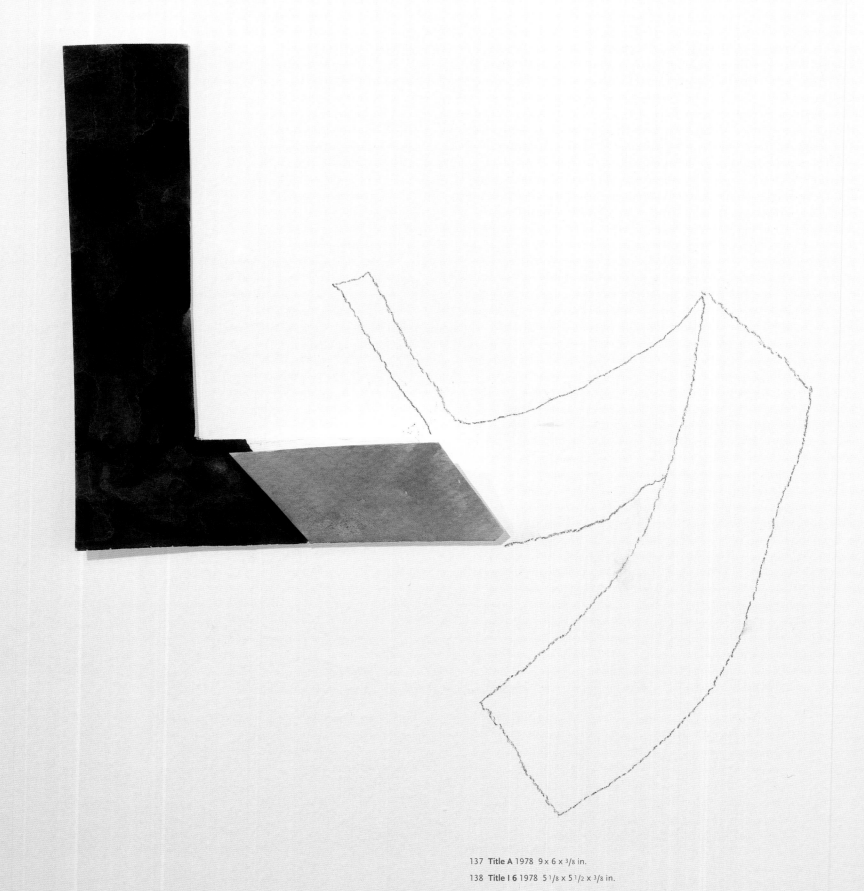

137 **Title A** 1978 9 x 6 x 3/8 in.
138 **Title I 6** 1978 5 1/8 x 5 1/2 x 3/8 in.

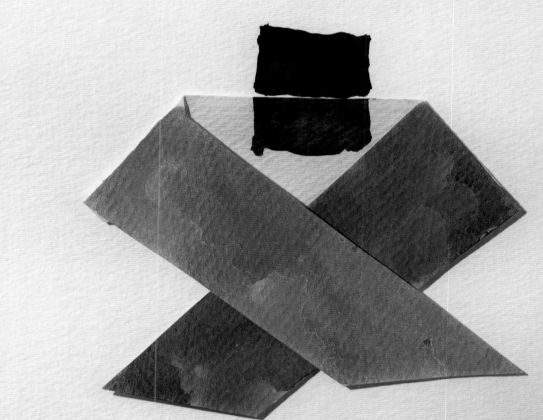

by Cornelia H. Butler

KINESTHETIC DRAWING

plate 140

I n 1970 Yvonne Rainer presented her dance work *Continuous Project—Altered Daily* at the Whitney Museum of American Art in New York. Titled after a Robert Morris sculpture executed at Leo Castelli Warehouse the preceding year, Rainer's piece was essentially a public choreographic experiment in which she reorganized all the terms of conventional performance in order to disarm not only her audience but her performers as well. By disrupting the medium's own taxonomies and parameters, Rainer gave birth to a new form of postmodern dance that was authentically nonhierarchical, process-based, and transitive. Incorporating backstage behavior into onstage presentation and arguing for the presence of lived activities in the dance itself,[1] *Continuous Project* was fundamentally collective in both its creation and its execution—a formulation that was, in 1970, a feminist one.

I can't help but recall a recent conversation with Richard Tuttle about feminist art of the 1970s in which the artist, declaring only half in jest that he is a woman, affirmed his alignment with feminist strategies and acknowledged his long-standing curiosity about other male practitioners of feminist art. In his view, this affinity lies in the notion of a quotidian practice of art—a generative process that flows from the removal of the authority of the author and from an ongoing interrogation of the hegemonies of making and material. Tuttle's self-fashioning as a maker of art is fundamentally tied to his notion of the artist as a kind of channeler of meaning through abstract form and material. Although his practice is solitary, his compulsion about the public function of his work parallels Rainer's thinking about her own radical and profoundly egalitarian conception of publicly expressed movement. *Continuous Project* began in the workshop environment and mined this unfinished, unrehearsed territory for the presentation of the "complete" work. According to Rainer:

> It was [here] that I first attempted to invent and teach new material during the performance itself.
> What ensued was an ongoing effort to examine what goes on in the rehearsal—or working-out
> and refining—process that normally precedes performance, and a growing skepticism about
> the necessity to make a clear-cut separation between these two phenomena. A curious by-product
> of this change has been...the beginning of a realization on my part that various controls that
> I have clung to are becoming obsolete.[2]

What is similarly moving and profound about Rainer's approach to dance and Tuttle's artistic practice is the idea of creative work as an offering—the idea that movement or, in Tuttle's case, drawings and objects, can be put into the world as daily extractions of the soul. Both artists strive for a certain transparency of process, by which they break down traditional distinctions between public and private experience and constructed and lived realities. Rainer's upending of the rehearsal/performance dichotomy shares certain conceptual underpinnings with Tuttle's own attempts to dismantle traditional media hierarchies and his embrace of an expanded notion of drawing that is no longer beholden to its more complete manifestation as painting or sculpture.

140 Yvonne Rainer **Continuous Project— Altered Daily** 1970
Photo by Peter Moore

Moreover, Rainer's example parallels the uniquely kinesthetic drawing practice that Tuttle employs to produce his _Wire Pieces_ (1972) and other related works. As with dance, the expressive physicality of his creative process is, in the end, a means of giving structure to time and space.

plates 109, 118–19

The incorporation of temporality into the making and exhibiting of visual art is an impulse that categorizes much of the work made between 1965 and 1975, the period in which Tuttle came of age artistically, and is indeed integral to the evolving status of drawing at the time. In a text titled "Some Kinds of Duration: The Temporality of Drawing as Process Art," art historian Pamela M. Lee makes the case for Process art's successful configuration of time within newly constructed parameters for the practice of drawing.[3] She argues for the representation of the transitive—the act of making—within the abstract gestures of process-based works on or of paper: "The transitive in these drawings is not the representation of transformation or flux as such; instead, the drawings reveal how the gesture is equally informed by the thing upon which it acts."[4] Indeed, it is Tuttle's devotion to the transformative gesture and to the daily practice of drawing that connects his production to the work of Rainer, whose approach to dance and movement is equally connected to the choreographic incorporation of quotidian activity. Tuttle and Rainer share an analogous relationship to form and its lack, and a similar privileging of the experience of the viewer—what you see is what you see. Both artists, through dispersed kinds of drawing on the one hand and movement on the other, have "tried to close the experiential gap between the body of the performer and the body of the viewer.... The performer...essentially creates the image of her own effort."[5]

To say that drawing is central to Tuttle's body of work and his practice as an artist is already to take for granted a shift in the definition and role of drawing that occurred during the late 1960s and early 1970s. Little has been written specifically about drawing at this juncture, and indeed the change was one that emerged slowly as Abstract Expressionism gave way to Minimalism and Conceptual art, and closely parallels the evolution and dematerialization of the sculptural object. In 1976, when Bernice Rose initiated the important series of _Drawing Now_ exhibitions at the Museum of Modern Art, New York, she traced the ascension of drawing over a period of two decades to a position liberated from other forms:

The tradition had been fixed in the seventeenth century, and until the advent of Conceptual art in the 1960s the two senses of drawing, the conceptual and the autographic, had not been rigorously distinguished.... The marks of a drawing have only a symbolic relationship with experience; it is not only that line does not exist in nature, but the whole relationship construct of a drawing is a conceptual proposition by the artist...to be completed by the spectator through an act of ideation.[6]

She further elaborated on drawing's changed relationship to illusion and a radically altered kind of mark-making:

It was not until drawing had transformed itself through its autographic function and was actually absorbed into a new aesthetic of "incompleted" painting, that drawing could cease to function primarily as a step toward painting and become an independent action, and that drawings could be made consistently as finished works—could function as an alternative major mode of expression.... The story of drawing from the mid-fifties onwards is the story of...an emotive cooling of the basic mark, the line itself.[7]

Rose's exhibition, which included Tuttle's work, historicized this important shift for the first time in the context of MoMA's project vis-à-vis modernism.

In moving away from the sublime of Abstract Expressionism toward the Conceptual art redress of the subsequent decade, Tuttle's generation largely dispensed with the illusion of the isolated mark in order to explore the contingent space of the phenomenological world. In the *Drawing Now* exhibition catalogue, a Tuttle *Wire Piece* of 1972 appears near the very end, after a full-page reproduction of Michael Heizer's *Circular Surface Planar Displacement* (1971) and Robert Smithson's *Slate Grind* (1973), each representing the grand scale and publicity of Earthworks, and Robert Mangold's quiet, minimalist exercises *Circle Drawings #1* and *#2* (both 1973). Following Tuttle's *Wire Piece* is Robert Morris's *Light-Codex-Artifacts I (Aquarius)* (1974), a graphite and Vaseline rubbing made directly on the wall, and the book concludes with a discussion of Morris's—and by extension Tuttle's—insistence on touch, the performative relationship of the body to the wall, and the inscription of a more intimate space for drawing. In a history that opens with Robert Rauschenberg's *Erased de Kooning Drawing* of 1953, clearly Tuttle's work was considered, in MoMA's constellation, to be among the most radical, intimate, and emotively cool.

Given the shifting taxonomy within the field of drawing, it was not unusual that an oeuvre like Tuttle's could include both conventionally conceived drawings (color studies on paper) and *Wire Pieces,* works that rely on a sort of conceptual performativity. The whole notion of working drawings, for example—essentialized through the production of minimalist sculpture, in which the labor of the fabricator replaces the hand of the artist—was interrogated in another important project of the time, *Working Drawings and Other Visible Things on Paper Not Necessarily Meant to Be Viewed as Art.* Produced in 1966 by Tuttle's contemporary Mel Bochner, the *Working Drawings* project appeared a year before Tuttle began experimenting with his first cloth pieces, whose very form takes on the problem of the "working drawing" (the cutouts serve

plate 141

141 Installation view of Mel Bochner's **Working Drawings and Other Visible Things on Paper Not Necessarily Meant to Be Viewed as Art** (1966) at the School of Visual Arts, New York

142 Installation view of Robert Morris's **Continuous Project Altered Daily** (1969) at Leo Castelli Warehouse, New York

as sculptural surrogates while referring to the history of pattern-making, architectural drafting, or model-making in exhibition design). Bochner began his project by asking friends for drawings, not necessarily works of art; his original plan was to photograph them, a process he felt problematized their objecthood. When it became prohibitively expensive to frame each contribution for exhibition, Bochner decided to photocopy them instead, reducing or enlarging them as necessary to fit the uniform size of a standard three-ring binder. By exhibiting four identical binders on sculpture pedestals, the artist effectively forced viewers to bend over awkwardly to view the contents. This stance parallels Tuttle's own discomfort in the creation of his *Wire Pieces*, which are produced through a series of controlled actions that, by his own description, leave him physically exhausted. Art, apparently, hurts a little, or is at least registered in the body of the maker/viewer.

Art historian James Meyer has described how Bochner's "*Working Drawings*...exposed the dependency of minimal art on the readymade, its flirtation with the mechanisms of mass production and consumption.... [They] propose a conceptual art of process, a process art located in the development of an idea. Bochner's 'conceptualism' thus emerges as a dynamic model, a thought-activity occurring in the gaps between language and things."[8] The gap between language and things is precisely where Tuttle's exploration of drawing unfolds as well. What Bochner characterizes as the bracketing of an already devalued medium and practice is the zone of qualification from which Tuttle begins. Institutionally aligned with sculptural "anti-form," this notion of the indeterminate, the impermanent, the contingent, and the interrogative is the horizontal plane from which Tuttle challenges the vertical, the permanent, and the nontransitive.

It is worth mentioning one other manifestation of this new expression, the Whitney Museum's 1969 exhibition *Anti-Illusion: Procedures/Materials*, which was organized by Marcia Tucker and James Monte and was, in itself, an experiment in process. Tuttle's cloth pieces, which were included in the exhibition, represent the beginning of his thinking about the conflation of the processes of drawing and sculpture. Like Rainer, who appropriated the notion of accumulation from Robert Morris's sculpture *Continuous Project Altered Daily*—a massive heap of studio detritus that was altered and recorded each day for the duration of its life—and transformed it into an accretion of labor and time, Tuttle elaborated his conception of drawing as sculpture. "From 1967 until 1972 I worked on the asymmetrical octagonal—it was almost Zen. I thought about how not to make art. This format offered a whole, so why do anything else? First, the dyed cloth octagonals, then the white pasted paper, and finally, the wire."[9] This idea more than any other, this recessive act of working

plate 142

against a self-conscious creation, combined with the spatial expression of line, embodies Tuttle's careerlong engagement with drawing.

Illustrated with a picture of Morris's installation at Castelli Warehouse, Tucker's essay in the *Anti-Illusion* catalogue is a declaration of the artist's and the object's liberation from the museum institution as well as from the architecture and economy of the studio. The publication argues for the conceptual and procedural unmooring of the object as neither painting nor sculpture but simply a three-dimensional occurrence activating space and time. The text is accompanied by a series of process shots (by Bob Fiore) of artists in motion. Because the works exhibited were produced either on-site or specifically for the Whitney exhibition, the artists are also represented by reproductions of previously existing works or actions. Tuttle's cloth octagonals appear in photographs without their author, hovering mysteriously and without orientation on the wall.

Tuttle had himself problematized the object status of his own work in 1967 with his dyed cloth pieces, which he called drawings and around which he cultivated an unorthodox approach to installation. Among them are the cloth octagonals; hand-sewn at their edges, the works are nailed to the wall in variable orientations or laid on the floor for the viewer to approach from any angle. Folds, seams, gaps, and shadows encourage their reading as three-dimensional objects that can occupy the space of painting on the wall or that of sculpture on the ground. The *Paper Octagonals* followed their canvas counterparts, confounding the expected evolution from drawing to painting—the more substantial (canvas) giving rise to the more ephemeral (paper). The uninterrupted plane of the paper adheres flat to the wall, which now acts as support and becomes an integral part of the work. The slippage around the reading of the work as painting or sculpture and the engagement of the viewer's body in apprehending both the cloth and paper octagonals anticipated another important drawing experiment Tuttle made in 1973. *Ten Kinds of Memory and Memory Itself* is a group of string drawings that engages both the body of the artist and the kinesthetic response of the viewer. Varying lengths of string, dimensionally standing in for graphic marks and lines, are thrown or placed on the floor through a series of specific, simple movements such as sitting, kneeling, or stretching. Reminiscent of Rainer's elementary manipulation of everyday matter—a pillow, cardboard, a rug—these simple gestures dictate the configuration of the string on the ground, occupying a middle ground between two and three dimensions. Tuttle simply ignores or, in fact, enacts in his work a kind of rejection of Western art's whole notion of drawing as a process of mediation or preparation by cultivating a territory of constant mediation—a rich in-between.

Tuttle has said that "art is discipline…and discipline is drawing," a dictum that recalls Rainer's mining of the rehearsal with its connotations of a daily discipline of the body that structures time and space.[10] Here, again, Tuttle's kinesthetic relationship to the act of drawing with sculptural materials—a kind of "drawing in space"—is akin to Rainer's own movement/body dialectic.[11] In

plates 21, 72–84

plates 23, 85–94

plate 121

143 Mel Bochner **A Theory of Sculpture: Leveling** 1969
Pencil and ink on paper, 11 x 13 5/8 in.
The Museum of Contemporary Art, Los Angeles,
given in memory of Victor Ganz

Ten Kinds of Memory and Memory Itself, Tuttle makes this connection yet more explicit, performative, and spatial. As is the case with Rainer's choreography, all elements of the gallery's architecture are fair game. The floor is as much a space for intervention, for drawing, as the wall might be a place for sculpture. As suggested by its title, this installation elicits the feeling of going through paces or compulsory exercises, even invoking the choreographic trope of muscle memory, an idea that Tuttle pushes further in the later *Wire Pieces,* the formal vocabulary of which he describes as somehow indelibly located in his body.

Tuttle's interrogation of presentation was elaborated further during the 1970s, which was a particularly prolific time in his drawing production. Several important groups of works on paper, known as the center point works, are in some ways more radical than his sculptural inventions. In them he investigated the circumstances of a drawing's installation by placing each at the center of a white wall at a predetermined point. The underlying ambition was, for Tuttle, to erase the notion of a conventional hanging height and to let the work itself find its correct location—a height that would be readable by any viewer. It is worth noting that Mel Bochner's slightly earlier drawings *A Theory of Sculpture: Leveling* and *No Vantage Point / Eye-Level Cross-Section of Room* (both 1969) diagrammatically map the same conceptual territory.

plates 175, 190

plate 143

Tuttle's series *Finding the Center Point* (1973) and *One Room Drawing* (1975) are organized around an exploration of space and time within the two-dimensional plane of the paper. Modestly sketchbook-scaled and, in the case of *One Room Drawing,* intended for viewing inside a loose, hand-bound book, the drawings, viewed one by one, are meant to linger in the visual memory. A horizontal line divides each page, and delicate applications of watercolor or pencil punctuate the horizon of the drawn line. The experience of the drawings is linked by the uniform experience of the horizon line, which bisects each sheet and makes a sort of synthesized timeline of perception

plate 175 / plate 194

along which incidental marks tease and dance. Each page stands in for the space of the wall—the "one room" of the drawings' title—as well as for the space of painting. The integrity of the marks is undeniably sculptural, making them appear to exist in another plane from the "room" of the horizontal space created by the line.

Tuttle has consistently experimented in his drawings with literalizing or subverting the space of the sheet. As early as 1964, in a luscious and exquisitely simple drawing titled *Blue Balloon with Horizontal,* he disrupted the page with a crudely cut, rectangular opening in the top left that seems to hang overhead, oblivious to the delicate, floating watercolor image of a blue balloon. The balloon is outlined with graphite, a device Tuttle has exploited repeatedly in his compositions to suggest a layering of both space

plate 144

144 Richard Tuttle **Blue Balloon with Horizontal** 1964
Watercolor and graphite on paper, 14 x 11 in.
The Dorothy and Herbert Vogel Collection, on deposit
with the National Gallery of Art, Washington, D.C.

plate 176

plate 71

and consciousness (the outline is used to similar effect in *Black Diamond with Pencil Line* and *Green Diamond with Pencil Line* [both 1973]). Reminiscent of Lucio Fontana's *Concetto spaziale* works and Jackson Pollock's late canvas cutouts, the blue balloon and its rectangular companion linger in a glorious, indeterminate state of compositional finish and hesitation.

plates 109, 118–19

To understand Tuttle's drive to construct a public life practiced through his art, it is essential to examine his seminal *1st through 48th Wire Pieces* (1972). Tuttle himself has talked about the *Wire Pieces* as initiating a kind of liberation through drawing—wanting, as he has said, to "make something that I'm the least part of, that I have the least to do with, that makes for a freer art."[12] Operating against the tendencies of minimalist sculpture by rendering something private and intimate in public, these works were made exactly at a moment when the practice and meaning of drawing, as both an end and a means, were in crisis. It is in the *Wire Pieces,* works that can only be called dimensional drawings, that Tuttle most fully explores the conflation of process and form. The pieces are made from the careful staging and interplay of three different kinds of line: pencil, wire, and shadow. Wire is attached to the wall near the endpoints of a pencil line and then allowed to spring or fall away from the surface, leaving its shadow as the third term in this quasisculptural arrangement. The resulting work is often difficult to apprehend. The shadow gives evidence to the wire, which, depending on the crucial element of light, can seem to disappear. The pencil line, which is in some ways the most tangible, appears to be the most fragile. The space of the wall—also exploited at the time as another territory and element of production by artists such as Sol LeWitt, Mel Bochner, Robert Morris, and Dorothea Rockburne—becomes a depthless field of white, a screen or plane of consciousness on which the delicate interaction unfolds. The forty-eight unique *Wire Pieces* that Tuttle made in 1972 can be installed only by the artist and are destroyed after each showing. Tuttle talks about the group's variation in almost stylistic terms that seem to counter his own stated intentions of keeping himself (and art history) out of the works as much as possible. In describing certain *Wire Pieces* as more baroque in nature and others as more archaic, Tuttle is perhaps playing with the arbitrary nature of art-historical nomenclature.

plate 145

plates 110–17

One of the more intriguing aspects of the *Wire Pieces* is the way in which the artist incorporates his body into their making. In conversation with Tuttle, one is aware of the constant movement of his sinuous and muscular hands; they are both graceful and agitated, as if constantly trying to articulate what his words cannot. Similarly, in early documentary photos of Tuttle installing his work, he is, in several instances, shirtless. This in itself is not unusual for the period; artists such as Gordon Matta-Clark and Michael Heizer often appear half-dressed, wielding power tools and hoisting machinery to complete their monumental works outside the confines of museum architecture. But Tuttle is, in one example, inside the Whitney Museum installing one of his *Paper Octagonals,* a work of great delicacy and little mass.[13] This is only worth bringing up to suggest the critical involvement of the artist as a physical, integral, active participant in his work. The artist's hand may be removed, but the body is intensely present. When he installs the *Wire Pieces*, by his own

145 Richard Tuttle and Marcia Tucker installing
Shadow (1965) in preparation for the
1975 exhibition **Richard Tuttle** at the Whitney
Museum of American Art, New York

account, he conjures a meditative state, planting his feet firmly on the floor and turning to face the wall before beginning to move his arm to initiate the first mark. He describes the creation of these deceptively simple works as emerging from the memory embedded in his muscles. In the end they look only like what they are and bear no marks of their making, as if born of benign exorcism. Far from Hans Namuth's filmic depiction of a heroic Jackson Pollock in action—imagery that provided one backdrop for Process art's turn away from the painterly gesture toward the more humble traces of labor—Tuttle's engagement is meditative and deeply kinesthetic.

In the 1975 catalogue for her groundbreaking and controversial survey of a decade of Tuttle's work at the Whitney Museum, Marcia Tucker employed the language of dance to describe what she calls "a translation into objects of interior states which have no physical analogue." Indeed, she describes Tuttle's desire to make an "ecstatic" work that no longer bears any sign of the artist's labor. It is through a deeply engaged physicality in the process of making, she argues, that this is possible:

> Tuttle readies himself as a dancer would for the activity of making the work present to himself and to us. That so much of Tuttle's work is a result of body activity is partly caused by the fact that physical activity is the most direct and common means we have of translating interior states into external expression; in a very direct way, frowning, smiling, closed or open body positions, etc., are our primary communicative means, because they are experientially rather than analytically comprehensible. Our own experience of our bodies is "pre-scientific," primitive and immediate.[14]

Tuttle's resistance not only to category but to fixing his work spatially and temporally within the institution presages the current mode of nomadic, unfixed practice, which itself functions as a hybridized institutional critique in a moment when virtually nothing is beyond the commodification of the commercial and private worlds of art.[15]

Tuttle's relocation of consciousness out of the private and into the public arena is articulated by curator and Tuttle scholar Jennifer Gross in her text "A Fine Line," which addresses Tuttle's interest in the writings of Japanese philosopher and poet Kitaro Nishida.[16] Describing Tuttle's site-specific sculpture at the Kunsthaus Zug, Switzerland, and its relationship to the artist's interest in a universal plane of consciousness, Gross quotes Nishida:

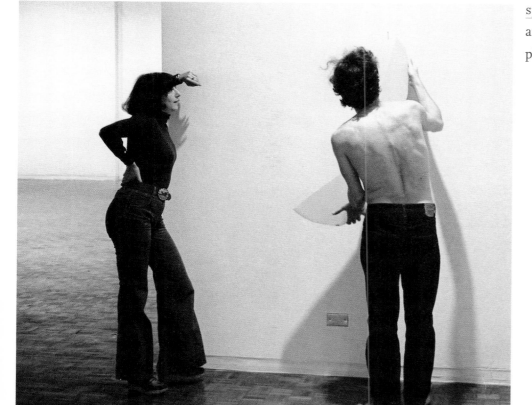

plate 30

> Action is the objectification of subjectivity and the subjectification of objectivity. It must be a kind of practice. Practice always is the union of subject and object. Therefore, human activities always construct culture. Human activity sees the world of trans-temporal ideas. The concept of acting as a variety of seeing arises from this. It means that the self sees itself through negating itself. The creative activity of the artist is a paradigm of this.[17]

What is curious about Tuttle's art is how, over the decades, it has consistently defied categorization. When confronted with the body of work it becomes all too easy to speak voluminously and philosophically about art and life. Tuttle is, in fact, one of the few artists one can think of who remains dedicated to a union of the two and who attempts it daily in his practice on a fully internalized and materialized basis. After the time-stopping events in New York on September 11, 2001, there was much talk about how contemporary art might respond; indeed, all efforts to make or look at art seemed frivolous or beside the point at best. The luminous 2003 exhibition of Tuttle's *"20 Pearls"* at Sperone Westwater, New York, was one memorable exception. Tuttle said at the time that the body of work was made in answer to the events of 9/11 and, for him, comprised an almost physical response to the effect that morning and its aftermath had on him and his family, who live in close proximity to the World Trade Center and witnessed the tragedy. The artist's utter clarity about the function of these works, and about even the notion of formulating a response to such events— a combination of sheer compulsion to create in the face of an act of aggression that profoundly violated the very idea of creation itself, and the chutzpah of making something beautiful and ethereal that might act to counter the weight of that act of violence—was pure Tuttle. And the exhibition was magic. Generous strokes of luscious watercolor swam on pieces of casually layered foam board, which, it occurs to me now, might be somehow reminiscent of the exquisitely painful image of bits of paper flying through the sky in the aftermath. The experience of the exhibition was all vision and light. There was a spatial sense of landscape and horizon, even a glorious hallucinatory opticality recalling for this viewer the shimmering pools of Monet's *Water Lilies* (ca. 1920) or the poignant but humorous fragility of David Hammons's *Bliz-aard Ball Sale* (1983), a work in which the artist sold snowballs on a Manhattan street corner. Water lilies and snowballs—a canvas, heavy with painting's history, and mounds of snow, all process and ephemerality; such an evocation of apparent opposites, of making sense out of chaos without regard for the usual hierarchies of materials and spectatorship—here was a succinct and timely aesthetic response.

 What was striking about Tuttle's expression was how brilliantly conventional it was, yet it demonstrated that art could transcend its own struggles and embody the emotional outpouring of humanity around that cataclysmic moment. Though the artist did not foreground its political impetus in any way, the exhibition was a testament to the vitality and contemporaneity of Tuttle's work. Robert Storr, writing in 1997 about Tuttle's influence and connection to the abject antiaesthetic of the 1990s, described the persistence of the artist's startling antiheroic style as "ambitiously unambitious," saying that Tuttle "[makes] things simultaneously ephemeral and jewel-like [and pits] impermanence against permanence, everyday temporality against aesthetic timelessness.... Tuttle the undeterred romantic and his disabused '90s brethren meet at a juncture where the only truly hopeless propositions seem to be those straining for heroic impact."[18]

plates 146, 349–53

146 Richard Tuttle **"20 Pearls (9)"** 2003
Acrylic on museum board and foam board,
21 1/4 x 17 1/8 in.
Private collection, New York

Though all good artists work intuitively, Tuttle makes us aware of how deeply instinctual and responsive his process is. The residual of his decisions is visible everywhere in his work, so that our own conditioned discomfort with things deeply felt that manifest in the experience of visual art—a conditioning that harks back to the postmodern moment from which the artist emerges—is put front and center. Perhaps this is why the exhibition was so effective as a kind of antidote to the horrors in New York. So clearly outside language, *"20 Pearls"* succeeded in engendering a sense of permission—a fitting summation of Tuttle's careerlong investigation of how very private emotions and impulses can be made public.

NOTES

1 See Sally Banes, "An Open Field: Yvonne Rainer as Dance Theorist," in *Yvonne Rainer: Radical Juxtapositions 1961–2002,* by Sid Sachs et al. (Philadelphia: Rosenwald-Wolf Gallery, University of the Arts, 2003), 37.

2 Yvonne Rainer, program notes for *Continuous Project—Altered Daily,* in *Yvonne Rainer: Work 1961–73* (Halifax: Press of the Nova Scotia College of Art and Design; New York: New York University Press, 1974), 129.

3 Pamela M. Lee, "Some Kinds of Duration: The Temporality of Drawing as Process Art," in *Afterimage: Drawing through Process,* by Cornelia H. Butler (Los Angeles: Museum of Contemporary Art; Cambridge, MA: MIT Press, 1999), 25–48.

4 Ibid., 43.

5 Carrie Lambert uses this language to describe *Trio A,* Rainer's groundbreaking dance work of 1966. See her "On Being Moved: Rainer and the Aesthetics of Empathy," in Sachs, *Yvonne Rainer: Radical Juxtapositions,* 46, 49.

6 Bernice Rose, *Drawing Now* (New York: Museum of Modern Art, 1976), 10.

7 Ibid., 14.

8 James Meyer, "The Second Degree: *Working Drawings and Other Visible Things on Paper Not Necessarily Meant to Be Viewed as Art,*" in Richard Field et al., *Mel Bochner: Thought Made Visible 1966–1973* (New Haven, CT: Yale University Art Gallery, 1995), 100, 102.

9 Quoted in *Richard Tuttle: Community* (Chicago: Arts Club of Chicago, 1999), 20.

10 Quoted in Paul Gardner, "Richard Tuttle's Paper Liberation," *On Paper* 1 (January–February 1997): 18. The reframing of the (rehearsal) studio as the nexus for artistic practice was common at this time, ranging from Bruce Nauman's video experiments to Barry Le Va's *Continuous and Related Activities* works of 1967.

11 Susan Harris has described the role of drawing in Tuttle's work and linked his use of it to the modernist sculptural tradition of so-called drawing in space and the work of such artists as Julio González. See Harris, "Twenty Floor Drawings," in *Richard Tuttle* (Amsterdam: Institute of Contemporary Art; The Hague: Sdu, 1991), 60–61.

12 Quoted in Gardner, "Richard Tuttle's Paper Liberation," 18.

13 This photograph appears as fig. 6 in Harris, "Twenty Floor Drawings" (p. 52). (Sadly, the negative has since been lost, so it cannot be reproduced here.)

14 Marcia Tucker, *Richard Tuttle* (New York: Whitney Museum of American Art, 1975), 15–16.

15 In "*Just* Exquisite? The Art of Richard Tuttle" (*Artforum* 36 [November 1997]), Robert Storr quotes Hilton Kramer's review of Tuttle's Whitney exhibition, in which the critic says that the artist reached "new standards of lessness, and fairly basks in the void of lessness. One is tempted to say that, so far as art is concerned, less has never been less than this" (p. 89). It is precisely this lessness, Storr argues, that resonates with the current generation of artists.

16 Jennifer Gross, "A Fine Line," in *Richard Tuttle: Replace the Abstract Picture Plane,* ed. Matthias Haldeman (Zug, Switzerland: Kunsthaus Zug; Ostfildern, Germany: Hatje Cantz, 2001), 96–97.

17 Ibid., 97.

18 Storr, "*Just* Exquisite," 93.

147 **Colored Line Series (1)** 1969 12 x 9 in.

148

149

150

151

152

153

154

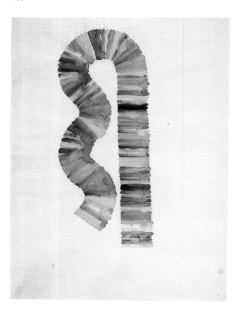

155

148–63 Selected works on paper 1969–73
dimensions vary

156

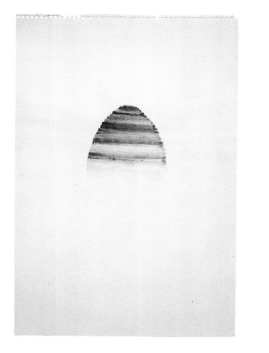

157

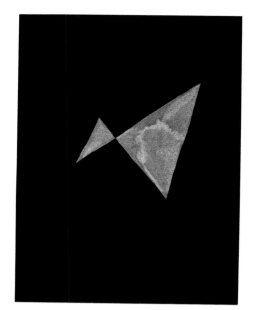

158

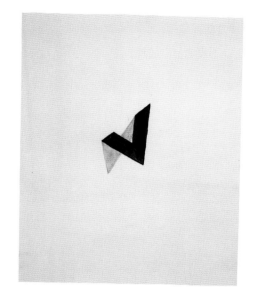

159

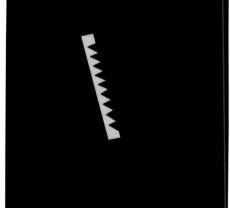

160

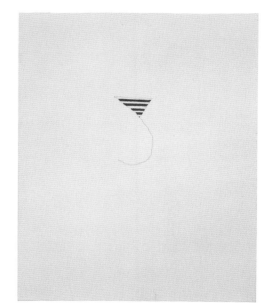

161

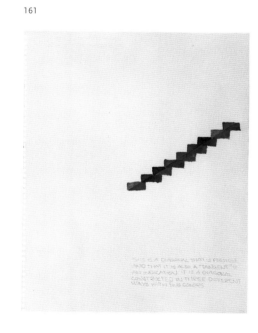

162

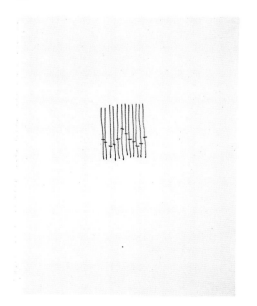

163

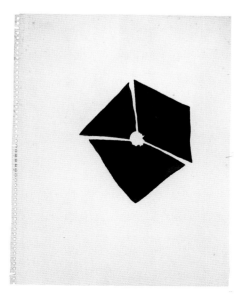

164

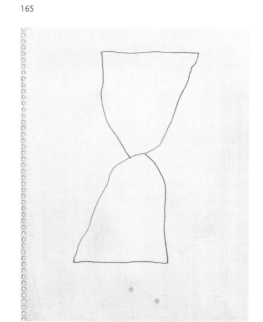

165

166

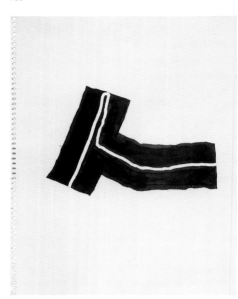

167

168

169

170

171

164–79 Selected works on paper 1970–73 dimensions vary

172

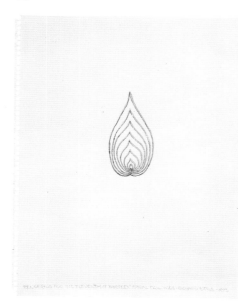

173

174

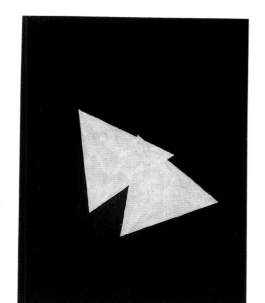

175

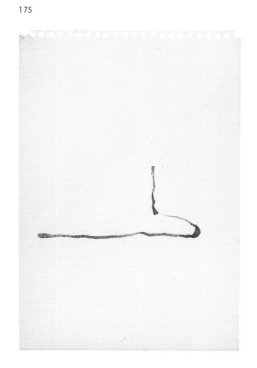

176

177

179

178

180

181

182

183

ONE OF TWO DRAWINGS MADE IN
ATHENS (SPRING, 1974) PRIMARILY
DEVELOPED IN THE DRAWINGS OF THIS
GROUP TORN FROM A SPIRAL NOTEBOOK

184

ONE OF TWO DRAWINGS MADE IN
ATHENS (SPRING, 1974) PRIMARILY
DEVELOPED IN THE DRAWINGS OF THIS
GROUP NOT TORN FROM A SPIRAL NOTEBOOK

186

185

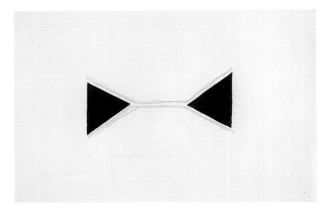

187

180–94 Selected works on paper 1972–77 dimensions vary

188

189

192

190

191

194

193

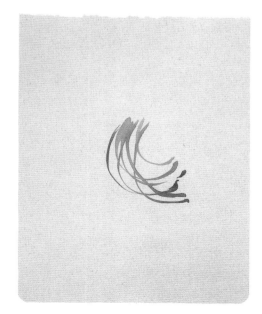

195

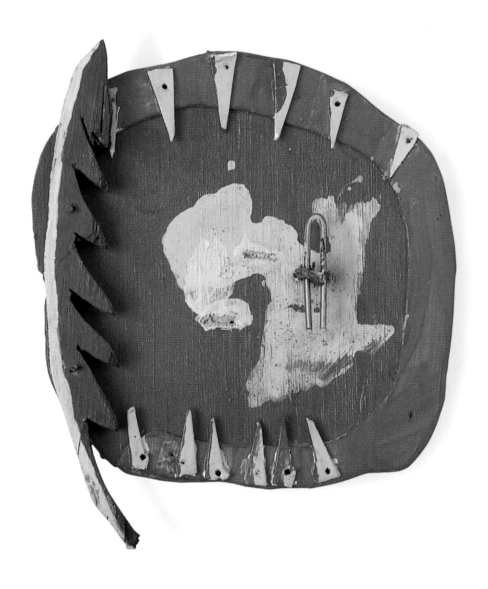

195 **B 1** 1981 5 1/4 x 4 1/8 x 3/4 in.
196 **G 1** 1981 9 1/2 x 10 x 3 1/2 in.

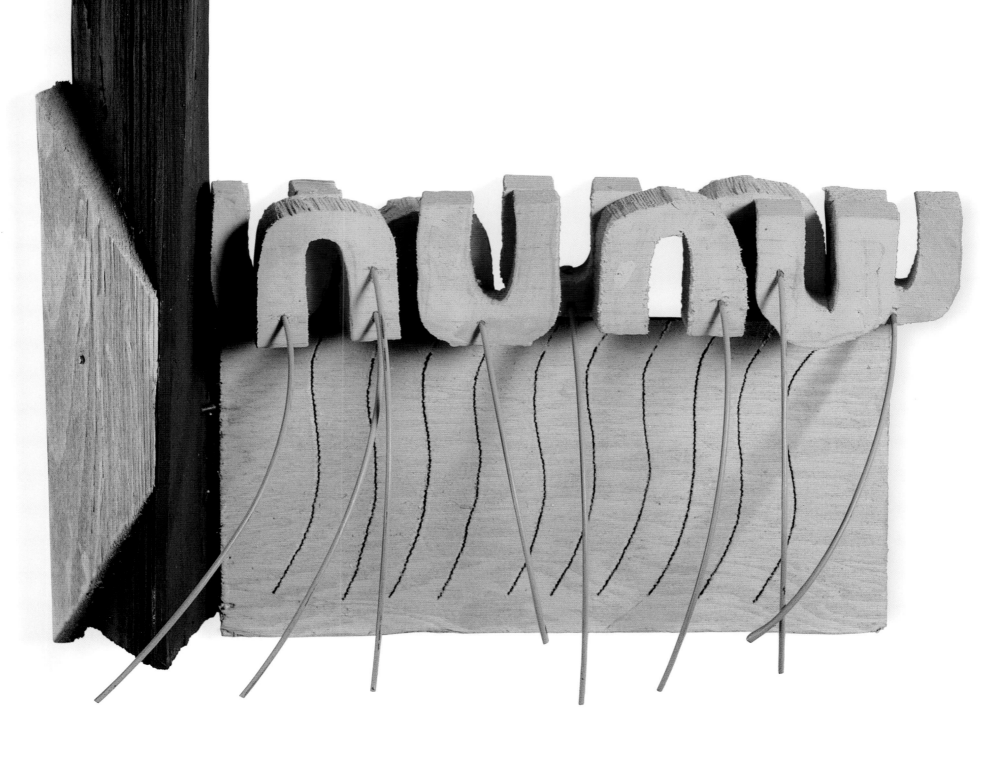

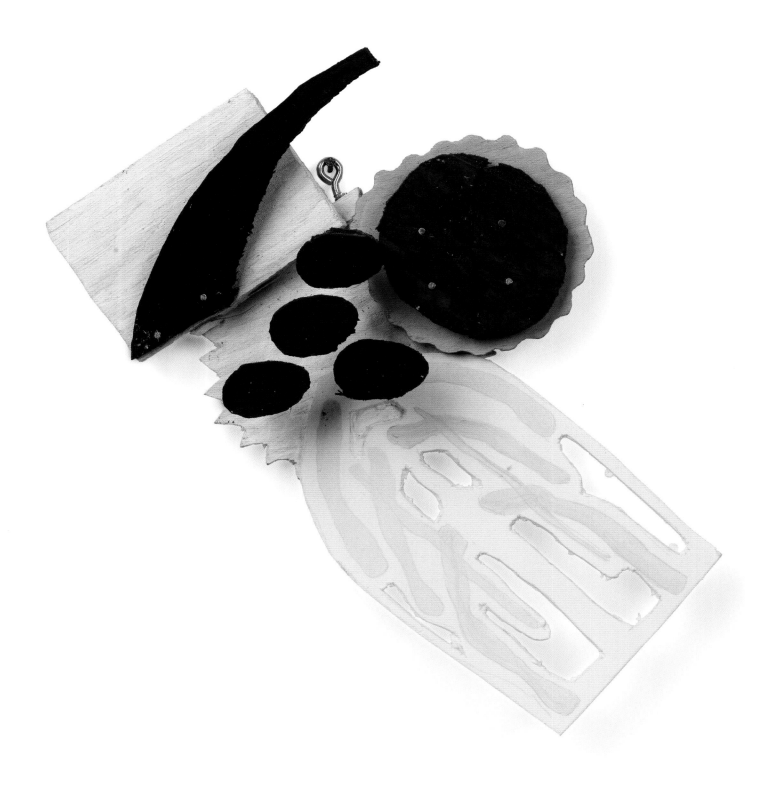

197 **W 1** 1981 8 1/8 x 6 1/8 x 1 3/4 in.
198 **L 1** 1981 10 3/8 x 9 1/4 x 2 3/4 in.

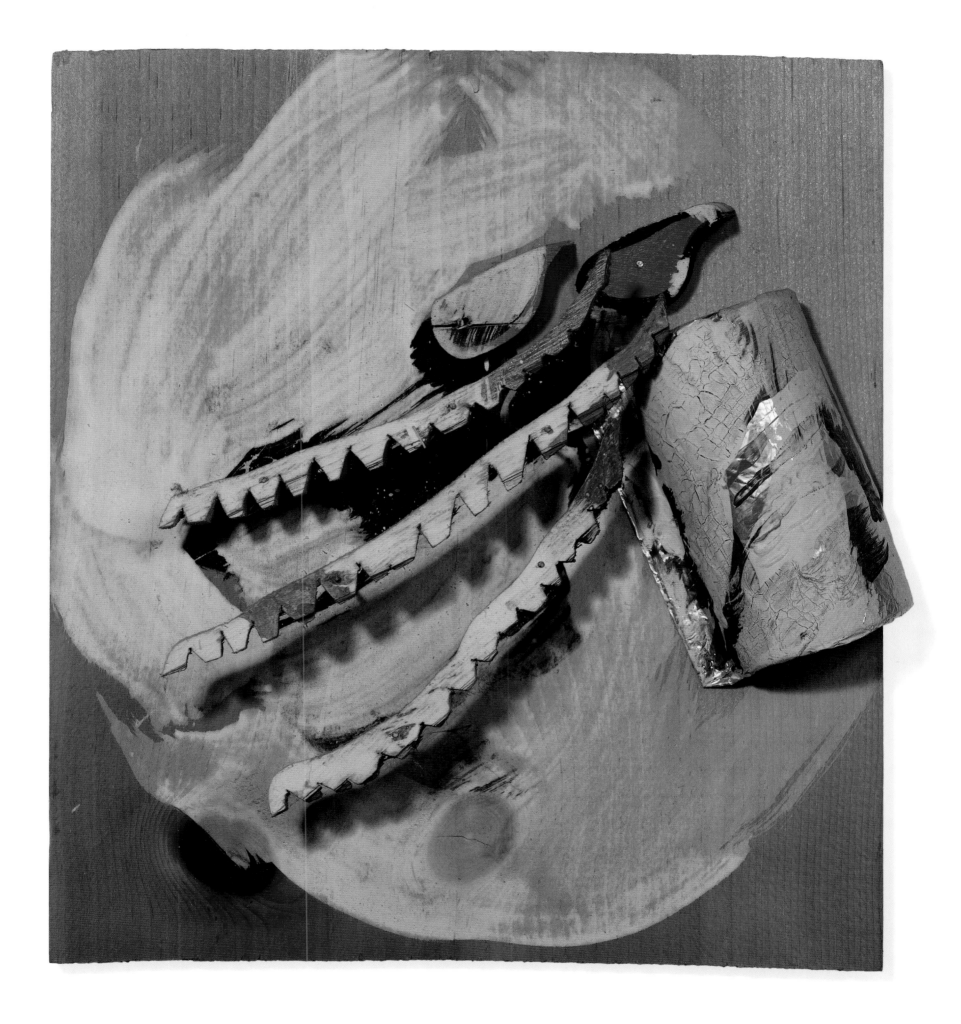

199 Installation view of the 1981 exhibition
Richard Tuttle at Galerie Yvon Lambert, Paris,
showing various wall assemblages (1981)

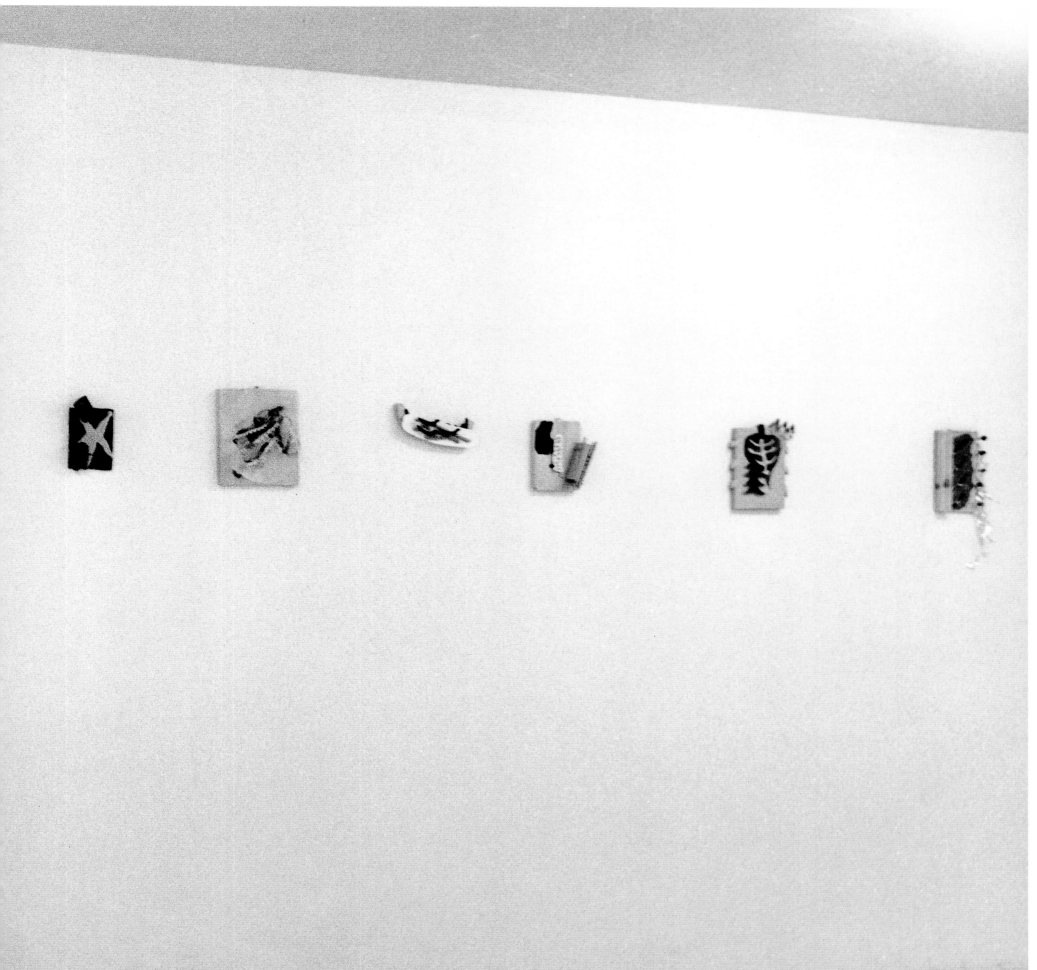

200 **Monkey's Recovery for a Darkened Room, 6** 1983
40 x 20 1/2 x 12 1/2 in.

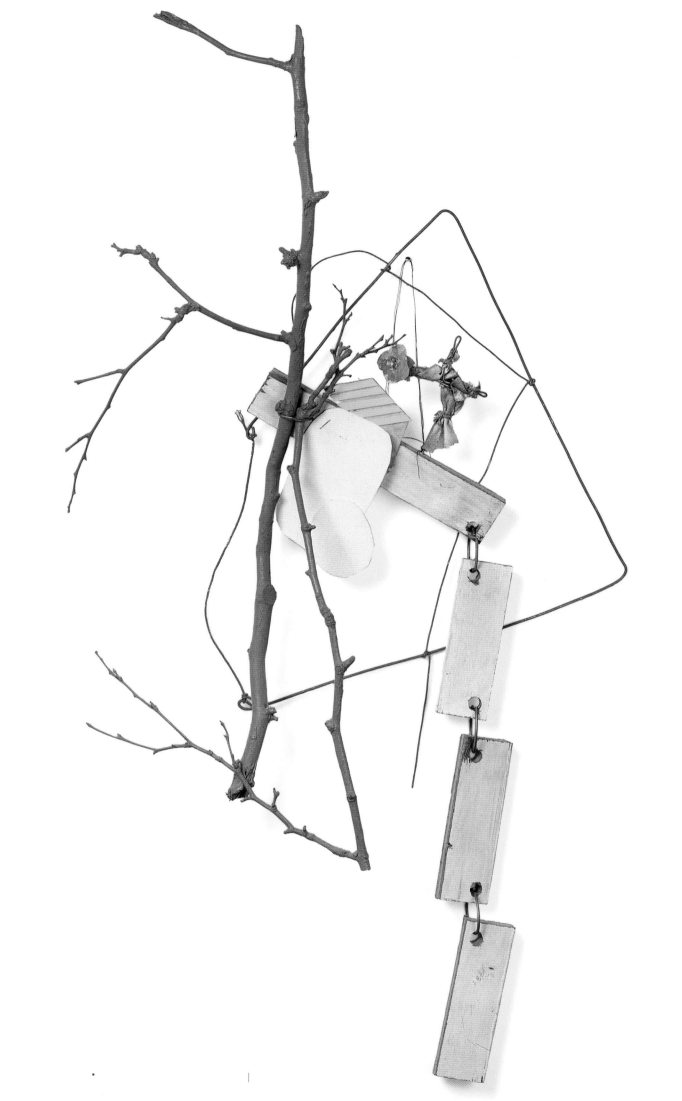

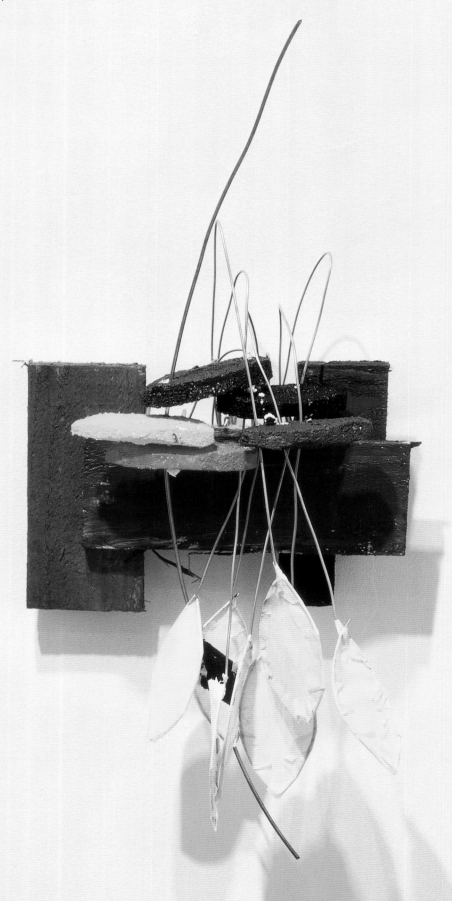

201 **Monkey's Recovery I, #3** 1983 24 x 9 x 6 in.

202 **Two or More III** 1984 30 1/2 x 18 1/2 x 6 in.

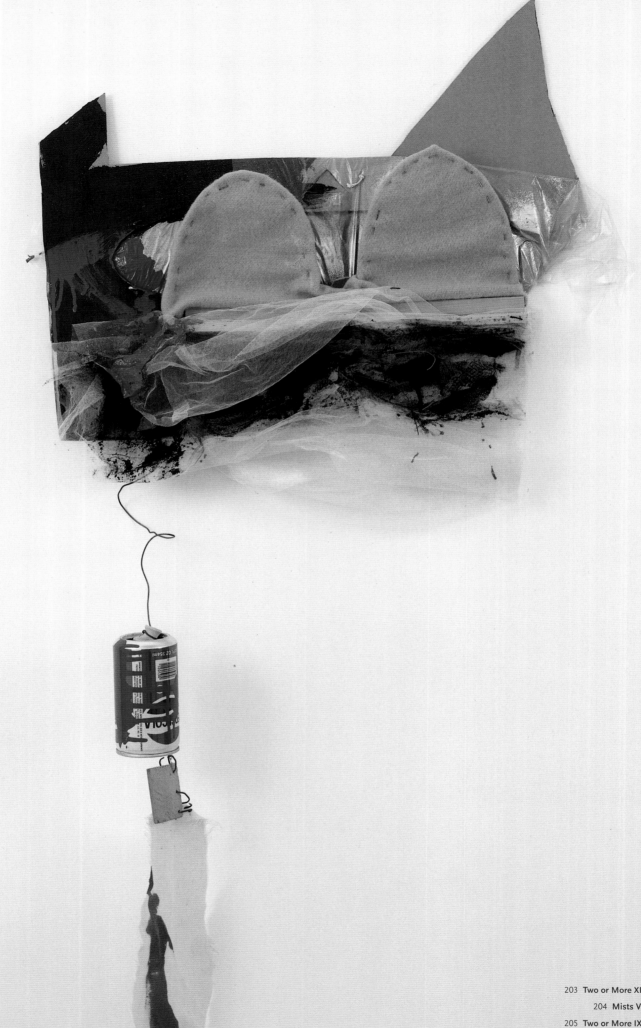

203 **Two or More XII** 1984 41 x 24 1/2 x 6 in.

204 **Mists VII** 1985 19 5/8 x 23 5/8 in.

205 **Two or More IX** (detail) 1984 50 3/4 x 32 1/2 x 3 1/8 in.

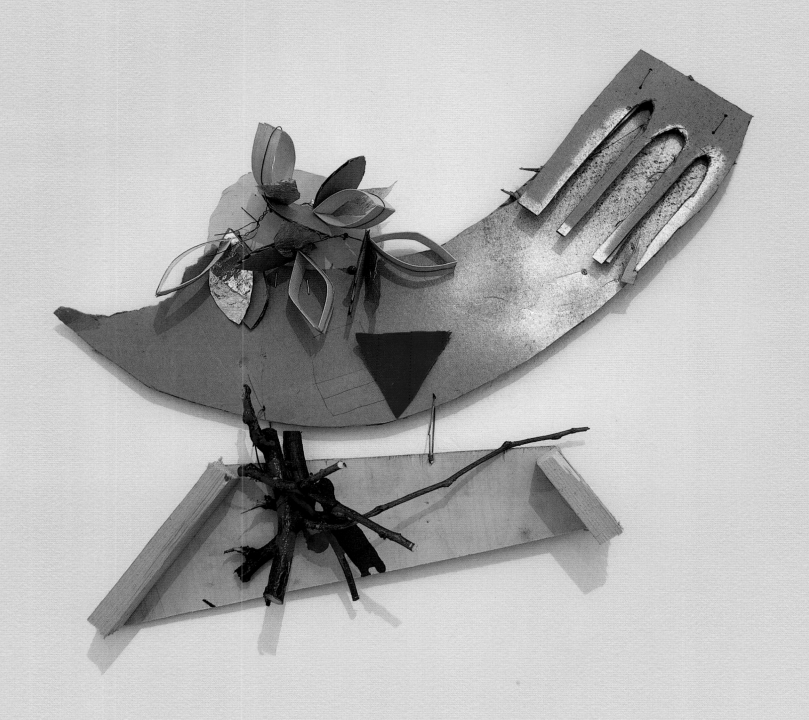

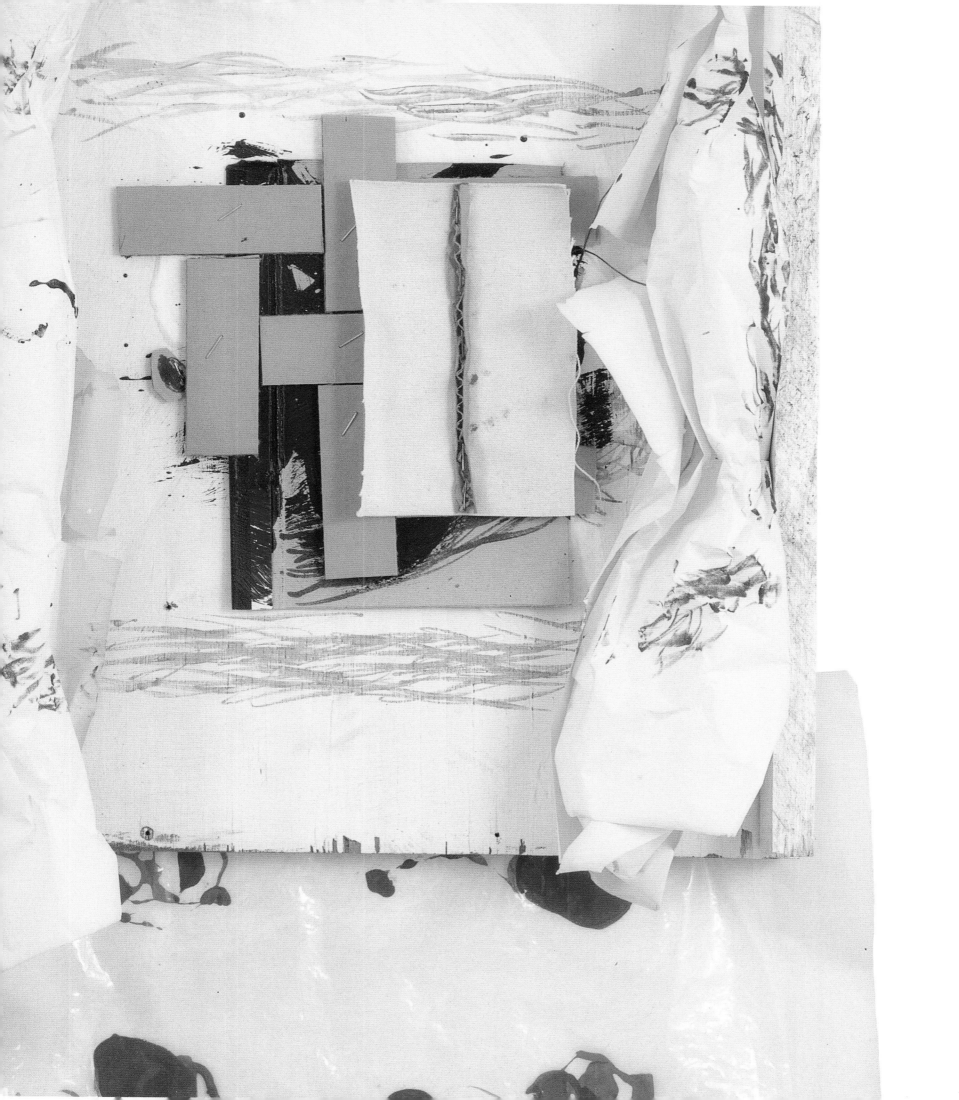

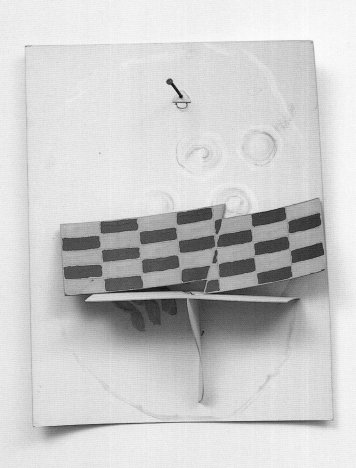

206 **Beethoven Stop on the Way to Egypt** 1986
overall 41 x 97 x 6 in.

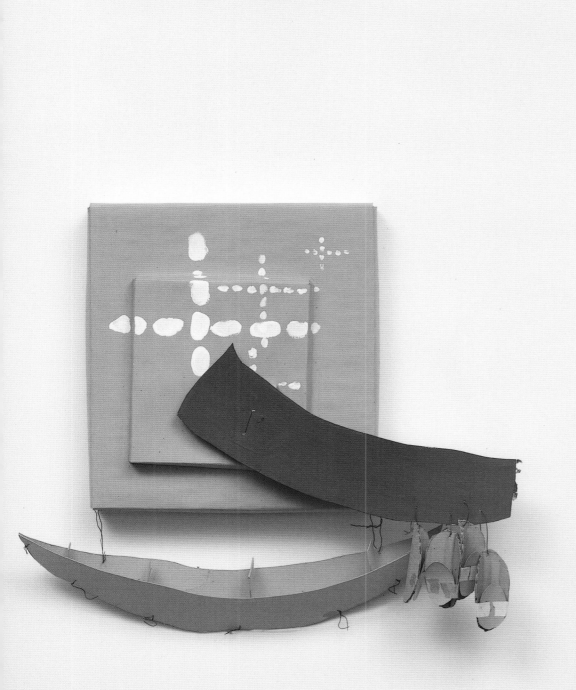
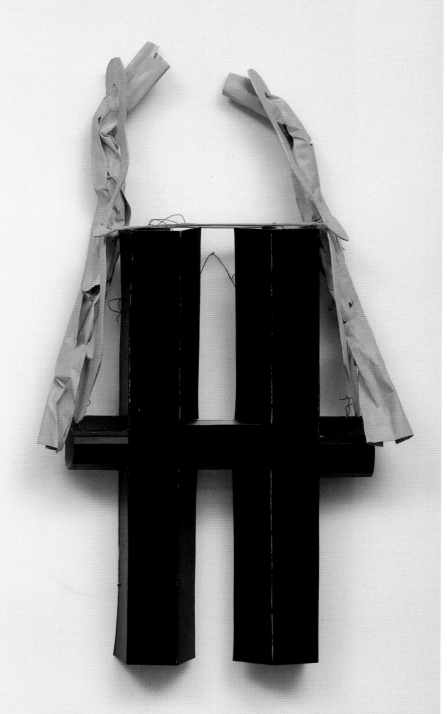

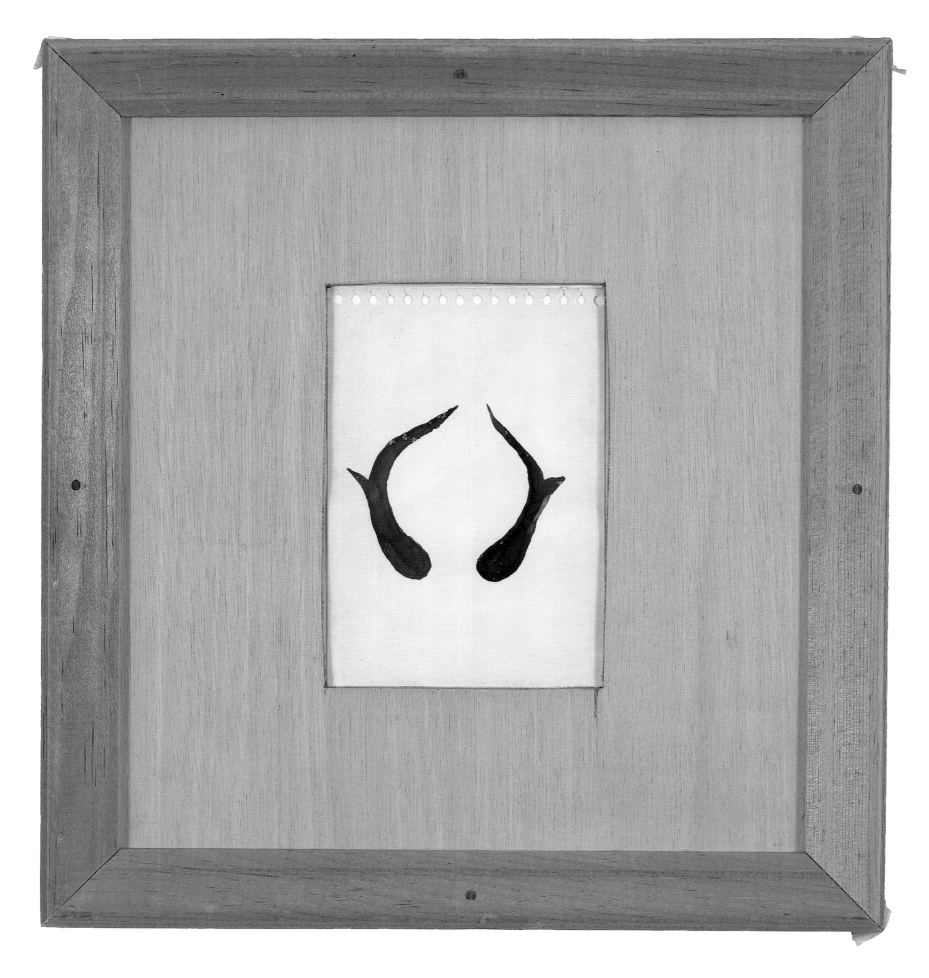

207 **Paris Arles #20** 1974 6 x 4 x 1¹/₂ in.

208 **India Work 9** 1980 11 x 9¹/₄ x 1¹/₂ in.

209 **India Work 17** 1980 11 x 9¹/₄ x 1¹/₂ in.

210 **India Work 26** 1980 11 x 9¹/₄ x 1¹/₂ in.

208

209

210

211–20 **Hong Kong Set** 1980 each 10 x 8¹/₂ x 1¹/₈ in.

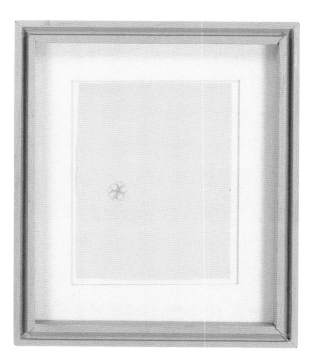

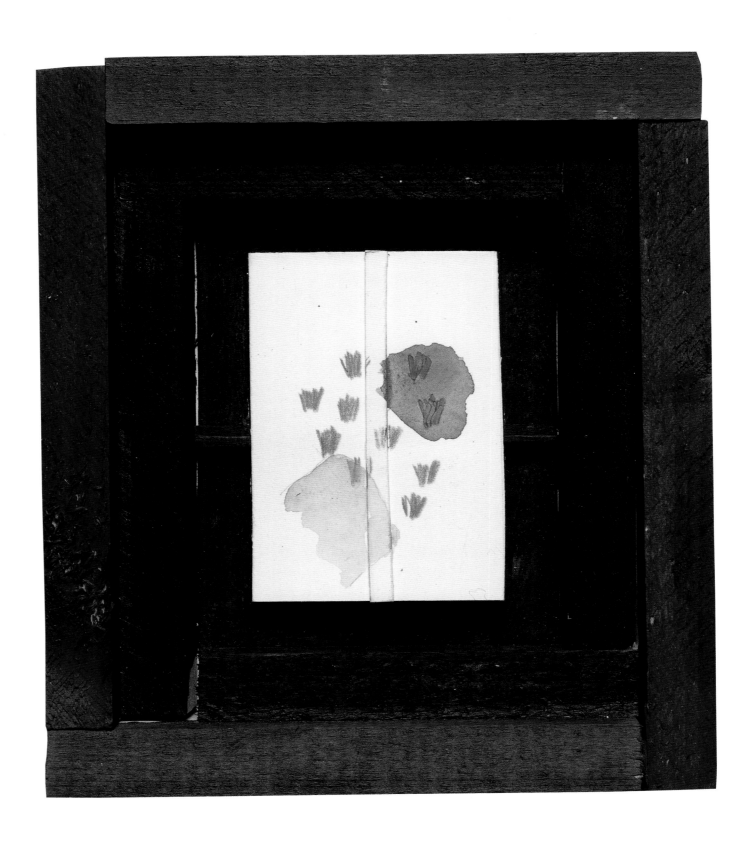

221 **Brown Bar #5** 1981 8 x 7 x 1 1/2 in.

222 **Brown Bar** 1981 each 8 x 7 x 1 1/2 in.

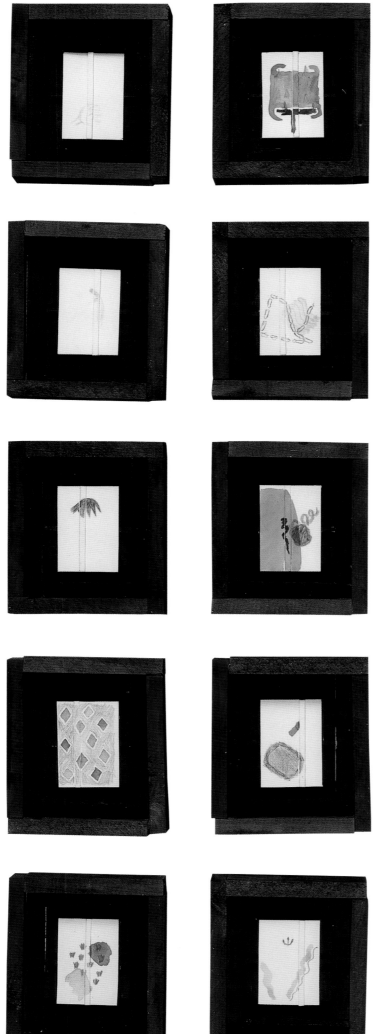

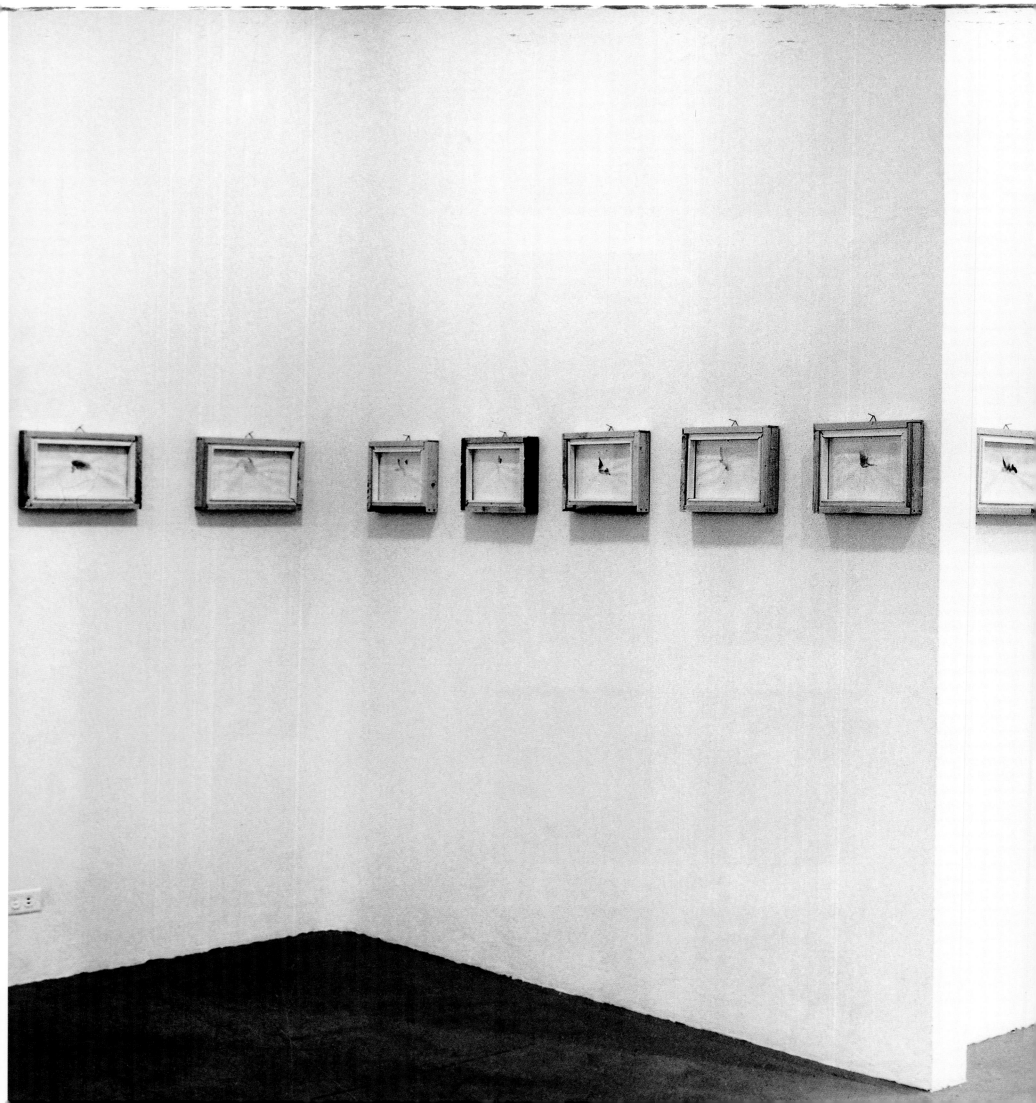

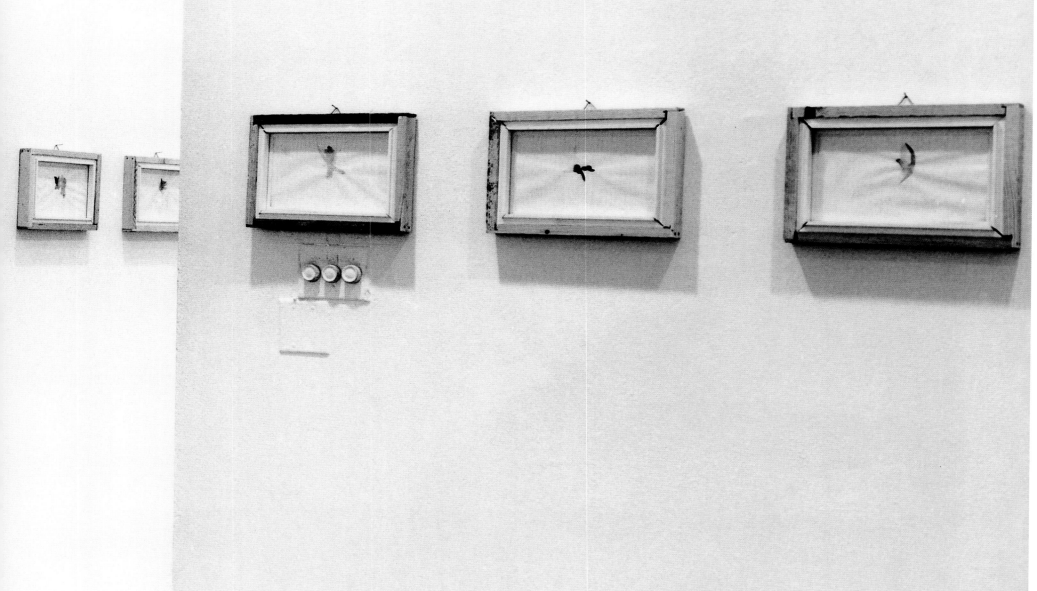

223 Installation view of the 1982 exhibition **New Work:
Richard Tuttle** at Betty Parsons Gallery, New York,
showing the series **Old Men and Their Garden** (1982)

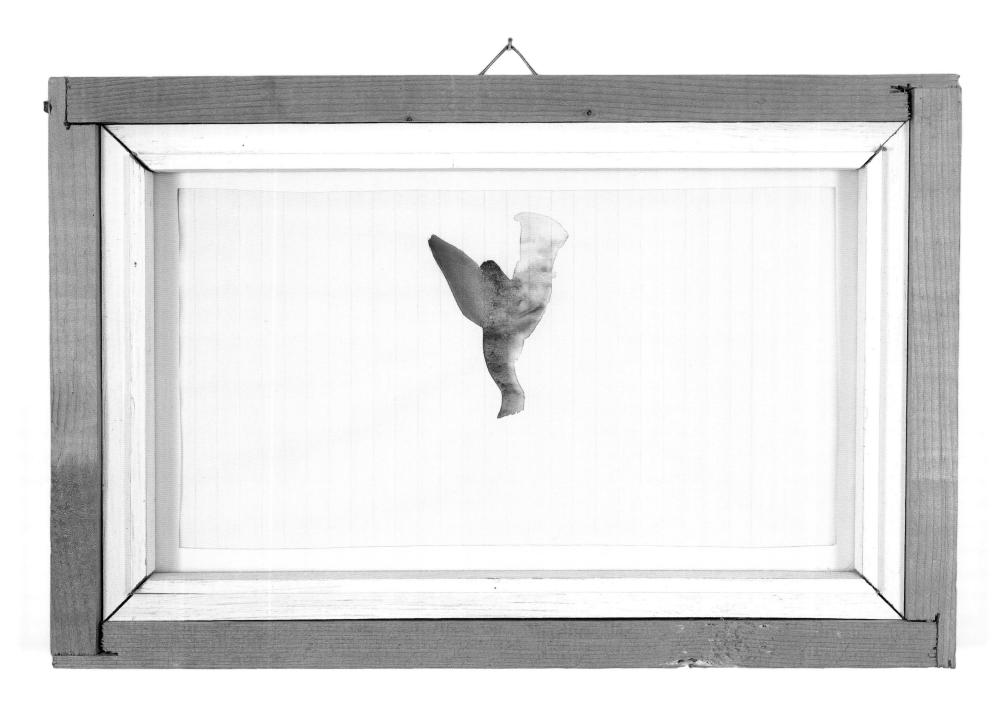

224 **#58 from Old Men and Their Garden** 1982 9 1/2 x 14 x 1 5/8 in.
225 **#60 from Old Men and Their Garden** 1982 9 1/2 x 14 x 1 5/8 in.

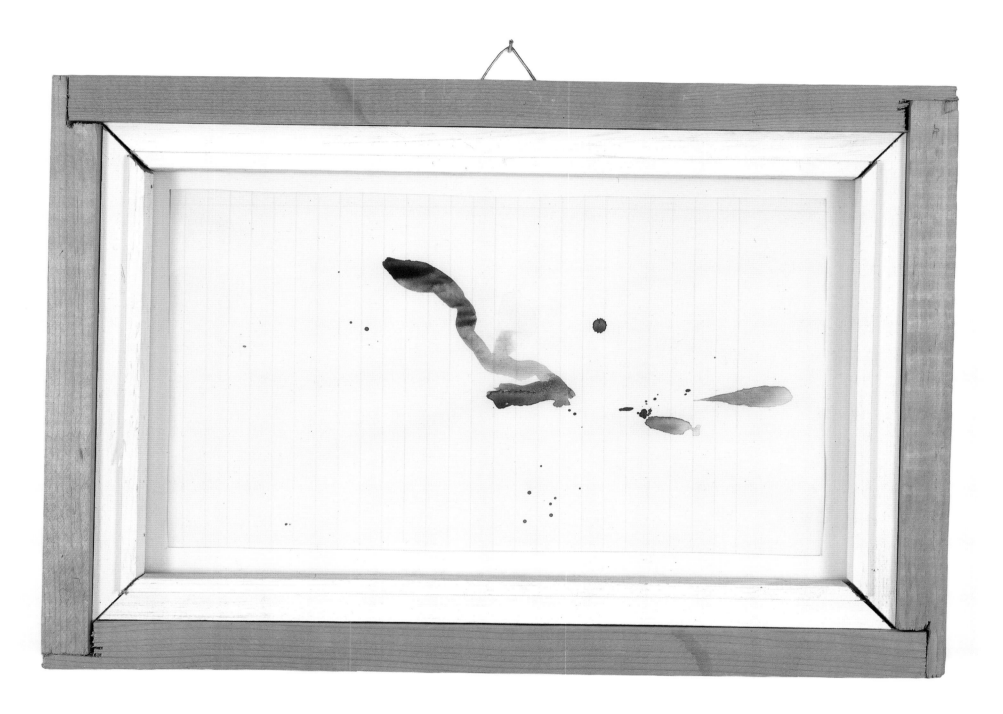

226 Installation view of the 1985 exhibition **Richard
Tuttle at Galerie Yvon Lambert, Paris, showing the
series **La Terre de Grenade** (1985)



227

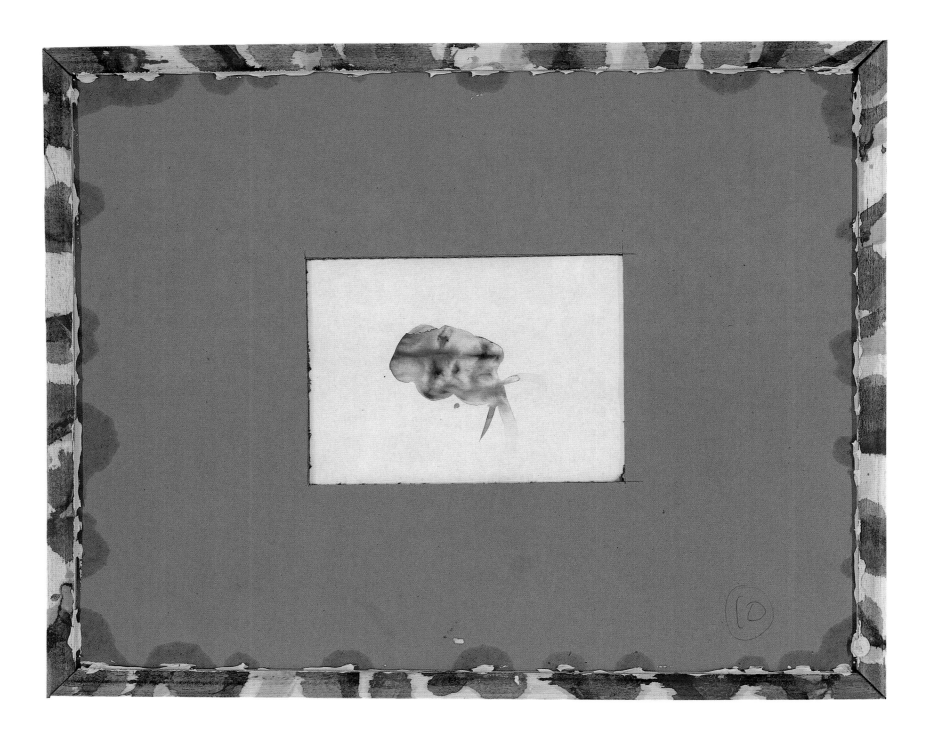

227 **La Terre de Grenade X** 1985 17 x 21 x 5/8 in.

228 **La Terre de Grenade I** 1985 17 x 21 x 5/8 in.

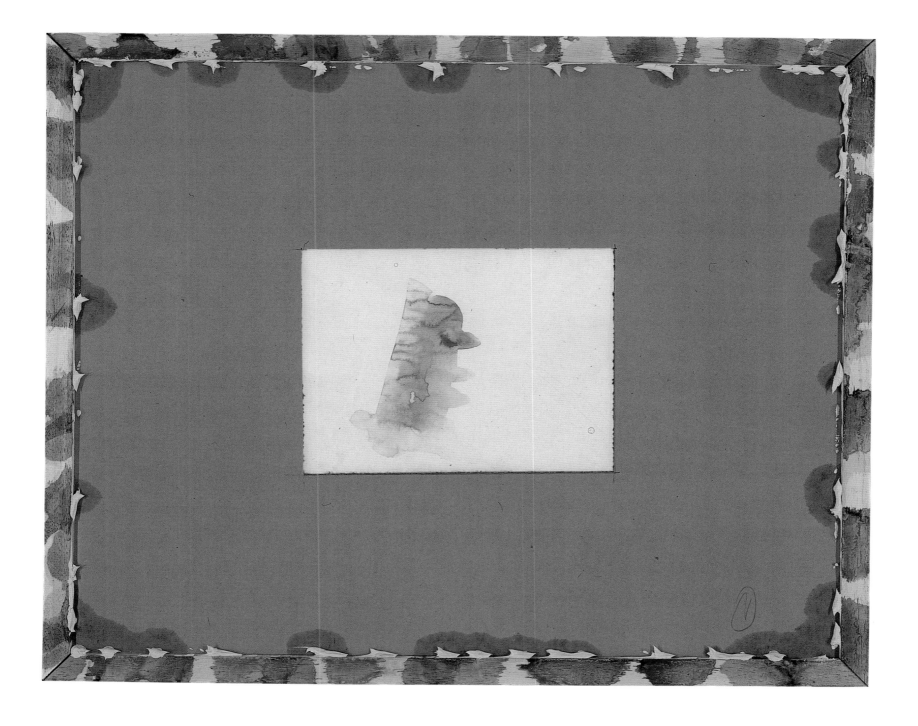

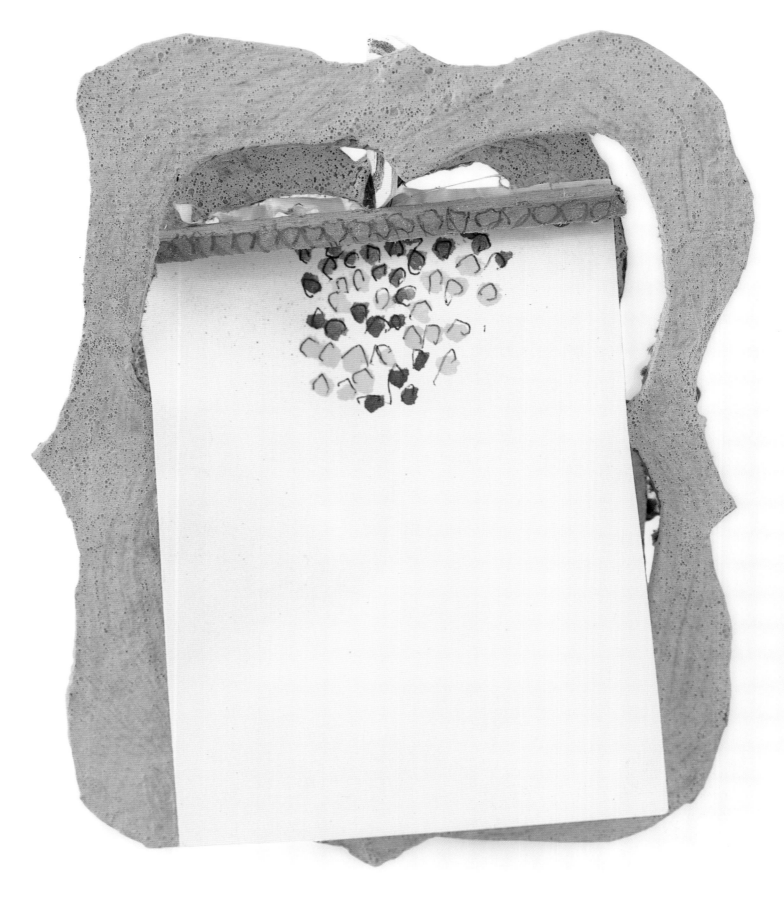

229 **Egyptian Works** (detail) 1986
6 1/4 x 5 1/2 x 1 1/8 in.

230 **Egyptian Works** 1986
each 6 1/4 x 5 1/2 x 1 1/8 in.

231 Installation view of the 1990 exhibition **Richard Tuttle: In Memory of Writing** at the Sprengel Museum Hannover, Germany, showing **System of Color** (1989) between Kurt Schwitters's **Merzbild 46a—Das Kegelbild** (1921) and **Merzbild P** (1930)

232

233

234

232 **Verbal Windows I** 1993 8 7/8 x 5 3/4 x 1 1/8 in.

233 **Verbal Windows II** 1993 8 7/8 x 5 3/4 x 1 1/8 in.

234 **Verbal Windows III** 1993 8 7/8 x 5 3/4 x 1 1/8 in.

235 **Icelandic #4** 1994 24 x 7 x 1 in.

236 Installation view of the 1996 exhibition **Richard Tuttle**
at the Mies van der Rohe Haus, Berlin,
showing **How It Goes Around the Corner** (1996)

237 **How It Goes Around the Corner** 1996 14 x 5 1/8 x 3 in.

238 **How It Goes Around the Corner** 1996 14 x 7 3/8 x 3 in.

239 **How It Goes Around the Corner** 1996 14 x 7 3/8 x 3 in.

*If you create the space between appearance and reality, you can
do anything.* RICHARD TUTTLE[1]

*...the infinite fold separates or moves between matter and soul, the facade
and the closed room, the outside and the inside.*

GILLES DELEUZE, *The Fold: Leibniz and the Baroque*[2]

Since 1974 Richard Tuttle has made several series of works on paper for which he constructed handmade frames. While certain of these frames envelop or protect the artwork situated within, others allow the imagery to seep out from such physical and psychological boundaries. At first glance, the "framed drawings," as they have come to be known, would seem to represent a significant departure from Tuttle's prior output. His constructed paintings, cloth pieces, wire works, and *Wood Slats* of the 1960s and early 1970s—all groups of works that marked his unique contribution to the radical, exploratory moment of Postminimalism—eschew any recourse to the physical frame that had historically set the limits of the easel painting and had served as a comfortable and concrete marker for where a picture began and ended. Yet for Tuttle the frame has never been simply a structure that holds a picture. The paradoxical freedom of the frame is that, while framing exists *a priori,* in that no creative act can occur without a frame (here Tuttle echoes Kant), a frame can be almost anything: language, knowledge, silence, a shadow, or, as Tuttle once whimsically proposed, "a child's hiccups held far-off like water dripping."[3]

Perhaps it is not surprising that Tuttle, a figure who has consciously operated on the fringes of the canon, of postwar art movements, and of major exhibitions and critical discourses surrounding their more central participants, would linger on the edges of his works. The labor of the cloth pieces (pls. 72–84), for example, is most evident in the stitched folds that mark their borders, and special attention is paid to the edges of the *Wood Slats* (1974; pls. 126–28), some of which have been painted white, making their function as boundaries even more elusive. The shadow of *3rd Rope Piece* (1974; pl. 125) is as visible, if not more so, than the short, squat, matter-of-fact length of rope itself. Bonding agents such as glue or nails become emphasized.[4] Works placed near the floor, such as the slats and colored triangles, activate another kind of edge: that between the wall and the floor. Despite such consistent attention to presumably marginal details, Tuttle maintains that all of these early works do in fact have a larger frame: space, the discovery of which he has described as "the quiet revolution of Postminimalism."[5]

In 1974, for a brief moment, Tuttle did, however, introduce traditional frames, albeit ones whose physical presence almost overwhelms the wisps of drawings they surround, in the series called *Paris Arles* (pl. 207).[6] It was through considering what these drawings needed (Tuttle's belief that it is possible, indeed imperative, to get something *just right* has Greenbergian undertones), that he devised the unfinished plywood frame and wide plywood "mat" to house the drawings. At the time, Tuttle was deeply engaged with the physicality of Gustave Courbet's paintings (specifically their thick impasto) and how that quality contributed to their pictorial realness, an effect he hoped to achieve with these works as well.[7] The physicality of the frame is tangible in Tuttle's use of unfinished plywood and four simple nails to hold the work together, revealing, rather than obscuring, its construction. Such nakedness dovetails with Tuttle's oft-quoted statement that "to make something which looks like itself...is the problem, the solution."[8] This approach to the artist's dilemma is strikingly similar to that of Arthur Dove, a fellow New Yorker–New Mexican whom Tuttle admires and whose handmade frames often incorporate found objects such as measuring sticks (pl. 241).

Traditionally, a painter such as Courbet would paint a picture with an empty strip of canvas surrounding it, knowing that the framer would cover that space when framing the work. Later, artists ranging from Claude Monet to Brice Marden would explore this narrow zone. Tuttle, too, has spent a great deal of time thinking about the "space between." In 1980, while recovering from an illness in Jaipur, India, he made his next series of framed pictures, *India Work,* which consists of smallish, matted watercolors held within wooden frames (pls. 208–10).[9] Seemingly infused with traces of the place's atmosphere, the abstract lines and patterns of the watercolors are often echoed by the repetitive shapes of the frames. But most important to the artist is an element not made by him at all (although orchestrated by him), and one that we might instinctively overlook: the inch-wide margin between the watercolor and the frame, a space (or interlude) that Tuttle would have us contemplate, honor, explore, walk around. This is the same bare space of old master paintings, ignored by the artist and covered up by the framer, a throwaway that Tuttle chooses instead to emphasize. It is a corollary to what John Cage called the silence between sounds: a marginal interlude shifted to the center.[10]

Hong Kong Set (1980; pls. 211–20), a series of ten framed drawings that Tuttle made just after *India Work* and on the same paper, functions similarly. This group, however, introduces a grooved frame that, along with the watercolor inside, creates a rippling effect of lines emanating outward. This kind of visual echo is rampant throughout Tuttle's oeuvre. An obvious heir

240 Installation view of the 1983 exhibition
Richard Tuttle at Galleria Ugo Ferranti,
Rome, showing watercolors on paper
in handmade wood frames and an original
poster by Tuttle in the window

to *Hong Kong Set* is the *"I See"* series, each of which has not one but three frames, pushing farther into the viewer's space (1993; pl. 242).[11] Tuttle's method of joining the frames creates a sense of counterclockwise motion: a spiral, one of his most recurrent visual motifs.

Herein lies a key to understanding Tuttle's work: rather than unfolding linearly, it doubles back on itself, with elements such as the spiral occurring again and again in drawing, sculpture, assemblage, and in his handmade frames, like the infinite fold Deleuze speaks of in this essay's epigraph. Deleuze uses the fold to characterize the Baroque as a series of unending twists and turns, pleats that tumble over one another. In his reading of the German philosopher Gottfried Wilhelm Leibniz, space and time are not Cartesian (or classical), but collapse into a multiplicity of meanings. Tuttle, who is quite sympathetic to the Baroque, sees his own work as a "collapsed narrative," a characterization not unlike the collapse Deleuze describes. Although the *Portland Works* group (pl. 31), for example, was made in 1976, Tuttle framed the pieces over a decade later. In addition to their physical frames, he explicitly gave them two conceptual frames: the eponymous catalogue for the series—"this publication is the frame the *Portland Works* never had," he wrote—and his professed ambivalence over their fragility. By carefully

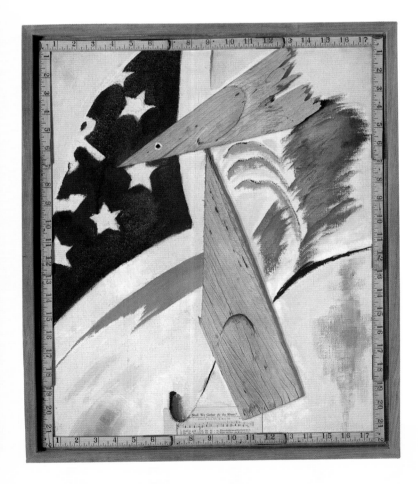

241 Arthur Dove **Portrait of Ralph Dusenberry** 1924
 Oil, ruler, wood, and paper on canvas, 22 x 18 in.
 Metropolitan Museum of Art, New York,
 Alfred Stieglitz Collection, 1949

242 Richard Tuttle **"I See" (3)** 1993
 Collage on paper in handmade wood frame, graphite,
 7 7/8 x 7 7/8 x 3 1/2 in.
 Collection of Marilena and Lorenzo Bonomo,
 Bari, Italy

nestling the delicate drawings in the same paper used for the cover of the catalogue, Tuttle echoes both conceptual frames and performs an act of "folding."

"A series is a sequence without origin or destination, simply occurrence," the poet Charles Bernstein has written about Tuttle's work, but "a sequence is a series with ulterior motives."[12] Tuttle's notebook drawings of 1982, made just after *India Work* and *Hong Kong Set,* are indeed *series.* Though they are numbered, they do not progress toward a goal: each glyphlike watercolor, drawn on an everyday sheet of lined notebook paper, is like a Chinese character, but no sentence is formed, no logical sequence developed. Installed en masse, they simply overwhelm with their unyielding recurrence (again the metaphor of "the fold" applies here) and methodical seriality, throwing down the gauntlet to Donald Judd and his infamous mantra of "one thing after another."[13]

For Tuttle, the notebook drawings function like modern-day depictions of Susannah and the Elders, a subject of sexual victimization taken up by artists ranging from Artemisia Gentileschi to Rembrandt van Rijn (pl. 243). Like Peeping Toms, we peer in at a trembling, vulnerable image, the frame a cinematic lens focused for optimal scopophilia.

Shown at Betty Parsons Gallery in 1982, the last series of notebook drawings, *Old Men and Their Garden* (pls. 223–25, 244), was an elegy to the recently deceased Parsons. This series' awkwardly sentimental title was inspired by Tuttle noticing "old men" in different community gardens in New York—the garden, with its hedges and borders, being yet another type of Tuttle frame. For each of these slight drawings, Tuttle constructed a bare-bones wood-strip frame. With deliberately imprecise joints and raw, splintery edges, they appear to have been banged together in a careless way.[14] But when installed, an obsessive exactitude emerges, a complete precision revealed in the "true" horizontal at their top edges and the precise spacing between pieces.

In the mid- to late 1980s, Tuttle's frames grew quirkier and more elaborate, mirroring his artistic practice as a whole during this time. *La Terre de Grenade* (pls. 227–28), from 1985, is a series of watercolors whose frames' multicolored paints bleed onto the adjoining expansive earth-tone mats. These drawings often are installed in a playful zigzag formation that suggests an effusiveness antithetical to the restrained precision of the notebook drawings' installation. The curvy, canary-yellow frames of *Egyptian Works* (pls. 229–30), from the following year, are objects in their own right—scaffolding more than

243 Rembrandt van Rijn **Susannah and the Elders** 1647
Oil on panel, 30 1/8 x 36 1/2 in.
Gemäldegalerie, Staatliche Museen zu Berlin

244 Richard Tuttle **#24 from Old Men and Their Garden** 1982
Watercolor on paper in handmade wood frame,
9 1/2 x 14 x 1 5/8 in.
Private collection

frames perhaps. And in 1989, several years into an investigation of assemblage that would take the form of sprawling "floor drawings" and smaller, wall-bound constructions, the frame actually becomes an element of assemblage in *System of Color* (pl. 231). The assemblage within is no longer contained by the frame but explodes beyond it, annexing it along the way as just one more component of the piece: wire, paint, paper, and wooden frames. Concurrently, Tuttle was using pieces of wood-strip frames in his floor drawings, thereby integrating the frame completely into the work.

In several series from the 1990s, such as *Verbal Windows* (1993; pls. 232–34), the frame shrinks to the point of being smaller than the drawing it ostensibly surrounds. Each of these fifteen watercolors on notebook paper is attached at the four corners to a galvanized metal box by small gold magnets (echoing the four nails of the *Paris Arles* group). A small foam-board "window" is placed over the center of each drawing. It is another testament to Tuttle's careerlong peripatetic approach to the frame, but it is as if the roles have been reversed, as if the picture now frames the frame. The title, *Verbal Windows,* recalls Tuttle's belief that language is a kind of frame, that before we begin to speak we are restricted by the frames of grammar, syntax, and vocabulary. In a similar series, *Indiana* (ca. 1993–94; pl. 245), Tuttle placed a blank white piece of paper within the frame of the notebook paper, and then *drew in* the blue lines so that it would resemble the surrounding lined paper. This is mimesis at its slightest (and its most sleight-of-hand). The frame (or edge) here performs its traditional role as delineator between illusion and reality, between the drawn and the "real" line.

Tuttle frequently makes work for an exhibition while in the space (or while thinking about the space), lending a degree of site-specificity to his practice. He created *How It Goes Around the Corner* (1996; pls. 236–39), one of his most recent series of framed drawings, with its exhibition space in mind: the Mies van der Rohe Haus in Berlin. Many of the elements of Tuttle's framed works discussed above appear here: seriality rather than sequencing; unfinished wood frames joined to create a sense of spiraling, counterclockwise motion; the transparent yet highly considered placement of the nails that hold each piece together; and even the "space between," which here is real space—a gap between scrap of canvas and wooden frame.

The Mies van der Rohe Haus was the last structure Mies built before immigrating to the United States. After his departure it was occupied by the Stasi, who adapted the original structure to their ends. Tuttle's work unfolds like a paean to the house, its architect, and its tenacity—the series a frame for the building as much as each individual work is a frame for the drawing inside. The works, which Tuttle has called "the tenderest thing I ever made,"[15] are spare and transparent, like Mies's architecture.

For Tuttle, there is only one question to pose regarding the frame: what is the *right* one? Tuttle's philosophical kindred spirit (one equally in pursuit of rightness), Kant, considered grace, mystery, and miracles to be the "frame" for reason.[16] These inexplicable phenomena are supplementary, exterior, and yet necessary: they *verge* on reason. What Tuttle so nimbly demonstrates is that the frame need not be simply that which cannot be accounted for or accommodated. A picture may act like a frame, and a frame like a picture. It is not so much that that which is peripheral, or just outside, must become central, or cross the threshold to the interior, but that the frame, whatever shape it may take, acts as a guide, for in Tuttle's work it will always lead to the crux of the matter.

TARA MCDOWELL

245 Richard Tuttle **Indiana #13** ca. 1993–94
Graphite, watercolor, colored pencil, and
gold on paper in handmade wood frame,
10 x 6 1/2 x 3/4 in.
Whereabouts unknown

NOTES

1 Conversation with the author, 1 August 2002.

2 Gilles Deleuze, *The Fold: Leibniz and the Baroque,* trans. Tom Conley (repr., Minneapolis: University of Minnesota Press, 1993), 35.

3 *Richard Tuttle: Portland Works 1976* (Cologne: Karsten Greve Gallery; Boston: Thomas Segal Gallery, 1988), 9.

4 As Robert Storr notes, Tuttle "subtly emphasiz[es] the *'colle'* and, more broadly, the tenuousness of the bonds between sticky, stapled, stitched, or delicately placed but unattached parts" (Robert Storr, *"Just* Exquisite? The Art of Richard Tuttle," *Artforum* 36 [November 1997]: 93).

5 Conversation with the author, 28 August 2004. That the space in which the work is situated can be the framework of the viewer's experience of that work is, of course, a central argument of Minimalism, rather than Postminimalism, once again proving the somewhat arbitrariness of the delineation between those two art-historical movements.

6 Tuttle actually made his first frame as early as 1968, for a drawing included in a group exhibition at Bykert Gallery in New York. For this series, which was made during stays in both Paris and the southern city of Arles, Tuttle has explained that he was interested in "the relationship between the North of France and the South...in a drawing as 'sandwiched' between two planes (possibly the North and the South) as a way to look at something" (quoted in Christine Mehring, "Richard Tuttle," in *Drawing Is Another Kind of Language: Recent American Drawings from a New York Private Collection* [Cambridge, MA: Harvard University Art Museums; Stuttgart: Daco-Verlag Günter Bläse, 1997], 210).

7 Conversation with the author, 4 January 2005.

8 Richard Tuttle, "Work Is Justification for the Excuse," *Documenta 5* (Kassel, Germany: Museum Fridericianum, 1972), section 17, 77.

9 Tuttle made a number of framed drawings around this time that he named after places he had traveled to, or where the work was exhibited, including *Finland Group, Egyptian Works, Indonesian Works, Japanese Works, Indiana,* and *La Terre de Grenade.*

10 Like Tuttle, Cage was deeply invested in Zen Buddhism, for which silence is an important concept.

11 This series was exhibited at Galleria Marilena Bonomo, Bari, Italy, in 1993.

12 Charles Bernstein and Ingrid Shaffner, *Richard Tuttle, In Parts, 1998–2001* (Philadelphia: Institute of Contemporary Art, University of Pennsylvania, 2001), unpaginated.

13 When he discovers an idea that he feels is particularly fertile, Tuttle will explore it exhaustively—this is true for the collage pieces of 1978, for example, and for the notebook drawings.

14 Tuttle considers the ineptitude of these frames a plea to framers to make "magical" frames.

15 Richard Tuttle, note in SFMOMA exhibition files, ca. 2002.

16 In a footnote to the *Critique of Pure Reason* later placed center stage by Jacques Derrida in his discussion of the *parergon* (that which surrounds the work, the "ergon"), Kant explained, "Because reason is 'conscious of its impotence to satisfy its moral need' it has recourse to the *parergon,* to grace, to mystery, to miracles. It needs the supplementary work" (quoted in Jacques Derrida, *The Truth in Painting,* trans. Geoff Bennington and Ian McLeod [Chicago: University of Chicago Press, 1987], 56).

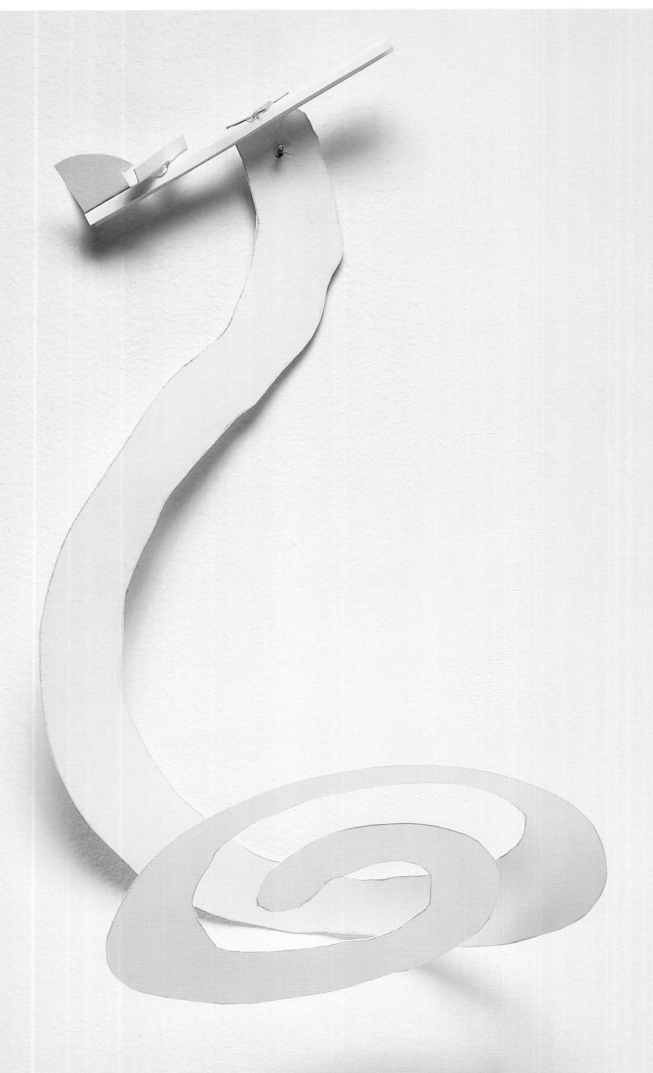

246 **The Spirals 11** 1986 10³/₈ × 7¹/₄ × 5 in.

247 Installation view of the 1987
exhibition **Richard Tuttle:
The Baroque and Color /
Das Barocke und die Farbe**
at Neue Galerie am
Landesmuseum Joanneum,
Graz, Austria, showing
The Baroque and Color #8
(1986)

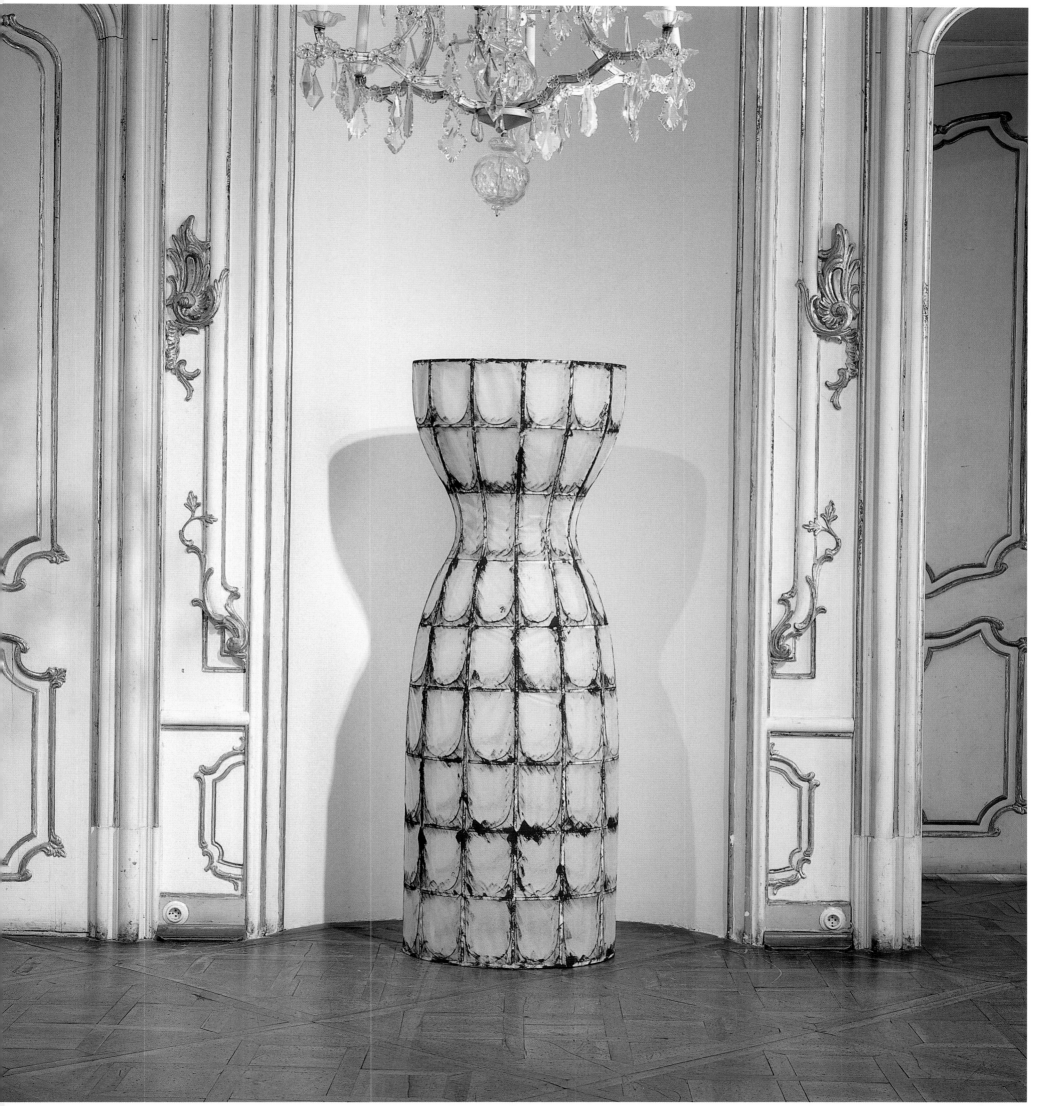

248 **Forms in Classicism** 1989 overall approx. 25 x 153 x 5 7/8 in.

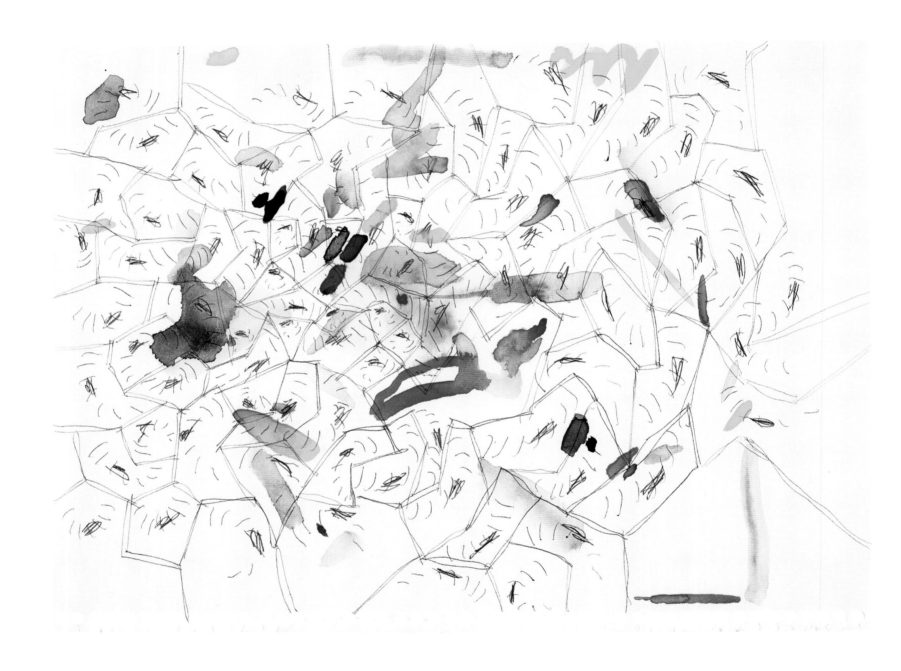

249 **40 Days** 1989 each 9 1/16 x 12 1/16 in., orientation variable

250 **40 Days #39** 1989 9 1/16 x 12 1/16 in.

251 **40 Days #9** 1989 12 1/16 x 9 1/16 in.

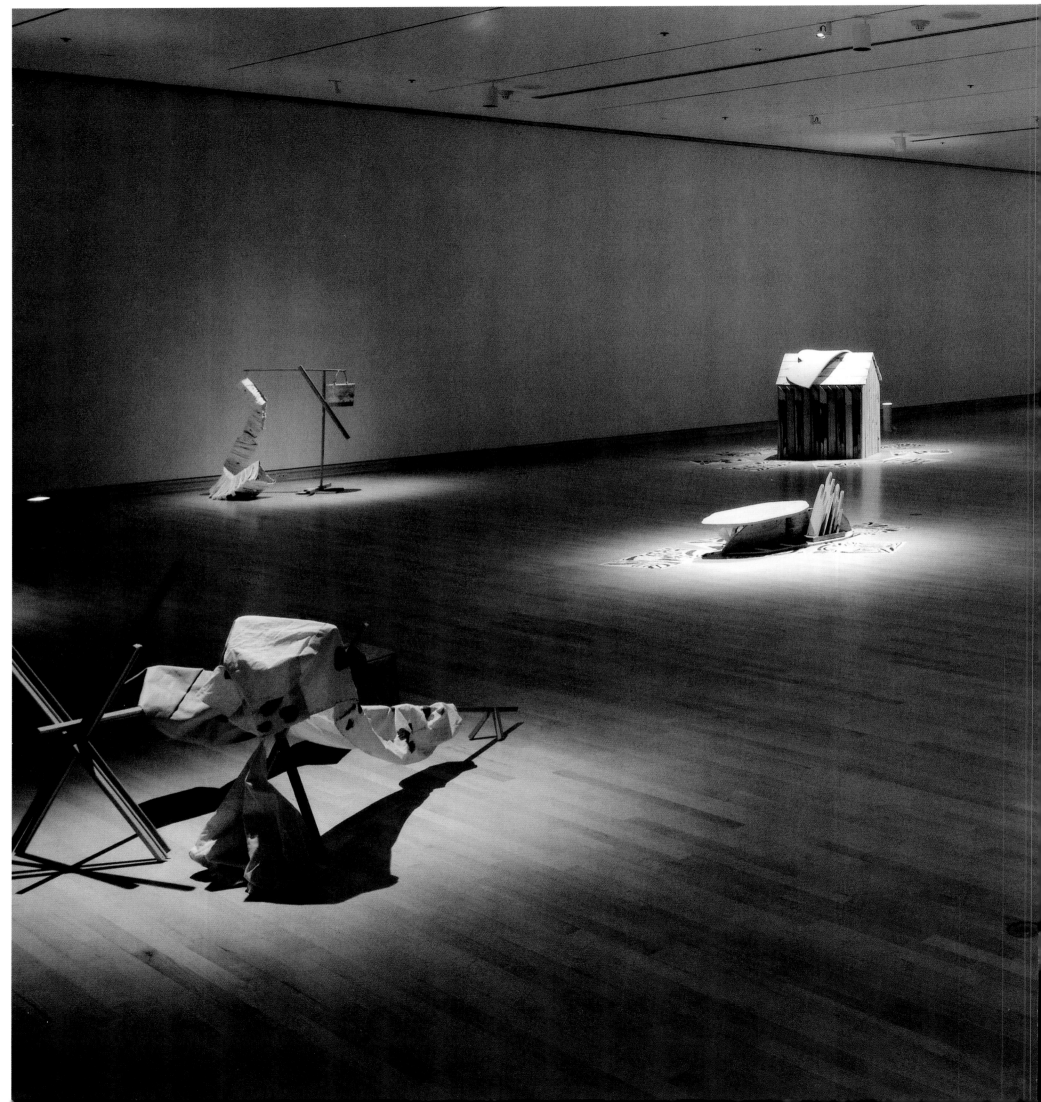

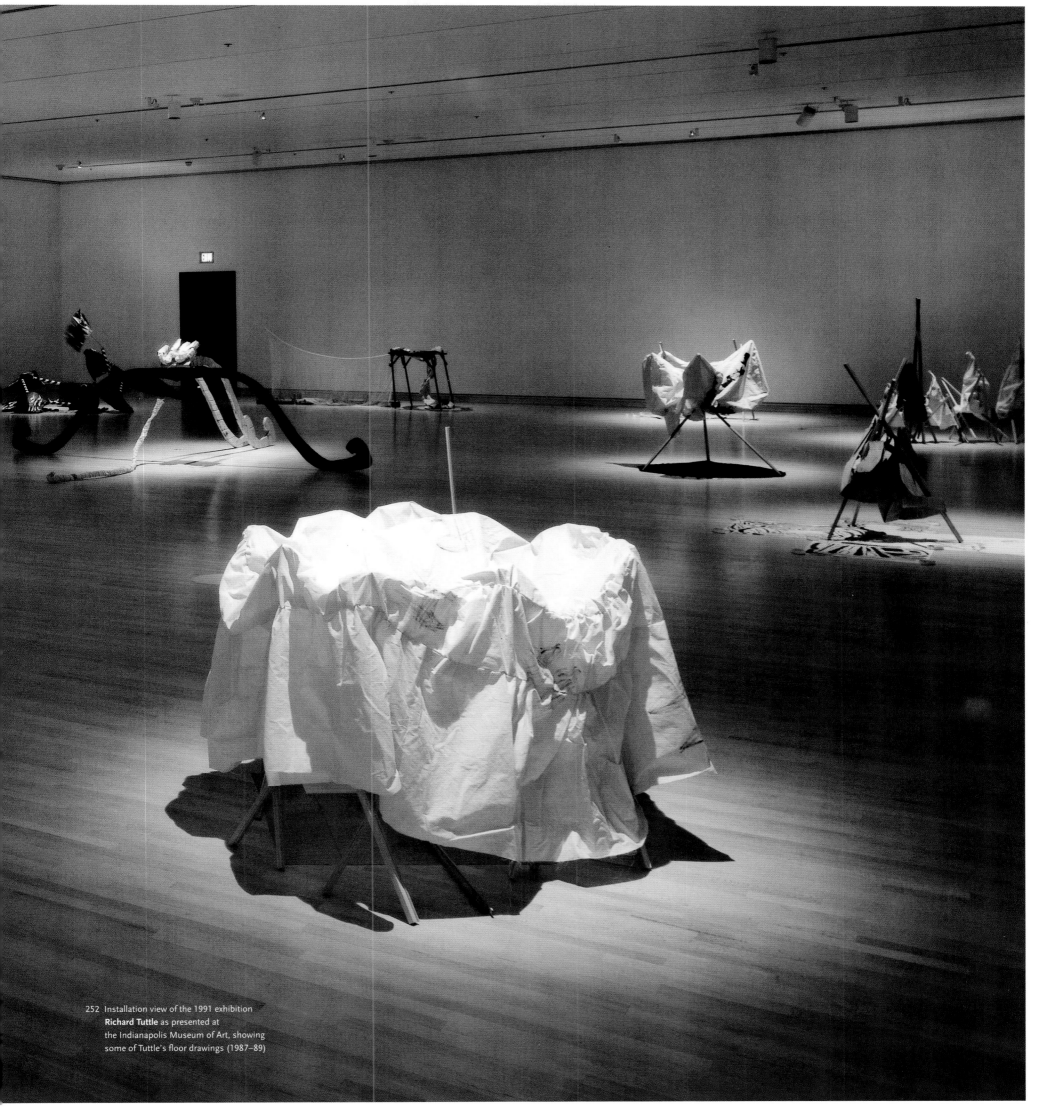

252 Installation view of the 1991 exhibition
Richard Tuttle as presented at
the Indianapolis Museum of Art, showing
some of Tuttle's floor drawings (1987–89)

253–60 Richard Tuttle installing **Four** (1987),
Taos, New Mexico, 2005

261 **Four** 1987 42 x 78 x 50 in.

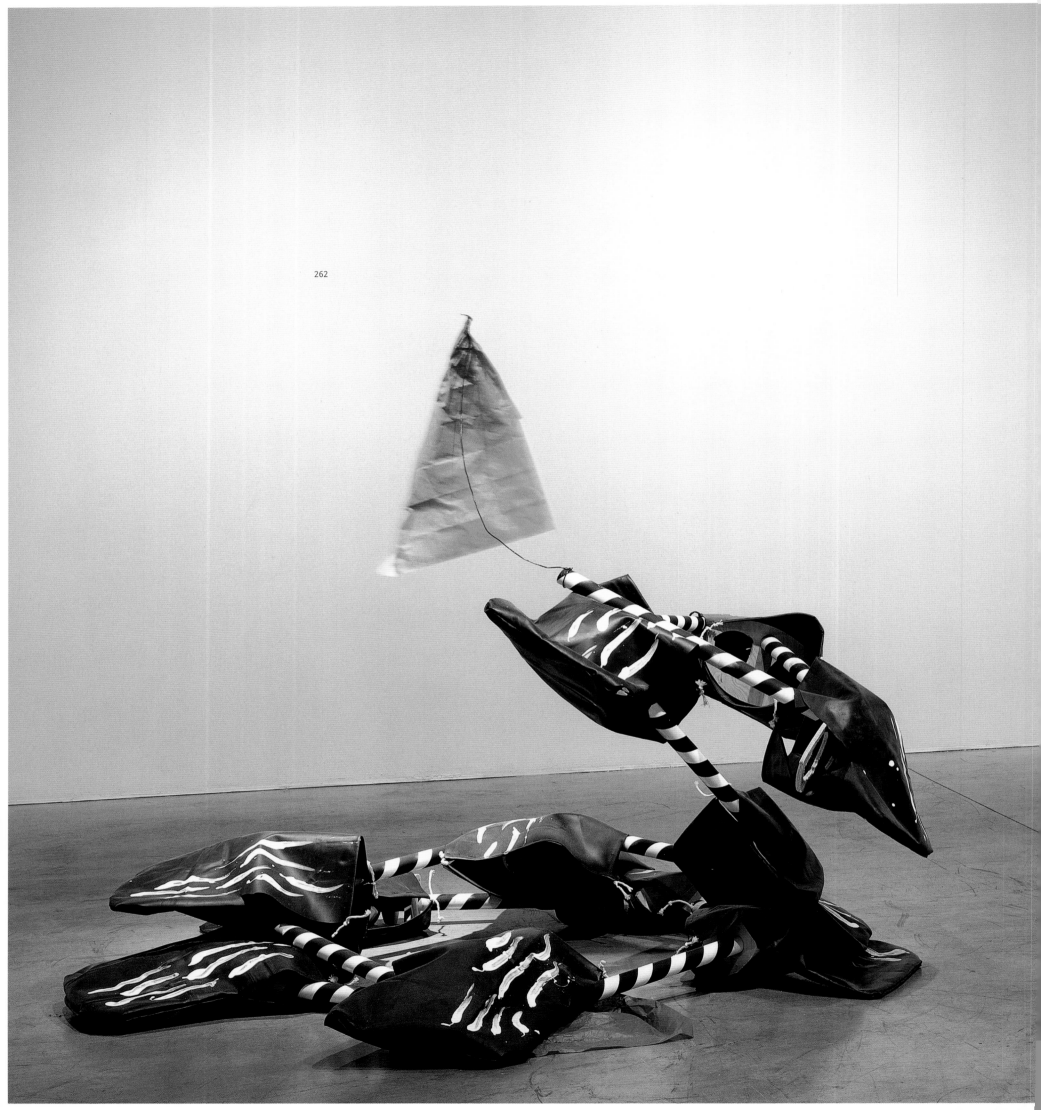

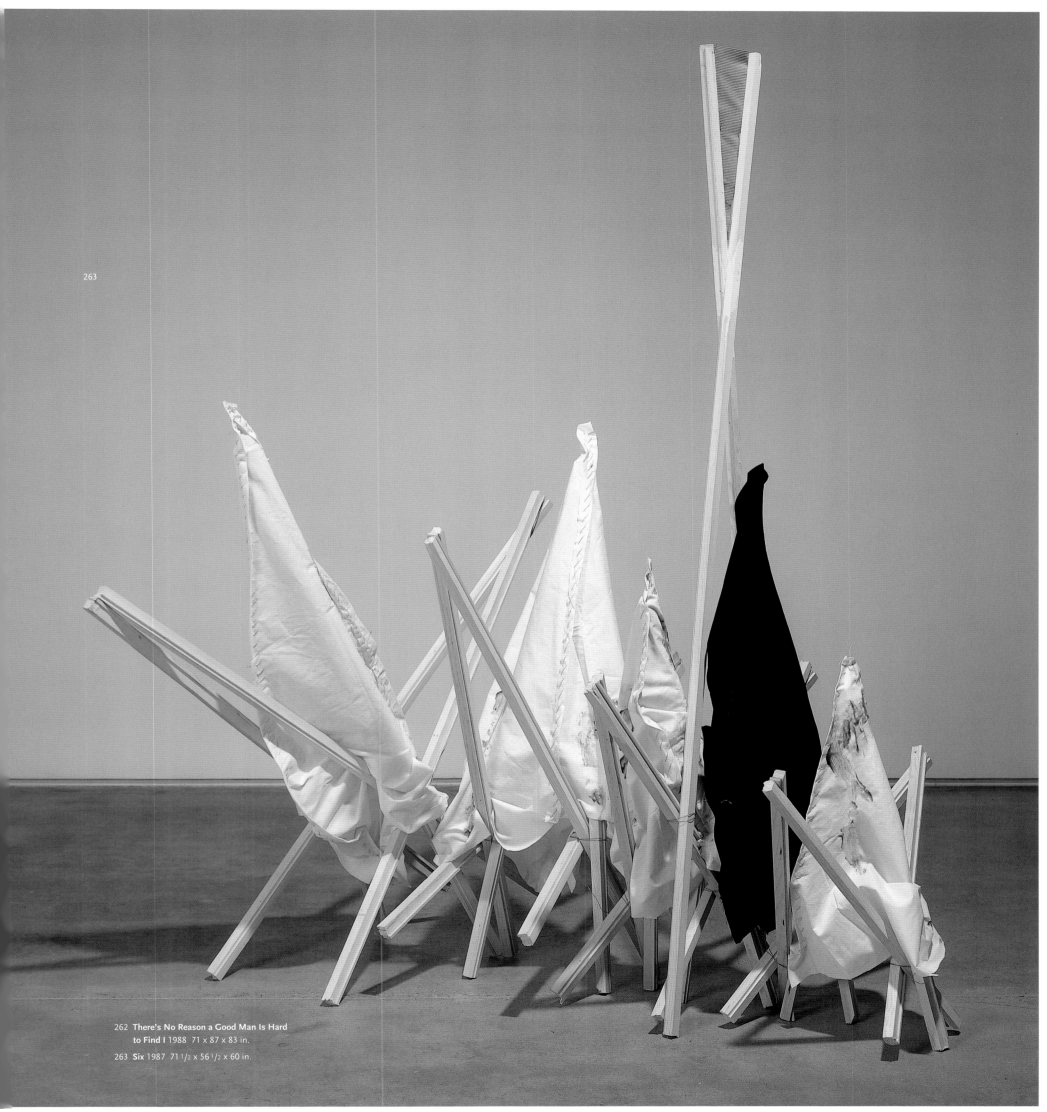

262　**There's No Reason a Good Man Is Hard
　　to Find I** 1988　71 x 87 x 83 in.

263　**Six** 1987　71 1/2 x 56 1/2 x 60 in.

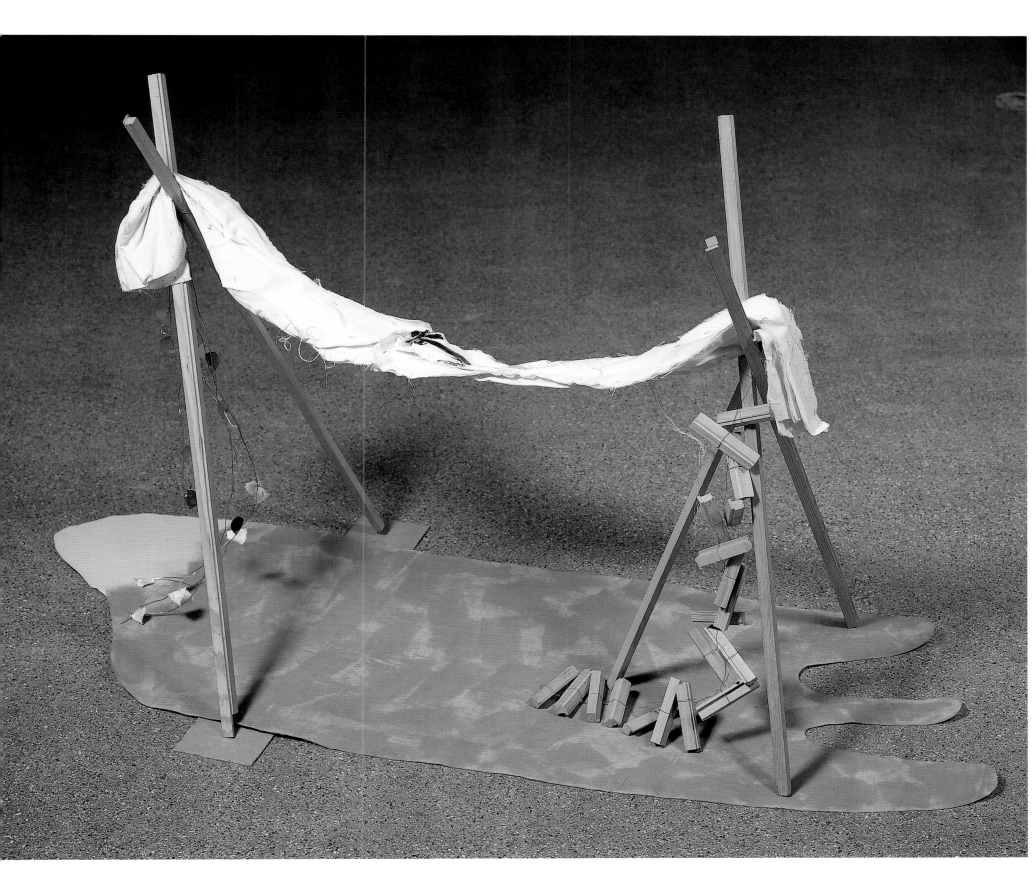

264 **Sand-Tree 2** 1988 overall 29 1/2 x 59 x 6 1/2 in.

265 **Turquoise I** 1988 34 1/4 x 70 7/8 x 35 3/8 in.

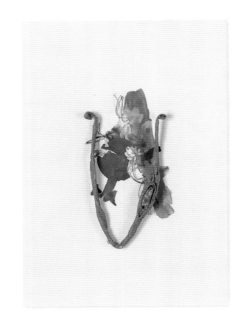
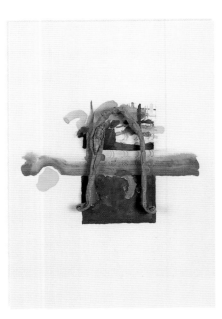

266–86 **Sustained Color** 1987
each 13 11/16 x 10 3/8 in.

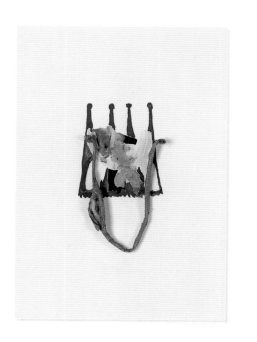
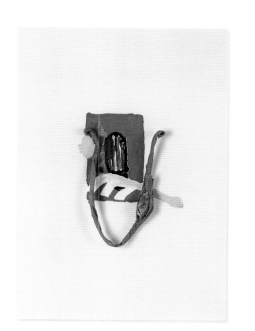

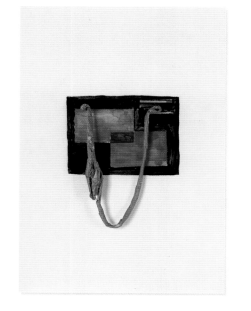
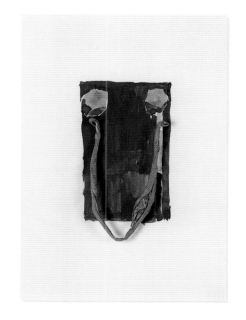
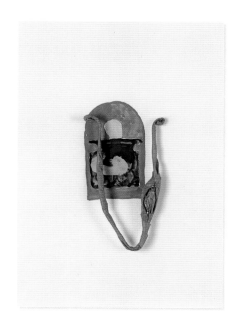

by Richard Shiff

IT
SHOWS

Richard Tuttle installing **There's No Reason a Good Man Is Hard to Find VI** (1988) in preparation for the 2002 exhibition **Richard Tuttle: When We Were at Home** at Galerie Schmela, Düsseldorf

In the field of the dream...what characterizes the images is it shows.... Our position in the
dream is profoundly that of someone who does not see. The subject does not see where it is leading,
he follows.... He may say to himself, It's only a dream. *But he does not apprehend himself*
as someone who says to himself—After all, I am the consciousness of this dream.

<div align="right">JACQUES LACAN, 1964[1]</div>

One person can make work for twenty-five years, and in the middle, something happens,
and there's no relationship between the early and the late work.... We always want to think
a human being has this connection, but the truth is the human being has no connection....
I'd really like to see the end of time or have an experience outside of time.... I'm not leading,
I'm following. I'm following something that is happening.

<div align="right">RICHARD TUTTLE, 1986, 1990[2]</div>

On February 19, 1964, psychoanalyst Jacques Lacan spoke about the curious vividness of dreams. To distinguish oneiric experience from other states of awareness, he set dreaming into a linguistic order, resorting to the impersonal voice of "it shows." In a dream, things happen—they just happen—including the subject's own acts of observation and response. Although the subject performs with apparent purpose within the dream-event, the dreamer feels removed from conscious intention and rationality. The most acute sense of the split between dreamer and subject-of-the-dream occurs at the moment of waking. A dream catches the dreamer outside the self, somewhere between the security of understanding what happens and the equal security of being aware of not understanding (knowing this for a fact). Aspects of intention, deliberation, expectation, and surprise show; yet the dreamer fails to perceive what the subject living the dream must know. Having identified with the emotional content of the situation, the dreamer still cannot acknowledge, "I am the consciousness of this dream."

In a waking state, we can assume a certain distance, regarding the self as an object of speculation, perhaps to ask, "Why did I just do that?" or, "Who am I? Who can this person be?" The dreamer's disconnection is different: involuntary rather than voluntary. The split between the one who watches the dream and the one who performs it escapes the control of ordinary discourse, the language we use to step into objectivity. Dreaming, we cannot set a first-person "I" in the position of a third person "he" or "she" as a thought experiment, organizing rational alternatives for possible action. We feel, "I'm not leading, I'm following."

Reacting to examples of his art, Richard Tuttle is sometimes now convinced, "I did not make this."[3] In 1975, he stated that he wanted work that looked "ecstatic, as though the artist had never been there."[4] To

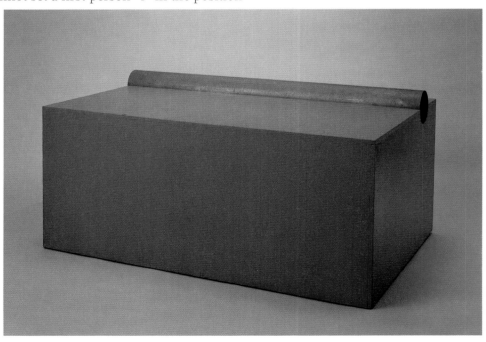

be ecstatic is to be outside oneself, untethered, disconnected: "I can look at the creative process in myself like I'm another person."[5] Tuttle must know that he produces his work in its material sense, yet he cannot fully acknowledge himself as the consciousness guiding its effects. His art loosens him from himself and his formation rather than asserting an individually formed personality and the general character of a culture—both his own. "My work is an effort to overcome identity," he says.[6] His art has no stable character, and the split he experiences is that of a dream. It has little to do with the controlled distinction between an "I" and its cultural alter ego: the "he" or "she" produced as a speculative object by self-analysis, the aesthetic mastery of self-expression, and the identity politics of competing social ideologies.

At the moment of Lacan's seminar, Tuttle was likely to be dreaming, even if awake. In 1964 he made the first series of works that he accepts as his mature production, his three-inch paper cubes (*Untitled*). Perhaps he understood immediately that such work had significance because plates 1–10, 39 something showed. Yet he was then, as he is now, a person who "does not see where it is leading." His conscious failure to see in the usual projective way (as when people direct their path to where they imagine they will have gotten) allows his art to span the divide between passive and active states, dreaming and waking. He risks incoherence by withdrawing the usual respect for mutually exclusive binaries—unconscious or conscious, inside or outside, self or other. Division of this sort structures reflective thought, eliminating insecurity by making the nature of human choices clear. While facilitating decisiveness, the same binaries restrict the flow of ideas and even emotions. Yet, in a well-disciplined society with standardized cultural forms, such limitations tend not to be perceived; few have cause to resist them.

Tuttle associates the exclusivity of binaries with what he calls the "canon," the set of practices and standards that delineates the realm of creative possibility. By defining right and wrong within a discipline, a canon can rule on everything a person might imagine doing. Doing the impermissible—representing obscenity, for example—may be "wrong" (in the sense of being recklessly offensive and a source of cultural violence), but it remains within the purview of the canon. Transgressing proper behavior is merely rebellious gainsaying, thoroughly understood in terms of established cultural patterns. An artist must be subtly inventive to realize a new freedom outside the recognized transgressions. Asked what his art addresses, Tuttle replies: "the moment where we feel least understanding."[7]

His older contemporary Donald Judd also dreamed of being released from the tyranny of binaries—proper or subversive, right or wrong, this or that. In sculptural practice, "a form that's neither geometric nor organic would be a great discovery," Judd mused.[8] He never claimed to have eliminated the geometric-organic divide, but his objects—boxlike, yet strangely unfamiliar— affected other canonical distinctions. Their way of projecting from the wall or the floor removed their space from the categorical boundaries of both painting and sculpture.[9] Constructing a floor box in 1963 (*Untitled*), Judd, thinking as Tuttle might, "did a great deal of juggling to make [its features]" plate 288

288 Donald Judd **Untitled** 1963
Oil on plywood with iron pipe,
22 1/8 x 45 3/8 x 30 1/2 in.
Hirshhorn Museum and Sculpture
Garden, Smithsonian Institution,
Washington, D.C., Joseph H. Hirshhorn
Purchase Fund, 1991

uncomposed."[10] Judd's advice to others in 1964: "Use a simple form that doesn't look like either order or disorder"; in other words, ignore the way things are supposed to look (whether geometrically regular or organically irregular) and let them show as they are.[11] However pragmatic his reasoning, Judd made art in the dreamlike realm of neither-nor.

Independently, this has also been Tuttle's realm, from the very start of his career: "To make something which looks like itself is...the problem, the solution."[12] He has released himself from canonical binaries through a long-sustained practice of "drawing." By capitalizing on the capacity of paper to be folded, his cubes of 1964 converted the conventional drawing support to a set of sculptural, even architectural forms with a capacity to display the volume of an inside along with the planarity of an outside ("It was as if I had to get into the space of the interior box and explore"[13]). Over the years, Tuttle has used a remarkable range of devices to extend into space and light such insubstantial materials as masking tape, bits of cloth, and sawdust. Given the particular nature of the material, he might crumple it, bend it, congeal it with glue, or stiffen it by various means—whether by adding an armature of wire, laminating it to a certain thickness, or combining it with another insubstantial but pliable material (often paint or paste). Several of these techniques are evident in small-scale, relieflike works such as _L 1_ (1981), _#28_ (1981), _The Spirals 7_ (1986), _Village III, No. II, 8_ (2004), and _Village III, No. II, 9_ (2004). Analogous techniques appear in large, expansive wall and floor pieces that combine unusually disparate materials; _Monkey's Recovery for a Darkened Room II, #5_ (1983) and _There's No Reason a Good Man Is Hard to Find VI_ (1988) are examples.

Tuttle has also put shadow into play as a "material." In _New Mexico, New York, #10_ (1998) and _"Two with Any To, #1"_ (1999) it becomes a constructive element despite its inherently immaterial nature. And there are various ways to experience it: "The shadow that's produced in artificial light can be useful in creativity in one way, whereas the shadow in natural light can be different."[14] Many works demonstrate that a vague shadow projected by very low relief, or from a sheet of paper lifting ever so slightly from a wall, can transform "sculpture" into "painting" (by removing hard and fast physical boundaries) and "painting" into "sculpture" (by articulating dimensional levels). The presence of shadow cannot be theorized as a definitive marker of either medium; it supplements and complicates both. The mere overlap of one sheet with another, so that shadow is present but hardly so—as in _Rose Weight_ (1989)—substantially alters the conditions of perception without indicating how the new sensory element should be integrated with the others.

plate 198
plate 289
plate 290
plate 287

plate 326
plate 341

plate 309

289 Richard Tuttle **Village III, No. II, 9** 2004
Acrylic, balsa wood, basswood, masking tape, and sawdust, 4 x 4 x 7/8 in.
Private collection

Tuttle's procedures bring a structural presence to fragile materials and inherently unstable phenomena that otherwise verge on invisibility. In turn, elements of his large, nominally sculptural constructions evoke the fluid transience of the finest of graphite lines. He calls *Turquoise I* plate 265 (1988), which extends to nearly six feet, a "floor drawing." It approaches the geometry of architecture while manifesting a sense of the rise, fall, and gravitational flow of the natural environment. The "base" of *Turquoise I* consists of a piece of painted canvas having no apparent structural function. Tuttle cut it so that its shape suggests fluidity, as if the canvas were a liquid spreading over the floor— like paint itself. Yet he brushed the paint in a manner that makes the difference between paint and canvas evident. Above this base, he suspended a second spread of canvas from two sets of wooden struts, shaping four separate strips of the pliable material into one by adding an armature of thin wire. The second canvas becomes more of a physical construction than a flat, projected image. Yet, as it stretches between its two wooden supports and sags in reaction to gravity, this fabric, too, assumes an "image" of fluidity. Analogously, from one of the two wooden supports, Tuttle hung wires with bits of canvas attached by strapping tape. Here the image, if it can be called one, is of branches and leaves; but the physical effect is of the fall or flow of repeating (fluttering?) leaflike shapes. From the opposite wooden support, a set of wooden bars suspended by wire likewise seems to fall. These wooden elements form a sequence, and therefore a linear, flowing movement. Each element is rigid and nearly perpendicular to the direction of the sequence, yet the image (again, if it is one) evokes fluidity. From the appearance of *Turquoise I,* a viewer is uncertain whether its construction is precarious or merely gives an impression of transient flow because of the shaping and positioning of its constitutive parts. The structure shows itself from every viewing angle, and yet there remains everything to learn about it. Would Tuttle admit to having created each possible image within this work and every structural analogy? Probably not—or no more than he would admit to having intended every conceivable ambiguity. In *Turquoise I,* something is happening, still, even now.

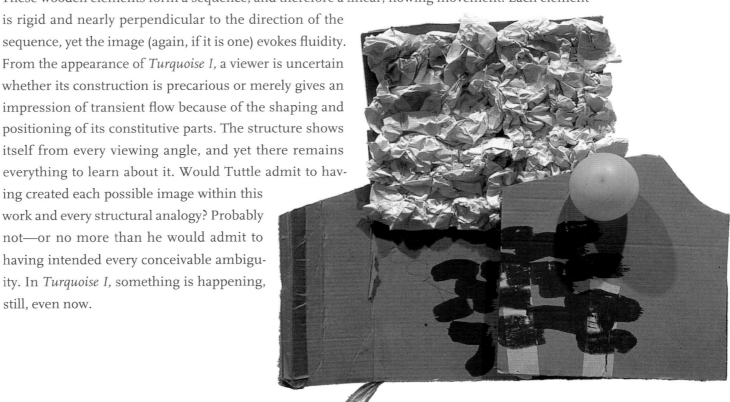

290 Richard Tuttle **Monkey's Recovery for a Darkened Room II, #5** 1983
Balloon, paper, corrugated cardboard, natural pigment, and acrylic binder,
25 3/4 x 31 x 8 in.
Collection of the artist

NOT-SEE

In 1964, while Lacan lectured on dreams and Judd (as well as others soon to be associated with Minimalism) was inventing volumetric objects designed to evade the strictures of a traditional sculptural aesthetic, Tuttle was in New York becoming an artist.[15] For the record, he had been taking courses at Cooper Union. His two activities—studying art, becoming an artist—may never have been coordinated. In a sense, Tuttle was an "artist" long before acquiring any professional training. He states that he "was born knowing the rules"—the pictorial rules.[16] At a very early stage, he somehow developed the sensitivity and skill to organize a composition in two or three dimensions so that those more experienced in art would appreciate it. He seems to have intuited quickly what others learned only gradually. Their study led them to the organized places where art had already been. In his case, with the rules assimilated at the start, art, having to lead somewhere, was leading elsewhere.

Asked to make an aesthetic declaration in 1968, he began: "In life you can do two things. In art you can do one thing."[17] In life, we make decisions, choosing one or the other binary alternative, often merely a yes or a no or an active or a passive, because we take a reasoned guess at the consequences likely to follow each of the options we perceive. Making voluntary choices, we give our life a direction. In art, it may be necessary to guess only as one moves along, rather than estimating beforehand. A time to guess is hardly there. Tuttle learned that knowing the rules is of little avail, for at any given moment there is but one way to go, whether with or against the rules. It shows—and only at the very moment.

Tuttle rejects no form or structure out of hand, because this would imply a theoretical knowledge of what art must be (through knowing by the logic of binaries what it cannot be). Nor would he wish to convert, subvert, or transform existing models, traditions, canons, or conventions. This would imply an understanding of which kind of art is right and which is wrong, as well as a sense of where art in its current practice should be heading. Tuttle avoids such judgments and lets his art do what it must do, often referring to it, Lacan-like, in a passive, depersonalized voice. His drawings "have come," he says.[18] He speaks of the "intelligibility" of the structure of a recent installation as something that "will become apparent as time goes on"—to him as much as to others. With regard to stating what the structure is, "it might be better to wait until it comes out by itself."[19] And if it comes out one way now, it may come out some other way later, with time and an altered perspective.

Accepting this insecurity, Tuttle nevertheless works with the greatest deliberation, assessing his results in order to build on them, seeking the meaning of what he has already accomplished, as if it were an allegory of a truth not yet revealed to him. Without rejecting canonical works of the past or the aesthetic standards they promote, he recognizes that they establish one of the most absolute of binaries: the visible and the invisible. Whatever art has already shown is the

visible. Everything else is invisible. This is not a question of the physical and the metaphysical or the material and the spiritual, for each culture makes certain intangibles visible, its metaphysical and spiritual truths, represented in that culture's art and literature. Whether material or spiritual—a distinction of little consequence to Tuttle—we attend to what we can see, that is, what we already know and believe. We ignore not only what we do not see but also, more perniciously, the human fact *that we do not see*. Alert to our conscious needs, we see only what we are looking for, that is, whatever affirms and pleases us: the shared cultural values and the personal predilections, which may themselves be a disguised product of the cultural values.

Tuttle recognizes that "drawing" can lead experience elsewhere. What kind of drawing would this be? "Successful drawings always fall on the side of what can be seen," whereas his drawings "fall on the side of what cannot be seen." He elaborates: "We don't really know what drawing is, for, as the failed side is lacking, drawing hasn't yet reached the whole of what it is." According to this distinction, his art—drawing that moves to its failure points—must be unsuccessful, even incoherent, by any canonical standards. Outside the logic of binaries, it admits the negative without rejecting the positive. A canon allows only two possibilities, mutually exclusive: success or lack of success, coherence or incoherence, positive or negative. In fact, "success" escapes Tuttle because his art has no standard end to reach. In this case, however, lack of success does not entail incoherence. Like Lacan's attentive dreamer, Tuttle simply "does not see where it is leading." Dreams do not appear incoherent; in fact, they *feel* quite coherent, but their logic escapes the dreamer. To see, Tuttle must not-see. His is a nonprojective vision: more of a feel that something is happening than a foreknowledge of the category of occurrence—its "identity."

"Suddenly," he says, "you get into a whole new world, which is like when you fall in love with someone and even love what you don't like." Unreserved, love is beyond prediction and projection. "If you really love drawings, you must even love the parts you don't like"—the parts that fail because they fail to affirm your taste, the parts that (in a canonical world) should be out of the picture, unseen. You must nevertheless love those parts, Tuttle says, "for you see them as drawings."[20] Through his act of drawing he often conceives of what it means to be a human being (whether human as a source of agency or human as an object of love): "An element within the drawing can [be the] causative factor for drawing another part of the drawing.... The drawing then becomes a drawing of drawing.... It feels [as if] the human being has an unlimited capacity."[21] Is there a gap in Tuttle's reasoning? Not really. Human beings make drawings. He argues that a drawing and a human being share similarly in autonomy; both are free to change. His commitment to follow the lead of drawing turns aesthetic "failure" into success, or at least into something that he must accept, however alien to him—because, for no reason other than that a drawing has gone somewhere, he can love it. "I get a lot of encouragement when I can't understand the reason why something exists. But it does exist."[22]

In September 1965, only twenty-four years old, Tuttle had a one-person exhibition at Betty Parsons Gallery. He installed forms he had rendered in thin, hollow sandwiches of sheets of painted wood. The forms were flat; yet they projected slightly into space, one to two inches above the support surface. Viewers could see them either as shaped paintings or as sculpture in low relief. He shaped the wood in accord with preparatory cartoons of cut paper, his pliant drawing material. The slightly irregular, wavering edges of both the paper and its imitation in wood evoke the quality of hand-drawn lines, exploratory vectors that respond to conditions while moving along. The more pliant and adaptable the materials, the more readily such responsiveness registers. In wood, because it is relatively rigid, straight cuts are easier to achieve than the irregular cuts of Tuttle's objects (e.g.,

plate 53

Drift III [1965]). Yet his irregularities avoid looking mannered and do not even seem fully intended; they express neither a style nor an attitude. Such irregular irregularity offered Tuttle the advantage of escaping straightness, a quality with the potential to be perfected. Perfection of this type—like the accentuated irregularity that signals an emotive, expressive individual—is a foreseeable goal. Tuttle's irregularity is otherwise, belonging to his forms and materials rather than his hand. (His

plate 291

frequent use of ordinary plywood, which can splinter when cut—*Two Blocks* [1970s]—and which

plate 340

catches unequal amounts of paint in its rippled grain—*Replace the Abstract Picture Plane IV* [1999], *Overlap A23* [2000]—may reflect his delight in such deadpan, canon-free irregularity.)

plate 63

For his 1965 installation, Tuttle placed some of his constructed paintings against the wall, others against the floor. He was more interested in the fact that wall and floor are distinct than in how this difference might generate a theory. Such a difference shows in context—that is to say, in action—as an object takes a position in relation to an impermanent environment of space, light, other objects, and the posturing of viewers. Especially with respect to viewing position, Tuttle became involved with the specific height at which certain (but not all) of his objects should be displayed against the wall (more on this to come). "Our response to any image," he stated recently, "is a response to the space it inhabits."[23] Some years after the inaugural Parsons exhibition, he gathered all the drawings that happened to be in his New York studio and moved them to Annemarie Verna Galerie in Zurich—"to promote their autonomous existence as a group in another place."[24] There the drawings redrew themselves.

291 Richard Tuttle **Two Blocks** 1970s
Plywood, nails, and string,
2 3/4 x 5 7/8 x 1/4 in.
Collection of Brooke Alexander, New York

Tuttle's wooden shapes of the 1960s were familiar in their simplicity, yet unfamiliar in the irregular specifics of their contours. A gray form approximated a thin arch or an inverted *U,* but it bore the title *Hill* (1965). For some viewers, this might cause the form to become more of a pictur- plate 292 esque landscape than either an element of architecture or a cipher of graphic design. If so, would it be an iconic, look-alike representation of a hill or an abstract symbol of the character of hillness—its silhouetted arc, its geological arching? Perhaps this form was no more than itself, a piece of painted wood with its distinctive shape, which might or might not refer to something else in the complex world of mental images and material structures. In certain contexts, the woodness of *Hill* might become more prominent than its hillness. Like an object worthy of love, the shape with its colored surface and projective depth exists in either case: it shows. Seen flat against the wall, such a "hill" of cut wood could morph into minimalist painting. Or it might become low, uninflected, sculptural relief.[25] The question of categorization has been particularly vexed in Tuttle's case, which is a factor of his achievement. Lack of conceptual stability has allowed his forms to be viewed freshly through several decades, even by their creator.

At the Parsons show, Tuttle presented two elongated bars painted with blue acrylic, set parallel to each other and at a diagonal in relation to both the horizontality of the floor and the verticality of the wall. He titled this work *Equals* (1965). Are the bars equal to each other—that is, are plate 47 they (two) equals? Does the irregularity of each—in cutting, in paint application, even in the angle of presentation—limit them to being equals in name only? The two bars taken together can be viewed as a single sign, the "equals" sign. Tuttle's title operates accordingly in two ways: it names the sign represented by the two wooden bars and alludes to an active judgment of equality between them, defining the condition of their equivalence (and if, to the contrary, the bars were judged unequal to each other, they would fail to constitute an equals sign—so their title, while raising the question, begs it). The word *equals* itself fluctuates between noun and verb, naming and doing, authoritative identification and assertive performance. Two things are equal only if, by some arbitrary operation, we determine the respect in which they demonstrate equivalence.

Tuttle's early objects equivocate over equivalence, moving between the familiar and the unfamiliar, sometimes shifting position from wall to floor, and sometimes changing appearance due to handling and wear or the interventions of collectors who display them.[26] His two wooden

292 Richard Tuttle **Hill** 1965
Acrylic on plywood,
37 x 43 1/4 x 1 1/8 in.
Louisiana Museum of Modern Art,
Humlebaek, Denmark

bars, with or without a title, are like words; they become through our cumulative use and experience of them more connotative than denotative. And like words, they seem public, available to be appropriated by an author-creator but immune to being permanently marked by the personality of any single author's hand. Unlike words, Tuttle's signs maintain a specific materiality, yet one that can approach invisibility. Many of his works are particularly small objects, with still smaller internal elements calling for visual attention (yet invisible to those too concept-bound to look). His series of white octagonal forms cut from relatively large, thin sheets of paper around fifty-four inches in diam-

plate 90

eter—*1st Paper Octagonal* (1970) is an example—approaches invisibility by other means. He pastes these forms flush to a white wall, pushing his materiality to the not-see limit of experience where an impersonal it-shows occurs. Tuttle expected that he could dramatically reduce the perceptible difference between his geometric shape and its supporting wall, but the *Paper Octagonals* proved him wrong: the space between remained "infinite."[27] When the space shows, you see—or not-see. You see what it shows. (Once you have not-seen, not-seeing and seeing can be the same.)

With forty years of public productivity now behind him, Tuttle is not an "artist" (this can be no more than an honorific title).[28] "Born knowing the rules," he is still *becoming* an artist. The rules do not enable him to see—foresee—how to make art. He makes no claim to universal success. He can only make art when he does, that is, when the art shows. In 1990, he admitted that his drawings and objects were unlikely to answer the questions they and his own life were posing. If answers were to appear, they would not be in a form that would register as an intellectual foundation for further action. Yet his practice of art was providing the greatest opportunity: "I think that I get a chance to be aware."[29]

So Tuttle remains a somewhat passive spectator in the midst of a very active artistic process that takes turns (reorientations) for which his previous experience gives him scant advance indication.[30] In this respect art is a paradigm for life. Its possible turns are a life's possible turns, made available to consciousness.[31] Tuttle has acknowledged the inevitability of changes that an individual cannot direct, changes so pronounced that they disrupt the inertial continuity of experience, which otherwise maintains each person's comforting sense of self, his or her self-connection: "In the middle, something happens."[32] "Middle" does not refer to any specific time. We live always in the middle of processes and events (going "through life like a cork floating on the sea" is how Tuttle sometimes imagines it[33]). An artist—a person ever becoming an artist—is one who sees the dream state under waking conditions. In the midst of a situation already formed and defined, an artist recognizes that something else is happening, something larger perhaps. It shows.

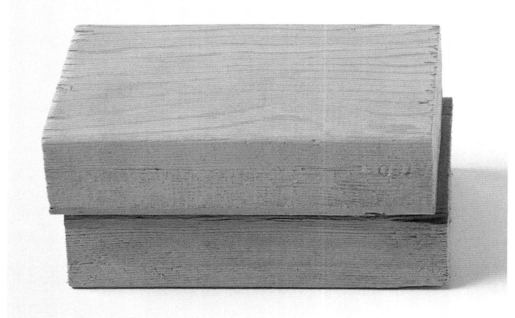

AFFECTATION VANISHING

Richard has the courage to change his thinking, and I don't want to use the word
experiment, *but I would use* change. HERBERT VOGEL, CA. 1990–91[34]

If I can free a humble material from itself, perhaps I can free myself from myself....
I think [my work] knows, is smarter than I am, better than I am. RICHARD TUTTLE, 2004[35]

Identity is stable and fixed. To the contrary, every happening constitutes a change in the given condition. To those who are attentive, materiality reveals unexpected qualities, properties, and relationships: "We would focus in on very slight details," recalls collector Dorothy Vogel, commenting on days spent looking with Tuttle.[36] Materiality offered him the means to explore a certain purpose: "to overcome identity."[37] This entailed abandoning every fantasy of continuity, connectedness, and control. If the self is my identity, to "free myself from myself" would be to change or counteract the culturally imposed force that makes things alike—the identity that induces me to act like myself.

"There seems to be a premium on the ability to contradict oneself totally while maintaining complete integrity, don't you agree," Tuttle remarked, at once seriously and facetiously, as if acting out his own thought. He was responding to my having probed the curious notion that individuals have "no connection" other than imagined ones.[38] A person's identity, which ought to be entirely specific, acts as a limiting generalization—the selection of a number of canonical characteristics taken to represent the whole. Once established, an identity does not change; this is the fantasy (not the dream) of connectedness. Like race, class, or gender identity, personal identity typecasts its possessor. It does so in such a subtle way that most people do not resist or contradict it; they let "I" be objectified as "me" and even a third-person "he" or "she." We willingly identify ourselves as a certain type and then predict our own reactions to events, as if this inversion of subject and object were granting us a kind of introspective knowledge. To the contrary, Tuttle believes of his work that it "is smarter than I am"—an uncommon attitude. He is not the smart one; the work is. He recognizes his dreamlike need to follow his art, ignorant of where it may be going, because virtually everything remains to be discovered. The more a work incorporates material change—freeing itself from its proper identity—the more exemplary and instructive it becomes. Tuttle "asks it to tell [him] what it knows and then [he] humbly listens—the payoff is greater than the humiliation."[39] Having been created, a work of art only just begins.

In 1996, preparing for an exhibition, Tuttle reviewed a set of small sculptures from the 1970s, works such as *White Rocker* and *Rest*: "Much to my surprise, pieces I didn't understand became understandable (as part of the attention given by the show, or due to the passage of time, I do not know)."[40] He recorded his experience of each work, sometimes in terms of an expanding set

plate 131 / plate 293

of questions. Concerning *Rest,* which sets a layer of bluish gray paint between two slightly offset wooden blocks, as if the color might act as a flexible, connective membrane, Tuttle asked, "Is there a way to see 'touching' in this way, i.e., which is inscribed as not seen?"[41] Presumably, the "rest" of the bluish gray continues beyond its visibly painted edges, lying between and therefore touching the two blocks, which touch (or "rest" against) each other, so that *Rest* constitutes a visual demonstration of the nonvisual nature of the tactile.

Herbert Vogel's reference to "change" as opposed to "experiment" was in part a response to Tuttle's sensory and intellectual openness to his past work, which for the artist, as for the viewer, is never more than nominally completed. Whereas experiment is voluntary and controlled, change is often involuntary and abrupt.[42] As if by chance, change happens. The fragility of Tuttle's work becomes the material representation of his acceptance of change: "People like something that lasts; I like something that vanishes."[43] Why? Perhaps vanishing is consistent with a loss or blurring of identity. Allowing one's hand-wrought creations to disappear is a step toward releasing an identity from its pretensions to permanence. Vogel comments: "He does not use rag paper but the cheapest paper…. He wanted that effect. Some of his constructions are so fragile that they will come apart in time."[44]

Tuttle's objects have an experiential transience independent of the passage of time. Because their irregularity is neither stylistic nor expressive, we cannot generalize, and therefore cannot remember their precise form. A memory would require a new view-

plate 21

ing. The individual sides of each of Tuttle's cloth octagonals, such as *Purple Octagonal* (1967), appear unequal in length but not absolutely so. Certain ones *might* be equal to certain others, that is, they appear neither obviously equal nor obviously unequal. The effect is of irregular irregularity—unmemorable in both its parts and its whole, but memorable as a unique visual experience that, with every reiteration, would require equally undiminished attention. A person does not become "familiar" with such an extreme degree of specificity. Scanning from one segment to another, either across the diameter or around the circumference, a viewer is at a loss for concepts leading to an efficient verbal description of the visual form. It hardly looks octagonal, even. Verification of the eight-sidedness demands counting.

The experiential transience of Tuttle's objects shows in many

plate 294

ways: for his recent *Village II, Sculpture* (2003) he applied glitter to a twisting column of Styrofoam, a form that induces a viewer to follow the twist around. In accord with the movement of viewing, the glitter catches ambient light in ever-changing ways, encouraging still more movement. The sculpture can be remembered only in terms of its motion—the viewer's, that is—for it has no experiential form that remains static. It has no "identity." "I am of a mind to

do everything for a short time," Tuttle states, believing that "all collectable from the past, all future precautions, everything, should be poured into the present, which is temporary."[45] The situation changes. Something is happening.

Tuttle's 1972 series of forty-eight *Wire Pieces* may be the easiest of his vanishing acts to grasp in principle (though we should hesitate to hold Tuttle to principles of any kind: principles establish canons, which frame identities). *21st Wire Piece*, like others of the type, consists of three elements: a line drawn by Tuttle on the surface of a wall; a wire strung along the length of this line, fastened to the wall by a nail at either end (the terminal points of the line); and the shadow or shadows cast by the wire upon the wall. Although a pencil line is for all practical purposes unlimited in flexibility and a wire is itself entirely linear, Tuttle's wire cannot follow the lead of his pencil because, as a result of having been coiled, it retains a certain stiffness and springiness; this, coupled with its weight (however slight), causes it to project out from the wall, rather unpredictably. The shadow then follows the wire, not the pencil, but its own linear configuration is equally determined by the position of the source of light.

plates 118–19

In *21st Wire Piece*, the three elements—pencil, wire, shadow—constitute very different states of drawing. The wire manifests the two nearly right-angle bends of the pencil as well as its very acute angle, but has curled upwards into a curve, which its shadow extends to a greater length. Tuttle comments, raising the essential issues:

> At the beginning of the Wire Pieces, the question for me was "how can I keep myself out of my work?"... Drawing for the Wire Pieces is intended to empty every capacity I have. I have a configuration in mind and try to draw it "perfectly," by hand.... I can know exactly what the pencil will be, but I never know what the wire will do, that's conditioned by many things. And then, I have really no idea of what the shadow will do, none at all.[46]

With his wall drawing effort, often quite a physical performance, he renders his capabilities—intellectual and emotional as well as manual—"empty." He (his identity) vanishes. Because of this, whatever sensibility he possesses as a mere living being remains free, clear, without direction; in his drained state, he becomes receptive to whatever may show. "The passage from individuality based on control and direction to an individuality which is time"—that is, change, movement, immediacy—"is one of the greatest sagas of our times, and the *Wire Pieces* chronicle this."[47]

An analogous way of keeping oneself out of the work is to remove all personal and cultural affectation. The "self," as Tuttle seems to conceive of it, is itself an affectation. So are beauty and art, that is, art in the forms that the culture tends to acknowledge. To defeat the self and its affectations, Tuttle ignores many of the niceties one would expect to come second nature to an aesthetically sensitive individual. Recall, however, that he "was born knowing the rules."[48] There may be little point to practicing what one already knows, which would amount to a life of instinct and habit. If the aesthetic end of art comes naturally, then create an art without succumbing to the instinct to aestheticize. Here is more of Tuttle's thinking about the *Wire Pieces*:

295 Richard Tuttle, **Wire Octagonal (#4)** 1971
Wire and nails, 46 x 28 in.
The Saint Louis Art Museum,
bequest of Helen K. Baer, by exchange

296–97 Richard Tuttle **3rd Rope Piece,** 1974
(as photographed in the 1970s [left] and 2005 [right])
Cotton and nails, 1/2 x 3 x 3/8 in.
National Gallery of Art, Washington, D.C.,
the Dorothy and Herbert Vogel Collection, gift
of Dorothy and Herbert Vogel, Trustees 2004

It is easy to get obsessive about executing [them]. The truth is I even do not know whether the wire goes clockwise or counterclockwise around the nails—something which I would think enormously important to know, but the fact that I do not saves them from ever becoming too precious and tells me something about what "art" thinks important.[49]

Having emptied himself by drawing, Tuttle became free to let the wire and nails perform outside his human-culture intervention ("I did not make this," he might have said).[50] Shortly before the *Wire Pieces*, he completed his series of octagonals with some variants in thin wire (*Wire Octagonal [#4]* [1971]). These followed the cloth and then the paper octagonals. Recalling his attitude, he stated: "It was almost Zen. I thought about how to not make art."[51]

plate 295

Making art and not making art can look quite alike (just as seeing can resemble not-seeing). Attitude is important. Tuttle's art leads me into his dreamlike not-see logic, which I can only follow, discovering where I go. When I viewed his *3rd Rope Piece* (1974) in a photographic reproduction published in several catalogues, I was struck by the art it seemed to exhibit. (Would Tuttle encase the word in quotation marks: "art"?) *3rd Rope Piece* consists of a three-inch length of white clothesline cord, three-eighths inch in diameter, centered along the width of a white wall, to which three small nails set nearly symmetrically, one at each end, one in the center, attach it. I noticed that the third nail was not only dead center but had been driven so as to avoid interfering with the braiding of the several plaits of cord. That detail, ever so clear in the photograph, impressed me; it even seemed that the central part of the cord swelled a bit, accommodating the nail. In addition, the end nails—having been hammered deeper than the center nail and becoming somewhat obscured by the surrounding fibers—appeared to work in harmony with the cord. By their action, they rounded the cord off at its slightly splayed, cut ends. These details reflected a hand entirely sensitive to the materials and relationships involved: the nails had been driven just far enough; the delicate, braided structure of the cord had been respected; a logical symmetry had been established. No artist need have accomplished this, just someone with ordinary aesthetic awareness. The aesthetic quality showed.

plate 296

When I reported my observations to Tuttle, they failed to confirm his emotional sense of having made the piece, nor did they conform to how he thought it ought to appear. Because he believes that certain of his works should be free to be installed by others—an instance of self-identity vanishing—he wondered if the source of the photograph was an installation in which he had not participated. But it was also possible that he had been remiss in this case. Instead of "I did not make this," his thought was "*Could* I have made this?"

> *It is hard not to be aesthetic and place the nail in between the plaiting, but one should not.*
> *Yes, anyone can put this piece on a wall. Usually I say, anyone can do it, but I can do it better*
> *than anyone. This is because I care more, but that is not definitive.*

Tuttle is the artist he is because he would indeed care more. Still, this "is not definitive," for the consequences of true care are unpredictable. Tuttle informed me that the degree of splaying and fraying at the ends would have resulted from his tapping the cord, not driving the nails. Nevertheless,

> *It is the nail that counts, not the cord. If one is thinking of the nail first and the rope second, it is easy*
> *to avoid the aesthetic trap of the space in the plaits. The art experience is much easier when there*
> *is no aesthetics around to get in the way, lessen, and pollute. The nail [can be] unaesthetic...a counter*
> *to and potential victim of the aesthetic of the plaited cord.... It is hard to get free of all the beauty*
> *in this world, and most of us fall its victim.... Beauty...is unavoidable, though art is not.*[52]

Beauty, when intentionally enhanced, is an affectation. Because beauty is already with us, art must show what beauty—its aestheticization—masks. If the braided cord is already beautiful, don't aestheticize the nail.

I realize that the effect I initially perceived in *3rd Rope Piece,* which seemed to project from its photograph, was "art" (not art). It was *"art"* that showed, if only to me. I saw the result I would have expected of myself, rather than not-seeing, dreamlike, Tuttle-like. The sensitivity I attributed to the construction of *3rd Rope Piece* may have been paradigmatically human, but it was also canonical, a manifestation of proper behavior. The photograph represented the wash cord as drawing, yet drawing withdrawn from its "unlimited capacity"—drawing having lost its link to the analogous capacity of the human.[53] Perhaps the view given by the photograph reflected a certain vanity, affectation, or pretense to perfection, the kind of perfection that ends in recognized beauty. Care does not lead to perfection of this sort, which would belong to a conceptual order (indeed, an aesthetics) rather than constitute a mode of living. A caring act of invention accomplishes its work without doing a noticeably good job any more than it does a noticeably bad job; it avoids making a fetish of its caring. In all art, wrote Agnes Martin, Tuttle's friend of many years, "technique is a hazard even as it is in living life."[54] Care becomes invisible for the sake of letting something other than technique and its beauties show.

298 Paul Cézanne **Sous-Bois** (Forest), ca. 1894
Oil on canvas, 45 3/4 x 32 in.
Los Angeles County Museum of Art,
Wallis Foundation Fund in memory
of Hal B. Wallis

plate 297

Tuttle has had a new photograph taken of a <u>different installation</u> of *3rd Rope Piece*, with a different three-inch segment of the original cord. In this instance, the center nail appears to violate the plaiting—but just barely, so that it neither passes definitively through the plait nor definitively avoids it. Tuttle also placed the two end nails less symmetrically, the left nail lying noticeably closer to the cut end of the cord than the right. In fact, each of the features that seemed to me to have aestheticized *3rd Rope Piece* are either lacking or have been mitigated in this new installation. The nails show because they are no longer there to arrange the cord; and so the cord shows also in all its specificity.

"My work is an effort to overcome identity," Tuttle says.[55] Remove the aesthetics from a work and its identity vanishes into specificity, with no feature or quality assuming dominance. Generalized description and analysis no longer comprehend it. My initial account of *3rd Rope Piece* abstracted from the work certain aesthetic features, distilling them in a manner consistent with general standards for objects that cultivate a personality and identity—objects with which humans customarily identify. Nothing about the word *identity* restricts it to being associated with this type of generality; in fact, it may seem far more natural (and therefore, ideologically sanctioned) to link what we call identity to individuality and specificity. Am I not free to cultivate *my* identity rather than someone else's? This straightforwardness does not accord with Tuttle's understanding of the motivation for abstract and nonobjective art as these modes developed during the modern period, so often as vehicles for self-expression. For him, identity appears as aesthetic standardization, not anaesthetic (beauty-denying) specificity. Identity is cultural identity.

Inherited from the culture, Tuttle's problem (ironically) is old. It was acknowledged by artists of the nineteenth and early twentieth centuries who advocated expressionistic, individualistic forms and unconventional techniques, self-consciously resisting the existing institutional norms. They recognized that the intellectual abstractions associated with artistic "content" or subject matter were cultural constructions linked to massive ideological generalizations. To counter the given institutional culture they shifted from its approved thematics to focus on immediate, sensory aspects of nature, a realm of experience they felt able to appropriate as their own. Ultimately, artists in this emerging alternative tradition would concentrate on the studio materials used to render naturalistic effects. Turning inward in a *physical* rather than intellectual sense—to handle paper, canvas, wood, metal, graphite, or paint—they evaded the most obvious ideological clichés of their era, finding individual expression by engaging with ordinary matter, yielding themselves to it. In this manner, certain early modernist artists abandoned the more cultivated, spiritualized side of the "self," which they came to regard as a social identity formed by cultural

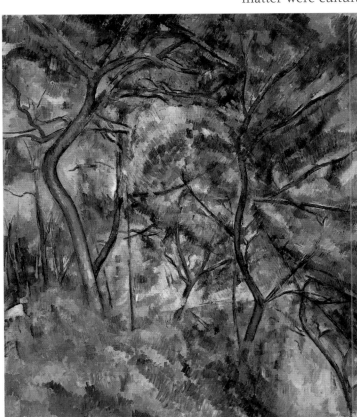

templates: one way or another—ideology. Paul Cézanne was especially appreciated within this Romantic-Modernist context because his art shifted the cultural realm of abstraction from intellectual dogma to an abstraction of the artist's means. The physical side of art connected far more immediately to an individual's desires and expressive mannerisms, assumed to be inborn and often at odds with the social and cultural environment. Personal identity came to the rescue of social identity. It may have been a noble solution then, but not one that Tuttle can now adopt.[56]

In its extremes, and in accord with a certain line of criticism, he might nevertheless almost accept it. Cézanne's paint strokes—as discrete marks, signs, gestures—lacked any obvious mimetic function to viewers of his time. They were *materially* abstract: even though they might cumulatively represent a scene, more or less naturalistically, they acted first in showing themselves (*Sous-Bois* [Forest, ca. 1894]).[57] In their own era, they were the "solution," albeit contested: "To make something which looks like itself is...the problem, the solution."[58] The trick to material abstraction of this sort was to resist not only forms of institutionalized beauty, but also one's own identification with the beauties of one's cultivated sensibilities and mastered skills (including, in Tuttle's case, those "rules" known from birth). Affectation appears when artists master their own styles, when what has become natural to the cultivated individual dominates what is simply natural and what is simply itself. The pointillist alternative to Cézanne's facture developed on the basis that the dot or point—even more than Cézanne's accentuated, repetitive stroke—was an impersonal mark that would never support or degenerate into aestheticism. Georges Seurat's early critics emphasized that regardless of the subject rendered, the "handling of the brush remains the same...manual facility becomes a negligible matter."[59] The most caring of Cézanne's paint strokes, like the most anonymous of a Pointillist's dots, resemble Tuttle's nail-heads: they show. Or, as he has said with regard to drawing: "The paper is just as much drawn as [the] mark is drawn."[60] If paper has any affectation...as Tuttle draws, it vanishes.

plate 298

SENSORY PARADOX

One remarkable phenomenon of my work is its love for being hung at a height of fifty-four inches from the floor.... [This height] brings me in contact with anything that's ever existed in human life. RICHARD TUTTLE, 2004, 2001[61]

Tuttle centers his *3rd Rope Piece* with respect to the width of the wall that supports it, but he fixes it at three feet above the floor, no matter where the installation occurs. At this height, in terms of the conventions of accessibility and display, the work is nowhere: too low to relate to a person "eye-to-eye" and too low even to be approached by the hand in an act of manipulation. Tuttle may prefer this height because it removes the work from all anthropomorphic fantasies. It can no longer be a person with whom I engage, nor can it be an object at my disposal. Not knowing what it is, I am open to not-see.

The fifty-four-inch height that Tuttle now uses for most of his wall pieces (measured from the center point of the individual work) is a very different matter. For hanging a drawing, this height is somewhat lower than, but still related to, the general standard. Rather than eye-to-eye height, it is hand-to-eye. A drawing at fifty-four inches does not quite look back but instead reaches out, making itself available to touch, inducing a viewer to reach out to it in turn. A point of comparison: light switches are usually located about fifty-four inches above the floor for ease of operation; with a very natural right-angle bend at the elbow, one's hand is in position to manipulate a switch or anything else placed at that level. We see the switch and then touch it; but, when in a darkened room, we easily locate it by touch alone. Tuttle had no pragmatic standard in mind, but rather intuited the fifty-four-inch measure through his experience and observation. As a viewer looks, this height brings the works close, not only in appearance but, more insistently, by an invitation to touch. Tuttle states that his work has a "love" of being hung at this height. It may have been an offhand comment, but with this love, everything that shows becomes drawing for both eye and hand, even "the parts you don't like."[62]

With respect to its viewing height, the intimacy of Tuttle's art has little to do with its size, but rather with the way we use our visual and tactile senses. The eye keeps its distance, whereas the hand acts effectively by contact. Traditionally, drawings are objects designed to be seen. When placed in a position that relates them equally to the hand, a certain conflict develops, or the potential for a new, hybrid kind of relationship, a noncanonical use of the senses (Tuttle's reflections about *Rest* might be relevant here). The simultaneous engagement of hand and eye at fifty-four inches—an engagement analogous to what an artist must do to make physical work like Tuttle's (more doing than theorizing)—expands a person's contact with the totality of human existence, just as Tuttle suggests.[63] His way of saying this: It is not a question of measuring bodily movement but "another kind of knowledge, of something being accurate."[64] The range of experience included within his type of sensory paradox accommodates the noncanonical cases of such accuracy—all the sensations not normally perceived.

plate 299

For a recent installation of a set of five *Villages* at the Drawing Center, New York, Tuttle used the fifty-four-inch measure not only to position various sizes of wall drawings and reliefs, but also to place relatively large sculptures in relation to them. *Village III, Sculpture* (2004) has a total height of sixty inches, which puts it in close correspondence with the tops of the larger of the two types of "drawing" hung along its installation wall. The sculpture consists of a three-dimensional grid of cubical, boxlike units of steel rods, each cube measuring twelve inches on a side and closed off at the front by a metal plate painted light blue with a relatively matte, industrial oil. A vertical row of five "boxes" reaches the compound height of sixty inches, while the grid is seven rows wide and oriented to structural columns along the center axis of the exhibition space. Penetrating into this grid from the front and center is a second gridlike structure of somewhat smaller, open boxlike units, irregular in measure and fabricated from a visually heavier kind of metal rod (rebar, which is used in industry to reinforce poured concrete).

If only because of the light blue plates that close them off at the front, the boxes forming Tuttle's primary grid are (physically) very heavy. He stacked them more than he constructed them. Screws set into the adjacent wall serve to stabilize the sculpture, but these have been used sparingly. It is primarily gravity that supports the grid, not the structural logic of a perfected geometry. The box-like units are joined rather irregularly, even casually, giving a sense of instability to the whole. But this instability is no more than visual—a visual impression caused by the spaces that appear between the units as well as the slight tilting of one unit in relation to another. Because the elements of *Village III, Sculpture* are so heavy, the work is actually remarkably secure. Tuttle must have been sensitive to this as he was installing the work, and viewers who take the liberty of touching it will discover the same (not usually allowed in public exhibitions, but a private collector could do this). With its immediate environment of a fifty-four-inch invitation to touch, Tuttle's sculpture relates to the hand in ways other than it does to the eye.

Village III, Sculpture appears unstable to the eye because of its light blue

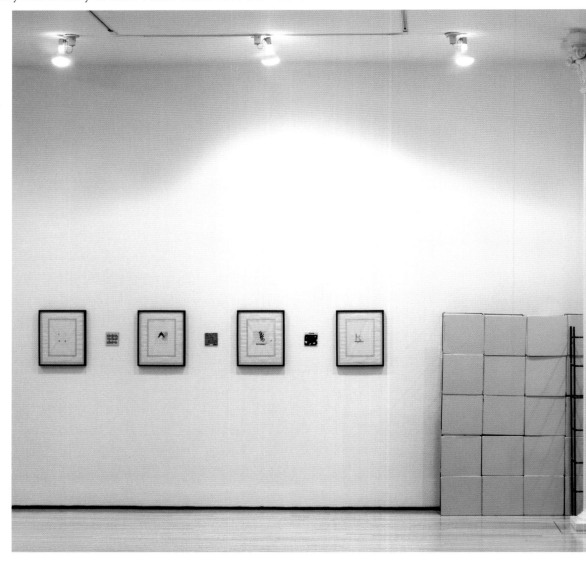

color and irregular structure, but it is stable to the hand because of its weight and rigidity. This disjunction or disconnection within the experience of a single object is a thematic feature of *Village III*, a group of objects on a not-see mission:

> The canon says that of all the colors one can't draw, the most undrawable is light blue. Color
> has no structure; therefore, there is nothing to draw. To expand the canon, we must remind it that
> a drawing must be on a page, a paper, a something, and that this is structure. Structure can [also]
> be known in the mind. When we realize the utter specificity with which a certain light blue can
> be known in the mind, we are outside the canon, and we know light blue can be drawn as structure
> when drawing has become everything drawing was meant to be.[65]

The materially heavy "wall" of light blue may well appear less substantial than the open grid of rebar placed in front of it—a sensory paradox that causes a viewer to expand the possibilities of light blue, of structure, and of drawing.

Sensory paradox has often been Tuttle's result; he accepts it, though he may not deliberately seek it. *Turquoise I* (already discussed), with its elements of wood, canvas, wire, and tape, fuses solidity with liquidity on a relatively grand scale. *Real and Drawn Twist* (1970s), a very modest five by two inches, may present just as profound a sensory challenge. Tuttle recalls it with fondness—it showed something, and it continues to show. He had been twisting strips of paper so that the back would come to the front, while also making drawings of such a twist on flat paper. As if to forge a material link between the two types of image, he decided to attach the twisted paper to a flat paper support, and on its verso he drew a twist.[66] Rarely has such a complex visual-tactile situation been so simply and directly produced. The drawing (a visual twist) is schematic, yet not at all regular; its "real" version (a tactile twist) introduces irregularities all the more pronounced. Or does it? Perhaps not, because the line drawing is one medium and the twisted paper is another. In Tuttle's expanded conception, paper becomes a medium of drawing—not a support, but the medium itself.

plates 300–301

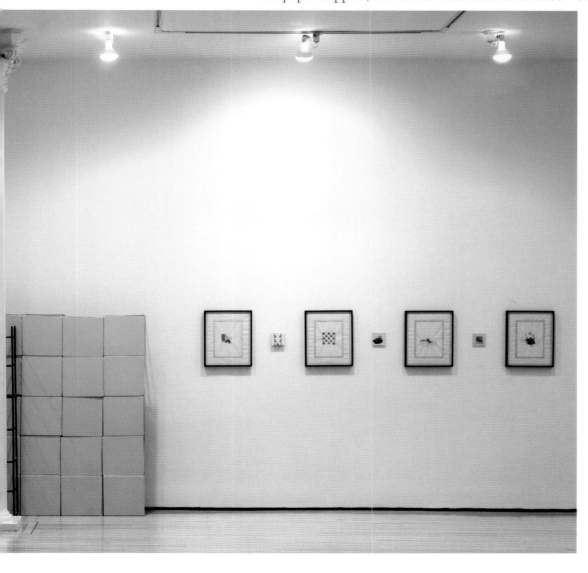

299 Installation view of the 2004 exhibition
Richard Tuttle: It's a Room for 3 People
at the Drawing Center, New York,
showing **Village III, Sculpture** (2004)
and related works

Back to back, the two renderings eliminate the front/back binary, while each medium generates its specific sense of a twist, possibly the same twist. Looking, we cannot determine whether Tuttle was willful in giving a particular waver to his line or in causing this degree of disorder in tearing and crumpling his twisted paper. Is the material leading the artist, or is the artist leading the material? We would need to test out the drawing and twisting in a version of our own, to see (or rather, not-see) what happens. *Something* happens, an experience other than "art." It happens in a human consciousness alert to sensory paradox.

Tuttle's kind of direct attention to materiality and the senses brings to each of us a degree of change: less affectation; reduced identity. He states, "My work is an effort to overcome identity."[67] Yes, it shows.

NOTES

1 Jacques Lacan (seminar, 19 February 1964), *The Four Fundamental Concepts of Psycho-Analysis*, ed. Jacques-Alain Miller, trans. Alan Sheridan (New York: Norton, 1978), 75–76 (emphasis in original; paragraphing suppressed). "Dans le champ du rêve...ce qui caractérise les images, c'est que *ça montre*.... Notre position dans le rêve est, en fin de compte, d'être foncièrement celui qui ne voit pas. Le sujet ne voit pas où ça mène, il suit.... Il peut se dire—*Ce n'est qu'un rêve*. Mais il ne se saisit pas comme celui qui se dit—*Malgré tout, je suis conscience de ce rêve*" (*Le Séminaire de Jacques Lacan*, ed. Jacques-Alain Miller [Paris: Seuil, 1973], 72). For essential aid in research, I thank Charlotte Cousins, Adrian Kohn, Herbert and Dorothy Vogel, Joanna Berman, Susan Harris, Brooke Alexander, and Sperone Westwater, New York.

2 Richard Tuttle, interview by Sylvie Couderc (October 1986), in *Richard Tuttle: Wire Pieces*, ed. Jean-Louis Froment (Bordeaux, France: CAPC Musée d'art contemporain de Bordeaux, 1987), 39; Richard Tuttle, unpublished interview by Mei-mei Berssenbrugge, 25–26 October and 12 November 1990, courtesy Richard Tuttle and Mei-mei Berssenbrugge. Susan Harris kindly supplied a transcript of this interview. The November session returned to some of the topics of the October sessions: "I found in my voice [in October] a kind of pretentiousness of not really speaking from the center of one's being. I was always slightly outside that, making some kind of pompous, ponderous statement, something of even greater, greater distance. I'd like to really get rid of that pretentious, authoritarian tone." Most of the statements that I have drawn from Berssenbrugge's interview belong nevertheless to the October sessions. In my judgment, they do not cause Tuttle to appear pretentious; but this is a matter to which (to his credit) he is extraordinarily sensitive.

3 Tuttle, conversation with the author, 11 December 2004.

4 Tuttle, conversation with Marcia Tucker, summer–fall 1975, quoted in Marcia Tucker, *Richard Tuttle* (New York: Whitney Museum of American Art, 1975), 5.

5 Tuttle, interview by Berssenbrugge.

6 Richard Tuttle, "Appendix IV," in *List of Drawing Material of Richard Tuttle & Appendices*, by Gianfranco Verna (Zurich: Annemarie Verna Galerie, 1979), 356.

7 Tuttle, interview by Berssenbrugge.

8 Donald Judd, "Statement" (1967), *Complete Writings 1959–1975* (Halifax: Nova Scotia College of Art and Design, 1975), 193.

9 See Richard Shiff, "A Space of One to One," *Donald Judd: 50 x 100 x 50, 100 x 100 x 50* (New York: PaceWildenstein, 2002), 5–23.

10 Donald Judd, in John Coplans, "An Interview with Don Judd," *Artforum* 9 (June 1971): 43.

11 Donald Judd, in "Questions to Stella and Judd," interview by Bruce Glaser (1964), ed. Lucy Lippard (some statements revised and augmented, 1965), *ARTnews* 65 (September 1966): 58.

12 Richard Tuttle, "Work Is Justification for the Excuse," statement for *Documenta 5*, Kassel, 1972, quoted in Tucker, *Richard Tuttle*, 5.

13 Richard Tuttle, "Richard Tuttle, 19 February 1998," in *Inside the Studio: Two Decades of Talks with Artists in New York*, ed. Judith Olch Richards (New York: Independent Curators International, 2004), 192.

14 Tuttle, interview by Berssenbrugge.

15 Any historical narrative or critical principle to be derived by connecting Lacan, Judd, and Tuttle should be considered arbitrary—a matter of certain coincidences of chronology, the historical agents' language, and the interests of the critical writer. Such coincidences, although dreamlike, are the stuff of history. They lead a writer from the individual agents to speculation about general cultural forces—a collective sensibility, a discourse, an ideology—causing history to follow canonical lines. Use with caution.

16 Tuttle, conversation with Herbert Vogel, Dorothy Vogel, and the author, 13 September 2004.

17 Richard Tuttle, statement dated 26 January 1968, *Art International* 12 (15 May 1968), 48.

18 Tuttle, "Appendix IV," 357.

19 Richard Tuttle, in "Drawing Matters: A Conversation between Richard Tuttle and Catherine de Zegher, April 2004," in *Richard Tuttle: Manifesto*, Drawing Papers 49 (New York: Drawing Center, 2004), 1.

20 Ibid., 3.

21 Tuttle, interview by Berssenbrugge.

22 Ibid.

23 Tuttle, interview by Michael Auping, 17 July 1997, quoted in Michael Auping, "On Relationships," *Agnes Martin / Richard Tuttle* (Fort Worth: Modern Art Museum of Fort Worth, 1998), 84.

24 Gianfranco Verna (representing Tuttle's thinking), "Foreword," trans. Gail J. Vine, *List of Drawing Material*, 7.

25 The Betty Parsons Gallery exhibition brochure by Gordon B. Washburn called the works "constructed paintings"; see Eduardo Lipschutz-Villa, ed., *Richard Tuttle* (Amsterdam: Institute of Contemporary Art, 1991), 86.

26 With regard to Tuttle's unstretched canvas works of 1967, such as *Purple Octagonal* (pl. 21), "We were told it did not matter in which way they were hung and that they could also be spread out on the floor" (Monica Schmela, statement [5 December 1990], in Lipschutz-Villa, *Richard Tuttle*, 88). Additionally, because Tuttle hemmed the octagonals on both sides, front and back could be reversed (Robert Pincus-Witten, "The Art of Richard Tuttle," *Artforum* 8 [February 1970]: 62). The distinctively wrinkled surfaces of these dyed canvases result from the "scrunched-up" conditions of storage between hangings (Auping, "On Relationships," 84).

27 Tuttle, "Drawing Matters," 6.

28 "I think when a person, an individual, calls themsel[f] an artist, I really don't know what they mean because either you're at reality and you wouldn't need to claim yourself as anything or you're not at reality, in which case it's a lie that you're an artist" (Tuttle, interview by Berssenbrugge).

29 Tuttle, interview by Berssenbrugge. Susan Harris quoted this passage in "Twenty Floor Drawings," in Lipschutz-Villa, *Richard Tuttle*, 49.

300–301 Richard Tuttle **Real and Drawn Twist** 1970s (left: recto; right: verso) Cardboard, paper, and ink, 4 7/8 x 2 x 1/8 in. Collection of Hans and Marie-Anne Rohr

30 The words of Gianfranco Verna (December 1990) are suggestive in this respect, as he refers to the situation of an artist who allows himself to see without foreseeing: "Anyone attempting to pursue this path can only do so as a companion, always a step behind, letting the unknown take its course. Not doing, but being done unto, perhaps in order to realize that this is the only way to experience what has not yet happened and need not necessarily happen" (reprinted in Lipschutz-Villa, *Richard Tuttle*, 98).

31 "Drawing is 'inside' the person; not on the paper. The appreciation, development of drawing is one of the great characteristics of a human well-being. The drawing gives the human the full possibility of exploring their possibility" (Tuttle, statement in *40 Tage: Zeichnunger Richard Tuttle* [Bonn: Galerie Erhard Klein, 1989]; quoted in Harris, in Lipschutz-Villa, *Richard Tuttle*, 56, 59).

32 See note 2.

33 Tuttle, statement to the author, 15 January 2005.

34 Herbert Vogel, statement (ca. 1990–91) in Richard Marshall, "An Interview with Herbert and Dorothy Vogel," in Lipschutz-Villa, *Richard Tuttle*, 80 (emphasis added).

35 Tuttle, quoted in Paul Gardner, "Odd Man In," *ARTnews* 103 (April 2004): 105; and in "Drawing Matters," 7.

36 Dorothy Vogel, statement (ca. 1990–91), in Marshall, "Interview," 74.

37 See note 6.

38 Tuttle, statement to the author, 21 December 2004; "no connection," see note 2.

39 Tuttle, statement to the author, 10 December 2004.

40 Tuttle, statement of 16 February 1998, *Small Sculptures of the 70s* (Zurich: Annemarie Verna Galerie, 1998), unpaginated.

41 Tuttle, commentary on *Rest, Small Sculptures of the 70s*, unpaginated.

42 Tuttle distinguishes the experience of his work in a private, casual setting such as the New York apartment of Herbert and Dorothy Vogel from the experience of the same or related work in the formal space of a public exhibition. The private setting can become a kind of "laboratory," but in the sense of an environment for discussion, exchange, and the realization of changing sensations, as opposed to systematically controlled experiment (Tuttle, conversation with the author, 11 December 2004).

43 Tuttle, statement in *Richard Tuttle: Portland Works 1976* (Boston: Thomas Segal Gallery; Cologne: Galerie Karsten Greve, 1988), reprinted in *Richard Tuttle: Community* (Chicago: Arts Club of Chicago, 1999), 26.

44 Herbert Vogel, in Marshall, "Interview," 85. Compare Tuttle, interview by Berssenbrugge: "I guess I play a little game. I think my work is full of puns. Whereas if I use a very inexpensive material, I'll tend to give it enormous respect. Or if I use a very expensive material, it might even be hidden inside a particular piece."

45 Richard Tuttle, "In Which to Find Significance," in *Richard Tuttle, Selected Works: 1964–1994* (Tokyo: Sezon Museum of Art, 1995), 13–14.

46 The first, fourth, and fifth sentences of this quotation are from Tuttle, interview by Couderc, in Froment, *Richard Tuttle: Wire Pieces*, 37–38; the second and third sentences are from a statement to the author, 21 December 2004, in response to a request for elaboration.

47 Richard Tuttle, "The Good and the Colors" (20 July 1986), in Froment, *Richard Tuttle: Wire Pieces*, 35.

48 See note 13.

49 Tuttle, *Richard Tuttle: Community*, 14.

50 See note 3.

51 Tuttle, *Richard Tuttle: Community*, 20.

52 *3rd Rope Piece* was the topic of several conversations between Tuttle and the author, conducted by e-mail and telephone during December 2004, from which the two quoted statements have been drawn.

53 See note 21.

54 Agnes Martin, handwritten note (ca. 1972) reproduced in *Agnes Martin*, ed. Hermann Kern (Munich: Kunstraum München, 1973), 64.

55 See note 6.

56 Nor does he accept the notion of liberating art through spontaneity, a concept often aligned with an artistic abstraction of the means, as in Harold Rosenberg, "The American Action Painters," *ARTnews* 51 (December 1952): 22–23, 48–50. "I call [spontaneity] crap," Tuttle said in the interview by Berssenbrugge, "only because I myself can't imagine what spontaneity is." In the later, November session, Tuttle added: "It was just pointed out to me that the reason I may not understand spontaneity is because I'm right in the middle of spontaneity. Therefore, it's assumed a kind of role of the invisible in my art."

57 On the late-nineteenth-century context and its aftermath, see Richard Shiff, "Puppet and Test Pattern: Mechanicity and Materiality in Modern Pictorial Representation," in *From Energy to Information: Representation in Science and Technology, Art, and Literature*, ed. Bruce Clarke and Linda Dalrymple Henderson (Stanford, CA: Stanford University Press, 2002), 327–50; idem., "Apples and Abstraction," in *Impressionist Still Life*, ed. Eliza E. Rathbone and George T. M. Shackelford (Washington, D.C.: Phillips Collection, 2001), 42–47, 227–28.

58 See note 12.

59 Félix Fénéon, *Les impressionnistes en 1886*, "L'Impressionnisme" (1887), reprinted in *Félix Fénéon: Oeuvres plus que complètes*, ed. Joan U. Halperin, 2 vols. (Geneva: Droz, 1970), 1:36, 67.

60 Tuttle, interview by Berssenbrugge.

61 Tuttle, statement to the author, 7 December 2004; Tuttle, quoted by Ingrid Schaffner, "The Spaces In Between," in *Richard Tuttle, In Parts, 1998–2001*, by Charles Bernstein and Ingrid Schaffner (Philadelphia: Institute of Contemporary Art, University of Pennsylvania, 2001), unpaginated.

62 See note 20.

63 Tuttle might well disagree. In 1990, he stated: "If I located a work at a certain height and that work was right, it would be right whether or not the viewer were seven feet tall or…a child three feet tall" (interview by Berssenbrugge).

64 Ibid.

65 Richard Tuttle, "Manifesto," in *Richard Tuttle: Manifesto*, inside back cover. My quotation eliminates numerals used to identify Tuttle's four successive points. Tuttle's remarks are vaguely Wittgensteinian: "You ought not to point to the color [the blue of the sky] with your hand, but with your attention…. Don't we at least *mean* something quite different when we look at a color and name our color-*impression*? It is as if we detached the color-*impression* from the object, like a membrane. (This ought to arouse our suspicions.)" (Ludwig Wittgenstein, *Philosophical Investigations*, trans. G. E. M. Anscombe [New York: Macmillan, 1958], 96 [emphasis in original]). See also Tuttle's statement of 1989 quoted in note 31. Tuttle's discussion of color—that it can acquire its structure in the mind—also has a Peircean resonance: "A *quality* [such as light blue] is a consciousness. I do not say a *waking* consciousness—but still, something of the nature of consciousness. A *sleeping* [dreaming?] consciousness, perhaps. A possibility, then, or potentiality [of some quality], is a particular *tinge* of consciousness" (Charles Sanders Peirce, "The Origin of the Universe" [1898], in *Collected Papers*, ed. Charles Hartshorne, Paul Weiss, and Arthur W. Burks, 8 vols. [Cambridge, MA: Harvard University Press, 1958–60], 6:149 [emphasis in original; paragraphing suppressed]).

66 Tuttle may have been responding to a revelation experienced somewhat earlier, when he pondered the twist in a beer-can tab. The twist seemed to represent a nonposition between positions, emblematic of process and change (Tuttle, statement to the author, 17 January 2005, paraphrased roughly; also, interview by Berssenbrugge). Compare *Study for Twist (1)* (1972; pl. 165).

67 See note 6.

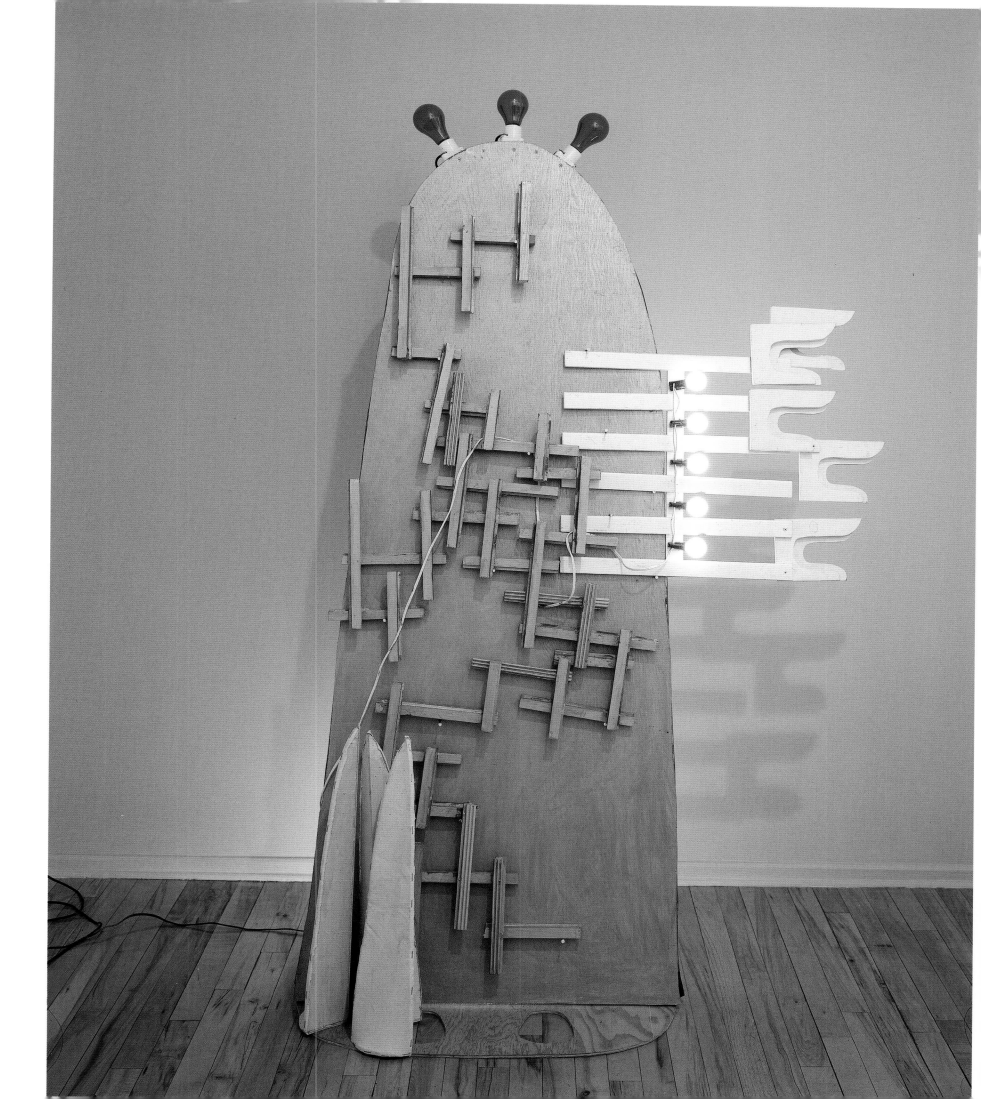

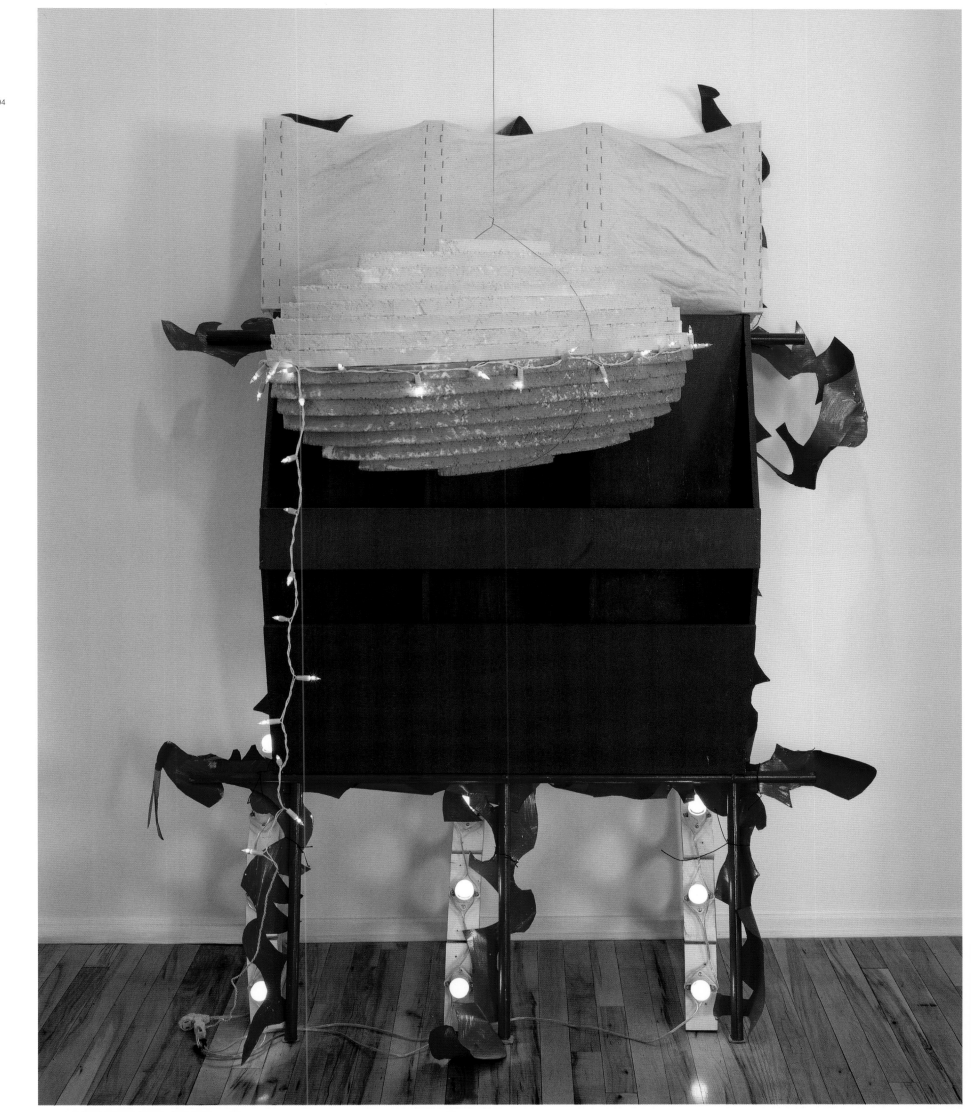

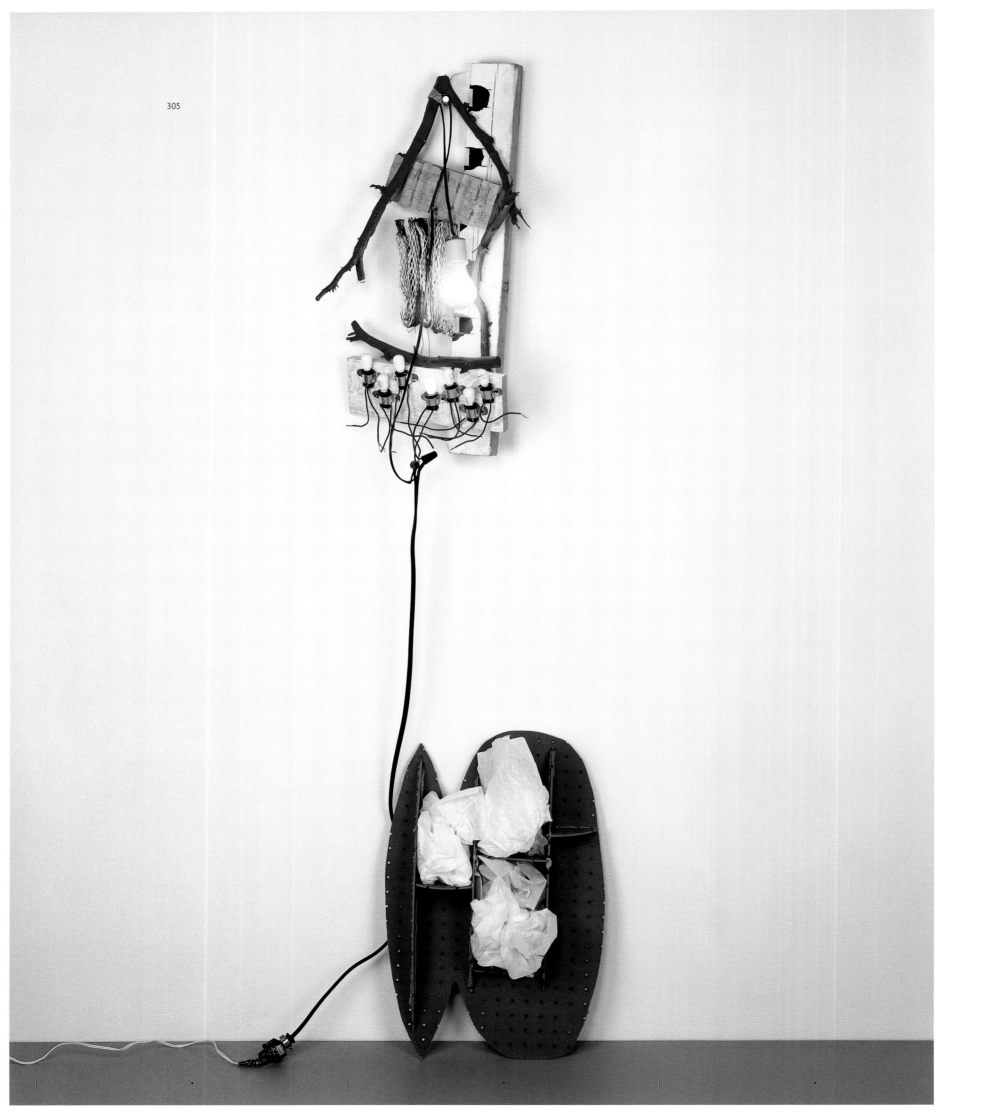

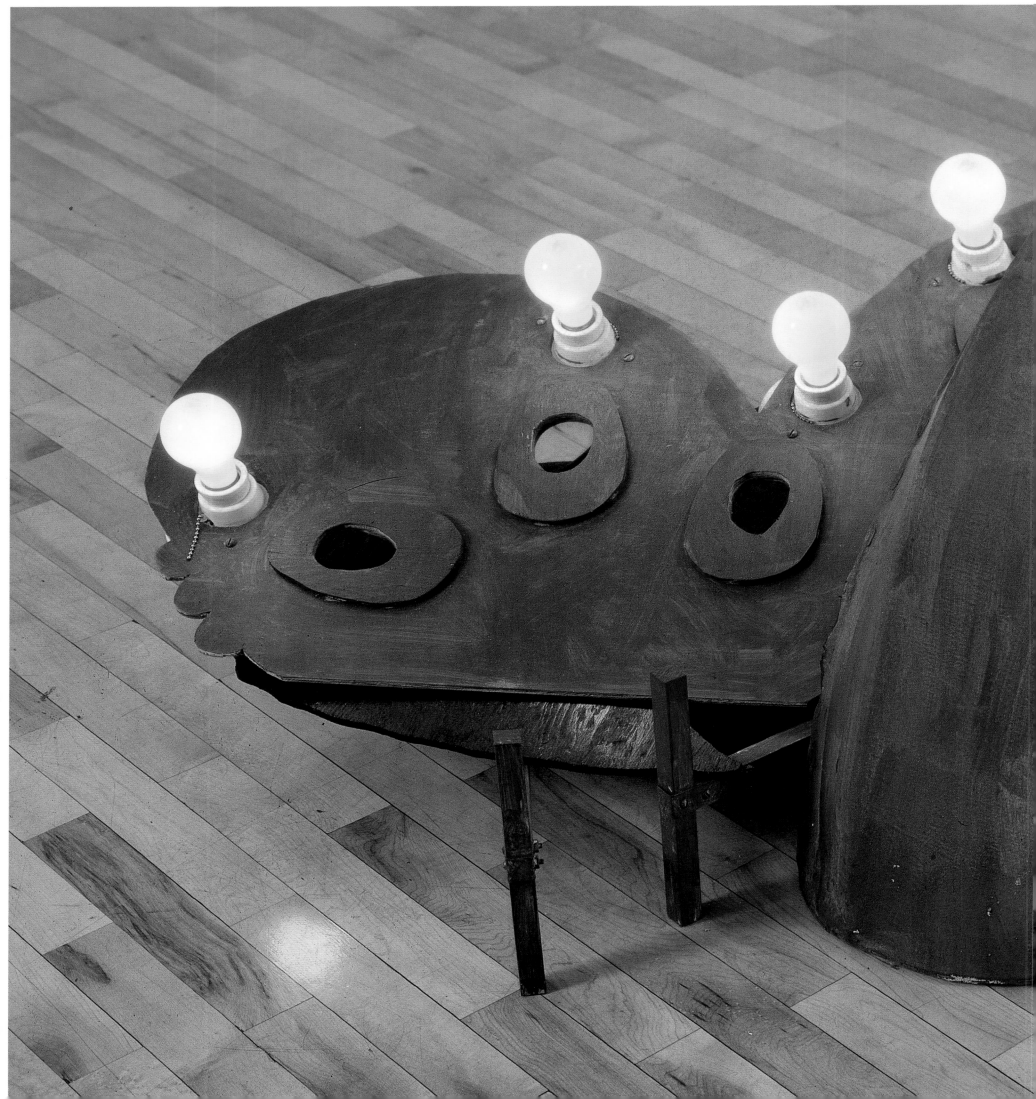

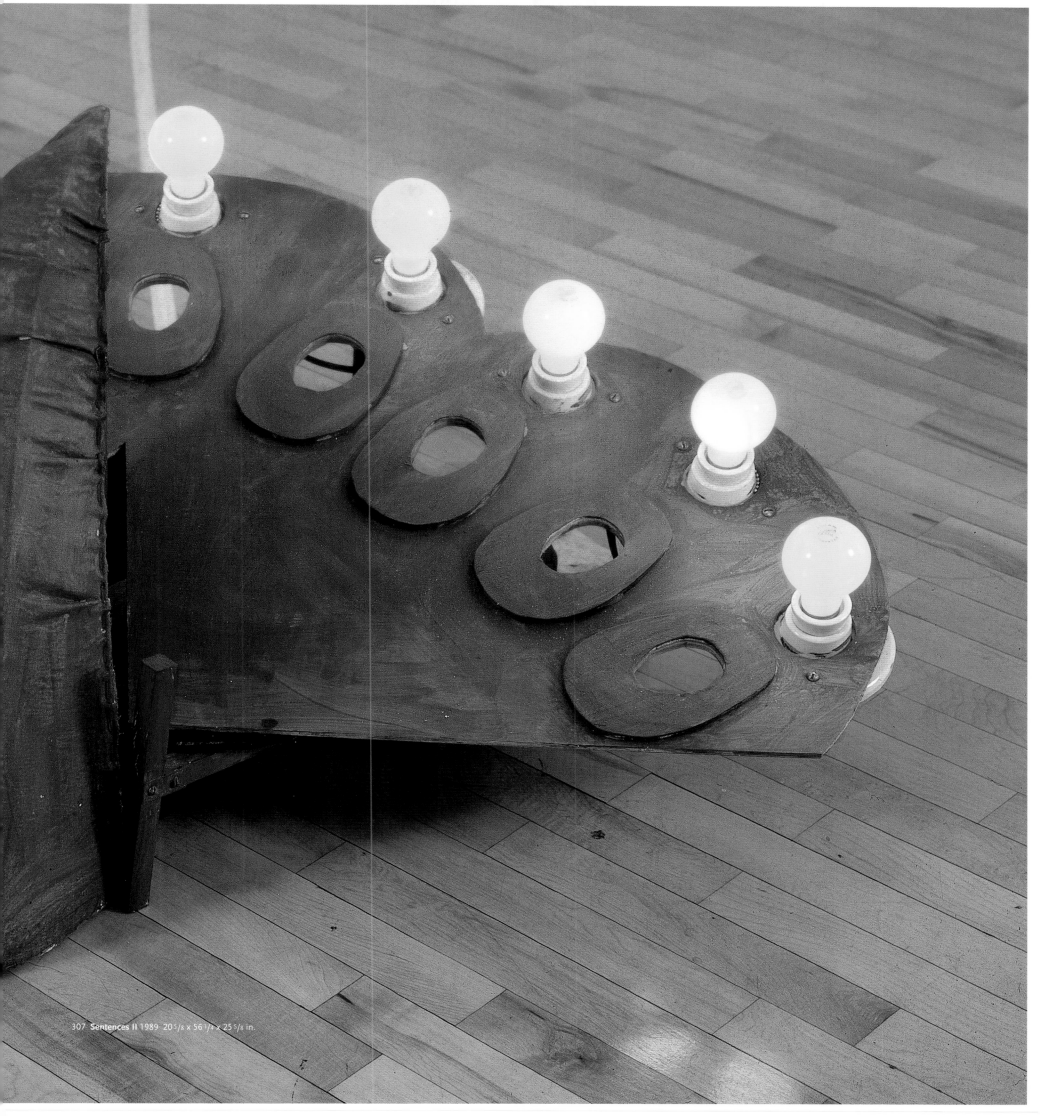

307 **Sentences II** 1989 20⅝ x 56¼ x 25⅝ in.

310 Installation view of the 1990 exhibition
Inside the Still Pure Form at Blum Helman
Gallery, New York

DESIGN PROJECTS

Richard Tuttle considers the work he has done in both art and design as interrelated components. While the functional objects he has made throughout his career meet the requirements of utility necessary to their purposes, they have been conceived and executed as aesthetic experiments in which issues of scale, proportion, color, texture, and resonance with context are paramount. Revealing his pursuit of a concerted direction that connects the entirety of his work, Tuttle acknowledges his design objects as part of an overarching inquiry into the parameters of the cube that manifested itself in his work as early as 1964. His most recent works in design are those related directly to the exhibition that this publication accompanies: vitrines, cases, and other furniture developed specifically for the presentation of examples of his oeuvre over the course of his forty-year career.

Yet Tuttle's functional objects are not purely extensions of his artistic vocabulary into the world of design. Instead, they represent a kind of synthesis between a purist approach to design as fundamentally distinct from that of art and an approach that is founded on an eradication of boundaries between the two.[1] Describing himself as someone who "works around the edges of things," Tuttle is responsive to various premises and elements that inform both worlds and draws freely from both to conjoin them.[2] He is particularly interested in the idea of reversing and questioning the conventional hierarchy between art and design, and in foregrounding the values that have been associated with each. This relationship is further blurred in certain of Tuttle's most recent projects that also fall outside of conventional artistic categories.

Tuttle's first foray into design stemmed from a 1978 invitation from the Fabric Workshop in Philadelphia to experiment with textiles, which led to a series of objects resembling clothing made from silkscreened cotton— shirts, pants, and a jumper. While the jumper and the three shirts designed by Tuttle in 1979 are relatively conventional in their appearance and adaptation to the human form, the pants extend far beyond the length of the human leg, transforming the idea of wearability into one of sculptural endeavor bordering on the performative and the absurd. Tuttle commented that "what interests me is that I don't know the relationship between my real work and what I am doing at the Fabric Workshop. I *know* there is a relationship, and a non-relationship, but I don't know the relationship. Every time I go there I try to find it out."[3] Most important, he recalls in retrospect, was the way in which the pants and the photograph of him wearing them (pl. 311) helped move his work away from a conventional subject-object relationship and more directly toward a social statement. This quizzical, experimental, and open-ended attitude has continued to animate Tuttle's work across a spectrum of media, and the idea of social utility remains crucial to his design activity that has followed.

Made at various times over the past fifteen years, Tuttle's subsequent experiments with functional objects have involved lighting and furniture— lamps, chandeliers, chairs, tables, daybeds—as well as rugs, banners, designs with textiles, and a plethora of additional projects that resist categorization but reflect his ideal of unity in direction. A group of chandeliers manifests flexibility in the balance between geometrical elements and hanging cylindrical forms in groupings of two, three, five, and seven. The cadences of relationships between the parts, their slightly awry visual quality, and their insistent three-dimensionality resonate strongly with Tuttle's sculpture, while at the same time the light fixtures are clearly functional.[4] Standing lamps made between 1989 and 1994 (*Mei-mei's Lamp* [pl. 312], *Lamp with No Style,* and *The Smell of Trees*) are almost interchangeable with his sculpture in their modest scale and formal relationships, and in some instances they strongly reference the severity of the Bauhaus aesthetic, while others are more playful, dynamic, and additive in form—rooted in ideas about use rather than stylistic concerns.

A notable feature of Tuttle's chairs and tables, some of which were made as prototypes, is that the artist envisions them as modifiable to the physical proportions of different users. He first explored this notion in his 1990 project *The Nature of the Gun* (pl. 313), consisting of two chairs, two benches, and a table. Simple and almost spartan in appearance—despite a synthesis of styles encompassing Florentine, Chinese, American Sheraton, and Moderne/ Deco furniture-making traditions—the scale of these objects derives from an empirical response to the particulars of the human form but also from a desire to explore the possibilities of social relations and human interactions offered by their grouping as a set or "suite."

More recently Tuttle's making of furniture has been informed by the principle of comfort, interrelated with the importance of proportion—a hallmark of his entire body of work. The artist has always pursued the making of objects that appear to be "just right," arriving at his solutions empirically, and as part of a quest for precision. Furniture allows for a more precise frame of reference—that of the human body—both as a source for his sculptural ideas and as the indicator of a shifting scale or ratio of proportions that is also "just right." In his recent *Turbulence Chair* (2004; pl. 315), a playful, dynamic composite of two joined, upholstered cubes allows multiple configurations in relation to the floor and the body.[5] Questioning the concept of turbulence as dramatic transformation or upheaval, Tuttle has emphasized comfort, informality, and a sense of energy inherent in the work. His straight-backed wooden *Mesa Chair* of 1994, inspired by the forms of the natural landscape of the West, incorporates the notion of comfort in a subtler way, in that its open back is designed to gently cradle and massage the sitter. Contrasting with these is Tuttle's design for a daybed characterized by imposing proportions

311 Richard Tuttle **Pants** 1979
Silkscreening on bleached cotton
muslin, ed. of 5, 72 x 26 in.
Created at the Fabric Workshop,
Philadelphia

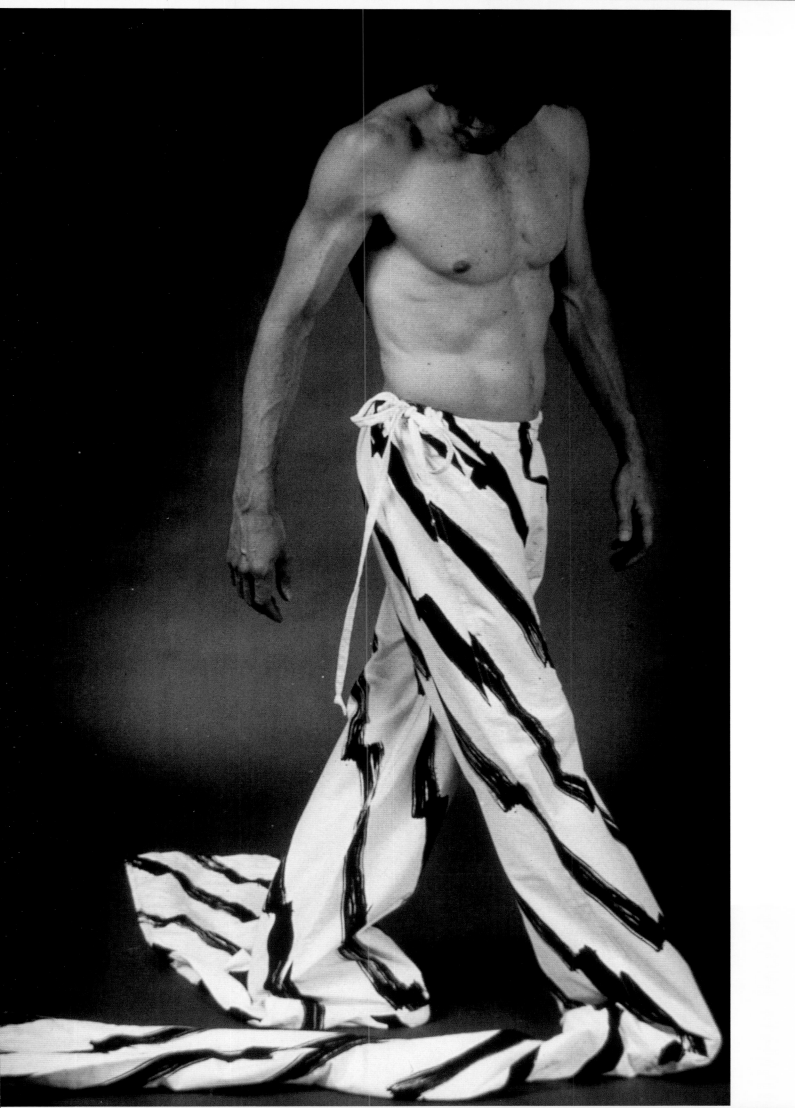

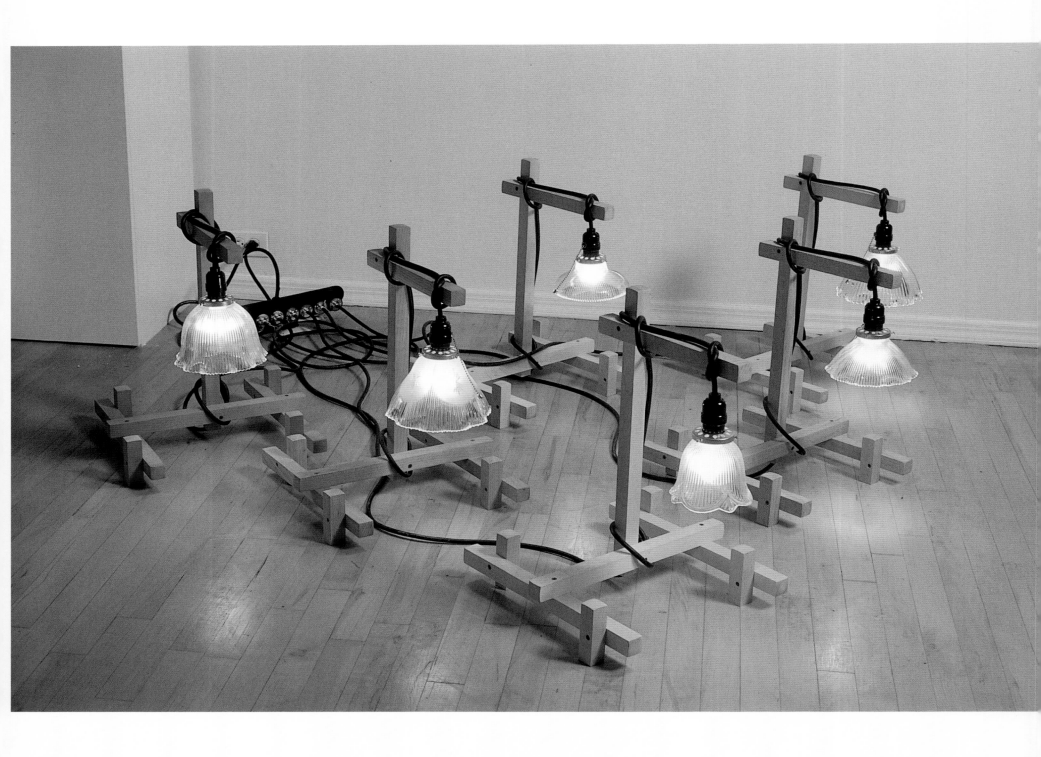

312 Richard Tuttle **Mei-mei's Lamp** 1989
Wood, drywall screws, electrical fixtures,
and mold-blown glass, each with
unique shade, ed. of 10, 21 x 16 x 16 in.
Published by A/D, New York

and decorative flourishes, an object based more squarely on a literary idea and an art-historical precedent—that of the Etruscan chaise on which a husband and wife ceremonially reclined—than on the premise of comfort or utility.

During the past decade, Tuttle has continued to find an ever-wider arena for his interests in the fluidity between media and artistic endeavors that defy categorization, including those that span function and aesthetics. Recent works related to design include *Bouquet* (pl. 314), a 2001 project in which he and the artist Kiki Smith transformed a nineteenth-century silk damask textile into a sculptural object intended to hold a brooch or jewel by "liberating" it from the confines of conventional display techniques and embellishing it to enable a heightened appreciation of its aesthetic and material properties. Tuttle has recently undertaken several additional projects with textiles, including a 1997 design for a rug titled *Is There a...?* in which he questions the hierarchy of patterns and the properties of color utilized in its weaving in a manner that approximates related explorations in his artwork.[6]

The idea of collaboration is of utmost importance to Tuttle in his design projects. He comments that design "can produce knowledge and be a place to use knowledge gained from private work. As such [design and art] naturally feed each other."[7] Whereas he sees the making of art as very much an individual act, he defines the participatory aspect of design as "a way to overcome the artist's natural alienation" and embraces the notion of working with others through several stages of an object's conception and execution. At times he allows his collaborators to play a large role in determining various aspects of a work's visual outcome, and he always acknowledges the contributions of those who participate in its technical realization. For Tuttle this is part of the social purpose of design, which encompasses the way in which objects are conceived and realized and the way in which they are used and received in the world.

Tuttle's concern with the properties of space and proportion—which he has likened to the relationship between calligraphy and architecture—lies at the heart of all of his various artistic endeavors. Staunchly opposed to categorical definitions and limitations, he continues to affirm his commitment to the idea of a "total art"—an extension and adaptation of the tradition of *Gesamtkunstwerk* into his own individualistic vocabulary and approach—and he cites Charles Rennie Mackintosh as a key figure in his own thinking about the synthesis of many different elements in order to achieve new forms.[8] Tuttle has reflected that "the world thinks design is not as important as 'fine art,' but I don't have that problem"—a stance consistent with the way he has always approached the making of objects regardless of functional or purely aesthetic concerns and with a fresh and abiding interest in fusing various realms of aesthetic experience into a fluid, yet clearly directed, body of work free of categorical limitations.[9]

ELIZABETH A. T. SMITH

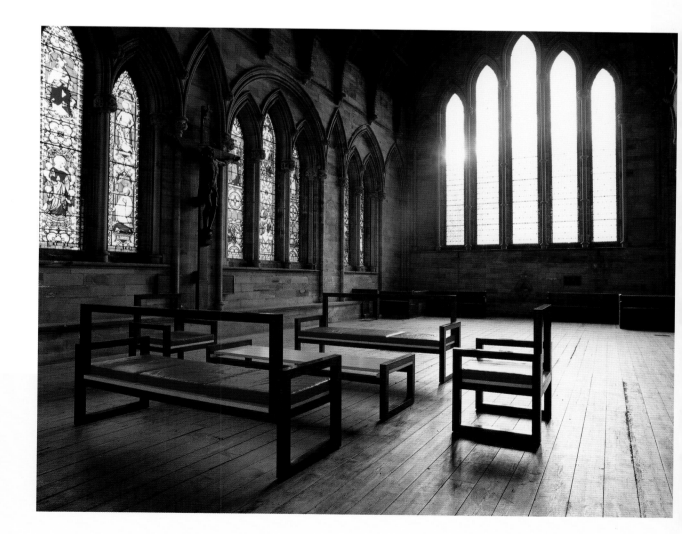

313 Installation view of Richard Tuttle's furniture ensemble **The Nature of the Gun** (1990) at Greville and Sophie Worthington's home (Saint Paulinus chapel), North Yorkshire, England

NOTES

1 Numerous examples of Tuttle's work in design were included in the exhibition *Design ≠ Art: Functional Objects from Donald Judd to Rachel Whiteread* at the Cooper-Hewitt, National Design Museum, in 2004–5. His artist's statement, titled "Thesis, Antithesis, Synthesis," is included on p. 203 of the exhibition catalogue (New York: Cooper-Hewitt, National Design Museum / Merrell Publishers, 2004). There he specifically states his position as one of synthesis, in contrast to other significant figures of his generation also featured in the show. He further comments that "it is important that synthesis happens at one time and space and does not [result from objects or ideas] that are conjoined in some way" (note to the author, September 2004).

2 Conversation with the author, June 2004.

3 *Material Pleasures: The Fabric Workshop at ICA* (Philadelphia: Institute of Contemporary Art, University of Pennsylvania, 1979), 21.

4 In this series, as with a group of three shirts designed earlier, Tuttle's interest lay partially in the exploration of nuances of relationships between similar objects in groups of three, which he describes as "like to like."

5 The title of the chair refers to that of a guest-house designed by architect Steven Holl for Tuttle and his wife, Mei-mei Berssenbrugge, for their home in New Mexico.

6 Additional recent projects include an exhibition of Indonesian textiles curated for the Tai Gallery/ Textile Arts in Santa Fe; a large-scale mural of glass tiles designed by Tuttle for the Aqua residential complex in Miami, Florida; and a series of banners for the exterior of the Wolfsonian—Florida International University in Miami, for which Tuttle also curated a 2004 exhibition of objects from the museum's design collections titled *Beauty-in-Advertising* (pl. 384).

7 Notes to the author, September 2004.

8 Tuttle also points to Louis Comfort Tiffany as a model for the unheroic ideal of the artist, an "invisible man" who allowed others to execute his work and who used society as a paintbrush, in contrast to the romantic ideal of heroic individualism of an artist such as Jackson Pollock (conversation with the author, September 2004).

9 Tuttle quoted in Barbara Bloemink, "Dialogues on the Relationship of Art and Design," in *Design ≠ Art*, 73.

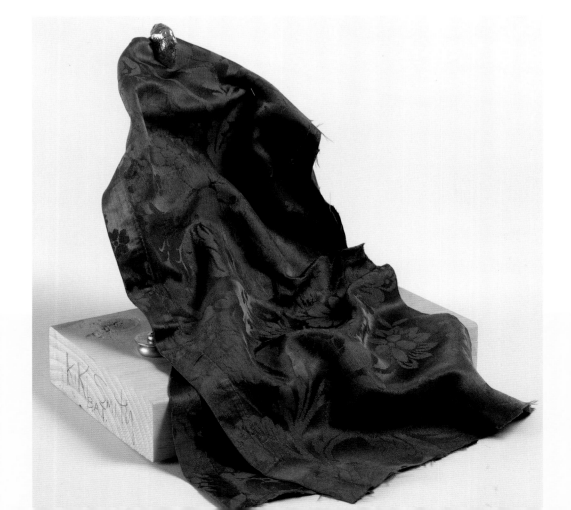

314 Richard Tuttle and Kiki Smith **Bouquet** 2001
Eighteen-karat gold, nineteenth-century
silk damask, armature wire, wood,
and hardware, ed. of 18, 8 1/2 x 9 x 5 1/2 in.
Published by Editions Fawbush, New York

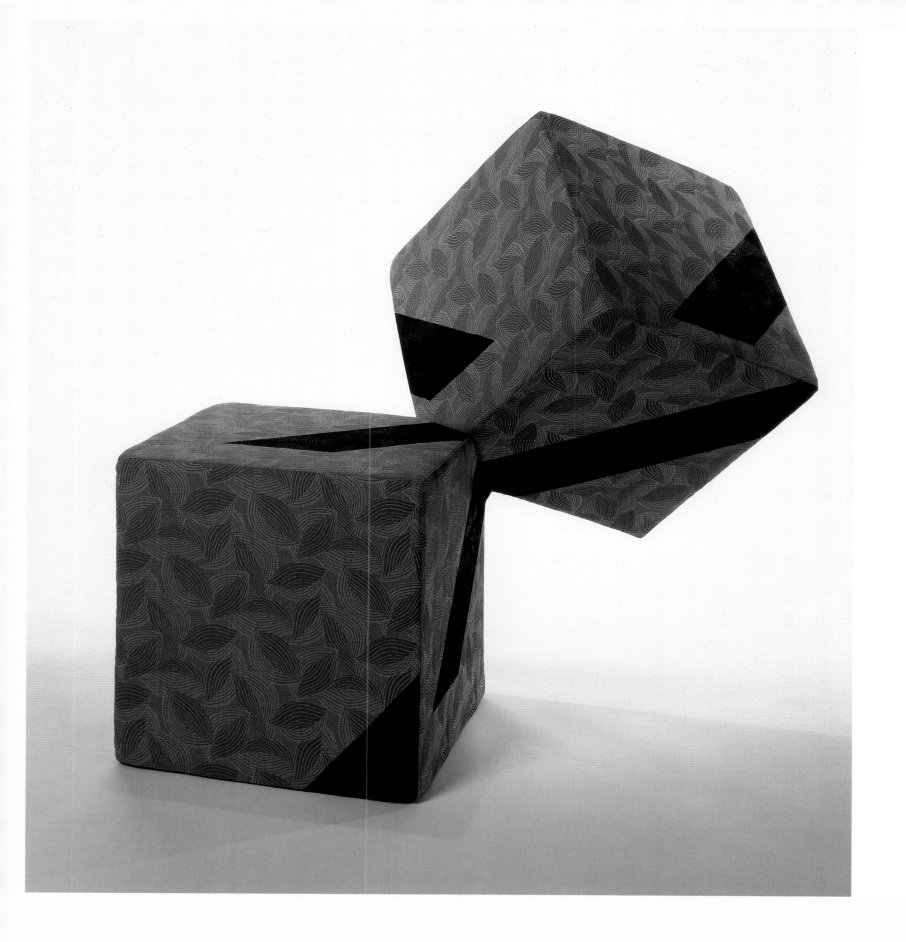

315 Richard Tuttle **Turbulence Chair** 2004
Fabric, foam, and wood, open edition,
37 x 23 x 37 in.
Published by Dwight Hackett Projects,
Santa Fe

316 Installation view of the 1992 exhibition **Richard Tuttle** at Mary Boone Gallery, New York, showing line pieces from the series **Fiction Fish** (1992)

318

317 **26th Line Piece** 1990 3 1/2 x 1 1/2 x 3/8 in.

318 **60th Line Piece** 1990 9 x 6 x 5/8 in.

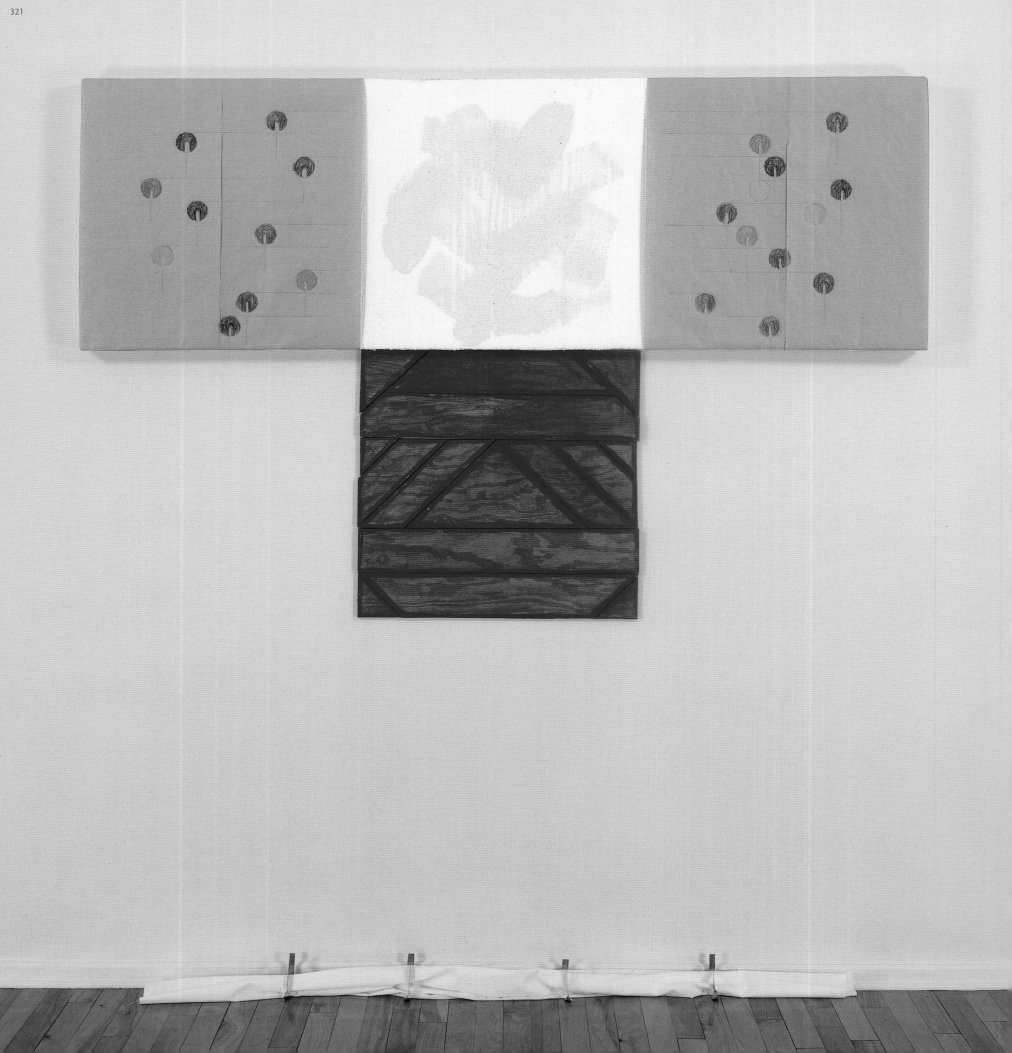

319 **Peace and Time (XII)** 1993 94 x 50 x 24 in.

320 **Paris Piece I** 1990 59 x 39 3/8 x 9 7/8 in.

321 **Whiteness 6** 1993 80 x 72 x 5 in.

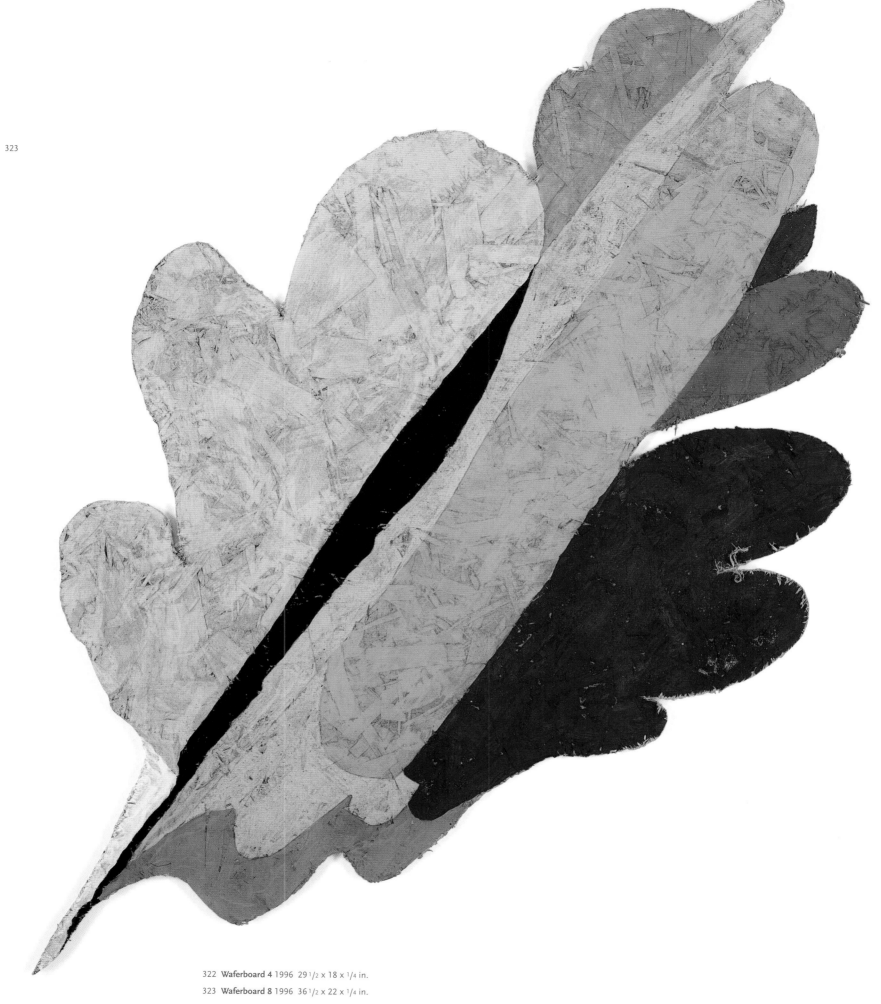

322 **Waferboard 4** 1996 29 1/2 x 18 x 1/4 in.
323 **Waferboard 8** 1996 36 1/2 x 22 x 1/4 in.

324 **Waferboard 1** (detail) 1996 33 x 19 x $^1/_4$ in.

325 **Waferboard 3** 1996 20 $^1/_4$ x 26 x $^1/_4$ in.

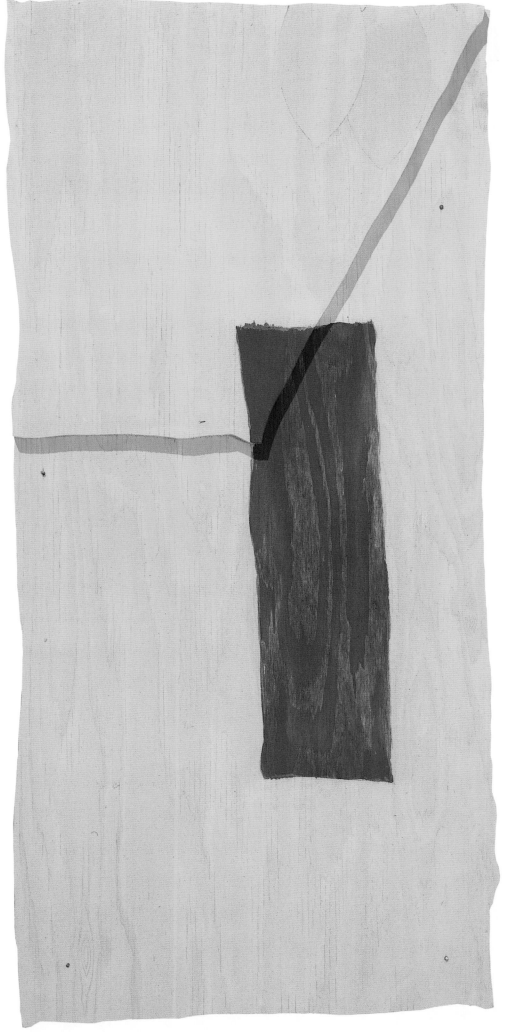

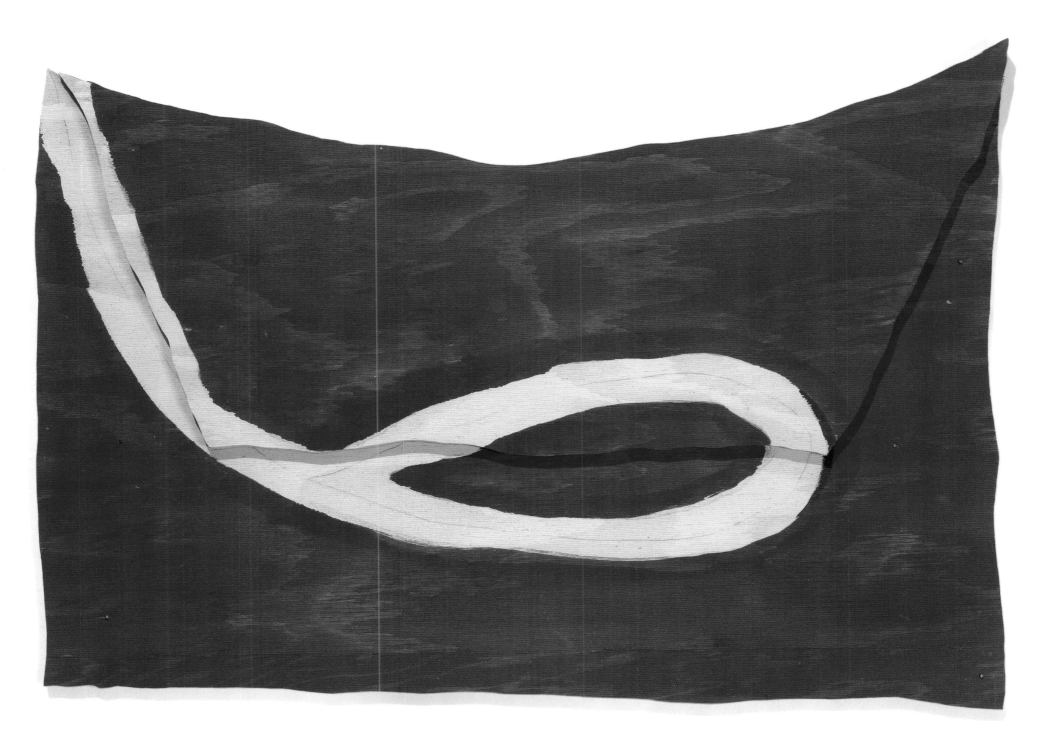

326 **New Mexico, New York, #10** 1998 22 3/4 x 10 1/2 x 1/2 in.

327 **New Mexico, New York, #14** 1998 16 1/2 x 23 1/4 x 1/2 in.

328 **New Mexico, New York, B, #13** 1998 23 x 25 1/4 x 1/2 in.

329 **New Mexico, New York, #24** (detail) 1998 21 x 25 x 1/2 in.

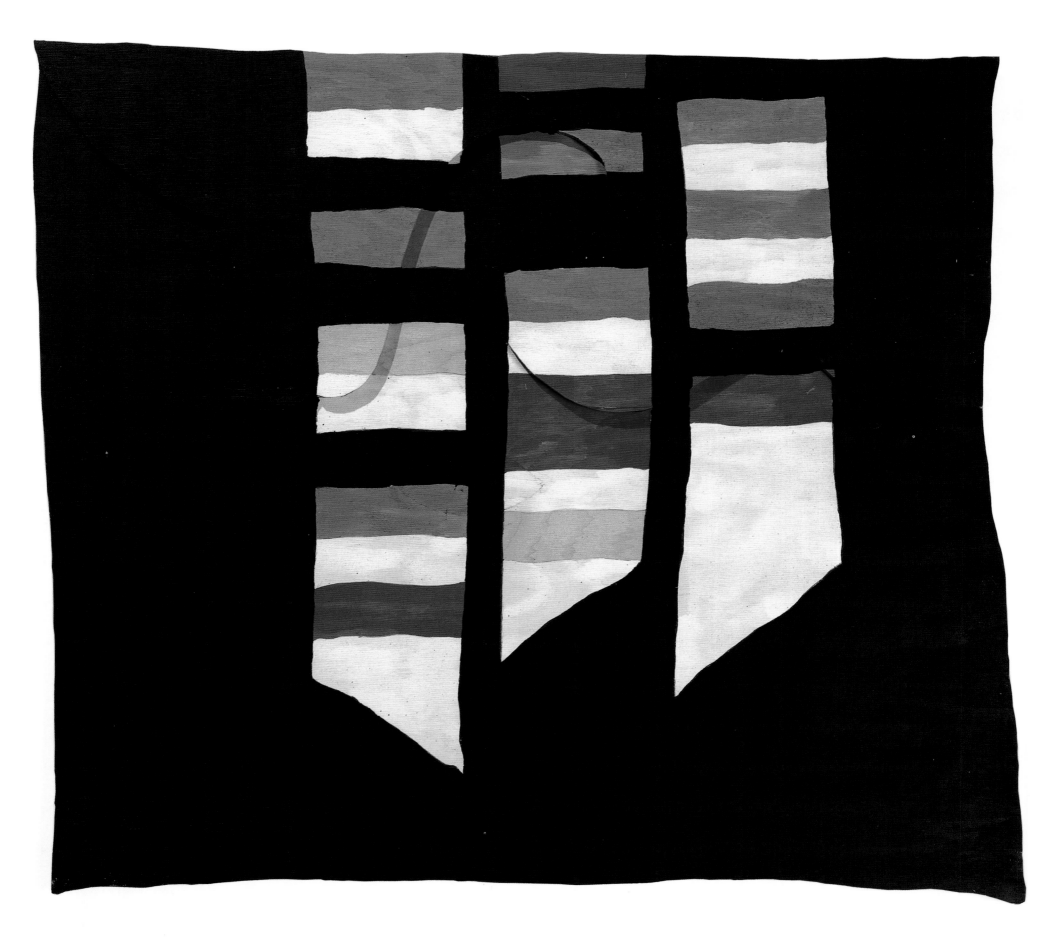

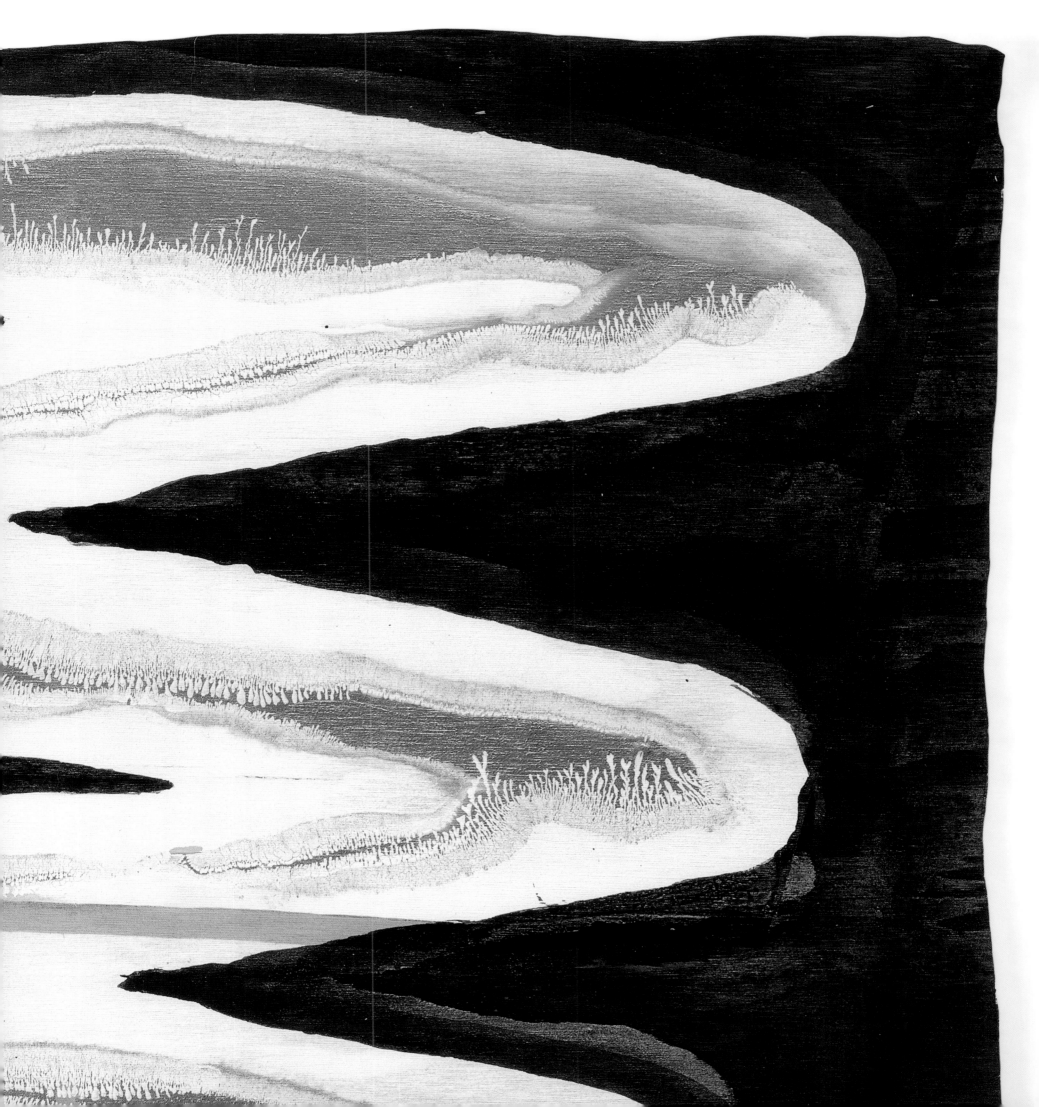

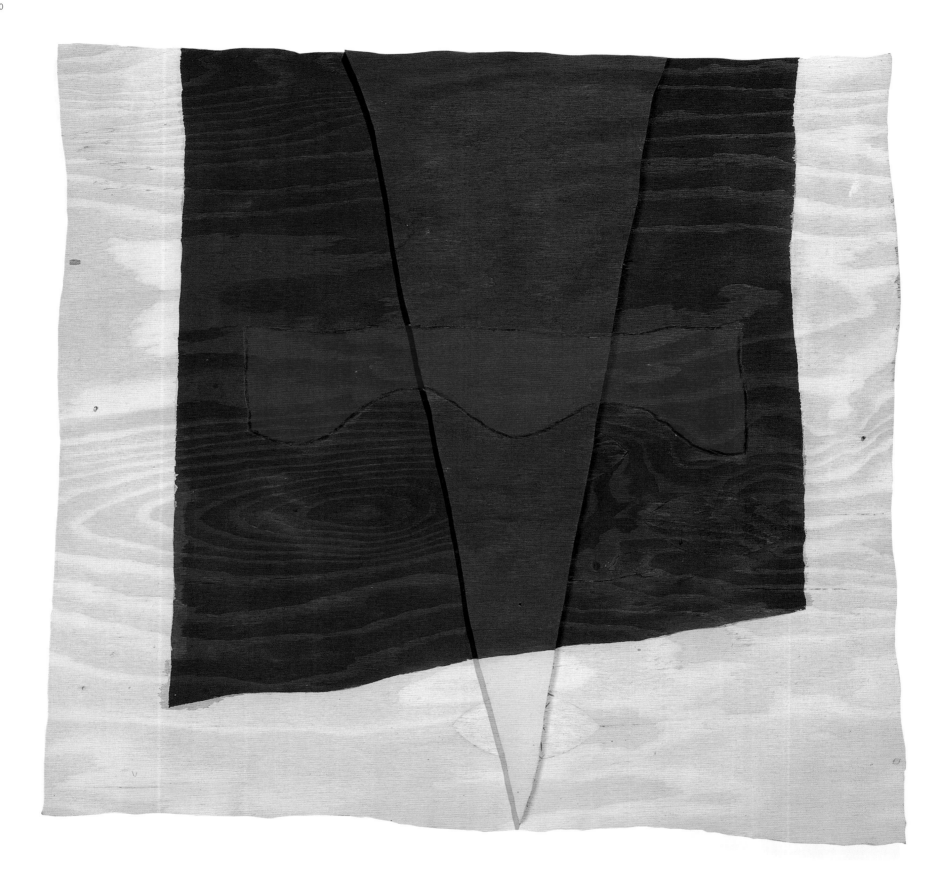

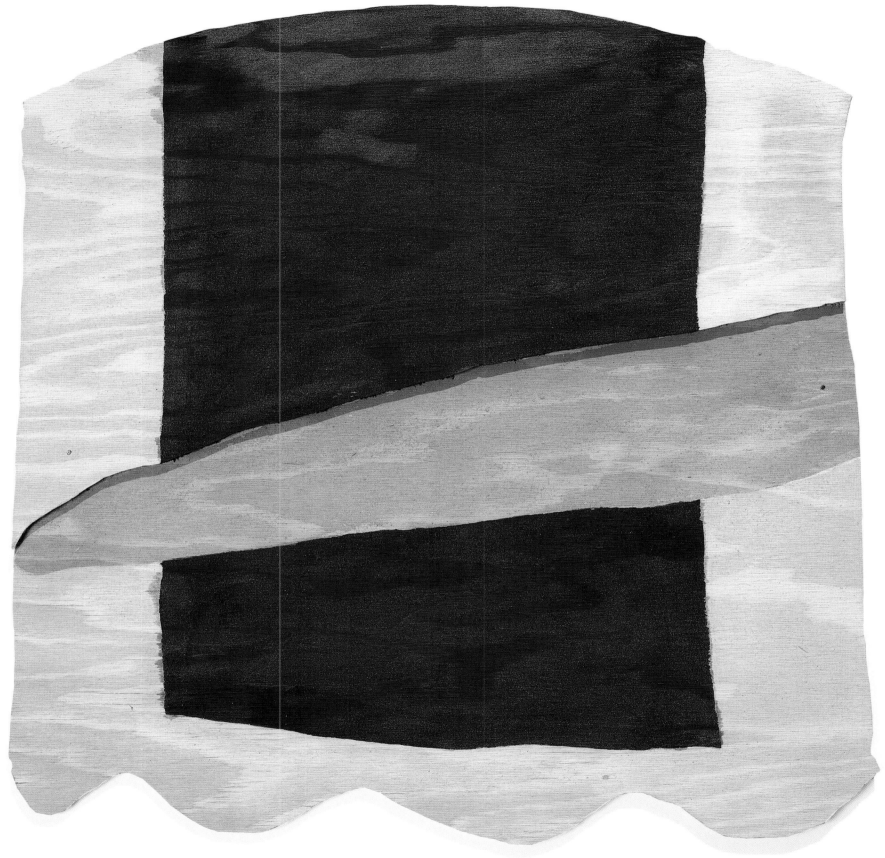

330 **New Mexico, New York, E, #1** 1998 23 1/2 x 24 3/4 x 1/2 in.

331 **New Mexico, New York, E, #3** 1998 21 x 21 x 1/2 in.

332–38 **Mandevilla** 1998 dimensions vary

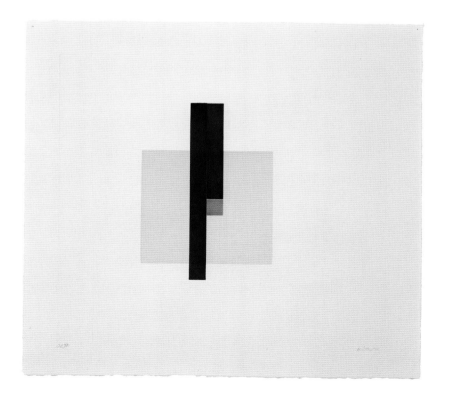

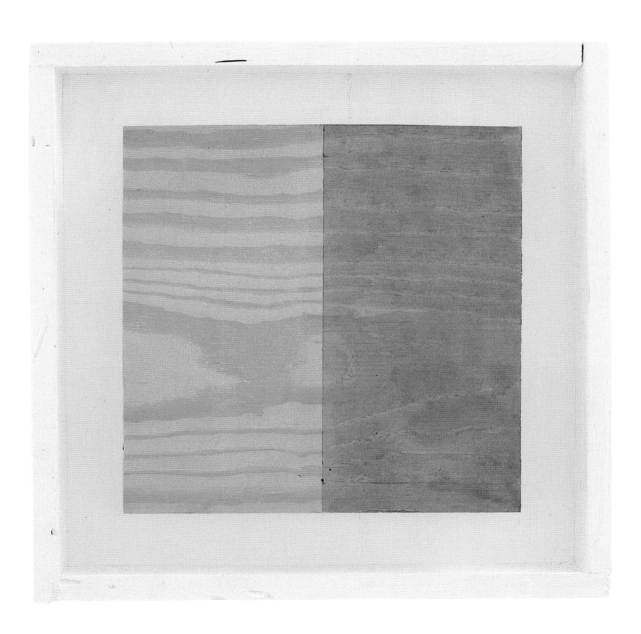

339 Installation view of the 1999 exhibition **Projekt Sammlung:
 Richard Tuttle; Replace the Abstract Picture Plane (1996–1999)**
 at the Kunsthaus Zug, Switzerland, showing **Replace the
 Abstract Picture Plane IV** (1999)

340 **Replace the Abstract Picture Plane IV** (detail) 1999 16 x 16 x 2 in.

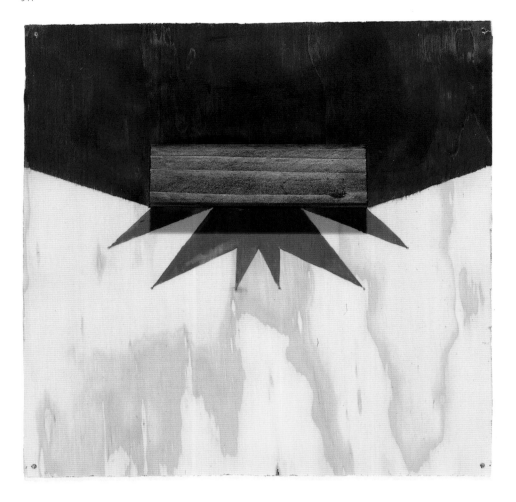

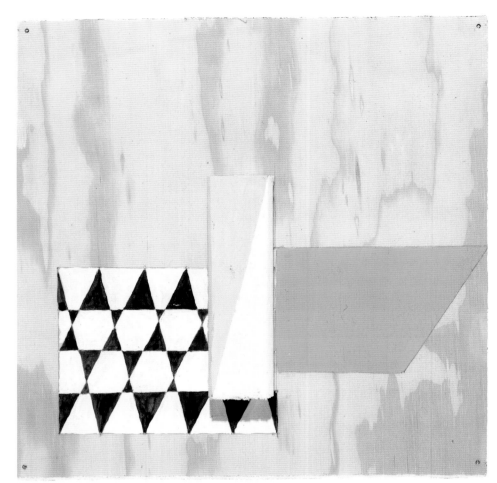

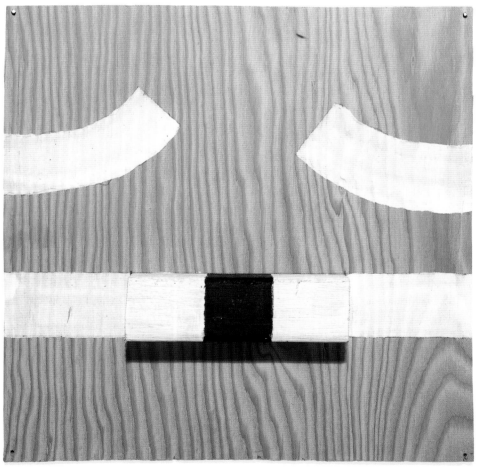

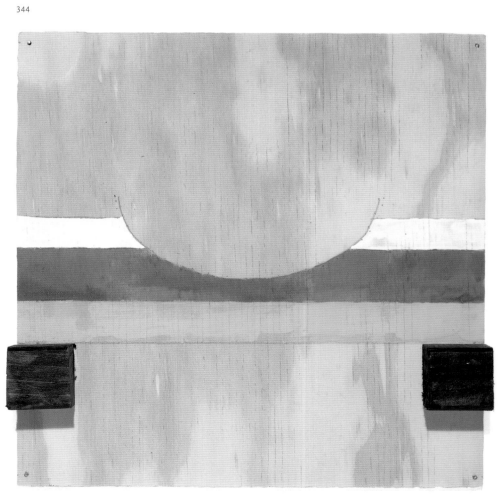

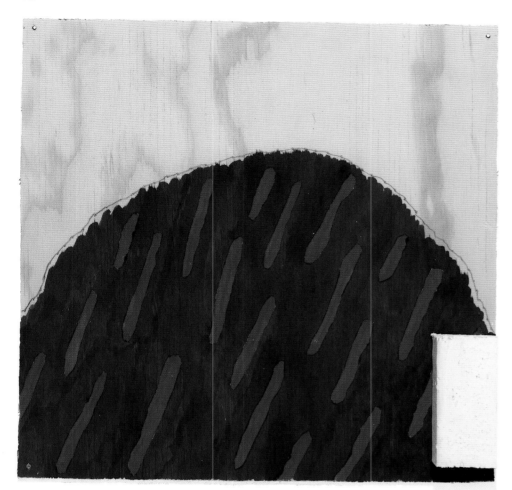

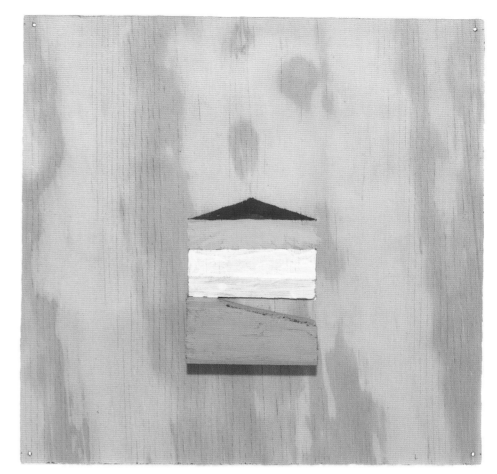

341 **"Two with Any To, #1"** 1999 11 x 11 x 1 3/4 in.

342 **"Two with Any To, #8"** 1999 11 x 11 x 1 3/4 in.

343 **"Two with Any To, #9"** 1999 11 x 11 x 1 3/4 in.

344 **"Two with Any To, #20"** 1999 11 x 11 x 1 3/4 in.

345 **"Two with Any To, #19"** 1999 11 x 11 x 1 3/4 in.

346 **"Two with Any To, #16"** 1999 11 x 11 x 1 3/4 in.

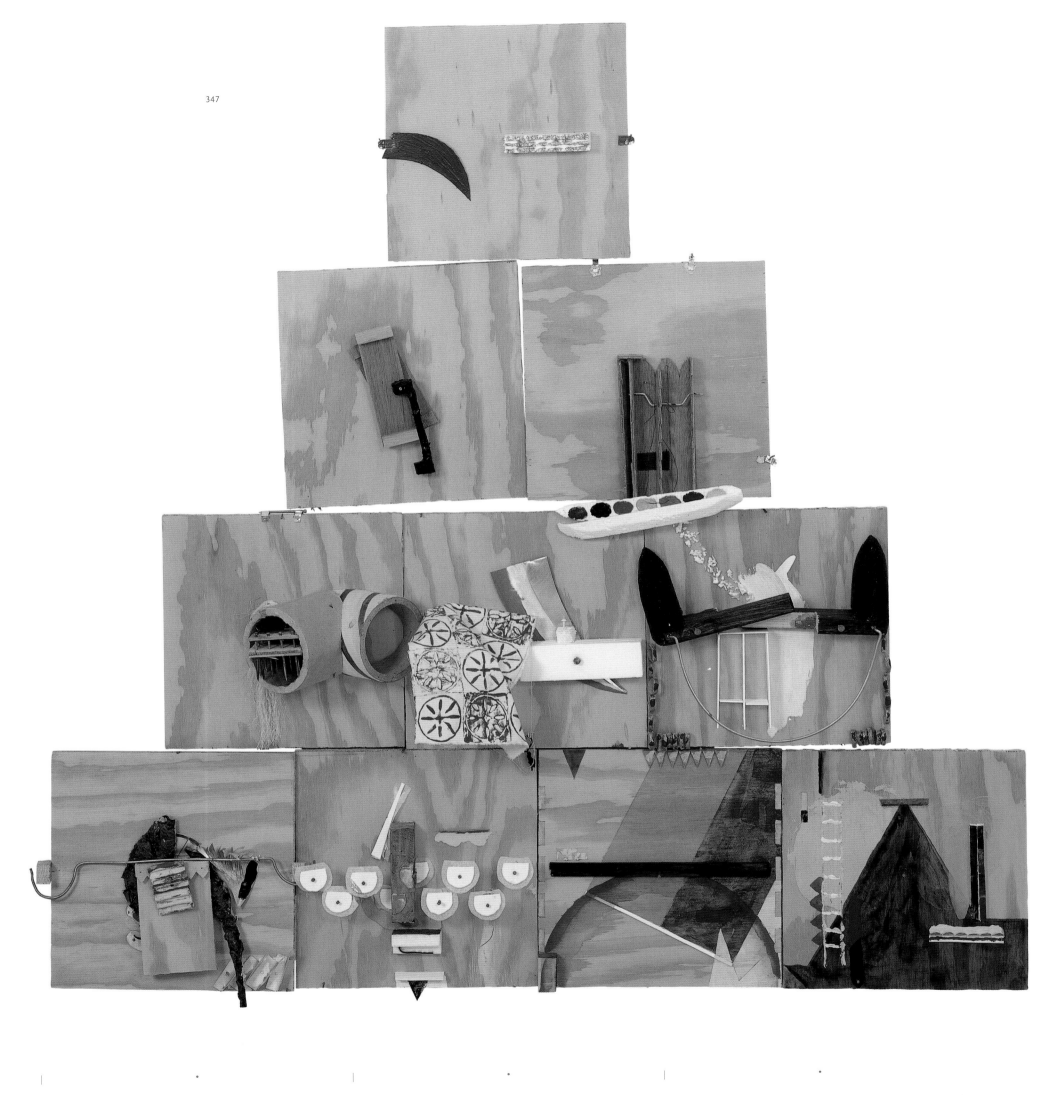

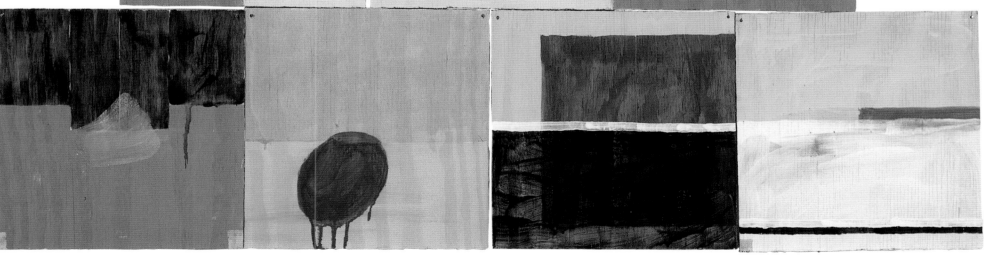

347 **Ten, A** 2000 overall 40 x 40 x 4 1/2 in.

348 **Ten, D** 2000 overall 40 x 40 x 1/4 in.

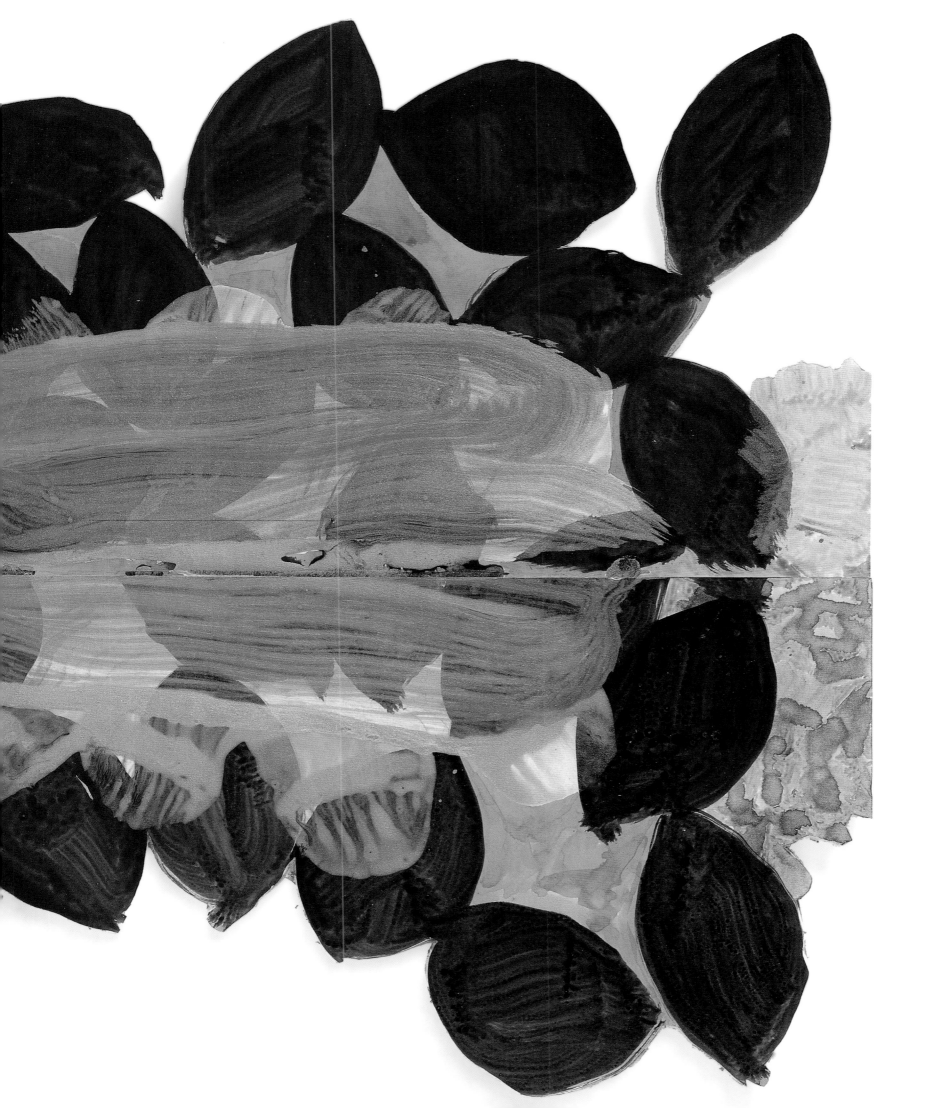

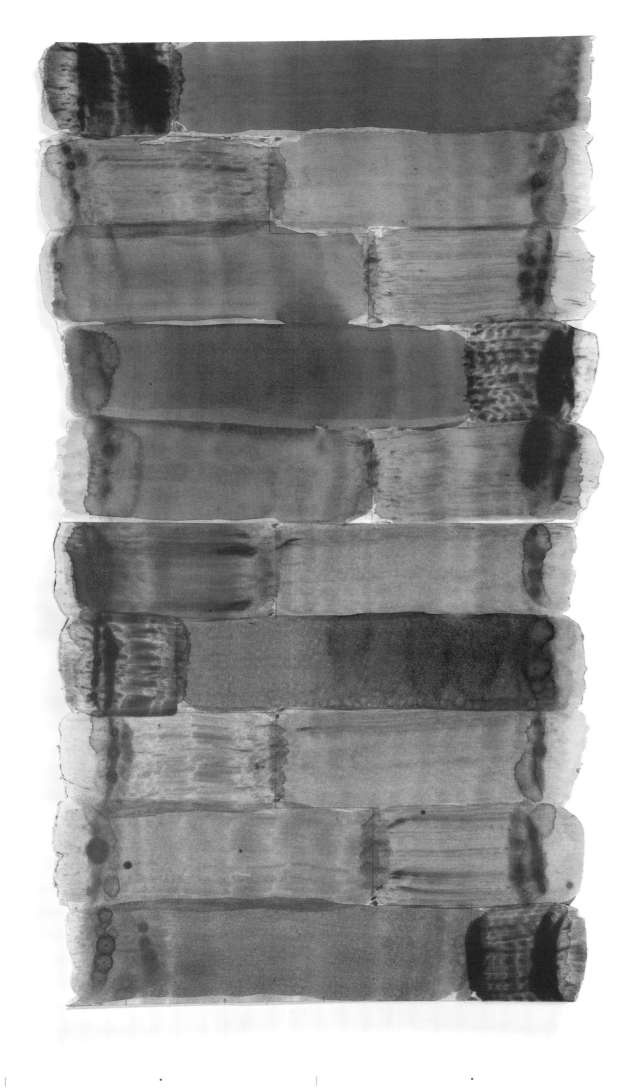

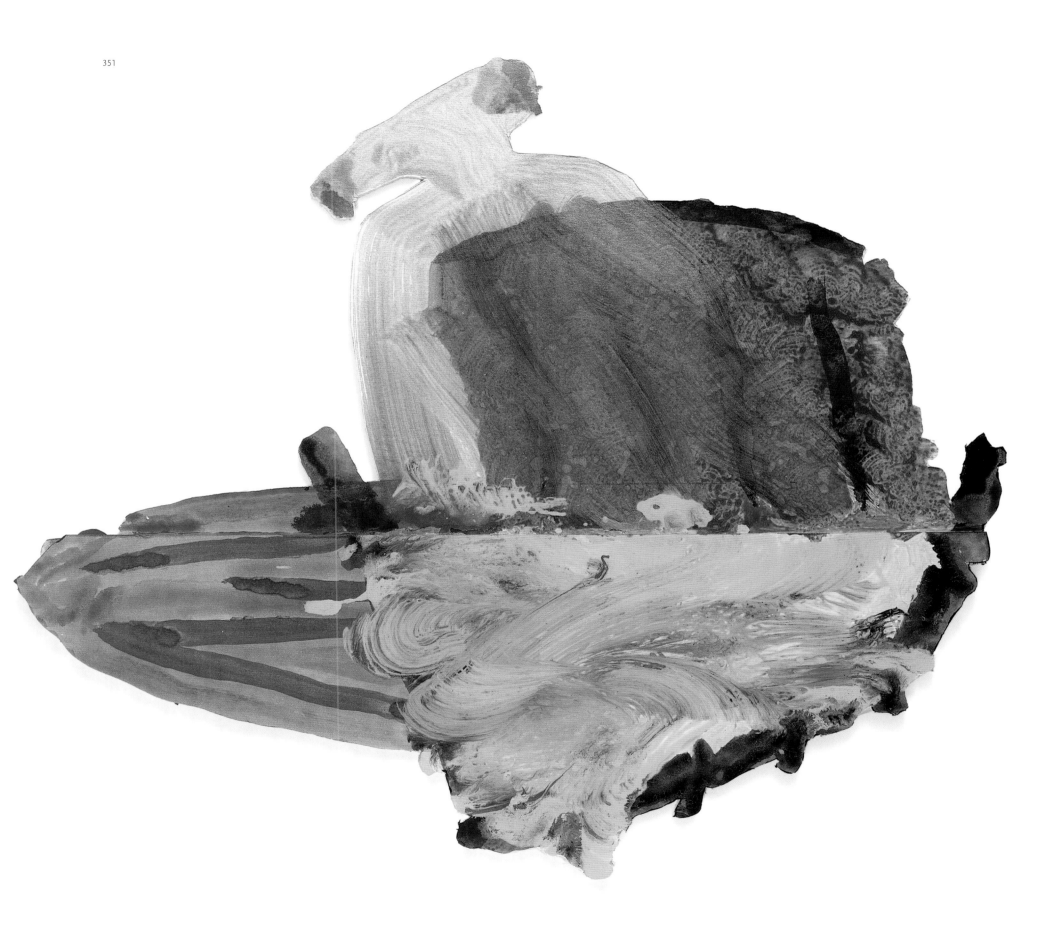

349　**"20 Pearls (12)"** 2003　18 5/8 x 19 x 3/4 in.

350　**"20 Pearls (14)"** 2003　20 x 11 1/4 x 3/4 in.

351　**"20 Pearls (7)"** 2003　16 x 18 5/8 x 3/4 in.

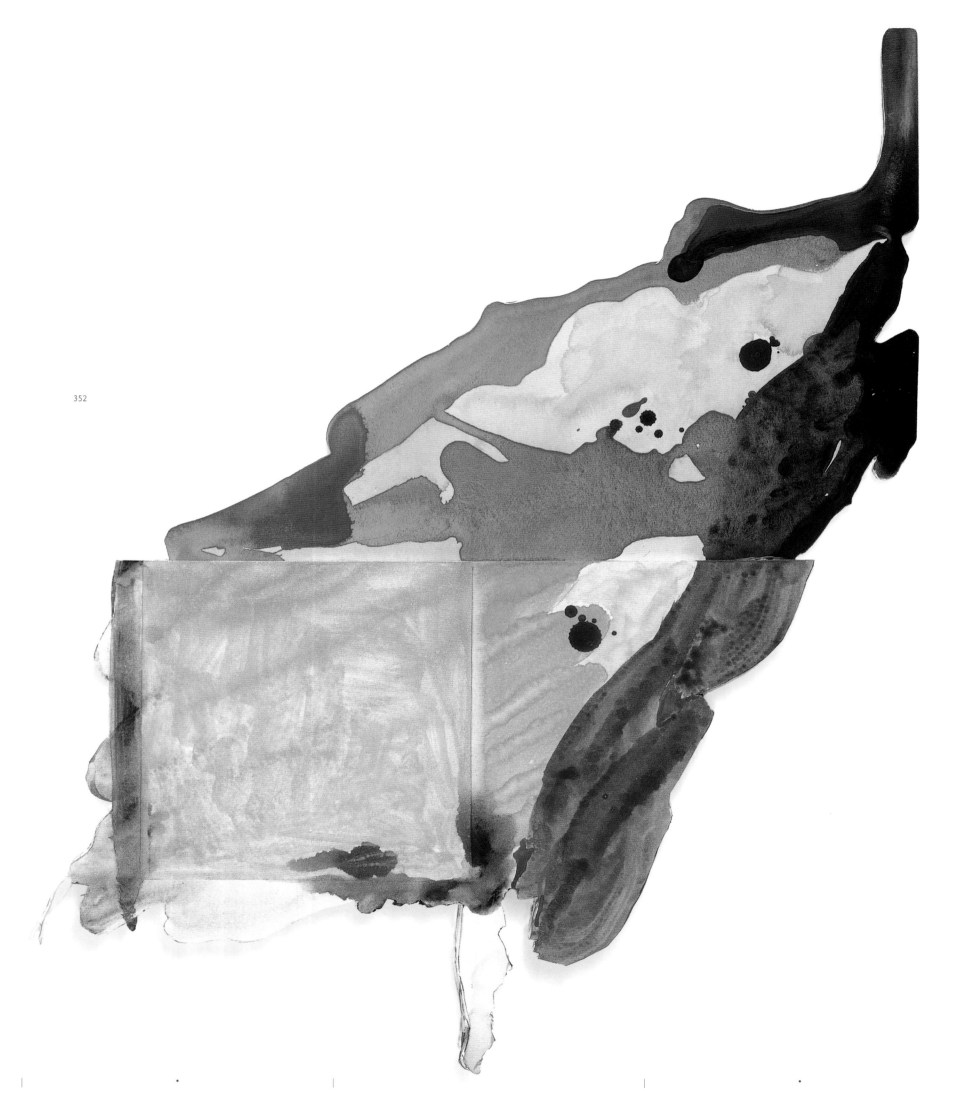

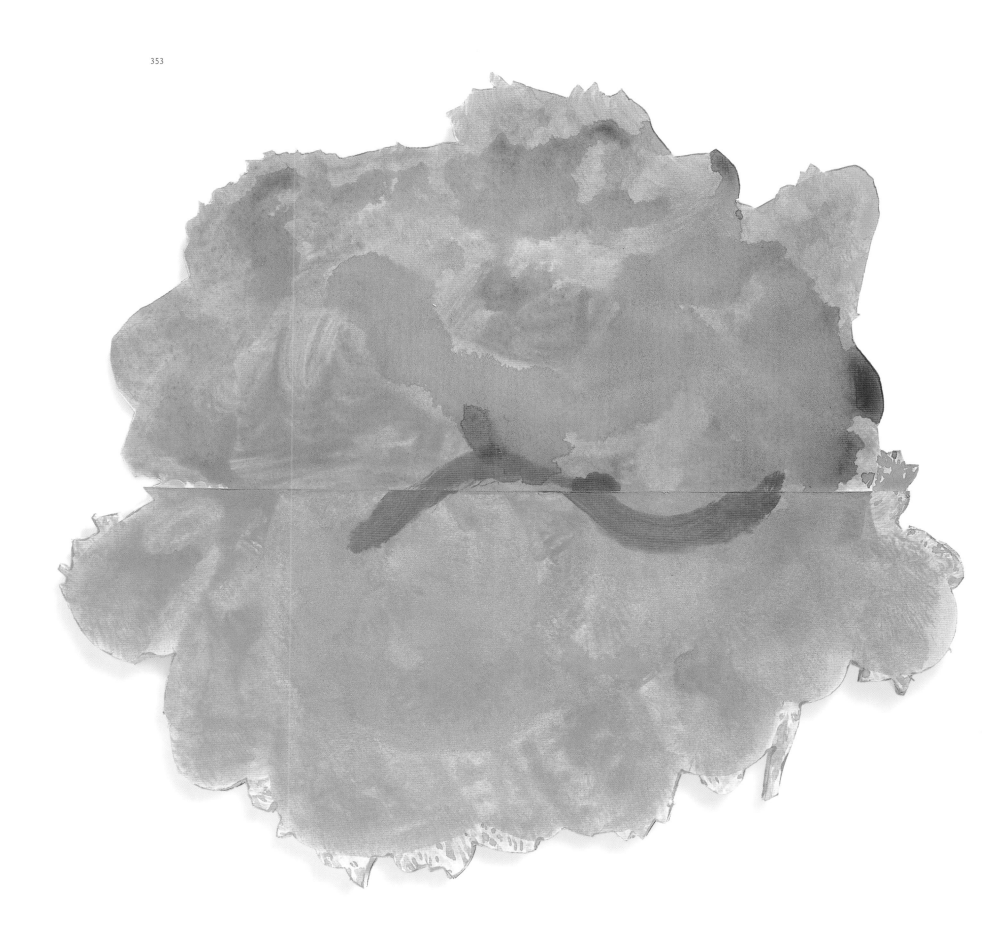

352 **"20 Pearls (8)"** 2003 19 3/4 x 16 1/4 x 3/4 in.

353 **"20 Pearls (5)"** 2003 13 5/8 x 14 5/8 x 3/4 in.

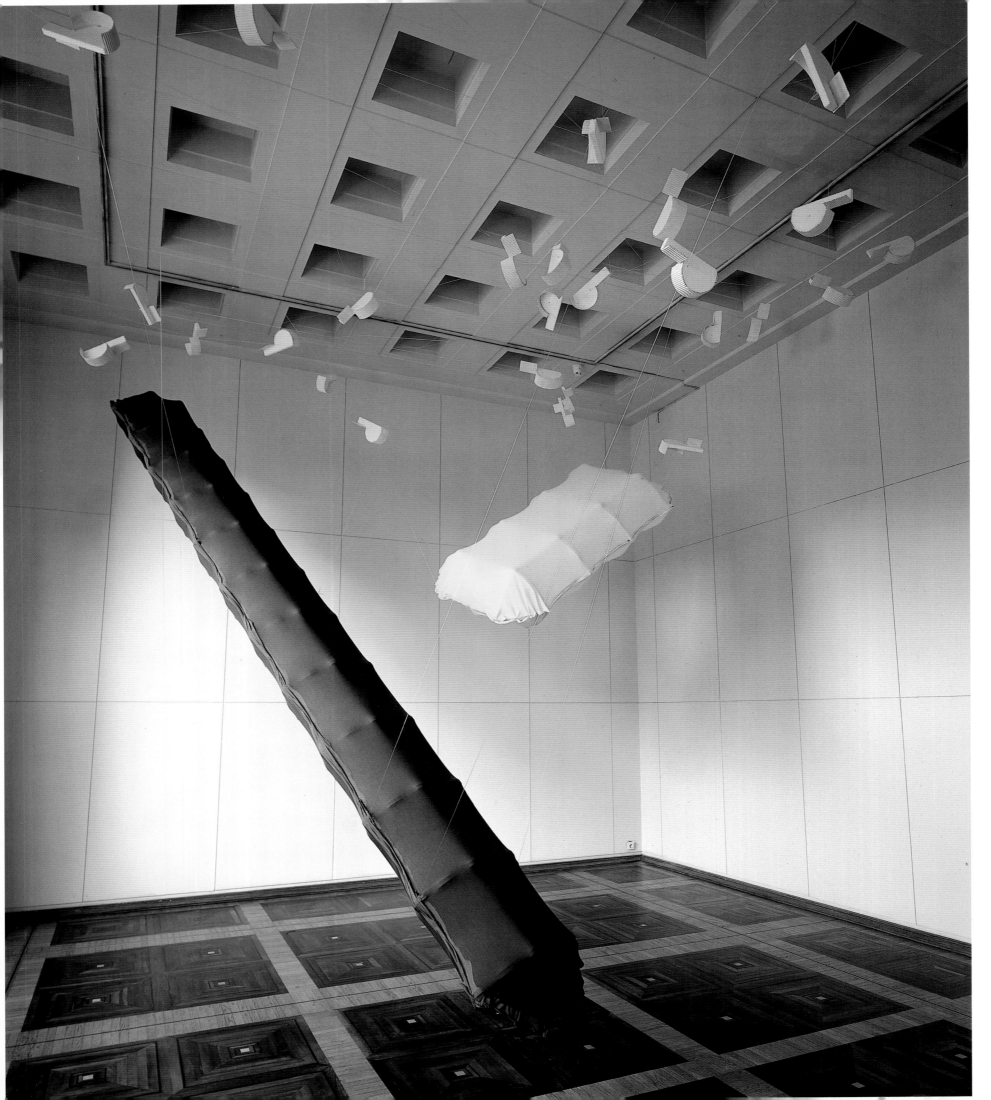

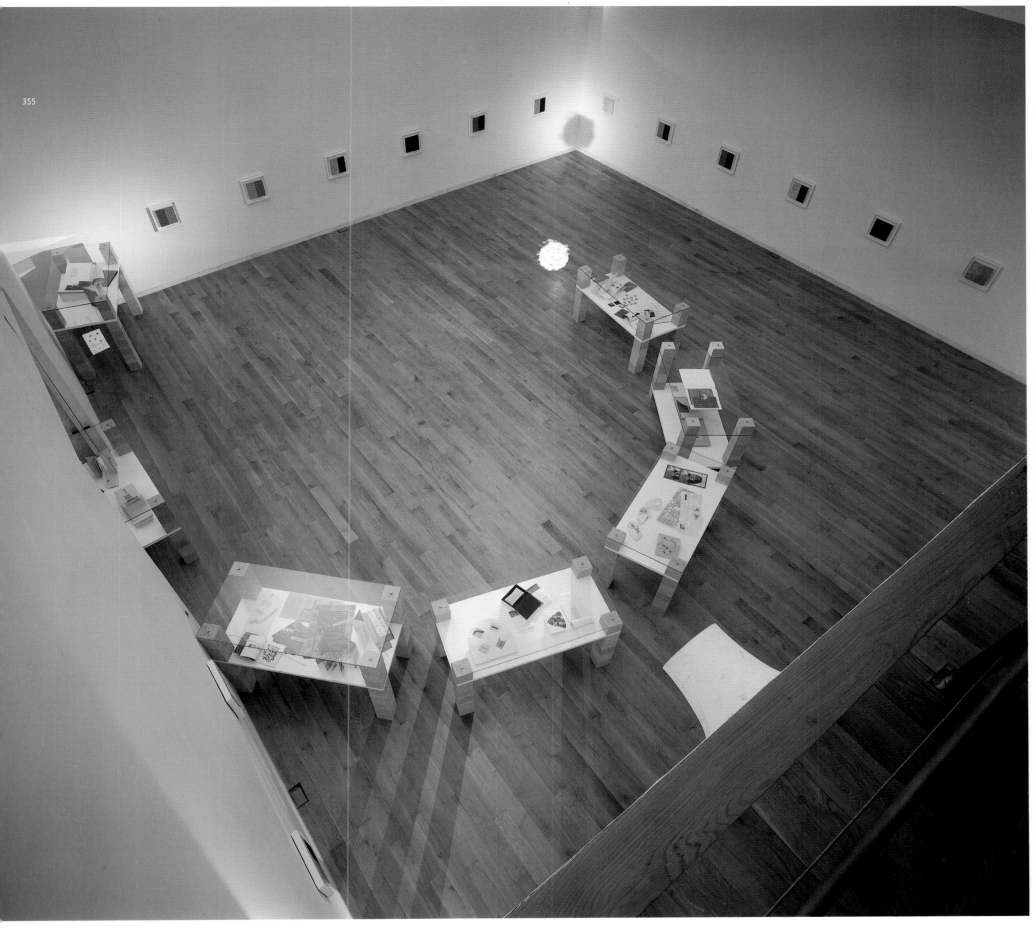

354 Installation view of the 2002 exhibition
Richard Tuttle: Memento at the Museu Serralves
de Arte Contemporânea, Porto, Portugal,
showing **Memento, Five, Grey and Yellow** (2002)

355 Installation view of the 2002 exhibition **Richard
Tuttle: cENTER** at the Centro Galego de Arte
Contemporánea, Santiago de Compostela, Spain,
showing the display of artist's books

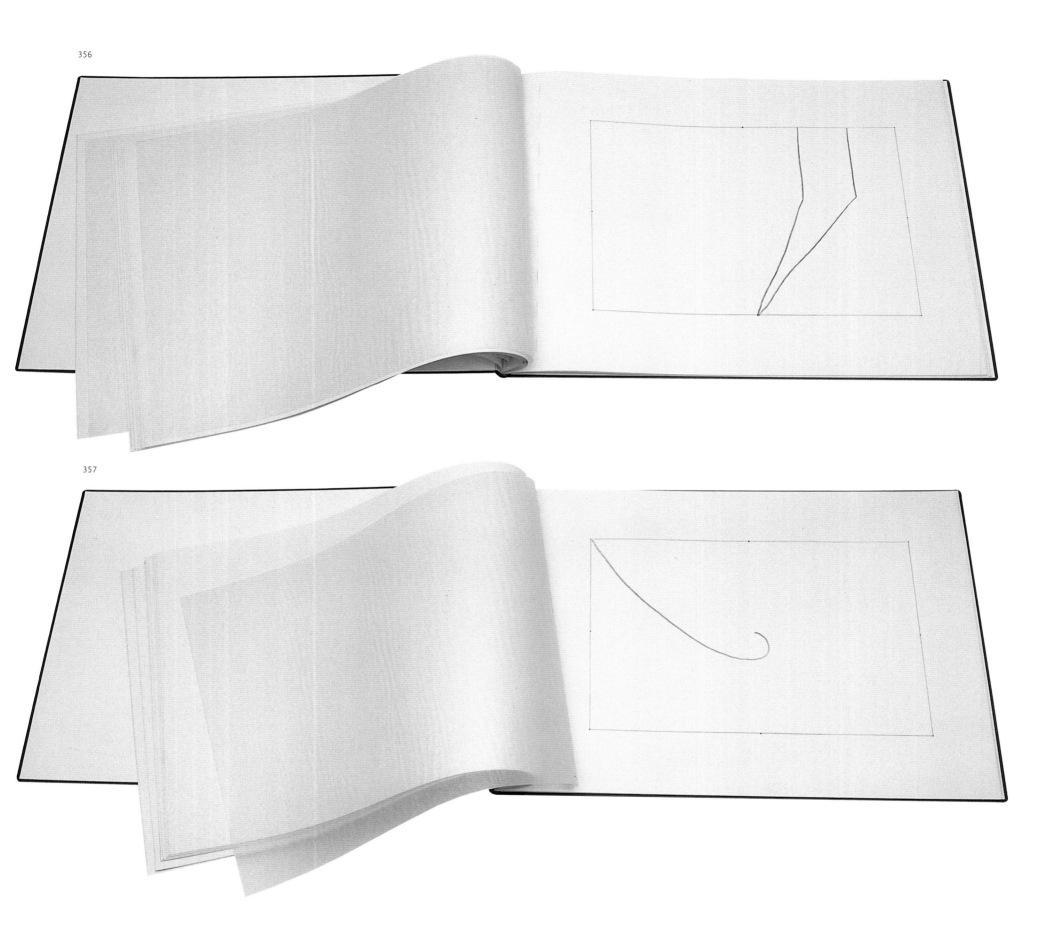

356

357

356–57 **Interlude: Kinesthetic Drawings** 1974
19 1/2 x 26 1/2 x 1 1/8 in.

358–59 **Sparrow** 1965
8 1/8 x 6 3/4 x 3/8 in.

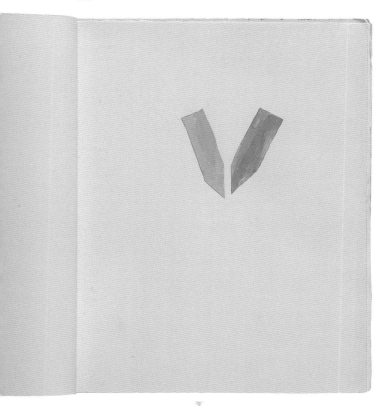

358

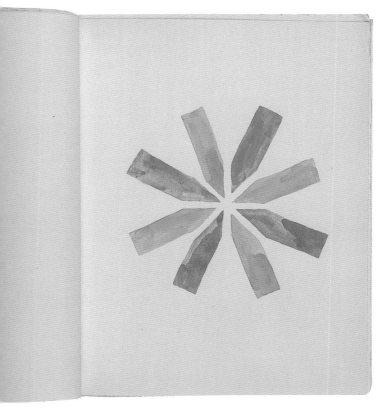

359

360

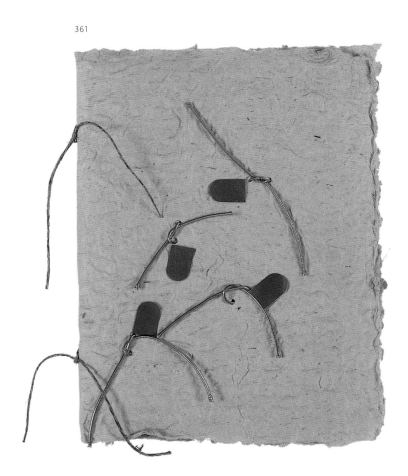

361

360 **Richard Tuttle: Grey Walls Work** 1996
8 5/8 x 8 5/8 x 1/4 in.

361 **Richard Tuttle: Community** 1999
approx. 8 5/8 x 6 3/8 x 3/8 in.

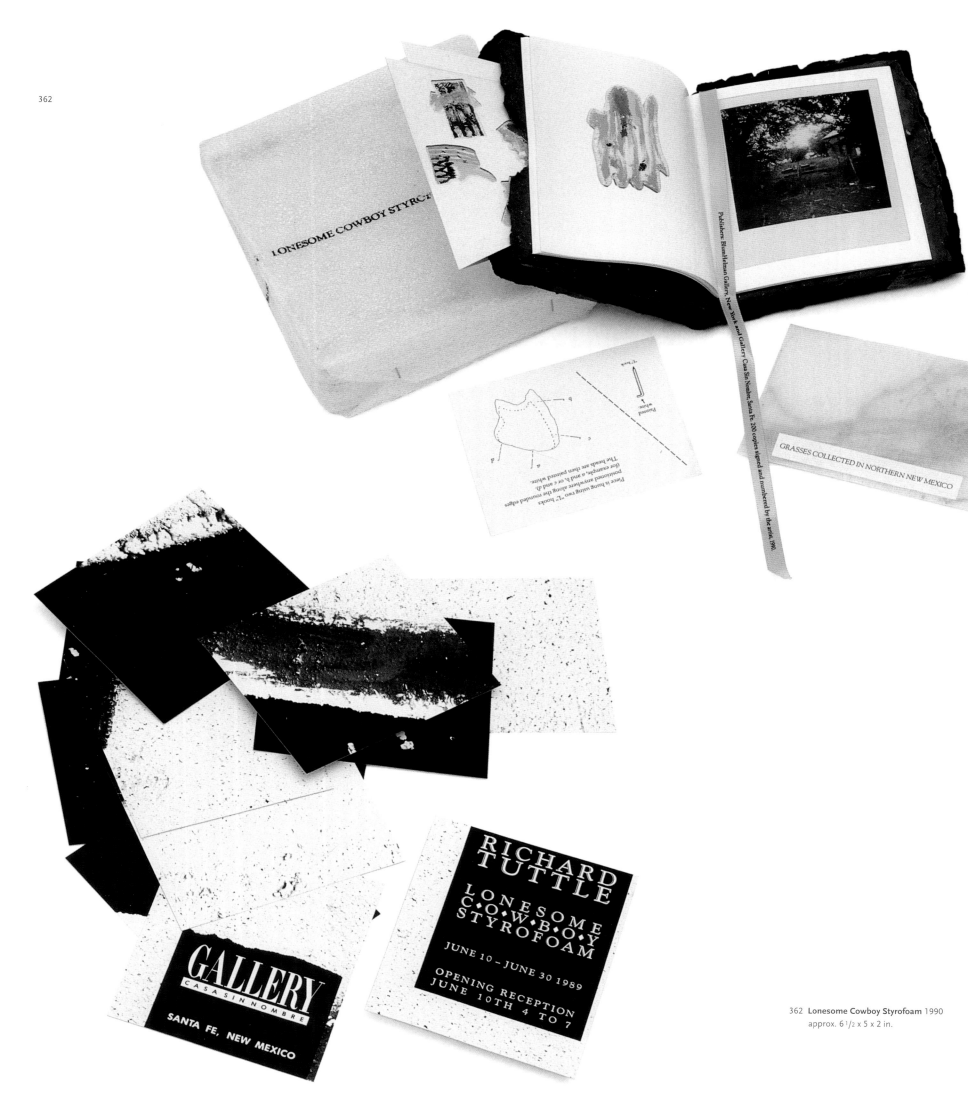

LONESOME COWBOY STYROFOAM

Publishers: Blum/Helman Gallery, New York and Gallery Casa Sin Nombre, Santa Fe. 200 copies signed and numbered by the artist, 1990.

GRASSES COLLECTED IN NORTHERN NEW MEXICO

Piece is hung using two "L" hooks positioned anywhere along the rounded edges (for example, a and b, or b, or c and d). The heads are then painted white.

RICHARD
TUTTLE
L·O·N·E·S·O·M·E
C·O·W·B·O·Y
STYROFOAM

JUNE 10 – JUNE 30 1989

OPENING RECEPTION
JUNE 10TH 4 TO 7

GALLERY
CASA SIN NOMBRE

SANTA FE, NEW MEXICO

362 **Lonesome Cowboy Styrofoam** 1990
approx. 6 1/2 x 5 x 2 in.

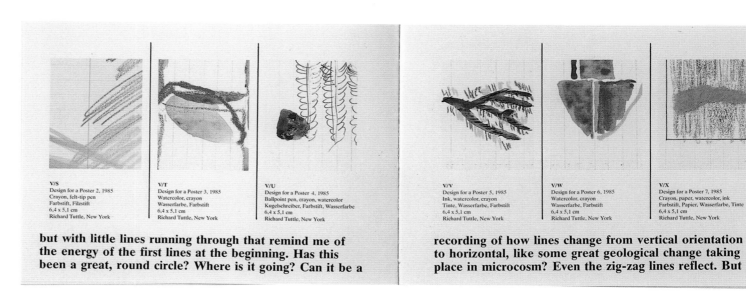

V/S
Design for a Poster 2, 1985
Crayon, felt-tip pen
Farbstift, Filzstift
6,4 x 5,1 cm
Richard Tuttle, New York

V/T
Design for a Poster 3, 1985
Watercolor, crayon
Wasserfarbe, Farbstift
6,4 x 5,1 cm
Richard Tuttle, New York

V/U
Design for a Poster 4, 1985
Ballpoint pen, crayon, watercolor
Kugelschreiber, Farbstift, Wasserfarbe
6,4 x 5,1 cm
Richard Tuttle, New York

V/V
Design for a Poster 5, 1985
Ink, watercolor, crayon
Tinte, Wasserfarbe, Farbstift
6,4 x 5,1 cm
Richard Tuttle, New York

V/W
Design for a Poster 6, 1985
Watercolor, crayon
Wasserfarbe, Farbstift
6,4 x 5,1 cm
Richard Tuttle, New York

V/X
Design for a Poster 7, 1985
Crayon, paper, watercolor, ink
Farbstift, Papier, Wasserfarbe, Tinte
6,4 x 5,1 cm
Richard Tuttle, New York

but with little lines running through that remind me of the energy of the first lines at the beginning. Has this been a great, round circle? Where is it going? Can it be a

recording of how lines change from vertical orientation to horizontal, like some great geological change taking place in microcosm? Even the zig-zag lines reflect. But

PERCEIVED
OBSTACLES

363 **Richard Tuttle** 1985
5 7/8 x 8 1/4 x 3/8 in.

364 **Perceived Obstacles** 2000
12 x 36 x 5/8 in.

by Katy Siegel

AS FAR AS LANGUAGE GOES

365 Richard Tuttle designing the endsheets
for the hardcover edition of this volume
at Green Dragon Office, Los Angeles, 2005

ONE (SUBTRACTION)

The work is self-justification, by default, through rebellion, like the number, –1.

<div align="right">RICHARD TUTTLE, 1972[1]</div>

When he moved to New York in 1963, Richard Tuttle began his first painting there by writing three sentences by the philosopher Alfred North Whitehead on a canvas.[2] He then painted over them with semitransparent paint. Tuttle believed that he had to get rid of language, ironically, in order to communicate. Today he sees that first work rather differently, as a painting of "ambiguity": on the one hand, language was "obscured, attacked, destroyed"; on the other, even after he laid on the top coat, the words shone through as both the ground of the painting and a kind of architectural structure.[3] His early rejection and later conflicted embrace of language distinguish Tuttle's approach from those of artists of either moment, freeing him to create his own particular relationship to letters, numbers, words, symbols, and books.

Just two years after that first painting, in 1965, Tuttle had a New York solo exhibition at Betty Parsons Gallery titled *Richard Tuttle: Constructed Paintings*. These painted wooden reliefs, made in 1964–65, are sometimes referred to as ideograms or pictographs; the artist prefers the term *glyph*. Some of them resemble the objects that their titles denote: the rounded arc of *Hill*, the stocky *Torso*, and the radiating *Fountain*. Others refer to their titles through color (the red *Fire*), while *House* invokes pictorial representation, because it *looks* like a house, as well as linguistic signification, because it also resembles a double letter *H*. Another of these first reliefs, *Equals*, references a mathematical symbol; like Jasper Johns's *Target* (1958), it both represents a symbol and is an actual instance of one.

These playful, bright objects move between common, familiar symbolic systems and a more personal, imaginary one. Combining concrete plainness and a fantastic aspect, they contrast sharply with other art of the time using language. Although Tuttle had some interest in Beat culture, the reliefs are far from either the surrealist sensibility of Wallace Berman or the neo-Dada attitudes of Fluxus, nor do they at all coincide with the interests and attitudes of the artists who would come to be known as conceptual. The latter—Joseph Kosuth, Mel Bochner, John Baldessari, and Lawrence Weiner, among others—turned to language to communicate more directly and clearly, believing that language, because it is conventional, is reliable and definitive, as opposed to the seductive but ambiguous nature of visual art. These beliefs may seem naive now, after years of poststructuralist insistence on language's indeterminacy. Today, Tuttle looks prescient in his lightly worn mistrust of language, whose arbitrary nature these early reliefs effortlessly express.

<div align="left">

plate 63

plate 292

plate 51 / plate 50

plate 43

plate 47

</div>

366 **Story with Seven Characters** 1965
Woodcuts on paper, board, and tape, ed. of 7,
12 1/8 x 11 1/4 x 3/8 in.
Published by Richard Tuttle, New York

The early constructed paintings also reject the antiexpressive absoluteness of Pop art, which had so recently confirmed its triumph over Abstract Expressionism. Critics of the time often mentioned the "trembling sensibility" of Tuttle's reliefs, as evidenced by their uneven contours, the result of the artist drawing by hand on paper templates rather than cutting with a straightedge.[4] This is one of the reiterated (and not necessarily incorrect) clichés about Tuttle's art: that it is one of sensibility, a truism often wedded to the assertion that his work is filled "with inward meanings," that it favors experience over absolute, obdurate materiality.[5] (Ten years later, this idea would reach its most influential formulation in Marcia Tucker's essay for her Whitney Museum of American Art catalogue, in which she asserted that Tuttle's work is not understood but felt.[6])

At the time Tuttle was making these reliefs, he started making books as well. The first, *Sparrow* (1965), is a lovely wordless narrative in which pairs of yellow and pink forms appear, page by page, to form a circle; the narrative then reverses, as a circle of blue-gray shapes is undone one by one. Flipping through the book is like watching the assembly and dismantling of *Fountain*, one of the reliefs made that same year, a circular form constructed from the same shapes used in *Sparrow*, here realized in white-painted wood. The book allows Tuttle to take the same shapes he used in the sculpture and animate them, adding time, motion, and narrative. In 1965 Tuttle also produced what is still perhaps his best-known book, *Story with Seven Characters*. The book's "story" develops through the spatial and temporal relationships between seven symbols—some of which also appear in his contemporaneous reliefs and in later work—which are introduced on the first page of the book.

plates 358–59

plate 366

Story was made using woodcuts, the earliest form of book printing; the technique also connects two- and three-dimensional objects, in that a woodblock itself is a sculpted thing used to make a graphic mark. Interestingly, Tuttle's name for his symbol-like shapes—glyph—links these two aspects: the term originally referred to a carved or sculptural representation, and then also to a pictographic mark, and has come to designate a typographic character. There is a second productive

ambiguity here, one suggested by the term *character* in the book's title—are these shapes characters in their resemblance to alphabetic forms? Or are they characters in the sense of being actors in a theatrical narrative? Because single characters often repeat on the same page, the former seems more likely; a being cannot exist more than once in a single place, at a single moment, while a symbol can. But in the imaginary space of the book, the artist can suspend this tension, leaving the characters to act both as individual beings and iterable signs.

An even more explicit reference to language, although still imaginative and opaque, can
plate 57 be found in Tuttle's *Letters (The Twenty-Six Series)* (1966). In this, one of several works based on the
Latin alphabet, or at least the number of elements in it, the artist cut out twenty-six letterlike forms
plate 56 / plate 18 in metal and exhibited them alternately on the floor, the wall, or on top of a pedestal.[7] Some of the
shapes lie flat, others are bent and twisted, posing en pointe or seemingly caught in the act of sitting
up. Because twenty-six symbols suggest, to most English speakers, a complete linguistic apparatus,
this work implies that we can comprehend our world and organize our understanding through a
representational system. But which system? While some of Tuttle's glyphs can be recognized as
letters— we can identify a *B* and a *T*, for example—others are completely unfamiliar. These "letters"
remind us of the radically arbitrary and conventional nature of any actual alphabet, including our
own, and suggest the possibility of others whose representational value would be no less for being
opaque to us. This "other" alphabet could belong to an imaginary foreign culture, or even to a single
individual rather than a society. Maybe Tuttle felt that he needed a new alphabet in order to say what
he wanted to say.

TWO (ADDITION)

The difference between two apples and "two" seems like the turning point in history to me.

RICHARD TUTTLE, 1975[8]

One of my favorite quotes is by Niels Bohr where he said, "On Earth we're only capable of doing
one thing at one time, but in the universe we must assume we can do two things at the same time."
It's almost that the pressure on people in the 20th century is that in fact you do do two things
at a time, which is to define your place on Earth as well as find your place in the universe.

RICHARD TUTTLE, 1997[9]

Tuttle has said more than once that the early part of his oeuvre describes a process of reduction, in
plates 23, 85–94 / plates 108–19 which the *Paper Octagonals* and wire works of the early 1970s were for him a final step, the paper
pieces being skin and the wire works being bones. From the mid-1970s forward, his work turned
from subtraction to addition. He not only added formal complexity and the flesh of materiality, as he
began to concentrate more on three-dimensional work; he also added actual language to his books
while playing with the related category of number.

plate 367 Tuttle's first foray into recognizable language was the wry but lovely *Book* (1974), in
which a single letter of the alphabet was printed on each page, and the letters followed their custom-
ary sequence. In the flatness of its forms and the sparseness of presentation, *Book* continued Tuttle's
tendency toward reduction of material at a time when his sculpture and painting were becoming
more complex and volumetric. This contradiction has characterized his work since the mid-1970s,

367 **Book** 1974
Letterpress ink on paper,
open edition, 9 7/8 x 6 5/8 x 3/8 in.
Published by Paul Bianchini Books,
Editions des Massons, Lausanne,
in collaboration with Yvon Lambert, Paris

which has continued to shift between flatness and depth, between, as he puts it, calligraphy and architecture. *Book* was also prophetic in the way the letters oscillate between referencing an actual language and exhibiting their concrete particularity as a beautiful aesthetic experience, the font as carefully chosen as the book's lovely gray paper.

Language in the guise of words and sentences first appears in a book Tuttle produced in 1977 together with Larry Fagin, a second-generation New York School poet who had been co-director of the Poetry Project at Saint Mark's Church.[10] *Poems: Larry Fagin / Drawings: Richard Tuttle,* the first of Tuttle's many collaborations with poets, combines short, seemingly nonsensical poems ("A big joint / with a little / avocado on it") and sweet drawings, simple black lines that describe forms wavering between absurd abstraction and representations of objects, such as a wire fence. At just this moment in the late 1970s, artists like Jenny Holzer and Barbara Kruger began to focus in their work on the exhortative, instrumental function of language in political slogans and advertising campaigns. In his growing love for a particular kind of poetry, Tuttle took the opposite tack, using a language form notable for its anti-instrumentalism, its resistance to mass-media usage and propaganda. His favored poets, including Fagin, Barbara Guest, Charles Bernstein, and Mei-mei Berssenbrugge, treat language as if meaning were not socially determined but open and malleable.

While these writers assert themselves against convention, it is not in the service of predictable expressionism or personal confession. As poet Hank Lazer describes the work of one of Tuttle's most frequent collaborators, "What Bernstein's poetry involves is a resistance to (but not absolute evasion of) self-expression and the poetics of signature, voice, and a homogeneous style. Indeed, Bernstein's work does not ignore but is in constant dialogue with such forces."[11] This kind of personal impersonality rhymes with Tuttle's sensibility. While today the artist's work seems

plates 368–69

more intimate than other, cooler projects of the 1960s and 1970s—such as the industrial sculpture of Donald Judd or the stark textual works by the conceptual artists mentioned above—Tuttle has never embraced a particular style, stroke, or signature. Robert Pincus-Witten tells an anecdote in a 1970 article: the critic points to a piece of wood in the artist's studio that is pierced by small nails, the points of which spell out "Tuttle."[12] The artist explains that he is thinking of "signing" his *Paper Octagonals* with this home-made printing device, and demonstrates that a handwritten signature ruins the work. His solution, a semimechanical, slightly distanced, but still handcrafted approach (basically a form of very low-tech printing) perfectly expresses his abstractly personal voice. Similarly, poets like Bernstein and Berssenbrugge show their hands through preferences and choices, not through narrating their lives.

Rather than communication or autobiography, then, Tuttle's collaborators tend to emphasize the bodily life of language, their poems always extremely precise in their line breaks and placement on the page. They often share Tuttle's dedication to formal effects that resonate physically and emotionally rather than in purely intellectual ways, and to a rather severe and demanding sense of beauty. Along with the look of the words, these poets thus often explore and exploit their sound, whether the words are read aloud or resonate in the reader's mind. Particularly in Bernstein's case, reading aloud (as the poetry seems to demand) accentuates the performative aspect of language lost when it is flattened out in print.[13]

These poets bring out an often disregarded feature of language. A letter, a word, a sentence: each is at once one and many. A word used in different sentences remains the same word even as it acquires individuality from its context, as well as from the tone with which it is spoken or the kind of mark used to write it. The dual nature of language sheds some light on Tuttle's persistent interest in and reference to number. One of his most-cited remarks is this rather cryptic one: "When I ask myself what the point is in my work of 1975–85, the answer is: the work is number. Number is held between idea and substance. The wall is idea; the work is number."[14]

This opaque yet tantalizing statement seems related to ideas about the relationship between abstraction and particularity shared by some of Tuttle's contemporaries. Writing in 1978, Fluxus artist and writer Dick Higgins spoke of "the Pythagorean system as developed in the Hermetic tradition and elsewhere as well as from Plato's *Timaeus*" as

> based on a hierarchy of "things" at the bottom, the perceptions, feelings, and qualities associated
> with them next, followed by the word or logos, next the idea or form, penultimately the numbers
> or ratios, and finally the divine principle itself, conceivable only metaphorically in the Music

368–69 **Poems: Larry Fagin / Drawings: Richard Tuttle** 1977
Lithography on paper, ed. of 200,
5 7/8 x 4 1/8 x 1/8 in.
Published by Topia Press,
Bradford, New York

A big joint
with a little
avocado on it.

of the Spheres. Within such a system, a word stood not for the thing it denoted but for the idea underlying it, and was thus a symbol of pure form. As such it was closer to the essence of numbers and ratios in the hierarchy than anything it might describe, and was therefore invested with a power which we sometimes find difficult to understand.... A similar sacred power was attributed to letters, which were not seen as mechanical components of the written word, but as essential and autonomous instruments expressing the process underlying them, analogous therefore to numbers and proportions.[15]

Pythagoras seems to have believed that the universe was structured by relations between numbers; Plato followed him in thinking of numbers as existing in the nonmaterial domain of ideas, entities more real, in fact, than physical objects, which they define. Tuttle's famous sentence seems to express something similar: that ideas ("idea" here meaning a transcendent truth rather than an intellectual conceit) provide the framework—the wall—on which concrete objects (wrestled from raw materials or "substance") made by artists can be hung.[16]

But Tuttle is a most un-Platonic Platonist, insisting that the particular is the metaphysical equal of the idea that supports it. If the number two exists in some ideal realm, as Tuttle (along with many mathematicians) believes, two pieces of plywood are just as real. And floating between them is the numeral 2, which both refers to a number and is itself a material thing, whether drawn on paper or spoken aloud. More generally, language states ideas while consisting of material signs or utterances. Every copy of *Moby-Dick* represents the same work of literature, and also exists as an individual object. From the point of view of literature, the universal—Herman Melville's novel—is what matters, rather than the particular copy. Tuttle, on the other hand, reminds us that we have access to the universal only in one particular or another.

The complicated play between concept, representation, and object figures in some of his most beautiful work, including *Interlude: Kinesthetic Drawings* (1974). *Interlude,* in an edition of twenty-four, consists of twelve lithographs of a rectangle, each side of which is marked at midpoint with an emphatically penciled dot. On each page, Tuttle made a different sweeping mark across the rectangle with a colored pencil or china marker. As the work's subtitle suggests, each of these marks follows a general gestural idea; in actual performance each mark veers from the original idea to become something particular—itself. Because these lines are kinesthetically rather than mimetically generated, matching pages in different copies of the book bear different marks, representing different experiences, different moments in time. Each one is an equally valid representation of some ideal form in the substance of the particular book.

plates 356–57

Tuttle handles language in a similar manner, moving between idea and thing to elide the normal difference between language and visual art. Language can be captured by a notation, a system of symbols (like numerals, musical notes, or letters) whose meaning is entirely determined

by their mutual relations. No matter which typeface is used, the letter *a* remains the same symbol in English and refers to the same class of sounds. There is no notation for art, in contrast, because any physical aspect of a picture or a sculpture is potentially significant. This is why no two objects, however similar, can be the same work.[17] (Two representations of the Virgin with Child are not the same painting in the way that two copies of *Moby-Dick* are exactly the same book.) Tuttle makes language into art, taking numerals and letters from the realm of notation to emphasize their concrete particularity. He finds his place on Earth as well as in the universe.

THREE (MULTIPLICATION)

It seems too boring to have one kind of happiness, and too schizophrenic to have two. I sense another number lurking that says what the situation really is. RICHARD TUTTLE, 1992[18]

In the early 1990s, Tuttle began to exhibit his books to emphasize their physicality and particularity in display, opening, twisting, and hanging them in their exhibition vitrines. During that decade, he also made artist's books that were themselves increasingly sculptural, often wildly unusual in their scale, dimensions, pagination, and covers, including, for example, *Lonesome Cowboy Styrofoam* (1990), *Octavo for Annemarie* (1990), *Open Carefully* (2000), and *White Sails* (2001). These objects do not match our conventional expectations of a book. In some, scale amplifies the element of surprise: *White Sails* is a tiny, precious box, while *Perceived Obstacles* (2000) is long and narrow to the point of absurdity. Others are not just pages between covers but containers holding anything from a nesting series of smaller books to photographs to colored gravel. Literary "content" takes on an entirely new meaning: not just descriptions of things, but things themselves.

A few years earlier, Tuttle had begun to collapse the genres of the artist's book and the exhibition catalogue. Tuttle has always pushed his catalogues to be specific and original, not just a medium for carrying information. From the very beginning he has had a hand in designing them: he laid out the brochure for his first show at Betty Parsons in 1965, and chose the paper (a celadon green

plate 362

plate 364

plate 370

370 Brochure for the 1965 exhibition
Richard Tuttle: Constructed Paintings
at Betty Parsons Gallery, New York

that, touchingly, still pleases him). He also worked on the catalogues for his 1971 Dallas Museum of Fine Arts exhibition and the 1979 exhibition at the Stedelijk Museum Amsterdam.[19] These early productions have a straightforward plainness that, while lovely to look at, does not necessarily announce the artist's presence or desire to explore the genre.

But beginning in the mid-1980s, catalogues such as *Richard Tuttle* (Mönchengladbach) and *Richard Tuttle. △s: Works 1964–1985 / Two Pinwheels: Works 1964–1985* (both 1985) expanded the genre of the exhibition catalogue, utilizing the inventiveness Tuttle had developed in creating his artist's books. The latter is a triangular book inserted in a rectangular case; when unfolded, it becomes a diamond. The Mönchengladbach catalogue, while a standard shape, combines vertical columns of reproductions on each page with a text by the artist that runs horizontally throughout the book. In *Richard Tuttle: Grey Walls Work* (1996), text and image literally intersect, lying in layers atop each other, and so challenging the independent value of either form of communication. All of Tuttle's recent catalogues visually acknowledge the text and how it interacts with the images. As he said in 1997, "If we had consistency between words and images, what would this mean since images can exceed words in communication? There is a magic which happens—and it can happen many different ways—when words and images are in consistency, do not threaten each other. I am amazed that book design is this consistency."[20]

Coordinating different kinds of production in unexpected ways, Tuttle has worked not only with writers but designers, printers, curators, and, in one particularly complex collaboration—the book *One Voice in Four Parts* (1999)—with an actor, a poet, and a playwright. (That project was rooted in a theatrical event, for which Tuttle designed the makeup and costumes.) His exhibitions are themselves large-scale collaborations, particularly *Richard Tuttle, In Parts, 1998–2001,* curated by Ingrid Schaffner at the Institute of Contemporary Art, University of Pennsylvania, in 2001. This was a collective endeavor undertaken by the artist, the curator, collectors, writers, and a book designer, all of whom added their visual, verbal, and emotional expressions to the artist's to create the book and the exhibition. Tuttle's process on such occasions reminds us of the social nature of all artistic production.

plate 363

plate 371

plate 360

plates 372–73

first one-man show
RICHARD TUTTLE
constructed paintings

BETTY PARSONS GALLERY
24 West 57th Street, NYC
September 7-25, 1965
opening: September 7, 5-7 o'clock

371 **Richard Tuttle. △s: Works 1964–1985 / Two Pinwheels: Works 1964–1985** 1985
Lithography on paper in cardboard box, open edition, book: 11 7/8 x 8 1/4 x 5/8 in.; box: 12 x 8 1/2 x 5/8 in. Published by Coracle Press, London; the Institute of Contemporary Art, London; and the Fruitmarket Gallery, Edinburgh

372–73 **Richard Tuttle, In Parts, 1998–2001** 2001
Lithography on paper, open edition,
9 1/2 x 6 5/8 x 3/8 in.
Published by the Institute
of Contemporary Art, University
of Pennsylvania, Philadelphia

Print quality, both in the sense of the fine-art print and in the photomechanical reproduction of three-dimensional work, also plays a very important role in his catalogues and artist's books. Some, like *Interlude,* have perforated pages, so that each page can be removed for display on the wall. By encouraging the transformation of a book into a set of lithographs, Tuttle questions the distinction between the two forms. More broadly, since the mid-1980s he has paid particular attention to the way that a page provides a context for a reproduced image. Often he uses colorful designs rather than the expected bland white page to create a true home for the image, as in the gray "brick wall" of the 1990 catalogue *Richard Tuttle: Einleitung* or the colorful scribbled blocks of *Richard Tuttle: Reservations* (2000). Composing each page individually rather than relying on a conventional grid, he places each image as if he were hanging it on a wall.

In a related vein, Tuttle works beautifully with shadows (a leitmotif for him since the 1972 *Wire Pieces*) to counter the usual image-on-a-page effect. In catalogues and books such as *Richard Tuttle: XX Blocks* (1988) and *Perceived Obstacles,* the reproduced works exist not in some imagined, ideal, no-context space, but seem to throw shadows on the page, rendering these photomechanical images eerily present. Tuttle's sensitivity to photomechanical printing works against the hierarchy of painting, sculpture, print, and reproduction by giving the images in his books their own lives and independent value. plates 109, 118–19 / plate 374

It is as if Tuttle denies the secondary nature we usually assign to books, catalogues in particular. Just as he emphasizes the particularity of each use of a letter or word, he constantly strives, against the prevailing bias, to make an editioned object unique. He asks the reader to participate in individualizing not only each book, but each *copy* of it. We collaborate in completing the cover of *Richard Tuttle: Community* (1999) by stringing gold cord through the provided holes and attaching green adhesive tabs. *Perceived Obstacles* is a perfect-bound book, a type of binding that becomes so fragile on a volume of such large dimensions that each copy begins to alter its shape from the moment the reader handles it, as the pages inevitably fall out. Tuttle not only underlines the truism that the reader finishes the work in the act of reception, but adds the opposing idea that the reader speeds the inevitable process of the work's decay. plate 361

BLOCK 2

374 **Richard Tuttle: XX Blocks** 1988
Lithography on paper, open edition,
13 x 9 1/4 x 1/4 in.
Published by Galleria Marilena
Bonomo, Bari, Italy

Perhaps, that's why the glyph, which is a level of more sure knowledge than either
[number or letter], ends the book. RICHARD TUTTLE, 1990[21]

At the outset of his career, Tuttle believed that because language interfered with attempts to communicate, it needed to be obliterated or completely reimagined. Forty years later, his perspective, not surprisingly, has changed: he now accepts language as given, for better or worse, something that will always be with us. He describes language as the grain on and against which he draws, or as the frame for his work. Both ways of seeing language—as always-present ground or as contextual presence—resign him to its inevitability, and motivate him to make use of it.[22]

Still, the artist hasn't completely surrendered his low opinion of language, conventionally used.[23] Critics often complain, in the nicest possible way, about Tuttle's "gnomic" way of expressing himself, a characteristically oblique way of speaking.[24] And Tuttle himself has complained to me about people "who should know better" trying to force him into the standard Q&A model of artist interviews.[25] In fact, when interviewed, he doesn't say what you expect to hear (what the form of the "artist's statement" mandates), or even what he himself expects to say (what the repetitious nature of personal expression usually dictates). Tuttle's point is that language, like other conventional symbol systems, is inadequate for expressing truths that might be ephemeral, spiritual, or sensual, or all of these at once, like the feel of one's body in relation to a horizon line. Not surprisingly, it's impossible to extract one coherent system from his play with both standard and homemade symbols.

Reconciled to language, Tuttle never uses it the way that he is supposed to, or even the way that other artists do. The story of his relationship to language, the social means of communication, is the story of a struggle with society. If many artists of his generation used language to exploit its communicative potential, Tuttle clearly believes that this potential is outweighed by language's limitations, the conventions that restrict what can be said. He wants his work to speak of ideas and feelings that transcend the social to reach the scale of the universal, even while these ideas demand attention to the particular and individual. This ambition doesn't rule out collaboration, as we saw, or—as the form of the book itself implies—sociality. The artist can make language new; if you understand this new language, as Tuttle says, you are part of a community.[26]

NOTES

My thanks to Mel Bochner, Alexander Dumbadze, Madeleine Grynsztejn, Paul Mattick, Robert Storr, and most of all Richard Tuttle for their generosity in talking about issues discussed in this essay. Thanks as well to Tara McDowell for expert research assistance and to Chad Coerver and Joseph Newland for truly helpful editing.

1 Richard Tuttle, artist's statement, in Bruce Kurtz, "Documenta 5: A Critical Preview," *Arts Magazine* 46 (Summer 1972): 39.

2 Tuttle recalls (e-mail communication with the author, 22 November 2004) that the sentences were excerpted from the following passage: "The misconception which has haunted the ages of thought down to the present time is that these criteria are easy to apply. For example, the Greek and the medieval thinkers were under the impression that they could easily obtain clear and distinct premises which conformed to experience. Accordingly they were comparatively careless in the criticism of premises, and devoted themselves to the elaboration of deductive systems. The moderns have, equally with the Greeks, assumed that it is easy to formulate exactly expressed propositions. They have also assumed that the interrogation of experience is a straightforward operation. But they have recognized that the main effort is to be devoted to the discovery of propositions which do in fact conform to experience. Thus the moderns stress induction. The view which I am maintaining is that none of these operations are easy. In fact they are extremely difficult. Apart from a complete metaphysical understanding of the universe, it is very difficult to understand any proposition clearly and distinctly, so far as concerns the analysis of its component elements" (Alfred North Whitehead, *The Function of Reason* [Boston: Beacon Press, 1958], 68).

3 E-mail communication with the author, 12 August 2004.

4 The very first instance of this is Gordon B. Washburn, *Richard Tuttle: Constructed Paintings*, exhibition brochure (New York: Betty Parsons Gallery, 1965), unpaginated; repeated as "sensitive," for example, in Dorothy Alexander, "Conversations with the Work and the Artist," in *Mel Bochner, Barry Le Va, Dorothea Rockburne, Richard Tuttle* (Cincinnati: Contemporary Arts Center, 1975), 44.

5 Washburn, *Richard Tuttle: Constructed Paintings*, unpaginated.

6 Marcia Tucker, *Richard Tuttle* (New York: Whitney Museum of American Art, 1975), 16.

7 Others being the *Blue/Red Alphabet* (2001), reliefs painted on plywood, and a series of mixed-media prints and accompanying sculpture called *Renaissance Unframed* (1995–96).

8 Richard Tuttle, "Time's Measurement and Interlude's 'Time,'" in Andrea Miller-Keller, *Matrix 10: Richard Tuttle*, exhibition brochure (Hartford: Wadsworth Atheneum, 1975), unpaginated.

9 Quote appears in Lis Bensley, "The 48," *Pasatiempo* (weekly magazine of the *Santa Fe New Mexican*), 6–12 June 1997.

10 *Poems: Larry Fagin / Drawings: Richard Tuttle* (New York: Topia Press, 1977). For full citations of other Richard Tuttle books discussed here, please see the bibliography in this volume.

11 Hank Lazer, "Charles Bernstein's 'Dark City': Polis, Policy, and the Policing of Poetry," *American Poetry Review* 24 (September–October 1995): 36.

12 Robert Pincus-Witten, "The Art of Richard Tuttle," *Artforum* 8 (February 1970): 67. In a *New York* magazine review of Tuttle's Whitney show, Thomas B. Hess asserts that in *Letters (The Twenty-Six Series)* (1966), the *T, U,* and *L* shapes are more strongly articulated, closer to our conventional letters than the other shapes ("Private Art Where the Public Works," *New York*, 13 October 1975, 76). The critics seem to search for a secret autobiographical content in work that appears so opaque, so abstract at first glance.

13 See Bernstein's introduction to *Close Listening: Poetry and the Performed Word* (New York: Oxford University Press, 1998).

14 The original statement ended, "The wall is idea, the work is substance" (quoted in *Richard Tuttle* [Mönchengladbach, Germany: Städtisches Museum Abteiberg, 1985], 124–25), and it is in this form that the remark is usually quoted. Tuttle caught his own logical slip and later suggested that perhaps this statement should be revised to read "The wall is idea, the work is number" (letter from Richard Tuttle to Jennifer Gross, cited in Gross, "Richard Tuttle: Reframing Modernism, 1965–1995," Ph.D. dissertation, CUNY Graduate Center, 1999, 153).

15 Dick Higgins, "Introduction," in *George Herbert's Pattern Poems: In Their Tradition*, excerpted in *L=A=N=G=U=A=G=E*, no. 1 (February 1978): 17.

16 We might think of the way Tuttle's wire works point to different levels of meaning (from the three-dimensional wire to the drawn line to the shadow) as paralleling the way that conceptual artists investigate levels of meaning or reality. I would suggest that this is something conceptual artists learned from artists such as Tuttle working with more visual and material concerns.

17 A modern philosopher who has dealt with these issues is Nelson Goodman, an anti-Platonist with a very different set of terms. The common subject for Goodman and Tuttle is the relationship between the individual and the abstract, or the universal and a particular object. Tuttle's use of language is autographic in Goodman's sense, meaning that the physical presence of the work is original and necessary. See Nelson Goodman, *Languages of Art* (Indianapolis: Hackett, 1976), 112–13.

18 Richard Tuttle, *Charge to Exist* (Winterthur, Switzerland: Kunstmuseum Winterthur, 1992), statement on reverse side of single-page book.

19 E-mail communication with the author, 16 September 2004.

20 Richard Tuttle, in *I Thought I Was Going on a Trip But I Was Only Going Down Stairs* (North York, Ontario: Art Gallery of York University, 1997), unpaginated. This is a good example of a particularly Tuttle-ish strategy: putting together two disparate things, and finding a third term that bridges them.

21 Richard Tuttle, *Lonesome Cowboy Styrofoam* (New York: Blum Helman Gallery; Santa Fe: Gallery Casa Sin Nombre, 1990), insert card number 7.

22 For language as grain, see "Knock on Wood," Tuttle statement from SFMOMA exhibition files. For frame as language, see Tuttle's letter to Erich Franz, excerpted in *Perceived Obstacles* (Cologne: Verlag der Buchhandlung Walter König, 2001), unpaginated.

23 Richard Tuttle, letter to Martin, dated 30 May 1995, SFMOMA exhibition files; interview with Tuttle in Gross, "Richard Tuttle: Reframing Modernism," 457.

24 See, for example, Nancy Princenthal's excellent article on his books, "Numbers of Happiness: Richard Tuttle's Books," *Print Collector's Newsletter* 24 (July–August 1993): 81–86.

25 While he can seem and is often portrayed as somewhat otherworldly, Tuttle clearly has an amused awareness of his image as a difficult communicator—in an interview published in a 1996 catalogue for the Camden Arts Centre, an interviewer seems to struggle with the recalcitrant subject; at the end, we find that Tuttle wrote the whole thing himself. There is also a very funny interview (or "attempted interview" in the words of the questioner) in which he completely frustrates a usually glib and witty journalist with his koanic one-word replies to questions. See Paul Nesbitt, "Interview," *Richard Tuttle: Grey Walls Work* (London: Camden Arts Centre, 1996), 45–50; Adrian Dannatt, "NY Artist Q&A: Richard Tuttle," *Art Newspaper*, February 2000, 69.

26 E-mail communication with the author, 12 August 2004.

by Richard Tuttle

SOMETHING IS HAPPENING

Something happens when a viewer takes my work someplace never intended. Something happens, my work's practice is most intended to satisfy.

A paper cube of 1964 may be a harbinger of deconstruction, the sinuous line of a constructed painting of 1965, its main tool, for some, but only because something has to be about something for it to move on, or only because something has to be exactly about what it is not, to be itself..., who knows?

There is a discrete charm in something that is made that allows it to circulate, even though what cannot may have greater charm, like the light in an otherwise blue sky, the twinkle in an eye. How do those circulate? Only by making what cannot be made, what is beyond its own fixity, what is not under control, like thought, place, or action. Something must be made for it to circulate, to happen, even as it passes the maker's limits, where the viewer intends the circulation to end, like making something that doesn't go together...

It is the possibility to create meaning in this way, why this system *is* maintained.

March 2005

CATALOGUE OF THE EXHIBITION

The catalogue below is arranged chronologically and represents the exhibition's presentation at the San Francisco Museum of Modern Art, which may vary from presentations at other venues. This information reflects the Museum's most complete knowledge at time of publication.

In cases where an artwork is remade for exhibition, only the year of its original conception and execution is listed. Some dimensions (for larger constructions, for artworks that may be installed with different rotations, or for works made in situ at each venue) may vary slightly depending on the installation. Dimensions were measured in inches and converted to centimeters. The artist has revised some titles in preparation for this exhibition.

Thanks are due to Tara McDowell and Lindsey Westbrook for their efforts in compiling this information.

Abstract, 1964 (pl. 45)
Acrylic on canvas on plywood
Four parts, overall: 57 3/4 x 4 1/2 x 4 1/8 in.
(146.7 x 11.4 x 10.5 cm)
Private collection, Switzerland

Chair, 1964
Ink, graphite, and chalk on paper
11 x 10 in. (27.9 x 25.4 cm)
Collection of Mimi Floback, Tavernier, Florida

The Elephant, 1964
Ink on paper
12 1/2 x 11 7/8 in. (31.8 x 30.2 cm)
Collection of Mary and Harold Zlot, San Francisco

Silver Picture [also **Silver Abstraction**],
1964 (pl. 44)
Spray enamel on plywood
28 x 87 x 2 in. (71.1 x 221 x 5.1 cm)
Collection of Frances Dittmer, Aspen, Colorado

Sum Confluence, 1964 (pl. 40)
Acrylic on plywood
20 5/8 x 36 1/2 x 3 in. (52.4 x 92.7 x 7.6 cm)
Collection of Judith Neisser, Chicago

Untitled [paper cubes], 1964 (pls. 1–10, 15, 39, 382)
Coated cardstock
Ten parts, each: 3 x 3 x 3 in. (7.6 x 7.6 x 7.6 cm),
overall dimensions vary with installation
Moderna Museet, Stockholm, gift 1985 from the
Betty Parsons Foundation through the American
Federation of the Arts

Any Ideas, 1965 (pl. 48)
Acrylic on plywood
30 x 68 1/4 x 1 3/8 in. (76.2 x 173.4 x 3.5 cm)
Collection of Shirley Ross Sullivan, San Francisco

Blue White, 1965 (pl. 54)
Acrylic on plywood
13 1/4 x 46 7/8 x 1 5/8 in. (33.7 x 119.1 x 4.1 cm)
Stedelijk Museum Amsterdam

Chelsea, 1965 (pls. 41, 67)
Acrylic on plywood
37 3/8 x 37 3/8 x 3/4 in. (94.9 x 94.9 x 1.9 cm)
Private collection, Cologne

Dish [also **Blue Diptych**], 1965 (pl. 46)
Acrylic on plywood
Two parts, overall: 30 x 31 1/4 x 2 1/2 in.
(76.2 x 79.4 x 6.4 cm)
Collection of the Art Supporting Foundation
to the San Francisco Museum of Modern Art

Drift III, 1965 (pls. 53, 387)
Acrylic on plywood
24 1/4 x 52 3/4 x 1 1/4 in. (61.6 x 134 x 3.2 cm)
Whitney Museum of American Art, New York,
purchase, with funds from Mr. and Mrs. William A.
Marsteller and the Painting and Sculpture
Committee

Equals, 1965 (pl. 47)
Acrylic on plywood
Two parts, overall: 39 x 47 1/4 x 1 1/2 in.
(99.1 x 120 x 3.8 cm)
Collection of Marguerite and Robert Hoffman,
Dallas

Fountain, 1965 (pl. 50)
Acrylic on plywood
1 x 39 1/8 x 38 3/4 in. (2.5 x 99.4 x 98.4 cm)
Whitney Museum of American Art, New York,
fiftieth anniversary gift of Richard Brown Baker

House, 1965 (pl. 43)
Acrylic on plywood
26 3/4 x 33 1/4 x 1 3/8 in. (67.9 x 84.5 x 3.5 cm)
Centre Pompidou, Musée national d'art moderne—
Centre de création industrielle, Paris

Sparrow, 1965 (pls. 358–59)
Watercolor and graphite on paper; ed. of 25
8 1/8 x 6 3/4 x 3/8 in. (20.6 x 17.1 x 1 cm)
Published by Richard Tuttle, New York
Exhibition copy courtesy Peter Freeman, Inc.,
New York

Storm, 1965 (pl. 52)
Acrylic on plywood
19 5/8 x 18 7/8 x 1 1/8 in. (49.8 x 47.9 x 2.9 cm)
Collection of Henry S. McNeil, Philadelphia

Story with Seven Characters, 1965 (pl. 366)
Woodcuts on paper, board, and tape; ed. of 7
12 1/8 x 11 1/4 x 3/8 in. (30.8 x 28.6 x 1 cm)
Published by Richard Tuttle, New York
Exhibition copy courtesy Spencer Collection,
the New York Public Library

Torso, 1965 (pl. 51)
Acrylic on plywood
35 7/8 x 26 x 1 1/8 in. (91.1 x 66 x 2.9 cm)
Collection of Annemarie and Gianfranco
Verna, Zurich

Two, 1965 (pl. 49)
Acrylic on plywood
31 1/2 x 22 3/4 x 1 1/4 in. (80 x 57.8 x 3.2 cm)
Collection of Connie and Jack Tilton, New York

Yellow Dancer, 1965 (pl. 42)
Acrylic on plywood
43 x 29 x 1 3/8 in. (109.2 x 73.7 x 3.5 cm)
The Ginny Williams Family Foundation,
the Collection of Ginny Williams

Letters (The Twenty-Six Series), 1966 (pls. 18, 56–57)
Galvanized iron
Twenty-six parts, each approximately: 6 x 9 x 5/8 in.
(15.2 x 22.9 x 1.6 cm), overall dimensions vary
with installation
The Museum of Modern Art, New York,
purchase, 2002

Wheel [large version, polychromed], 1966 (pl. 55)
Enamel on wood
31 1/2 x 31 1/2 x 8 1/4 in. (80 x 80 x 21 cm)
The Edward R. Broida Collection

Bow-Shaped Light Blue Canvas, 1967 (pls. 24, 62, 72)
Dyed canvas and thread
52 3/8 x 51 3/4 in. (133 x 131.4 cm), orientation
variable
Emanuel Hoffmann Foundation, permanent
loan to the Öffentliche Kunstmuseum Basel,
Switzerland

Canvas Dark Blue, 1967 (pl. 80)
Dyed canvas and thread
70 x 35 1/2 in. (177.8 x 90.2 cm), orientation variable
Stenn Family Collection, Chicago

First Green Octagonal, 1967 (pls. 82, 123)
Dyed canvas and thread
64 1/2 x 36 in. (163.8 x 91.4 cm),
orientation variable
Private collection, Cologne

Ladder Piece, 1967 (pl. 77)
Dyed canvas and thread
19 1/4 x 77 1/2 in. (48.9 x 196.9 cm),
orientation variable
Collection Lambert en Avignon, France

Octagonal Cloth Piece, 1967 (pl. 83)
Dyed canvas and thread
58 1/4 x 61 3/8 in. (148 x 155.9 cm),
orientation variable
Kaiser Wilhelm Museum, Krefeld, Germany

Pale Blue Canvas, 1967 (pl. 75)
Dyed canvas and thread
64 1/8 x 70 7/8 in. (162.9 x 180 cm),
orientation variable
Stedelijk Museum Amsterdam

Purple Octagonal, 1967 (pl. 21)
Dyed canvas and thread
54 7/8 x 55 1/2 in. (139.4 x 141 cm),
orientation variable
Museum of Contemporary Art, Chicago,
gift of William J. Hokin

Second Cloth Octagonal, 1967
Dyed canvas and thread
66 x 65 in. (167.6 x 165.1 cm), orientation variable
Collection of Connie and Jack Tilton, New York

Untitled, 1967 (pl. 79)
Dyed canvas and thread
51 1/2 x 56 1/4 in. (130.8 x 142.9 cm),
orientation variable
Private collection

Untitled, 1967 (pls. 74, 123–124, 391)
Dyed canvas and thread
38 3/4 x 46 1/2 in. (98.4 x 118.1 cm),
orientation variable
Private collection, courtesy Greenberg
Van Doren Gallery, Saint Louis

Untitled, 1967 (pl. 81)
Dyed canvas and thread
43 1/2 x 55 in. (110.5 x 139.7 cm),
orientation variable
Collection of Elisabeth Cunnick and
Peter Freeman, New York

Untitled [drawings for cloth pieces], 1967
(pls. 58–61)
Watercolor and graphite on paper
Eleven drawings, each: 13 3/4 x 10 3/4 in.
(34.9 x 27.3 cm)
Fogg Art Museum, Harvard University Art
Museums, Cambridge, Massachusetts, Margaret
Fisher Fund and Purchase through the generosity
of Frances and John Bowes in honor of James Cuno

Untitled [notebook of studies for cloth pieces], 1967
Watercolor and ink on paper
17 x 14 x 5/8 in. (43.2 x 35.6 x 1.6 cm)
Collection of Marilena and Lorenzo Bonomo,
Bari, Italy

W-Shaped Yellow Canvas, 1967 (pls. 76, 389)
Dyed canvas and thread
53 1/4 x 60 5/8 in. (135.3 x 154 cm),
orientation variable
San Francisco Museum of Modern Art,
gift of Rena Bransten

Yellow Triangle with Three Thicknesses, 1967
(pl. 78)
Dyed canvas and thread
49 x 55 1/8 in. (124.5 x 140 cm), orientation variable
Collection of Marilena and Lorenzo Bonomo,
Bari, Italy

Colored Line Series (1), 1969 (pl. 147)
Gouache and graphite on paper
12 x 9 in. (30.5 x 22.9 cm)
Kolumba, Cologne, Germany

Colored Line Series (9), 1969
Gouache, graphite, and ink on paper
12 x 9 in. (30.5 x 22.9 cm)
Stedelijk Museum Amsterdam

Invented Paintings (1), 1969 (pl. 149)
Paper collage and watercolor-tinted gouache
on paper
12 x 9 in. (30.5 x 22.9 cm)
Private collection, Cologne

Invented Paintings (3), 1969 (pl. 152)
Graphite on paper
12 x 9 in. (30.5 x 22.9 cm)
Kolumba, Cologne, Germany

Invented Paintings (6), 1969
Graphite and watercolor on paper
12 x 9 in. (30.5 x 22.9 cm)
Kolumba, Cologne, Germany

On the Way to New York, 1969
Ballpoint pen on paper
8 1/4 x 5 3/8 in. (21 x 13.7 cm)
National Gallery of Art, Washington, D.C.,
the Dorothy and Herbert Vogel Collection,
gift of Dorothy and Herbert Vogel, Trustees 2004

Two Books, 1969
Cutouts and screen printing on paper in slipcase;
ed. of 200
12 1/8 x 9 1/4 x 1 in. (30.8 x 23.5 x 2.5 cm)
Published by Galerie Rudolph Zwirner, Cologne,
and Betty Parsons Gallery, New York
Exhibition copy collection of the artist; courtesy
Sperone Westwater, New York

Water in 30/60° Triangle, 1969
Graphite, ballpoint pen, and watercolor on paper
11 x 8 1/2 in. (27.9 x 21.6 cm)
Kolumba, Cologne, Germany

Corner, 1970s
Steel
5 x 5 x 1 1/8 in. (12.7 x 12.7 x 2.9 cm)
Collection of Dr. J. Drolshammer, Zurich

Lines, 1970s (pl. 130)
Galvanized metal
Two parts, overall: 1 x 4 7/8 x 1 1/8 in.
(2.5 x 12.4 x 2.9 cm)
The Rachofsky Collection, Dallas

Piece, 1970s
Heavy-gauge wire
5 1/2 x 13 3/8 x 5 1/2 in. (14 x 34 x 14 cm)
Collection of Ziba and Pierre de Weck, London

Rest, 1970s (pl. 293)
Acrylic on wood
3 x 6 1/8 x 3 1/2 in. (7.6 x 15.6 x 8.9 cm)
Collection of Greta Meert, Brussels

Two Blocks, 1970s (pl. 291)
Plywood, nails, and string
2 3/4 x 5 7/8 x 1/4 in. (7 x 14.9 x 0.6 cm)
Collection of Brooke Alexander, New York

White Rocker, 1970s (pl. 131)
Latex paint on plywood
3 x 5 x 1 in. (7.6 x 12.7 x 2.5 cm)
Fogg Art Museum, Harvard University Art
Museums, Cambridge, Massachusetts,
purchase through the generosity of Barbara Lee
and the Frances F. and John Bowes Fund

1st Paper Octagonal, 1970 (pl. 90)
Paper and starch paste
Approximately 54 in. (137.2 cm) diameter,
orientation variable
Collection of the artist; courtesy Sperone
Westwater, New York

2nd Paper Octagonal, 1970
Paper and starch paste
Approximately 54 in. (137.2 cm) diameter,
orientation variable
Collection of the artist; courtesy Sperone
Westwater, New York

3rd Paper Octagonal, 1970
Paper and starch paste
Approximately 54 in. (137.2 cm) diameter,
orientation variable
Collection of the artist; courtesy Sperone
Westwater, New York

4th Paper Octagonal, 1970
Paper and starch paste
Approximately 54 in. (137.2 cm) diameter,
orientation variable
Collection of the artist; courtesy Sperone
Westwater, New York

5th Paper Octagonal, 1970 (pl. 92)
Paper and starch paste
Approximately 54 in. (137.2 cm) diameter,
orientation variable
Collection of the artist; courtesy Sperone
Westwater, New York

6th Paper Octagonal, 1970
Paper and starch paste
Approximately 54 in. (137.2 cm) diameter,
orientation variable
Collection of the artist; courtesy Sperone
Westwater, New York

7th Paper Octagonal, 1970 (pl. 94)
Paper and starch paste
Approximately 54 in. (137.2 cm) diameter,
orientation variable
Collection of Mary and David Robinson,
Sausalito, California

8th Paper Octagonal, 1970 (pl. 91)
Paper and starch paste
Approximately 54 in. (137.2 cm) diameter,
orientation variable
Collection of Walker Art Center, Minneapolis,
anonymous gift, 2002; and collection
of Angela Westwater, New York

9th Paper Octagonal, 1970
Paper and starch paste
Approximately 54 in. (137.2 cm) diameter,
orientation variable
The Museum of Modern Art, New York,
gift of Thea Westreich and Ethan Wagner, 2002

10th Paper Octagonal, 1970
Paper and starch paste
Approximately 54 in. (137.2 cm) diameter,
orientation variable
Whitney Museum of American Art, New York,
gift of Daniel Weinberg

11th Paper Octagonal, 1970 (pl. 85)
Paper and starch paste
Dimensions variable, orientation variable
Collection of the artist; courtesy Sperone
Westwater, New York

12th Paper Octagonal, 1970 (pl. 23)
Paper and starch paste
Approximately 54 in. (137.2 cm) diameter,
orientation variable
Collection of the Israel Museum, Jerusalem,
gift of the Srulek Kaner Foundation to the
American Friends of the Israel Museum in honor
of the 30th anniversary of the Israel Museum

Black Rising, 1970
Ink on paper
13 3/8 x 10 1/4 in. (34 x 26 cm)
Collection of Marilena and Lorenzo Bonomo,
Bari, Italy

Dallas Exercise, 1970
Watercolor on paper
23 x 19 in. (58.4 x 48.3 cm)
Collection of Mary and Harold Zlot, San Francisco

Dorothy's Soldiers, 1970 (pl. 148)
Watercolor on paper
11 15/16 x 8 7/8 in. (30.3 x 22.5 cm)
National Gallery of Art, Washington, D.C.,
the Dorothy and Herbert Vogel Collection,
gift of Dorothy and Herbert Vogel, Trustees 2004

Drawing Developed from Travel-Sketches
Made in Turkey, 1970 (pl. 154)
Graphite on paper
19 3/4 x 16 in. (50.2 x 40.6 cm)
National Gallery of Art, Washington, D.C.,
the Dorothy and Herbert Vogel Collection,
gift of Dorothy and Herbert Vogel, Trustees 2004

Green Constructed Drawing, 1970 (pl. 167)
Graphite and watercolor on paper
10 3/4 x 8 1/4 in. (27.3 x 21 cm)
Collection of Heinz Teichmann, Germany

Preliminary Drawing for Schematic Drawing #3
Included in Dallas Show Catalogue, 1970 (pl. 151)
Ink and graphite on paper
8 5/16 x 8 9/16 in. (21.1 x 21.8 cm)
National Gallery of Art, Washington, D.C.,
the Dorothy and Herbert Vogel Collection,
Ailsa Mellon Bruce Fund, Patrons' Permanent Fund
and gift of Dorothy and Herbert Vogel 1991

Premus, 1970 (pl. 153)
Ink on paper
11 13/16 x 9 1/16 in. (30 x 23 cm)
Collection of Marilena and Lorenzo Bonomo,
Bari, Italy

Rendering for Second Dallas Drawing, 1970
Graphite and ink on paper
11 x 8 1/2 in. (27.9 x 21.6 cm)
Kolumba, Cologne, Germany

Three Triangles and Three Colors, 1970
Felt-tip pen on verso of colophon page of **Two
Books**
12 x 9 in. (30.5 x 22.9 cm)
National Gallery of Art, Washington, D.C.,
the Dorothy and Herbert Vogel Collection,
Ailsa Mellon Bruce Fund, Patrons' Permanent
Fund and gift of Dorothy and Herbert Vogel 1991

Works on Black Paper (3), 1970 (pl. 159)
Tape on paper
12 x 9 in. (30.5 x 22.9 cm)
Kolumba, Cologne, Germany

Works on Black Paper (8), 1970 (pl. 157)
Ink on paper
12 x 9 in. (30.5 x 22.9 cm)
Kolumba, Cologne, Germany

I Blue and White (Dallas), 1971
Gouache and graphite on paper
10 7/8 x 8 3/8 in. (27.6 x 21.3 cm)
National Gallery of Art, Washington, D.C.,
the Dorothy and Herbert Vogel Collection,
gift of Dorothy and Herbert Vogel, Trustees 2004

II Blue and Pale Blue (Dallas), 1971
Gouache and graphite on paper
10 7/8 x 8 3/8 in. (27.6 x 21.3 cm)
National Gallery of Art, Washington, D.C.,
the Dorothy and Herbert Vogel Collection,
gift of Dorothy and Herbert Vogel, Trustees 2004

1st Wire Bridge, 1971 (pl. 108)
Florist wire and nails
37 1/2 x 38 1/2 x 1/2 in. (95.3 x 97.8 x 1.3 cm)
The Rachofsky Collection, Dallas

Experiment with 3-Sided World, 1971
Crayon on paper
13 3/4 x 10 13/16 in. (34.9 x 27.5 cm)
Collection Lambert en Avignon, France

Green Transfer, 1971 (pl. 162)
Felt-tip pen on paper
13 7/8 x 10 13/16 in. (35.2 x 27.5 cm)
National Gallery of Art, Washington, D.C.,
the Dorothy and Herbert Vogel Collection,
gift of Dorothy and Herbert Vogel, Trustees 2004

Onion Sketch Treatise, 1971
Felt-tip pen and graphite on paper
13 7/8 x 10 13/16 in. (35.2 x 27.5 cm)
National Gallery of Art, Washington, D.C.,
the Dorothy and Herbert Vogel Collection,
Ailsa Mellon Bruce Fund, Patrons' Permanent Fund
and gift of Dorothy and Herbert Vogel 1991

**Stacked Color Drawing with Arch of Egg-Shaped
Form Painted,** 1971 (pl. 156)
Watercolor and graphite on paper
17 15/16 x 12 in. (45.6 x 30.5 cm)
National Gallery of Art, Washington, D.C.,
the Dorothy and Herbert Vogel Collection,
Ailsa Mellon Bruce Fund, Patrons' Permanent Fund
and gift of Dorothy and Herbert Vogel 1991

Stacked Color with Wavy and Straight Side, 1971
(pl. 155)
Watercolor and graphite on paper
11 7/8 x 8 15/16 in. (30.2 x 22.7 cm)
National Gallery of Art, Washington, D.C.,
the Dorothy and Herbert Vogel Collection,
Ailsa Mellon Bruce Fund, Patrons' Permanent Fund
and gift of Dorothy and Herbert Vogel 1991

Three Part Form, 1971 (pl. 150)
Graphite and felt-tip pen on paper
12 1/8 x 10 in. (30.8 x 25.4 cm)
Kolumba, Cologne, Germany

Untitled, 1971 (pl. 163)
India ink on paper
13 3/4 x 10 13/16 in. (34.9 x 27.5 cm)
Collection of Heinz Teichmann, Germany

Untitled, 1971 (pls. 95–105)
Watercolor and graphite on paper
Eleven drawings, each: 13 3/4 x 10 3/4 in.
(34.9 x 27.3 cm)
Collection of Laura D. and Marshall B. Front,
Chicago

Untitled, 1971
Graphite on paper
10 1/2 x 8 1/4 in. (26.7 x 21 cm)
Collection of Joel Wachs

Untitled (Belmore), 1971
Graphite and ink on paper
11 x 8 9/16 in. (27.9 x 21.7 cm)
Collection of Annemarie and Gianfranco
Verna, Zurich

Brush Drag, ca. 1972
Watercolor on paper
16 5/16 x 13 3/8 in. (41.4 x 34 cm)
Collection Lambert en Avignon, France

1st Wire Piece, 1972
Florist wire, nails, and graphite
Dimensions vary with installation
Collection of the artist; courtesy Sperone
Westwater, New York

10th Wire Piece, 1972 (pls. 109–17)
Florist wire, nails, and graphite
Dimensions vary with installation
Collection of the artist; courtesy Sperone
Westwater, New York

14th Wire Piece, 1972
Florist wire, nails, and graphite
Dimensions vary with installation
Collection of the artist; courtesy Sperone
Westwater, New York

21st Wire Piece, 1972 (pls. 118–19)
Florist wire, nails, and graphite
Dimensions vary with installation
Collection of Judith Neisser, Chicago

23rd Wire Piece, 1972
Florist wire, nails, and graphite
Dimensions vary with installation
Collection of Angela Westwater
and David Meitus, New York

25th Wire Piece, 1972
Florist wire, nails, and graphite
Dimensions vary with installation
Collection of the artist; courtesy Sperone
Westwater, New York

42nd Wire Piece, 1972
Florist wire, nails, and graphite
Dimensions vary with installation
Collection of the artist; courtesy Sperone
Westwater, New York

48th Wire Piece, 1972 (pl. 119)
Florist wire, nails, and graphite
Dimensions vary with installation
Collection of Annemarie and Gianfranco
Verna, Zurich

Day, 1972 (pl. 169)
Ink on paper
11 13/16 x 8 7/8 in. (30 x 22.5 cm)
National Gallery of Art, Washington, D.C.,
the Dorothy and Herbert Vogel Collection,
gift of Dorothy and Herbert Vogel, Trustees 2004

Marker Series (2), 1972
Felt-tip pen and water on paper
9 1/2 x 6 in. (24.1 x 15.2 cm)
Kolumba, Cologne, Germany

Marker Series (3), 1972
Felt-tip pen and water on paper
9 1/2 x 6 in. (24.1 x 15.2 cm)
Kolumba, Cologne, Germany

Night, 1972
Ink on paper
9 3/16 x 11 15/16 in. (23.3 x 30.3 cm)
National Gallery of Art, Washington, D.C.,
the Dorothy and Herbert Vogel Collection,
Ailsa Mellon Bruce Fund, Patrons' Permanent
Fund and gift of Dorothy and Herbert Vogel 1991

Red and Gold Hook, 1972 (pl. 164)
Watercolor and graphite on paper
11 15/16 x 9 in. (30.3 x 22.9 cm)
National Gallery of Art, Washington, D.C.,
the Dorothy and Herbert Vogel Collection,
Ailsa Mellon Bruce Fund, Patrons' Permanent
Fund and gift of Dorothy and Herbert Vogel 1991

Study for Twist (1), 1972 (pl. 165)
Graphite on paper
12 x 9 in. (30.5 x 22.9 cm)
Private collection, Cologne

**Summer Notebook Drawing, (July & August 1972)
No. 1,** 1972
Watercolor and graphite on paper
13 3/4 x 11 in. (34.9 x 27.9 cm)
National Gallery of Art, Washington, D.C.,
the Dorothy and Herbert Vogel Collection,
Ailsa Mellon Bruce Fund, Patrons' Permanent
Fund and gift of Dorothy and Herbert Vogel 1991

**Summer Notebook Drawing, (July & August 1972)
No. 2,** 1972 (pl. 160)
Watercolor and graphite on paper
14 1/16 x 11 in. (35.7 x 27.9 cm)
National Gallery of Art, Washington, D.C.,
the Dorothy and Herbert Vogel Collection,
Ailsa Mellon Bruce Fund, Patrons' Permanent
Fund and gift of Dorothy and Herbert Vogel 1991

**This Is a Diagonal That Is Possible and That
It Is Also a "Tangent" Is an Indication
It Is a Diagonal Constructed in Three Different
Ways with Two Colors,** 1972 (pl. 161)
Watercolor and graphite on paper
13 3/8 x 10 1/4 in. (34 x 26 cm)
Collection of Marilena and Lorenzo Bonomo,
Bari, Italy

This Is an Attempt at a Black and White Center with the Black Form Acting Like a Shadow and Trying to Be Like White, Which It Is, 1972
Ink and graphite on paper
13 9/16 x 10 5/8 in. (34.4 x 27 cm)
Collection of Marilena and Lorenzo Bonomo, Bari, Italy

This Is an Attempt to Break the True Verticle, 1972
Ink and graphite on paper
13 9/16 x 10 5/8 in. (34.4 x 27 cm)
Collection of Marilena and Lorenzo Bonomo, Bari, Italy

Two Red Squares, 1972 (pl. 187)
Watercolor on paper
7 5/8 x 8 7/8 in. (19.4 x 22.5 cm)
Museum of Contemporary Art, North Miami, Florida, gift of Jock Truman and Eric Green

Two Triangles Intersecting, 1972 (pl. 174)
Ink on paper
11 15/16 x 9 in. (30.3 x 22.9 cm)
National Gallery of Art, Washington, D.C., the Dorothy and Herbert Vogel Collection, Ailsa Mellon Bruce Fund, Patrons' Permanent Fund and gift of Dorothy and Herbert Vogel 1991

Untitled, 1972 (pl. 170)
Graphite on paper
6 7/8 x 5 in. (17.5 x 12.7 cm)
Museum of Contemporary Art, North Miami, Florida, gift of Jock Truman and Eric Green

Whitney Series, ca. 1973
Ink on paper
11 3/4 x 9 in. (29.8 x 22.9 cm)
Collection of Elisabeth Cunnick and Peter Freeman, New York

2nd of 10 Summer 1973, 1973
Graphite and gouache on paper
14 x 10 5/8 in. (35.6 x 27 cm)
Collection of Annemarie and Gianfranco Verna, Zurich

10th of 10 Summer 1973, 1973
Graphite on paper
14 x 10 5/8 in. (35.6 x 27 cm)
Collection of Annemarie and Gianfranco Verna, Zurich

Acropolis, 1973 (pl. 166)
Ink and graphite on paper
14 x 11 in. (35.6 x 27.9 cm)
National Gallery of Art, Washington, D.C., the Dorothy and Herbert Vogel Collection, Ailsa Mellon Bruce Fund, Patrons' Permanent Fund and gift of Dorothy and Herbert Vogel 1991

Black & Gray with Diagonal, 1973 (pl. 158)
Watercolor and graphite on paper
13 7/8 x 10 15/16 in. (35.2 x 27.8 cm)
National Gallery of Art, Washington, D.C., the Dorothy and Herbert Vogel Collection, Ailsa Mellon Bruce Fund, Patrons' Permanent Fund and gift of Dorothy and Herbert Vogel 1991

Blue Spiral Drawing, 1973
Graphite, gouache, and watercolor on paper
14 x 11 in. (35.6 x 27.9 cm)
Collection of Annemarie and Gianfranco Verna, Zurich

Dane Grey, 1973
Ink and graphite on paper
14 x 11 in. (35.6 x 27.9 cm)
Whitney Museum of American Art, New York, purchase, with funds from the Albert A. List Family

Drawing for Paint-Structure, 1973 (pl. 171)
Graphite and gouache on paper
8 13/16 x 5 7/8 in. (22.4 x 14.9 cm)
Kolumba, Cologne, Germany

Drawing with One Line, 1973
Graphite on paper
14 x 11 in. (35.6 x 27.9 cm)
National Gallery of Art, Washington, D.C., the Dorothy and Herbert Vogel Collection, gift of Dorothy and Herbert Vogel, Trustees 2004

Drop of Grey, 1973 (pl. 177)
Watercolor and graphite on paper
13 7/8 x 10 7/8 in. (35.2 x 27.6 cm)
Collection Lambert en Avignon, France

Finding the Center Point, #6, 1973
Ink and ink wash on paper
9 x 6 in. (22.9 x 15.2 cm)
National Gallery of Art, Washington, D.C., the Dorothy and Herbert Vogel Collection, gift of Dorothy and Herbert Vogel, Trustees 2004

Finding the Center Point, #7, 1973
Ink and ink wash on paper
9 x 6 in. (22.9 x 15.2 cm)
National Gallery of Art, Washington, D.C., the Dorothy and Herbert Vogel Collection, gift of Dorothy and Herbert Vogel, Trustees 2004

Finding the Center Point, #8, 1973
Ink, ink wash, and graphite on paper
9 x 6 in. (22.9 x 15.2 cm)
National Gallery of Art, Washington, D.C., the Dorothy and Herbert Vogel Collection, gift of Dorothy and Herbert Vogel, Trustees 2004

Finding the Center Point, #9, 1973 (pl. 175)
Ink and ink wash on paper
9 x 6 in. (22.9 x 15.2 cm)
National Gallery of Art, Washington, D.C., the Dorothy and Herbert Vogel Collection, gift of Dorothy and Herbert Vogel, Trustees 2004

French Hotel Drawing, 1973
Graphite on paper
11 x 8 7/16 in. (27.9 x 21.4 cm)
National Gallery of Art, Washington, D.C., the Dorothy and Herbert Vogel Collection, gift of Dorothy and Herbert Vogel, Trustees 2004

Green Diamond with Pencil Line, 1973 (pl. 176)
Watercolor and graphite on paper
11 7/8 x 8 7/8 in. (30.2 x 22.5 cm)
National Gallery of Art, Washington, D.C., the Dorothy and Herbert Vogel Collection, gift of Dorothy and Herbert Vogel, Trustees 2004

Green Spiral Drawing, 1973
Gouache and graphite on paper
14 x 11 in. (35.6 x 27.9 cm)
Collection of the artist; courtesy Sperone Westwater, New York

Red Spiral Drawing (1), 1973
Watercolor and graphite on paper
14 x 11 in. (35.6 x 27.9 cm)
Collection of Annemarie and Gianfranco Verna, Zurich

Red Spiral Drawing (2), 1973 (pl. 172)
Watercolor and graphite on paper
14 x 11 in. (35.6 x 27.9 cm)
National Gallery of Art, Washington, D.C., the Dorothy and Herbert Vogel Collection, Ailsa Mellon Bruce Fund, Patrons' Permanent Fund and gift of Dorothy and Herbert Vogel 1991

Rendering for the Fourth of Thirteen Spiral Drawings, 1973
Gouache on paper
14 x 11 in. (35.6 x 27.9 cm)
Collection of Heinz Teichmann, Germany

Rendering for the Eleventh of Thirteen Spiral Drawings, 1973 (pl. 173)
Ink, watercolor, and felt-tip pen on paper
14 x 11 in. (35.6 x 27.9 cm)
Private collection

Rendering for the Twelfth of Thirteen Spiral Drawings, 1973
Ink and graphite on paper
14 x 11 in. (35.6 x 27.9 cm)
National Gallery of Art, Washington, D.C., the Dorothy and Herbert Vogel Collection, Ailsa Mellon Bruce Fund, Patrons' Permanent Fund and gift of Dorothy and Herbert Vogel 1991

Rising Colors along Frontal Diagonal with Downward Slant, 1973
Watercolor and graphite on paper
13 13/16 x 11 in. (35.1 x 27.9 cm)
National Gallery of Art, Washington, D.C., the Dorothy and Herbert Vogel Collection, gift of Dorothy and Herbert Vogel, Trustees 2004

3 Lines Beginning at a Point & Intersecting in 2 Different Ways, 1973
Graphite on paper
13 13/16 x 10 15/16 in. (35.1 x 27.8 cm)
National Gallery of Art, Washington, D.C., the Dorothy and Herbert Vogel Collection, gift of Dorothy and Herbert Vogel, Trustees 2004

Two Dips Plus X, 1973 (pl. 168)
Watercolor and graphite on paper
12 x 9 in. (30.5 x 22.9 cm)
National Gallery of Art, Washington, D.C., the Dorothy and Herbert Vogel Collection, gift of Dorothy and Herbert Vogel, Trustees 2004

Untitled (#2), 1973
Graphite and gouache on paper
13 3/4 x 10 15/16 in. (34.9 x 27.8 cm)
Collection of Annemarie and Gianfranco Verna, Zurich

Untitled (#3), 1973
Graphite on paper
13 3/4 x 10 15/16 in. (34.9 x 27.8 cm)
Collection of Annemarie and Gianfranco Verna, Zurich

Walking, 1973 (pl. 178)
Graphite on paper
13 15/16 x 11 1/16 in. (35.4 x 28.1 cm)
National Gallery of Art, Washington, D.C., the Dorothy and Herbert Vogel Collection, Ailsa Mellon Bruce Fund, Patrons' Permanent Fund and gift of Dorothy and Herbert Vogel 1991

Yellow and Grey Structured, 1973 (pl. 179)
Watercolor and graphite on paper
8 13/16 x 5 7/8 in. (22.4 x 14.9 cm)
Kolumba, Cologne, Germany

3rd Rope Piece, 1974 (pls. 125, 296–97)
Cotton and nails
1/2 x 3 x 3/8 in. (1.3 x 7.6 x 1 cm)
National Gallery of Art, Washington, D.C.,
the Dorothy and Herbert Vogel Collection,
gift of Dorothy and Herbert Vogel, Trustees 2004

4th Summer Wood Piece, 1974 (pl. 129)
Cloth, wood, and staples
30 x 20 x 1 in. (76.2 x 50.8 x 2.5 cm)
National Gallery of Art, Washington, D.C.,
the Dorothy and Herbert Vogel Collection,
gift of Dorothy and Herbert Vogel, Trustees 2004

2nd Wood Slat, 1974
Plywood, latex paint, and nails
31 3/4 x 12 x 1/4 in. (80.6 x 30.5 x 0.6 cm)
The LeWitt Collection, Chester, Connecticut

7th Wood Slat, 1974 (pl. 127)
Plywood, latex paint, and nails
36 x 8 x 1/4 in. (91.4 x 20.3 x 0.6 cm)
Collection of Craig Robins, Miami, Florida

8th Wood Slat, 1974 (pl. 128)
Plywood, latex paint, and nails
36 x 3 x 1/4 in. (91.4 x 7.6 x 0.6 cm)
Collection of Craig Robins, Miami, Florida

Ahingus, 1974 (pl. 191)
Gouache on paper
12 x 9 in. (30.5 x 22.9 cm)
Collection of Annemarie and Gianfranco
Verna, Zurich

Black and White around Center Point, 1974
Ink, gouache, and graphite on paper
12 x 8 7/8 in. (30.5 x 22.5 cm)
National Gallery of Art, Washington, D.C.,
the Dorothy and Herbert Vogel Collection,
gift of Dorothy and Herbert Vogel, Trustees 2004

Broken Line Drawing, 1974 (pl. 180)
Graphite on airmail paper
9 x 6 in. (22.9 x 15.2 cm)
National Gallery of Art, Washington, D.C.,
the Dorothy and Herbert Vogel Collection,
gift of Dorothy and Herbert Vogel, Trustees 2004

Diagonal-Triangulation Series (1), 1974 (pl. 181)
Ink on paper
11 13/16 x 8 5/16 in. (30 x 21.1 cm)
Kolumba, Cologne, Germany

Drawing with Three Ends, 1974 (pl. 182)
Graphite and ink on paper
14 x 11 in. (35.6 x 27.9 cm)
Collection of Annemarie and Gianfranco
Verna, Zurich

How Paint Meets Line Group (2), 1974
Graphite on paper
14 x 11 in. (35.6 x 27.9 cm)
Kolumba, Cologne, Germany

How Paint Meets Line Group (3), 1974
Gouache and graphite on paper
14 x 11 in. (35.6 x 27.9 cm)
Collection of Annemarie and Gianfranco
Verna, Zurich

How Paint Meets Line Group (4), 1974 (pl. 188)
Gouache and graphite on paper
14 x 11 in. (35.6 x 27.9 cm)
Private collection, Cologne

How Paint Meets Line Group (6), 1974 (pl. 189)
Watercolor and graphite on paper
14 x 11 in. (35.6 x 27.9 cm)
Kolumba, Cologne, Germany

Interlude: Kinesthetic Drawings, 1974 (pls. 356–57)
Lithography, china marker, graphite, and die cuts
on paper with cloth and board binding; ed. of 24
19 1/2 x 26 1/2 x 1 1/8 in. (49.5 x 67.3 x 2.9 cm)
Published by Brooke Alexander, New York
Exhibition copy collection of Brooke Alexander,
New York

One of Two Drawings (1), 1974 (pl. 183)
Gouache and graphite on paper
12 x 9 in. (30.5 x 22.9 cm)
Collection of Heidi Pfanzelt, Germany

One of Two Drawings (2), 1974 (pl. 184)
Ink and graphite on paper
12 x 9 in. (30.5 x 22.9 cm)
Collection of Heidi Pfanzelt, Germany

Paris Arles #20, 1974 (pl. 207)
Watercolor on paper in handmade wood frame
6 x 4 x 1 1/2 in. (15.2 x 10.2 x 3.8 cm)
Collection of Connie and Jack Tilton, New York

Portrait of Herbert Vogel, 1974
Acrylic ink on heavy-gauge wire
3 1/2 x 3 1/2 x 2 1/4 in. (8.9 x 8.9 x 5.7 cm)
National Gallery of Art, Washington, D.C.,
the Dorothy and Herbert Vogel Collection,
gift of Dorothy and Herbert Vogel, Trustees 2004

Sirakus, 1974 (pl. 192)
Ink on paper
14 x 11 in. (35.6 x 27.9 cm)
Whitney Museum of American Art, New York,
purchase, with funds from the Albert A. List Family

Study for Sculpture (2), 1974
Ink on paper
14 x 11 in. (35.6 x 27.9 cm)
Collection of Annemarie and Gianfranco
Verna, Zurich

Study for Twisting Motion, 1974 (pl. 186)
Graphite on paper
14 x 11 in. (35.6 x 27.9 cm)
Kolumba, Cologne, Germany

**Union of 3 & 4 w/ 2 Black Triangles & 7 Pencil
Lines, 3 on Top, 4 Underneath,** 1974 (pl. 185)
Ink and graphite on paper
11 7/8 x 18 in. (30.2 x 45.7 cm)
National Gallery of Art, Washington, D.C.,
the Dorothy and Herbert Vogel Collection,
gift of Dorothy and Herbert Vogel, Trustees 2004

Untitled, 1974
Gouache and graphite on paper
13 3/4 x 11 in. (34.9 x 27.9 cm)
Collection of Annemarie and Gianfranco
Verna, Zurich

Even, 1975
Ink and graphite on paper
14 x 11 in. (35.6 x 27.9 cm)
Collection of Annemarie and Gianfranco
Verna, Zurich

52 1/2" Center Point Works II (2), 1975 (pl. 190)
Ink and graphite on paper
14 x 11 in. (35.6 x 27.9 cm)
Courtesy Peter Freeman, Inc., New York

One Room Drawing #1, 1975
Gouache and graphite on paper
12 x 8 15/16 in. (30.5 x 22.7 cm)
National Gallery of Art, Washington, D.C.,
the Dorothy and Herbert Vogel Collection,
gift of Dorothy and Herbert Vogel, Trustees 2004

One Room Drawing #3, 1975
Graphite and watercolor on paper
12 x 8 15/16 in. (30.5 x 22.7 cm)
National Gallery of Art, Washington, D.C.,
the Dorothy and Herbert Vogel Collection,
gift of Dorothy and Herbert Vogel, Trustees 2004

One Room Drawing #8, 1975 (pl. 194)
Graphite and watercolor on paper
12 x 8 15/16 in. (30.5 x 22.7 cm)
National Gallery of Art, Washington, D.C.,
the Dorothy and Herbert Vogel Collection,
gift of Dorothy and Herbert Vogel, Trustees 2004

60" Center Point Works (8), 1975
Ink and graphite on paper
14 x 11 in. (35.6 x 27.9 cm)
Collection of Rainer and Susanna Peikert,
Zug, Switzerland

Spiral Notebook Drawing 1, 1975
Gouache and graphite on paper
11 x 8 7/16 in. (27.9 x 21.4 cm)
National Gallery of Art, Washington, D.C.,
the Dorothy and Herbert Vogel Collection,
gift of Dorothy and Herbert Vogel, Trustees 2004

Untitled, 1975
Felt-tip pen on paper
10 5/8 x 8 1/4 in. (27 x 21 cm)
Collection of Marilena and Lorenzo Bonomo,
Bari, Italy

Untitled (N), 1975
Felt-tip pen on paper
10 13/16 x 8 7/16 in. (27.5 x 21.4 cm)
Collection of Marilena and Lorenzo Bonomo,
Bari, Italy

Portland Works: Group I, 1976 (pl. 31)
Watercolor on airmail paper and handmade
paper in handmade wood frames
Seven parts, each: 12 1/8 x 9 x 1 1/8 in.
(30.8 x 22.9 x 2.9 cm)
Collection of Rosalind and Walter Bernheimer,
Waban, Massachusetts

Dorothy's Favorite, 1977 (pl. 193)
Watercolor on paper
7 11/16 x 6 1/8 in. (19.5 x 15.6 cm)
National Gallery of Art, Washington, D.C.,
the Dorothy and Herbert Vogel Collection,
gift of Dorothy and Herbert Vogel, Trustees 2004

Maine Works (I), 1977
Watercolor on paper
19 1/4 x 16 in. (48.9 x 40.6 cm)
Collection of Joel Wachs

Untitled [collage drawings], 1977
Watercolor and paper on paper
Ten drawings, each: 14 x 11 in. (35.6 x 27.9 cm)
Collection of Annemarie and Gianfranco
Verna, Zurich

Titel 3, 1978
Watercolor and paper
7 11/16 x 9 7/8 x 3/8 in. (19.5 x 25.1 x 1 cm)
Collection of Heinz Herrmann, Baden, Switzerland

Title 1, 1978 (pls. 133–34)
Watercolor and paper
7 x 10 x 3/8 in. (17.8 x 25.4 x 1 cm)
Collection of the artist; courtesy Sperone
Westwater, New York

Title A, 1978 (pl. 137)
Watercolor, graphite, and paper
9 x 6 x 3/8 in. (22.9 x 15.2 x 1 cm)
Collection of the artist; courtesy Sperone
Westwater, New York

Title I, 1978
Watercolor, gouache, graphite, and paper
5 x 5 1/4 x 3/8 in. (12.7 x 13.3 x 1 cm)
Collection of the artist; courtesy Sperone
Westwater, New York

Title I 6, 1978 (pls. 138–39)
Gouache, graphite, and paper
5 1/8 x 5 1/2 x 3/8 in. (13 x 14 x 1 cm)
Collection of Brooke and Daniel Neidich

Title N, 1978 (pl. 139)
Gouache and paper
23 1/2 x 17 7/16 x 3/8 in. (59.7 x 44.3 x 1 cm)
Collection of Brooke and Daniel Neidich

Titolo 2, 1978
Graphite and watercolor on paper
5 7/8 x 8 1/2 x 3/8 in. (14.9 x 21.6 x 1 cm)
Collection of the artist; courtesy Sperone
Westwater, New York

Titolo 4, 1978 (pl. 136)
Watercolor and paper
10 3/4 x 11 3/4 x 3/8 in. (27.3 x 29.8 x 1 cm)
Courtesy Anthony Grant, Inc., New York

Titre 2, 1978 (pl. 135)
Watercolor, graphite, and paper
7 1/2 x 9 5/8 x 3/8 in. (19.1 x 24.4 x 1 cm)
Courtesy Anthony Grant, Inc., New York

Hong Kong Set, 1980 (pls. 211–20)
Watercolor and graphite on paper in handmade
wood frames
Ten parts, each: 10 x 8 1/2 x 1 1/8 in.
(25.4 x 21.6 x 2.9 cm)
Collection of Connie and Jack Tilton, New York

India Work 9, 1980 (pl. 208)
Watercolor on paper in handmade wood frame
11 x 9 1/4 x 1 1/2 in. (27.9 x 23.5 x 3.8 cm)
National Gallery of Art, Washington, D.C.,
the Dorothy and Herbert Vogel Collection,
gift of Dorothy and Herbert Vogel, Trustees 2004

India Work 17, 1980 (pl. 209)
Watercolor and graphite on paper in handmade
wood frame
11 x 9 1/4 x 1 1/2 in. (27.9 x 23.5 x 3.8 cm)
National Gallery of Art, Washington, D.C.,
the Dorothy and Herbert Vogel Collection,
gift of Dorothy and Herbert Vogel, Trustees 2004

India Work 26, 1980 (pl. 210)
Colored pencil on paper in handmade wood frame
11 x 9 1/4 x 1 1/2 in. (27.9 x 23.5 x 3.8 cm)
National Gallery of Art, Washington, D.C.,
the Dorothy and Herbert Vogel Collection,
gift of Dorothy and Herbert Vogel, Trustees 2004

B 1, 1981 (pl. 195)
Wood, cardboard, thread, metal, and acrylic
5 1/4 x 4 1/8 x 3/4 in. (13.3 x 10.5 x 1.9 cm)
Collection of Gilles Fuchs, Paris

G 1, 1981 (pl. 196)
Wire, wood, and acrylic
9 1/2 x 10 x 3 1/2 in. (24.1 x 25.4 x 8.9 cm)
Collection Lambert en Avignon, France

J 1, 1981
Wood, acrylic, and nails
11 1/4 x 7 1/2 x 1 1/8 in. (28.6 x 19.1 x 2.9 cm)
Stedelijk Museum Amsterdam

K 1, 1981 (pl. 33)
Plywood, acrylic, sawdust, and nails
7 7/8 x 5 1/4 x 1 3/8 in. (20 x 13.3 x 3.5 cm)
Stedelijk Museum Amsterdam

L 1, 1981 (pl. 198)
Wood, wire, paper, aluminum foil, and acrylic
10 3/8 x 9 1/4 x 2 3/4 in. (26.4 x 23.5 x 7 cm)
Collection of Didier Grumbach, Paris

P 1, 1981
Wood, aluminum foil, masking tape,
acrylic, and wire
15 3/4 x 6 1/4 x 1 3/8 in. (40 x 15.9 x 3.5 cm)
Private collection

W 1, 1981 (pl. 197)
Wood, cardboard, nails, and acrylic
8 1/8 x 6 1/8 x 1 3/4 in. (20.6 x 15.6 x 4.4 cm)
Stedelijk Museum Amsterdam

Brown Bar #1, 1981 (pl. 222)
Watercolor, colored pencil, graphite, and museum
board in handmade wood frame
8 x 7 x 1 1/2 in. (20.3 x 17.8 x 3.8 cm)
National Gallery of Art, Washington, D.C.,
the Dorothy and Herbert Vogel Collection,
Ailsa Mellon Bruce Fund, Patrons' Permanent
Fund and gift of Dorothy and Herbert Vogel 1991

Brown Bar #2, 1981 (pl. 222)
Watercolor, colored pencil, graphite, and museum
board in handmade wood frame
8 x 7 x 1 1/2 in. (20.3 x 17.8 x 3.8 cm)
National Gallery of Art, Washington, D.C.,
the Dorothy and Herbert Vogel Collection,
Ailsa Mellon Bruce Fund, Patrons' Permanent
Fund and gift of Dorothy and Herbert Vogel 1991

Brown Bar #3, 1981 (pl. 222)
Watercolor, colored pencil, graphite, and museum
board in handmade wood frame
8 x 7 x 1 1/2 in. (20.3 x 17.8 x 3.8 cm)
National Gallery of Art, Washington, D.C.,
the Dorothy and Herbert Vogel Collection,
Ailsa Mellon Bruce Fund, Patrons' Permanent
Fund and gift of Dorothy and Herbert Vogel 1991

Brown Bar #4, 1981 (pl. 222)
Watercolor, colored pencil, graphite, and museum
board in handmade wood frame
8 x 7 x 1 1/2 in. (20.3 x 17.8 x 3.8 cm)
National Gallery of Art, Washington, D.C.,
the Dorothy and Herbert Vogel Collection,
Ailsa Mellon Bruce Fund, Patrons' Permanent
Fund and gift of Dorothy and Herbert Vogel 1991

Brown Bar #5, 1981 (pls. 221–22)
Watercolor, colored pencil, graphite, and museum
board in handmade wood frame
8 x 7 x 1 1/2 in. (20.3 x 17.8 x 3.8 cm)
National Gallery of Art, Washington, D.C.,
the Dorothy and Herbert Vogel Collection,
Ailsa Mellon Bruce Fund, Patrons' Permanent
Fund and gift of Dorothy and Herbert Vogel 1991

#9 from Old Men and Their Garden, 1982
Watercolor on paper in handmade wood frame
with copper hanger
9 1/2 x 14 x 1 5/8 in. (24.1 x 35.6 x 4.1 cm)
Private collection

#10 from Old Men and Their Garden, 1982
Watercolor on paper in handmade wood frame
with copper hanger
9 1/2 x 14 x 1 5/8 in. (24.1 x 35.6 x 4.1 cm)
Collection of Connie and Jack Tilton, New York

#24 from Old Men and Their Garden, 1982 (pl. 244)
Watercolor on paper in handmade wood frame
with copper hanger
9 1/2 x 14 x 1 5/8 in. (24.1 x 35.6 x 4.1 cm)
Private collection

#36 from Old Men and Their Garden, 1982
Watercolor on paper in handmade wood frame
with copper hanger
9 1/2 x 14 x 1 5/8 in. (24.1 x 35.6 x 4.1 cm)
Private collection

#39 from Old Men and Their Garden, 1982
Watercolor on paper in handmade wood frame
with copper hanger
9 1/2 x 14 x 1 5/8 in. (24.1 x 35.6 x 4.1 cm)
Collection of Connie and Jack Tilton, New York

#44 from Old Men and Their Garden, 1982
Watercolor on paper in handmade wood frame
with copper hanger
9 1/2 x 14 x 1 5/8 in. (24.1 x 35.6 x 4.1 cm)
Private collection, Switzerland

#52 from Old Men and Their Garden, 1982
Watercolor on paper in handmade wood frame
with copper hanger
9 1/2 x 14 x 1 5/8 in. (24.1 x 35.6 x 4.1 cm)
Collection of Craig Robins, Miami, Florida

#58 from Old Men and Their Garden, 1982 (pl. 224)
Watercolor on paper in handmade wood frame
with copper hanger
9 1/2 x 14 x 1 5/8 in. (24.1 x 35.6 x 4.1 cm)
Collection of Connie and Jack Tilton, New York

#60 from Old Men and Their Garden, 1982 (pl. 225)
Watercolor on paper in handmade wood frame
with copper hanger
9 1/2 x 14 x 1 5/8 in. (24.1 x 35.6 x 4.1 cm)
Collection of Connie and Jack Tilton, New York

Monkey's Recovery for a Darkened Room, 6
[also **Monkey's Recovery for a Darkened
Room (Bluebird)**], 1983 (pl. 200)
Wood, wire, acrylic, matboard, string, and cloth
40 x 20 1/2 x 12 1/2 in. (101.6 x 52.1 x 31.8 cm)
National Gallery of Art, Washington, D.C.,
the Dorothy and Herbert Vogel Collection,
gift of Dorothy and Herbert Vogel, Trustees 2004

Monkey's Recovery I, #3, 1983 (pl. 201)
Styrofoam, wood, wire, glue, acrylic, and paper
24 x 9 x 6 in. (61 x 22.9 x 15.2 cm)
Collection of Gilles Fuchs, Paris

Two or More III, 1984 (pl. 202)
Bubble wrap, wood, staples, corrugated cardboard,
acrylic, enamel, and wire
30 1/2 x 18 1/2 x 6 in. (77.5 x 47 x 15.2 cm)
Private collection, Houston

Two or More IX, 1984 (pl. 205)
Wire, plastic, paper, canvas, wood, ink, and
cardboard
50 3/4 x 32 1/2 x 3 1/8 in. (128.9 x 82.6 x 7.9 cm)
Onnasch Collection, Berlin

Two or More XII, 1984 (pl. 203)
Fabric, aluminum Pepsi can, wire, feather,
glass, cardboard, enamel, acrylic, spray enamel,
and dry pigment
41 x 24 1/2 x 6 in. (104.1 x 62.2 x 15.2 cm)
Onnasch Collection, Berlin

La Terre de Grenade I, 1985 (pl. 228)
Watercolor on paper, plastic, and cardboard
in handmade wood frame
17 x 21 x 5/8 in. (43.2 x 53.3 x 1.6 cm)
Collection Fondation Cartier pour l'art
contemporain, Paris

La Terre de Grenade X, 1985 (pl. 227)
Watercolor on paper, plastic, and cardboard
in handmade wood frame
17 x 21 x 5/8 in. (43.2 x 53.3 x 1.6 cm)
Collection Fondation Cartier pour l'art
contemporain, Paris

Mists VII, 1985 (pl. 204)
Cardboard, wood, twigs, spray enamel, wire,
enamel, acrylic, and aluminum foil
19 5/8 x 23 5/8 in. (49.8 x 60 cm)
Collection of Angelo Baldassarre, Bari, Italy

Richard Tuttle, 1985 (pl. 363)
Lithography on paper; special ed. of 150
with photogravure print
5 7/8 x 8 1/4 x 3/8 in. (14.9 x 21 x 1 cm)
Published by Städtisches Museum Abteiberg,
Mönchengladbach, Germany
Exhibition copy collection of the artist;
courtesy Sperone Westwater, New York

**Richard Tuttle. △s: Works 1964–1985 / Two
Pinwheels: Works 1964–1985,** 1985 (pl. 371)
Lithography on paper in cardboard box; open edition
Book: 11 7/8 x 8 1/4 x 5/8 in. (30.2 x 21 x 1.6 cm);
box: 12 x 8 1/2 x 5/8 in. (30.5 x 21.6 x 1.6 cm)
Published by Coracle Press, London;
the Institute of Contemporary Art, London;
and the Fruitmarket Gallery, Edinburgh
Exhibition copy collection of Penny Cooper
and Rena Rosenwasser, Berkeley

The Baroque and Color #8, 1986 (pl. 247)
Powdered pigment and acrylic binder
on rice paper over wood armature
63 x 24 3/4 x 19 5/8 in. (160 x 62.9 x 49.8 cm)
Sammlung Hoffmann, Berlin

Beethoven Stop on the Way to Egypt, 1986 (pl. 206)
Acrylic, cardboard, paper, wire, and nails
Three parts, overall: 41 x 97 x 6 in.
(104.1 x 246.4 x 15.2 cm)
Norton Museum of Art, West Palm Beach, Florida,
purchase, acquired through the generosity of the
friends and family of Jack Friedland in honor of his
birthday

Egyptian Works, 1986 (pls. 229–30)
Cardboard, wood, graphite, wire, paper,
ballpoint pen, watercolor, felt-tip pen, and acrylic
Nine drawings, each approximately:
6 1/4 x 5 1/2 x 1 1/8 in. (15.9 x 14 x 2.9 cm)
Private collection

The Spirals 7, 1986
Museum board
10 x 13 x 3 in. (25.4 x 33 x 7.6 cm)
Collection of the artist; courtesy Sperone
Westwater, New York

The Spirals 11, 1986 (pl. 246)
Museum board and graphite
10 3/8 x 7 1/4 x 5 in. (26.4 x 18.4 x 12.7 cm)
Collection of the artist; courtesy Sperone
Westwater, New York

Four, 1987 (pls. 253–61, 379)
Wood, canvas, bookbinding fabric, felt-tip pen,
nails, and linen thread
42 x 78 x 50 in. (106.7 x 198.1 x 127 cm)
Private collection

Hiddenness, 1987
Color-pulp and hand-stamped images,
letterpress ink, lithography, and screen printing
on paper in paper-covered box; ed. of 120
15 1/2 x 10 3/4 x 1 3/8 in. (39.4 x 27.3 x 3.5 cm)
Published by Library Fellows of the Whitney
Museum of American Art, New York
Exhibition copy collection of the artist; courtesy
Sperone Westwater, New York

Six, 1987 (pl. 263)
Wood, canvas, acrylic, corduroy fabric, nails,
florist wire, and linen thread
71 1/2 x 56 1/2 x 60 in. (181.6 x 143.5 x 152.4 cm)
Indianapolis Museum of Art, gift of Christopher
and Ann Stack

Sustained Color, 1987 (pls. 266–86)
Gouache, wire, masking tape, nails,
and acrylic on paper
Twenty-one parts, each: 13 11/16 x 10 3/8 in.
(34.8 x 26.4 cm)
Private collection, courtesy Fondation H.
Looser, Zurich

Nica Lift-Off, 1988 (pl. 379)
Watercolor, graphite, paper, Homosote, oil, tape,
glass, and wire
Fifteen parts, each: 6 3/4 x 4 3/4 in. (17.1 x 12.1 cm)
Private collection, New York

Richard Tuttle: Portland Works 1976, 1988
Lithography on paper with handmade paper
cover; open edition
10 1/8 x 7 1/8 x 1/8 in. (25.7 x 18.1 x 0.3 cm)
Published by Galerie Karsten Greve, Cologne,
and Thomas Segal Gallery, Boston
Exhibition copy collection of the artist; courtesy
Sperone Westwater, New York

Sand-Tree 2, 1988 (pl. 264)
Wood, construction paper, cardstock, metal
sanding screen, Styrofoam, and brass wire
Six parts, overall: 29 1/2 x 59 x 6 1/2 in.
(74.9 x 149.9 x 16.5 cm)
Courtesy Peter Freeman, Inc., New York

There's No Reason a Good Man Is Hard to Find I,
1988 (pl. 262)
Wood, PVC pipe, metal bolts and screws,
heavy-gauge wire, tissue paper, acrylic,
imitation leather, and industrial-quality thread
71 x 87 x 83 in. (180.3 x 221 x 210.8 cm)
IVAM, Instituto Valenciano de Arte Moderno,
Generalitat Valenciana, Valencia, Spain

Turquoise I, 1988 (pls. 265, 379)
Wood, canvas, acrylic, nails, wire, tape, and staples
34 1/4 x 70 7/8 x 35 3/8 in. (87 x 180 x 89.9 cm)
Collection of Greta Meert, Brussels

Done by Women Not by Men, 1989 (pl. 303)
Wood, cloth, plastic, metal, light string, cable,
and acrylic
72 1/2 x 63 x 15 3/4 in. (184.2 x 160 x 40 cm)
Sprengel Museum Hannover, Germany

Forms in Classicism, 1989 (pl. 248)
Wood, acrylic, model-airplane paper, and paper
Five parts, overall approximately: 25 x 153 x 5 7/8 in.
(63.5 x 388.6 x 14.9 cm)
Collection of Henry S. McNeil, Philadelphia

40 Days, 1989 (pls. 249–51)
Watercolor and graphite on paper
Forty drawings, each: 9 1/16 x 12 1/16 in.
(23 x 30.6 cm), orientation variable
Kolumba, Cologne, Germany

**40 Tage: Mit Einem Text des Künstlers /
Zeichnungen,** 1989
Lithography on paper; ed. of 700
11 5/8 x 16 1/2 x 1/4 in. (29.5 x 41.9 x 0.6 cm)
Published by Galerie Erhard Klein, Bonn,
and Galerie Hubert Winter, Vienna
Exhibition copy collection of Penny Cooper
and Rena Rosenwasser, Berkeley

Rose Long, 1989 (pl. 306)
Watercolor on paper
9 x 27 in. (22.9 x 68.6 cm)
Collection of Christiane and Lothar Pues,
Essen, Germany

Rose Term, 1989
Watercolor on paper
10 x 15 5/8 in. (25.4 x 39.7 cm)
Kunstmuseum Winterthur, Switzerland,
purchase with a special contribution
by the Canton of Zurich, 2001

Rose Weight, 1989 (pl. 309)
Watercolor on paper
14 1/8 x 9 in. (35.9 x 22.9 cm)
Kunstmuseum Winterthur, Switzerland,
purchase with a special contribution
by the Canton of Zurich, 2001

Sentences II, 1989 (pls. 307, 379)
Wood, natural pigments, enamel, canvas,
galvanized metal, ceramic light fixtures,
and lightbulbs
20 5/8 x 56 1/4 x 25 5/8 in. (52.4 x 142.9 x 65.1 cm)
Collection of Elsa and Theo Hotz, Zurich

Sentences III, 1989 (pl. 302)
Wood, acrylic, ceramic light fixtures,
lightbulbs, and canvas
72 x 42 x 35 in. (182.9 x 106.7 x 88.9 cm)
Des Moines Art Center, purchased with funds
from the Coffin Fine Art Trust; Nathan Emory
Coffin Collection of the Des Moines Art Center

Sentences IV, 1989 (pl. 304)
Polyurethane, metal tubing, ceramic light fixtures,
Styrofoam, lightbulbs, canvas, wood, sheet metal,
natural pigments, acrylic binder, and monofilament
75 x 57 x 48 in. (190.5 x 144.8 x 121.9 cm)
Collection of Ulrike and Franziska Schmela,
Düsseldorf

System of Color, 1989 (pl. 231)
Wood, paper, aluminum, plastic, cellophane,
acrylic, and dry pigment
Eight parts, each approximately: 5 1/8 x 5 1/4 x 2 in.
(13 x 13.3 x 5.1 cm)
Private collection, Mülheim/Ruhr, Germany

26th Line Piece, 1990 (pl. 317)
Wood, paper, ink, and graphite
3 1/2 x 1 1/2 x 3/8 in. (8.9 x 3.8 x 1 cm)
Collection of the artist; courtesy Sperone
Westwater, New York

60th Line Piece, 1990 (pl. 318)
Paper, watercolor, foam board, glue, and graphite
9 x 6 x 5/8 in. (22.9 x 15.2 x 1.6 cm)
Collection of the artist; courtesy Sperone
Westwater, New York

Inside the Still Pure Form, 1990 (pl. 310)
Installation of sculptures and drawings
in three parts:

Inside the Still Pure Form, 1990
Wood, graphite, latex paint, watercolor,
and spray enamel
Thirteen parts, each approximately:
15 1/4 x 7 1/2 x 1 1/2 in. (38.7 x 19.1 x 3.8 cm)
Collection of the artist; courtesy Sperone
Westwater, New York

The Table and a Chair, 1990
Gouache and graphite on paper
Five drawings, each approximately:
12 1/4 x 18 1/4 in. (31.1 x 46.4 cm),
orientation variable
Collection of the artist; courtesy Sperone
Westwater, New York

You and Me, 1990
Gouache and graphite on paper
Nine drawings, each approximately:
9 x 11 3/4 in. (22.9 x 29.8 cm),
orientation variable
Collection of the artist; courtesy Sperone
Westwater, New York

Lonesome Cowboy Styrofoam, 1990 (pl. 362)
Lithography and letterpress ink on paper,
photographic film, grass, glassine envelope,
balloon, earth pigment, puzzle, handmade
paper, staples, and ribbon in foam-wrap slipcase;
ed. of 200
Approximately 6 1/2 x 5 x 2 in. (16.5 x 12.7 x 5.1 cm)
Published by Blum Helman Gallery, New York,
and Gallery Casa Sin Nombre, Santa Fe
Exhibition copy collection of the artist; courtesy
Sperone Westwater, New York

Octavo for Annemarie, 1990
Color-pulp images and letterpress ink on
handmade paper in maple-wood box; ed. of 5
4 x 3 1/8 x 1 in. (10.2 x 7.9 x 2.5 cm)
Published by Annemarie Verna Galerie, Zurich
Exhibition copy collection of the artist; courtesy
Sperone Westwater, New York

Paris Piece I, 1990 (pl. 320)
Wood, acrylic, fabric, and vinyl
59 x 39 3/8 x 9 7/8 in. (149.9 x 100 x 25.1 cm)
Collection FRAC Auvergne, Clermont-
Ferrand, France

Relative in Our Society, 1990 (pl. 305)
Wood, wire mesh, cedar branch, light fixtures,
lightbulbs, paper, Masonite, and acrylic
73 x 23 x 10 in. (185.4 x 58.4 x 25.4 cm)
Modern Art Museum of Fort Worth, museum
purchase

Richard Tuttle: Sprengel Museum Hannover, 1990
Lithography, screen printing, paper, and board
in cardboard box; open edition
9 x 9 x 7/8 in. (22.9 x 22.9 x 2.2 cm)
Published by Sprengel Museum Hannover,
Germany
Exhibition copy collection of the artist;
courtesy Sperone Westwater, New York

Vienna Gotico, 1990
Lithography on paper; ed. of 500
4 1/2 x 5 1/2 x 1/8 in. (11.4 x 14 x 0.3 cm)
Published by Galleria Alessandra Bonomo, Rome
Exhibition copy collection of the artist; courtesy
Sperone Westwater, New York

The Altos, 1991
Softground etchings with hand-coloring on paper,
pigskin binding; ed. of 120
17 1/2 x 14 x 1 1/8 in. (44.5 x 35.6 x 2.9 cm)
Published by Hine Editions / Limestone Press,
San Francisco
Exhibition copy courtesy Spencer Collection,
the New York Public Library

Early Auden, 1991
Sugarlift aquatints, etchings, monotypes,
and letterpress ink on paper and handmade
paper; ed. of 80
12 x 8 1/2 x 1 1/8 in. (30.5 x 21.6 x 2.9 cm)
Published by Hine Editions, San Francisco
Exhibition copy collection of the artist; courtesy
Sperone Westwater, New York

The Last Light Work, 1991 (pl. 308)
Wood, cardboard, lightbulbs, light fixtures,
vinyl, and acrylic
55 x 20 x 7 in. (139.7 x 50.8 x 17.8 cm)
Collection of Donna and Howard Stone, Chicago

Richard Tuttle: Crickets, 1991
Lithography on paper; open edition
8 1/4 x 8 1/4 x 1/8 in. (21 x 21 x 0.3 cm)
Published by Fundació "la Caixa," Barcelona
Exhibition copy collection of the artist; courtesy
Sperone Westwater, New York

Book and Cover, 1993
Graphite and cutouts on paper; ed. of 250
5 1/2 x 4 3/8 x 1/4 in. (14 x 11.1 x 0.6 cm)
Published by Tallgrass Press, Santa Fe
Exhibition copy collection of the artist; courtesy
Sperone Westwater, New York

"I See" (3) [also **Bonomo Box (3)**], 1993 (pl. 242)
Collage on paper in handmade wood frame,
graphite
7 7/8 x 7 7/8 x 3 1/2 in. (20 x 20 x 8.9 cm)
Collection of Marilena and Lorenzo Bonomo,
Bari, Italy

"I See" (5) [also **Bonomo Box (5)**], 1993
Collage on paper in handmade wood frame,
graphite
7 7/8 x 7 7/8 x 3 1/2 in. (20 x 20 x 8.9 cm)
Collection of Marilena and Lorenzo Bonomo,
Bari, Italy

"I See" (10) [also **Bonomo Box (10)**], 1993
Collage on paper in handmade wood frame,
graphite
7 7/8 x 7 7/8 x 3 1/2 in. (20 x 20 x 8.9 cm)
Collection of Marilena and Lorenzo Bonomo,
Bari, Italy

Peace and Time (XII), 1993 (pl. 319)
Foam rubber, copper, plastic pipe, chicken wire,
shingle, enamel, and graphite
94 x 50 x 24 in. (238.8 x 127 x 61 cm)
The Edward R. Broida Collection

Verbal Windows I, 1993 (pl. 232)
Acrylic, gouache, watercolor, and foam board
on paper with magnets on galvanized metal box
8 7/8 x 5 3/4 x 1 1/8 in. (22.5 x 14.6 x 2.9 cm)
Collection of the artist; courtesy Sperone
Westwater, New York

Verbal Windows II, 1993 (pl. 233)
Acrylic, gouache, watercolor, and foam board
on paper with magnets on galvanized metal box
8 7/8 x 5 3/4 x 1 1/8 in. (22.5 x 14.6 x 2.9 cm)
Collection of the artist; courtesy Sperone
Westwater, New York

Verbal Windows III, 1993 (pl. 234)
Acrylic, gouache, watercolor, and foam board
on paper with magnets on galvanized metal box
8 7/8 x 5 3/4 x 1 1/8 in. (22.5 x 14.6 x 2.9 cm)
Collection of the artist; courtesy Sperone
Westwater, New York

Whiteness 6, 1993 (pl. 321)
Styrofoam, paper, colored pencil, graphite,
latex paint, enamel, plywood, nails, cotton cloth,
galvanized metal, and masking tape
80 x 72 x 5 in. (203.2 x 182.9 x 12.7 cm)
The Museum of Modern Art, New York, Marcia
Riklis Fund, 1997

Icelandic #4, 1994 (pl. 235)
Watercolor and pen on paper, magnets, steel,
spray enamel, and handmade wood frame
24 x 7 x 1 in. (61 x 17.8 x 2.5 cm)
Collection of the artist; courtesy Sperone
Westwater, New York

Icelandic #5, 1994
Watercolor and pen on paper, magnets, steel,
spray enamel, and handmade wood frame
24 x 7 x 1 in. (61 x 17.8 x 2.5 cm)
Collection of the artist; courtesy Sperone
Westwater, New York

The Gyres: Source of Imagery, 1995
Woodcuts and watermark on paper; ed. of 50
with 10 deluxe copies on papier de chine
15 1/4 x 15 3/8 x 3/4 in. (38.7 x 39.1 x 1.9 cm)
Published by Kaldewey Press, Poestenkill,
New York
Exhibition copy collection of the artist; courtesy
Sperone Westwater, New York

How It Goes Around the Corner, 1996 (pl. 237)
Canvas, wood, thread, and nails
14 x 5 1/8 x 3 in. (35.6 x 13 x 7.6 cm)
Collection of the artist; courtesy Sperone
Westwater, New York

How It Goes Around the Corner, 1996 (pl. 238)
Canvas, wood, thread, and nails
14 x 7 3/8 x 3 in. (35.6 x 18.7 x 7.6 cm)
Collection of the artist; courtesy Sperone
Westwater, New York

How It Goes Around the Corner, 1996 (pl. 239)
Canvas, wood, thread, and nails
14 x 7 3/8 x 3 in. (35.6 x 18.7 x 7.6 cm)
Collection of the artist; courtesy Sperone
Westwater, New York

Richard Tuttle: Grey Walls Work, 1996 (pl. 360)
Lithography on paper; open edition
8 5/8 x 8 5/8 x 1/4 in. (21.9 x 21.9 x 0.6 cm)
Published by Camden Arts Centre, London
Exhibition copy collection of the artist; courtesy
Sperone Westwater, New York

Waferboard 1, 1996 (pl. 324)
Acrylic on waferboard
33 x 19 x 1/4 in. (83.8 x 48.3 x 0.6 cm)
Private collection, New York

Waferboard 3, 1996 (pl. 325)
Acrylic on waferboard
20 1/4 x 26 x 1/4 in. (51.4 x 66 x 0.6 cm)
Collection of Marion Boulton Stroud, Philadelphia

Waferboard 4, 1996 (pls. 322, 393)
Acrylic on waferboard
29 1/2 x 18 x 1/4 in. (74.9 x 45.7 x 0.6 cm)
Collection of Henry S. McNeil, Philadelphia

Waferboard 8, 1996 (pl. 323)
Acrylic on waferboard
36 1/2 x 22 x 1/4 in. (92.7 x 55.9 x 0.6 cm)
Collection of Rainer and Susanna Peikert,
Zug, Switzerland

**I Thought I Was Going on a Trip But I Was Only
Going Down Stairs,** 1997
Lithography on paper; ed. of 500
8 1/4 x 6 1/4 x 1/8 in. (21 x 15.9 x 0.3 cm)
Published by Art Gallery of York University,
North York, Ontario
Exhibition copy collection of the artist; courtesy
Sperone Westwater, New York

Richard Tuttle: Books and Prints, 1997
Lithography on paper; open edition
11 x 8 x 1/8 in. (27.9 x 20.3 x 0.3 cm)
Published by the New York Public Library
Exhibition copy collection of the artist; courtesy
Sperone Westwater, New York

Mandevilla, 1998 (pls. 332–38)
Color aquatints on paper; ed. of 40
Seven parts, dimensions vary
Published by Crown Point Press, San Francisco
Exhibition copy courtesy Crown Point Press,
San Francisco

New Mexico, New York, #10, 1998 (pl. 326)
Acrylic on plywood
22 3/4 x 10 1/2 x 1/2 in. (57.8 x 26.7 x 1.3 cm)
Collection of Anne and Joel Ehrenkranz,
New York

New Mexico, New York, #14, 1998 (pl. 327)
Acrylic on plywood
16 1/2 x 23 1/4 x 1/2 in. (41.9 x 59.1 x 1.3 cm)
Collection of Susan Harris and Glenn Gissler,
New York

New Mexico, New York, #24, 1998 (pl. 329)
Acrylic on plywood
21 x 25 x 1/2 in. (53.3 x 63.5 x 1.3 cm)
Collection of Helen Marden, New York

New Mexico, New York, B, #13, 1998 (pl. 328)
Acrylic on plywood
23 x 25 1/4 x 1/2 in. (58.4 x 64.1 x 1.3 cm)
Collection of Donald L. Bryant, Jr., Saint Louis

New Mexico, New York, E, #1, 1998 (pl. 330)
Acrylic on plywood
23 1/2 x 24 3/4 x 1/2 in. (59.7 x 62.9 x 1.3 cm)
Collection of Kohlberg Kravis Roberts & Company

New Mexico, New York, E, #3, 1998 (pl. 331)
Acrylic on plywood
21 x 21 x 1/2 in. (53.3 x 53.3 x 1.3 cm)
Hort Family Collection

Reading Red, 1998
Lithography on paper; ed. of 800
8 x 8 x 3/8 in. (20.3 x 20.3 x 1 cm)
Published by Verlag der Buchhandlung Walther
König, Cologne
Exhibition copy collection of the artist; courtesy
Sperone Westwater, New York

One Voice in Four Parts, 1999
Color photocopy on vellum and letterpress ink
on paper; ed. of 250
11 7/8 x 8 5/8 x 1/4 in. (30.2 x 21.9 x 0.6 cm)
Published by Printed Matter Inc., New York
Exhibition copy collection of the artist; courtesy
Sperone Westwater, New York

Replace the Abstract Picture Plane IV, 1999
(pls. 339–40)
Acrylic on wood in wood frames
Forty parts, each: 16 x 16 x 2 in. (40.6 x 40.6 x 5.1 cm)
Twenty parts collection of the artist, courtesy
Sperone Westwater, New York; twenty parts
collection of Kunsthaus Zug, Switzerland

Richard Tuttle: Community, 1999 (pl. 361)
Lithography on paper, green stickers,
and gold cord with handmade paper cover;
open edition
Approximately 8 5/8 x 6 3/8 x 3/8 in.
(21.9 x 16.2 x 1 cm)
Published by the Arts Club of Chicago
Exhibition copy collection of the artist; courtesy
Sperone Westwater, New York

"Two with Any To, #1," 1999 (pl. 341)
Acrylic on plywood
11 x 11 x 1 3/4 in. (27.9 x 27.9 x 4.4 cm)
Collection of Douglas S. Cramer

"Two with Any To, #8," 1999 (pl. 342)
Acrylic on plywood
11 x 11 x 1 3/4 in. (27.9 x 27.9 x 4.4 cm)
Courtesy John Berggruen Gallery, San Francisco

"Two with Any To, #9," 1999 (pl. 343)
Acrylic on plywood
11 x 11 x 1 3/4 in. (27.9 x 27.9 x 4.4 cm)
Courtesy Sperone Westwater, New York

"Two with Any To, #16," 1999 (pl. 346)
Acrylic on plywood
11 x 11 x 1 3/4 in. (27.9 x 27.9 x 4.4 cm)
Collection of Angela Westwater and David Meitus,
New York

"Two with Any To, #19," 1999 (pl. 345)
Acrylic on plywood
11 x 11 x 1 3/4 in. (27.9 x 27.9 x 4.4 cm)
Collection of Elisabeth Cunnick and Peter Freeman,
New York

"Two with Any To, #20," 1999 (pl. 344)
Acrylic on plywood
11 x 11 x 1 3/4 in. (27.9 x 27.9 x 4.4 cm)
Collection of Alvin Hall, New York

Open Carefully, 2000
Plastic, stones, ink, and paper; open edition
Approximately 5 1/2 x 9 1/4 x 1 1/4 in.
(14 x 23.5 x 3.2 cm)
Published by Sperone Westwater, New York
Exhibition copy courtesy Sperone Westwater,
New York

Perceived Obstacles, 2000 (pl. 364)
Lithography on paper; open edition
12 x 36 x 5/8 in. (30.5 x 91.4 x 1.6 cm)
Published by Verlag der Buchhandlung Walther
König, Cologne
Exhibition copy collection of the artist; courtesy
Sperone Westwater, New York

Richard Tuttle: Reservations, 2000
Lithography on paper; open edition
8 5/8 x 12 x 1/4 in. (21.9 x 30.5 x 0.6 cm)
Published by BAWAG Foundation, Vienna
Exhibition copy collection of the artist; courtesy
Sperone Westwater, New York

Ten, A, 2000 (pl. 347)
Wood, cardboard, museum board, foam board,
tissue paper, paper, sandpaper, sheet metal,
Styrofoam, fabric, tape, nails, wire, rope, leather,
thread, acrylic, gouache, and graphite
Ten parts, overall: 40 x 40 x 4 1/2 in.
(101.6 x 101.6 x 11.4 cm)
San Francisco Museum of Modern Art,
Accessions Committee Fund purchase

Ten, D, 2000 (pl. 348)
Acrylic on plywood
Ten parts, overall: 40 x 40 x 1/4 in.
(101.6 x 101.6 x 0.6 cm)
Collection of Craig Robins, Miami, Florida

White Sails, 2001
Lithography on paper in cloth-covered box;
ed. of 250
3 x 3 x 5/8 in. (7.6 x 7.6 x 1.6 cm)
Published by Annemarie Verna Galerie, Zurich
Exhibition copy collection of the artist; courtesy
Sperone Westwater, New York

Memento, Five, Grey and Yellow, 2002 (pl. 354)
Wood, fabric, corrugated cardboard, latex paint,
and monofilament
Twenty-seven parts: one 16 x 24 x 193 in.
(40.6 x 61 x 490.2 cm), one 20 x 39 x 79 in.
(50.8 x 99.1 x 200.7 cm), and twenty-five 8 x 5 x 2 in.
(20.3 x 12.7 x 5.1 cm)
Courtesy Sperone Westwater, New York

Nest, 2003
Lithography on paper; open edition
8 1/2 x 6 1/4 x 1/4 in. (21.6 x 15.9 x 0.6 cm)
Published by Kelsey Street Press, Berkeley
Exhibition copy collection of the artist;
courtesy Sperone Westwater, New York

"20 Pearls (5)," 2003 (pl. 353)
Acrylic on museum board and foam board
13 5/8 x 14 5/8 x 3/4 in. (34.6 x 37.1 x 1.9 cm)
Collection of Francesco Clemente, New York

"20 Pearls (7)," 2003 (pl. 351)
Acrylic on museum board and foam board
16 x 18 5/8 x 3/4 in. (40.6 x 47.3 x 1.9 cm)
The Museum of Contemporary Art, Los Angeles,
purchased with funds provided by the Friends
of Joel Wachs

"20 Pearls (8)," 2003 (pl. 352)
Acrylic on museum board and foam board
19 3/4 x 16 1/4 x 3/4 in. (50.2 x 41.3 x 1.9 cm)
Collection of Byron R. Meyer, San Francisco

"20 Pearls (12)," 2003 (pl. 349)
Acrylic on museum board and foam board
18 5/8 x 19 x 3/4 in. (47.3 x 48.3 x 1.9 cm)
Hort Family Collection

"20 Pearls (14)," 2003 (pl. 350)
Acrylic on museum board and foam board
20 x 11 1/4 x 3/4 in. (50.8 x 28.6 x 1.9 cm)
Collection of Craig Robins, Miami, Florida

Color as Language, 2004
Lithography on paper, handmade paper,
and string; ed. of 100
9 1/4 x 6 1/8 x 1/4 in. (23.5 x 15.6 x 0.6 cm)
Published by the Drawing Center, New York
Exhibition copy courtesy San Francisco Museum
of Modern Art Research Library

Indonesian Textiles, 2004
Lithography on paper with fiber dust jacket;
open edition
8 1/4 x 7 1/4 x 5/8 in. (21 x 18.4 x 1.6 cm)
Published by Tai Gallery / Textile Arts, Santa Fe
Exhibition copy collection of the artist; courtesy
Sperone Westwater, New York

L'EXCÈS: cette mesure, 2004
Silkscreening on paper with parchment
binding, leather, and gold stamping
in velvet-covered box; ed. of 108
13 1/2 x 10 x 1 3/8 in. (34.3 x 25.4 x 3.5 cm)
Published by Yvon Lambert, Paris
Exhibition copy courtesy Yvon Lambert, Paris

RICHARD TUTTLE

Born Rahway, New Jersey, 1941
BA, Trinity College, Hartford, 1963
Also enrolled in classes at Pratt Institute,
New York, summer 1962; Cooper Union,
New York, fall 1963

FELLOWSHIPS AND AWARDS

C. Douglas Dillon Foundation, New York, 1965
National Endowment for the Arts, Washington,
D.C., 1968
Biennial Prize, 74th American Exhibition,
Art Institute of Chicago, 1982
Skowhegan Medal for Sculpture, 1998
Aachen Art Prize, Ludwig Forum für Internationale
Kunst, Germany, 1998

EXHIBITION HISTORY

Compiled by Lori Cavagnaro

*No title is listed for exhibitions simply called
Richard Tuttle. Entries cite catalogues, booklets, and
selected reviews whenever possible. For additional
books and periodicals, please consult the bibliography
on pages 376–79.*

*Thanks are due to Christine Jenny, Karen Levine,
Joseph N. Newland, and Lindsey Westbrook for their
assistance in gathering and verifying information.*

SELECTED SOLO EXHIBITIONS

1965

Richard Tuttle: Constructed Paintings, Betty Parsons
Gallery, New York, September 7–25. Booklet by
Gordon B. Washburn.
> Campbell, Lawrence. Review. *ARTnews* 64
> (September 1965): 11.
> Hoene, Anne. Review. *Arts Magazine* 40
> (November 1965): 65–66.
> Lippard, Lucy R. "New York Letter."
> *Art International* 9 (November 1965): 41.
> Preston, Stuart. "For the Future." *New York
> Times*, 12 September 1965.
> Review. *New York Herald Tribune*, 11 September
> 1965.
> Review. *Time*, 24 September 1965.
> Rosenblum, Constance S. Review. *Chelsea-
> Clinton News*, 23 September 1965.

1967

Betty Parsons Gallery, New York, February 15–
March 4.
> Glueck, Grace. Review. *New York Times*,
> 25 February 1967.
> Mellow, James R. Review. *Art International* 11
> (April 1967): 61.
> Tabachnick, Anne. Review. *ARTnews* 66
> (April 1967): 9–10.

1968

Ten New Works by Richard Tuttle, Betty Parsons
Gallery, New York, January 3–20.
> Burton, Scott. Review. *ARTnews* 66
> (January 1968): 56.

Canaday, John. Review. *New York Times*,
6 January 1968.
> Perreault, John. "Simple, Not Simple-Minded."
> *Village Voice*, 18 January 1968, 16–17.
> Wasserman, Emily. Review. *Artforum* 6
> (March 1968): 56–57.

Galerie Schmela, Düsseldorf, March 26–April 17.
> Lanser, Günter. "Kunst in Minimum-Form:
> Zur ersten Ausstellung von Richard Tuttle
> in Deutschland." *Aachener Nachrichten*,
> 3 April 1968.
> "Stoff voller Poesie: Schmela stellt jungen
> Amerikaner Tuttle vor." *Düsseldorfer
> Nachrichten*, 17 April 1968.

1969

Nicholas Wilder Gallery, Los Angeles, opened
May 10.
> Garver, Thomas H. Review. *Artforum* 8
> (September 1969): 67.

1970

New Work by Richard Tuttle, Betty Parsons Gallery,
New York, February 17–March 7.
> Last, Martin. Review. *ARTnews* 69 (April 1970):
> 75–76.
> Perreault, John. Review. *Village Voice*,
> 26 February 1970, 19.
> Ratcliff, Carter. "New York Letter." *Art
> International* 14 (May 1970): 76.

Neue Arbeiten von Richard Tuttle, Galerie Rudolf
Zwirner, Cologne, June 4–30.

Member's Gallery of the Albright-Knox Art Gallery,
Buffalo, October 15–November 29.

1971

Dallas Museum of Fine Arts, February 10–March 28.
Catalogue by Robert M. Murdock.
> Murdock, Robert. "Richard Tuttle." *Art
> International* 15 (May 1971): 59.
> Kutner, Janet. Review. *Art Gallery*, 1 February
> 1971, 22.
> ———. "Tuttle Offers Innovative Work." *Dallas
> Morning News*, 14 February 1971.

Helman Gallery, Saint Louis, opened March 6.
> King, Mary. "Silhouettes in Canvas in Richard
> Tuttle Show." *Saint Louis Post-Dispatch*,
> 10 March 1971.

1972

Richard Tuttle will show new work, Betty Parsons
Gallery, New York, February 1–26.
> Borden, Lizzie. Review. *Artforum* 10
> (May 1972): 84.
> Campbell, Lawrence. Review. *ARTnews* 71
> (March 1972): 56.
> Josephson, Mary. "Richard Tuttle at Betty
> Parsons." *Art in America* 60 (May–June
> 1972): 31–33.
> Mellow, James R. Review. *New York Times*,
> 13 February 1972.
> Perreault, John. "A Healthy Pluralism."
> *Village Voice*, 17 February 1972, 21–22.
> Smith, Alvin. "New York Letter." *Art
> International* 16 (April 1972): 59.

Projects: Richard Tuttle and David Novros, Museum
of Modern Art, New York, June 12–July 17.
> Borden, Lizzie. Review. *Artforum* 11 (October
> 1972): 88.
> Schjeldahl, Peter. "Two 'Projects' That Project."
> *New York Times*, 25 June 1972.

Richard Tuttle: Drahtstucke 1971–1972, Galerie
Rudolf Zwirner, Cologne, June 15–July 30.
> Catoir, Barbara. Review. *Das Kunstwerk* 25
> (September 1972): 42–43.
> Kerber, Bernhard. "Documenta and Szene
> Rhein-Ruhr." *Art International* 16 (October
> 1972): 68–77.

New Work by Richard Tuttle, Galerie Yvon Lambert,
Paris, June 20–July 20.
> Pluchart, Françoise. Review. *Artitudes*, no. 8–9
> (August–September 1972): 20.

1973

Clocktower Gallery, Institute for Art and Urban
Resources, New York, May 3–27.
> Crimp, Douglas. Review. *ARTnews* 72
> (Summer 1973): 100–101.
> Mayer, Rosemary. Review. *Arts Magazine* 48
> (November 1973): 60–61.

*Richard Tuttle: Das 11. Papierachteck und
Wandmalereien / Richard Tuttle: The 11th Paper
Octagonal and Paintings for the Wall*, Kunstraum
München, Munich, May 22–August 19.
Catalogue by Hermann Kern.
> Morschel, Jürgen. Review. *Das Kunstwerk* 26
> (September 1973): 75–76.

375 Richard Tuttle applying starch paste
to a **Paper Octagonal** in preparation
for the 1977 exhibition **Richard Tuttle**
at Hopkins Hall Gallery, Ohio State
University, Columbus

Galerie Heiner Friedrich, Munich, May 22–August 19.

Ten Kinds of Memory and Memory Itself, Daniel Weinberg Gallery, San Francisco, opened June 6.
Dunham, Judith L. Review. *Artweek,* 23 June 1973, 1, 16.

Drawings: Richard Tuttle, Galleria Françoise Lambert, Milan, June 14–July 15.

1974
New Work: Richard Tuttle, Betty Parsons Gallery, New York, March 12–30.
Foote, Nancy. "Bill Bollinger at O.K. Harris, Richard Tuttle at Betty Parsons." *Art in America* 62 (May–June 1974): 102–3.
Heinemann, Susan. Review. *Artforum* 12 (June 1974): 75–76.
Herrera, Hayden. Review. *ARTnews* 73 (Summer 1974): 114.
Lubell, Ellen. Review. *Arts Magazine* 48 (May 1974): 58.
Mellow, James R. Review. *New York Times,* 23 March 1974.
Schwartz, Barbara. Review. *Craft Horizons* 34 (August 1974): 38.

New Works: Richard Tuttle, Galleria Toselli, Milan, April.

Galleria Marilena Bonomo, Bari, Italy, April 19–May 19.

Annemarie Verna Galerie, Zurich, May 17–June 28.

Galerie Yvon Lambert, Paris, July 4–September 9.

Artpark, Lewiston State Park, Lewiston, New York, July 22–August 4.

A group of very small colored metal plates set at various distances from the wall in the different rooms of the gallery from November 6, 1974, Barbara Cusack Gallery, Houston, opened November 6.

Forty October Drawings + Interlude, Nigel Greenwood, London, opened December 10.
Crichton, Fenella. Review. *Art Spectrum* 1 (March 1975): 29.
Newall, Christopher. Review. *Arts Review* 27 (7 February 1975): 71–72.

1975
D'Alessandro-Ferranti, Rome, February 8–March 10.

Thirteen Spiral Drawings by Richard Tuttle, Parsons-Truman Gallery, New York, April 22–May 20.
Frank, Peter. Review. *ARTnews* 74 (September 1975): 113.

Matrix 10: Richard Tuttle, Wadsworth Atheneum, Hartford, July–August. Booklet by Andrea Miller-Keller.

Whitney Museum of American Art, New York, September 12–November 16. Traveled to Otis Art Institute Gallery of Los Angeles County, Los Angeles. Catalogue by Marcia Tucker.
Alloway, Lawrence. "Art." *The Nation,* 11 October 1975.
Ballatore, Sandy. "Tuttle and Serra: Antithetical Systems." *Artweek,* 21 February 1976, 1, 16.
Battcock, Gregory. "More or Less? The People Speak." *Soho Weekly News,* 23 October 1975, 23.
———. "High Art at Braniff." *Soho Weekly News,* 6 November 1975, 22.
Baur, John I. H. "Bourdoned." *Village Voice,* 13 October 1975, 4.
Bourdon, David. "Playing Hide and Seek in the Whitney." *Village Voice,* 29 September 1975, 97.
Frank, Peter. Review. *ARTnews* 75 (January 1976): 126–27.
———. Review. *Museumjournaal* 21 (April 1976): 80–81.
Hess, Thomas B. "Private Art Where the Public Works." *New York,* 13 October 1975, 83–84.
Kramer, Hilton. "Tuttle's Art on Display at Whitney." *New York Times,* 12 September 1975.
North, Charles. "Richard Tuttle: Small Pleasures." *Art in America* 63 (November–December 1975): 68–69.
Perreault, John. "Tuttle's Subtle Output." *Soho Weekly News,* 18 September 1975, 22.
Ratcliff, Carter. "New York Letter." *Art International* 19 (November 1975): 65–66.
Schwartz, Barbara. Review. *Craft Horizons* 35 (December 1975): 16.
Sheffield, Margaret. Review. *Studio International* 190 (November–December 1975): 235.

Smith, Roberta. Review. *Artforum* 14 (January 1976): 60–61.
Wilson, William. "Adrift in the Wide Open Spaces [review of Los Angeles exhibition]." *Los Angeles Times,* 9 February 1976.

Richard Tuttle "Paper-Strips," Barbara Cusack Gallery, Houston, opened September 29.
Crossley, Mimi. Review. *Houston Post,* 9 October 1975.

1976
Richard Tuttle: Books and Prints 1964–1976, Brooke Alexander, New York, March 13–April 19.

Richard Tuttle: 2 Days, Galerie Yvon Lambert, Paris, April 2–3.

Northwest Artists Workshop, Portland, Oregon, April 6–May 1.

Richard Tuttle: The Cincinnati Pieces, Julian Pretto, New York, opened September 18.

Graeme Murray Gallery, Edinburgh, October 6–November 6.

McIntosh Gallery, University of Western Ontario, London, Ontario, November 24, 1976–January 9, 1977. Booklet by R. W. McKaskell.

1977
Hopkins Hall Gallery, Ohio State University, Columbus, January 4–February 13.

Undici carte di Richard Tuttle, Galleria Marilena Bonomo, Bari, Italy, February 24–April 9.

Galleria Ugo Ferranti, Rome, opened April 5.

Richard Tuttle, New York, Zeichnungen und Aquarelle 1968–1976. 140 Werke, Kunsthalle Basel, Switzerland, June 11–September 11. Catalogue by Maria Netter titled *Richard Tuttle, New York, 100 Zeichnungen und Aquarelle 1968–1976.*
Christ, Dorothea. "Fliegen und Zeichen und Bauen." *Radio der Deutschen Schweiz,* 24 June 1977.
"Lautlose Sprache der Zeichen." *Der Bund,* 7 July 1977.
Monteil, Annemarie. "Panamarenko und Tuttle in Basler Kunsthalle." *Vaterland* (Lucerne), 16 June 1977.
———. Review. *Der Landbote Winterthur,* 15 June 1977.

Richard Tuttle: Die Gesamte Druckgraphik und alle Bücher, Galerie Heiner Friedrich, Munich, October–November.
Glozer, Laszlo. "Grenzgebiete der Sensibilität: Zeitgenössische Kunst in Münchner Galerien [Kunstraum München and Galerie Heiner Friedrich exhibitions]." *Süddeutsche Zeitung,* 26–27 November 1977.

Richard Tuttle: Zwei mit Zwei / Two with Any Two, Kunstraum München, Munich, October 10–December 12.

Richard Tuttle: Maine Works, Two with Any Two, Nigel Greenwood, London, December 1–24.

Richard Tuttle: Gesamte Grafiken, Illustrierte Bücher, Galerie Thomas Borgmann, Cologne, December 1977–February 1978.

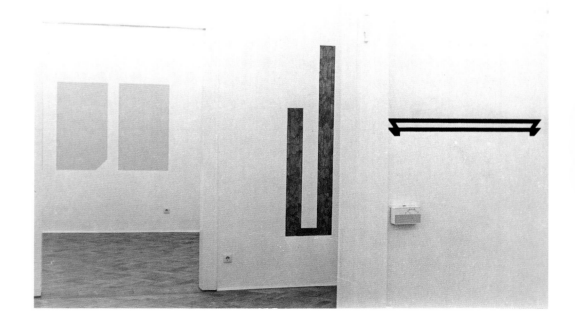

376 Installation view of the 1973 exhibition **Richard Tuttle: Das 11. Papierachteck und Wandmalereien / Richard Tuttle: The 11th Paper Octagonal and Paintings for the Wall** at Kunstraum München, Munich, showing (from left to right) **9th Painting for the Wall, 3rd Painting for the Wall,** and **2nd Painting for the Wall** (all 1970)

1978

Richard Tuttle: New Works at Betty Parsons Gallery,
Betty Parsons Gallery, New York, January 24–
February 11.
 Frackman, Noel. Review. *Arts Magazine* 52
 (April 1978): 31.
 Greenspan, Stuart. Review. *Artforum* 16
 (April 1978): 66–67.
 Russell, John. Review. *New York Times,*
 10 February 1978.
 Wooster, Ann-Sargent. Review. *ARTnews* 77
 (April 1978): 156.

Richard Tuttle: New Work, Young Hoffman Gallery,
Chicago, February 10–March 11.
 Leaderman, Pamela. Review. *New Art Examiner*
 5 (March 1978): 15.
 Schulze, Franz. "Tut-tutting Richard Tuttle."
 Chicago Daily News, 25–26 February 1978.

David Winton Bell Gallery, Brown University,
Providence, April 29–May 21. Booklet
by Nancy Versaci.
 Sozanski, Edward J. "Richard Tuttle Pushes
 Perception Past All Boundaries." *Providence
 Journal,* 5 May 1978.

Sticks, Galleria Françoise Lambert, Milan,
May 18–June 30.

Museum Van Hedendaagse Kunst, Ghent, Belgium,
June 3–July 3. Catalogue by Jan Hoet titled
*Raoul de Keyser, David Rabinowitch, Richard Tuttle,
Philippe van Snick: 4 individuele tentoonstellingen.*

Daniel Weinberg Gallery, San Francisco,
June 3–July 8.
 Dunham, Judith. "Richard Tuttle: Discerning
 Details." *Artweek,* 1 July 1978, 1, 20.

Galerie Yvon Lambert, Paris, September 9–
October 6. Artist's book *Five by Seven for Yvon
Lambert. A Study of 45°, Color, 5" x 7" Rectangle
and Corrugated Cardboard. Nine Works by Richard
Tuttle* published in conjuction with exhibition.
 Blistène, Bernard. Review. *Flash Art* 84–85
 (October–November 1978): 18.
 Hahn, Otto. Review. *L'express,* 25 September 1978.
 Lecombre, Sylvain. Review. *Art Press* 23
 (December 1978): 18.

Richard Tuttle, Drawings, Jean Marie Antone Gallery,
Annapolis, Maryland, September 10–October 7.

Richard Tuttle: Zeichnungen, Galerie Schmela,
Düsseldorf, October 7–November 9.

Galleria Ugo Ferranti, Rome, opened November 18.
 Lambarelli, Roberto G. Review. *Flash Art* 86–87
 (January–February 1979): 10.

1979

*Richard Tuttle: Title 1–6, Title I–VI, Title A–N,
Title 11–16, Titre 1–8, Titolo 1–8,* Stedelijk Museum
Amsterdam, January 18–March 4. Artist's
book/catalogue.
 Beek, Willem van. "Richard Tuttle: Relatie me
 de Ruimte." *Kunstbeeld* 3 (November 1979):
 28–30.

Zutter, Jörg. Review. *Flash Art* 88–89 (March–
 April 1979): 11–12.

Annemarie Verna Galerie, Zurich, January
26–March 6.
 Monteil, Annemarie. "Für Liebhaber des
 Leisen." *Die Weltwoche,* 31 January 1979, 26.
 Netter, Maria. "Zarte Objekte mit hohem
 Anspuch." *Schweizerische Finanzzeitung,*
 21 February 1979.

48 1/2" center-point works, Brooke Alexander,
New York, February 10–March 10.
 Whelan, Richard. Review [Brooke Alexander
 and Truman Gallery exhibitions]. *ARTnews*
 78 (Summer 1979): 186–87.

*Presentation of the Book: List of Drawing Material
of Richard Tuttle and Appendices,* G. & A. Verna,
R. Krauthammer, A. Gutzwiller, Zurich, February 10–
March 10. Catalogue titled *List of Drawing Material
of Richard Tuttle & Appendices* by Gianfranco Verna.
 Curiger, Bice. "Minimalität der Zeichnungen
 und Zeichen [catalogue review]." *Tages
 Anzeiger,* 8 September 1979.

Yale Pieces, 6" x 4" Notebook, Truman Gallery,
New York, February 10–March 10.

An Exhibition of the Work of Richard Tuttle,
College of Creative Studies, University of California,
Santa Barbara, February 14–March 11.
 Ames, Richard. "Sculpture Show Found
 Puzzling." *Santa Barbara News-Press,*
 17 February 1979.

Galleria Marilena Bonomo, Spoleto, Italy, July 1–30.

Centre d'arts plastiques contemporains, Bordeaux,
France, November 22–December 29. Catalogue.

Richard Tuttle: Dallas Exercises, Galleria Ugo Ferranti,
Rome, December 14, 1979–January 14, 1980.

1980

Richard Tuttle: Pairs, 1973, Centre d'art
contemporain, Geneva, January 24–February 23.
 Mayou, Roger Marcel, "Richard Tuttle:
 Le dessin essentiel." *Le Courrier,*
 2 February 1980.

*Richard Tuttle: 12 Drahtoktogonale, 1971, und 25
Wasserfarbenblätter, 1980,* Museum Haus Lange,
Krefeld, Germany, January 27–March 9. Catalogue
by Marianne Stockebrand.
 Catoir, Barbara. "An der Schwundstufe des
 Sichtbaren." *Frankfurter Allgemeine Zeitung,*
 8 March 1980.
 Frese, Hans Martin. "Richard Tuttle in Krefeld:
 Das Achteck—ein Gag?" *Rheinische Post,*
 6 March 1980.
 Johnen, Jörg. Review. *Das Kunstwerk* 33, no. 3
 (1980): 84.
 Pohlen, Annelie. Review. *Flash Art* 96–97
 (March–April 1980): 55.
 Stauch-v. Quitzow, Wolfgang. "Acht Nägel
 und ein Draht." *Mannheimer Morgen,*
 21 February 1980.

Richard Tuttle: From 210 Collage-Drawings, Georgia
State University Art Gallery, Atlanta, February 4–22.
Traveled to Baxter Art Gallery, California Institute
of Technology, Pasadena. Catalogue by Susan C.
Larsen.
 Armstrong, Richard. Review. *Artforum* 18
 (April 1980): 85.
 Muchnic, Suzanne. "Unassuming Expressions
 [review of Pasadena exhibition]."
 Los Angeles Times, 17 February 1980.
 Wortz, Melinda. Review. *ARTnews* 79
 (May 1980): 141.

1981

Galerie Yvon Lambert, Paris, April 4–May 7.
 Dagbert, Anne. Review. *Art Press* 49 (June
 1981): 40.

Galleria Ugo Ferranti, Rome, opened April 23.
 Menna, Filiberto. "Come se costruisse giochi
 infantili: A Roma, un felice allestimento
 della opere più recenti di Richard Tuttle."
 Pese Sera, 17 May 1981.

Galerie Baronian-Lambert, Ghent, Belgium,
opened October 6.

Annemarie Verna Galerie, Zurich, December 5,
1981–February 3, 1982.
 Gassert, Siegmar. Review. *Basler Zeitung,*
 27 January 1982.
 Vachtova, Ludmilla. Review. *Neue Züricher
 Zeitung,* 21 December 1981.

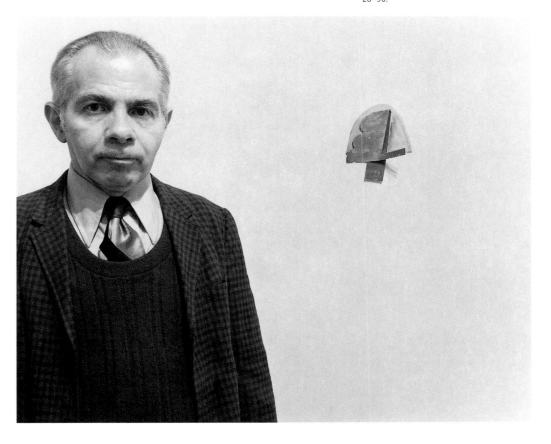

377 Herbert Vogel standing next to **Title C**
(1978) at the 1978 exhibition **Richard
Tuttle**, David Winton Bell Gallery,
Brown University, Providence

1982

Nigel Greenwood Gallery, London, March 12–April 8.
> Ayers, Robert. Review. *Artscribe* 35 (June 1982): 60.
> Collier, Caroline. Review. *Flash Art* 107 (May 1982): 53.

Galleria Ugo Ferranti, Rome, opened May 28.

New Work: Richard Tuttle, Betty Parsons Gallery, New York, October 9–27.
> Lubell, Ellen. Review. *Art in America* 71 (March 1983): 161.
> Schoenfeld, Ann. Review. *Arts Magazine* 57 (January 1983): 42.

Richard Tuttle: Pairs, Musée de Calais, France, December 10, 1982–February 10, 1983. Catalogue.

1983

Taidemariliiton Galleria, Helsinki, March 4–20.

Galleria Ugo Ferranti, Rome, opened May 19.

Richard Tuttle: Recent Sculpture, Blum Helman Gallery, New York, October 12–November 5.
> Brenson, Michael. Review. *New York Times,* 21 October 1983.
> Moorman, Peggy. Review. *ARTnews* 83 (January 1984): 150–51.
> Smith, Roberta. Review. *Village Voice,* 8 November 1983, 79.
> Windshield, Walter. Review. *East Village Eye* 5 (November 1983): 39.

Galerie Hubert Winter, Vienna, November 12–December 3.
> Bohm, Ecke. "Portal: Wie ein Eingang." *Wolkenkratzer Art Journal* 1/84 (February–March 1984): 78.
> Köcher, Helga. Review. *Artefactum* 2 (February–March 1984): 67.
> ———. Review. *Kunstforum International* 71–72 (April–May 1984): 362–63.
> Review. *Falter* 24 (December 1983): 23.

Richard Tuttle, Zeichnungen 1968–1974, Städtisches Museum Abteiberg, Mönchengladbach, Germany, November 13, 1983–January 3, 1984.
> Clahsen, Marga. "Strahlende Farbkleckse und heiter beschwingte Linien: Das Museum Abteiberg stellt Richard Tuttles Zeichnungen aus." *Westdeutsche Zeitung,* 12 November 1983.

1984

Studio la Città, Verona, opened February 25.

Galerie Yvon Lambert, Paris, March 17–April 4.

Richard Tuttle: Wandobjekte, Galerie Schmela, Düsseldorf, March 20–April 28.

Richard Tuttle: 16 Works From India 1980, Galleriet, Lund, Sweden, May 5–31.

Galleria Ugo Ferranti, Rome, opened May 23.

Richard Tuttle: Recent Work, Daniel Weinberg Gallery, Los Angeles, September 8–October 6.
> Larsen, Susan C. Review. *Artforum* 23 (December 1984): 93–94.
> Muchnic, Suzanne. "La Cienega Area." *Los Angeles Times,* 14 September 1984.

Annemarie Verna Galerie, Zurich, October 27–December 1.
> Gassert, Siegmar. Review. *Basler Zeitung,* 15 November 1984.
> Hälsi, Richard. Review. *Neue Zürcher Zeitung,* 13 November 1984.

Richard Tuttle: Engineer, Portland Center for the Visual Arts, Oregon, November 2–December 9. Booklet by Sabrina Ullmann.

Richard Tuttle: New Sculpture, Blum Helman Gallery, New York, November 7–December 1.
> Campbell, Lawrence. Review. *Art in America* 72 (February 1984): 146–47.
> Evans-Clark, Philippe. Review. *Art Press* 88 (January 1985): 57.
> Smith, Roberta. "Weighing In." *Village Voice,* 27 November 1984, 113.

1985

Richard Tuttle: Vienna Works, Indonesian Works, Monkey's Recovery for a Darkened Room, Galerie Schmela, Düsseldorf, January 25–March 8.
> Meister, Helga. "Ein Ringen um das Innere in der äuß Erscheinung: Richard Tuttle aus New York stellt bei Schmela aus." *Westfälische Zeitung,* 31 January 1985.
> Neyster, Silvia. "Richard Tuttles Objekte in der Galerie Schmela: Dünne Drähte und Papier." *Rheinische Post,* 5 February 1985.
> Pohlen, Annelie. Review. *Kunstforum International* 79 (May–June 1985): 283–84.

Galleria Toselli, Milan, February–March.
> Grazioli, Elio. Review. *Flash Gallerie* 3 (March 1985): 43–44.

Neve/Snow, Galleria Marilena Bonomo, Bari, Italy, February 14–March 31. Artist's book/catalogue.

Städtisches Museum Abteiberg, Mönchengladbach, Germany, September 22–November 24. Artist's book/catalogue.
> Adolphs, Volker. Review. *Das Kunstwerk* 38 (December 1985): 77.
> Catoir, Barbara. "Richard Tuttle, eine Austellung in Mönchengladbach: Raumen, Zeiche, Materilien." *Frankfurter Allgemeine Zeitung,* 15 November 1985.
> "Halb Bild halb Skulptur: Richard Tuttle stellt in Mönchengladbach aus." *Iserlohner Kreis-Anzweifler und Zeitung Iserlohn,* 4 October 1985.
> "Museum: Grosses Echo." *Westdeutsche Zeitung,* 24 September 1985.
> "Ein 'Poet' lehrt uns das Sehen: Richard Tuttle, Museum Abteiberg." *Stadt-Panorama,* 26 September 1985.
> Pohlen, Annelie. Review. *Artforum* 24 (February 1986): 115.
> Reinke, Klaus U. "Richard Tuttle, Austellung in Mönchengladbachs Museum: Ein amerikanischer Poet." *Handelsblatt,* 22 October 1985.
> "'Serra nannte mich einen amerikanischen Poeten': Richard Tuttle zeigt Werke aus 20 Jahren in Abteimuseum." *Rheinische Post,* 21 September 1985.
> Willems, Sophia. "Auf dem Weg Kunst zu werden." *Westdeutsche Zeitung,* 21 September 1985.

Galerie Yvon Lambert, Paris, October 11–November 8.
> Thomas, Mona. Review. *Figura* 7–8 (1986): 73.

Richard Tuttle: Works 1964–84, Institute of Contemporary Arts, London, October 30–December 8. Traveled to Fruitmarket Gallery, Edinburgh. Artist's book/catalogue titled *Richard Tuttle. △s: Works 1964–1985 / Two Pinwheels: Works 1964–1985.*

1986

Richard Tuttle: New Work, Victoria Miro Gallery, London, March 17–April 18.
> Cooke, Lynne. Review. *Artscribe International* 58 (June–July 1986): 73.

Richard Tuttle: The Spirals, Galerie Onnasch, Berlin, April 18–May 31.
> Wulffen, Thomas. Review. *Kunstforum* 85 (October 1986): 298–99.

Richard Tuttle: Wire Pieces, CAPC Musée d'art contemporain de Bordeaux, France, October 3–November 23. Catalogue. Artist's book *Richard Tuttle, la bonheur et la couleur* published in conjunction with exhibition.

Painted Sculpture, Blum Helman Gallery, New York, December 3, 1986–January 3, 1987.
> Smith, Roberta. Review. *New York Times,* 2 January 1987.

Richard Tuttle: I See in France, ARC Musée d'art moderne de la ville de Paris, December 12, 1986–February 8, 1987. Artist's book/catalogue.

1987

Richard Tuttle: New Work, Annemarie Verna Galerie, Zurich, March 18–May 2.
> Hollenstein, Roman. Review. *Neue Zürcher Zeitung,* 22 April 1987.

Richard Tuttle: The Baroque and Color / Das Barocke und die Farbe, Neue Galerie am Landesmuseum Joanneum, Graz, Austria, May 27–June 21. Artist's book/catalogue.
> Draxler, Helmut. Review. *Artforum* 31 (September 1987): 141–42.

Richard Tuttle: Nîmes au printemps, Galerie des Arènes, Nîmes, France, July 11–August 30. Artist's book/catalogue.

Galerie Yvon Lambert, Paris, September 26–October 24.
> Thomas, Mona. "Portrait: Richard Tuttle." *Beaux Arts Magazine* 50 (October 1987): 110–13.

Richard Tuttle: Early & Recent Works, Anders Tornberg Gallery, Lund, Sweden, October 3–28.

Richard Tuttle: New Work, Blum Helman Gallery, Los Angeles, December 10, 1987–January 30, 1988.

1988

Space in Finland: Richard Tuttle, Galerie Schmela, Düsseldorf, March 4–April 10. Artist's book/ catalogue.

Richard Tuttle: Portland Works, Galerie Karsten Greve, Cologne, March 18–April 23. Exhibition in conjunction with and traveled to Thomas Segal Gallery, Boston. Artist's book/catalogue.

Galerie Meert Rihoux, Brussels, May 11–June 4.
 Wilson, Andrew. Review. *Artscribe* 72 (November–December 1988): 91.

Richard Tuttle: XX Blocks, Galleria Marilena Bonomo, Bari, Italy, October 31–November 30. Artist's book/catalogue.
 D'Elia, Anna. "Esigui come recordi." *La Gazzetta del Mezzogiorno*, 9 November 1988.

There's No Reason a Good Man Is Hard to Find, Blum Helman Warehouse, New York, November 5– December 3.
 Kalina, Richard. Review. *Arts Magazine* 63 (February 1989): 80.
 Kuspit, Donald. Review. *Artforum* 27 (February 1989): 127.
 Princenthal, Nancy. Review. *Art in America* 77 (March 1989): 143.

5 Pieces Richard Tuttle 1987, Annemarie Verna Galerie, Zurich, November. Booklet.

1989

Richard Tuttle: The Point from the Corner of the Room, 1973–74, Galerie Hubert Winter, Vienna, May 13–June 3. Artist's book/catalogue.

Richard Tuttle: Vienna Gotico, Galleria Alessandra Bonomo, Rome, May 19–30. Artist's booklet.

Richard Tuttle: Lonesome Cowboy Styrofoam, Gallery Casa Sin Nombre, Santa Fe, June 10–30. Artist's book/catalogue.

1990

Richard Tuttle: Einleitung, Galerie Schmela, Düsseldorf, January 12–February 28. Artist's book/ catalogue.
 Friedrichs, Yvonne. "Fragile Wandobjekte." *Rheinische Post*, 1 February 1990.
 Willems, Sophia. "Das Leichte ist konpliziert: Neue Kunstgeschöpfe von Richard Tuttle in der Galerie Schmela." *Düsseldorfer Nachrichten*, 16 January 1990.
 Winter, Peter. "Pappteller und Poesie: Richard Tuttle in einer Düsseldorfer Galerieausstellung." *Frankfurter Allgemeine Zeitung*, 6 February 1990.
 ———. "Shape Is Not Abstract." *Art International* 11 (Summer 1990): 79.

Richard Tuttle: 70s Drawings, Brooke Alexander, New York, January 27–February 28.
 Grove, Nancy. Review. *Art and Antiques* 7 (May 1990): 151.

Galerie Yvon Lambert, Paris, March 17–April 10.
 Castro, X. Antón. Review. *Next* 68 (May 1990): 77.
 Zahm, Olivier. Review. *Art Press* 147 (May 1990): 96.

New Mexico Silver / Firenze Gold, Galleria Victoria Miro, Florence, May 16–June 12.

Richard Tuttle: In Memory of Writing, Sprengel Museum Hannover, Germany, June 6–August 19. Artist's book/catalogue titled *Richard Tuttle: Sprengel Museum Hannover*.
 Kipphoff, Petra. "Weniger ist Mehr." *Die Zeit*, 6 July 1990, 60.
 Kreibohm, Joachim. Review. *NIKE* 34 (July– September 1990): 42.
 Nobis, Beatrix. "Ein Narr am Hofe der Modern." *Süddeutsche Zeitung*, 31 July 1990.
 Schlagheck, Irma. "Hannover: Richard Tuttle, ein Asket entdeckt die Opulenz." *Art: Das Kunstmagazin* 6 (June 1990): 124–25.
 Schmidt, Eva. "Richard Tuttle: Objekte und Zeichnungen, Sprengel-Museum." *Kunstforum International* 109 (August– October 1990): 370–71.
 Zerull, Ludwig. "Kunst zum Suchen." *Hannoversche Allgemeine Zeitung*, 14 June 1990.

Richard Tuttle: New Mexico Silver / Firenze Gold, Galerie Hubert Winter, Vienna, September 10– October 13.

The Nature of the Gun: Richard Tuttle, A/D, New York, October.

Inside the Still Pure Form, Blum Helman Gallery, New York, November 20, 1990–January 12, 1991.
 Faust, Gretchen. Review. *Arts Magazine* 65 (March 1991): 103.
 Grove, Nancy. Review. *Art and Antiques* 8 (May 1991): 103.
 Levin, Kim. Review. *Village Voice*, 15 January 1991, 93.
 Schaffner, Ingrid. Review. *Artscribe* 87 (Summer 1991): 68.
 Smith, Roberta. Review. *New York Times*, 7 December 1990.

Richard Tuttle: Slats, 1974, Lawrence Markey Gallery, New York, December 1990–February 1991.

1991

Rhona Hoffman Gallery, Chicago, March 1–30.
 Artner, Alan G. "Tuttle Collages Speak Softly But Powerfully." *Chicago Tribune*, 15 March 1991.

Richard Tuttle: Crickets, Sala d'exposicions de la Fundació "la Caixa" Carrer de Montcada, Barcelona, March 22–May 12. Artist's book/catalogue.
 Fontrodona, Oscar. "Richard Tuttle: 'El arte es invisible; está en algún lugar entre la materia y el espíritu.'" *ABC Cataluña*, 26 March 1991.
 Review. *Diari de Lleida*, 20 March 1991.
 Review. *El Observador*, 23 March 1991.

Richard Tuttle: Sculptures et aquarelles, Galerie Pierre Hubert, Geneva, September 4–25.
 Ainardi, Dolène. Review. *Art Press* 163 (November 1991): 100.
 Chauvy, Laurence. "A l'image de la spirale." *Journal de Genève*, 10 September 1991.
 Nyffenegger, François. Review. *Tribune de Genève*, 7–8 September 1991.

Galeria Weber, Alexander, y Cobo, Madrid, September 16–November 17.
 Brea, José Luis. Review. *Artforum* 30 (December 1991): 111.
 Fernandez, Horacio. "Arte y Ensayo: Acuarelas de Richard Tuttle." *El Mundo*, 11–17 October 1991, 78.
 Review. "Richard Tuttle, en su pequeño mundo." *A B C*, 19 September 1991, 129.
 Serraller, F. Calvo. "La poética del orden." *El País*, 28 September 1991.

Institute of Contemporary Art, Amsterdam, September 7–October 20. Catalogue titled *Richard Tuttle* by Susan Harris and Dieter Schwarz. Traveled to Kunstmuseum Winterthur, Switzerland (titled *Time to Do Everything: Floor Drawings and Recent Work*); Instituto Valenciano de Arte Moderno, Valencia, Spain; Indianapolis Museum of Art. Artist's book *Charge to Exist* published in conjunction with Winterthur exhibition.
 Giger, Romeo. "Homo ludens americanus: Richard Tuttle im Kunstmuseum Winterthur." *Neue Zürcher Zeitung*, 9 April 1992.
 Hiltmann, Gabriela. "Richard Tuttle im Kunstmuseum Winterthur: Schritte über Grenzen." *Basler Zeitung*, 14 April 1992.

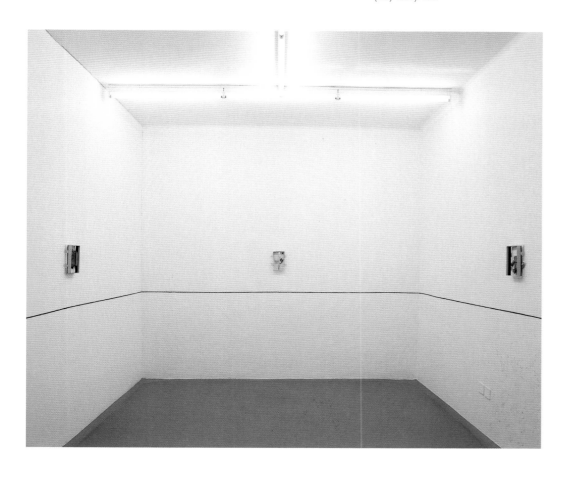

378 Installation view of the 1987 exhibition **Richard Tuttle: New Work** at Annemarie Verna Galerie, Zurich, showing **Drawing for Bern Sculpture** (1987) with drawn line on the wall

Jarque, Vicente. "Dibujo en el espacio [review of Valencia exhibition]." *El País*, 13 July 1992.

Krebs, Edith. "Spielerische Archaik: Zur Ausstellung des Amerikaners Richard Tuttle in Winterthur." *Tages-Anzeiger*, 15 April 1992.

———. "There's No Reason...Zu den Floor Drawings von Richard Tuttle." *Artis* 44 (March 1992): 44–48.

Lademann, Christoph. "Typische Galerien- und Kunsthallenkunst: Neuere Arbeiten von Richard Tuttle in Kunstmuseum Winterthur." *Zürcher Unterlaender Züruchbieter*, 1 April 1992.

Mack, Gerhard. "Energie in Formen bringen: Der amerikaner Richard Tuttle in Kunstmuseum Winterthur." *Schaffhauser Nachrichten*, 8 April 1992.

———. "Formen für Formloses: Richard Tuttles 'Floor Drawings' im Kunstmuseum Winterthur." *Suddeutshe Zeitung*, 27 April 1992.

Mebold, Adrian. "Fragiles, Preziöses und Kunst über Kunst." *Der Landbote*, 4 April 1992.

———. "Wenn die Zeichnungen poetische Konstruktionen werden." *Der Landbote*, 30 March 1992.

Review. *Der Bund*, 14 April 1992.

"Richard Tuttle im Kunstmuseum Winterthur: Fragile Skulpturen." *Elgger Zeitung*, 2 April 1992.

Roth, Jean-Jacques. "Le maîde l'anti-sems est à Winterthour." *Le Nouveau Quotidien*, 6 May 1992.

Von Däniken, Hans-Peter. "Zeichnungen in drei Dimensionen: Richard Tuttle im Kunstmuseum Winterthur." *Luzerner Neuste Nachrichten*, 2 April 1992.

Richard Tuttle & Oboes and Clarinets, Feuerle, Cologne, November 15–December 20.

New Works: Richard Tuttle, Victoria Miro Gallery, London, December 20, 1991–January 31, 1992.

1992

Studio la Cittá 2, Verona, Italy, January 19–March 10. Review. *Arena*, 10 February 1992.

Richard Tuttle: New Work, Annemarie Verna Galerie, Zurich, March 3–April 11.
Jolles, Claudia. Review. *Artforum* 30 (Summer 1992): 120–21.

Galerie Yvon Lambert, Paris, May 16–June 20.
"Agnes Martin, Richard Tuttle." *Le Gazette*, 12 June 1992.
Bouyeure, Claude. Review. *L'Oeil* 442 (June 1992): 76.

The Poetry of Form: Richard Tuttle, Drawings from the Vogel Collection, Instituto Valenciano de Arte Moderno, Valencia, Spain, June 25–August 30 (joint exhibition with *Richard Tuttle* at Institute of Contemporary Art, Amsterdam). Traveled to Indianapolis Museum of Art; Museum of Fine Arts, Santa Fe. Artist's book/catalogue by Carmen Alborch, Jack Cowart, Holliday T. Day, Susan Harris, Eduardo Lipschutz-Villa, and Bret Waller.
Andujar Chavarri, E. L. "Tuttle, en el IVAM: Un minimal en la corte del Rey Instalación." *Las Provincias*, 9 July 1992.
Fernandez-Cid, Miguel. "La más completa exposición de Richard Tuttle, en el IVAM valenciano." *Diario*, 15 August 1992.
"El IVAM inaugurará el Jueves la primera retrospectiva europeä de Richard Tuttle." *El País*, 23 June 1992.
Jarque, Vincente. "Dibujo en el espacio." *El País*, 13 July 1992.
LaGardera, Juan. "El IVAM reconstruye el camino creativo de Tuttle, del minimalismo al desenfreno." *La Vanguardia*, 17 July 1992.
Manheimer, Steve. "Tut, Tut-Tuttle's Star Is Rising, with 'Whole' Show at IMA." *Indianapolis Star*, 10 October 1993.
Stoddard, Leah. Review. *New Art Examiner* 21 (February 1994): 38–39.
Yague, Amparo. "En los límites de Richard Tuttle." *A B C de Las Artes*, 28 August 1992.

Mary Boone Gallery, New York, September 12–October 31.
Cotter, Holland. Review [Mary Boone and Lawrence Markey exhibitions]. *New York Times*, 30 October 1992.
Glueck, Grace. "In the Spirit of Gogol, a Gag on Soviet Clichés." *New York Observer*, 5 October 1992.

Liebmann, Lisa. Review. *Artforum* 31 (January 1993): 82.
Ross, Michael. Review. *Flash Art* 167 (November–December 1992): 97.

Richard Tuttle: Early Drawings, Lawrence Markey Gallery, New York, September 15–October 30.
Kalina, Richard. Review [Mary Boone and Lawrence Markey exhibitions]. *Art in America* 80 (November 1992): 131–32.
Welish, Marjorie. Review [Mary Boone and Lawrence Markey exhibitions]. *Tema Celeste* 39 (Winter 1993): 82–83.

Richard Tuttle: New Work, Laura Carpenter Fine Art, Santa Fe, October 3–November 7.
Van de Walle, Mark. Review. *THE Magazine: Santa Fe's Monthly Magazine of the Arts* 1 (November 1992): 34.

Oxyderood / Red Oxide, curated by Richard Tuttle, Museum Boymans-van Beuningen, Rotterdam, the Netherlands, November 8, 1992–January 17, 1993. Artist's book/catalogue.
"Red Oxyd: Richard Tuttle's Choice." *Kunst & Museumjournaal* 4 (1992): 70.
Steenbergen, Renée. "Richard Tuttle maakt van Boymans' collective expositie: Hooghartig of vrolijk aardewerk." *NRC Handelsblad*, 7 November 1992.

1993

Small...edition!, Wassermann Galerie, Munich, January 15–February 27. Artist's book *Painted Frames*, for Alma Ruempol published in conjunction with exhibition.

Richard Tuttle: Arbeiten auf Papier, Galerie Karsten Greve, Cologne, February 12–April 30.

Richard Tuttle: Chaos, die/the Form, Staatliche Kunsthalle Baden-Baden, Germany, February 20–April 25. Catalogue by Jochen Poetter.
Haesli, Richard. "An American Poet: Richard Tuttle in der Kunsthalle Baden-Baden." *Neue Zürcher Zeitung*, 15 March 1993.

Galleria Marilena Bonomo, Bari, Italy, June 5–July 30.
"L'americano Tuttle e spazio tra cose." *Puglia*, 5 June 1993.
D'Elia, Anna. "Richard Tuttle: l'occhio al fondo delle cassette." *La Gazzetta del Mezzogiorno*, 24 June 1993.

Crown Point Press, San Francisco, September 9–October 16.
Baker, Kenneth. "Tuttle Shows in Berkeley, S.F. [University Art Museum and Crown Point Press exhibitions]." *San Francisco Chronicle*, 23 September 1993.

Matrix: Richard Tuttle, Space/Sculpture, University Art Museum, University of California, Berkeley, October 13, 1993–January 2, 1994. Booklet by Lawrence Rinder. Artist's book *Folded Space* published in conjunction with exhibition.
Baker, Kenneth. "Richard Tuttle at University Art Museum." *San Francisco Chronicle*, 10 November 1993.
Bonetti, David. "Zen and the Art of Filling UAM." *San Francisco Examiner*, 19 November 1993.

Richard Tuttle: Drawing Works, Jack Tilton Gallery, New York, November 6–December 4.

Mary Boone Gallery, New York, November 6–December 23.

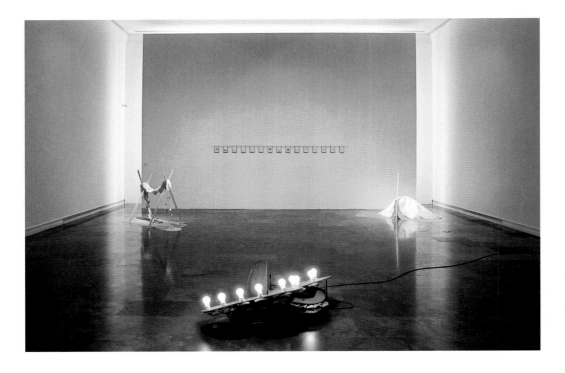

379 Installation view of the 1991 exhibition **Richard Tuttle** as presented at the Instituto Valenciano de Arte Moderno, Valencia, Spain, showing (clockwise from left) **Turquoise I** (1988), **Nica Lift-Off** (1988), **Four** (1987), and **Sentences II** (1989)

1994

Richard Tuttle, Le temps retrouvé, Galerie Yvon
Lambert, Paris, March 12–April 30.
 Pinte, Jean-Louis. Review. *Figaroscope,*
 6–12 April 1994.
 Suchère, Eric. Review. *Les Journal des Expositions*
 15 (April 1994).
 Vezin, Luc. Review. *Infomatin,* 29 March 1994.

Prints and Related Works, Brooke Alexander
Editions, New York, March 19–April 30.

Jürgen Becker, Hamburg, March 26–June 4.

Second Floor Exhibition Space, Reykjavik,
April–May.

Annemarie Verna Galerie, Zurich, September 20–
November 19.
 Steiner, Juri. "Verlassene Kultstätte: Richard
 Tuttle, Ausstellung in Zürich." *Neue Zürcher
 Zeitung,* 1 October 1994.

*Richard Tuttle: A Lamp, a Chair, a Chandelier:
A Work in Process,* A/D, New York, November.

Discontinuous Space, Burnett Miller Gallery,
Santa Monica, California, December 3, 1994–
January 24, 1995.
 Greene, David A. "Dangerous Curves Ahead:
 Richard Tuttle's Open-Ended Abstraction."
 Los Angeles Reader, 13 January 1995, 11.
 Iannaccone, Carmine. Review. *Art Issues* 37
 (March–April 1995): 43.
 Pagel, David. "Richard Tuttle, a Minimalist
 Who Likes Going to Extremes." *Los Angeles
 Times,* 15 December 1994.

Texas Gallery, Houston, December 13, 1994–
January 14, 1995.
 Chadwick, Susan. "Richard Tuttle's Atypical
 Artwork Opens the Mind." *Houston Post,*
 27 December 1994.
 Kalil, Susie. "Original Art? Works and the Menil
 and Texas Gallery Suggest Artists Can Still
 Be Unique—Even in Imitation." *Houston
 Press,* 5–11 January 1995, 30–31.

1995

Mary Boone Gallery, New York, March 4–April 29.
 Duncan, Michael. Review. *Art in America* 83
 (September 1995): 106.

Richard Tuttle: Verbal Windows, Galleria Marilena
Bonomo, Bari, Italy, March 7–April 23.
 Papa, Liviano. "Itinerari turistici sulle orme
 dell'arte: Dalla pittura figurativa all scultura
 intellettuale." *Il Nord,* 16 March 1995.

North/South Axis, Museum of Fine Arts, Santa Fe,
March 11–June 11. Artist's booklet.

Anders Tornberg Gallery, Lund, Sweden,
closed April 26.
 Lind, Ingela. "Anspråkslösa rop på evigheten."
 Dagens Nyheter, 23 April 1995.
 Zetterström, Jelena. "Det operfektas
 perfektionist." *Sydsvenska Dagbladet,*
 22 April 1995.

Richard Tuttle: Neue Arbeiten, Galerie Fahnemann,
Berlin, June 23–August 26.

Richard Tuttle, Selected Works: 1964–1994, Sezon
Museum of Art, Tokyo, September 7–October 10.
Catalogue by Richard Tuttle, Gerhard Mack,
and Shigemi Oka.
 Fujimaki, Mary. "Soaring High among the
 Seraphim." *Japan Times,* 23 September 1995.
 Perron, Joel. "Richard Tuttle's Subtle Rebuttal
 to Modernism." *Daily Yomiuri,* 15 September
 1995.

Time/Line, Daniel Weinberg Gallery, San Francisco,
September 14–October 31.
 Baker, Kenneth. "Artist's Night-Lights for
 a Dark Time." *San Francisco Chronicle,*
 6 October 1995.

Europe Wired, 1–10, 1994, and Mesa Pieces, 1995,
Kohn Turner Gallery, Los Angeles, September 16–
October 21.

Richard Tuttle: Warm Brown, 1–67 and Mesa Pieces,
Kunsthalle Ritter, Klagenfurt, Austria, October 18,
1995–January 14, 1996. Artist's book/catalogue
by Arnulf Rohsmann and Gerhard Mack.

Richard Tuttle: Source of Imagery, Rhona Hoffman
Gallery, Chicago, November 10–December
23. Artist's book *The Gyres: Source of Imagery*
published in conjunction with exhibition.
 Artner, Alan G. "At Hoffman, Tuttle's Collages
 Sneak into Three Dimensions." *Chicago
 Tribune,* 1 December 1995.
 Camper, Fred. "Space Oddities." *Chicago
 Reader,* 24 November 1995, 30.
 Hawkins, Margaret. "Tuttle Brings Invisible
 World to Light." *Chicago Sun-Times,*
 24 November 1995.

1996

Retrospektiv II: Sol LeWitt und Richard Tuttle,
Annemarie Verna Galerie, Zurich, January 10–
February 17.
 Mack, Gerhard. "Kunst für Zwei: Richard Tuttle
 und Sol LeWitt in Zürich." *Cash,*
 16 February 1996.

Galleria Eva Menzio, Turin, Italy, closed March 10.
 Curto, Guido. Review. *La Stufa,* 16 February 1996.

A Chair, a Table, a Book: Richard Tuttle, Brian Kish
Office for Architecture & Art, New York, March 20–
April 27. Booklet.

Richard Tuttle: Renaissance Unframed 1–26,
University of South Florida Contemporary Art
Museum, Tampa, May 15–June 24. Traveled
to University Art Museum, California State
University, Long Beach. Booklet.
 Frank, Peter. Review. *LA Weekly,* 18–24 April 1997.
 Gottlieb, Shirley. "25 Enigmatic Artworks
 That Defy Description." *Press-Telegram,*
 9 April 1997.
 Wilson, William. "The '60s Unite Contrasting
 Exhibitions." *Los Angeles Times,* 29 March
 1997.

Richard Tuttle: Replace the Abstract Picture Plane,
Kunsthaus Zug, Switzerland, June 2–September 1.
Joint catalogue for four Kunsthaus Zug exhibitions
(see 1999 exhibition).
 Gerber, Elisabeth. "Das Museum im Kopf:
 Das Zuger 'Projekt Sammlung.'" *Stehplatz* 5
 (June–August 1996): 3.
 Giger, Romeo. "Brücke zwischen Kunst und
 Leben: Ein beachtenswertes Experiment
 im Kunsthaus Zug." *Neue Zürcher Zeitung,*
 8 July 1996.
 Mack, Gerhard. "Kultur im Zuge der Zeit:
 Warum die Steueroase Zug neuerdings
 Magnet für internationale Kunstatars ist."
 Cash, 7 July 1996.
 ———. "Der Künstler als Zugvogel: Das
 Kunsthaus im schweizerischen Zug erprobt
 ein neues Konzept." *Süddeutsche Zeitung,*
 26 November 1996.
 ———. "Der Künstler als Zugvogel: Das
 Kunsthaus Zug erprobt ein neues
 Sammlungskonzept." *Kunst-Bulletin* 6
 (1996): 22–25.
 "Neuartiges Sammlungs-Projekt." *Thurgauer
 Tagblatt,* 5 August 1996.
 Oehmigen, Karin. "Wir sammeln Künstler nicht
 Kunst: Pionierhaftes Projekt im Kunsthaus
 Zug." *Sonntags Zeitung,* 2 June 1996.
 Omlin, Sybille. "Künstler sammeln statt Kunst."
 Neue Zuger Zeitung, 1 June 1996.
 Review. *Neue Zürcher Zeitung,* 9 July 1997.
 Schenkel, Ronald. "Das Kunstwerk als
 Metapher für die Welt." *Neue Zuger Zeitung,*
 29 May 1996.
 ———. "Die Welt und ihre Darstellbarkeit."
 Neue Zuger Zeitung, 18 July 1996.

Richard Tuttle: Gold and Silver on Easy Pieces,
Galerie Yvon Lambert, Paris, June 5–July 13.
 Review. *Figaroscope,* 26 June 1996.

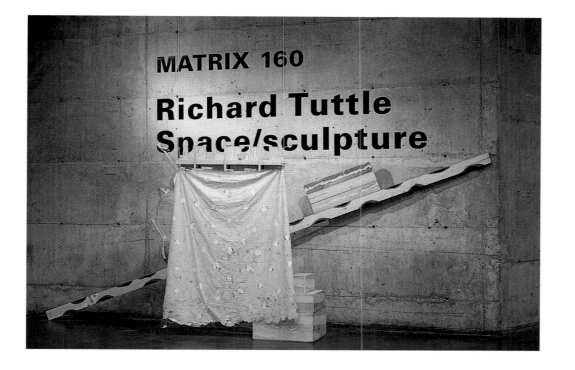

380 Entrance to the 1993 exhibition
 Matrix: Richard Tuttle, Space/Sculpture
 at the University Art Museum,
 University of California, Berkeley

Richard Tuttle: New and Early Work, Sperone Westwater, New York, September 12–October 26.
Euaclaire, Sally. Review. *ARTnews* 95 (October 1996): 137.
Kimmelman, Michael. Review. *New York Times,* 20 September 1996.
Schjeldahl, Peter. "After the Revolution." *Village Voice,* 1 October 1996, 76.

Richard Tuttle: Books and Prints, Widener Gallery, Trinity College, Hartford, October 3–December 8. Traveled to New York Public Library. Booklet by Alden R. Gordon, Robert Rainwater, and Robert M. Murdock.
Filler, Martin. "Art Books Whose Art Is the Book." *New York Times,* 16 February 1997.
Fleishmann, Eric. "Ephemera Eternalized." *Hartford Advocate,* 14 November 1996.
MacAdam, Alfred. Review. *ARTnews* 96 (September 1997): 72.
Schwendenwein, Jude. "Tuttle Show Could Use More of His Sculptures." *Hartford Courant,* 3 November 1996.

Richard Tuttle: Source of Imagery, Galleria Bonomo, Rome, October 22–December 10. Traveled to Galleria Marilena Bonomo, Bari, Italy.
Cataldo, Luciana. "Alla Galleria Bonomo l'americano Richard Tuttle." *Puglia,* 23 March 1997.
Di Tursi, Marilena. "Un sussurro di esistenza dalle opere di Richard Tuttle." *Barisera,* 18 February 1997.
Petruzzelli, Giusy. "Richard Tuttle et la poetica binaria." *Il Roma* (Naples), 22 February 1997.

Galerie Volker Diehl, Berlin, October 31, 1996–January 18, 1997.

Mies van der Rohe Haus, Berlin, November 1, 1996–January 19, 1997. Catalogue.
Reissner, Katja. "Zweitweise Gast im ästhetischen Raum: Ausstellung des Amerikaners Richard Tuttle im Mies van der Rohe Haus." *Der Tages Spiegel,* 11 December 1996.
Roßling, Ingo. "'Striche' von Richard Tuttle im perfekt komponierten Rahmen." *Berliner Morgenpost,* 11 December 1996.

Richard Tuttle: Grey Walls Work, Camden Arts Centre, London, November 22, 1996–January 19, 1997. Traveled to Douglas Hyde Gallery, Dublin; Inverleith House, Royal Botanic Garden, Edinburgh. Catalogue by Jenni Lomax.
Clancy, Luke. "Making Something Out of Nothing." *Irish Times,* 30 April 1997.
Coomer, Martin. Review. *Time Out London,* 8–15 January 1997, 49.
Cruz, Juan. Review. *Art Monthly* 203 (February 1997): 28–29.
Godfrey, Tony. Review. *Burlington Magazine* 139 (February 1997): 133–34.
Gooding, Mel. Review. *Galleries* 14 (December 1996).
McEwen, John. "Big and Very Teutonic." *Sunday Telegraph,* 5 January 1997.
Parsons, Deborah. "Material Metaphysics." *London Student,* 3 December 1996, 16.
Searle, Adrian. "Splash on the Trash." *The Guardian,* 7 January 1997.
Sutherland, Giles. Review. *The Scotsman,* 27 June 1997.

1997
Brooke Alexander, New York, February 15–March 29.

Dan Asher, Richard Tuttle, Galerie Bismarck, Bremen, Germany, June 5–August 31.

Projekt Sammlung: Richard Tuttle, Replace the Abstract Picture Plane, Works 1964–1996, Kunsthaus Zug, Switzerland, June 8–August 31. Joint catalogue for four Kunsthaus Zug exhibitions (see 1999 exhibition).
"Défricheur de zones hybrides entre peinture et sculpture, Richard Tuttle se prend le pieds dans les broussailles." *Journal de Genève,* 9 August 1997.
Hürlimann, Adrian. "Das Schlimmste ist der Erfolg!" *Zuger Presse,* 6 June 1997.
Kurjakovic, Daniel. "Entzug des Sichbaren zwecks Sehen: Richard Tuttle im Kunsthaus Zug." *Neue Zürcher Zeitung,* 9 July 1997.
Livingston, Mark. "Der unverklärte Blick auf die Kunst." *Zuger Presse,* 23 July 1997.
Schenkel, Ronald. "Nichts ist schlimmer als der Erfolg." *Neue Zuger Zeitung,* 6 June 1997.
———. "Dokumentation und Interpretation." *Neue Zuger Zeitung,* 17 July 1997.

Zwez, Annelise. "Kann man zeitgenössische Kunst überhaupt noch sammeln? Zug sucht Wege der Zusammenarbeit." *Solothurner Zeitung,* 14 June 1997.
———. "Objekte in labilen Gkeichgewichten." *Aargauer Zeitung,* 14 June 1997.

Richard Tuttle: Symbol, Galerie Limmer, Cologne, June 26–August 8.
Roos, Renate. "Poesie der groben Platten, Puristische Gestaltung: Werek von Richard Tuttle in der Galerie Limmer." *Kölner Stadt-Anzeiger,* 29 July 1997.

Richard Tuttle: New and Early Work, Art Gallery of York University, North York, Ontario, September 25–November 16. Artist's book *I Thought I Was Going on a Trip But I Was Only Going Down Stairs* published in conjunction with exhibition.
Dault, Gary Michael. "The Spare, Effortless Charms of Richard Tuttle." *Globe and Mail,* 29 October 1997.

Carte Blanche: Richard Tuttle; Artis 49 (October–November 1997): 34–42.

1998
Richard Tuttle: New Mexico, New York, Sperone Westwater, New York, February 14–March 21.
Altfest, Ellen. Review. *NY Arts,* March–April 1998, 10.
Amy, Michaël. Review. *Art in America* 86 (September 1998): 121–22.
Morgan, Robert C. "The Return of Richard Tuttle." *Review,* 1 March 1998, 24–25.
Review. *Tema Celeste* 69–70 (July–September 1998): 65, 109.
Schwabsky, Barry. Review. *Artforum* 36 (May 1998): 146.
Smith, Roberta. Review. *New York Times,* 27 February 1998.

Richard Tuttle: The Thinking Cap, Fabric Workshop and Museum, Philadelphia, February 26–April 11.

Agnes Martin / Richard Tuttle, Modern Art Museum of Fort Worth, April 26–August 2. Traveled to SITE Santa Fe. Catalogue by Michael Auping.
Kutner, Janet. "Shared Line of Work." *Dallas Morning News,* 26 April 1998.

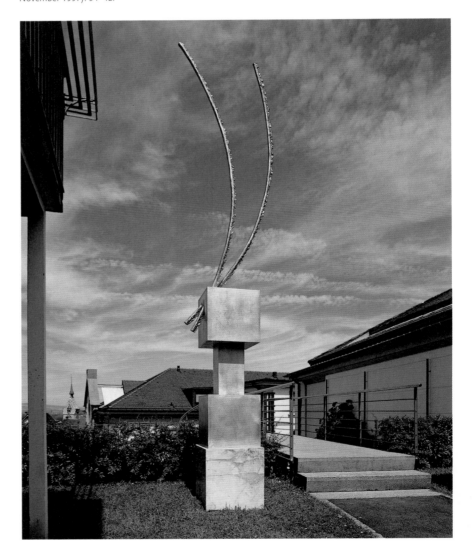

381 Richard Tuttle **Replace the Abstract Picture Plane II** 1997
Aluminum and marble, 181 1/8 x 35 3/8 x 21 5/8 in.
Kunsthaus Zug, Switzerland

Mitchell, Charles Dee. "A Metaphysics
of Simplicity." *Art in America* 86
(November 1998): 122–23.
Pulkka, Wesley. "Reconstructions Reflect
Peaceful Insanity." *Albuquerque Journal*,
20 August 1998.
Weinstein, Joel. Review. *Art Papers* 22
(November–December 1998): 61.

Richard Tuttle: Chandeliers, A/D, New York,
May 28–July 31.
Glueck, Grace. Review. *New York Times*,
19 June 1998.

Richard Tuttle: Small Sculptures of the 70s,
Annemarie Verna Galerie, Zurich, July 3–October 3.
Artist's book/catalogue.
Affentranger-Kirchrath, Angelika. "Punktierte
Räume: Richard Tuttle bei Annemarie
Verna." *Neue Zürcher Zeitung*, 15 August
1998.
———. Review. *Neue Bildende Kunst* 8
(October–November 1998): 75–76.
Mauer, Simon. "Richard Tuttle, 70er Jahre
ungealtert." *Züritip*, 17–23 August 1998, 32.
Princenthal, Nancy. "Artist's Book Beat
[catalogue review]." *Art on Paper* 3 (March–
April 1999): 70–71.

Richard Tuttle: New Etchings, Crown Point Press,
San Francisco, September 15–November 7.
Booklet by Kathan Brown.

*Richard Tuttle: Replace the Abstract Picture Plane,
Books & New Works, The Kamm Collection of the
Kunsthaus: A Selection by the Artist*, Kunsthaus Zug,
Switzerland, November 21, 1998–January 17, 1999.
Joint catalogue for four Kunsthaus Zug exhibitions
(see 1999 exhibition).
Livingston, Mark. "Mit den Augen des
Künstlers sehen." *Zuger Presse*, 20
November 1998.
Review. *Neue Zürcher Zeitung*, 27 November
1998.
"Richard Tuttle und die Wiener Moderne."
Die Weltwoche, 3 December 1998.
Schenkel, Ronald. "Mit den Augen des
Künstlers sehen." *Neue Zuger Zeitung*,
20 November 1998.

Here and Now: Richard Tuttle, Church of Saint
Paulinus, Brough Park, Catterick, England,
in collaboration with Henry Moore Sculpture Trust,
November 23–December 23.
Godfrey, Tony. Review. *Burlington Magazine* 141
(May 1999): 309.

Richard Tuttle: Die Konjunktion der Farbe, Ludwig
Forum für Internationale Kunst, Aachen, Germany,
December 11, 1998–February 14, 1999.
Catoir, Barbara. "Flieg, wohin dein Aug'
dich trägt." *Frankerfurter Allgemeine*,
20 January 1999.
Puvogel, Renate. Review. *Kunstforum
International* 144 (March–April 1999):
367–68.

1999

*Richard Tuttle: Mandevilla—Aquatints from
Crown Point Press*, Greg Kucera Gallery, Seattle,
January 7–30.
Hackett, Regina. "Opposites Converge
Fluidly at Kucera." *Seattle Post-Intelligencer*,
22 January 1999.

Richard Tuttle: New Work, Galleria Marilena
Bonomo, Bari, Italy, March 14–May 30.
Marino, Pietro. "A Bari l'arte di Tuttle linea
di frontiera contro il càos del mondo."
La Gazetta del Mezzogiorno, 3 April 1999.
Scardi, Gabi. Review. *Il Sole 24 Ore*, 9 May 1999.

Richard Tuttle: Community, Arts Club of Chicago,
April 16–June 18. Artist's book/catalogue by Kathy
Cottong and Jennifer R. Gross.
Artner, Alan G. "Community Is Key When
Tuttle Puts up a Show." *Chicago Tribune*,
13 May 1999.

Richard Tuttle: 70's Drawings, Jürgen Becker,
Hamburg, April 30–July 3.

*Richard Tuttle, The Dust When You Come Over the
Hill (Morocco)*, Rhona Hoffman Gallery, Chicago,
May 1–29.

Galleria Cardi, Milan, October 7–November 27.
Poli, Francesco. Review. *Tema Celeste* 77
(January–February 2000): 96–97.

*Projekt Sammlung: Richard Tuttle; Replace the
Abstract Picture Plane (1996–1999)*, Kunsthaus
Zug, Switzerland, November 20, 1999–February 13,
2000. Joint catalogue by Jennifer Gross, Matthias
Haldemann, and Richard Tuttle for four Kunsthaus
Zug exhibitions titled *Richard Tuttle: Replace the
Abstract Picture Plane*.
Chauvy, Laurence. "Avec l'artiste Richard Tuttle
la peinture sort de ses cadres." *Le Temps*,
14 December 1999.
Herzog, S. "Kunst aus sem Untergeschoss."
Neue Zürcher Zeitung, 21 January 2000.
"Kunst aus dem Untergeschoss." *Neue Zürcher
Zeitung*, 21 January 2000.
Livingston, Mark. "Über Emotionen zur
Einfachheit." *Zuger Presse*, 10 November
1999.
Schenkel, Ronald. "Das Kustwerk als Geste."
Neue Zuger Zeitung, 20 November 1999.

2000

Two With Any To, Sperone Westwater, New York,
January 5–February 12.
Arning, Bill. Review. *Time Out, New York*, 3–10
February 2000, 61.
Esplund, Lance. "Lit: Three Artists Sculpting
with Light." *Modern Painters* 13 (Spring
2000): 108–11.
Goodrich, John. Review. *Review*, 15 January
2000, 14–15.
Kimmelman, Michael. Review. *New York Times*,
28 January 2000.
Nahas, Dominique. Review. *Review*, 15 January
2000, 12–13.
Princenthal, Nancy. Review. *Art in America* 88
(May 2000): 160–61.
Review. *Village Voice*, 1 February 2000, 87.
Siegel, Katy. Review. *Artforum* 38 (April 2000): 140.
Wilkin, Karen. "At the Galleries." *Partisan
Review* 67 (Spring 2000): 291.

A/D, New York, March 2–April 29.

Richard Tuttle; White Sails, Annemarie Verna
Galerie, Zurich, March 30–May 20.

Richard Tuttle, 1981–1999, Galerie Meert Rihoux,
Brussels, April 6–May 20.

Richard Tuttle, Perceived Obstacles, Stiftung
Schleswig-Holsteinische Landesmuseum,
Schloss Gottorf, Schleswig, Germany,
July 2–September 3. Traveled to Westfälisches
Landesmuseum für Kunst und Kulturgeschichte,
Münster, Germany; Akademie der Künste,
Berlin. Catalogue by Erich Franz.
Catoir, Barbara. "Richard Tuttle in Münster."
Frankfurter Allgemeine Zeitung,
16 March 2001.
Kuhn, Nicola. "Das Hindernis ist das Ziel."
Tagesspiegel, 23 October 2001.
"Mehr wissen: Werke von Richard Tuttle
in Berlin." *Kölner Stadtanzeiger*,
16 October 2001.
Ruthe, Ingeborg. "Wahrgenommene
Hindernisse, Richard Tuttle will Stille und
Konzentration: Die Akademie der Künste
Berlin zeigt sein Werk erstmals in Berlin."
Berliner Zeitung, 27 September 2001.
Tanner, Christoph. Review. *Radio Drei*,
24 September 2001.

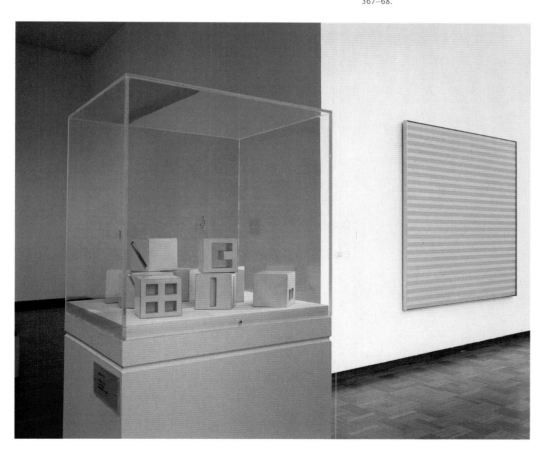

382 Installation view of the 1998 exhibition **Agnes
Martin / Richard Tuttle** at the Modern Art
Museum of Fort Worth, showing (from left
to right) Tuttle's untitled paper cubes (1964)
and Martin's **Untitled #10** (1985)

Richard Tuttle: Reservations, BAWAG Foundation, Vienna, September 15–November 26. Artist's book/catalogue by John Yau and Christine Kintisch.

Borchhardt-Birbaumer, Brigitte. "Bekannter Post-Minimalist." *Wiener Zeitung*, 14 November 2000.

Hofleitner, Johanna. "Die Grenzen Erforschen: Neuigkeiten von Richard Tuttle in der Bawag Foundation." *Parnass* 3 (September–October 2000): 128.

Horny, Henriette. "Das ausgeschlossene Ich." *Kurier*, 15 September 2000.

"Introvertierte Endlosschleife." *Die Furche*, 21 September 2000.

Kruntorad, Paul. "Die Vollendung der 'Antiform' in Oktagon." *Der Standard*, 15 September 2000.

Rath, Elisabeth. Review. *Salzburger Nachrichten*, 16 September 2000.

"Tuttle's Quest for the 'Loved Line.'" *Austria Today*, 12 September 2000.

"Verletzlich und flüchtig." *Die Presse*, 25 September 2000.

2001

Anthony Meier Fine Arts, San Francisco, January 12–February 16, 2001.

Baker, Kenneth. "Great Art from Humble Means: Tuttle Work Vibrant at Meier Fine Arts Show." *San Francisco Chronicle*, 20 January 2001.

Galerie Yvon Lambert, Paris, February 2–March 6.

Richard Tuttle: New Books & Portfolios, Annemarie Verna Galerie, Zurich, March 20–March 31.

Richard Tuttle: Werken op Papier uit de Verzameling van Museum Overholland / Works on Paper from the Museum Overholland Collection, Kabinet Overholland, Stedelijk Museum Amsterdam, April 28–June 24.

Richard Tuttle, In Parts, 1998–2001, Institute of Contemporary Art, University of Pennsylvania, Philadelphia, December 8, 2001–February 10, 2002. Artist's book/catalogue by Charles Bernstein and Ingrid Schaffner.

Brown, Gerard. "Four Elements." *Philadelphia Weekly*, 28 November 2001.

Princenthal, Nancy. "Artist's Book Beat [catalogue review]." *Art on Paper* 6 (March–April 2002): 98–99.

Sozanski, Edward J. Review. *Philadelphia Inquirer*, 16 December 2001.

2002

Tomio Koyama Gallery, Tokyo, April 12–May 11.

"Richard Tuttle's Modest, But Magnificent Art." *Daily Yomiuri*, 18 April 2002.

Richard Tuttle: When We Were at Home, Galerie Schmela, Düsseldorf, April 20–June 14. Artist's book/catalogue by Christian Schneegass.

Catoir, Barbara. "Die Galerie Schmela ist zurück mit Richard Tuttle." *Frankfurter Allgemeine Zeitung*, 20 April 2002.

Herchenröder, Christian. "Wiedereröffnung der Düsseldorfer Galerie Schmela." *Handelsblatt*, 23 April 2002.

Meister, Helga. "Poesie der Erinnerung an den grossen Galeristen." *Westdeutsch zeitung / Düsseldorfer Nachrichten*, 24 April 2002.

———. Review. *Kunstforum International* 160 (June–July 2002): 381–82.

Richard Tuttle: cENTER, Centro Galego de Arte Contemporánea, Santiago de Compostela, Spain, June 27–September 22 (joint exhibition with *Richard Tuttle: Memento*, Porto). Catalogue by Miguel Fernández-Cid and Dieter Schwarz titled *Field of Stars: A Book on the Books / Richard Tuttle*.

Estevez, Jose Luis. "Richard Tuttle se retira con dos proyectos en Santiago y Oporto." *El País*, 1 July 2002.

Richard Tuttle: Memento, Museu Serralves de Arte Contemporânea, Porto, Portugal, June 28–September 29 (joint exhibition with *Richard Tuttle: cENTER*, Santiago de Compostela). Catalogue by Susan Harris.

Stolz, George. Review. *ARTnews* 101 (October 2002): 176.

Dwight Hackett Projects, Santa Fe, August 10–September 28.

Collins, Tom. "'Field of Dreams': New Art Space Opens with Noteworthy Exhibit in Industrial Area of Santa Fe." *Albuquerque Journal*, 23 August 2002.

2003

Richard Tuttle: Twenty Pearls, Sperone Westwater, New York, April 15–May 31.

Cotter, Holland. Review. *New York Times*, 30 May 2003.

Kuspit, Donald. Review. *Artforum* 41 (Summer 2003): 184.

Reed, Rex. "Slack Minimalist." *New York Observer*, 12 May 2003.

Schjeldahl, Peter. "The Little Paintings That Could." *The New Yorker*, 5 May 2003, 20.

Richard Tuttle: Costume, Crown Point Press, San Francisco, May 1–June 28. Booklet.

Richard Tuttle: Celebration, Annemarie Verna Gallery, Zurich, May 7–July 5. Booklet.

Affentranger-Kirchrath, Angelika. Review. *Neue Zürcher Zeitung*, 18 June 2003.

2004

Richard Tuttle: Neue Arbeiten, Galerie Schmela, Düsseldorf, May 11–July 10.

Richard Tuttle: Type, Crown Point Press, San Francisco, June 8–August 28. Booklet by Kathan Brown.

Indonesian Textiles, curated by Richard Tuttle, Tai Gallery / Textile Arts, Santa Fe, July 17–August 1. Catalogue by Richard Tuttle.

Indyke, Dottie. Review. *ARTnews* 103 (October 2004): 193.

Richard Tuttle: Dogs In A Hurry, De Kanselarij, organized by Foundation VHDG, Leeuwarden, the Netherlands, September 6, 2004–February 21, 2005. Artist's book/catalogue.

Richard Tuttle: It's a Room for 3 People, Drawing Center, New York, November 6, 2004–February 26, 2005. Artist's book/catalogue titled *Richard Tuttle: Manifesto*, Drawing Papers 49. Artist's book *Color as Language* published in conjunction with exhibition.

Baird, Daniel. "Richard Tuttle." *Border Crossings* 24 (February 2005): 18–25.

Cotter, Holland. "Eluding Artistic Pigeonholes." *New York Times*, 5 November 2004.

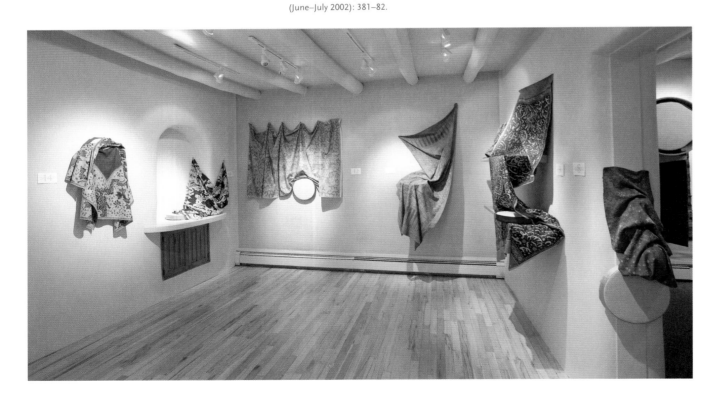

383 Installation view of the 2004 exhibition **Indonesian Textiles,** curated by Richard Tuttle, at Tai Gallery / Textile Arts, Santa Fe

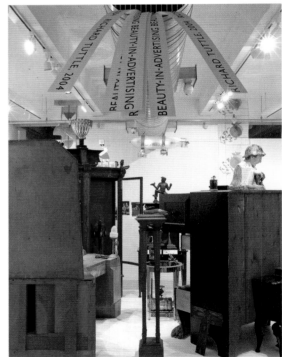

384 Installation view of the 2004 exhibition **Beauty-in-Advertising,** curated by Richard Tuttle, at the Wolfsonian—Florida International University, Miami

Esplund, Lance. "Richard Tuttle's Sweet
 Nothings." *New York Sun*, 4 November 2004.
"Goings On About Town: A Fine Line."
 The New Yorker, 15 November 2004, 10.
Goodbody, Bridget. "Minding the Gap: Richard
 Tuttle's Anthropological Experiment." *Art
 on Paper* (January–February 2005): 34–35.
Levin, Kim. "Show World." *Village Voice*, 7
 December 2004, 73.
Naves, Mario. "David Reed's Chilly Contrivance:
 Hyperstylized, Squiggly Forms / Tinkering
 Tuttle." *New York Observer*, 29 November
 2004.
Ratner, Megan. Review. *Frieze*, April 2005, 106–7.

Beauty-in-Advertising, installation and exhibition
curated by Richard Tuttle, Wolfsonian—Florida
International University, Miami, December 3,
2004–January 31, 2005.
 Kimmelman, Michael. "Postwar Japan, Mon
 Amour." *New York Times*, 26 December 2004.

SELECTED GROUP EXHIBITIONS

1965
*The Seventh Selection of the Society for the
Encouragement of Contemporary Art: A New York
Collector Selects*, San Francisco Museum of Art,
January 22–February 14.

The Box Show, Byron Gallery, New York.

*Contemporary American Painting: 11th Annual
Exhibition*, Ralph Wilson Gallery, Lehigh University,
Bethlehem, Pennsylvania.

1966
Selections from the Art Lending Service, Penthouse
Gallery, Museum of Modern Art, New York,
February 14–April 18.

2e Salon International de Galeries Pilotes, Musée
cantonal des Beaux-Arts, Palais de Rumine,
Lausanne, Switzerland, June 12–October 2.
Catalogue.

Twenty-Five Paintings '65, organized by Betty
Parsons Gallery, New York, for Virginia Museum
of Fine Arts, Richmond, opened June 21. Traveled
to six additional venues in Virginia.
 "Abstractionist Paintings Set for Exhibition."
 Richmond News-Leader, 18 June 1966.
 Cossitt, F. D. "New Exhibits at the Museum."
 Richmond Times-Dispatch, 8 July 1966.
 "Summer Show Opens at Museum Tuesday."
 Richmond Times-Dispatch, 19 June 1966.

Twentieth Anniversary, 1946–1966: Pattern Art, Betty
Parsons Gallery, New York, October 4–29. Booklet.

*Contemporary American Painting: 12th Annual
Exhibition*, Ralph Wilson Gallery, Lehigh University,
Bethlehem, Pennsylvania.

1968
Preview 1968, Widener Gallery, Trinity College,
Hartford, January 18–February 8.

Painting: Out from the Wall, Des Moines Art Center,
February 16–March 10. Catalogue.

Betty Parsons' Private Collection, Finch College
Museum of Art, New York, March 13–April 24.
Traveled to Cranbrook Academy of Art, Bloomfield,
Michigan; Brooks Memorial Art Gallery, Memphis.
Catalogue.

Anti-Form, John Gibson Gallery, New York,
October 5–November 7.

Group Show, Bykert Gallery, New York,
October 6–November 12.

*American Abstract Artists: 32nd Anniversary
Exhibition*, Riverside Museum, New York,
October 6–December 1.

Some Younger American Painters and Sculptors,
traveling exhibition organized by American
Federation of the Arts, New York, October 1968–
October 1969.

1969
Here & Now, Washington University Gallery of Art,
Saint Louis, January 11–February 21. Catalogue.
 Karp, Ivan. "Here and Now." *Arts Magazine* 43
 (March 1969): 49.

*Thirty-First Biennial Exhibition of Contemporary
American Painting*, Corcoran Gallery of Art,
Washington, D.C., February 1–March 16. Catalogue.
 Andreae, Christopher. Review. *Christian Science
 Monitor*, 8 March 1969.
 Gold, Barbara. "Corcoran: Art's New
 'Sensibility.'" *Baltimore Sun*, 9 February
 1969.
 ———. "Corcoran Biennial: New Sensibility
 in Washington." *Arts Magazine* 43 (April
 1969): 30–31.
 Richard, Paul. "Courageous Corcoran."
 Washington Post, 2 February 1969.
 Wasserman, Emily. "Corcoran Biennial."
 Artforum 7 (April 1969): 71–72.

Soft Art, New Jersey State Museum Cultural Center,
Trenton, March 1–April 27. Catalogue.
 Andreae, Christopher. "Trends: 'Soft Art'
 in New Jersey." *Christian Science Monitor*,
 24 March 1969.
 Pomeroy, Ralph. "Soft Objects at the New
 Jersey State Museum." *Arts Magazine* 43
 (March 1969): 46–48.

*When Attitudes Become Form: Works—Concepts—
Processes—Situations—Information*, Kunsthalle
Bern, Switzerland, March 22–April 27. Traveled

to Institute of Contemporary Arts, London;
Museum Haus Lange, Krefeld, Germany. Catalogue
titled *Live in Your Head: When Attitudes Become
Form: Works—Concepts—Processes—Situations—
Information*.
 Ammann, Jean-Cristophe. "Schweitzer Brief."
 Art International 13 (20 May 1969): 47–50.
 Pierre, José. "Les grandes vacances de l'art
 moderne." *L'Oeil* 173 (May 1969): 10–18, 72.

Sammlung Helmut Klinker, Städtische Kunstgalerie
Bochum, Germany, April 17–May 18. Catalogue.

Anti-Illusion: Procedures/Materials, Whitney
Museum of American Art, New York, May 19–July 6.
Catalogue.
 Burton, Scott. "Time on Their Hands."
 ARTnews 68 (Summer 1969): 40–43.

Other Ideas, Detroit Institute of the Arts,
September 10–October 19. Catalogue.

Young Artists from the Collection of Charles Cowles,
Aldrich Museum of Contemporary Art, Ridgefield,
Connecticut, September 28–December 14.
Catalogue.

*Art on Paper 1969: The Weatherspoon Annual
Exhibition*, University of North Carolina,
Greensboro, November 16–December 19.
Catalogue.

1970
New Materials: Procedures in Sculpture, Austin Arts
Center, Trinity College, Hartford, April 16–30.

Using Walls (Indoors), Jewish Museum, New York,
May 13–June 21. Catalogue.
 Glueck, Grace. "Art Shows Overflow Jewish
 Museum." *New York Times*, 14 May 1970.

Zeichnungen Amerikanischer Künstler, Galerie Ricke,
Cologne, May 15–June 25. Catalogue.

American Drawings, Galerie Yvon Lambert, Paris,
September.

Die Sammlung der Emanuel Hoffman-Stiftung,
Kunstmuseum Basel, Switzerland, November 7,
1970–January 24, 1971. Catalogue.

Paperworks, Art Lending Service, Penthouse Gallery,
Museum of Modern Art, New York, November 24,
1970–January 10, 1971.

385 Installation view of the 1966 exhibition
Twenty-Five Paintings '65 as presented at the
Virginia Museum of Fine Arts, Richmond,
showing Richard Tuttle's constructed
paintings **Medusa** and **One** (top and bottom
left, respectively; both 1965)

1971

Paintings Without Supports, Bennington College, Vermont, March 30–April 23.

Funf Sammler: Kunst unserer Zeit, Von der Heydt-Museum, Wuppertal, Germany, June 5–July 11. Catalogue.

Die Hanspeter Schulthess-Oeri-Siftung, 1961–1971, Kunstmuseum Basel, Switzerland, November 20, 1971–January 16, 1972. Catalogue.

1972

Recent Painting and Sculpture, Munson-Williams-Proctor Institute, Utica, New York, January 9–February 13.

Meisterwerke des 20. Jahrhunderts, Galerie Schmela, Düsseldorf, March–April.

Amerikanische Graphik seit 1960, Bünder Kunsthaus, Chur, Switzerland, May 6–June 18. Traveled to Kunstverein Solothurn, Switzerland; Musée d'art et d'histoire, Geneva; Kunsthaus Aarau, Switzerland; Kunsthalle Basel, Switzerland. Catalogue.

Drawing in Space: 19 American Sculptors, Katonah Gallery, Katonah, New York, May 14–June 25.

Documenta 5: Befragung der Realitat: Bildwelten heute, Museum Fridericianum, Kassel, Germany, June 30–October 8. Catalogue.
 Stabler, Margit. "Documenta 5: Einige Bemerkungen." *Art International* 16 (October 1972): 78–81.

Book as Artwork 1960/72, Nigel Greenwood, London, September 20–October 14. Catalogue.

Actualité d'un Bilan, Galerie Yvon Lambert, Paris, October 29–December 5. Catalogue.

[Drawing], Museum of Modern Art, Oxford, England, November 18–December 23. Booklet.

Small Series, Paula Cooper Gallery, New York, December 9, 1972–January 13, 1973.

1973

Yngre Amerikansk Kunst: Tenginger og grafik, Gentofte Rådhus, Charlottenlund, Norway, January 24–February 11. Traveled to Århus Kunstmuseum, Denmark; Henie Onstad Kunstsenter Oslo, Norway; Hamburger Kunsthalle, Germany; Moderna Museet, Stockholm. Catalogue.

Bilder, Objekte, Filme, Konzepte, Städtische Galerie im Lenbachhaus, Munich, April 3–May 13. Catalogue.

Options and Alternatives: Some Directions in Recent Art, Yale University Art Gallery, New Haven, Connecticut, April 4–May 16. Catalogue.

Arte come arte, Centro Comunitario di Brera, Milan, April 26–May. Catalogue.

Art in Evolution, Xerox Square Exhibition Center, New York, May 16–June 27. Catalogue.

American Drawings 1963–1973, Whitney Museum of American Art, New York, May 25–July 22. Catalogue.
 Borden, Lizzie. "Art Economics and the Whitney Drawing Show." *Artforum* 12 (October 73): 85–88.

Of Paper, Newark Museum, New Jersey, June 23–September 3.
 Halasz, Piri. "A Daring Paper-Art Exhibit." *New York Times*, 26 August 1973.

New American Graphic Art, Fogg Art Museum, Harvard University, Cambridge, Massachusetts, September 12–October 28. Booklet.

A Selection of American and European Paintings from the Richard Brown Baker Collection, San Francisco Museum of Art, September 14–November 11. Traveled to Institute of Contemporary Art, University of Pennsylvania, Philadelphia. Catalogue.

Contemporanea, Parcheggio di Villa Borghese, Rome, November 1973–February 1974. Catalogue.

Drawings, Barbara Cusack Gallery, Houston, December 11, 1973–January 8, 1974.

Hand Colored Prints, Brooke Alexander, New York. Traveled to Webb and Parsons, Bedford Village, New York; Graphics I & II, Boston. Booklet.
 Kelder, Diane. "Prints: Artists' Alterations." *Art in America* 62 (March 1974): 96–97.

1974

Line as Language: Six Artists Draw, Art Museum, Princeton University, New Jersey, February 23–March 31. Catalogue.
 Anderson, Laurie. Review. *ARTnews* 73 (Summer 1974): 113–14.
 Gilbert-Rolfe, Jeremy. "Line as Language: Six Artists Draw." *Artforum* 12 (June 1974): 66–68.
 Halasz, Piri. "Princeton: A Puzzling Art Exhibit." *New York Times*, 10 March 1974.

Works on Paper, Art Lending Service Exhibition, Penthouse Gallery, Museum of Modern Art, New York, February 25–May 24.

Printed, Cut, Folded, and Torn, Museum of Modern Art, New York, May 10–August 11.
 Schjeldahl, Peter. "Non-event at the Museum of Modern Art: Graphics Show on Specious Theme." *New York Times*, 21 July 1974.

Painting and Sculpture Today, 1974, Contemporary Art Society of the Indianapolis Museum of Art, May 22–July 14. Traveled to Contemporary Arts Center and Taft Museum, Cincinnati. Catalogue.

The Bay Area Collects: Sandra and Breck Caldwell, University Art Museum, University of California, Berkeley, July 3–August 11. Booklet.

Recent Prints, Brooke Alexander, New York.

1975

Mel Bochner, Barry Le Va, Dorothea Rockburne, Richard Tuttle, Contemporary Arts Center, Cincinnati, January 8–February 16. Catalogue.

Color, exhibition organized by the International Council of the Museum of Modern Art, New York. Traveled to Museo de Arte Moderno, Bogotá, February 24–March 30; Museo de Arte de São Paulo, Brazil; Museu de Arte Moderna, Rio de Janeiro; Museo de Bellas Artes, Caracas; Museo de Arte Moderno, Mexico City.

Abstract Watercolors: 1942–1975, Buecker & Harpsichords, New York, March 1–April 26.

Fourteen Artists, Baltimore Museum of Art, Maryland, April 15–June 1.

Selections from the Collection of Dorothy and Herbert Vogel, Clocktower Gallery, Institute for Art and Urban Resources, New York, April 19–May 17.

Richard Brown Baker Collects! A Selection of Contemporary Art from the Richard Brown Baker Collection, Yale University Art Gallery, New Haven, Connecticut, April 24–June 22. Catalogue.

The Small Scale in Contemporary Art, Society for Contemporary Art of the Art Institute of Chicago, May 8–June 15.

USA Zeichnungen 3, Städtisches Museum Schloss Morsbroich, Leverkusen, Germany, May 15–June 29. Catalogue.

Galleria Marilena Bonomo, Bari, Italy, June 18–July 31.

Tendances actuelles de la nouvelle peinture americaine, ARC 2, Musée d'art moderne de la ville de Paris, June 24–August 31. Catalogue.

Recent Drawings, traveling exhibition organized by American Federation of the Arts, New York, June 1975–December 1976. Catalogue.

Painting, Drawing, and Sculpture of the '60s and '70s from the Dorothy and Herbert Vogel Collection, Institute of Contemporary Art, University of Pennsylvania, Philadelphia, October 7–November 18. Traveled to Contemporary Arts Center, Cincinnati. Catalogue.

Art on Paper 1975: The Weatherspoon Annual Exhibition, University of North Carolina, Greensboro, November 16–December 14. Catalogue.

386 Installation view of the 1976 exhibition **Critical Perspectives in American Art** as presented at the **37th Venice Biennale**, showing Richard Tuttle's **Portrait of Marcia Tucker; at Venice** (1976)

1976

The Book as Art, Fendrick Gallery, Washington, D.C., January 12–February 14. Booklet.

Drawing Now, Museum of Modern Art, New York, January 19–March 7. Traveled to Kunsthalle Basel, Switzerland; Kunsthaus Zürich; Staatliche Kunsthalle Baden-Baden, Germany; Graphische Sammlung Albertina, Vienna; Tel Aviv Museum, Israel. Catalogue.
 Smith, Roberta. "Drawing Now (and Then)." *Artforum* 14 (April 1976): 52–59.

Line, Visual Arts Museum, New York, January 26–February 18. Traveled to Philadelphia College of Art, Pennsylvania. Booklet.

Two Hundred Years of American Sculpture, Whitney Museum of American Art, New York, March 16–September 26. Catalogue.

Davidson National Print and Drawing Competition, Stowe Gallery, Davidson College, North Carolina, March 21–April 23. Catalogue.

Critical Perspectives in American Art, Fine Arts Center Gallery, University of Massachusetts, Amherst, April 10–May 9. Traveled to *37th Venice Biennale.* Catalogue.
 Kramer, Hilton. "Our Venice Offering— More a Syllabus than a Show." *New York Times,* 2 May 1976.
 Martin, Henry. Review [Venice exhibition]. *Art International* 20 (September–October 1976): 14–24, 59.

Ideas on Paper 1970–1976, Renaissance Society at the University of Chicago, May 2–June 6.

Rooms, P.S. 1, Institute for Art and Urban Resources, Long Island City, New York, June 9–26. Catalogue.

Russell, John. "An Unwanted School in Queens Becomes an Ideal Art Center." *New York Times,* 20 June 1976.

Bis Heute: Zeichnungen für das Kunstmuseum Basel aus dem Karl A. Burckhardt-Koechlin-Fonds, Kunsthalle Basel, Switzerland, June 12–August 15. Catalogue.

American Artists: A New Decade, Detroit Institute of Arts, July 31–September 19. Traveled to Fort Worth Art Museum; Grand Rapids Art Museum. Catalogue.
 Kutner, Janet. "Visceral Aesthetic of a New Decade's Art." *Arts Magazine* 51 (December 1976): 100–103.

New York in Europa, Nationalgalerie Berlin, September 4–November 7. Catalogue titled *Amerikanische Kunst von 1945 bis heute: Kunst der USA in europäischen Sammlungen.*

Torn, Folded, and Crumpled, Parsons-Dreyfuss Gallery, New York, October 5–23.

Private Notations: Artists' Sketchbooks II, Philadelphia College of Art, Pennsylvania, October 23–November 24. Catalogue.

100 dessins du Musée de Grenoble, 1900–1976, Grenoble, France, November–December 1976. Catalogue.

The Magazine Show, organized by Institute for Art and Urban Resources, New York, *Artforum* 15 (December 1976): 18–24.

Artists' Books, traveling exhibition organized by Arts Council of Great Britain. Catalogue.

Soft Works of the Late Sixties, Buecker & Harpsichords, New York.

1977

Brooke Alexander, New York, January 8–February 5.

Selected Works on Paper Published by Brooke Alexander, Hansen-Cowles Gallery, Minneapolis, opened February 5.

1977 Biennial Exhibition, Whitney Museum of American Art, New York, February 19–April 3. Catalogue.

Ideas in Sculpture: 1965–1977, Renaissance Society at the University of Chicago, May 1–June 11.
 Leaderman, Pamela. "Contemporary Sculpture." *Midwest Art* 4 (Summer 1977): 7.

Documenta 6, Orangerie, Kassel, Germany, June 24–October 2. Catalogue.

20th-Century American Art from Friends' Collections, Whitney Museum of American Art, New York, July 27–September 27. Booklet.

American Drawing, 1927–1977, Minnesota Museum of Art, Saint Paul, September 6–October 29. Catalogue.

A View of a Decade, Museum of Contemporary Art, Chicago, September 10–November 10. Catalogue.

Small Objects, Whitney Museum of American Art, Downtown Branch, New York, November 3–December 7.

Works from the Collection of Dorothy and Herbert Vogel, University of Michigan Museum of Art, Ann Arbor, November 11, 1977–January 1, 1978. Catalogue.

Marta & Maria, Galleria d'arte Spagnoli, Florence. Booklet.

1978

Brooke Alexander: A Decade of Print Publishing, Boston University Art Gallery, February 6–26. Booklet.

20th Century American Drawings: Five Years of Acquisitions, Whitney Museum of American Art, New York, July 28–October 1. Catalogue.

New Editions, Brooke Alexander, New York, September 5–26.

Sol LeWitt, Richard Long, Richard Tuttle, Yale School of Art, New Haven, Connecticut, September 5–30.

Door beeldouwers gemaakt / Made by Sculptors, Stedelijk Museum Amsterdam, September 14–November 5. Catalogue.

1979

Drawings About Drawing Today, Ackland Memorial Museum, University of North Carolina, Chapel Hill, January 28–March 11. Catalogue.

Drawings and Sculpture, Adler Gallery, Los Angeles, February 3–March 17.

Pittura-Ambiente, Palazzo Reale, Milan, June 9–September 16. Catalogue.

Material Pleasures: The Fabric Workshop at ICA, Institute of Contemporary Art, University of Pennsylvania, Philadelphia, June 13–July 21. Catalogue.

New York: A Selection from the Last Ten Years, Otis Art Institute, Los Angeles, June 14–July 14.

American Abstract Artists: The Language of Abstraction, Betty Parsons Gallery and Marilyn Pearl Gallery, New York, June 19–August 3. Catalogue.

Fabric Workshop, Marian Locks Gallery, Philadelphia, December 1–31.

Re: Figuration, Max Protetch Gallery, New York, opened December 18.

1980

Art/Book/Art, traveling exhibition organized by Detroit Institute of Arts. Traveled to Slusser Gallery, University of Michigan, Ann Arbor, January 5–February 3; Mid-Michigan Community College, Harrison; Urban Institute for Contemporary Art, Grand Rapids; Willard Library, Battle Creek, Michigan; Ella Sharp Museum, Jackson, Michigan. Catalogue.

Die Sammlung der Emanuel Hoffman-Stiftung, Museum für Gegenwartskunst, Öffentliche Kunstsammlung, Basel, Switzerland, February 7–September 28.

Printed Art: A View of Two Decades, Museum of Modern Art, New York, February 14–April 1. Catalogue.

Explorations in the '70s, Pittsburgh Plan for Art, Pennsylvania, April 12–May 4. Catalogue.

Pier + Ocean: Construction in the Art of the Seventies, Hayward Gallery, London, May 8–June 22. Traveled to Rijksmuseum Kröller-Müller, Otterlo, the Netherlands. Catalogue.
> Crichton, Fenella. Review. *Art and Artists* 15 (July 1980): 22–27.
> ———. Review. *Pantheon* 38 (October–December 1980): 327–28.

Skulptur im 20. Jahrhundert, Wenkenpark Riehen, Basel, Switzerland, May 10–September 14. Catalogue.

Zeichnungen: Neuerwerbungen, 1976–80, Museum Haus Lange, Krefeld, Germany, August 17–October 12.

Maximum Coverage: Wearables by Contemporary American Artists, John Michael Kohler Arts Center, Sheboygan, Wisconsin, September 7–November 9. Traveled to University of North Dakota, Grand Forks. Catalogue.

Drawn in Space, Washington Project for the Arts, Washington, D.C., October 14–November 22. Booklet.
> Lewis, Jo Ann. Review. *Washington Post,* 1 November 1980.

Selected Works from the Betty Parsons Gallery, Heath Gallery, Atlanta.

1981

New Works of Contemporary Art and Music, Fruitmarket Gallery, Edinburgh, April 11–May 9. Catalogue.

Vonal, Pécsi Galéria, Pécs, Hungary, April 26–May 17. Catalogue.

Heidi Glück, Joshua Neustein, David Reed, Joel Shapiro, Richard Tuttle, Bertha Urdang Gallery, New York, May 2–29.

Westkunst: Zeitgenössische Kunst seit 1939, Museen der Stadt, Cologne, May 30–August 16. Catalogue.

Il limite svelato: Artista, cornice, pubblico, Museo Civico di Torino, Mole Antonelliana, Turin, Italy, July–October. Catalogue.

Drawing Distinctions: American Drawings of the Seventies, Louisiana Museum of Modern Art, Humlebaek, Denmark, August 15–September 20. Traveled to Kunsthalle Basel, Switzerland; Städtische Galerie im Lenbachhaus, Munich (titled *Amerikanische Zeichnungen der Siebziger Jahre*); Wilhelm-Hack-Museum, Ludwigshafen, Germany. Catalogue.
> Rein, Ingrid. Review [Munich exhibition]. *Das Kunstwerk* 35 (June 1982): 79–80.

Drawing Acquisitions, 1978–1981, Whitney Museum of American Art, New York, September 17–November 15. Catalogue.

Selections from the Chase Manhattan Bank Art Collection, University Gallery, University of Massachusetts, Amherst, September 19–December 20. Traveled to Robert Hull Fleming Museum, University of Vermont, Burlington; David Winton Bell Gallery, Brown University, Providence. Catalogue.

Relief(s): Richard Tuttle, Nancy Bowen, Don Hazlitt, Institut Franco-Américain, Rennes, France, October 6–30. Booklet.

No Title: The Collection of Sol LeWitt, Wesleyan University Art Gallery and Davidson Art Center, Middleton, Connecticut, October 21–December 20. Catalogue.

Amerikanische Malerei: 1930–1980, Haus der Kunst, Munich, November 14, 1981–January 31, 1982. Catalogue.

Art Materialized: Selections from the Fabric Workshop, traveling exhibition organized by Independent Curators Incorporated, New York. Traveled to New Gallery for Contemporary Art, Cleveland, December 11, 1981–January 16, 1982; Gibbes Art Gallery, Charleston, South Carolina; Hudson River Museum, Yonkers, New York; University of South Florida Art Galleries, Tampa; Art Museum and Galleries, California State University, Long Beach; Alberta College of Art Gallery, Calgary; Pensacola Museum of Art, Florida. Catalogue.

Galerie Schmela, Düsseldorf, December 11, 1981–January 1982.

Murs, Centre National d'art et de culture Georges Pompidou, Musée national d'art moderne, Paris, December 17, 1981–February 8, 1982. Catalogue.

1982

Artists' Photographs, Crown Point Gallery, Oakland, California, January–February. Special issue of *Vision* 5 (1982) published in conjunction with exhibition.

Du livre, concurrent exhibitions at Musée des Beaux-Arts, Rouen; Bibliothèque Municipale, Rouen; Galerie Déclinaisons, Rouen; École des Beaux-Arts, Rouen; and C.R.D.P., Mont-Saint-Aignan, France, January 18–February 28. Booklet.

'60–'80: Attitudes/Concepts/Images, Stedelijk Museum Amsterdam, April 9–July 11. Catalogue.
> Carlson, Prudence. "Report from Amsterdam: Arriving at the '80s." *Art in America* 71 (January 1983): 19–25.

Prints by Contemporary Sculptors, Yale University Art Gallery, New Haven, Connecticut, May 18–August 31. Catalogue.

25 Jahre Galerie Schmela: 1957–1982, Galerie Schmela, Düsseldorf, June 6–July.

American Painting and Sculpture: 74th Annual, Art Institute of Chicago, June 12–August 1. Catalogue titled *74th American Exhibition.*

Documenta 7, Museum Fridericianum, Kassel, Germany, June 19–September 28. Catalogue.

Papyrus Abstractus: From Drawing to Sculpture, Town Hall Gallery, Westport, Connecticut, July 23–August 13.

Ryman/Tuttle/Twombly: New Work, Blum Helman Gallery, New York, September 15–October 9.
> Harris, Susan A. Review. *Arts Magazine* 57 (November 1982): 59.
> Licht, Matthew. Review. *Arts Magazine* 57 (November 1982): 51.

Marilena Bonomo: Invitation à un voyage à travers l'art contemporain, Centre d'art contemporain, Geneva, September 24–December 20.

20th Anniversary Exhibition of the Vogel Collection, Brainerd Art Gallery, State University College of Arts and Science, Potsdam, New York, October 1–December 1. Traveled to Gallery of Art, University of Northern Iowa, Cedar Rapids. Catalogue.

Arbeiten auf Papier, Galerie Schmela, Düsseldorf, December 16, 1982–March 28, 1983.

1983

Abstract Painting: 1960–1969, P.S. 1, Institute for Art and Urban Resources, New York, January 16–March 13.
> Glueck, Grace. "An Experimental Outpost Looks Back." *New York Times,* 6 February 1983.

Drawings—Disegni—Zeichnungen I, Annemarie Verna Galerie, Zurich, January 29–February 8.

Small Is Beautiful, Freedman Gallery, Albright College, Reading, Pennsylvania, February 8–March 4. Traveled to Center Gallery, Bucknell University, Lewisburg, Pennsylvania.

When Art Becomes Book, When Books Become Art, Annemarie Verna Galerie, Zurich, opened March 22.

Objects, Structures, Artifice, SVC Fine Arts Gallery, University of South Florida, Tampa, April 9–May 30. Traveled to Center Gallery, Bucknell University, Lewisburg, Pennsylvania. Catalogue.

Minimalism to Expressionism: Painting and Sculpture Since 1965 from the Permanent Collection, Whitney Museum of American Art, New York, June 2–December 4. Booklet.

10 Jahre Kunstraum München, Jubiläumsausstellung, Kunstraum München, Munich, June 8–July 31.

Ars 83 Helsinki, Ateneumin taidemuseo, Helsinki, October 14–November 12. Catalogue.

Werke auf Papier / Works on Paper: James Bishop, Sol LeWitt, Robert Mangold, Richard Tuttle, Annemarie Verna Galerie, Zurich, October 30–November 24.

15 Jahre Sammlung Helga und Walther Lauffs im Kaiser Wilhelm Museum Krefeld, Kaiser Wilhelm Museum, Krefeld, Germany, November 13, 1983–April 8, 1984. Catalogue titled *Sammlung Helga und Walther Lauffs im Kaiser Wilhelm Museum Krefeld: Amerikanische und Europaische Kunst der sechziger und siebziger Jahre.*

The First Show: Painting and Sculpture from Eight Collections 1940–1980, Museum of Contemporary Art, Los Angeles, November 20, 1983–February 19, 1984. Catalogue.

American Works on Paper: 100 Years of American Art History, traveling exhibition organized by Smith Kramer Art Connections, Kansas City, Missouri, December 11, 1983–December 29, 1985. Catalogue.

1984

Forms That Function, Katonah Gallery, Katonah, New York, January 22–March 4. Booklet.
> Raynor, Vivien. "'Forms That Function' at Katonah: 'Twixt Art and the Crafts.'" *New York Times,* 29 January 1984.

The Tremaine Collection: Twentieth-Century Masters, The Spirit of Modernism, Wadsworth Atheneum, Hartford, February 26–April 29. Catalogue.

Painting and Sculpture Today, 1984, Indianapolis Museum of Art, May 1–June 10. Booklet.

Drawings by Sculptors: Two Decades of Non-Objective Art in the Seagram Collection, Montreal Museum of Fine Arts, May 3–June 10. Traveled to Vancouver Art Gallery, British Columbia; Nickle Arts Museum, Calgary, Alberta; Seagram Building, New York; London Regional Art Gallery, Ontario. Catalogue.

Zeichnungen für die dritte Dimension (eigene Bestände), Basel Museum für Gegenwartskunst, Switzerland, June 22–August 12.

American Sculpture, Margo Leavin Gallery, Los Angeles, July 17–September 15.

Aquarelle, Kasseler Kunstverein, Kassel, Germany, November 16, 1984–January 6, 1985. Catalogue.

In Existum Cuiusdam, Annemarie Verna Gallery, Zurich, December 11, 1984–January 30, 1985.

Sculptors' Drawings 1910–1980: Selections from the Permanent Collection, Whitney Museum of American Art, Visual Arts Gallery, Florida International University, Miami. Traveled to Aspen Art Museum, Colorado; Art Museum of South Texas, Corpus Christi; Philbrook Art Center, Tulsa. Booklet.

1985

Fortissimo: Thirty Years from the Richard Brown Baker Collection of Contemporary Art, Museum of Art, Rhode Island School of Design, Providence, March 1–April 28. Traveled to San Diego Museum of Art, California; Portland Museum of Art, Oregon. Catalogue.

Drawings by Sculptors, Brooke Alexander, New York, March 5–30.
> Russell, John. Review. *New York Times*, 15 March 1985.

In offener Form, Museum Haus Esters, Krefeld, Germany, May 16–June 30.

Drawing Acquisitions: 1981–1985, Whitney Museum of American Art, New York, June 11–September 22. Catalogue.

Wasserfarbenblätter von Joseph Beuys, Nicola De Maria, Gerhard Richter, Richard Tuttle, Westfälischer Kunstverein Münster, Germany, June 14–July 28. Catalogue.

Dan Flavin, Morris Louis, Brice Marden, Richard Serra, Richard Tuttle: Neue Daierleihgaben aus der Sammlung Reinhard Onnasch, Berlin, Städtisches Museum Abteiberg, Mönchengladbach, Germany, June 19–August 25.

Affiliations: Recent Sculpture and Its Antecedents, Whitney Museum of American Art, Fairfield County, Stamford, Connecticut, June 28–August 24. Booklet.

American/European Part I: Painting Sculpture 1985, LA Louver, Venice, California, July 16–August 17.

Accrochage, Galerie Schmela, Düsseldorf, September 13–December.

Dreissig Jahre durch die Kunst: Museum Haus Lange, 1955–1985, Museum Haus Lange and Museum Haus Esters, Krefeld, Germany, September 15–December 1. Catalogue.

Sculptures, première approach pour un parc, Fondation Cartier pour l'art contemporain, Jouy-en-Josas, France, October 6, 1985–January 5, 1986. Catalogue.

Three Sculptors: John Duff, Joel Shapiro, Richard Tuttle, Krannert Art Museum, University of Illinois, Urbana-Champaign, November 9–December 22. Catalogue.

American Eccentric Abstraction, Blum Helman Gallery, New York, November 16, 1985–January 18, 1986.
> Plagens, Peter. "I Just Dropped In to See What Condition My Condition Was In..." *Artscribe* 56 (February–March 1986): 22–29.

Vom Zeichnen: Aspekte der Zeichnung 1960–1985, Frankfurter Kunstverein, Frankfurt, Germany, November 19, 1985–January 1, 1986. Traveled to Kasseler Kunstverein, Kassel, Germany; Museum Moderner Kunst Wien, Vienna. Catalogue.

Spuren, Skulpturen und Monumente ihrer präzisen Reise, Kunsthaus Zürich, November 29, 1985–February 16, 1986. Catalogue.
> McEvilley, Thomas. Review. *Artforum* 24 (April 1986): 120–21.
> Zellweger, Harry. Review. *Das Kunstwerk* 39 (February 1986): 67–69.

Correspondences: New York Art Now, Laforet Museum Harajuku, Tokyo, December 20, 1985–January 19, 1986. Traveled to Tochigi Prefectural Museum of Fine Arts, Japan. Catalogue.

1986

Wien Fluss, 1986, Wiener Secession am Steinhof-Thaterbau, Vienna, May 14–June 29. Catalogue.

Entre la Geometría y el Gesto: Escultura Norteamericana, 1965–1975, Palacio de Velázquez, Parque del Retiro, Madrid, May 23–July 31. Catalogue.

Drawings from the Collection of Dorothy and Herbert Vogel, Department of Art Galleries, University of Arkansas, Little Rock, September 7–November 16. Traveled to Moody Gallery of Art, University of Alabama, Tuscaloosa; Museum of Art, Pennsylvania State University, State College. Catalogue.

Prospect 86, Frankfurter Kunstverein, Frankfurt, Germany, September 9–November 2. Catalogue.

Esculturas sobre la pared, Galería Juana de Aizpuru, Madrid, October 24–December 3.

SkulpturSein, Städtische Kunsthalle Düsseldorf, Germany, December 13, 1986–February 1, 1987. Catalogue.

Beelden in Glas / Glass Sculpture, Fort Asperen, Leerdam, the Netherlands. Catalogue.

1987

White, Blum Helman Gallery, New York, January 7–31.

Selections from the Roger and Myra Davidson Collection of International Contemporary Art, Art Gallery of Ontario, Toronto, January 17–March 22. Catalogue.

Rauschenberg, Schwitters, Tuttle, Blum Helman Gallery, New York, February 4–28.

Metaphor: Myron Stout, Richard Tuttle, Richard Wentworth, Win Knowlton, Kent Fine Art, New York, February 12–March 14. Catalogue.
> Brenson, Michael. Review. *New York Times*, 20 February 1987.

1967: At the Crossroads, Institute of Contemporary Art, University of Pennsylvania, Philadelphia, March 13–April 26. Catalogue.

Die Gleichzeitigkeit des Andern: Materialien zu einer Austellung, Kunstmuseum Bern, Switzerland, March 21–June 14. Catalogue.

1987 Biennial Exhibition, Whitney Museum of American Art, New York, March 31–July 5. Catalogue.
> .Richard, Paul. "Fads & Furious: At the Whitney, the Show You Love to Hate." *Washington Post*, 26 April 1987.

Jenseits des Bildes: Werke von Robert Barry, Sol LeWitt, Robert Mangold, Richard Tuttle aus der Sammlung Dorothy and Herbert Vogel, New York, Kunsthalle Bielefeld, Germany, May 3–July 5. Catalogue.
> Winter, Peter. Review. *Das Kunstwerk* 40 (September 1987): 185–87.

Summer Group Show, Blum Helman Gallery, New York, June 10–July.

Skulptur Projekte in Münster 1987, Westfälisches Landesmuseum, Münster, Germany, June 14–October 4. Catalogue.
> Cameron, Dan. "Documenta 8 Kassel: What Comes After the Hunger for Pictures? A Cautious Post-Modernism Whose Mysterious Logic Satisfies No One. An Overview of *Documenta* and *Skulptur Projekte* in Münster." *Flash Art* 136 (October 1987): 61–68.

Early Concepts of the Last Decade, Holly Solomon Gallery, New York, closed October 13.

Beuys, Cahn, Fontana, Graubner, Lohman, Meuser, V. Nagel, Oldenburg, Polke, Saure, Scully, Tinguely, Tuttle, Twombly, Zeithamml, Galerie Schmela, Düsseldorf, December 1987–January 1988.

Seldom Seen, Genovese Graphics, Boston, December 4, 1987–January 4, 1988.

Sculptors on Paper: New Work, Madison Art Center, Wisconsin, December 5, 1987–January 31, 1988. Traveled to Sheldon Memorial Art Gallery, University of Nebraska, Lincoln. Catalogue.

1988

Source and Inspiration: A Continuing Tradition, Hirschl & Adler Folk, New York, January 16–February 20. Catalogue.

(C)Overt: A Series of Exhibitions, P.S. 1, Institute for Art and Urban Resources, New York, January 17–March 6. Booklet.

Group Show, Blum Helman Gallery, New York, February 3–27.

Amerikkalaista nykytaidetta, Sara Hildén Art Museum, Tampere, Finland, February 6–April 10. Traveled to Kunstnernes Hus, Oslo, Norway. Catalogue.

Richard Artschwager, Multiples; Dan Flavin, Sculptures; Donald Judd, Sculptures; Richard Tuttle, Objects, Galerie Tanit, Munich, May 11–July 2.

Group Exhibition, Blum Helman Gallery, New York, September 7–October 1.

Zeichenkunst der Gegenwart: Sammlung Prinz Franz von Bayern, Staatliche Graphische Sammlung München, Munich, September 21–December 18. Catalogue.

Skulpturen Republik, Kunstraum Wien im Messepalast, Vienna, October–December. Traveled to John Hansard Gallery, Southampton University, England. Catalogue.

From the Collection of Dorothy and Herbert Vogel, Arnot Art Museum, Elmira, New York, October 15–December 31. Traveled to Grand Rapids Art Museum; Terra Museum of American Art, Chicago; Laumeier Sculpture Park, Saint Louis; Art Museum at Florida International University, Miami. Catalogue.

Black and White, Fabric Workshop, Philadelphia, November 4–December 31.

Köln sammelt: Zeitgenössische Kunst aus Kölner Privatbesitz, Museum Ludwig, Cologne, November 5–December 11. Catalogue.

Works on Paper, Blum Helman Gallery, New York, December 7, 1988–January 7, 1989.

Three Decades: The Oliver-Hoffman Collection, Museum of Contemporary Art, Chicago, December 17, 1988–February 5, 1989. Catalogue.

1989

Object of Thought: A Collection of Objects and Small Sculptures, Anders Tornberg Gallery, Lund, Sweden, January 14–February 1.

Galerie Schmela, Düsseldorf, March–April.

Alan Kirili, Richard Tuttle, William Wegman, Holly Solomon Gallery, New York, March 16–April 1.

A/D, New York, May 11–July 28.

Rain of Talent: Umbrella Art, Fabric Workshop and Museum, Philadelphia, May 18–July 15.

Group Show, Blum Helman Gallery, New York, June 7–July 28.

Richard Tuttle, Michael Young, José María Sicilia, Blum Helman Gallery, New York, September 6–30.

Domenico Bianchi, Robert Ryman, Richard Tuttle, Sperone Westwater, New York, September 16–October 24.

Immaterial Objects: Works from the Permanent Collection of the Whitney Museum of American Art, New York. Traveled to North Carolina Museum of Art, Raleigh, October 14–December 13; Albany Museum of Art, Georgia; San Jose Museum of Art, California. Catalogue.

The Library, A/D, New York, November 9, 1989–January 6, 1990.

The Eighties in Review: Selections from the Permanent Collection of the Whitney Museum of American Art, Whitney Museum of American Art, Fairfield County, Stamford, Connecticut, December 8, 1989–February 28, 1990.

1990
Minimal Art, Blum Helman Gallery, New York, January 10–February 10.
 Carrier, David. "New York: Why We Love What We See." *Art International* 11 (Summer 1990): 66–68.

Contemporary Illustrated Books: Word and Image, 1967–1988, Franklin Furnace Archive, New York, January 12–February 28. Traveled to Nelson-Atkins Museum of Art, Kansas City, Missouri; University of Iowa Museum of Art, Iowa City. Catalogue.

About Round, Round About: A Collection of Circles, Spheres, & Other Round Matter, Anders Tornberg Gallery, Lund, Sweden, January 20–February 7.

Group Show, Blum Helman Gallery, New York, February 14–March 17.

Concept Art, Minimal Art, Arte Povera, Land Art: Sammlung Marzona, Kunsthalle Bielefeld, Germany, February 18–April 8. Catalogue.

The New Sculpture 1965–75: Between Geometry and Gesture, Whitney Museum of American Art, New York, February 20–June 3. Traveled to Museum of Contemporary Art, Los Angeles. Catalogue.
 Anfam, David. "Evaluating a Radical Decade." *Art International* 12 (Autumn 1990): 94–95.
 Baker, Kenneth. "It's the '60s Again with 'New Sculpture.'" *San Francisco Chronicle*, 2 May 1991.
 Bonetti, David. "Ten Who Shaped Their World." *San Francisco Examiner*, 20 March 1991.
 Carrier, David. Review. *Burlington Magazine* 132 (May 1990): 377–78.
 Cutajar, Mario. "An Acquiescent Dignity." *Artweek*, 11 April 1991, 1, 16.
 Heartney, Eleanor. Review. *ARTnews* 89 (September 1990): 168.
 Huard, Michael. "Le Whitney célèbre dix ans de sculpture Américaine." *Espace* 7 (September–November 1990): 11–13.
 Knight, Christopher. "MOCA's 'New Sculpture' a Fine Match of Work, Space." *Los Angeles Times*, 20 February 1991.
 Pincus, Robert L. "Ambitious Survey of Contemporary Sculpture." *San Diego Union*, 7 April 1991.
 Smith, Roberta. "Sculpture at the Whitney: The Radical Years." *New York Times*, 9 March 1990.

Accrochage, Galerie Schmela, Düsseldorf, March–April.

Stendhal Syndrome: The Cure, Andrea Rosen Gallery, New York, June 29–August 4. Catalogue.

John Cage, Alan Saret, Richard Tuttle, Christine Burgin Gallery, New York, July.

Quotations, Part III, Annemarie Verna Galerie, Zurich, November 24, 1990–January 27, 1991.

The Garden, A/D, New York.

1991
Masterworks of Contemporary Sculpture, Blum Helman Gallery, New York, January 16–February 23.

Ulrich Rückriem, Richard Tuttle, Remy Zaugg, Brooke Alexander, New York, February 7–March 2.

Poets/Painters Collaborations, Brooke Alexander, New York, March 13–30.

Ellsworth Kelly, Robert Moskowitz, Richard Tuttle, Blum Helman Gallery, New York, May 1–June 1.

Drawings By Sculptors, Greenberg Gallery, Saint Louis, closed July 27.
 Harris, Paul A. Review. *St. Louis Post-Dispatch*, 30 June 1991.

Essentially Raw, Sue Spaid Fine Art, Los Angeles, closed August 25.
 Pagel, David. "Ephemerality Is Essential in 'Raw' Exhibit." *Los Angeles Times*, 8 August 1991.

Karl August Burckhardt-Koechlin-Fonds: Zeichnungen des 20. Jahrhunderts, Kunstmuseum Basel, Switzerland, September 1–December 8. Catalogue.

Den Gedanken auf der Spur bleiben, Museum Haus Lange and Museum Haus Esters, Krefeld, Germany, September 29–November 17.

Discarded, Emerson Gallery, Rockland Center for the Arts, West Nyack, New York, October 6–November 15. Booklet.
 Caioppo, Nancy. "From Waste to Art: Artists Find Beauty in Refuse at Center for the Arts Exhibit." *Rockland Journal-News*, 4 October, 1991.

Zimmer, William. "Big Names in the Recycling Game Coax Poetry from Debris." *New York Times*, 20 October 1991.

Stubborn Painting: Now and Then, Max Protetch Gallery, New York, December 19, 1991–January 25, 1992. Catalogue.
 Review. *The New Yorker*, 27 January 1991, 10.

Drawings, Brooke Alexander, New York, December 21, 1991–January 25, 1992.

1992
Arte Americana, 1930–1970, Fiat-Lingotto, Turin, Italy, January 11–March 31. Catalogue.

15th Anniversary Exhibition, Rhona Hoffman Gallery, Chicago, May 8–June 13.

Gifts and Acquisitions in Context, Whitney Museum of American Art, New York, May 22–July 5.
 Cotter, Holland. "Better to Display than to Merely Receive." *New York Times*, 29 May 1992.

Paolo Uccello: Battaglie nell'arte del XX secolo, La Salerniana, Erice, Italy, July 25–October 10. Catalogue.

1993
Sculpture & Multiples, Brooke Alexander, New York, January 8–February 13.

The Contemporary Artist's Book: The Book as Art, 871 Fine Arts, San Francisco, September 9–December 30.

Das Einfache ist das Schwierge, Kunsthaus Zug, Switzerland, November 28, 1993–January 16, 1994.

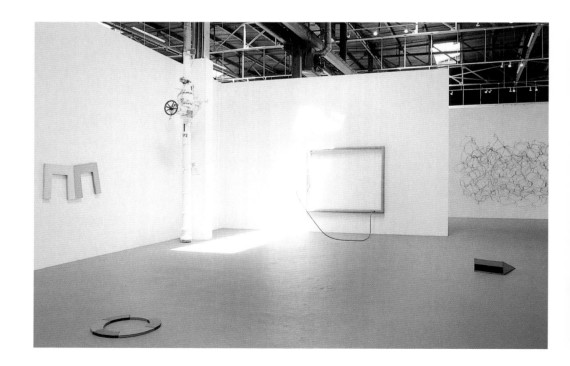

387 Installation view of the 1990 exhibition **The New Sculpture 1965–75: Between Geometry and Gesture** as presented at the Museum of Contemporary Art, Los Angeles, showing Richard Tuttle's **Drift III** and **Light and Dark Green Circle** (top and bottom left, respectively; both 1965) among works by (clockwise from center) Eva Hesse, Alan Saret, and Bruce Nauman

1994

Western Artists / African Art, Museum for African Art, New York, May 6–August 7. Catalogue.

Evolutions in Expression: Minimalism and Post-Minimalism from the Permanent Collection of the Whitney Museum of American Art, Whitney Museum of American Art at Champion, Stamford, Connecticut, May 13–July 6. Catalogue.
Raynor, Vivian. "Minimalism, and After That." *New York Times*, 26 June 1994.

From Minimal to Conceptual Art: Works from the Dorothy and Herbert Vogel Collection, National Gallery of Art, Washington, D.C., May 29–November 27. Catalogue. Traveled to Portland Museum of Art, Oregon; Archer M. Huntington Art Gallery, University of Texas, Austin; Wäinö Aaltonen Museum of Art, Turku, Finland; Tel Aviv Museum of Art, Israel.
Carnegie, M. D. "Playfulness—or Fakery—on Display." *Washington Times*, 29 May 1994.
Levine, Angela. "Collecting on a Shoestring." *Jerusalem Post*, 10 July 1998.
Lewis, Jo Ann. "A Prescient Present: The Vogels Collected Art No One Wanted. Now It's Prized by the National Gallery." *Washington Post*, 5 June 1994.
Schade, Christopher. "Absence Makes the Minimalist Grow Profounder." *Austin American-Statesman*, 26 November 1997.

Zimmer in denen die Zeit nicht zählt: Die Sammlung Udo und Anette Brandhorst, Museum für Gegenwartskunst, Öffenliche Kunstsammlung, Basel, Switzerland, June 5–September 18. Catalogue.

Printed in the 1970s, Brooke Alexander, New York, June 25–July 29.

Praticamente argento / Basically silver, Studio La Città, Verona, Italy, opened September 16.

Ethereal Materialism, Apex Art, New York, October 15–November 26.

Amerikanische Zeichnungen und Graphik: Von Sol LeWitt bis Bruce Nauman, Kunsthaus Zurich, December 2, 1994–February 5, 1995. Catalogue.

1995

Works on Paper, Jürgen Becker, Hamburg, opened February 3.

Abstrakt, Galerie Klein, Bad Münstereifel-Mutscheid, Germany, March 19–May 10.

Carnegie International, 1995, Carnegie Museum of Art, Pittsburgh, November 5, 1995–February 18, 1996. Catalogue.

1996

On Paper II, Schmidt Contemporary Art, Saint Louis, January 23–February 20.

West Meets East: Works on Paper, Numark Gallery, Washington, D.C., closed May 11.

Schwere-los Skulpturen, Oberösterreichisches Landesmuseum, Landesgalerie Linz, Austria, December 5, 1996–February 2, 1997. Traveled to Ludwig Múzeum, Budapest. Catalogue.
Zsófia, Beke. "Súlytalan Szobrok Súlyos Térbe?" *Új Muvészet* 8 (Summer 1997): 19–23.

1997

Die Sammlung Anne-Marie und Ernst Vischer-Walder: Ein Vermächtnis, Öffentliche Kunstsammlung Basel, Switzerland, January 11–March 9. Catalogue.

New York on Paper, Baumgartner Galleries, Washington, D.C., February 7–March 22.

Works on Paper: James Bishop, Paul Feeley, Shirley Jaffe, Richard Tuttle, Lawrence Markey, New York, March 1–29.

Wood Not Wood: Work Not Work, A/D, New York, March 22–May 10.

47th Venice Biennale, June 15–November 9. Catalogue.
Vetrocq, Marcia E. "The 1997 Biennale: A Space Odyssey." *Art in America* 85 (September 1997): 66–77.

Papierskulptur, Oberösterreichisches Landesmuseum, Landesgalerie Linz, Austria, June 18–September 21. Catalogue.

At the Threshold of the Visible: Minuscule and Small-Scale Art, 1964–1996, Herbert F. Johnson Museum of Art, Cornell University, Ithaca, New York, August 30–October 26, 1997. Traveled to Meyerhoff

Galleries, Maryland Institute of Art, Baltimore; Art Gallery of Ontario, Toronto; Art Gallery of Windsor, Ontario; Virginia Beach Center for the Arts, Virginia; Santa Monica Museum of Art, California; Edmonton Art Gallery, Alberta; Center on Contemporary Art, Seattle. Catalogue.
Cotter, Holland. "A Show That Could Travel in Just a Carry-on Bag." *New York Times*, 14 December 1997.

About Context: Eva Hesse, Roni Horn, Agnes Martin, Ree Morton, Sylvia Plimack Mangold, James Bishop, Giulio Paolini, Forrest Bess, Fred Sandback, Richard Tuttle, Annemarie Verna Galerie, Zurich, September 16–November 23.

Obsession + Devotion, Haines Gallery, San Francisco, October 15–November 15.

Drawing Is Another Kind of Language: Recent American Drawings from a New York Private Collection, Arthur M. Sackler Museum, Harvard University, Cambridge, Massachusetts, December 12, 1997–February 22, 1998. Traveled to Kupferstichkabinett, Academy of Fine Arts, Vienna; Kunstmuseum Winterthur, Switzerland; Kunst-Museum Ahlen, Germany; Akademie der Künste, Berlin; Fonds regional d'art contemporain de Picardie and Musée de Picardie, Amiens, France; Parrish Art Museum, Southampton, New York; Lyman Allyn Art Museum, New London, Connecticut; Northwestern University, Evanston, Illinois; Contemporary Museum, Honolulu. Catalogue.
Sherman, Mary. "Exhibit Redefines the Nature of Drawing." *Boston Herald*, 11 January 1998.

1998

Original Scale, Apex Art, New York, January 8–February 7. Booklet.

Painting, Object, Film, Concept: Works from the Herbig Collection, Christie's, New York, February 17–March 1. Catalogue.

The Edward R. Broida Collection: A Selection of Works, Orlando Museum of Art, Florida, March 12–June 21. Catalogue.

Drawing the Question: Dan Asher, Eva Hesse, Ree Morton, Sol LeWitt, Sheila Pepe, and Richard Tuttle, Dorsky Gallery, New York, April 29–June 20. Booklet.

Sculpture, Rhona Hoffman Gallery, Chicago, May 1–June 13.

Art in New Mexico, Part 1: Works by Agnes Martin, Bruce Nauman, Susan Rothenberg, Richard Tuttle, James Kelly Contemporary, Santa Fe, July 31–October 3.
Domandi, Mary-Charlotte. Review. *ARTnews* 97 (November 1998): 173.

Jürgen Becker, Hamburg, opened September 4.

Spatiotemporal, Magasin 3 Stockholm Konsthall, November 12–December 20. Catalogue titled *Magasin 3 Stockholm 10 år=ten years, 1988–1998*.

Next to Nothing: Minimalist Works from the Albright-Knox Art Gallery, Anderson Gallery, State University of New York, Buffalo, November 21, 1998–February 7, 1999.

Art Wares, Numark Gallery, Washington, D.C., closed January 9, 1999.
Protzman, Ferdinand. Review. *Washington Post*, 21 December 1998.

1999

twistfoldlayerflake, Wattis Institute for Contemporary Arts, California College of Arts and Crafts, Oakland, January 27–March 17.
Narwocki, James. Review. *New Art Examiner* 26 (May 1999): 61.
Scherr, Apollinaire. "Prying Our Minds Open." *East Bay Express*, 19 February 1999, 20.

Deutsch-amerikanischer Dialog, Galerie Fahnemann, Berlin, February 19–March 30.

ITINERE 2, Palazzo delle Papesse, Centro Arte Contemporanea, Siena, Italy, March 28–May 30.

Afterimage: Drawing through Process, Museum of Contemporary Art, Los Angeles, April 11–August 22. Traveled to Contemporary Arts Museum, Houston; Henry Art Gallery, Seattle. Catalogue.
Johnson, Reed. "Under the Hood of Modern Art: Method Means Everything at MOCA Show." *Daily News of Los Angeles*, 6 August 1999.
Pagel, David. "'Afterimage' Reviews Artists Making Rational Art on Paper." *Los Angeles Times*, 21 April 1999.
Roth, Charlene. Review. *New Art Examiner* 27 (November 1999): 50–51.

White Fire, Flying Man: Amerikanische Kunst 1959–1999 in Basel, Werke aus der Öffenliche Kunstsammlung Basel und der Emanuel Hoffmann-Stiftng, Museum für Gegenwartskunst, Basel, Switzerland, June 5–September 26. Catalogue.

Circa 1968, Museu Serralves, Museu de Arte Contemporânea, Porto, Portugal, June 6–August 29. Catalogue.
Barten, Walter. "Lustoord voor elite." *Het Financieele Dagblad,* 31 July 1999.
Sussman, Elisabeth. "Report from Oporto: Sorting Out the '60s." *Art in America* 88 (May 2000): 59–63.

That Certain Look: The Minimalist Tradition in New Mexico, University Art Museum, University of New Mexico, Albuquerque, June 8–September 26.

Sperone Westwater, New York, June 18–July 30.

Mixed Bag: Summer Group Show, Schmidt Contemporary Art, Saint Louis, June 22–July 24.

Twenty Years of the Grenfell Press, Paul Morris Gallery, New York, July 8–August 6.

The Rocket Four: Artist Books of the Turkey Press, Julie Cencebaugh Gallery, New York, July 14–August 14. Catalogue.

The American Century: Art & Culture 1950–2000: Part II, 1950–2000, Whitney Museum of American Art, New York, September 26, 1999–February 13, 2000. Catalogue.

The Great Drawing Show, Kohn Turner Gallery, Los Angeles, closed October 30.

Drawings from the 1970s by Mel Bochner, Sol LeWitt, Robert Mangold, Sylvia Plimack Mangold, Robert Moskowitz, Fred Sandback, Richard Tuttle, Lawrence Markey, New York, October 30–December 11.

Drawings from the 1960s, Curt Marcus Gallery, New York, closed December 4.

Size Immaterial, Department of Coins and Medals, British Museum, London, December 7, 1999–April 9, 2000.
Windsor, John. "Alternative Investments: It's Pinned to the Art." *Observer,* 5 March 2000.

2000

Whitney Biennial, Whitney Museum of American Art, New York, March 23–June 4. Catalogue.
Baker, Kenneth. "Millennial Biennial: Whitney's Showcase Expands Its Borders While Also Looking Inward." *San Francisco Chronicle,* 23 March 2000.
Kimmelman, Michael. "A New Whitney Team Makes Its Biennial Pitch." *New York Times,* 24 March 2000.
Kutner, Janet. "New Looks: Whitney Goes National with Biennial Survey of Modern Scene." *Dallas Morning News,* 23 April 2000.
Plath, Carina. Review. *Kunst-Bulletin,* no. 5 (May 2000): 39–40.
Richard, Raul. "Whitney's Sampler: For Browsers, Biennial 2000 Goes Down Easy, Leaves No Aftertaste." *Washington Post,* 31 March 2000.
Schjeldahl, Peter. "Pragmatic Hedonism: The Pleasant Surprise of the New, in Two Big Surveys." *The New Yorker,* 3 April 2000, 94–95.
Siegel, Katy. "Biennial 2000." *Artforum* 38 (May 2000): 171–73.
Stevens, Mark. "Built for Comfort." *New York* 33 (3 April 2000): 58, 60.
Thon, Ute. "Konfektionsware Kunst." *Kunstforum International* 151 (July–September 200): 408–11.

Soft White: Lighting Design By Artists, University Gallery, Fine Arts Center, University of Massachusetts, Amherst, April 8–May 19. Catalogue.

Arte Americana: Ultimo decennio, Loggetta lombardesca, Ravenna, Italy, April 8–June 25. Catalogue.

Cosmologies, Sperone Westwater, New York, May 4–August 30.

The '70s at Crown Point Press and New Releases by Tom Marioni and Richard Tuttle, Crown Point Press, San Francisco, May 24–July 1.

Pintura, FRAC Auvergne, France, June 9–September 2. Catalogue.

Food for the Mind: Die Sammlung Udo und Anette Brandhorst, Bayerische Staatsgemäldesammlungen / Staatsgalerie moderner Kunst München, Munich, June 9–October 8. Catalogue.

In Depth: Recent Acquisitions in Prints, Whitney Museum of American Art, New York, July 22–November 26.
Hirsch, Faye. Review. *Art on Paper* 5 (January–February 2001): 88.

Times are Changing, Auf dem Wege! Aus dem 20. Jahrhundert! Eine Auswahl von Werken der Kunsthalle Bremen 1950–2000, Kunsthalle Bremen, Germany, September 1–October 29. Catalogue.

Da Warhol al 2000: Gian Enzo Sperone 35 anni di mostre fra Europa e America, Palazzo Cavour, Turin, Italy, October 6, 2000–January 14, 2001. Catalogue.

Group Show, Grant Selwyn Fine Art, New York, November–December.

To Infinity and Beyond: Editions for the Year 2000, Brooke Alexander, New York, November 2–December 23.

Hard Pressed: 600 Years of Prints and Process, AXA Gallery, New York, November 2, 2000–January 13, 2001. Traveled to Boise Art Museum, Idaho; Museum of Fine Arts, Santa Fe; Naples Museum of Fine Art, Florida. Catalogue.
Glueck, Grace. "Primer on Printmaking That Stresses Innovation." *New York Times,* 8 December 2000.

Process/Reprocess: Japan and the West, Leslie Tonkonow, New York, November 4–December 23.

The Contemporary Illustrated Book: A Collaboration Between Artist and Author, 1960 to the Present, Garcia Street Books, Santa Fe, December 9, 2000–January 7, 2001.

Soft Core, Joseph Helman Gallery, New York, December 13, 2000–January 20, 2001.

Brand New Prints, Karen McCready Gallery, New York.
Sheets, Hilarie M. Review. *ARTnews* 99 (December 2000): 158, 160.

Horizon 2000: Artist Woodturners, Brookfield Craft Center, Brookfield, New York.

2001

À contretemps, FRAC Picardie, Paris, January 27–March 15.

Peaks, Kagan Martos Gallery, New York, closed March 3.

Objective Color, Yale University Art Gallery, New Haven, Connecticut, February 2–March 25.

Poetry Plastique, Marianne Boesky Gallery, New York, February 9–March 9. Catalogue.

Eye of Modernism, Georgia O'Keeffe Museum, Santa Fe, March 23–September 4. Booklet.

Measure/Mass: Rita McBride, Sylvia Plimack Mangold, Agnes Martin, James Bishop, Joseph Egan, Robert Ryman, Fred Sandback, Richard Tuttle, Annemarie Verna Galerie, Zürich, April 5–May 5.

wall>sculpture, Margarete Roeder Gallery, New York, April 21–May 26.

Art Express: Art minimal et conceptuel américain, état d'une collection, Cabinet des estampes au Musée d'art moderne et contemporain, Geneva, May 31–September 30.

Plateau of Humankind, Venice Biennale, June 10–November 4. Catalogue.
Siegel, Katy. "Human, All Too Human." *Artforum* 40 (September 2001): 166–97.

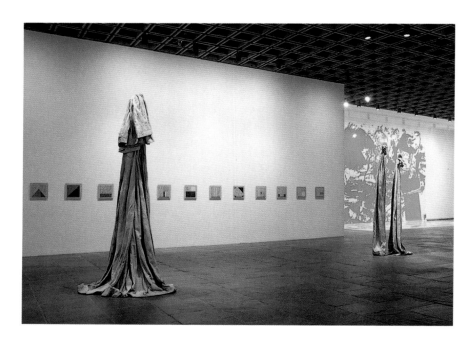

388 Installation view of the 2000 Biennial at the Whitney Museum of American Art, New York, showing Richard Tuttle's series **Rough Edges** (1999; on wall) among artworks by Joseph Havel and Ingrid Calame

Storr, Robert. "Harry's Last Call." *Artforum* 40 (September 2001): 158–59.

Helmut Dorner, Richard Tuttle, Franz West, Brooke Alexander, New York, September 20–October 27.

Extra Art: A Survey of Artists' Ephemera, 1960–1999, Logan Galleries, California College of the Arts, San Francisco, October 12–December 8. Traveled to Institute of Contemporary Art, London. Catalogue.

Green on Greene, Sperone Westwater, New York, November 1–December 15. Catalogue.
 Yablonsky, Linda. Review. *Time Out New York,* 22–29 November 2001, 58.

The Onnasch Collection: Aspects of Contemporary Art, Museo d'Art Contemporani de Barcelona, November 8, 2001–January 20, 2002. Traveled to Museu Serralves, Museu de Arte Contemporânea, Porto, Portugal. Catalogue titled *Onnasch: Aspects of Contemporary Art.*

Letters, Signs, & Symbols, Brooke Alexander Editions, New York, November 10, 2001– January 25, 2002.

A Century of Drawing: Works on Paper from Degas to LeWitt, National Gallery of Art, Washington, D.C., November 18, 2001–April 7, 2002. Catalogue.

The Devil Is in the Details, Allston Skirt Gallery, Boston, November 30–December 29.

Extreme Connoisseurship, Sert Gallery, Carpenter Center for Visual Arts and Fogg Art Museum, Harvard University, Cambridge, Massachusetts, December 8, 2001–April 14, 2002.

Selections from the Permanent Collection, Museum of Contemporary Art, North Miami, Florida, June 1–July 29.

Mills, Michael. "A Powerful Male/Female Dynamic Gives Life to MoCA's Latest Permanent-Collection Show." *New Times Broward-Palm Beach,* 19 July 2001.

2002

Watercolor: In the Abstract, Michael C. Rockefeller Arts Center Gallery, Fredonia State College, Buffalo, January 25–February 22.

To Be Looked At: Painting and Sculpture from the Collection, Museum of Modern Art, Queens, New York, opened June. Catalogue.
 MacAdam, Barbara A. "MoMA QNS," *ARTnews* 101 (September 2002): 149.

netWork: Joseph Egan, James Bishop, Richard Tuttle, Jerry Zeniuk, Andreas Christen, Giulio Paolini, Sylvia Plimack Mangold, Glen Rubsamen, David Rabinowitch, Robert Mangold, Rita McBride, Sol LeWitt, Dan Flavin, Fred Sandback, Donald Judd, Annemarie Verna Galerie, Zurich, July 16– September 28.

Drawings of Choice from a New York Collection, Krannert Art Museum, University of Illinois, Urbana-Champaign, September 4–November 3. Traveled to Arkansas Art Center, Little Rock; Georgia Museum of Art, Athens; Bowdoin College Museum of Art, Brunswick, Maine; Cincinnati Museum of Art. Catalogue.

Works on Paper, Lawrence Markey, New York, December 3, 2002–January 18, 2003.

The Fall Line: Intuition and Necessity in Contemporary Abstract Drawing, Open Studio Press, Boston, closed January 25, 2003.

2003

Invitational Exhibition, American Academy of Arts and Letters, New York, March 3–April 6.

Spring Fever V: Group Exhibition, Crown Point Press, San Francisco, March 6–April 19.

Recent Acquisitions of Contemporary Artists Books, California Palace of the Legion of Honor, San Francisco, June 21, 2003–January 4, 2004.

Divergent, Galerie Lelong, New York, June 26– August 1, 2003.
 Cohen, David. Review. *New York Sun,* 3 July 2003.

Back to the Present: Minimalist Works from the Museum's Collection, Rhode Island School of Design Museum, Providence, June 27– September 7. Booklet.

In Full View, Andrea Rosen Gallery, New York, July 18–September 13.
 Mar, Alex. Review. *New York Sun,* 14 August 2003.

International Abstraction: Making Painting Real, Part II, Seattle Art Museum, August 15, 2003– February 29, 2004.
 Hackett, Regina. "SAM Survey Brings Minimalism into the Present." *Seattle Post-Intelligencer,* 5 September 2003.

The Heroic Century: The Museum of Modern Art Masterpieces, 200 Paintings and Sculptures, Museum of Fine Arts, Houston, September 21, 2003–January 4, 2004. Catalogue titled *Visions of Modern Art: Painting and Sculpture from the Museum of Modern Art.*

Flirting with Rodchenko, Henry Art Gallery, University of Washington, Seattle, October 18, 2003–January 11, 2004.
 Hackett, Regina. "Exhibit Flirts with Abstraction." *Seattle Post-Intelligencer,* 5 December 2003.

Arp Artschwager Tuttle, Kent Gallery, New York, October 30–December 20.

Primary Matters: The Minimalist Sensibility, 1959 to the Present, San Francisco Museum of Modern Art, November 8, 2003–January 11, 2004.
 Baker, Kenneth. "The Minimalist Challenge." *San Francisco Chronicle,* 8 November 2003.

Assemblage, Zwirner and Wirth, New York, November 11, 2003–January 31, 2004. Catalogue.

Dwight Hackett Projects, Santa Fe, November 26, 2003–January 10, 2004.
 Randall, Teri Thompson. Review. *Santa Fe New Mexican,* 2 January 2004.

Tony Feher, Arturo Herrera, Nancy Shaver, and Richard Tuttle, Brent Sikkema, New York, December 4, 2003–January 10, 2004.
 Deitcher, David. Review. *Time Out New York,* 8–15 January 2004.

2004

Das MoMA in Berlin: Meisterwerke aus dem Museum of Modern Art, New York, Neue Nationalgalerie, Berlin, February 20–September 19. Catalogue.

ULAE: The Print Show, Oklahoma City Museum of Art, Oklahoma, May 6–August 22.

Transmit + Transform, Santa Fe Art Institute, July 2–August 13.

Artists' Books: No Reading Required, Selections from the Walker Art Center Library Collection, organized by Walker Art Center for Star Tribune Gallery at the Minnesota Center for Book Arts, Minneapolis, August 28–November 6.

Design ≠ Art: Functional Objects from Donald Judd to Rachel Whiteread, Cooper-Hewitt, National Design Museum, Smithsonian Institution, New York, September 10, 2004–February 27, 2005. Traveled to Museum of Design, Atlanta, Georgia; Aspen Art Museum, Colorado. Catalogue.
 Gopnik, Blake. "Pull Up a Chair: At the Cooper-Hewitt, Sculptors Who Explore Elevating Design to Fine Art." *Washington Post,* 28 September 2004.
 Murray, Sarah. "A Beautiful Usefulness: A New Exhibition Highlights the Blurring Line between Aesthetic and Functional Art." *Financial Times,* 18 September 2004.
 Smith, Roberta. "Designers for a Day: Sculptors Take a Turn." *New York Times,* 10 September 2004.

2005

A Little Romance: Highlights from the Permanent Collection, Museum of Contemporary Art, North Miami, Florida, February 12–April 3.

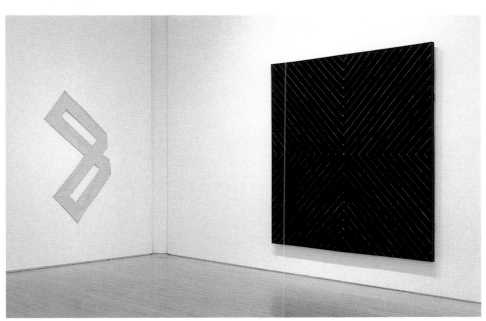

389 Installation view of the 2003 exhibition **Primary Matters: The Minimalist Sensibility, 1959 to the Present** at the San Francisco Museum of Modern Art, showing (from left to right) Richard Tuttle's **W-Shaped Yellow Canvas** (1967) and Frank Stella's **Zambezi** (1959)

SELECTED BIBLIOGRAPHY

The following represents a selection of Richard Tuttle's artist's books, statements, and books and periodicals that discuss the artist and his work. The first of these sections includes artist's books and other publications conceived or designed by Tuttle and published in conjunction with exhibitions. Entries are arranged chronologically by year published. For other catalogues and exhibition reviews, please consult the exhibition history on pages 357–75.

Thanks are due to Olga K. Owens, Karen Levine, and Joseph N. Newland for their assistance in gathering and verifying information.

ARTIST'S BOOKS

Sparrow. New York: Richard Tuttle, 1965.

Story with Seven Characters. New York: Richard Tuttle, 1965.

Two Books. Cologne: Galerie Rudolph Zwirner; New York: Betty Parsons Gallery, 1969.

Book. Lausanne: Paul Bianchini Books, Editions des Massons; Paris: Yvon Lambert, 1974.

Interlude: Kinesthetic Drawings. New York: Brooke Alexander, 1974.

Stacked Color Drawings 1971. New York: Brooke Alexander, 1974.

Poems: Larry Fagin / Drawings: Richard Tuttle. Bradford, NY: Topia Press, 1977.

Five by Seven for Yvon Lambert. A Study of 45°, Color, 5" x 7" Rectangle and Corrugated Cardboard. Nine Works by Richard Tuttle. Paris: Yvon Lambert, 1978.

Richard Tuttle: Title 1–6, Title I–VI, Title A–N, Title 11–16, Titre 1–8, Titolo 1–8. Amsterdam: Stedelijk Museum Amsterdam, 1979.

A Drawing Book. Vienna: Galerie Hubert Winter, 1983.

Neve. Bari, Italy: Galleria Marilena Bonomo, 1985.

Richard Tuttle. Mönchengladbach, Germany: Städtisches Museum Abteiberg, 1985.

Richard Tuttle. △s: Works 1964–1985 / Two Pinwheels: Works 1964–1985. London: Coracle Press / Institute of Contemporary Art; Edinburgh: Fruitmarket Gallery, 1985.

Richard Tuttle, le bonheur et la couleur. Bordeaux, France: CAPC Musée d'art contemporain de Bordeaux, 1986.

Berssenbrugge, Mei-mei. *Hiddenness.* New York: Library Fellows of the Whitney Museum of American Art, 1987.

Cutts, Simon, and Richard Tuttle. *Loophole.* London: Victoria Miro Gallery / Coracle Press, 1987.

Richard Tuttle: The Baroque and Color / Das Barocke und die Farbe. Graz, Austria: Neue Galerie am Landesmuseum Joanneum, 1987.

Richard Tuttle: I See in France. Contribution to exhibition catalogue *Richard Tuttle.* Paris: ARC, Musée d'art moderne de la ville de la Paris, 1987.

Richard Tuttle: Nîmes au Printemps. Nîmes, France: Galerie des Arènes, Musée d'Art Contemporain— Carré d'Art, 1987.

Richard Tuttle: Portland Works 1976. Cologne: Galerie Karsten Greve; Boston: Thomas Segal Gallery, 1988.

Richard Tuttle: Space in Finland. Düsseldorf: Galerie Schmela, 1988.

Richard Tuttle: XX Blocks. Bari, Italy: Galleria Marilena Bonomo, 1988.

40 Tage: Mit Einem Text des Kunstlers / Zeichnungen. Bonn: Galerie Erhard Klein; Vienna: Galerie Hubert Winter, 1989.

Eight Words from a Reading at Brooklyn College. Florence: Galleria Victoria Miro, 1990.

Lonesome Cowboy Styrofoam. New York: Blum Helman Gallery; Santa Fe: Gallery Casa Sin Nombre, 1990.

Octavo for Annemarie. Zurich: Annemarie Verna Galerie, 1990.

Richard Tuttle: Sprengel Museum Hannover. Hannover, Germany: Sprengel Museum Hannover, 1990.

Vienna Gotico. Rome: Galleria Alessandra Bonomo, 1990.

Early Auden. San Francisco: Hine Editions, 1991.

Guest, Barbara. *The Altos.* San Francisco: Hine Editions / Limestone Press, 1991.

Richard Tuttle: Crickets. Barcelona: Fundació "la Caixa," 1991.

Charge to Exist. Winterthur, Switzerland: Kunstmuseum Winterthur, 1992.

Oxyderood / Red Oxide. Rotterdam, the Netherlands: Museum Boymans-van Beuningen, 1992.

Plastic History. Munich: Wassermann Galerie, 1992.

The Poetry of Form: Richard Tuttle, Drawings from the Vogel Collection. Amsterdam: Institute of Contemporary Art; Valencia, Spain: Instituto Valenciano de Arte Moderno, 1992.

Book and Cover. Santa Fe: Tallgrass Press, 1993.

Folded Space. Berkeley: University Art Museum and Pacific Film Archive; Limestone Press, 1993.

Sphericity: Mei-mei Berssenbrugge, Poems; Richard Tuttle, Drawings. Berkeley: Kelsey Street Press, 1993.

Painted Frames, for Alma Ruempol. Munich: Wassermann Edition, 1995.

Pamphlet, 1995. Los Angeles: Kohn Turner Gallery, 1995.

Yeats, W. B. *The Gyres: Source of Imagery.* Poestenkill, NY: Kaldewey Press, 1995.

Richard Tuttle: Grey Walls Work. London: Camden Arts Centre, 1996.

Anthology. Edinburgh: Morning Star Publications, 1997.

I Thought I Was Going on a Trip But I Was Only Going Down Stairs. North York, Ontario: Art Gallery of York University, 1997.

390 Installation view of the 1998 exhibition
Richard Tuttle: Replace the Abstract Picture Plane, Books & New Works, The Kamm Collection of the Kunsthaus: A Selection by the Artist at the Kunsthaus Zug, Switzerland, showing Richard Tuttle's artist's books

Bernstein, Charles. *Reading Red*. Cologne: Verlag der Buchhandlung Walther König, 1998.

Berssenbrugge, Mei-mei, and Richard Tuttle. *Four Year Old Girl*. Berkeley: Kelsey Street Press, 1998.

Richard Tuttle: Small Sculptures of the 70s. Zurich: Annemarie Verna Galerie, 1998.

One Voice in Four Parts. New York: Printed Matter Inc., 1999.

Richard Tuttle: Community. Chicago: Arts Club of Chicago, 1999.

Open Carefully. New York: Sperone Westwater, 2000.

Perceived Obstacles. Cologne: Verlag der Buchhandlung Walther König, 2000.

Yau, John, and Christine Kintisch. *Richard Tuttle: Reservations*. Vienna: BAWAG Foundation, 2000.

Bernstein, Charles, and Ingrid Schaffner. *Richard Tuttle, In Parts, 1998–2001*. Philadelphia: Institute of Contemporary Art, University of Pennsylvania, 2001.

Rakusa, Ilma. *White Sails*. Zurich: Annemarie Verna Galerie, 2001.

Deedman, Heather, Richard Tuttle, and Zoe Irvine. *Cowboy Story*. Newcastle and Gateshead, UK: Morning Star / BALTIC: The Centre for Contemporary Art, 2002.

Berssenbrugge, Mei-mei. *Nest*. Bay Shore, NY: Universal Limited Art Editions; Berkeley: Kelsey Street Press, 2003.

Color as Language. New York: Drawing Center, 2004.

L'EXCÈS: cette mesure. Paris: Yvon Lambert, 2004.

Indonesian Textiles. Santa Fe: Tai Gallery / Textile Arts, 2004.

Richard Tuttle: Manifesto. Drawing Papers 49. New York: Drawing Center, 2004.

Dogs In A Hurry. Leeuwarden, the Netherlands: VHDG Publishers, 2005.

ARTIST'S STATEMENTS

[Statement.] In "Artists on Their Art." *Art International* 12 (15 May 1968): 48.

[Statement.] In Bruce Kurtz. "Documenta 5: A Critical Preview." *Arts Magazine* 46 (Summer 1972): 39.

"Work Is Justification for the Excuse." In *Documenta 5*, section 17, 77. Kassel, Germany: Museum Fridericianum, 1972. Reprinted in *Theories and Documents of Contemporary Art: A Sourcebook of Artists' Writings*, edited by Kristine Stiles. California Studies in the History of Art 35. Berkeley and Los Angeles: University of California Press, 1996.

"Richard Tuttle: Tre Mostre a Roma alla Galleria Ugo Ferranti, 1975, 1977, 1978." *Domus* 591 (February 1979): 47.

"*Book for Nigel Greenwood*: A Project by Richard Tuttle." *Artforum* 20 (Summer 1982): 45.

"A Love Letter to Fontana." In *Lucio Fontana*. Amsterdam: Stedelijk Museum Amsterdam; London: Whitechapel Art Gallery, 1988.

Tuttle, Richard, and Mei-mei Berssenbrugge. "Epilogue." In *Literary Vision*. New York: Jack Tilton Gallery, 1988.

"Kunst kann man so oder so nicht sehen—One Can See Art in This Way or Not in That." In *Moskau, Wien, New York: Kunst zur Zeit: Eine Ausstellung der Wiener Festwochen*, edited by Hubert Winter. Vienna: Der Festwochen, 1989.

"Quotation of the Day." *New York Times*, 11 February 1992.

Transcript of lecture. Skowhegan School of Painting and Sculpture, Skowhegan, Maine, 4 August 1995.

"Working the Land: Artists' Relationships to Their Place." In *Voices in New Mexico Art*, edited by David Turner and Susan Benforado Bakewell. Santa Fe: Museum of Fine Arts, Museum of New Mexico, 1996.

Richard Tuttle. Two audio discs. From the series *Construction of Memory*. Recording of speech given on 7 October 1996 at the School of the Art Institute of Chicago, Events and Exhibits, Visiting Artists Program.

"September 21, 1989, for Karl Hikade." In "Ripple Effects: Painting and Language," *New Observations*, no. 113 (Winter 1996): 30; and http://www.plexus.org/newobs/113/index.html.

"From Some Source." In *Tony Smith: Paintings and Sculpture 1960–65*. New York: Mitchell-Innes & Nash, 2001.

"Stopped and Started Motion." In *XLIX Esposizione d'arte: La Biennale di Venezia*. Venice: La Biennale di Venezia, 2001.

"Artists Curate: Cosmic Relief." *Artforum* 40 (February 2002): 116–21.

"What Does One Look at in an Agnes Martin Painting? Nine Musings on the Occasion of Her Ninetieth Birthday." *American Art* 16 (Fall 2002): 92–95.

[Statement on portfolio *Costume*.] In *Overview* [Crown Point Press newsletter] (Spring 2003): 1, 3.

"Richard Tuttle, 19 February 1998." In *Inside the Studio: Two Decades of Talks with Artists in New York*, edited by Judith Olch Richards. New York: Independent Curators International, 2004.

[Statement on portfolio *Type*.] In *Overview* [Crown Point Press newsletter] (June 2004): 1–2.

"Thesis, Antithesis, Synthesis." In *Design ≠ Art: Functional Objects from Donald Judd to Rachel Whiteread*. New York: Cooper-Hewitt, National Design Museum / Merrell, 2004.

BOOKS

Szeemann, Harald. *Live in Your Head: When Attitudes Become Form: Works—Concepts—Processes—Situations—Information*. Bern, Switzerland: Kunsthalle Bern, 1969.

Tucker, Marcia, and James Monte. *Anti-Illusion: Procedures/Materials*. New York: Whitney Museum of American Art, 1969.

Hunter, Sam. *American Art of the 20th Century*. Englewood Cliffs, NJ: Prentice-Hall; New York: Harry N. Abrams, 1973.

Krauss, Rosalind E. *Line as Language: Six Artists Draw*. Princeton, NJ: Princeton University Art Museum, 1974.

Tucker, Marcia. *Richard Tuttle*. New York: Whitney Museum of American Art, 1975.

Johnen, Jörg. *Poetische Punkte: Der Zufall als Erkenntinsprinzip im Werk von Richard Tuttle (Poetic Scores: The Coincidence as Realization Principle in the Work of Richard Tuttle)*. Cologne: Jörg Johnen, 1977.

Brown, Milton W., Sam Hunter, John Jacobus, Naomi Rosenblum, and David M. Sokol. *American Art: Painting, Sculpture, Architecture, Decorative Arts, Photography*. New York: Harry N. Abrams, 1979.

Verna, Gianfranco. *List of Drawing Material of Richard Tuttle & Appendices*. Zurich: Annemarie Verna Galerie, 1979.

Cummings, Paul. *Twentieth-Century Drawings: Selections from the Whitney Museum of American Art*. New York: Dover, 1981.

Hughes, Robert. *The Shock of the New*. New York: Alfred A. Knopf, 1981.

Freeman, Phyllis, Eric Himmel, Edith Pavese, and Anne Yarowsky, eds. *New Art*. New York: Harry N. Abrams, 1984.

Joosten, Joop M., ed. *20 jaar verzamelen : aanwinsten Stedelijk Museum Amsterdam, 1963–1984: schilder- en beeldhouwkunst / 20 Years of Art Collecting : Acquisitions Stedelijk Museum Amsterdam, 1963–1984: Painting and Sculpture*. Amsterdam: Stedelijk Museum Amsterdam, 1984.

Schjeldahl, Peter. *Art of Our Time: The Saatchi Collection*, vol. 1. London: Lund Humphries, 1984.

Cutts, Simon. *Palpa: For Richard Tuttle*. London: Victoria Miro Gallery, 1987.

Richard Tuttle: Wire Pieces. Bordeaux, France: CAPC Musée d'art contemporain de Bordeaux, 1987.

Baker, Kenneth. *Minimalism: Art of Circumstance*. New York: Abbeville Press, 1988.

Rudenstine, Angelica Zander. *Modern Painting, Drawing & Sculpture: Collected by Emily and Joseph Pulitzer, Jr.*, vol. 4. Cambridge, MA: Harvard University Art Museums, 1988.

Sandler, Irving. *American Art of the 1960s*. New York: Harper & Row, 1988.

Van Bruggen, Coosje. *Bruce Nauman*. New York: Rizzoli, 1988.

Hall, Lee. *Betty Parsons: Artist, Dealer, Collector*. New York: Harry N. Abrams, 1991.

Richard Tuttle. Amsterdam: Institute of Contemporary Art; The Hague: Sdu, 1991.

Wheeler, Daniel. *Art Since Mid-Century: 1945 to the Present*. New York: Vendome Press, 1991.

Kerber, Bernhard. *Bestände Onnasch*. Bremen: Neuen Museums Weserburg, 1992.

Strickland, Edward. *Minimalism: Origins*. 1993. Reprint, Bloomington and Indianapolis: Indiana University Press, 2000.

Richard Tuttle, Selected Works: 1964–1994. Tokyo: Sezon Museum of Art, 1995.

Brown, Kathan. *Ink, Paper, Metal, Wood: Painters and Sculptors at Crown Point Press*. San Francisco: Chronicle Books, 1996.

Butler, Cornelia H. *Afterimage: Drawing through Process*. Los Angeles: Museum of Contemporary Art; Cambridge, MA: MIT Press, 1999.

Gross, Jennifer. "Richard Tuttle: Reframing Modernism, 1965–1995." Ph.D. diss., CUNY Graduate Center, 1999.

Bee, Susan, and Mira Schor, eds. *M/E/A/N/I/N/G: An Anthology of Artists' Writings, Theory, and Criticism*. Durham, NC: Duke University Press, 2000.

Ratcliff, Carter. *Out of the Box: The Reinvention of Art 1965–1975*. New York: Allworth Press / School of Visual Arts, 2000.

Egan, Christine Jenny. "Drift—Transformationen im Werk Richard Tuttles, 1965/1975." Ph.D. diss., Kunsthistorisches Seminar, Basel, 2001.

Haldemann, Matthias, ed. *Richard Tuttle: Replace the Abstract Picture Plane*. Zug, Switzerland: Kunsthaus Zug; Ostfildern, Germany: Hatje Cantz, 2001.

Field of Stars: A Book on the Books / Richard Tuttle. Santiago de Compostela, Spain: Centro Galego de Arte Contemporánea, 2002.

Heartney, Eleanor, et al. *A Capital Collection: Masterworks from the Corcoran Gallery of Art*. Washington, D.C.: Corcoran Gallery of Art; London: Third Millennium, 2002.

Stroud, Marion Boulton. *New Material as New Media: The Fabric Workshop and Museum*. Cambridge, MA: MIT Press, 2002.

Waters, John, and Bruce Hainley. *Art—A Sex Book*. London: Thames & Hudson, 2003.

Richards, Judith Olch, ed. *Inside the Studio: Two Decades of Talks with Artists in New York*. New York: Independent Curators International, 2004.

Jenny, Christine. *Transformationen im Werk Richard Tuttles 1965–1975*. Berlin: Dietrich Reimer Verlag, 2005.

AUDIO / VIDEO

Brown, Kathan, and Bruce Schmeichen. *Ink, Paper, Metal, Wood: 35 Years at Crown Point Press*. Video. San Francisco: Crown Point Press; Fine Arts Museums of San Francisco, 1998.

Maybach, Chris, and Paul Gardner. *Art City: Simplicity*. Video. Los Angeles: Twelve Films, 2002.

[Artist profile.] *Art:21—Art in the Twenty-First Century*, season three. PBS, Fall 2005.

JOURNALS AND NEWSPAPERS

Rose. Barbara. "ABC Art." *Art in America* 53 (October–November 1965): 57–69.

"The Avant-Garde: Subtle, Cerebral, Elusive." *Time*, 22 November 1968.

Davis, Douglas M. "'This Is the Loose-Paint Generation': The New Painting Harks Back to Abstract Expressionism." *The National Observer*, 4 August 1969.

391 Cover of **Artforum** magazine, February 1970, showing Richard Tuttle's **Untitled** (1967)

392 Cover of **Arts Magazine,** November 1972, showing Richard Tuttle's **36th Wire Piece** (1972)

Pincus-Witten, Robert. "The Art of Richard Tuttle." *Artforum* 8 (February 1970): 62–67, and cover. Reprinted in *Postminimalism into Maximalism: American Art, 1966–1986*, by Robert Pincus-Witten. Ann Arbor: UMI Research Press, 1987. Also reprinted in *The New Sculpture 1965–75: Between Geometry and Gesture*, edited by Richard Armstrong and Richard Marshall. New York: Whitney Museum of American Art, 1990.

Lubell, Ellen. "Wire/Pencil/Shadow: Elements of Richard Tuttle." *Arts Magazine* 47 (November 1972): 50–52, and cover. Reprinted in *The New Sculpture 1965–75*, edited by Richard Armstrong and Richard Marshall. New York: Whitney Museum of American Art, 1990.

Celant, Germano. "La 'pittura fredda' americana / American 'Cool' Painting." *Domus* 523 (June 1973): 49–51.

Krauss, Rosalind. "Sense and Sensibility: Reflection on Post '60s Sculpture." *Artforum* 12 (November 1973): 43–53. Reprinted in *Minimalism*, edited by James Meyer. London: Phaidon, 2000.

Hodgson, Moira. "Creating the Eternal Moment." *Soho Weekly News*, 18 September 1975, 22, 24, 28.

North, Charles. "Richard Tuttle: Small Pleasures." *Art in America* 63 (November 1975): 68–69. Reprinted in *No Other Way: Selected Prose*. Brooklyn: Hanging Loose Press, 1998.

Perlmutter, E. F. "New Editions." *ARTnews* 74 (March 1975): 59.

Ratcliff, Carter. "Notes on Small Sculpture." *Artforum* 14 (April 1976): 35–42.

Loring, John. "Judding from Descartes, Sandbacking, and Several Tuttologies." *Print Collector's Newsletter* 7 (January–February 1977): 165–68.

Kertess, Klaus. "Imagining Nowhere." *Artforum* 22 (November 1983): 44–45.

Nadelman, C. "New Editions." *ARTnews* 82 (October 1983): 86–93.

Yau, John. "Richard Tuttle and His *Old Men and Their Garden*." *Arts Magazine* 57 (January 1983): 126–28.

Köcher, Helga. "Richard Tuttle: *Drawing Books*." *Kunstforum International* 71–72 (April–May 1984): 362–63.

"Secret Ways to Remain Happy No. 1–5." *Taidehalli* (Helsinki) 86 (1986).

Philpott, Clive. "Artist's Booklets." Printed Matter 1986–87 catalogue, http://www.printedmatter.org/about/booklets.cfm.

Morgan, Robert C. "Eccentric Abstraction and Postminimalism: From Biomorphic Sensualism to Hard-Edge Concreteness." *Flash Art* 144 (January–February 1989): 73–81.

Cohen, Ronny H. "Minimal Prints." *Print Collector's Newsletter* 21 (May–June 1990): 42–46.

Brunon, Bernard. "Richard Tuttle, *Collage-Drawings*." *Artstudio* (Paris) 23 (Winter 1991): 120–27.

Nobis, Beatrix. "Zwischen Abbruch und Aufbau des Werkes die Utopie verwirklichen: Anmerkungen zur Ironie in der Skulptur und Objektkunst der Gegenwart." *Kunst und Antiquitäten* 12 (1991): 50–55.

Alberge, Dalya. "Contemporary Art Market: 14-inch Plank Communicates Delicate Interplay for £6,000." *The Independent*, 20 January 1992.

Gardner, Paul. "Waking Up and Warming Up: How Some Artists Get Motivated to Work." *ARTnews* 91 (October 1992): 114–17.

Holman, Bob. "Richard Tuttle [interview]." *Bomb*, October 1992, 30–36.

"Multiples and Objects and Books." *Print Collector's Newsletter* 23 (July–August 1992): 106–7.

"Prints and Photographs Published." *Print Collector's Newsletter* 23 (July–August 1992): 103–6.

Harris, Susan. "Forum: Richard Tuttle's *Beckmann Drawing VII*." *Drawing* 15 (May–June 1993): 11–12.

Princenthal, Nancy. "Numbers of Happiness: Richard Tuttle's Books." *Print Collector's Newsletter* 24 (July–August 1993): 81–86.

Cross, G. "Exclusive Interview with Richard Tuttle." *The Magazine* 3 (April 1995): 8–13.

Diehl, Carol. "Birds, Beads, and Bannerstones: Twelve Artists Describe Their Personal Collections." *ARTnews* 95 (Summer 1996): 76–84.

Gardner, Paul. "Richard Tuttle's Paper Liberation." *On Paper* 1 (January–February 1997): 18–21.

MacAdam, Alfred. "An Affair with the Book." *ARTnews* 96 (September 1997): 72.

Storr, Robert. "*Just Exquisite?* The Art of Richard Tuttle." *Artforum* 36 (November 1997): 87–93, 130, and cover.

Searle, Adrian. "Arts: Splash on the Trash." *The Guardian*, 7 January 1997.

Sutherland, Giles. "Window on an Open Mind." *The Scotsman*, 30 June 1997.

Gardner, Paul. "Taking the Plunge." *ARTnews* 97 (February 1998): 110–13.

Whitney, Kathleen. "Richard Tuttle: No Way You Can Frame It." *Sculpture* 17 (March 1998): 32–37, and cover.

Kimmelman, Michael. "At the Met with Richard Tuttle: Influence Cast in Stone." *New York Times*, 14 May 1999.

Dannatt, Adrian. "NY Artist Q&A: Richard Tuttle." *Art Newspaper*, February 2000, 69.

Baker, Kenneth. "Soul Searching: Current Events Cast New Light on Visual Art." *San Francisco Chronicle*, 22 September 2001.

Hirsch, Faye. "Working Proof." *Art on Paper* 7 (December 2002): 54–57.

Kudielka, Robert. "Über Richard Tuttle." *Sinn und Form* 1 (2002): 131–34.

Moreno, Gean. "Emily's Way: Art as Idiosyncrasy." *Art Papers* 26 (January–February 2002): 13.

Perl, Jed. "Colors." *New Republic* 226 (4 & 11 March 2002): 27–30.

Storr, Robert. "Cosmic Relief: Richard Tuttle." *Artforum* 40 (February 2002): 116–21.

Siegel, Katy. "Shadow Boxes." *Bookforum*, Summer 2003, 55.

Gardner, Paul. "Odd Man In." *ARTnews* 103 (April 2004): 102–5.

Salamon, Julie. "Artist or Guru, He Aims Deep." *New York Times*, 3 December 2004.

393 Cover of **Artforum** magazine, November 1997, showing Richard Tuttle's **Waferboard 4** (1996)

INDEX

PHOTO CREDITS

Unless otherwise indicated below, all artworks by Richard Tuttle are reproduced courtesy of the artist.

Pls. 1–10: courtesy Moderna Museet, Stockholm; pl. 11: courtesy New-York Historical Society; pl. 12: © 2005 The Franz Kline Estate / Artists Rights Society (ARS), New York, photo by Richard Stoner, courtesy Carnegie Museum of Art, Pittsburgh; pl. 13: courtesy Trinity College and Richard Tuttle; pls. 14, 132, 182, 191, 291, 293, 300–301: J. P. Kuhn, courtesy Annemarie Verna Galerie, Zurich; pl. 15: courtesy *Art in America* / Brant Publications, Inc.; pl. 16: © Agnes Martin, courtesy PaceWildenstein, New York; pl. 17: © Judd Foundation, Licensed by VAGA, New York; pl. 19: © Estate of Robert Smithson / Licensed by VAGA, New York, courtesy James Cohan Gallery and the estate of Robert Smithson; pls. 20, 40, 46, 71, 80, 128, 131, 134, 202, 304, 307–8, 348: courtesy Sperone Westwater, New York; pl. 21: © Museum of Contemporary Art, Chicago; pl. 22: courtesy Kunstraum München; pl. 23: Dorothy Alexander; pl. 24: Harry Shunk, courtesy Dr. Harald Szeemann; pl. 25: Rob Crandall / Time & Life Pictures / Getty Images; pl. 26: courtesy Leo Castelli Gallery, New York; pls. 27, 379: courtesy IVAM, Instituto Valenciano de Arte Moderno, Generalitat Valenciana, Valencia, Spain; pl. 28: © Estate of Eva Hesse, Hauser & Wirth Zurich London; pl. 29: David Lees / Time & Life Pictures / Getty Images; pls. 30, 62, 86–89, 339–40, 381, 390: Guido Baselgia, courtesy Kunsthaus Zug, Switzerland; pl. 31: courtesy Sotheby's, New York; pl. 32: D. James Dee, courtesy Galerie Schmela, Düsseldorf, Germany; pls. 33, 54, 75, 197: courtesy Stedelijk Museum Amsterdam; pls. 34, 235, 253–61: Pat Pollard; pls. 35, 294, 299: Cathy Carver, NYC, © 2004, courtesy Drawing Center, New York; pls. 36, 391, 393: © *Artforum*; pls. 37, 48, 58–61, 90, 108–9,

146, 246, 289, 302, 321–31, 341–46, 349–53: Tom Powel, courtesy Sperone Westwater, New York; pl. 38: Ira Schrank, courtesy Crown Point Press, San Francisco; pl. 39: Per-Anders Allsten, courtesy Moderna Museet, Stockholm; pls. 41, 82: F. Rosenstiel, Cologne, courtesy the lender; pls. 42, 45, 52, 74, 149, 165, 183–84, 188, 195, 201, 248, 266–86, 306: courtesy the lenders; pl. 43: CNAC / MNAM / Dist. Réunion des Musées Nationaux / Art Resource, New York; pl. 44: Michael Tropea, courtesy Richard Tuttle; pl. 47: courtesy Anthony Meier Fine Arts, San Francisco; pls. 49, 211–20: courtesy Jack Tilton Gallery, New York; pls. 50, 388: Jerry L. Thompson, courtesy Whitney Museum of American Art, New York; pl. 51: courtesy Annemarie Verna Galerie, Zurich; pls. 53, 56, 122–24: Geoffrey Clements, courtesy Whitney Museum of American Art, New York; pl. 55: © Christie's Images Inc. 2005; pl. 57: Digital Image © The Museum of Modern Art / Licensed by SCALA / Art Resource, New York; pl. 63: © 2005 Estate of Rudy Burckhardt / Artists Rights Society (ARS), New York; pl. 64: © Robert Ryman, courtesy PaceWildenstein, New York; pl. 65: © 2005 Bruce Nauman / Artists Rights Society (ARS), New York, courtesy Leo Castelli Gallery, New York; pl. 66: © 2005 Artists Rights Society (ARS), New York / VG Bild-Kunst, Bonn, Germany, courtesy Blauel-Gnamm, Bayerische Staatsgemäldesammlungen, Sammlung Moderne Kunst in der Pinakothek der Moderne Munich and Kunstdia-Archiv ARTOTHEK, D-Weilheim; pl. 67: courtesy Galerie Schmela, Düsseldorf, Germany; pl. 68: © 2005 Frank Stella / Artists Rights Society (ARS), New York, photo by Lee Fatherree, courtesy Anderson Collection; pl. 69: Digital Image © The Museum of Modern Art / Licensed by SCALA / Art Resource, New York, artwork © 2005 Artists Rights Society (ARS), New York / SIAE, Rome; pl. 70: © 2005 Artists Rights Society (ARS), New York / VG Bild-Kunst, Bonn, Germany, courtesy Daros Services AG, Zurich; pl. 72: Martin Bühler, courtesy Kunstmuseum Basel, Switzerland; pls. 73, 106–7: courtesy Archives, Dallas Museum of Art; pls. 76, 110–19, 137, 139: Ben Blackwell; pls. 77, 177, 199, 226: André Morain, courtesy Collection Lambert en Avignon, France; pls. 78, 126, 153, 161: Beppe Gernone, courtesy Galleria Marilena Bonomo, Bari, Italy; pl. 79: Robert Pettus; pl. 81: courtesy Peter Freeman, Inc., New York; pl. 83: V. Döhne, courtesy Kaiser

Wilhelm Museum, Krefeld, Germany; pl. 84: Duane Michals, courtesy Pace/MacGill Gallery, New York; pls. 85, 92, 133, 232–34, 237–39, 245, 252, 290, 370, 375, 377, 386: courtesy Richard Tuttle; pl. 91: courtesy Walker Art Center, Minneapolis; pls. 93, 354: Attilio Maranzano, courtesy Museu Serralves, Porto, Spain; pl. 94: Roger Gass, courtesy Richard Tuttle; pls. 95–105: Michael Tropea; pls. 120, 145: courtesy Marcia Tucker; pl. 121: Andre Morain, courtesy Richard Tuttle; pls. 125, 129, 297: Lee Ewing, © Board of Trustees, National Gallery of Art, Washington, D.C.; pls. 127, 173: courtesy Lawrence Markey, San Antonio, Texas; pl. 130: Harrison Evans, courtesy the lender; pls. 135–36: courtesy Anthony Grant, Inc., New York; pl. 138: Ian Reeves; pl. 140: Photo by Peter Moore, © Estate of Peter Moore / VAGA, New York; pl. 141: courtesy Mel Bochner; pl. 142: © 2005 Robert Morris / Artists Rights Society (ARS), New York, courtesy Leo Castelli Gallery, New York; pl. 143: courtesy Museum of Contemporary Art, Los Angeles; pls. 144, 148, 151, 154–56, 158, 160, 162, 164, 166, 168–69, 172, 174–76, 178, 180, 185, 193–94, 208–10, 221–22: Ricardo Blanc, © Board of Trustees, National Gallery of Art, Washington, D.C.; pls. 147, 150, 152, 157, 159, 171, 179, 181, 186, 189, 250–51: © Lothar Schnepf / Kolumba, Cologne, Germany; pls. 163, 167: George Meister, courtesy the lender; pls. 170, 187: Tim McAfee, courtesy Museum of Contemporary Art, North Miami, Florida; pls. 190, 206, 223: D. James Dee, courtesy Peter Freeman, Inc., New York; pl. 192: courtesy Whitney Museum of American Art, New York; pl. 196: André Morin, courtesy Collection Lambert en Avignon, France; pl. 198: Fabrice Gousset; pl. 200: © Board of Trustees, National Gallery of Art, Washington, D.C.; pls. 203, 205: courtesy Zwirner & Wirth, New York; pl. 204: Giorgio Columbo, courtesy Galleria Marilena Bonomo, Bari, Italy; pls. 207, 224–25: Jason Mandella; pl. 223: Otto E. Nelson, courtesy Richard Tuttle; pls. 227–28: Jacques Hoepffner, courtesy Fondation Cartier pour l'art contemporain, Paris; pls. 229–30: Sofie Knijff; pl. 231: Michael Herling / Aline Gwose, courtesy Sprengel Museum Hannover, Germany; pl. 236: Enzo Enzel, courtesy Richard Tuttle; pl. 240: Mimmo Capone, courtesy Galleria Ugo Ferranti, Rome; pl. 241: © 1991 Metropolitan Museum of Art, New York; pl. 242: courtesy Galleria Marilena Bonomo, Bari, Italy; pl. 243: Bildarchiv Preussischer Kulturbesitz / Art Resource, New York; pl. 244:

Brad Flowers; pl. 247: courtesy Neue Galerie Graz am LM Joanneum, Austria; pl. 249: courtesy Kunsthaus Lempertz, Cologne; pl. 262: Bill Jacobson, courtesy Joseph Helman Gallery, New York; pl. 263: © 1987 Douglas M. Parker, courtesy Indianapolis Museum of Art; pl. 265: Phillippe de Gobert, courtesy Galerie Meert Rihoux, Brussels; pl. 287: Manfred Leve; pl. 288: © Judd Foundation, Licensed by VAGA, New York, photo by Lee Stalsworth, courtesy Hirshhorn Museum and Sculpture Garden, Smithsonian Institution, Washington, D.C.; pl. 292: courtesy Louisiana Museum for Moderne Kunst, Humlebaek, Denmark; pl. 295: courtesy Saint Louis Art Museum; pl. 296: Bill Orcutt, courtesy Richard Tuttle; pl. 298: © 2005 Museum Associates / LACMA; pl. 303: courtesy Sprengel Museum Hannover, Germany; pl. 305: Tom Jenkins, courtesy Modern Art Museum of Fort Worth; pl. 309: courtesy Kunstmuseum Winterthur, Switzerland; pl. 310: Adam Reich, courtesy Joseph Helman Gallery, New York; pl. 311: Will Brown, courtesy Fabric Workshop and Museum, Philadelphia; pl. 312: Ken Schles, courtesy A/D, New York; pl. 313: © Edina van der Wyck—Interior Archive; pl. 314: courtesy Editions Fawbush, New York; pl. 315: courtesy Dwight Hackett Projects, Santa Fe; pl. 316: courtesy Mary Boone Gallery, New York; pls. 317–18: Richard Tuttle; pl. 319: © Robert Reck.com; pl. 320: courtesy FRAC Auvergne, Clermont-Ferrand, France; pls. 332–338: courtesy Crown Point Press, San Francisco; pls. 355–64, 366–69, 371–74: Mark Ritchie, courtesy Centro Galego de Arte Contemporánea, Santiago de Compostela, Spain; pl. 347: Ben Blackwell, courtesy San Francisco Museum of Modern Art; pl. 365: Robert Ruehlman; pl. 376: Interfoto—Friedrich Rauch, courtesy Richard Tuttle—Friedrich Rauch, courtesy Richard Tuttle; pl. 378: Thomas Cugini, Zurich, courtesy Annemarie Verna Galerie, Zurich; pl. 380: courtesy University of California, Berkeley Art Museum; pl. 382: courtesy Modern Art Museum of Fort Worth; pl. 383: Eric Swanson, courtesy Tai Gallery / Textile Arts, Santa Fe; pls. 384, 394: Thomas Delbeck, courtesy Wolfsonian—Florida International University, Miami, Florida; pl. 385: © Virginia Museum of Fine Arts, courtesy Richard Tuttle; pl. 387: Paula Goldman, courtesy Richard Tuttle; pl. 389: Ian Reeves, courtesy San Francisco Museum of Modern Art.

This catalogue is published by the San Francisco Museum of Modern Art on the occasion of the exhibition *The Art of Richard Tuttle,* organized by Madeleine Grynsztejn at the San Francisco Museum of Modern Art.

Hardcover edition published in association with D.A.P. / Distributed Art Publishers, Inc., New York.

Exhibition Schedule:
San Francisco Museum of Modern Art
July 2–October 16, 2005

Whitney Museum of American Art, New York
November 10, 2005–February 5, 2006

Des Moines Art Center
March 18–June 11, 2006

Dallas Museum of Art
July 15–October 8, 2006

Museum of Contemporary Art, Chicago
November 11, 2006–February 4, 2007

Museum of Contemporary Art, Los Angeles
March 18–June 25, 2007

This exhibition is generously supported by The Henry Luce Foundation, Mimi and Peter Haas, the Edward E. Hills Fund, Helen and Charles Schwab, and Agnes Gund and Daniel Shapiro.

Additional support has been provided by the Andy Warhol Foundation for the Visual Arts, the National Endowment for the Arts, Shirley Ross Sullivan and Charles Sullivan, the Irving Stenn Family, the Kadima Foundation, the Frances R. Dittmer Family Foundation, Jeanne and Michael Klein, Tim Nye and the MAT Charitable Foundation, Craig Robins, Louisa Stude Sarofim, Sperone Westwater, Joseph Holtzman, Emily Rauh Pulitzer, and Carolyn and Preston Butcher.

Support for the catalogue has been provided by Anthony and Celeste Meier, the Neisser Family Fund, and Marion Boulton Stroud.

NATIONAL
ENDOWMENT
FOR THE ARTS

Director of Publications: Chad Coerver
Managing Editor: Karen A. Levine
Editor: Joseph N. Newland, Q.E.D.
Designers: Green Dragon Office, Los Angeles, Lorraine Wild and Robert Ruehlman with Stuart Smith
Production Manager: Nicole DuCharme
Publications Assistant: Lindsey Westbrook
Indexer: Elaine Luthy

Typeset in Scala and Scala Sans
Separations by Professional Graphics Inc., Rockford, Illinois
Printed and bound in Italy by Mondadori

Cover: **21st Wire Piece** (detail), 1972, dimensions vary with installation (see pls. 118–19)

Endsheets (hardcover edition only): Designed by Richard Tuttle, 2005

Frontispiece: **Ten, A** (detail), 2000, overall 40 x 40 x 4¹/₂ in. (see pl. 347)

Overleaf (pl. 394): View of Richard Tuttle's paper streamers installed on the exterior of the Wolfsonian—Florida International University, Miami, on the occasion of the 2004 exhibition **Beauty-in-Advertising**

Library of Congress
Cataloging-in-Publication Data
Tuttle, Richard, 1941–
The art of Richard Tuttle / edited
by Madeleine Grynsztejn.
p. cm.
Catalog of an exhibition at the San Francisco
Museum of Modern Art, July 2–Oct. 16, 2005.
Includes bibliographical references.
ISBN 1-933045-00-0 (hardcover)—
ISBN 0-918471-75-3 (pbk.)
1. Tuttle, Richard, 1941——Exhibitions.
I. Grynsztejn, Madeleine. II. San Francisco
Museum of Modern Art. III. Title.

N6537.T8A4 2005
709'.2—dc22

2005004159

DATE DUE

DISCARDED

HIGHSMITH #45230

Printed
in USA